PHOTOGRAPHING
THE DOLOMITES

VISIT THE MOST BEAUTIFUL PLACES, TAKE THE BEST PHOTOS

A PHOTO-LOCATION AND
VISITOR GUIDEBOOK

BY JAMES RUSHFORTH

SECOND EDITION

PHOTOGRAPHING
THE DOLOMITES
BY JAMES RUSHFORTH

First published in the United Kingdom in 2017 by fotoVUE.
www.fotovue.com

Copyright © fotoVUE Limited 2025.
Text and Photography: Copyright © James Rushforth 2025.
Foreword Copyright © Roberto Sysa Moiola 2017.

James Rushforth has asserted his right under the Copyright, Designs and Patents Act 1988 to be identified as the author of this work.

All rights reserved. No part of this book may be reproduced or transmitted in any form or by any means, electronic or mechanical, including photocopying, recording, or by any information storage and retrieval system without the written permission of the publisher, except for the use of brief quotations in a book review.

TRADEMARKS: fotoVUE and the fotoVUE wordmark are the registered trademarks of fotoVUE Ltd.

Edited by James Rushforth *and Mick Ryan – fotoVUE Ltd*
Photo editing by James Rushforth
® Design by Ryder Design – *www.ryderdesign.studio*
Layout by James Rushforth and Nathan Ryder

All maps within this publication were produced by Don Williams of Bute Cartographics.
Map location overlay and graphics by Mick Ryan.
Maps based on OpenStreetMap (Open Database License) licensed as CC BY-SA., SRTM topography data and local information sources.
© OpenStreetMap contributors, SRTM topography data 2025.

A CIP catalogue record for this book is available from the British Library.

ISBN 978-1-7395083-6-4
10 9 8 7 6 5 4 3 2 1

The author, publisher and others involved in the design and publication of this guide book accept no responsibility for any loss or damage users may suffer as a result of using this book. Users of this book are responsible for their own safety and use the information herein at their own risk. Users should always be aware of weather forecasts, conditions, time of day and their own ability before venturing out.

Front cover: *Cinque Torri in autumn (page 330). DJI Mavic Pro 3, 166mm, ISO 100, 1/500s at f/4, Oct.*
Rear cover left: *The moored up boats at Lago di Braies (page 94). Nikon Z7II, 24–120mm at 50mm, ISO 100, 1/200s at f/9, Oct.*
Rear cover right: *Looking south-east towards the Tre Cime from Monte Specie (page 104). Nikon Z7II, 24–120mm at 60mm, ISO 64, 1/400s at f/8, Oct. (page 104).*
Opposite: *The classic view of the Tre Cime di Lavaredo from Rifugio Locatelli. Nikon D810, 14–24mm at 14mm, ISO 100, 1/160s at f/6.3, June.*

Printed and bound in China by Latitude Press Ltd.

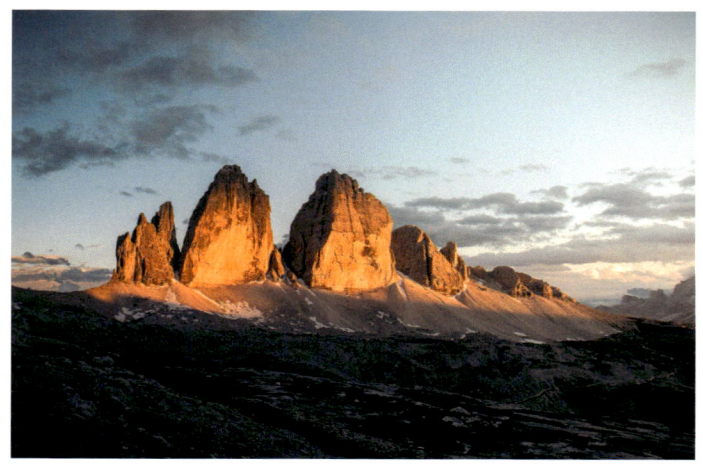

"A traveller who has visited all the other mountain-regions of Europe, and remains ignorant of the scenery of the Dolomite Alps, has yet to make acquaintance with Nature in one of her loveliest and most fascinating aspects."

John Ball, Guide to the Eastern Alps, 1868

CONTENTS

Locations overview	6
Acknowledgements	8
Foreword by Roberto Sysa Moiola	10
Introduction	12
Introduzione	14
Einführung	16

LOGISTICS

Getting To & Around The Dolomites	20
Venice	22
Where To Stay/Accommodation	26
Dolomites Lift Information	28
Dolomites Weather & Seasonal Highlights	32
Climate & Weather Charts	34
Mountain Safety	36
Using This Guidebook To Get The Best Images	42
Camera, Lenses & Captions	46
Photography Equipment	48
Location Planner	50
Access & Behaviour	52

HISTORY, CULTURE & WILDLIFE

Dolomites Geology	56
Dolomites Flora	58
Storm Vaia (Adrian) & The European Spruce Bark Beetle	60
Dolomites Fauna	62
Dolomites War History	64
Dolomites Culture	66
Dolomites Cuisine	68

VAL PUSTERIA

INTRODUCTION … 74
Area Map … 76

1	Terento Sentiero dei Mulini / Terenten Mühlenweg	78
2	Brunico / Bruneck	82
3	Piramidi di Terra a Perca / Erdpyramiden Percha	90
4	Lago di Braies / Pragser Wildsee	94
5	Monte Specie / Strudelkopf	104
6	Lago di Dobbiaco / Toblacher See	110

BOLZANO, CATINACCIO & CAREZZA

INTRODUCTION … 114
Area Map … 116

1	Bolzano / Bozen	118
2	Piramidi di terra di Longomoso / Erdpyramiden Lengmoos (Ritten)	124
3	Lago Carezza / Karersee	130
4	Torri del Vajolet / Vajoletturm	136
5	Val Duron	142

VAL DI FUNES & VAL GARDENA

INTRODUCTION … 146
Area Map … 148

1	Chiusa / Klausen	150
2	Monastero di Sabiona / Säben Viewpoint	154
3	Santa Maddalena / Magdalena	158
4	Chiesetta di San Giovanni in Ranui / St. Johann	162
5	Chiesa di San Valentino / St. Valentino Kirche	166
6	Alpe di Siusi / Seiser Alm	172
7	Chiesa di San Giacomo / St. Jakobs Kirche	184
8	Puez Odle / Geisler – Seceda & Col Raiser	186
9	Passo Gardena Prato / Grödner Joch Wiese	192
10	Passo Gardena / Grödner Joch	194

ALTA BADIA

INTRODUCTION … 203
Area Map … 202

1	Brigata Tridentina Viewpoint	206
2	Corvara – Rio Pissadú / Kurfar	210
3	Parrocchia di Colfosco / Pfarrkirche Kolfuschg	212
4	Pralongià	216
5	Sasso della Croce / Sass dla Crusc / Heiligkreuzkofel	222
6	Seres – Val di Morins / Muhlenweg	226
7	Passo delle Erbe / Würzjoch	230

PASSO SELLA, PORDOI & FEDAIA

INTRODUCTION … 237
Area Map … 236

1	Città dei Sassi / Steinerne Stadt	238
2	Sass Pordoi / Pordoi Spitze	250

3	Portavescovo	258
4	Torrente Avisio – Pent de Giaveis	262
5	Serrai di Sottoguda	266

VAL FIORENTINA & PASSO GIAU
INTRODUCTION 274
Area Map 275

1	Monte Civetta Viewpoint	276
2	Colle Santa Lucia	280
3	Passo Giau	282
4	Lago delle Baste	290
5	Tornanti al Passo Giau	292
6	Lago Federa – Croda da Lago	296

PASSO FALZAREGO
INTRODUCTION 306
Area Map 307

1	Sass de Stria / Hexenstein	310
2	Monte Lagazuoi	316
3	Lago Limides / Limedes	326
4	Cinque Torri	330
5	Sentiero Astaldi	346

CORTINA D'AMPEZZO & PASSO TRE CROCI
INTRODUCTION 353
Area Map 352

1	Malga ra Stua – Torrente Boite	354
2	Val di Fanes	362
3	Lago Ghedina	368
4	Cortina d'Ampezzo	374
5	Lago di Sorapis	378

MISURINA
INTRODUCTION 387
Area Map 386

1	Valle della Rienza / Rienztal	388
2	Lago di Landro / Dürrensee	390
3	Lago Misurina	394
4	Monte Piana / Piano	398
5	Lago Antorno	406
6	Tre Cime di Lavaredo / Drei Zinnen	416

| 7 | Monte Campedelle & Cadini di Misurina Viewpoint | 434 |

PALE DI SAN MARTINO
INTRODUCTION 440
Area Map 441

1	Val Focobon	442
2	Laghi di Colbricon	450
3	Cima & Lago Cavallazza	452
4	Monte Castellazzo	456
5	Baita Segantini & Cimon della Pala	460
6	Belvedere Geologica di Crode Rosse	466
7	Val Pradidali	470
8	Lago di Calaita	474

BRENTA
INTRODUCTION 478
Area Map 480

1	Lago Nambino	484
2	Via delle Bocchette	488
3	Vallesinella	492
4	Fogajard Viewpoint	496
5	Laghi di Corniselloe Lago Nero – Tre Laghi	498
6	Val Genova	508
7	Lago di Tovel	514
8	Molveno	518

FEATURE PAGES

Drone Information	524
Shows & Events	528
Mountain Sports – Climbing & Via Ferrata	534
Mountain Sports – Skiing & Ice Climbing	538
Mountain Sports – Road & Mountain Biking	540
Appendix A – Useful Contact Information	544
Appendix B – Glossary Of Place Names	546
Appendix C – Useful Phrases	548
About The Author – James Rushforth	550
About FotoVUE	552
Index	554

VAL PUSTERIA

1. Terento Sentiero dei Mulini / Terenten Mühlenweg 78
2. Brunico / Bruneck 82
3. Piramidi di Terra a Perca / Erdpyramiden Percha 90
4. Lago di Braies / Pragser Wildsee 94
5. Monte Specie / Strudelkopf 104
6. Lago di Dobbiaco / Toblacher See .. 110

BOLZANO, CATINACCIO & CAREZZA

1. Bolzano / Bozen 118
2. Piramidi di terra di Longomoso / Erdpyramiden Lengmoos (Ritten) .. 124
3. Lago Carezza / Karersee 130
4. Torri del Vajolet / Vajoletturm 136
5. Val Duron 142

ALTA BADIA

1. Brigata Tridentina Viewpoint 206
2. Corvara – Rio Pissadú / Kurfar 210
3. Parrocchia di Colfosco / Pfarrkirche Kolfuschg 212
4. Pralongià 216
5. Sasso della Croce / Sass dla Crusc / Heiligkreuzkofel 222
6. Seres – Val di Morins / Muhlenweg 226
7. Passo delle Erbe / Würzjoch 230

VAL DI FUNES & VAL GARDENA

1. Chiusa / Klausen 150
2. Monastero di Sabiona / Säben Viewpoint 154
3. Santa Maddalena / Magdalena ... 158
4. Chiesetta di San Giovanni in Ranui / St. Johann 162
5. Chiesa di San Valentino / St. Valentino Kirche 166
6. Alpe di Siusi / Seiser Alm 172
7. Chiesa di San Giacomo / St. Jakobs Kirche 184
8. Puez Odle / Geisler – Seceda & Col Raiser 186
9. Passo Gardena Prato / Grödner Joch Wiese 192
10. Passo Gardena / Grödner Joch 194

PASSO SELLA, PORDOI & FEDAIA

1. Città dei Sassi / Steinerne Stadt .. 238
2. Sass Pordoi / Pordoi Spitze 250
3. Portavescovo 258
4. Torrente Avisio – Pent de Giaveis .. 262
5. Serrai di Sottoguda 266

VAL FIORENTINA & PASSO GIAU

1. Monte Civetta Viewpoint 276
2. Colle Santa Lucia 280
3. Passo Giau 282
4. Lago delle Baste 290
5. Tornanti al Passo Giau 292
6. Lago Federa – Croda da Lago 296

PASSO FALZAREGO

1. Sass de Stria / Hexenstein 310
2. Monte Lagazuoi 316
3. Lago Limides / Limedes 326
4. Cinque Torri 330
5. Sentiero Astaldi 346

Elevation legend:
- 3000m +
- 2250 - 3000m
- 1500 - 2250m
- 750 - 1500m
- 0 - 750m

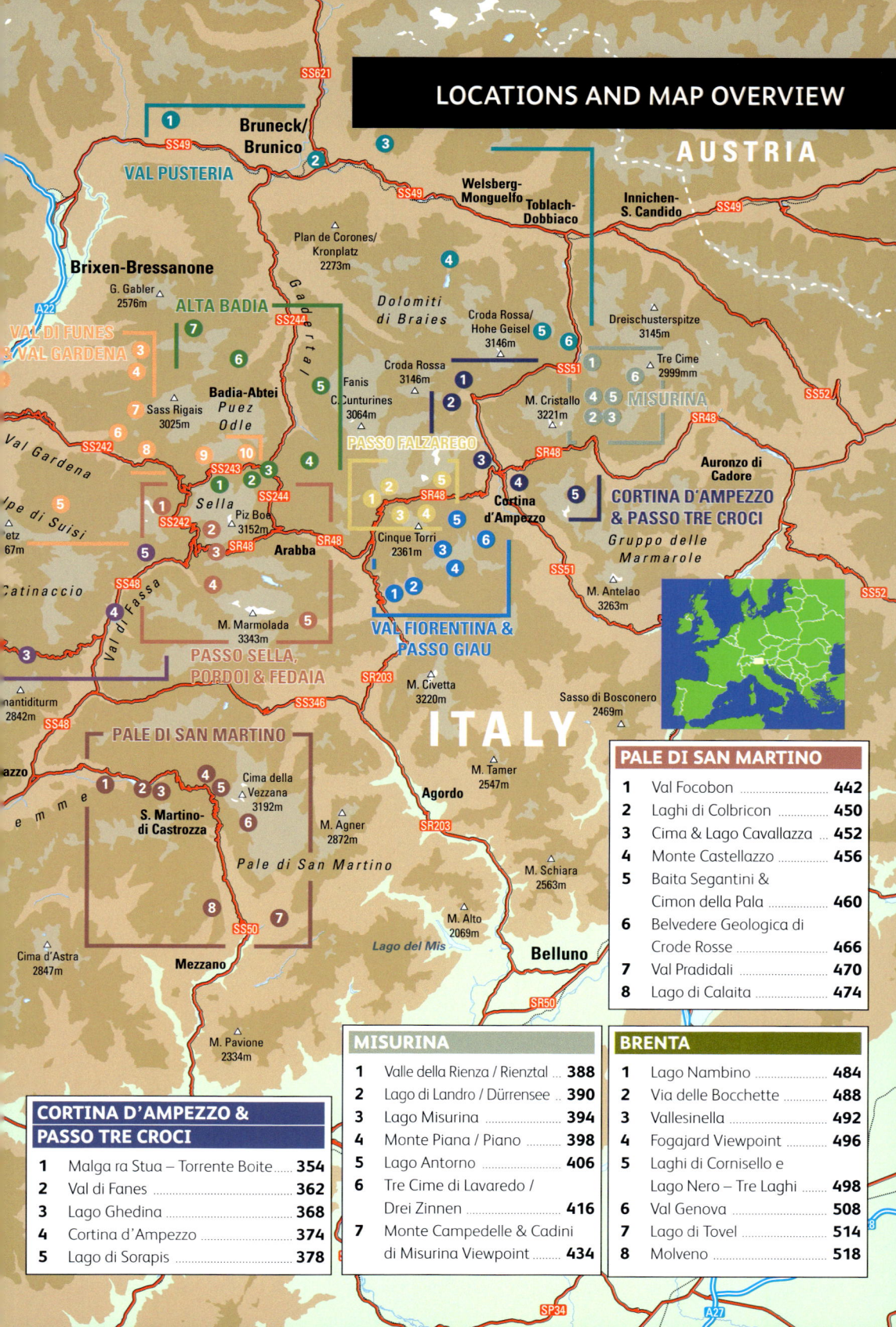

ACKNOWLEDGEMENTS

The creation of this guidebook was only made possible by the enormous and generous support of many people. First and foremost, thanks to everyone I've had the pleasure of sharing innumerable adventures with over the last two decades of exploration. Invariably it is the small details that keep you motivated – the repartee amongst friends following another 4 am start, good company in the mountains, a sunset shared and the inevitable post-day analysis over a Weissbier.

Thank you to all the local and visiting photographers who provided viewpoint and location information, stimulating new ideas and perspectives on classic vantage points and motivating me to find new ones. There was some excellent feedback from the first guide and I've tried to incorporate the various requests into this new edition.

My thanks to the Club Alpino Italiano, the Alpine Guides and the locals who work tirelessly to construct and maintain the paths, tracks, lifts and infrastructure that make the Dolomites so wonderfully accessible to all. This includes the many people who have worked hard to collate and document the wealth of information now available on the area.

As always my family have provided support, guidance and encouragement throughout the project. Thanks to everyone who endured the advances of a large lens pointed in their direction; in particular, Lynne Hempton who has accompanied me on so many adventures over the years – hiking, climbing, ski mountaineering and hiking.

Throughout the project, I've benefited from some excellent technical assistance from a great team. Thanks to Nathan Ryder for his design expertise, Don Williams of Bute Cartographics for creating the base maps, and to Lynne for proofreading once again.

Finally, my thanks to Mick Ryan of fotoVUE, who has assisted, steered and helped shape the evolution of this venture from a tentative email in 2014 to the second edition you now see before you.

James Rushforth
June 2025

A still winters morning at Chiesa di S.Vigilio in the Alta Badia. Nikon Z7II, 24–120mm at 24mm, ISO 64, 1/50s at f/11, Mar.

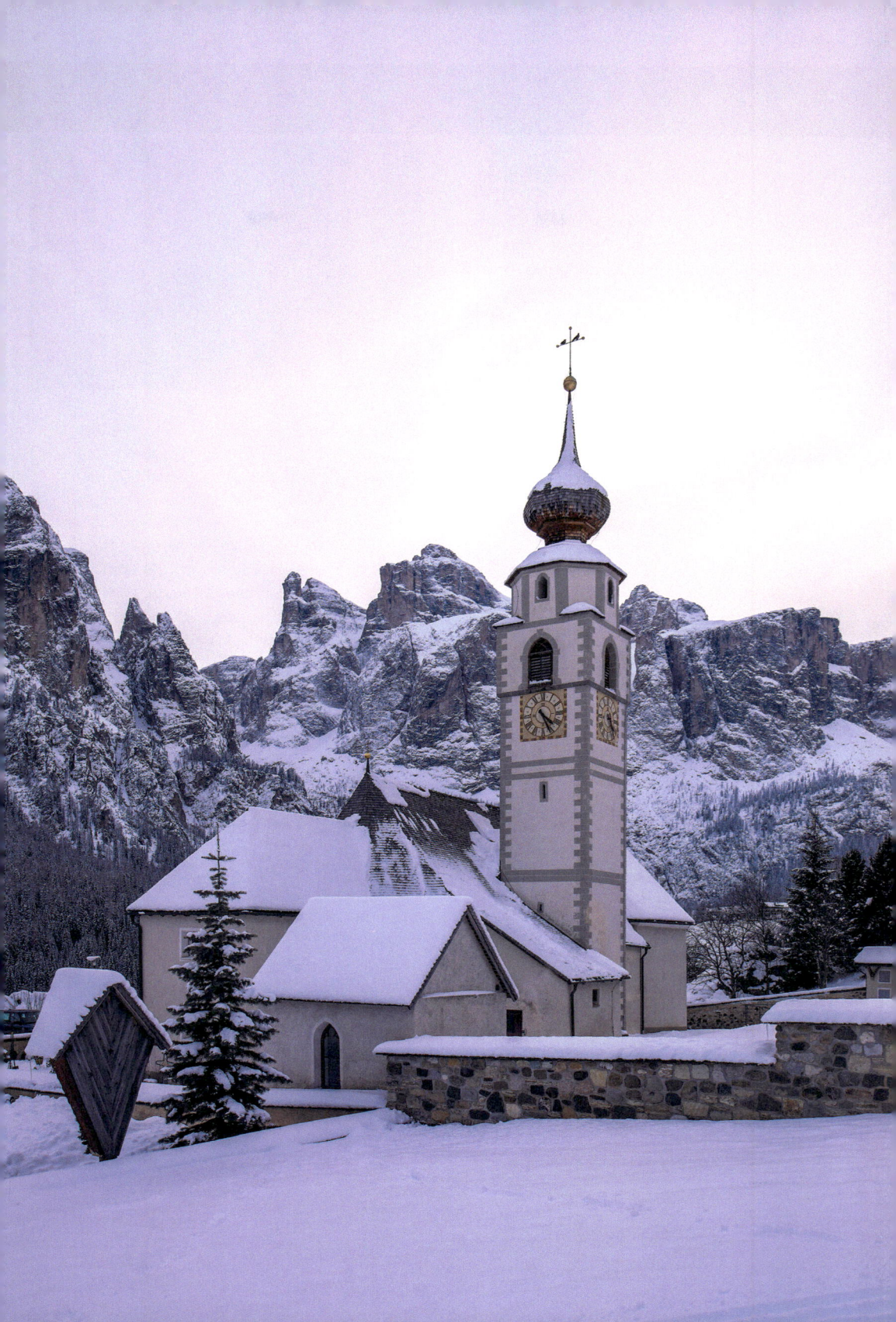

FOREWORD

Foreword by Roberto Sysa Moiola

High up in the eastern heart of the Alps, we are blessed with a view of extraordinarily beautiful and unique geological formations: the Dolomites. Standing before these great rock cathedrals, one is rewarded with fresh tremors of emotion every time. Unlike the mountains of the central and western Italian Alps, the so-called 'Pale Alps' are much more accessible and this is just one reason why, tourists from the world over come to the Dolomites to fall in love with these great and unimaginably shaped amphitheatres and spires.

And of course, such a place would not be complete without photographers who, with their increasing talent and artistic flair, succeed in capturing the Dolomites in its various forms of beauty. I have seen so many books about these mountains, so many photos on social media; they are on the covers of magazines and in the finals of the most prestigious photography competitions. And yet, turning the pages of this new masterpiece by James Rushforth, we are shown just how much remains to be expressed as we travel these mountains, whether from the roadside on the Pordoi Pass or seeking solitude on Via Ferrata Giovanni Lipella on Tofana di Rozes. It is a truly complete work, the result of many years spent exploring the Dolomites far and wide, working, travelling and sleeping in a van.

This is the incredible story of this young British photographer, the hallmark of his work simply his love for adventure and the mountains. His photographs capture those special characteristics which make the Dolomites such a unique place: the warm kiss of Enrosadira on the Dolomia, the silent clouds caressing the limestone, the streams bubbling in the green forests, the clarity of the star-studded sky in this part of Italy which thus far has escaped the effects of light pollution.

Let yourself be transported by one of the greatest mountain photographers in the world, using his practical guide to find out how to reach each location, when to go and the best time of year to visit these breathtaking places.

Roberto Sysa Moiola
President of Clickalps, Italian Photo Agency
August 2017

Torre Wundt and the Tre Cime di Lavaredo. Canon 5D Mark II, 24–70mm at 30mm, ISO 250, 1/125s at f/5.6, Jun. © Roberto Sysa Moiola.

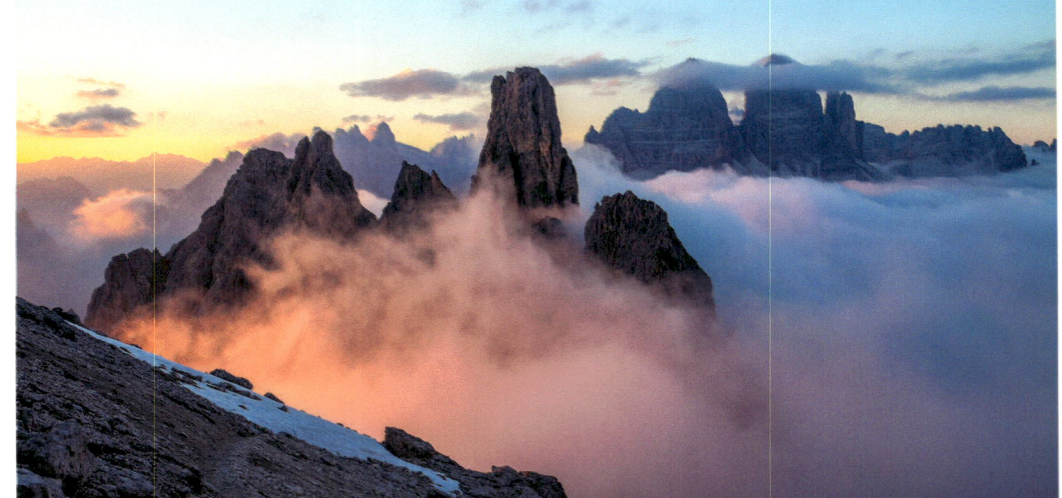

Prefazione da Roberto Sysa Moiola

E' lassù, nel cuore orientale delle Alpi, che possiamo ammirare formazioni geologiche uniche al mondo; le Dolomiti. Ogni volta che ci si presenta di fronte a queste cattedrali di roccia è un sussulto. A differenza delle montagne nelle Alpi Centrali e Occidentali d'Italia i Monti Pallidi sono ben più accessibili e questo ha fatto sì che oggi, il turismo mondiale, venga ogni anno ad innamorarsi di questi anfiteatri e obelischi dalle forme inimmaginabili.

E non possono mancare di certo i fotografi che, con la loro crescente bravura ed arte, riescono a presentare ogni giorno le Dolomiti nelle più svariate forme di bellezza. Ho visto molti libri su queste montagne, tante foto ogni giorno animano i social network, sono in copertina alle riviste o vanno in finale ai concorsi più prestigiosi. Eppure, sfogliando le pagine del nuovo capolavoro di James Rushforth abbiamo la dimostrazione di quanto ancora ci sia da esprimersi nel girovagare tra queste montagne, che si tratti di uno scatto a bordo strada al Passo del Pordoi oppure in solitaria sulla ferrata Giovanni Lipella.

Un lavoro davvero completo, frutto di cinque anni spesi a girovagare in lungo e in largo le Dolomiti con l'appoggio di un van. E' questa l'incredibile storia del ragazzo inglese, biglietto da visita con stampato l'amore verso la montagna e l'esplorazione. Le sue fotografie riescono a raccontarci quelle caratteristiche particolari che fanno delle Dolomiti un luogo unico: l'Enrosadira che con il suo calore bacia la dolomia, le nuvole che sbattendo silenziose accarezzano il calcare, i ruscelli che scorrono nei verdi boschi, il cielo stellato di rara nitidezza in questa porzione d'Italia ancora risparmiata dall'inquinamento luminoso. Lasciatevi trasportare e guidare da uno dei più bravi foto-alpinisti mondiali, con delle pratiche schede che ci danno utili consigli su come raggiungere le location, agli orari e nelle stagioni migliori.

Vorwort von Roberto Sysa Moiola

Hier oben im östlich gelegenen Herzen der Alpen können wir weltweit einmalige geologische Formationen bewundern: die Dolomiten. edes Mal, wenn man vor diesen wie Kathedralen wirkenden Felsen steht, beginnt das Herz schneller zu schlagen. Anders als die Berge in den Zentral- und Ostalpen sind die „Monti Pallidi" (die bleichen Berge) viel zugänglicher, weshalb sich heute jedes Jahr Touristen aus aller Welt in diese Amphitheater und Obelisken mit ihren unvorstellbaren Formen verlieben.

Selbstverständlich gilt das auch für Fotografen, denen es mit ihrem stetig wachsenden Können und ihrer Kunst gelingt, die Schönheit der Dolomiten jeden Tag in den unterschiedlichsten Formen zu erfassen. Ich habe mir viele Bücher über diese Berge angesehen und auch viele Fotos, die täglich die sozialen Netzwerke beleben, auf den Titelblättern von Zeitschriften abgebildet sind oder bei den namhaftesten Wettbewerben zu den Finalisten gehören. Beim Durchblättern des neuen Meisterwerks von James Rushforth wird uns jedoch bewusst, wie viele Dinge es noch zu entdecken gibt, wenn man in diesen Bergen wandert. Sei es nun ein Foto am Straßenrand am Pordoijoch oder in einer von der Welt abgeschiedenen Gegend auf dem Klettersteig Giovanni Lipella.

Es ist ein vollendetes Werk und das Ergebnis eines fünfjährigen Streifzugs, der in einem Van kreuz und quer durch die Dolomiten führte. Das ist die unglaubliche Geschichte eines jungen Engländers, auf dessen Visitenkarte die Liebe zu den Bergen und zur Entdeckung aufgedruckt ist. Seine Fotografien erzählen von jenen Besonderheiten, die Dolomiten zu einem einzigartigen Ort machen: vom Alpenglühen („Enrosadira"), bei dem die Abendsonne die Berge in feurigem Rot erstrahlen lässt, von den Wolken, die den Kalkstein sanft umhüllen, von den Bächen, die in den Wäldern fließen, und vom sternenübersäten Himmel, der in diesem Teil von Italien noch von der Lichtverunreinigung verschont geblieben ist. Lassen Sie sich von einem der besten bergsteigenden Fotografen der Welt begleiten und führen. Die praktischen Karten mit Beschreibungen enthalten nützliche Tipps, wie und in welcher Zeit man die Orte erreicht und welche Jahreszeit die beste ist, um sie zu entdecken.

INTRODUCTION

Located in northern Italy, the majestic spires of the Dolomites are widely regarded as the most photogenic mountain range on the planet. Indeed it is rare to see an international landscape photography competition without at least one finalist image featuring these stunning natural formations. Once known as the Monti Pallidi or 'Pale Alps', the carbonate rock takes its current name from the 18th-century French mineralogist Déodat Gratet de Dolomieu and is characterised by impossibly steep towers, spires, pinnacles, jagged ridges and sharp pinnacles that thrust skyward from the picturesque villages and alpine meadows below. These resplendent peaks are often likened to natural cathedrals and invoke an almost religious sense of wonder among the South Tyrolean populace and visitors alike.

Spanning some 500 square miles, this complex labyrinth of rock walls, forest, rivers, alpine pastures and wildflower meadows is surprisingly accessible. The excellent road, transport and lift networks found within the Dolomites ensure that many of the locations included in this guide are blessed with short approaches that can be enjoyed by photographers with limited mobility. For the intrepid adventurer, possibilities abound and there are many hidden gems located off the beaten track which can be enjoyed in solitude. The area was designated a UNESCO World Heritage Site in 2009 and is exceptionally diverse from a photographer's perspective, both in terms of appearance and culture. The unique mélange of Italian, Austrian and Ladin societies has created a trilingual community which is exceptionally distinct in nature and rich in heritage, and the resulting Tyrolean architecture, traditional dress and farming methods provide the perfect foreground to the varied and ever-changing backdrops.

Over the last two decades, I've had the pleasure of exploring the Dolomites high and low, through the day and night, in summer and winter, climbing, ski mountaineering and hiking. My discoveries and favourite places are detailed in this guide; I hope you find it a useful resource that serves as a creative catalyst to one of my favourite places in the world. The images I've selected are designed to inspire your own personal interpretations of these beautiful places and I would encourage every photographer to exercise their own unique style while using this book as a reference point. The contents are by no means exhaustive and despite this being the second edition and my fourth Dolomite guidebook to the region, I do not doubt that there is still so much here that I have yet to discover.

I hope that these beautiful landscapes inspire you as much as they have me. Wishing you exciting adventures, good light and most of all an enjoyable trip to the Dolomites.

James Rushforth
June 2025

On the initial traverse of Via Ferrata Bocchette Centrali (p.488). Nikon 24–120mm at 24mm, ISO 64, 1/1000s at f/8, Aug.

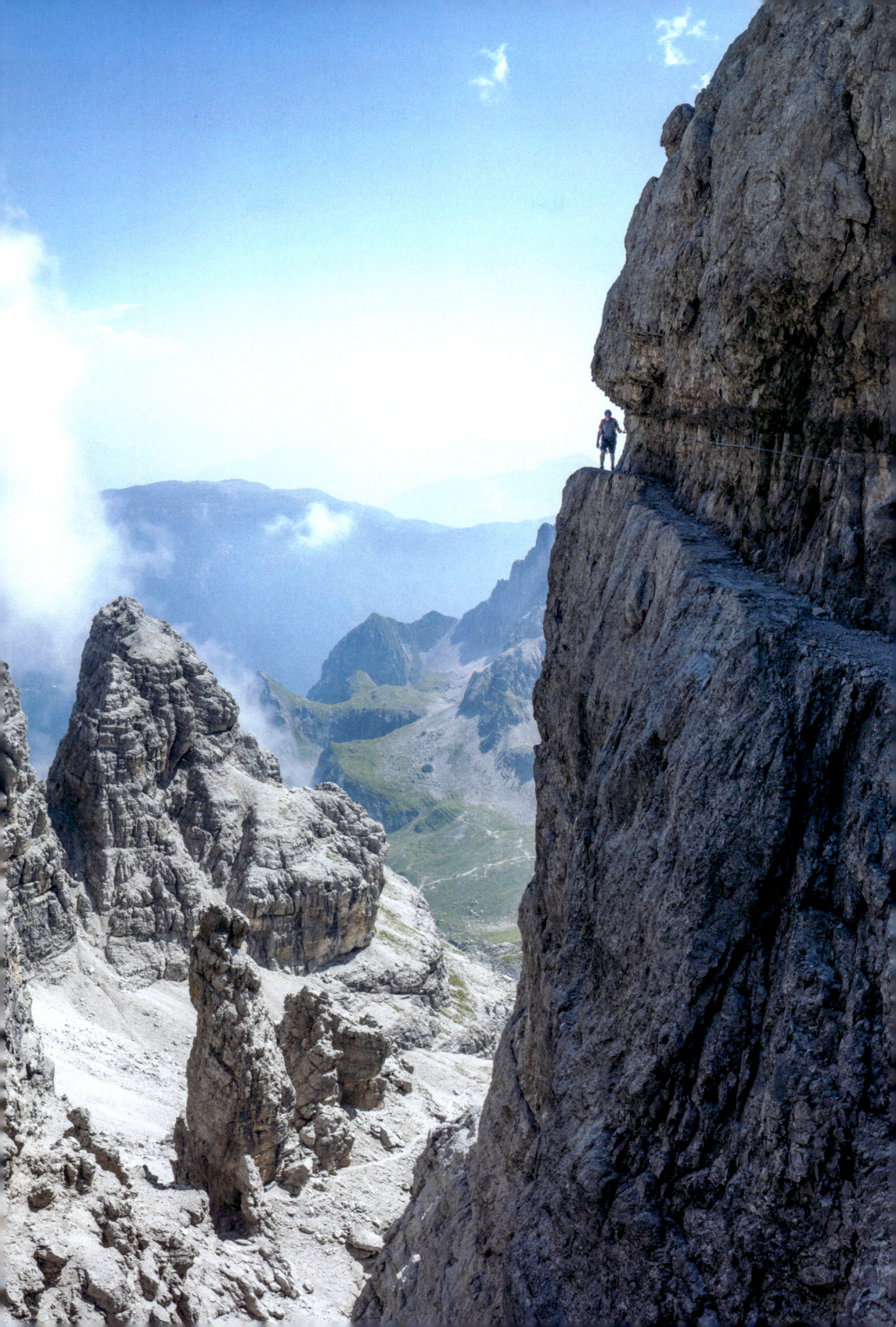

INTRODUZIONE

Situate nel nord Italia, le maestose guglie delle Dolomiti sono ampiamente considerate il paesaggio più fotogenico del mondo, ed è raro vedere un concorso fotografico internazionale senza almeno un'immagine finalista che mostra questi fenomeni naturali. Chiamati anche "Monti Pallidi", la loro roccia carbonata prende il nome attuale dal mineralologo francese Déodat Gratet de Dolomieu. Sono caratterizzati da ripide torri, guglie, creste addentellate e pinnacoli che salgono verso il cielo dai villaggi e dai prati idilliaci che costellano le valli. Queste cime splendenti sono spesso paragonate a delle cattedrali naturali ed evocano un senso quasi religioso di meraviglia sia tra la gente del luogo sia dai turisti venuti da lontano.

Esteso per circa 800 chilometri quadrati, questo complesso labirinto di muri, boschi, torrenti, pascoli e prati di fiori alpini è molto più accessibile di quanto si potrebbe immaginare. Grazie alla rete di strade, mezzi pubblici e impianti, molti luoghi descritti in questa guida sono dotati di accessi molto corti che possono essere affrontati anche da fotografi con mobilità ridotta. Per gli esploratori più intrepidi ci sono infinite possibilità con tanti gioielli nascosti e lontani dei percorsi battuti dove si può godere dell'ambiente in assoluta solitudine. La zona è stata designata sito di patrimonio mondiale UNESCO nel 2009 e offre una vasta gamma di possibilità dal punto di visto fotografico, non solo nei confronti dei paesaggi montuosi ma anche in termini di folklore e tradizioni. La miscela unica di storia italiana, austriaca e ladina ha creato una comunità trilingue molto particolare, ricca di cultura con il conseguente risultato nell'architettura, nei costumi tipici e nelle attività agrarie. Tutto questo offre la scena ideale, in contrasto ai vari sfondi in continua evoluzione.

Nell'ultimo decennio ho avuto il piacere di poter esplorare le Dolomiti in mille modi, le montagne e le valli, di giorno e di notte, in estate e in inverno, a piedi, con le scarpe da roccia e sugli sci. I miei luoghi preferiti sono descritti in questa guida che spero vi possa servire come un'utile risorsa e che agisca da stimolo creativo per un posto che ormai è la mia casa. Le immagini inserite nelle pagine seguenti sono state scelte per aiutare a ispirare le interpretazioni personali verso questi bellissimi luoghi e incoraggino ogni fotografo a intraprendere un suo stile originale, usando questo libro soltanto come punto di riferimento. Infatti, i contenuti non sono affatto esaustivi e malgrado il fatto che questa sia la mia quarta guida sulle Dolomiti, non ho dubbi che esistano ancora tantissimi luoghi ed eventi che io stesso non ho ancora scoperto.

Spero che questi paesaggi bellissimi vi ispirino quanto hanno ispirato me e vi auguro una vacanza produttiva, creativa ma soprattutto emozionante e memorabile nelle Dolomiti.

James Rushforth
June 2025

Afternoon light on the Tre Cime south faces as seen from Lago Antorno (p.416). Nikon D810, 28–300mm at 50mm, ISO 100, 50s at f/29, tripod, ND filter, Jun.

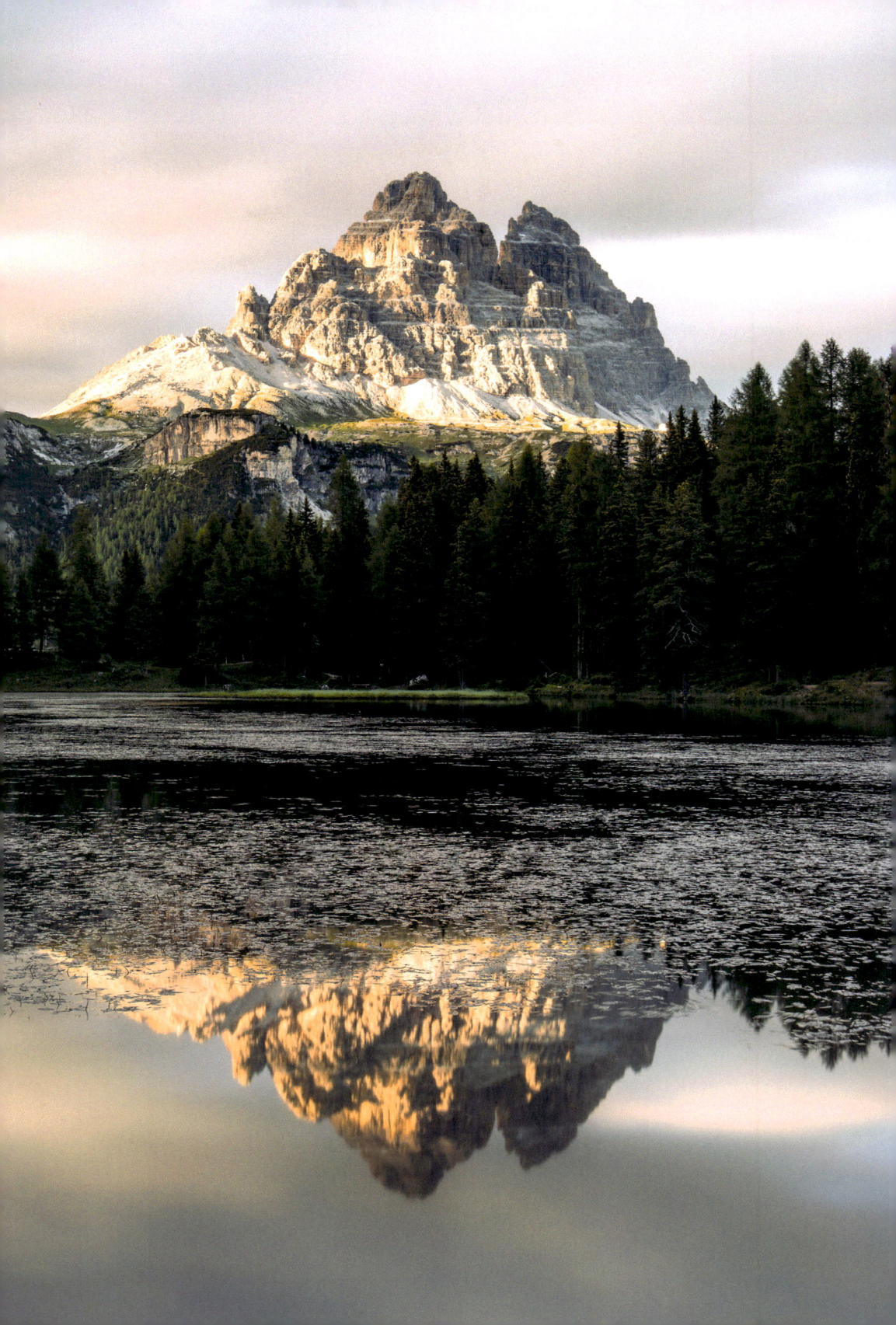

EINFÜHRUNG

Die majestätischen Türme der norditalienischen Dolomiten gelten weithin als die fotogenste Bergkette unseres Planeten und man trifft tatsächlich nur selten auf einen internationalen Wettbewerb zur Landschaftsfotografie, bei dem es nicht wenigstens ein Bild dieser atemberaubenden Bergformationen in die Endauswahl schafft. Einst als Monti Pallidi oder „Blasse Alpen" bekannt, verdankt das Karbonatgestein seinen heutigen Namen dem französischen Mineralogen Déodat Gratet de Dolomieu. Es ist geprägt von unglaublich steilen Türmen, Spitzen, scharfen Felsnadeln und gezackten Felsgraten, die hoch über den malerischen Dörfern und Gebirgswiesen im Tal aufragen. Diese prächtigen Gipfel werden oft mit majestätischen Naturkathedralen verglichen und rufen sowohl bei der Südtiroler Bevölkerung als auch unter Touristen ein fast religiöses Staunen hervor.

Dieses komplexe Labyrinth von Felswänden, Wäldern, Flüssen, Hochgebirgsweiden und Wildblumenwiesen, das sich über eine Fläche von circa 500 Quadratkilometern erstreckt, ist erstaunlich leicht zugänglich. Die hervorragenden Straßen, Transport- und Liftverbindungen in den Dolomiten machen es möglich, tfnen sich unzählige Möglichkeiten und es finden sich abseits der häufig begangenen Wege viele versteckte Juwele, die man in völliger Einsamkeit bewundern kann.

Im Jahr 2009 wurde die Gegend zum UNESCO Welterbe ernannt. Aus dewvr Perspektive eines Fotografen verfügt sie über eine außergewöhnliche Vielgestaltigkeit in optischer und kultureller Hinsicht. Die einzigartige Mischung italienischer, österreichischer und ladinischer Gemeinschaften hat eine dreisprachige Gesellschaft geschaffen, die sich durch den besonderen Charakter ihrer Natur und ihr reiches kulturelles Erbe auszeichnet.

Die daraus entstandene Tiroler Architektur, die Trachten und die landwirtschaftlichen Methoden liefern den perfekten Vordergrund für die unterschiedlichen, sich ständig verändernden Kulissen im Hintergrund.

In den vergangenen zehn Jahren hatte ich das Vergnügen, die Dolomiten in ihrer ganzen Vielfalt zu erforschen, beim Klettern, Skifahren und Wandern, zu allen Tages- und Jahreszeiten. Meine Entdeckungen und Lieblingsplätze werden in diesem Buch ausführlich dargestellt. Ich hoffe, dass es dem Leser als nützliche Quelle dient und ihm ein kreativer Anstoß zur Begegnung mit einer Gegend sein kann, die für mich mittlerweile zur Heimat geworden ist. Die Bilder, die ich ausgesucht habe, sollen zur persönlichen Begegnung mit dieser wunderbaren Landschaft anregen. Ich möchte jeden Fotografen dazu ermutigen, seinen eigenen, persönlichen Stil zu realisieren und dieses Buch einfach als Bezugspunkt zu nutzen. Der Inhalt ist in keiner Weise vollständig: Dies ist mein viertes Buch über die Dolomiten, doch ich bin sicher, dass es dort immer noch viel für mich zu entdecken gibt.

Ich hoffe, dass diese wunderschönen Landschaften den Leser genauso inspirieren wie mich und wünsche Ihnen allen eine produktive, kreative und genussvolle Reise in die Dolomiten.

James Rushforth
June 2025

Opposite: The superbly situated Rifugio Nuvolau high above the Passo Giau (p.282).

Next spread: Tre Cime di Lavaredo at sunset (p.416). Nikon D850, 14–24mm at 14mm, ISO 100, 1/100s at f/6.3, Jun.

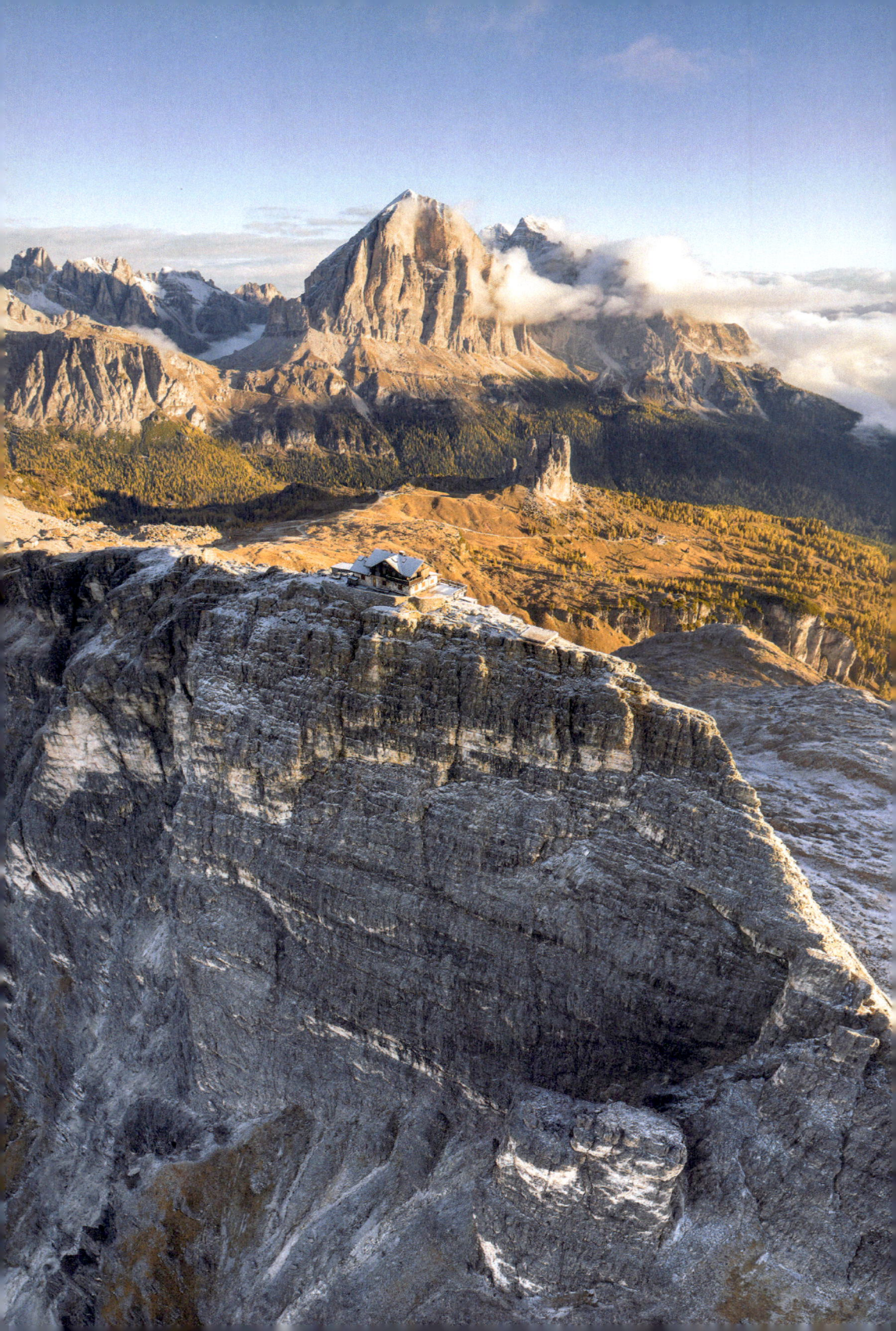

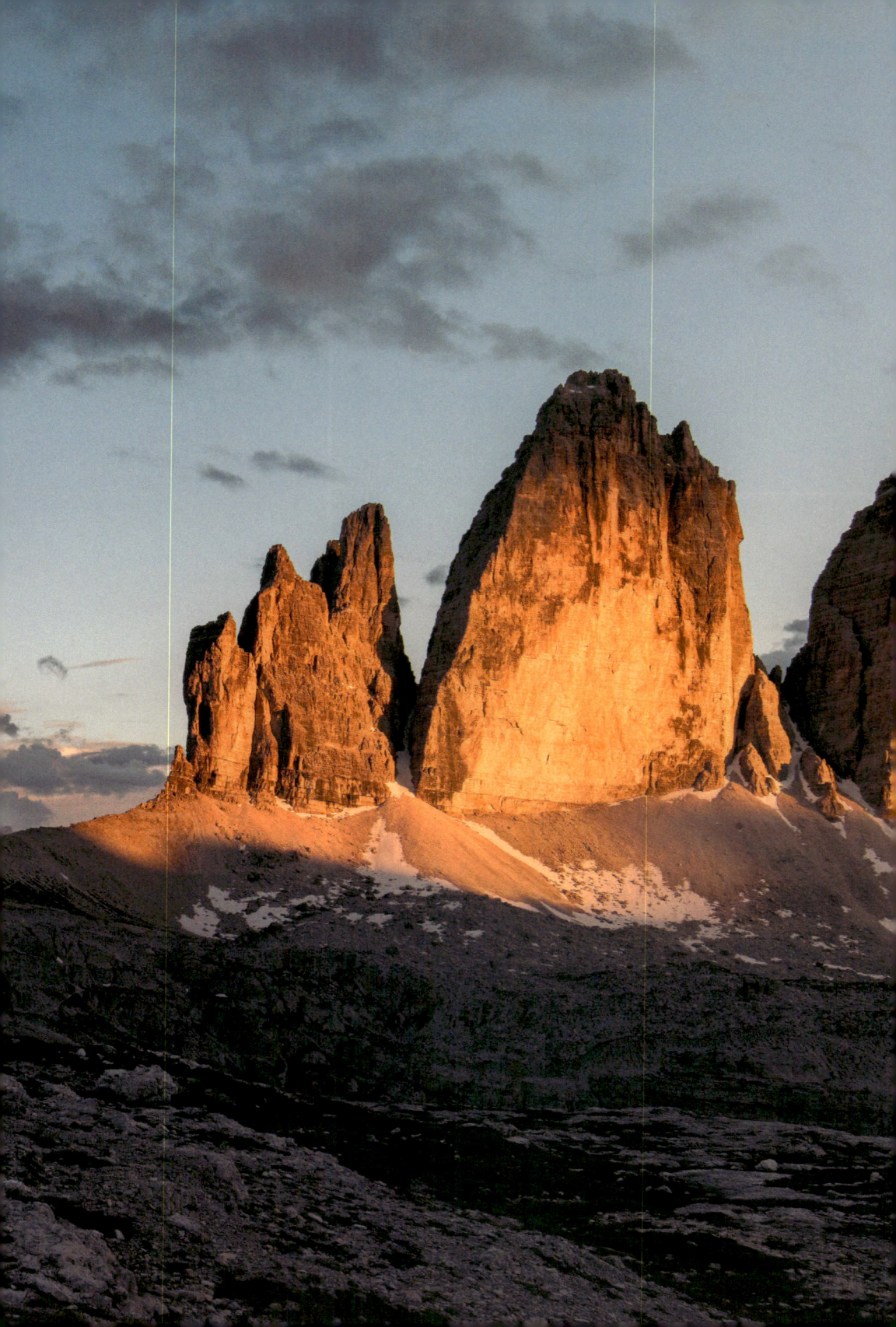

DOLOMITES LOGISTICS

GETTING TO AND AROUND THE DOLOMITES

The Dolomites are located equidistant between Venice (and Treviso), Innsbruck and Verona, all of which can be reached from the UK by budget airlines. Other airport options are Munich, Brescia and Bergamo. It is possible to continue to the Dolomites by public transport and private shuttle services, but given the difficulties in accessing many of the locations in this guide by bus, it is recommended to hire a car at the airport and complete the journey by road. Rough distances and driving times to Cortina d'Ampezzo from the major airports are given below:

Major airport distance & drive times

Treviso	130 km, 2h 10 min
Venice Marco Polo	149 km, 2h 10 min
Innsbruck	163 km, 2h 25 min
Verona Villafranca Airport	270 km, 3h 00 min
Brescia	322 km, 3h 40 min
Munich	357 km, 3h 50 min

Car hire

Car hire is available at all the major airports. You will need your driving licence, a credit card and a substantial deposit. The comparison site *www.carrentals.co.uk* is a useful resource for sorting through the maze of companies and offers, but be aware that the cheapest prices offered usually sting you for expensive compulsory insurance at the pick-up desk. If you're hiring during the winter and spring (between the 15th November and the 15th April), vehicles driving in the Dolomites are required to have either snow tyres or snow chains. It is best to book these in advance.

Self drive

If you wish to bring your own vehicle, the fastest route from the UK is through France and takes around 12 hours. However, the French motorway tolls make this an expensive option and as such a route through Belgium, Germany and Austria is a slightly longer but more affordable alternative – allow 14 hours. Italian motorways are tolled while Austria operates a Vignette system – this can be purchased at petrol stations and motorway services and is available for ten days, two months or a year. The Brenner pass, the main road in from Austria, has a separate, fixed toll of around €10.

Italian road rules

Italian road rules differ from UK regulations in several respects. Current road rules for Italy can be checked at: *www.rac.co.uk/drive/travel/country/italy*

- Driving takes place on the right-hand side of the road.
- A warning triangle, first aid kit, spare bulbs and reflective jackets (one for each passenger) must be carried.
- Headlamp beam deflectors must be used on right-hand drive vehicles to avoid dazzling oncoming traffic.
- Headlights should be on while driving through urban areas, even during bright sunlight.
- Snow tyres or snow chains are required in mountainous areas from the 15th November to 15th April.
- The following documents must be carried at all times: full valid driving licence, proof of car insurance, V5C registration certificate, photo identification (passport).

Travelling around the Dolomites

The driving infrastructure is generally excellent within the Dolomites, with well-maintained and clearly signposted roads. Mountain passes characterise much of the driving requiring confidence behind the wheel, particularly during the winter season and in adverse weather conditions.

It is possible to drive between all of the locations in this guide in a day; the longest drive you could make between Brunico in the far north to San Martino di Castrozza in the southern Dolomites takes 2hrs 40 minutes.

Bus

While a car is preferable for travelling between destinations, the Dolomites has a good bus transport network. For a list of bus operators and timetable resources see Appendix A on page 544.

Train

Although there is a rail link running the length of the Val Pusteria and Valle Isarco, there is no access to the central Dolomites by train. There are stations at Bolzano, Brunico and Dobbiaco which can be used to approach the range before changing for the local bus services.

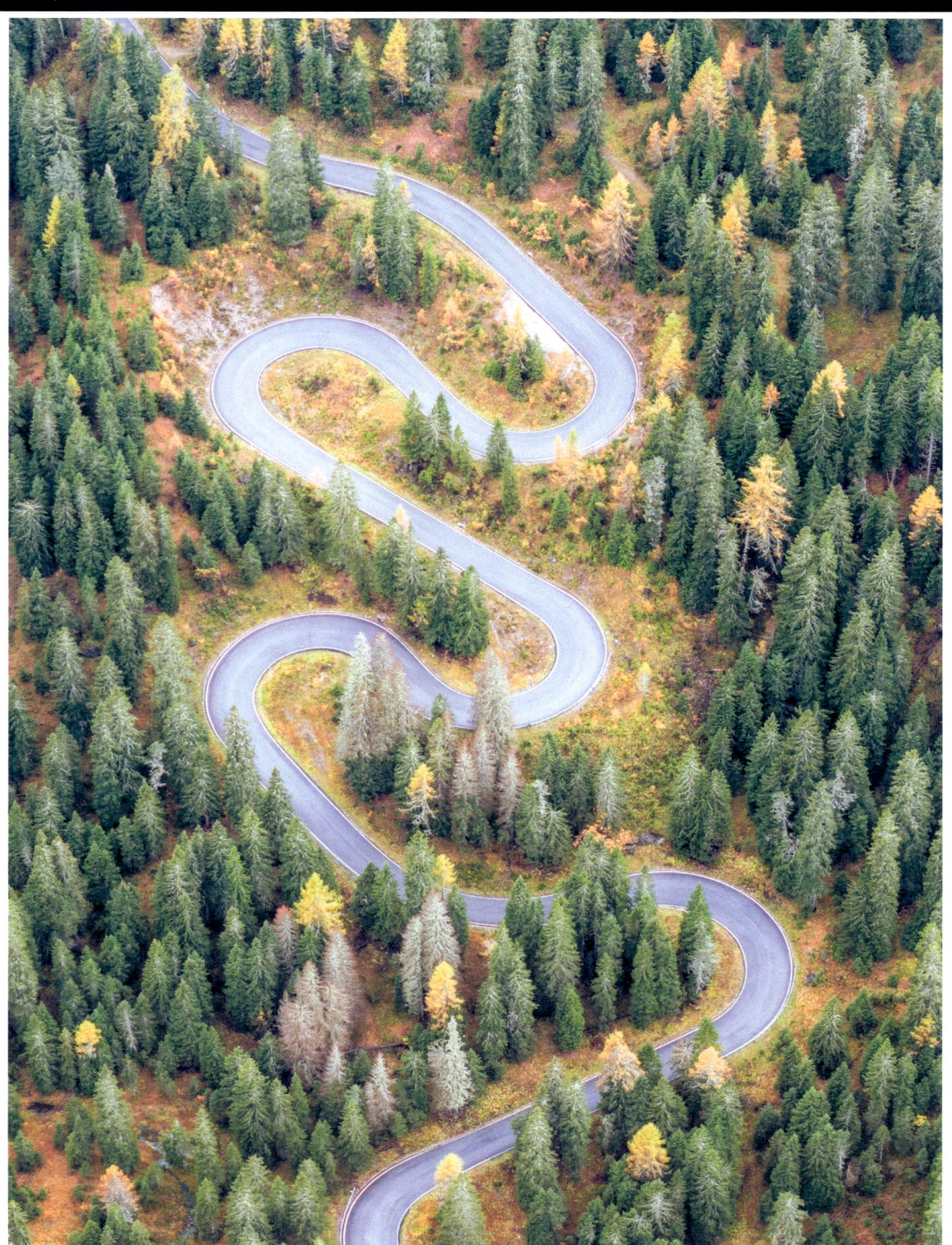
Switchbacks on the Passo Giau (p.282). DJI Mavic Pro 3, 70mm, ISO 110, 1/15s at f/2.8, Oct.

VENICE

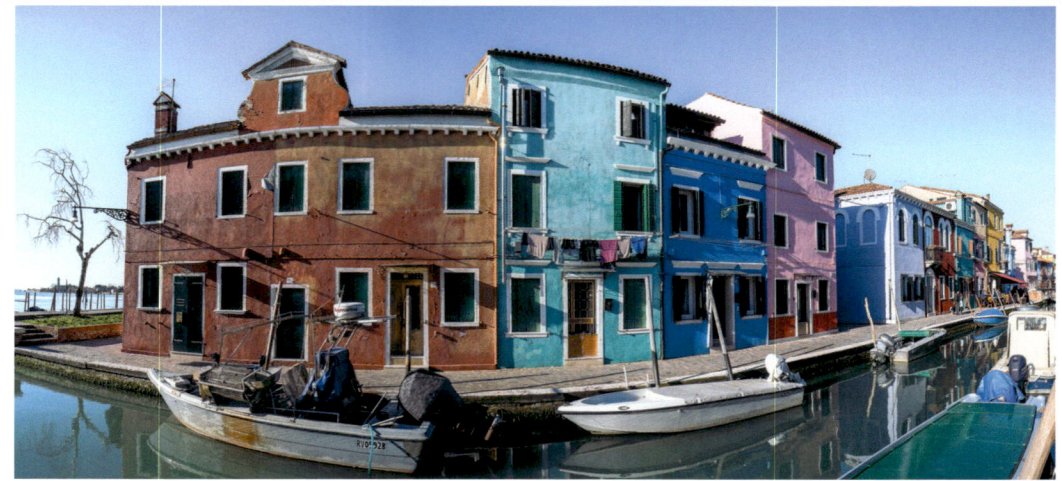

A six image panorama of Burano's colourful streets. Nikon Z7II, 24–120mm at 24mm, ISO 64, 1/80s at f/11, Mar.

Venice

An overnight stay in Venice is highly recommended for photographers flying into Marco Polo or Treviso airports. Vaporetto (water bus) can be taken directly from Venice Marco Polo International Airport, providing easy access to this wonderfully photogenic city.

While some of the most famous landmarks are listed opposite, the best way to photograph Venice is to get lost in the maze of backstreets, camera in hand.

Framing a gondola between two beautiful doorways. Nikon Z7II, 24–120mm at 40mm, ISO 500, 1/250s at f/8.

Location ideas

Piazza San Marco (St Marks Square) – St. Mark's Basilica, St. Mark's Campanile, Palazzo Ducale and Caffè Florian
San Giorgio Maggiore (island)
Basilica Santa Maria della Salute (church)
Ponte di Rialto (Rialto Bridge)
Ponte dell'Accademia (Accademia Bridge)
Ponte dei Sospiri (Bridge of Sighs)
Riva degli Schiavone (waterfront)
Burano (island)

***Opposite**: Chiesa del Santissimo Redentore at sunset. Nikon Z7II, 100–400mm at 400mm, ISO 200, 1/400s at f/8, Jan.*

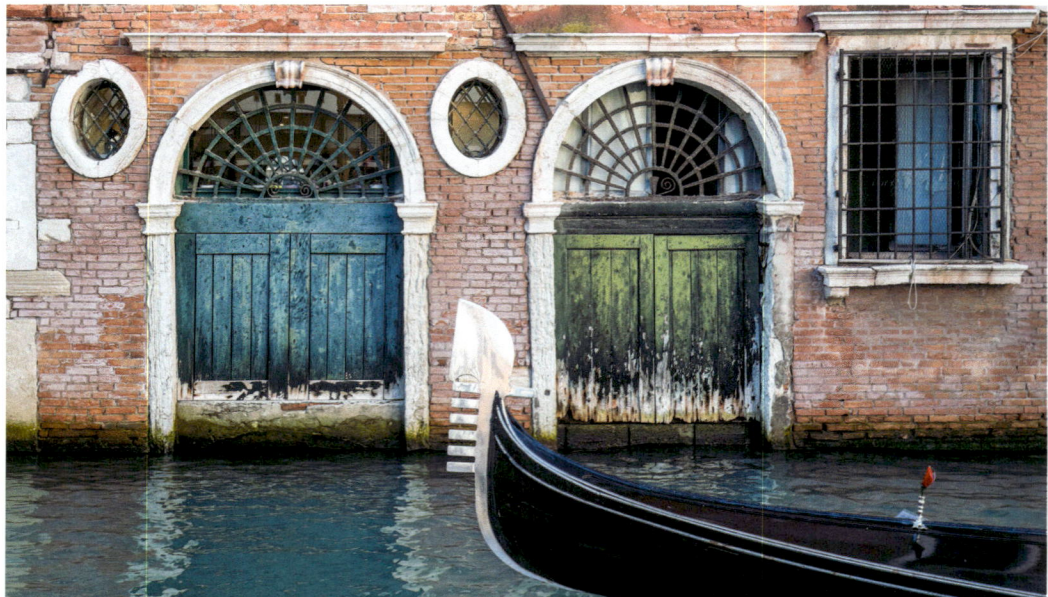

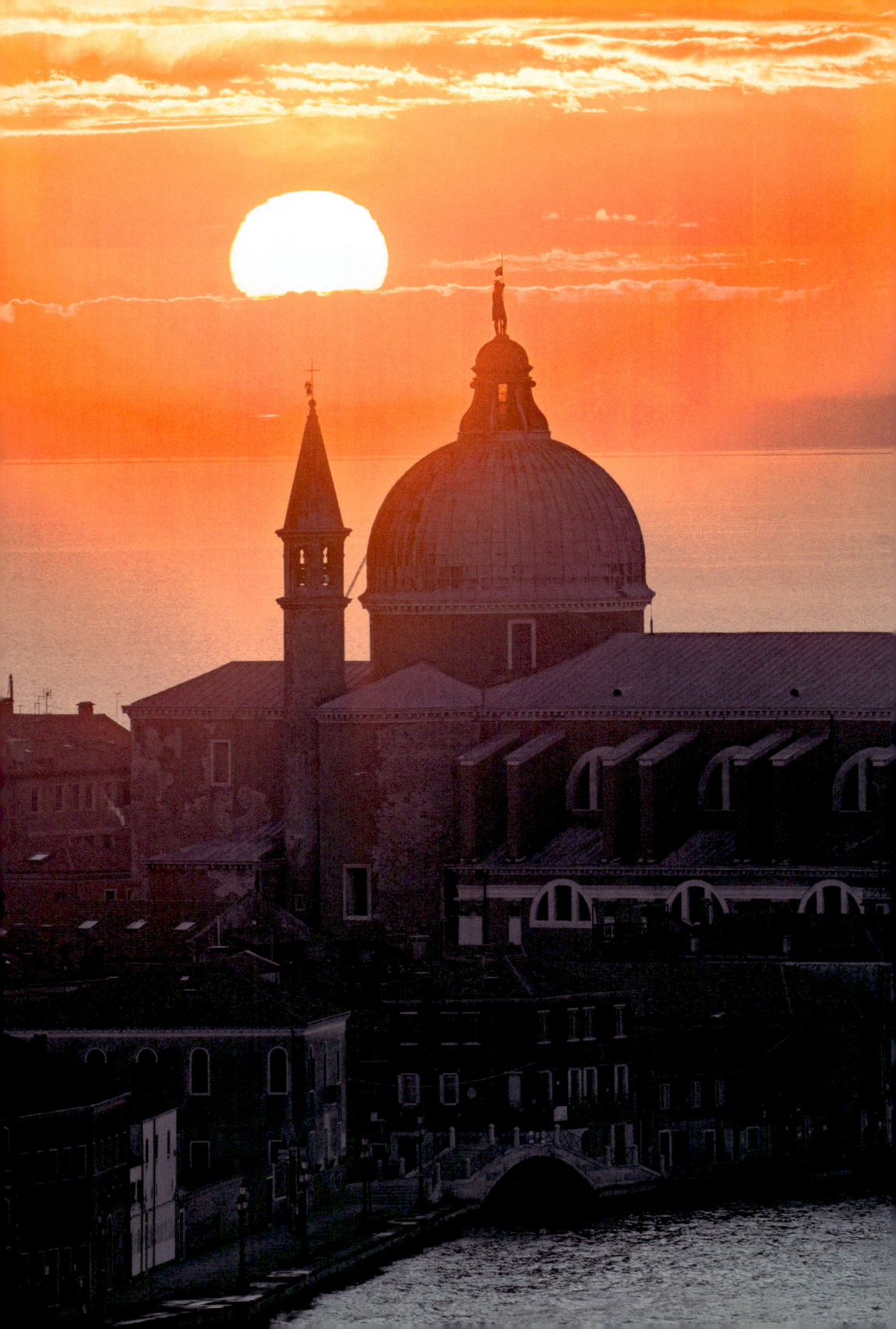

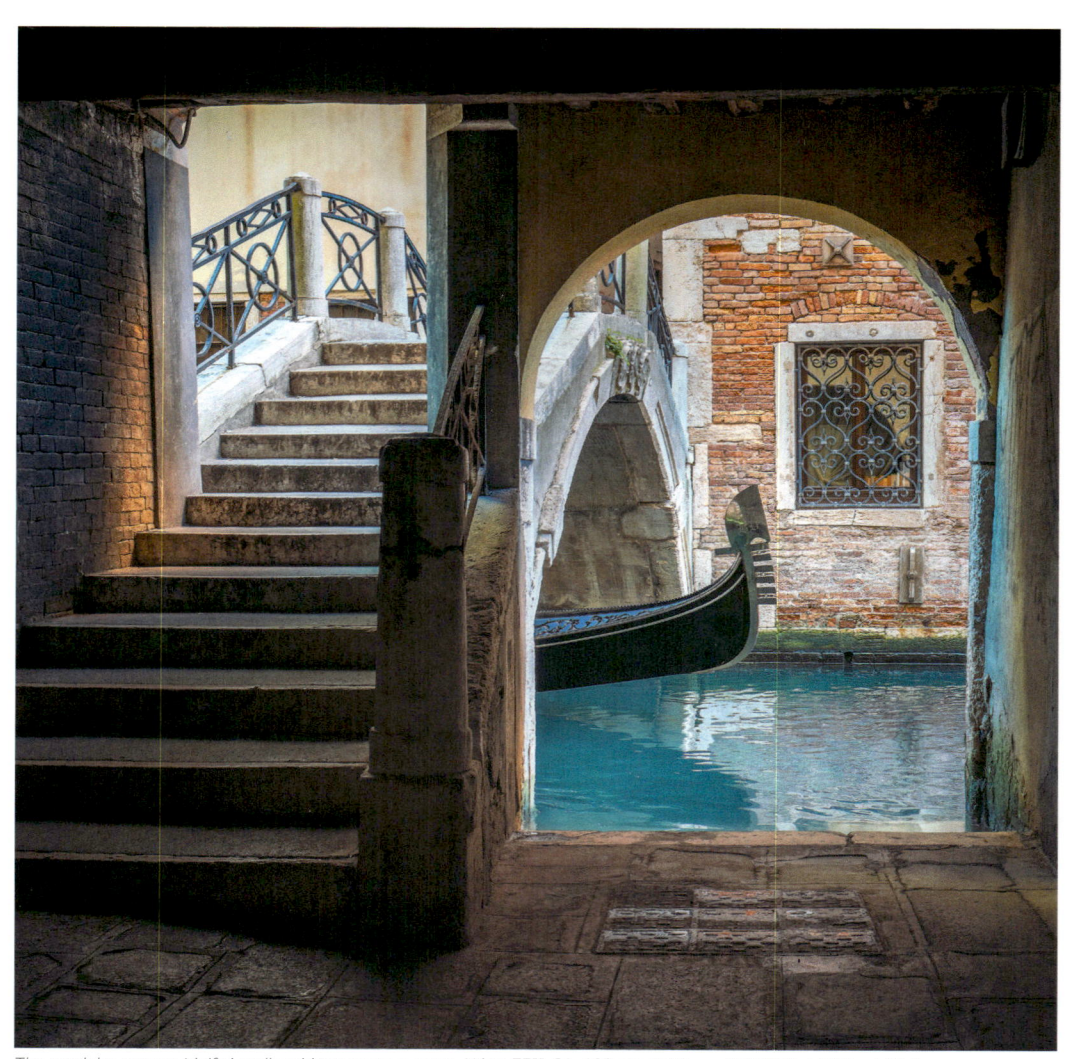
The gondolas prow or 'dolfin' really add interest to a scene. Nikon Z7II, 24–120mm at 30mm, ISO 1000, 1/250s at f/6.3.

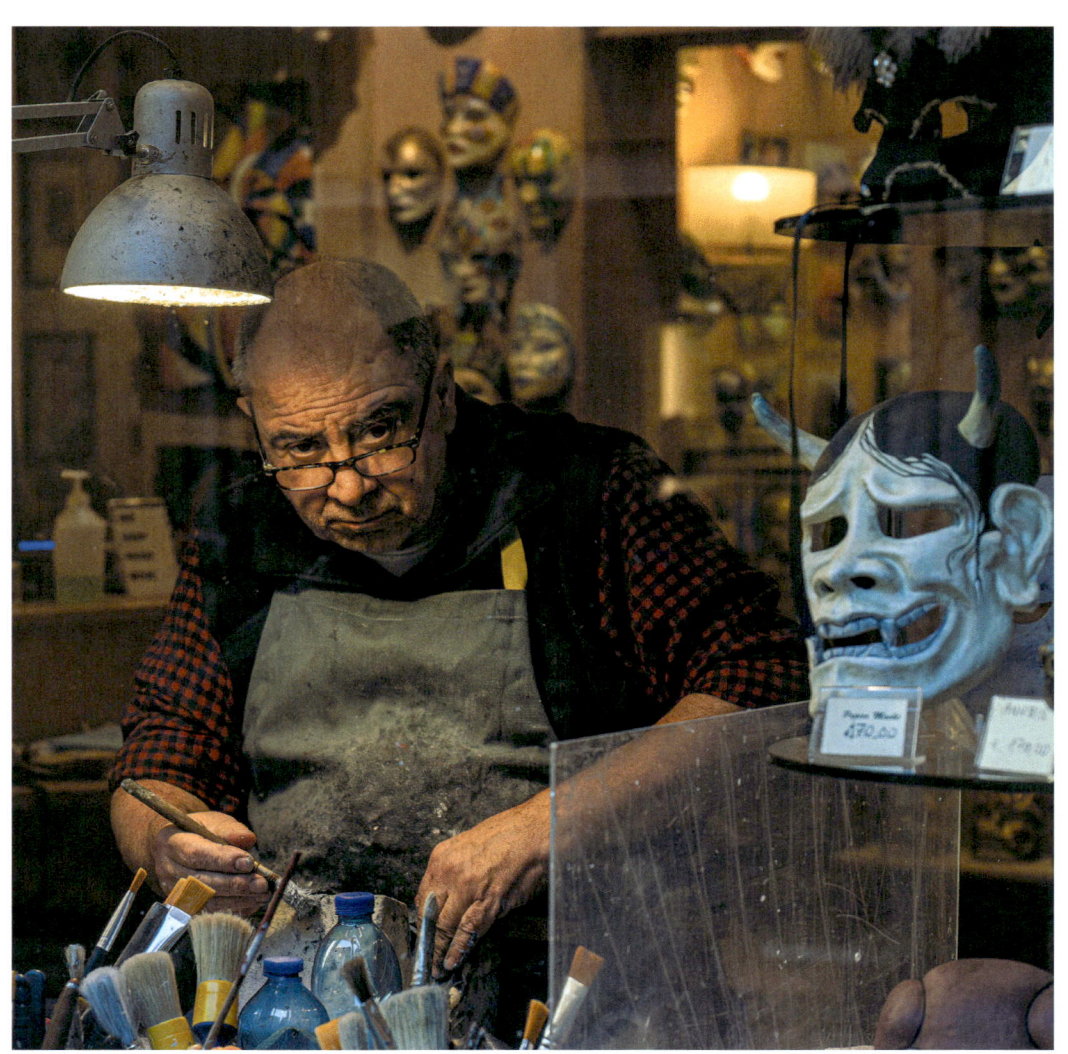
Venice is wonderful for street photography – a mask maker at work. Nikon Z7II, 24–120mm at 54mm, ISO 1000, 1/250s at f/5.6.

WHERE TO STAY / ACCOMMODATION

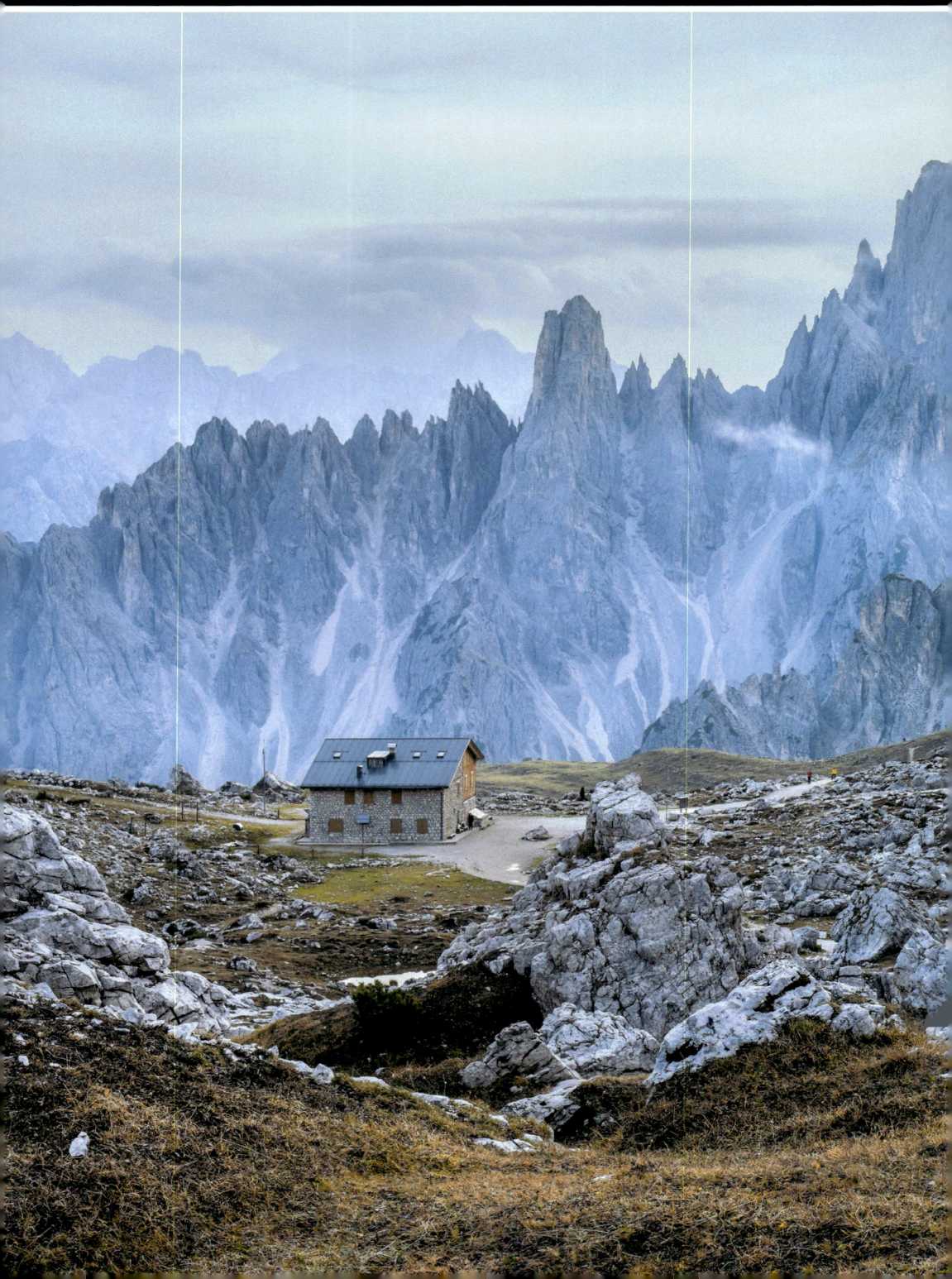

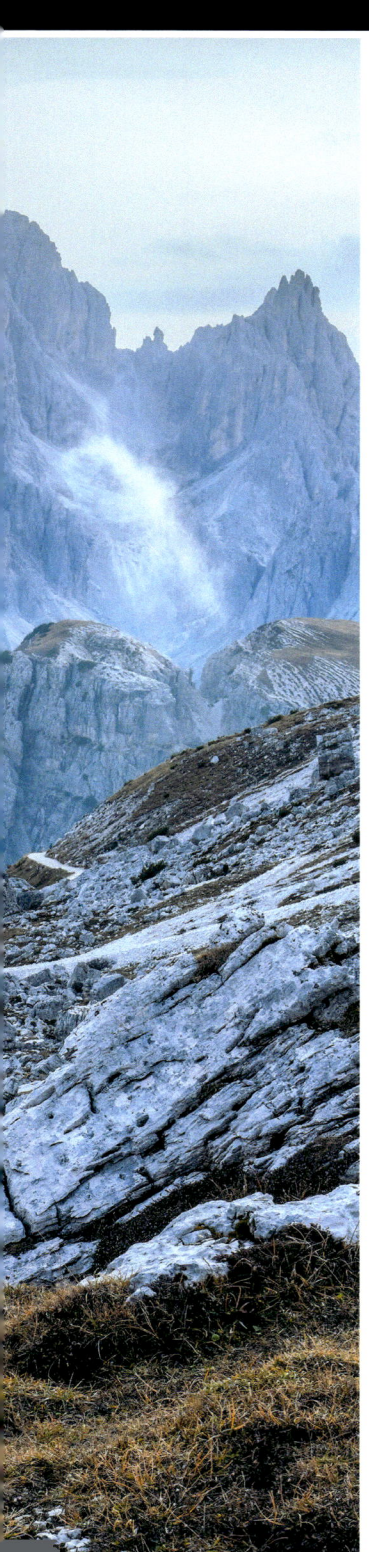

There is no shortage of accommodation in the Dolomites and all the main towns and villages offer a variety of options ranging from the most basic to the most luxurious. Hotels of all standards abound and there are numerous garnì (bed and breakfasts) and self-catering apartments. Hotels styling themselves as 'Sport' or offering 'Wellness' usually have spa facilities such as saunas, steam rooms and Turkish baths.

In addition to the accommodation in the valleys, there are countless rifugios in the mountains themselves; literally meaning refuge, these are more akin to plush alpine hotels offering good sleeping quarters (sometimes with a choice of private rooms or dorms), a decent breakfast and a three-course evening meal.

Accommodation in most places in the Dolomites is available with three options – solo pernottamento (overnight stay), con colazione (bed and breakfast) and mezza pensione (half-board). If opting for the bunk room option in the rifugios, a sleeping bag liner is usually expected. There are also quite a few camp sites dotted around the Dolomites; many of these have developed into quite luxurious sites with good facilities, but unfortunately this does mean that they are not the budget option they once were.

If you visit the Dolomites in a camper van, the cheapest option is to make use of the 'aree attrezzate' or 'stellplatz' – these are effectively car parks where camper vans are allowed to park for a small fee. There is often running water and sometimes a waste water disposal area.

In some of the more remote mountainous areas, there are a number of 'bivacchi' or shelters. These are rarely more than just that, with facilities limited to bunks and blankets, but can be a novel way of spending a night if venturing into some of the more remote areas of the Dolomites. Use is on an honesty basis and it is not possible to guarantee a space, although despite this they are rarely crowded.

Nearly every town or village in the Dolomites has a tourist information office (Ufficio Turistico) which provides good, up-to-date information on accommodation, as well as information on lifts, public transport and cultural events. English is usually spoken in the larger offices, while the offices in the smaller villages may require a little more gesticulating.

The superbly situated Rifugio Lavaredo backdropped by the Cadini di Misurina. Nikon Z7II, 24–120mm at 45mm, ISO 64, 1/100s at f/10, Aug.

DOLOMITES LIFT INFORMATION

The Dolomites has a comprehensive network of some 450 lifts which provide photographers with a quick and efficient means of approaching a number of panoramic viewpoints. The lifts, some of which operate in summer as well as winter, are particularly useful for disabled photographers and those with limited mobility. The best resources for lift information are:

Summer – www.dolomitisupersummer.com/en
Winter – www.dolomitisuperski.com/en

Opening dates
The exact dates vary from season to season and each region or lift network has its own opening policy. As a general rule, the lifts run from:

Summer – Mid-June to late September
Winter – Early December to mid-April

If you plan on using the lifts at either end of the season, it is worth checking the specifics online or with the local tourist information offices.

Opening times
Once again lift opening times vary between seasons and valleys but generally speaking they start running at 8:30am and finish at 5pm. In keeping with the rest of Italy, lifts generally close for several hours around lunchtime. Unfortunately the operating times don't coincide with the golden hours of photography, often necessitating an overnight stay in one of the many mountaintop rifugios.

Lift type and disabled access
Gondolas and cable cars are a well-run service in the summer season and embarking and disembarking is a civilised affair. The Dolomites is currently working on an 'access for all' initiative and there is generally good disabled access at the lift stations. If in doubt, the local tourist information office will be able to advise more specifically and contact individual lift stations on your behalf.

For several locations in this guide, specifically Sasso della Croce / Sass dla Crusc and Cinque Torri, the approach is via chairlift. While this may seem an unusual concept in summer it is not as daunting a prospect as it might first appear. The lift is slowed down considerably as it enters the station at either end and the staff are very diligent; just speak to them if you have any concerns. Unfortunately, wheelchairs are not usually accommodated on chairlifts.

Lift passes
The Dolomites offer a confusing array of lift pass options through the summer and winter months and although the specific ticket offers vary year to year, generally speaking unless you're planning on utilising the lifts extensively it is simpler and easier to pay as you go. If you are planning on using the lifts frequently it is worth researching the following options:

Summer
Super Summer Card – Ideal for repeated lift use on specific days and activities such as downhill mountain biking. The pass is non-transferable between individuals.

Points Value Card – Essentially a top up card where you prepay for a certain number of points and then use them on the lifts. The longer and larger the lift, the more points it requires. This pass can be transferred between people and is ideal for groups.

Winter
As a general guide, you can buy either a local pass for a particular valley or a full pass which covers all 450 lifts in the Dolomiti Superski network, including the Sella Ronda. There are numerous options for single and multi-day passes, and individual tickets are available for certain lifts.

Funivia Sass Pordoi. Nikon Z7II, 24–120mm at 24mm, ISO 100, 1/800s at f/9, Sep.

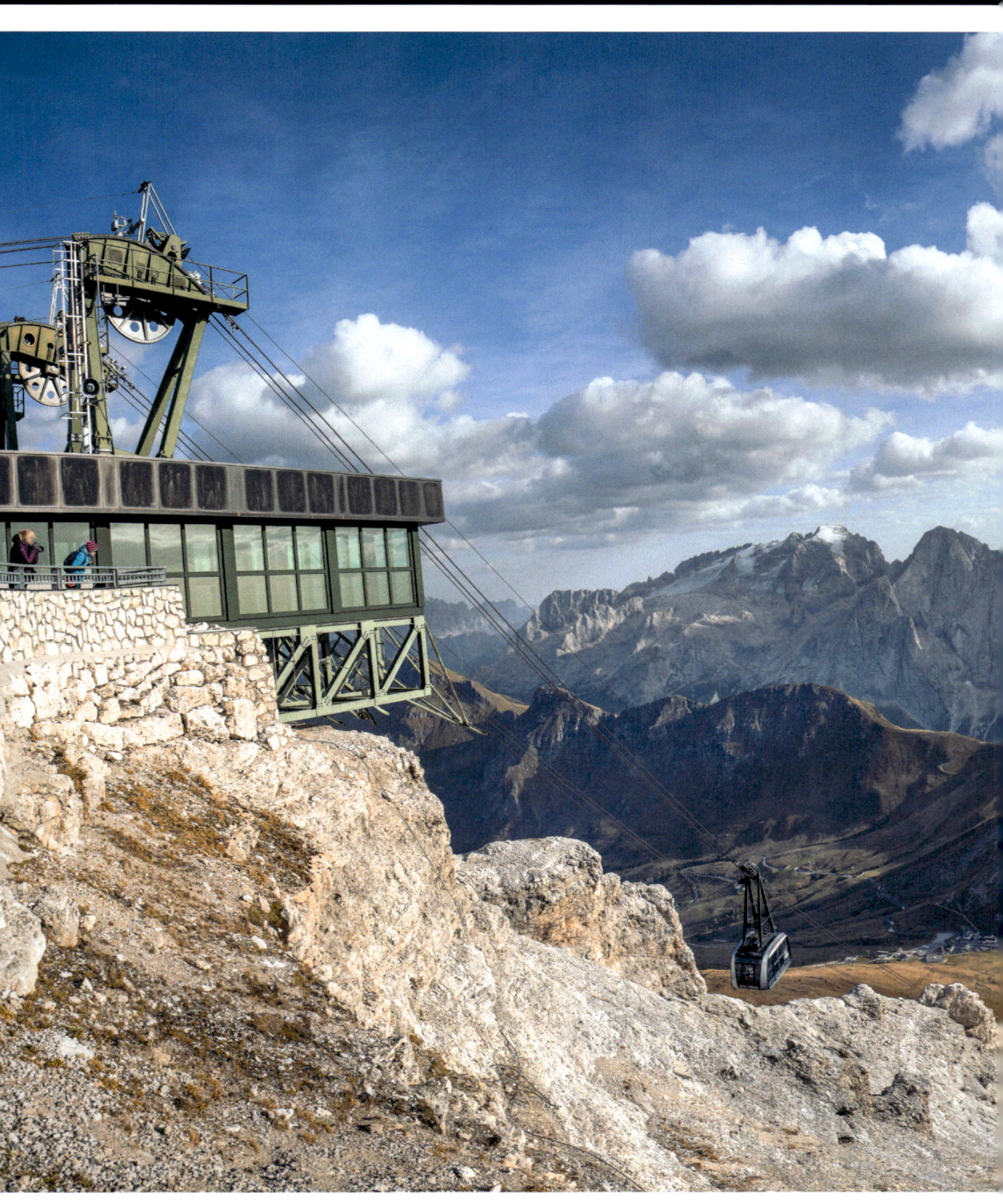

DOLOMITES WEATHER AND SEASONAL HIGHLIGHTS

Situated on the southern edge of the Alpine Arc, the Dolomites are characterised by distinct seasons and large temperature variations.

Annually the region receives less rainfall than the surrounding Alps, with the southern peaks bearing the worst of the weather as moist air masses move up the Venetian plains. The range is usually snow covered between December and April while thunderstorms are common through high summer and during the hottest weather.

Due to the elevation, the temperature range varies drastically, occasionally reaching +30°C in the valleys in summer and falling to a chilling -30°C on the summit of the Marmolada during the winter.

While it is possible to visit the Dolomites throughout the year, some forethought needs to be given to the likely conditions at any given period. Please note that the following information is indicative only and is subject to seasonal variation.

The Enrosadira phenomenon when the sun is low in the sky. Nikon Z7II, 100–400mm at 220mm, ISO 200, 1/200s at f/5.6, Oct.

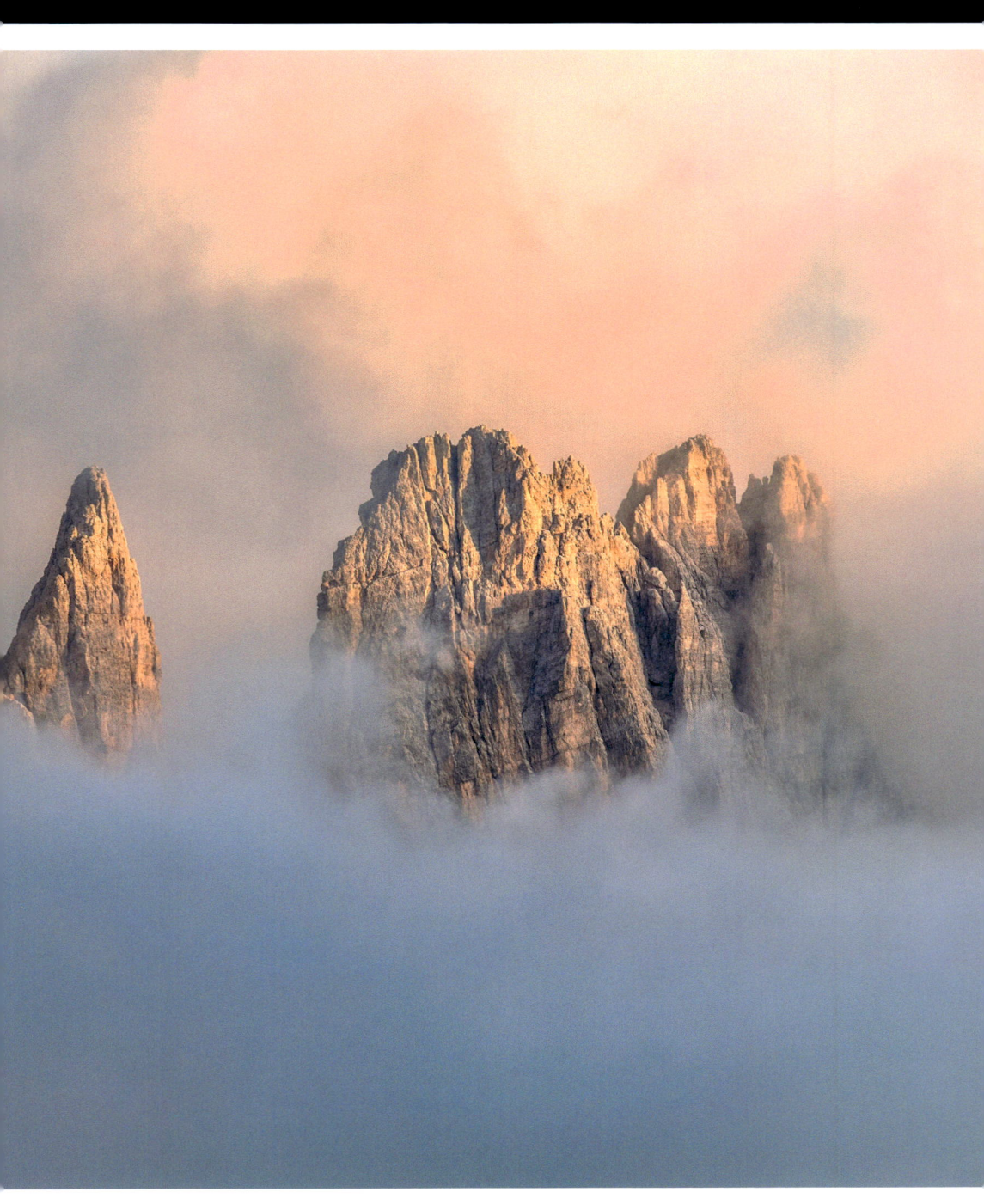

DOLOMITES WEATHER AND SEASONAL HIGHLIGHTS

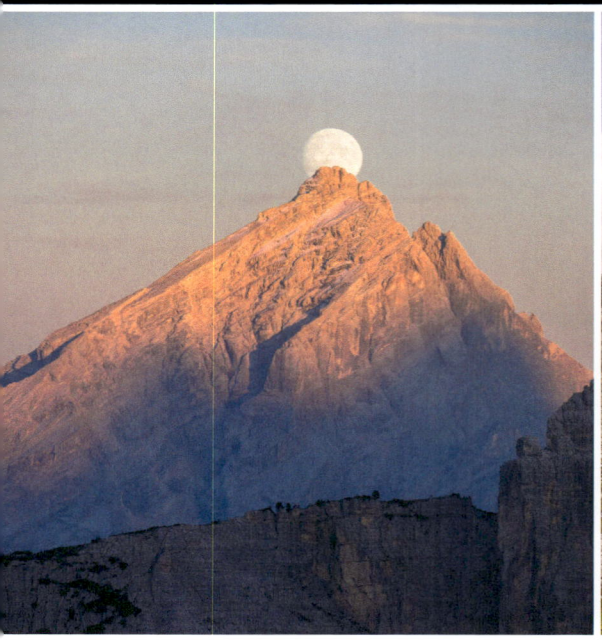 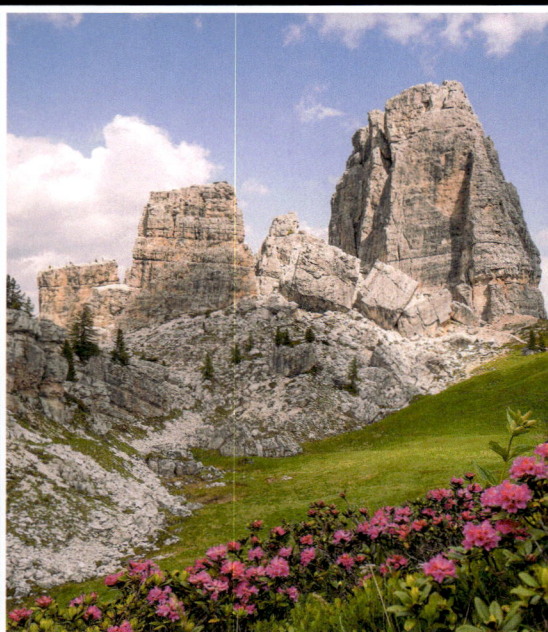

SPRING – March, April, May

During March and early April the ski season is still in full swing, making the Dolomites an ideal photography venue if you're into winter sports and terribly inconvenient if you're not. The snow makes logistics challenging as the passes are sometimes closed, snow chains are often required and the locations can be difficult to access without mountaineering experience.

That said, if you do have the means and experience, solitude is all but guaranteed at many of the destinations. For skiers the 1200km of linked piste throughout the Dolomites makes traversing the range incredibly easy, with convenient access to high points granted by the comprehensive network of 450 lifts.

Late April and May are difficult months for photographers as the retreating snow leaves behind brown grass and muddy patches and generally gives the area a tired look. Additionally the tourist infrastructure shuts down and building work commences as the area prepares for the approaching summer season.

SUMMER – June, July, August

Due to the high altitude and persistence of winter snow, early summer in the Dolomites is best equated to spring in the UK. The rapidly retreating snow gives way to carpets of wildflowers during June and July, the vibrant meadows contrasting beautifully with the still white-capped peaks. This beautiful spectacle attracts botanists from across the globe who come to capture images of some of the 1400 species of wildflower on display.

The harsh sun associated with mid-summer can make shooting difficult throughout much of the day, often necessitating an early start and late finish in order to capture the best light. However, the many cultural celebrations and festivals which take place throughout the summer ensure there are shooting possibilities at all hours.

By August the wildflowers have lost much of their splendour and the entire Italian nation descends upon the region over the Ferragosto celebrations in the middle of the month. It is now possible to set your watch by the afternoon thunderstorms which can produce some wonderfully dramatic images.

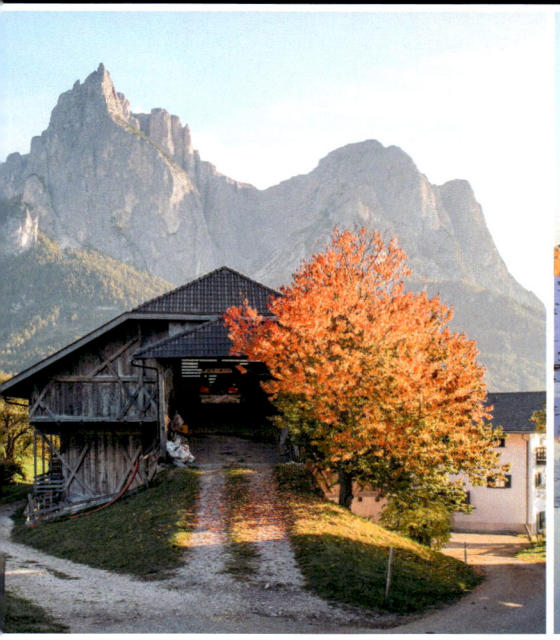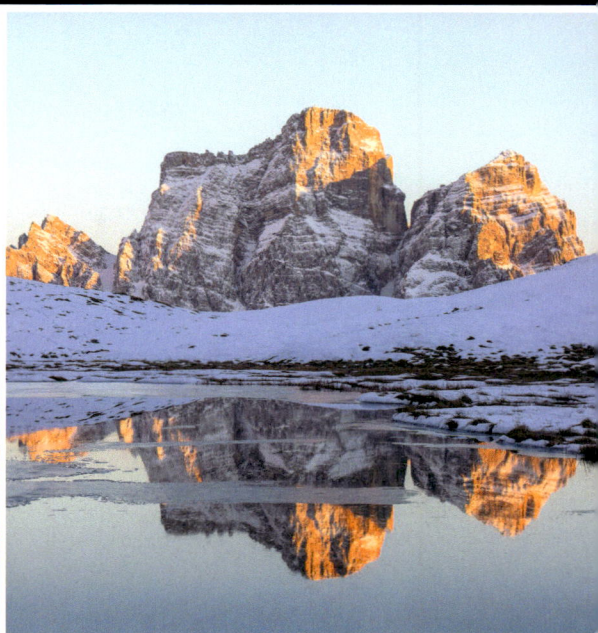

AUTUMN – September, October, November

Autumn is quite literally the golden season of the Dolomites and is to be recommended to photographers who enjoy solitude and don't mind a little hardship to attain it.

Come September the crowds have abated and the main tourist season begins to wind down; by October the region is positively deserted. The lifts are now closed, as is the majority of accommodation, shops and indeed supermarkets. Once these inconveniences have been addressed however, a land of opportunity awaits.

Precipitation now falls as snow on the highest peaks, returning an sense of alpine grandeur to the area as it highlights and defines the tallest spires. The most exciting transformation then occurs in mid-October as the larch forests turn sunset orange – a scene that every photographer should endeavour to witness at least once.

November is then somewhat of a lottery depending upon when the snows return. While it is perfectly possible to have a productive trip, it is generally better to plan a spontaneous visit in favourable conditions rather than booking in advance.

WINTER – December, January, February

As with early spring, winter in the Dolomites is defined by the ski season which starts with the opening of the lifts in early December. In recent years the snow has arrived increasingly late, with cold and dry air masses across much of the region resulting in rather barren landscapes and challenging photographic conditions. In fact, recent statistics show the sun shines an unparalleled 8 out of 10 days through the winter months. However, the festive season is rich with shows, events and celebrations offering a host of street and action photography opportunities.

While it is still possible to create very effective landscape shots, the snow and ice does force a more considered approach throughout the winter. The streams, watercourses and lakes are usually frozen and covered in snow, while the more remote venues will be inaccessible. Although skis and snowshoes can be used to aid progression, it is generally recommended to use the road and lift network to approach the photography locations. For those physically able, a trip to the frozen gorge of Serrai di Sottoguda (p.266) is to be particularly recommended, as rarely is it possible to shoot so many ice climbers with such (relatively) easy access.

CLIMATE AND WEATHER CHARTS

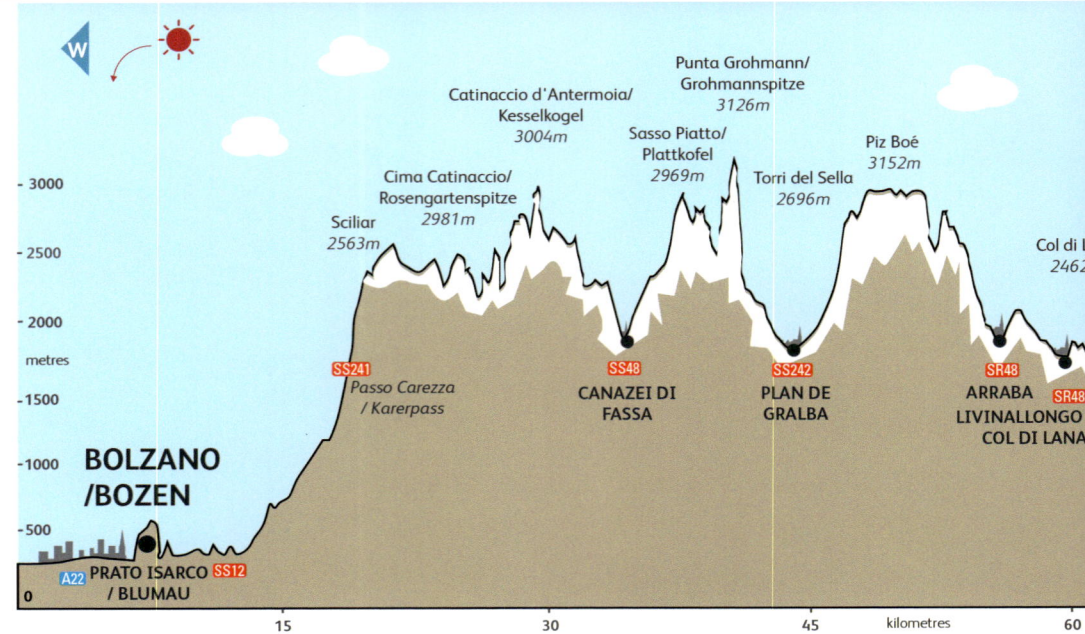

Preparing for the weather

Don't let bad or dynamic weather deter you from using your camera; it is often when the best photos are taken.

Protect your camera

There are simple, cost effective ways to protect your camera if it isn't equipped with its own weather-proofing. Large zip-loc bags and tape or rubber bands work but it can get a bit cumbersome. Disposable rain hoods that fit over your camera are a cheap and effective solution.

Protect yourself

Waterproof materials such as Goretex are expensive but handle pretty much everything the weather can throw at them. Waterproof footwear also makes life more bearable when it's wet underfoot. A good umbrella is worth carrying; golf umbrellas are ideal but can be difficult to control in windy conditions.

Checklist

- Check the forecast the day before you go out and again in the morning to help with location choice.
- Look at wind strength and direction as this will have a big impact on long exposure photography.
- See if there is suitable shelter or an escape route nearby.
- Protect your camera with a dry bag or plastic bag.
- Bring a chamois leather to dry your lens.
- A UV filter can provide extra protection for your lens and can also be removed if it gets wet and dirty.
- Wrap up well, pack waterproofs and spare layers
- Hot food and drink in a flask can really help you stay warm.
- Focus on the effects of weather: puddles, raindrops, people battling the elements – wind blowing the vegetation works well with a slow shutter speed.

Local weather forecasts

1. **Arpav Dolomiti Meteo:**
www.arpa.veneto.it/previsioni/it/html/meteo_dolomiti.php
2. **Dolomiti Meteo**: www.dolomitimeteo.it/en
3. **Wetter Südtirol**: www.weather.provinz.bz.it/default.asp

Dolomites webcams

1. **Dolomites.org**:
www.dolomites.org/en/webcams-dolomites-south-tyrol.asp
2. **Alto-Adige.com**: www.alto-adige.com/webcam

A transect of the Dolomites from Bolzano/Bozen in the west to the alpine village of Sesto/Sexten in the east.

Meteorological averages for Cortina d'Ampezzo

Elevation 1,224m (4,106')
Location: 46.5369, 12.13903
Data from: *en.climate-data.org*

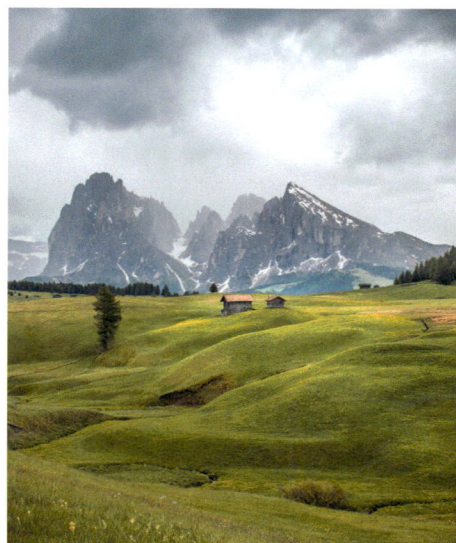

Storms are common in the Dolomites throughout the summer.
Nikon D850, 24–70mm at 30mm, ISO 64, 1/80s at f/8, Jun.

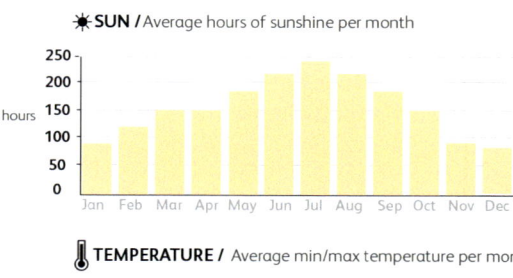

SUN / Average hours of sunshine per month

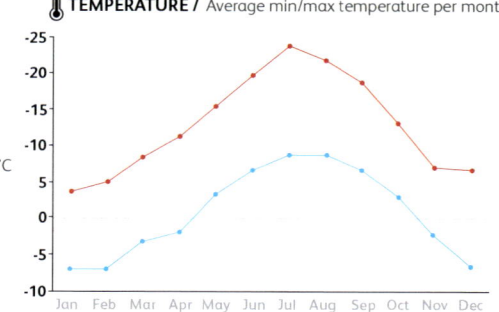

TEMPERATURE / Average min/max temperature per month °C

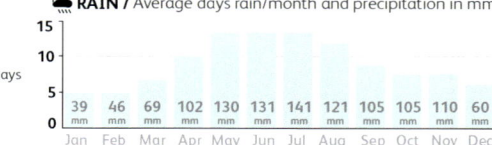

RAIN / Average days rain/month and precipitation in mm

Jan	Feb	Mar	Apr	May	Jun	Jul	Aug	Sep	Oct	Nov	Dec
39mm	46mm	69mm	102mm	130mm	131mm	141mm	121mm	105mm	105mm	110mm	60mm

CLIMATE AND WEATHER CHARTS

MOUNTAIN SAFETY

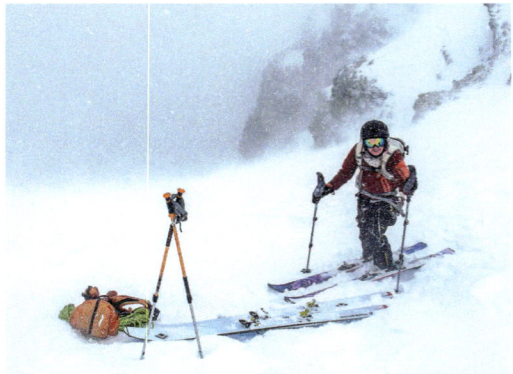

The weather closes in fast whilst ski touring across the Sella plateau. Nikon D810, 24–70mm at 24mm, ISO 100, 1/250s at f/8, Apr.

Despite the accessible nature of the Dolomites range, it is important to remember that the region is a high mountain group which should be treated with an appropriate level of respect. More often than not, this simply means taking the time to prepare yourself adequately and taking sensible precautions.

The following steps should be taken to minimise risk whilst photographing the Dolomites, particularly at the more remote locations found within this guidebook.

Check the weather forecast
Adverse weather can make navigation difficult, can lead to heatstroke or hypothermia, and can trigger avalanches and cause lightning storms. Choose itineraries appropriate to the expected conditions and be prepared to be flexible if the forecast is inaccurate.

Choose an itinerary suitable for your party's experience
Some of the locations found within this guide are remote, with exposed terrain on the approach or at some of the viewpoints. Check the accessibility information provided for each location, taking particular note of the approach distances and the likely terrain to be encountered.

Familiarise yourself with the map
It is important to take a detailed scaled map to remote locations to assist with navigation and help locate emergency escape routes should the need arise. The appropriate 1:25,000 Italian Tabacco map number is supplied in the information box for each location.

Take the correct equipment
The weather in the Dolomites is unpredictable and exceptionally changeable with huge temperature variations. A good raincoat, warm clothing and some spare layers should always be packed. Sufficient food and water are a must; don't be tempted to rely on rifugios which may close unexpectedly. Keeping a head torch in your rucksack is always a good idea, even if you're not planning on being out late. A dry bag is great for keeping your kit dry and a mobile phone is useful in an emergency.

Ensure you have the correct insurance
Despite the accessibility of the Dolomites many of the locations within this guidebook are still situated in rugged mountain environments and visitors should make sure they are appropriately insured. Helicopter rescues, even for seemingly innocuous injuries can cost in excess of €10,000. It is worth keeping a copy of your travel insurance documents in your camera bag for easy access.

Notify someone of where you are going
It is important to let someone know where you are going, especially if traveling on your own or are a group practicing night photography. Rifugios and hotels often have logbooks where you can record your planned itinerary.

In the event of an emergency – Call 118
If you are unlucky enough to be involved in an accident, the emergency contact number for mountain rescue is 118. Mobile phone coverage is generally very good in the Dolomites, although there are occasional black spots in the more remote areas.

Opposite: Precipitous ledges on the Via delle Bocchette circuit. Nikon Z7II, 24–120mm at 24mm, ISO 64, 1/80s at f/8, Aug.

Next spread: A story of three – ski touring around the Tre Cime. Nikon D810, 14–24mm at 14mm, ISO 100, 1/640s at f7.1, Feb.

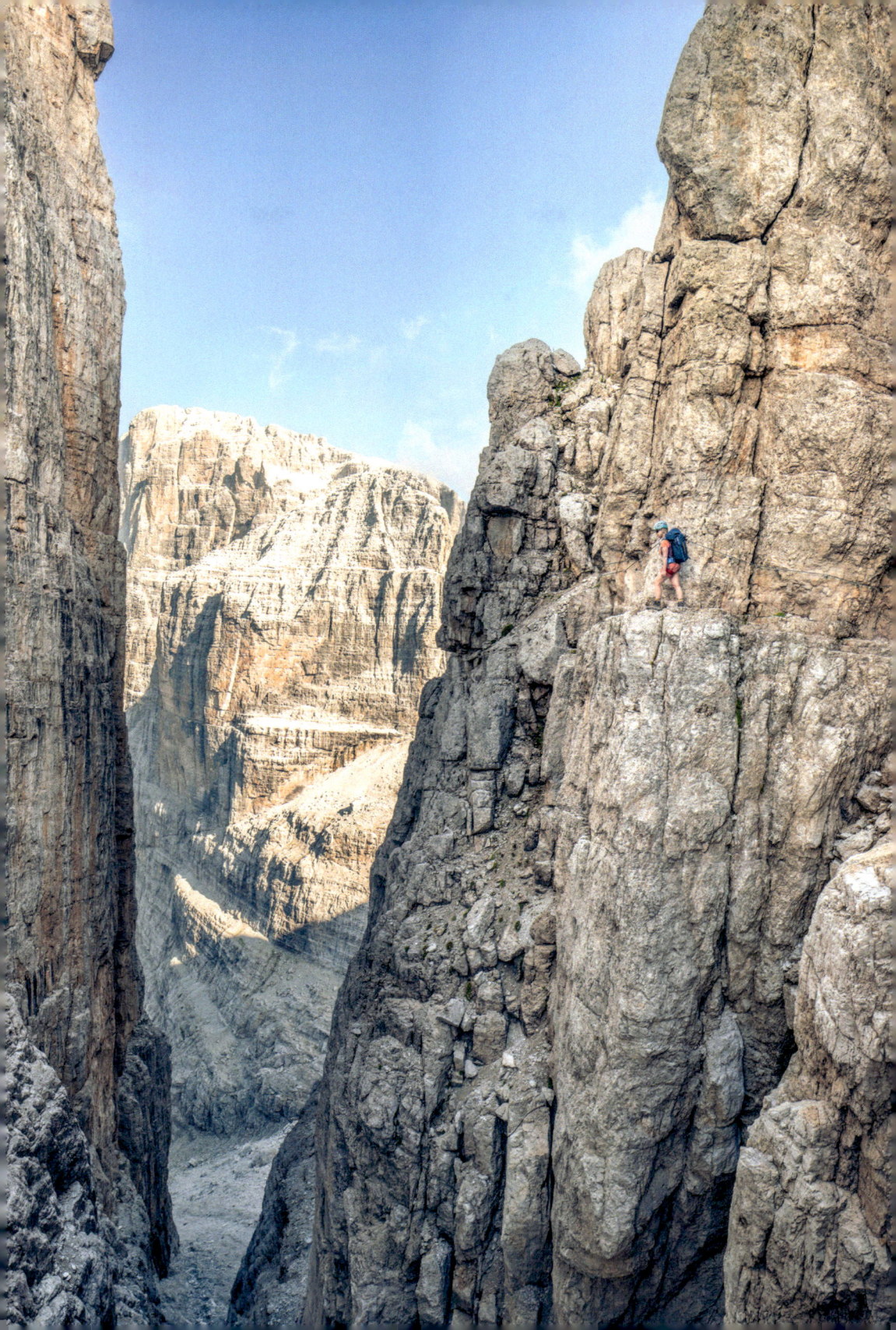

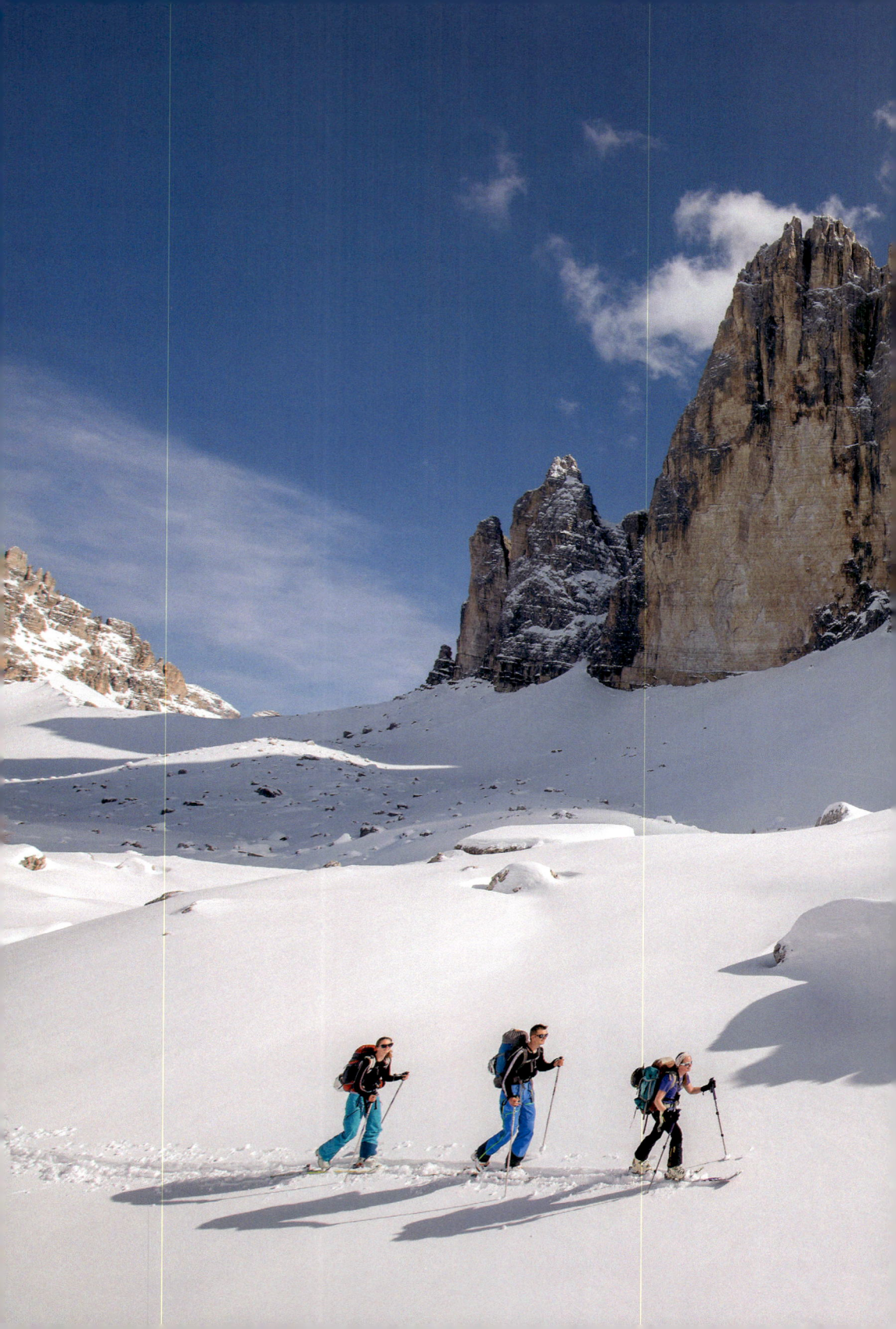

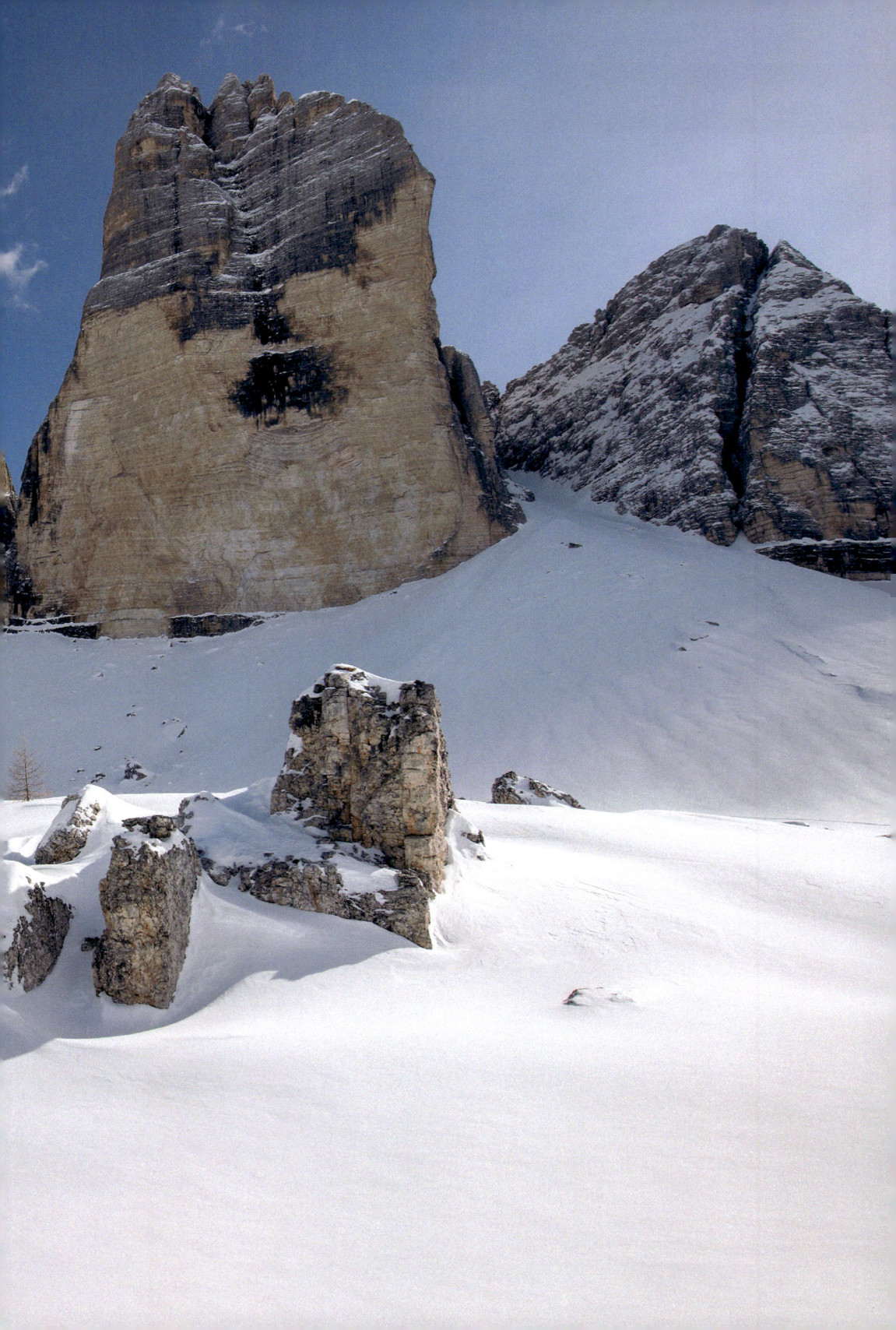

USING THIS GUIDEBOOK TO GET THE BEST IMAGES

Great photographs require being in the right place at the right time, regardless of whether you are using a digital, film or mobile phone camera. This is what fotoVUE photo-location guidebooks are about – giving you the information and inspiration to get to interesting locations in the best photographic conditions.

In the right place

Each location has a grey box titled 'How to get here', with written directions, a set of decimal degree GPS coordinates, a what3words identifier and scannable quick response (QR) code to the relevant parking area. The maps feature location pins and parking symbols.

```
Tre Cime di Lavaredo main car park
    P Lat/Long:     46.61284, 12.29311
    P what3words:   ///spaceman.terminated.backlash
    P Tabacco:      Map 10 (1:25.000)
    P Kompass:      Map 47 (1:25.000)
```

The QR-code

The QR code is the fastest and most efficient way of navigating to a location. Using a smartphone, point the camera display at the code and follow the on-screen instructions. On some older operating systems you may have to download a QR code reader app first. Once read, your phone will launch Google maps, placing a location pin which can be used to navigate to the desired destination.

///What3Words

Download the free app at *what3words.com*

This is a great resource for those lacking a QR compatible phone. What3words have divided the world into three-metre-square grids, assigning a unique 3 word address to each square. Download the free what3words app, then either dictate, type in, or scan the 3 word address to get a location pin. You can save multiple destinations on your phone, which is useful for planning a day's itinerary.

Dolomites Maps

The relevant topographic maps are detailed in the chapter introductions and location boxes. The two main map providers are Tabacco – *www.tabaccomapp.it* and Kompass – *www.kompass.de*. Both offer GPS smartphone apps.

The fotoVUE maps

Each chapter contains a detailed overview map marked with photo locations, points of interest and local services. Complicated locations or those that feature long hikes are also accompanied by specific larger scale maps to help with orientation. Please note a proper topographic paper map should always be taken for the more remote locations.

Our map symbols

Our maps are anotated with the following symbols:

Locations
A location is marked by a numbered circle and name

Viewpoints ●
Viewpoints are marked with a coloured circle.

Footpaths - - - - - -
Not all footpaths are marked on our maps, only footpaths that are useful to get to a location and its viewpoints.

Hikers
Denotes a strenuous approach, often with steep uphill walking.

Stellplatz
An official pay and display parking area for campers.

Bivacco
An unmanned shelter in the mountains that usually sleeps up to eight people.

Rifugio
A manned mountain hut that usually offers food and accommodation.

Campsite
Church
Building
Castle
Bar
Via Ferrata
Official car park / parking
Small parking area / lay-by
Chairlift / cable car / gondola

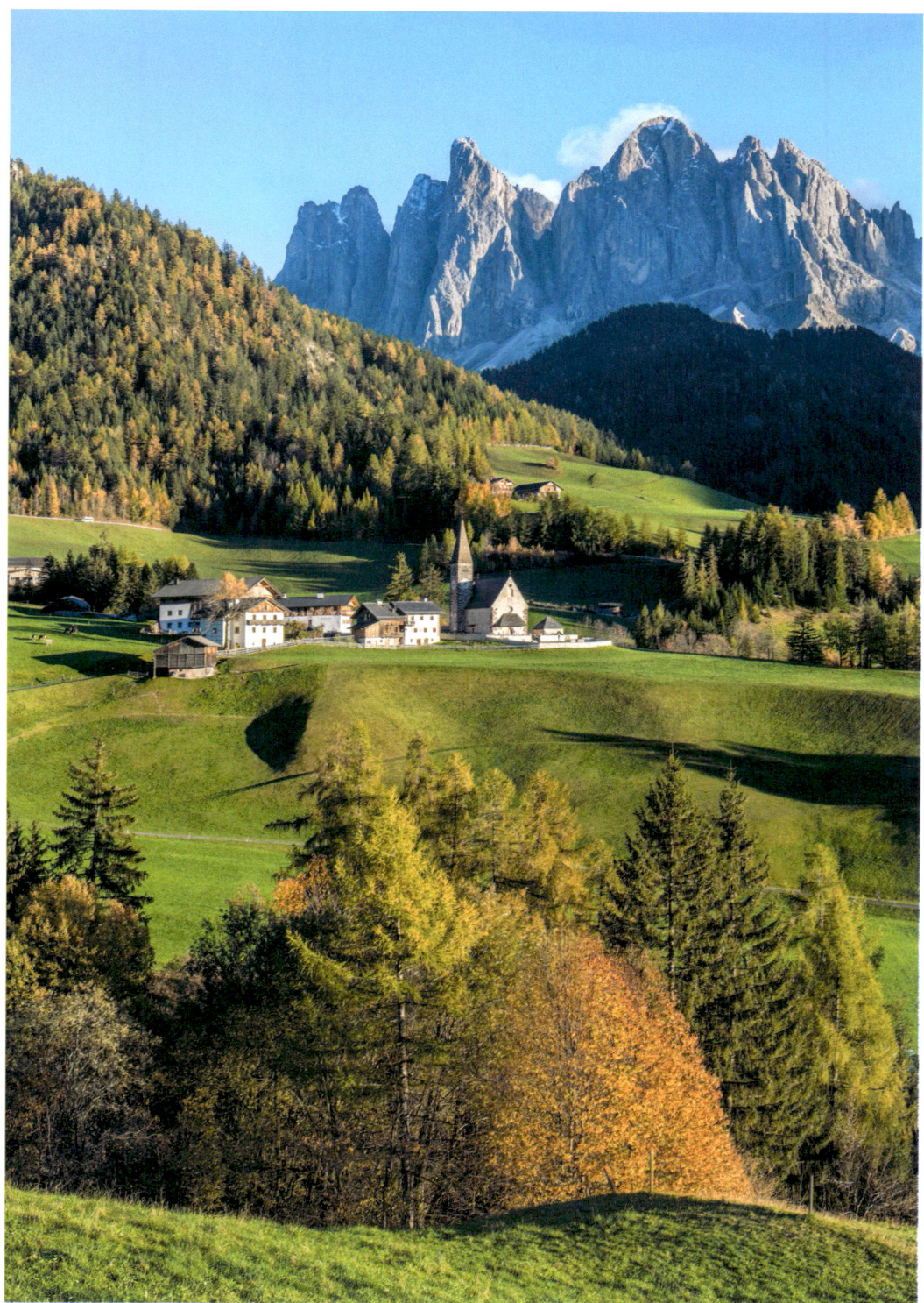
A perfect autumn day in the Val di Funes (p.159). Nikon Z7II, 24–120mm at 50mm, ISO 64, 1/100s at f/8, Oct.

USING THIS GUIDEBOOK TO GET THE BEST IMAGES

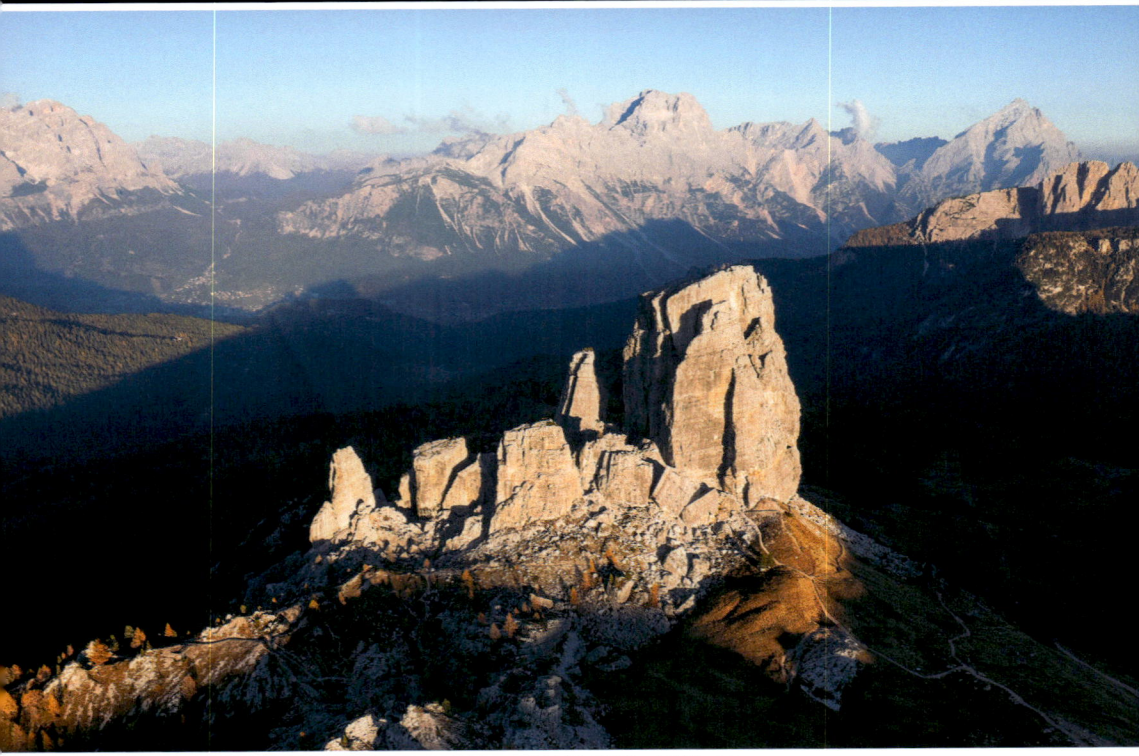

Last light at Cinque Torri (p.416). DJI Mavic 3 Pro, 166mm, ISO 110, 1/600s at f/2.8, Oct.

At the right time
Each location in this book is accompanied by detailed notes on the optimum time of year and day to visit a location to get the best photographic results. Good light can occur at any time, however. Often the best time to visit a location is when conditions are rapidly changing, such as after a storm.

Weather
Check the weather forecast a few days before and the day before a planned outing. Arpav Dolomiti Meteo is an excellent resource – *wwwold.arpa.veneto.it*.

Sun
Topography, sun position and weather determine how light falls on the land. Use the sun position compass on the front flap of this guidebook for sunrise and sunset times, to find out where the sun rises and sets on the compass (there is a big difference between summer and winter) and sun elevation (how high the sun rises in the sky).

Useful websites and apps include **The Photographer's Ephemeris** (*photoephemeris.com*), **photopills** (*photopills.com*) and **sun calculator** (*suncalc.org*).

Exploration
This guidebook will help you reach some of the best photographic locations in the range. Try not to replicate the images within this guide exactly, and instead use them as a creative springboard for your own take on a particular location. The satellite view in both Google and Apple maps is superb for scouting your own locations, particularly for aerial and drone photography.

*Opposite left: Torrente Boite. Nikon D810, 16–35 at 35mm, ISO 100, 3s at f/8, tripod, ND filter, Oct. **Right middle**: Lago di Braies. © Daniel Seßler. **Right bottom**: Sunset at the Tre Cime. Nikon Z7II, 14–24mm, ISO 64, 1/100s at f/7.1, Jun.*

Next spread: Using a long exposure to smooth the reflections of the Tre Cime south faces at Lago Antorno (p.406). Nikon D850, 24–70mm at 30mm, ISO 100, 30s at f/16, tripod, ND filter, Jun.

Above: A 40 minute exposure of the Tre Cime south faces. Nikon D610, 14–24mm at 14mm, ISO 400, 30s at f/2.8 (x80), tripod, Jan.

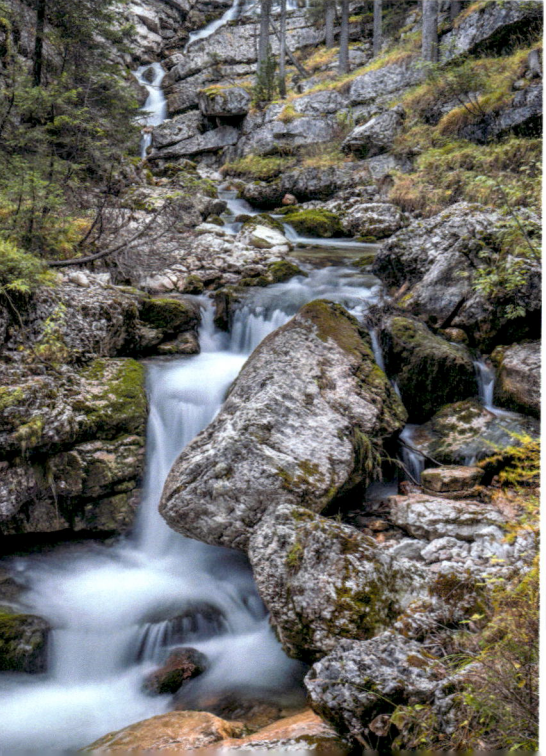

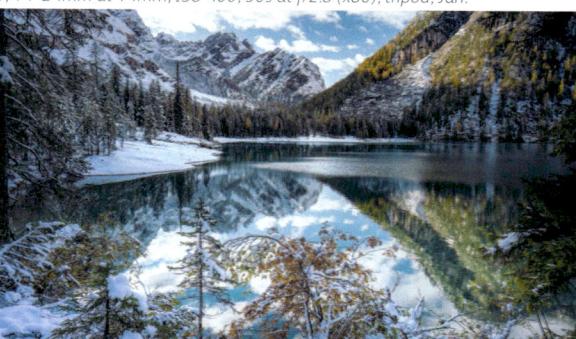

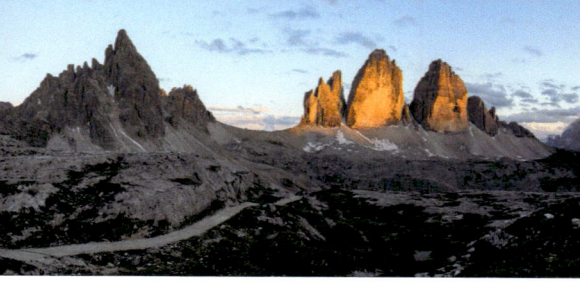

USING THIS GUIDEBOOK TO GET THE BEST IMAGES

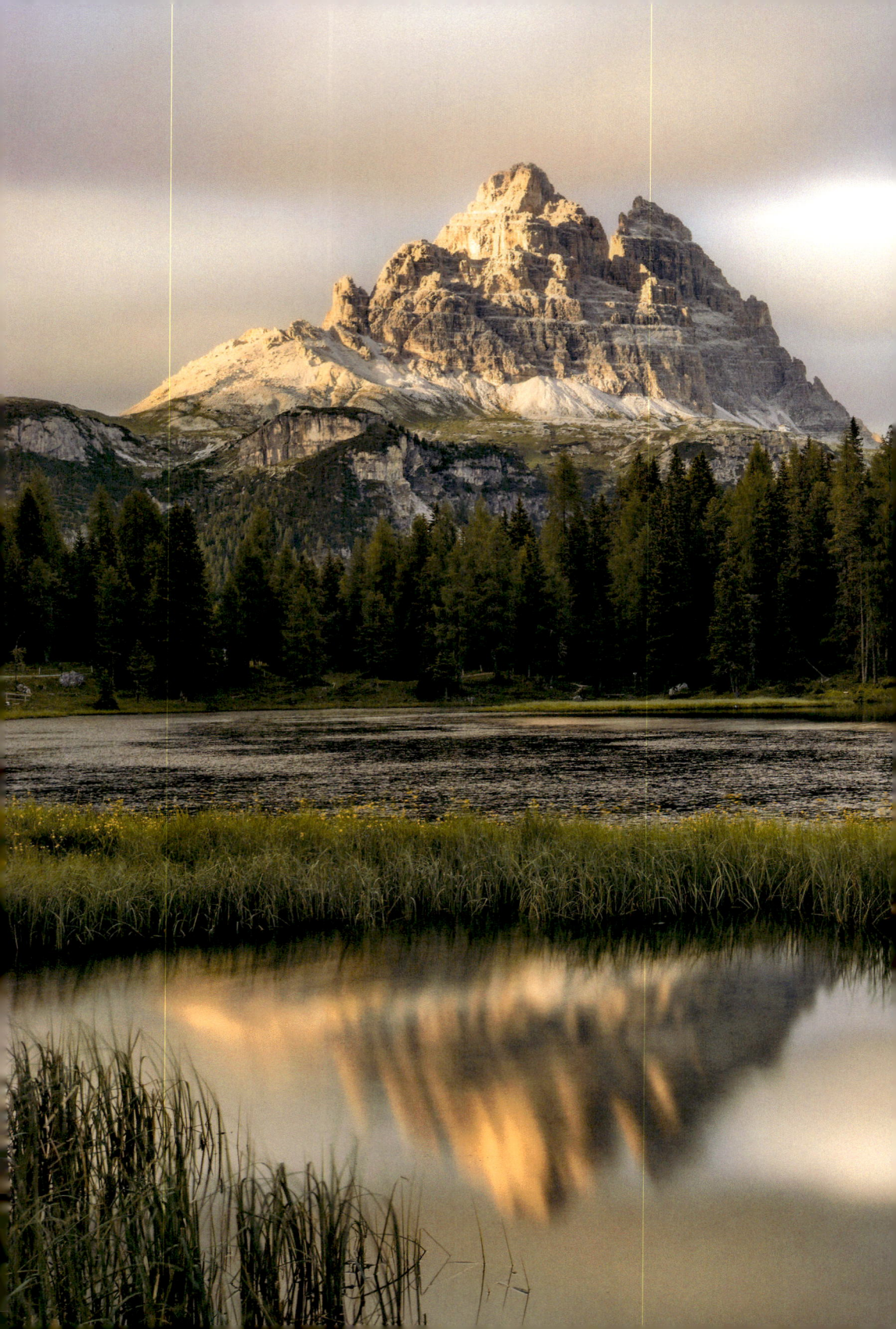

CAMERA, LENSES AND CAPTIONS

"The best camera is the one you have with you …"
Chase Jarvis

Each of the images found within this guide are captioned in an effort to assist with location planning. The camera settings (EXIF data) are not meant to be copied as this will vary according to the light and conditions. Rather it is designed to provide a point of reference, particularly with regards lens choice, focal length and the conditions you are likely to encounter at any given time of year.

"The single most important component of a camera is the twelve inches behind it."
Ansel Adams

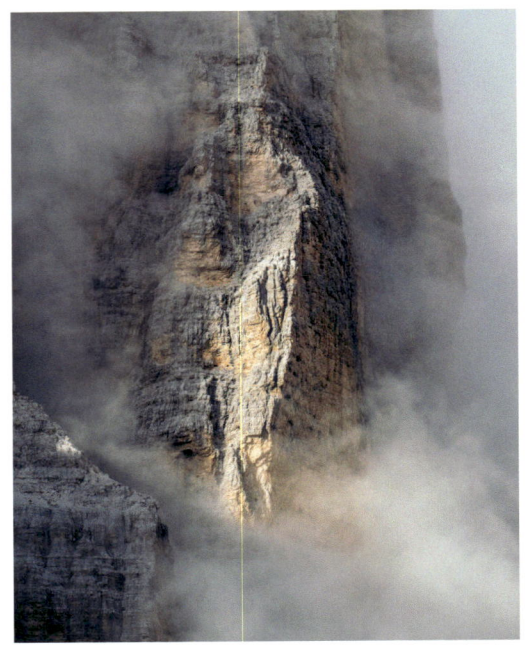

Fleeting morning light on Tofana di Rozes. Nikon Z7II, 100–400mm at 400mm, ISO 200, 1/400s at f/8, Aug.

Photo captions
The photo captions in fotoVUE guidebooks are in two parts:

1 Descriptive caption
First is a caption that describes where the photograph was taken, mentioning any references to viewpoints in the accompanying text and any other useful information.

2 Photographic information
The second part of the caption lists the camera, lens, exposure, and the month the photograph was taken. This information is from the Exchangeable Image File Format (EXIF data) that is recorded on each image file when you take a photograph.

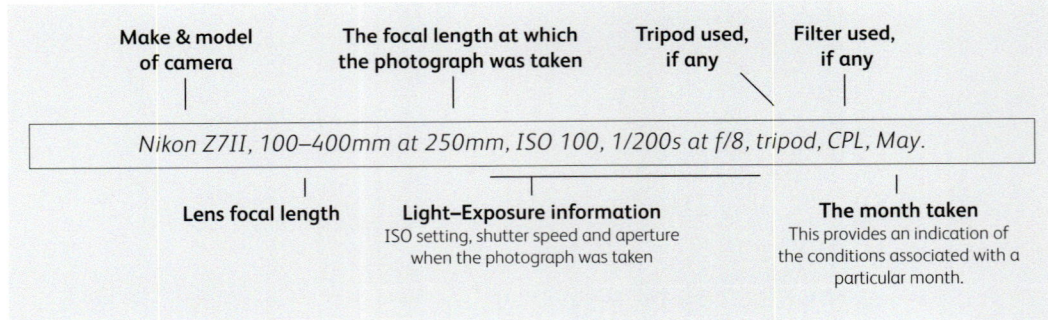

The Piramidi di Terra a Perca near Brunico. Nikon Z8, 24–120mm at 30mm, ISO 64, 1/30s at f/13, tripod, Oct.

PHOTOGRAPHY EQUIPMENT

The images captured by the author throughout this guide were taken and processed using the following equipment:

Equipment list

In the Field:

Camera bodies
- Nikon Z8
- Nikon Z7II

Lenses
- Nikon Z 14–24mm f/2.8 S
- Nikon Z 20mm F/1.8 S
- Nikon Z 24–120mm F/4 S
- Nikon Z 100–400mm f/4.5-5.6 VR S

Filters
- Breakthrough Photography X4 CPL
- Breakthrough Photography X4 ND 6, 10 & 15 stop

Drones
- DJI Mavic 3 Pro
- DJI Mini 4 Pro

Tripods, Rucksack & Storage
- Gitzo GT3542LS Series 3 6X Systematic Tripod with Induro BHL1 Ball Head
- Gitzo GT0545T Series 0 4x Traveller Tripod with Gitzo Center Series 3 Ball Head
- f-stop AJNA 37L DuraDiamond Rucksack
- Peli 1615 Air Case

Accessories
- Zooey QD L-Bracket for Nikon Z8
- 3 Legged Thing Zelda L-Bracket for Nikon Z7II
- Kirk LP-70 Replacement Lens Foot for Nikon 100–400mm
- Peak Design Slide Lite | Carryology Camera Strap

Office & Processing:

Computing
- Apple 16 Inch M3 Max, 64GB UM, 4TB SSD
- Apple 27 Inch 5K Studio Display

Data Storage
- QNAP TVS-h1288X 12 Bay NAS populated with:
- 8x Seagate 16TB IronWolf Pro SATA HDDs
- 4x 2TB Seagate IronWolf 125 2.5-inch SATA SSDs
- 2x 1TB IronWolf 525 NVMe SSDs

Accessories
- QNAP QSW-M804-4C 10GbE Managed Network Switch
- Apple Magic Keyboard & Logitech G502 Mouse
- Twelve South Laptop Stand

Software
- Adobe Creative Cloud
- Photopills
- SkySafari 7

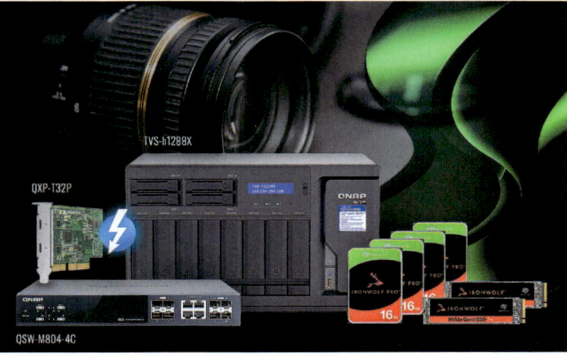

PHOTOGRAPHY EQUIPMENT

LOCATION PLANNER

The sheer scale, complexity and potential of the Dolomites can make planning an itinerary a daunting logistical undertaking.

Fortunately, you can't go too far wrong as the area is universally excellent and there are viewpoints in every chapter that I would count amongst my 'favourites'. While I would always encourage self exploration for photographers familiar with the area, the following base and viewpoint recommendations are provided as a reference point for first-time visitors.

Recommended bases for first time visitors

The following towns are all perfectly situated in central locations and offer a good range of amenities.

- Cortina d'Ampezzo
- Selva in Val Gardena
- Canazei in Val di Fassa
- Corvara in Badia
- *San Martino di Castrozza

*San Martino is located on the southern edge of the Dolomites but is well placed for exploring the Pale di San Martino.

Recommended and classic locations

The following locations are not necessarily the best but rather are the archetypal Dolomites classics, offering plenty of potential and making for a logical start point.

VAL PUSTERIA
Lago di Braies / Pragser Wildsee	94

BOLZANO, CATINACCIO & CAREZZA
Lago Carezza / Karersee	130

VAL DI FUNES & VAL GARDENA
Santa Maddalena / Magdalena	158
Chiesetta di San Giovanni in Ranui	162
Alpe di Siusi / Seiser Alm	172
Puez Odle / Geisler – Seceda & Col Raiser	186

ALTA BADIA
Pralongià	216
Sasso della Croce / Sass dla Crusc	222

PASSO SELLA, PORDOI & FEDAIA
Città dei Sassi / Steinerne Stadt	238
Sass Pordoi / Pordoi Spitze	250

VAL FIORENTINA & PASSO GIAU
Passo Giau	282
Lago Federa – Croda da Lago	296

PASSO FALZAREGO
Monte Lagazuoi	316
Lago Limides / Limedes	326
Cinque Torri	330

CORTINA D'AMPEZZO & PASSO TRE CROCI
Val di Fanes	362
Lago di Sorapis	378

MISURINA
Lago Antorno	406
Tre Cime di Lavaredo / Drei Zinnen	416

PALE DI SAN MARTINO
Monte Castellazzo	456
Baita Segantini & Cimon della Pala	460
Lago di Calaita	474

BRENTA
Laghi di Cornisello e Lago Nero – Tre Laghi	498
Molveno	518

Wet weather options

Brunico / Bruneck	82
Corvara – Rio Pissadú	210
Colfosco – Chiesa Parrocchiale San Vigilio	212
Bolzano / Bozen	118
Torrente Avisio – Pent de Giaveis	262
Serrai di Sottoguda	266
Colle Santa Lucia	280
Malga Ra Stua / Torrente Boite	354
Cascate di Fanes & Cengia di Mattia	362
Lago Ghedina	368
Cortina d'Ampezzo	374
Lago Antorno	406
Vallesinella	492
Val Genova	508

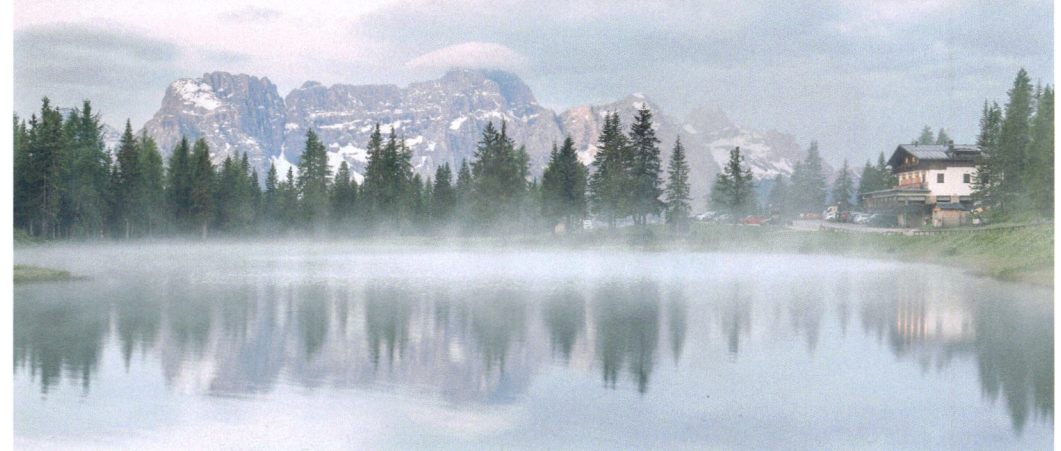

Morning mist at Lago Antorno (p.406). Nikon Z7II, 24–120mm at 40mm, ISO 64, 1/6s at f/8, tripod, Jun.

Roadside and lift-top landscape locations

There are many impressive landscape photography locations in the Dolomites that feature roadside or lift access. These locations are perfect for photographers with limited mobility or those who are short of time or simply want an easier day.

In the order found in the book, these are some of the most accessible viewpoints in the Dolomites. Locations offering disabled access are marked with the wheelchair symbol. See each location's page for specific access information and detailed location descriptions.

VAL PUSTERIA
Brunico / Bruneck ♿	82
Lago di Braies / Pragser Wildsee ♿	94
Lago di Dobbiaco / Toblacher See ♿	110

BOLZANO, CATINACCIO & CAREZZA
Bolzano / Bozen ♿	118
Lago Carezza / Karersee ♿	130

VAL DI FUNES & VAL GARDENA
Chiusa / Klausen ♿	150
Monastero di Sabiona / Säben Viewpoint ♿	154
Santa Maddalena / Magdalena ♿	158
Chiesetta di San Giovanni in Ranui / St. Johann ♿	166
Alpe di Siusi / Seiser Alm ♿	172
Puez Odle / Geisler – Seceda & Col Raiser ♿	186
Passo Gardena / Grödner Joch ♿	194

ALTA BADIA
Brigata Tridentina Viewpoint ♿	206
Parrocchia di Colfosco / Pfarrkirche Kolfuschg ♿	212

PASSO SELLA, PORDOI & FEDAIA
Città dei Sassi / Steinerne Stadt ♿	238
Sass Pordoi / Pordoi Spitze ♿	250
Torrente Avisio – Pent de Giaveis ♿	262

VAL FIORENTINA & PASSO GIAU
Monte Civetta Viewpoint ♿	276
Colle Santa Lucia ♿	280
Passo Giau ♿	282

PASSO FALZAREGO
Monte Lagazuoi ♿	316
Cinque Torri ♿	330

CORTINA D'AMPEZZO & PASSO TRE CROCI
Lago Ghedina ♿	368
Cortina d'Ampezzo ♿	374

MISURINA
Lago Misurina ♿	394
Lago Antorno ♿	406

PALE DI SAN MARTINO
Baita Segantini & Cimon della Pala ♿	460
Belvedere Geologica di Crode Rosse ♿	466
Lago di Calaita ♿	474

BRENTA
Fogajard Viewpoint ♿	496
Val Genova ♿	508
Molveno ♿	518

ACCESS AND BEHAVIOUR

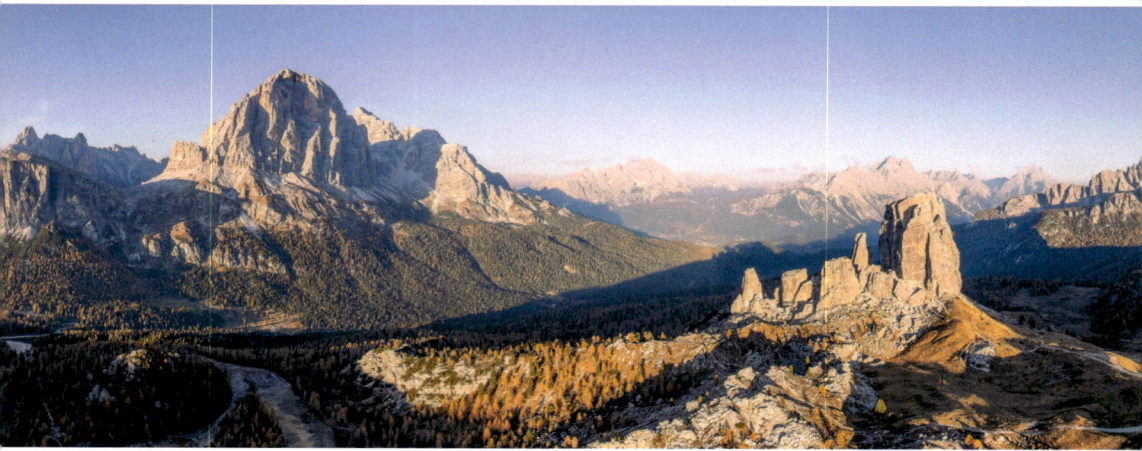

Looking out over Cinque Torri, the Passo Falzarego and Tofana di Rozes. DJI Mavic Pro 3, 70mm, ISO 100, 1/800s at f/2.8, Oct.

Being outdoors means living life to the full and should be enjoyed by all, but we have to share it with others and stay safe. Here is some information and guidelines on accessing the outdoors and looking after yourself.

Be a respectful photographer

The obvious is always worth stating: do not climb over walls or fences, shut all gates, don't drop litter, pick up litter others have dropped, keep dogs at home or on a lead, drive slowly in rural and urban areas, give way to cyclists, agricultural vehicles and horse riders, park considerately, don't scare livestock and keep quiet (don't play music or fly drones near others) but always say hello to fellow outdoor enthusiasts.

Respect other people

- Consider the local community and other people enjoying the outdoors
- Park carefully so access to gateways and driveways is kept clear
- Leave gates and property as you find them
- Follow paths but give way to others where it's narrow

Protect the natural environment

- Leave no trace of your visit; take all your litter home
- Don't have barbecues or fires
- Keep dogs under effective control
- Bag and bin dog poo

Enjoy the outdoors

- Plan ahead, check what facilities are open, be prepared
- Follow advice and local signs, and obey any social distancing measures

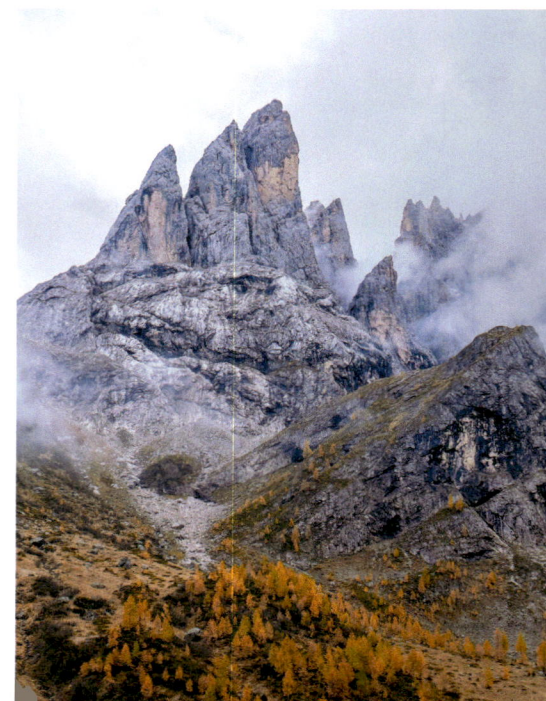

Campanili di Lastei towers in the Focobon group (p.442). DJI Mavic Pro 3, 24mm, ISO 280, 1/500s at f/2.8, Oct.

Busy viewpoints

As photography becomes more popular, some accessible locations and viewpoints can become busy in times of good light. In some circumstances this can cause conflict between photographers as they look for the best spot from which to compose their shot. If you arrive at a location and someone is already set up, give them space and don't get in their way. Talking and negotiating helps; they may be OK with you setting up next to them, or with you using their spot after they have finished. There are usually alternative viewpoints, but just make sure you aren't in their line of fire. If there is a crowd at a particular spot, it's often best just to find another viewpoint.

Mobility ♿

If you can't walk far or up steep slopes, or if you use a wheelchair or have an injury and need to know whether a location is suitable for you, each location chapter has a brief Access Notes section describing the terrain and distance from the road to a viewpoint. Most locations in this guidebook are usually not far from the road and some are roadside.

If a location or viewpoint has the wheelchair symbol, part or all of it will be accessible by wheelchairs. Bear in mind that access for wheelchair users may not be exactly as described in the text, and you should use your own judgment as to how far you proceed at any given location.

Before you go
- Wear appropriate clothing and footwear.
- Let someone know where you are going and at what time you plan to return.
- Take a fully charged mobile phone with you.
- Take a proper topographic paper map on the longer hikes and in the more remote locations.

Once outside
- Stay away from cliff edges, especially if it's windy or if the ground is wet.
- Avoid walking below cliffs as many are unstable.
- Obey warning signs and don't climb over fences.
- Always take a head torch with you.
- If you're taking a selfie, be safe.

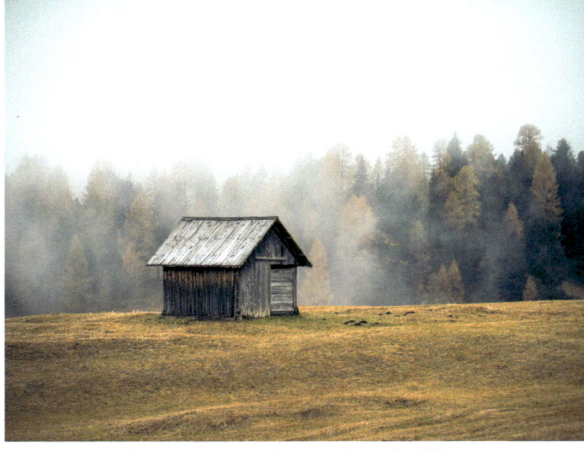

One of many photogenic huts on the Prato Piazza (p.104). Nikon Z8, 24–120mm at 120mm, ISO 500, 1/50s at f/4, Nov.

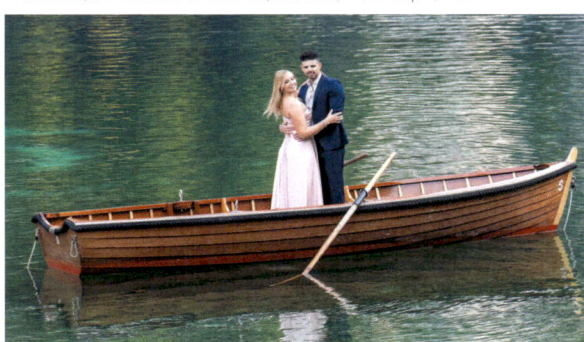

Wedding shoots are common at Lago di Braies (p.94). Nikon D850, 70–200mm at 200mm, ISO 800, 1/500s at f/8, Jul.

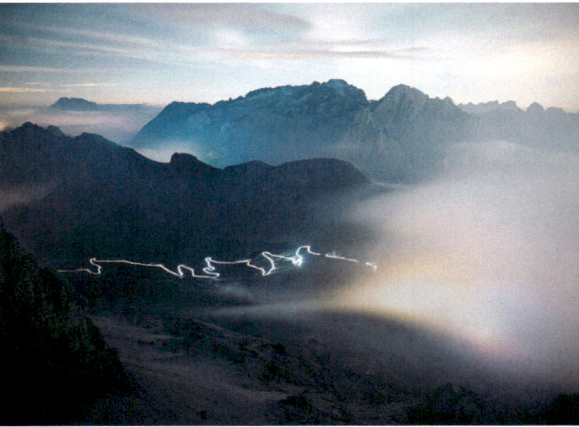

A composite (15 minute exposure to capture the car lights) image of the Passo Pordoi from Sass Pordoi (p.250). Nikon D810, 24–70mm at 24mm, ISO 1000, 30s at f/2.8, tripod, Sep.

HISTORY, CULTURE & WILDLIFE

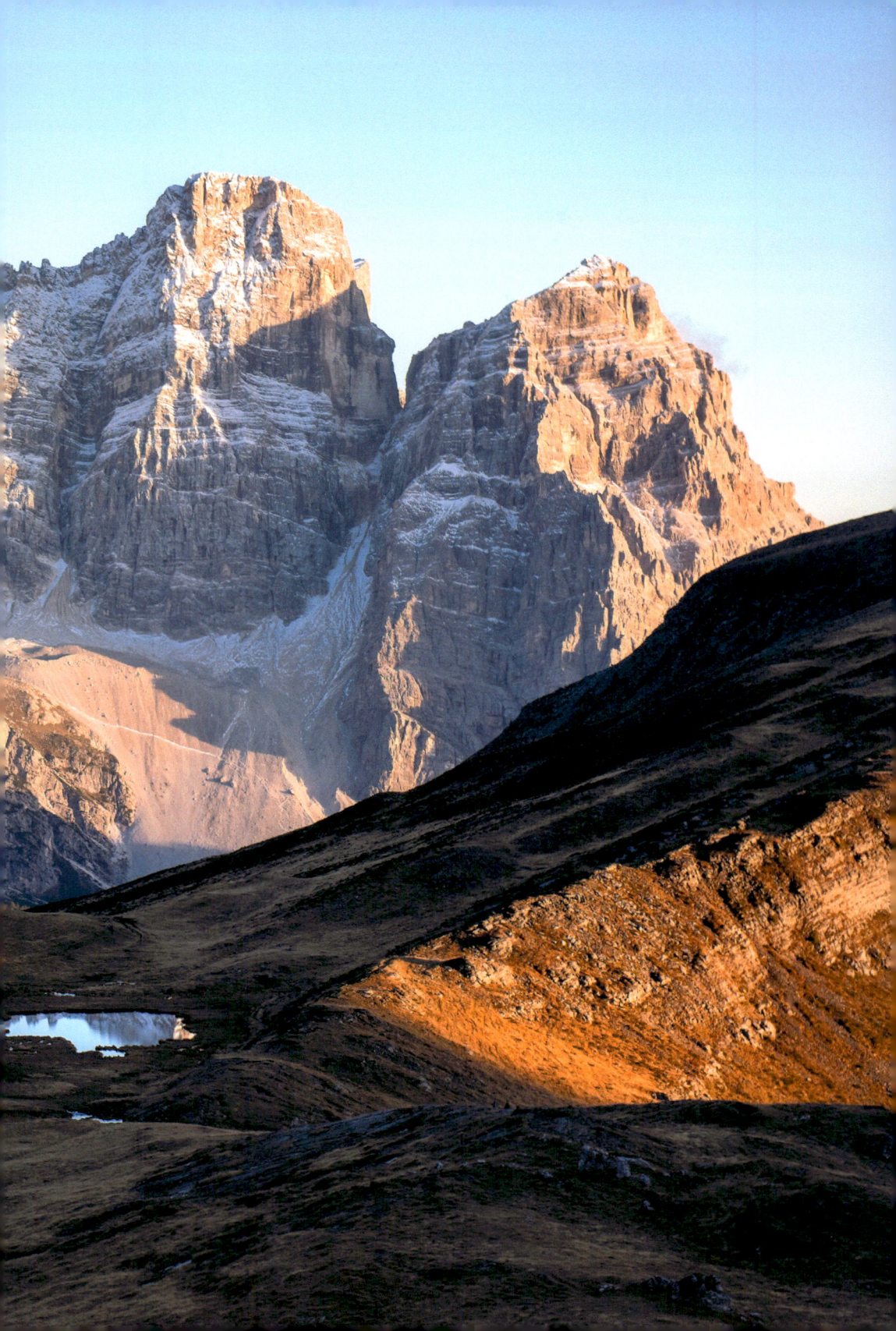

DOLOMITES GEOLOGY

When observing the striking and unusually sheer rock formations of the Dolomites, watching their colours change from grey, to red, to orange, to pink as the light hits them at different times of day, one cannot help but wonder just how these spires and towers were created.

The history of the Dolomites began around 280 million years ago in the mid-Permian era. At this time the earth was composed of a single supercontinent, Pangea, and the region we now know as the Dolomites was located near the equator, where the ancient Hercynian mountains stood on the banks of the Tethys Ocean.

Over time these mountains began to sink and the land began to fracture with huge volumes of volcanic ash and lava spewing out to cover the area. Slowly, over the course of several million years, the mountains became completely submerged and the area became flooded with a warm, shallow sea.

The sea bed continued to subside and around 240 million years ago, tiny organisms which required light to live began to create reefs in order to counteract the progressive lowering of the sea floor, the fluctuating sea level leading to the formation of atolls and archipelagos as the skeletons of the organisms deposited mineral-rich sediment onto the base of the ocean. Volcanic activity further morphed the reefs and islands and as the volcanoes became inactive, the cyclical recession and transgression of the Tethys Ocean continued, resulting in deposits of thick layers of carbonate sediment.

As pronounced subsistence led to the creation of another ocean, Pangea began to break up and in the subsequent 100 million years marine sedimentation continued, resulting in vast deposits of limestone and marl. This environment of shallow waters and reefs seems far removed from the mountains we see today, but towards the end of the Cretaceous period the African and Eurasian plates clashed, folding the sediments of the former Tethys Ocean and thrusting them upwards.

Interestingly, tectonic deformation, the process by which sediments are compressed, folded and moulded, was less severe than in other areas of the Alps, which is why the different bedding planes from different periods can be observed more clearly in the Dolomites than elsewhere.

The unique geology and orogeny of the Dolomites was not discovered until a French scientist, Déodat de Dolomieu, analysed a sample of rock collected in the Valle Isarco and discovered that it was in fact a different type of limestone to those previously studied. Unlike limestone, which is formed of calcite and aragonite, dolomite, so-called after its discoverer, is formed of calcium magnesium carbonate, thought to occur when magnesium-rich groundwater modifies pure calcite.

Following the orogenic processes, the Dolomites were then moulded by climatic factors, with water, ice, karstification and freeze-thaw processes eroding the various layers of rock and sculpting the mountains into the unique formations you see today.

Previous spread: Lago delle Baste and Monte Pelmo (p.290). Nikon Z7II, 24–120mm at 75mm, ISO 64, 1/100s at f/5, Nov.

Opposite: The spectacular geological formations of Crode Rosse in the Pala Dolomites (p.466). Nikon D810, 80–400mm at 280mm, ISO 140, 1/320s at f/5.6, Oct.

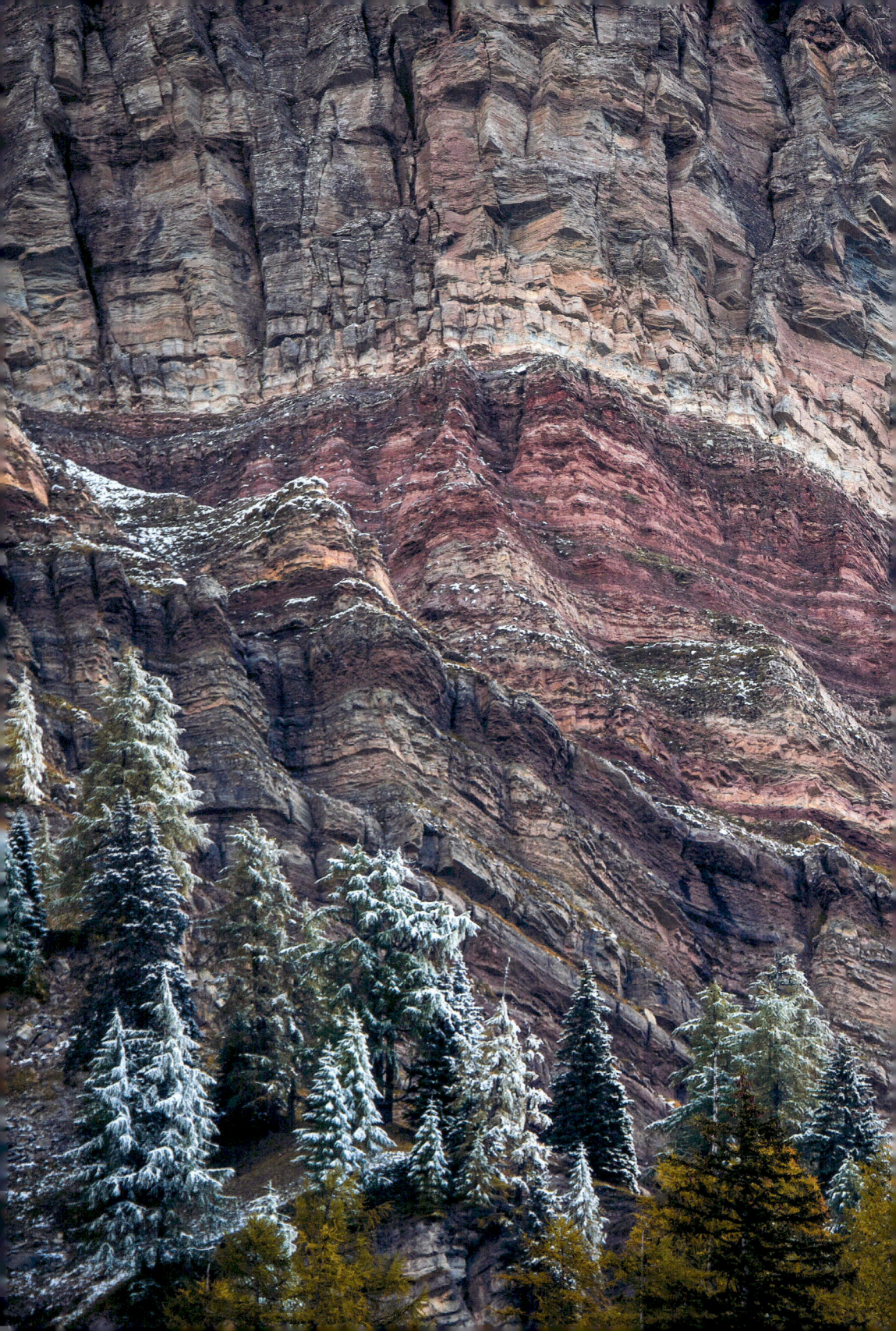

DOLOMITES FLORA

The rich variety of mountain vegetation in the Dolomites is primarily due to the unique diversity of the geological substrata, the diverse geomorphological conditions and the specific micro-climates of each area, as well as human processes such as agriculture, forestation and, more recently, conservation and land management. The unusual combination of rock types, ranging from limestone, volcanic conglomerate and the ubiquitous dolomite, located at various altitudes and facing different aspects, results in varying soil fertility and this, in turn, has enabled a spectacular array of plant life to flourish, with over 1,400 different species recorded across the area. The altitudinal variation in the Dolomites is such that from the valley floors to the top of the highest peaks, flowers and plants which thrive in the four major altitudinal zones – Montane, Subalpine, Alpine and Nival – can be observed throughout the summer months.

Like all alpine areas, the Dolomites are characterised by a pronounced seasonality and this has a profound effect on the mountain flora. As winter gives way to spring and the snow begins to melt, perennials such as the purple fringed Alpine snowbell (Soldanella alpina) and the yellow globeflower (Trollius europaeus) begin to emerge, bringing the first hint of colour to the meadows. However, from a photographer's perspective, the best time to observe the full display is undoubtedly in late June and early July when the snows in the meadows, carefully cultivated and managed for centuries, have receded to give way to a vibrant blanket of colour. Around fifty different species of orchid grow in the region, ranging from the fragrant orchid (Gymnadenia conopsea), vanilla orchid (Gymnadenia nigra), false musk orchid (Chamorchis alpine) the elusive white adder's mouth orchid (Malaxis monophyllos), and the much sought-after lady's-slipper orchid (Cypripedium calceolus), to name but a few.

At higher altitudes, spring gentians (Gentiana nivalis) bring a touch of colour to the rocky slopes, while the glacial buttercup (Ranunculus glacialis) and the endemic Dolomite houseleek (Sempervivum dolomiticum) can be seen among the scree of the higher slopes. Edelweiss, long associated with the Alps and best-known locally not for the song but for the ancient tradition of young mountaineers venturing into the hills to bring one back for their beloved, thrives on thin, stony soil and can also be seen in abundance clinging heroically to the rock between July and August.

In autumn, the alpine flowers reach the end of their season and it is the woodland which creates the next spectacle; the deciduous broad leaf trees of the lower altitudes are interspersed with conifers and beech trees, while higher up Swiss stone pine, Norway spruce and larch predominate, the latter transforming into a truly stunning scene of yellow, gold and red shades in October and early November.

A hoverfly feeds on a pink cinquefoil (Potentilla nitida). Nikon D810, 105mm, ISO 100, 1/250s at f/8, Aug.

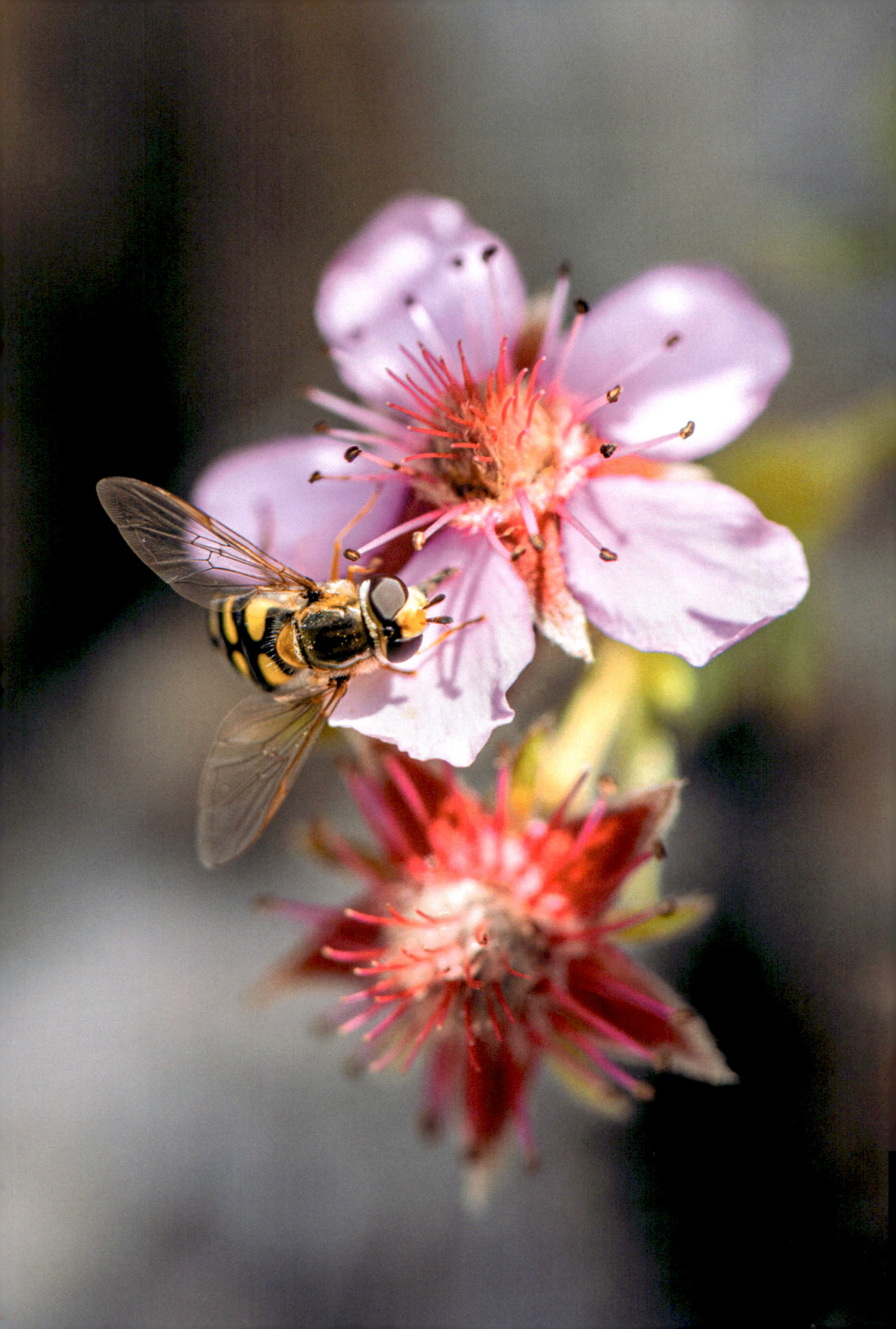

STORM VAIA (ADRIAN) & THE EUROPEAN SPRUCE BARK BEETLE

Two seemingly unrelated events have dramatically reshaped the Dolomites landscape in the last few years. The first occurred in October 2018, when storm or 'Tempesta' Vaia (known over much of Europe as Adrian) generated wind speeds over 180 km/h, with the worst affected areas receiving some 850mm of rain over a three-day period. Between 14 and 15 million trees were flattened, as 8 million cubic metres of wood came crashing down. Damage from widespread landslides, flooding and environmental devastation cost the area an estimated €1.7 billion, with a significant loss to both infrastructure and dramatic changes made to the natural topography.

This destruction would become the catalyst for the region's next environmental disaster, this time in the form of the normally innocuous European spruce bark beetle. Rising temperatures combined with an excess of both dead wood and weakened trees following storm Vaia have led to an explosion in the insect population. Male beetles burrow into the trees, creating intricate passages and nest chambers for the females – this in turn interrupts the sap flow and ultimately kills the tree.

Fortunately, this is now leading to a greater diversification strategy for forests within the Dolomites, as broad-leaf trees and conifers are planted adjacent to the more vulnerable spruce. Today much of the devastation from Storm Vaia has been tidied, though you will still notice barren areas and large expanses of dead trees, particularly in the more exposed locations. Most notably for photographers the backdrop to Lago Carezza (p.130) is a little bare and Sottoguda (p.266) remains inaccessible until the work there is completed.

A lone spruce on a rocky outcrop.
Nikon Z8, 100–400mm at 400mm,
ISO 220, 1/400s at f/8, Nov.

DOLOMITES FAUNA

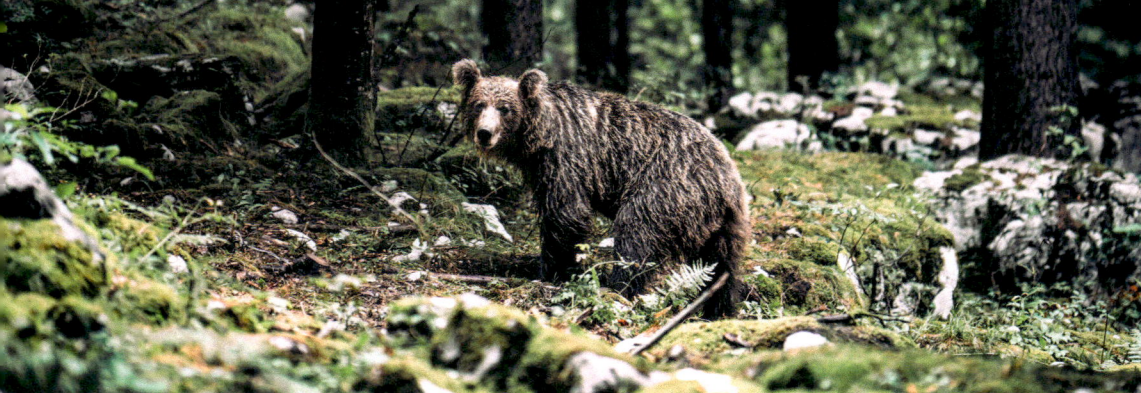

Alpine brown bears are only found in the Brenta Dolomites, predominantely the Adamello Park. © Federico Di Dio.

Thanks to the diverse nature of the natural environment, the Dolomites are home to numerous species of mountain wildlife and the various habitats found within the region – from meadows, woodland, rivers, rocky plateaus and scree slopes – offer different living conditions that suit certain animals, birds and reptiles adapted to high mountain environments.

The woodlands of the lower slopes are home to large colonies of roe deer, seeking shelter in the dark undergrowth and venturing into more open terrain at night. On the steep scree slopes and rocky hillsides, it is not uncommon to see chamois, a breed of small alpine goat, crossing impossibly steep terrain with practiced ease. Sighted less frequently but still well-established is the long-haired ibex, a distinctive ungulate with long curved horns which was successfully reintroduced into the Dolomites after numbers fell to almost zero following excessive hunting and loss of habitat.

Another common sight on the open slopes is the ubiquitous marmot, well known for its high-pitched warning call and meerkat-like sentry position. The marmots live in large family units and build extensive burrows across the hillside with numerous chambers and bolt holes, and early in the season it is not unusual to see turned-up earth outside these entrances, a sure sign that the burrow is still inhabited and the seasonal "spring clean" is underway.

Bears were once reasonably established in the Dolomites but hunting and loss of habitat through deforestation led to many years of extinction. Recently however, following improved environmental conditions, bears have occasionally been known to venture back in the Dolomites and ten brown bears were reintroduced from Slovenia into the Trentino province as part of a European rewilding project.

Bird life is also rich in the area, with alpine choughs offering aerial displays around the rocky peaks. Woodland grouse or capercaille hide in the forests and undergrowth, the distinctive white ptarmigan, whose plumage changes to brown in the summer months, can occasionally be spotted and there are also various species of woodpecker, jay, skylark and finch. The woodlands are home to pygmy owls and boreal owls, while golden eagles can sometimes be observed soaring high above the mountains. Although rare, bearded vultures (also known as Lammergeier) have occasionally been sighted venturing into the Dolomites from nearby Austria.

Opposite: *Marmots are a common sight in the Dolomites. © Hans Ott.*

DOLOMITES WAR HISTORY

Like all landscapes, the Dolomites have been shaped not only by geological and environmental factors but also human aspects, and one of the most defining periods of modern European history in this region of northern Italy was undoubtedly the First World War.

Unified into a nation-state in 1861, when the war broke out in August 1914 Italy was still a young country with an ill-prepared army, and so despite being a member of the Triple Alliance, a secret agreement between Austro-Hungary, Germany and Italy signed in 1882, Italy refrained from declaring war on the basis that the alliance had originally been forged for defensive reasons.

In fact, old rivalries had been simmering between Austro-Hungary and Italy since the 1880s, as radicalist Italian groups sought to promote the annexation of Italian-inhabited territories of Austro-Hungary such as the Tyrol to Italy, and this soon became established as a primary goal in Italy's pre-war negotiations.

In April 1915, following months of secret negotiations, Italy joined forces with the Allies and renounced its membership of the Triple Alliance. By this time, the Austro-Hungarian forces had been heavily engaged on the Eastern front for nearly a year and the Dolomites were largely undefended. The Italian army quickly took control of Cortina d'Ampezzo, but poor organisation meant a rapid advance was impossible and they soon lost the advantage as Imperialist troops established secondary lines on the more readily defensible peaks and passes. The White War, as the Dolomites front became known, had begun.

At this time, like most mountainous regions the Dolomites was home to a relatively insular community based on a traditional economy of alpine agriculture, and the local people had little concept or recognition of national borders. Consequently, the Dolomites front became something of a civil war, with German-speaking troops fighting in the Austrian Kaiserjager while their Italian-speaking neighbours opposed them in the ranks of the Alpini.

Progress on either side was slow and by the end of 1915 the two sides had settled into entrenched, largely stationary positions. Each army attempted to occupy and fortify the highest positions possible but given the extraordinarily harsh environmental conditions, these high-altitude fortifications came at a high cost; in winter 1916 the Dolomites was struck by record snowfall of more than 10 metres and more than 10,000 men lost their lives from avalanche in that year alone.

The trench warfare of the Great War is well-documented and the Dolomites was no different; areas such as Cinque Torri and Monte Piana were excavated to construct shallow trenches in such close quarters that often troops would live within earshot of the enemy soldiers. Given the strategic importance of high ground, positions on mountain summits were heavily contested and trenches were taken a step further, with both sides resorting to extraordinary mining and tunnelling operations. In certain areas, in particular Lagazuoi, the Tre Cime and the Marmolada, kilometres of tunnels were painstakingly excavated with the aim of quite literally undermining the enemy positions above.

Despite the efforts of both armies and the huge loss of life on both sides, the front line remained largely stationary and asides from small gains and losses, neither army succeeded in making any significant advancements.

The war in the Dolomites finally came to an end in November 1917 following the catastrophic defeat of the Italian forces at the Battle of Caporetto, north of Trieste. With their defence in ruins, the Italians quickly retreated to form defensive positions on the River Piave. From this point onwards the Italian front had only a minor role in the war as major events played out elsewhere and the Dolomites front was all but deserted. However, with the assistance of British and French troops, the Italians succeeded in holding the Piave line until the end of 1918 when the armistice agreement was signed and the First World War came to an end.

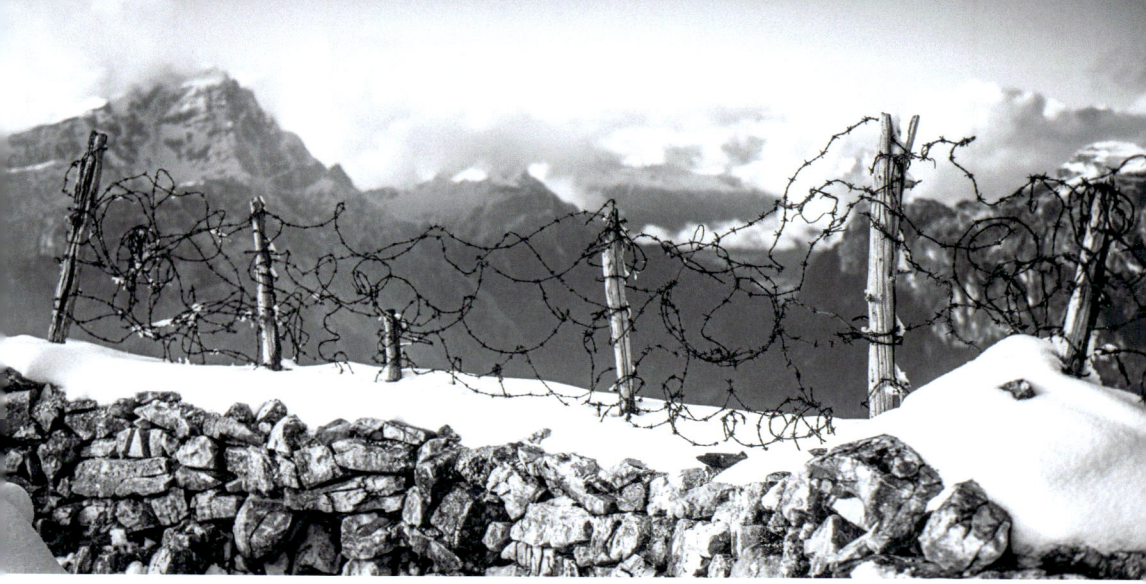

In the aftermath of the war, Italy achieved its original ends and as the former Austro-Hungarian Empire was divided, Italy's borders were swelled by a number of formerly Austrian regions. As well as the Dalmatian coast and the port of Trieste, the entire Dolomites region was annexed to Italy and the national population was boosted by over 1.6 million new Italian citizens.

In the Dolomites, the centuries-old solidarity of the alpine community was fractured as families came to terms with the new situation. These divisions were further deepened by the Fascist Italianisation regime of the 1920s and 30s; in 1919, over 90 % of the population in the South Tyrol was German-speaking, yet in 1923 Italian became the mandatory language in provincial and local government and by 1925 all court affairs had to be conducted in Italian. Places were renamed (leading to the confusing practice of multiple names found throughout the Dolomites) and typically Austrian cultural traditions were repressed. To combat separatist sentiment and to encourage Italians from the southern and central parts of the country to move to the South Tyrol, the Italian government offered generous incentives and tax benefits, contributing to the area's overall wealth. The Italianisation process was abandoned with the onset of the Second World War and Italy's alliance with Germany, then in 1943, following Italy's surrender to the Allies, German forces invaded part of the South Tyrol.

The German language, which had never been truly abandoned, was freely spoken again but as Mussolini, ousted from power but rescued by the Germans, was still a German ally, anti-Italian feelings were largely contained.

After the war, it was decided that the South Tyrol should remain part of Italy. German and Italian were made official languages and both were taught in schools. These days, both Italian and German are widely spoken and any animosity is, for the most part, consigned to the past. However, the tragic events of the First World War in particular have left their mark on the region, and many war remains can be seen in many of the areas described in this guide. The coils of barbed war, rudimentary trenches and kilometres of dark, steep tunnels serve as a sombre reminder of past events and add a pronounced poignancy to the region's photographic potential.

War remains can be seen in evidence at the following locations contained within the guide:

Locations with photogenic war remains

Brunico / Bruneck	82
Sass de Stria / Hexenstein	310
Monte Lagazuoi	316
Cinque Torri	330
Monte Piana / Monte Piano	398
Tre Cime di Lavaredo / Drei Zinnen	416
Monte Castellazzo	456

DOLOMITES CULTURE

The Dolomites has been moulded by a unique blend of factors; from its geological beginnings, early human inhabitation, ancient agricultural practices, historical borders, role in both the First and Second World Wars and, most recently, the rise of mountain tourism, the Dolomites is characterised by a culture which is no less distinctive than the iconic mountains for which the area is most famous.

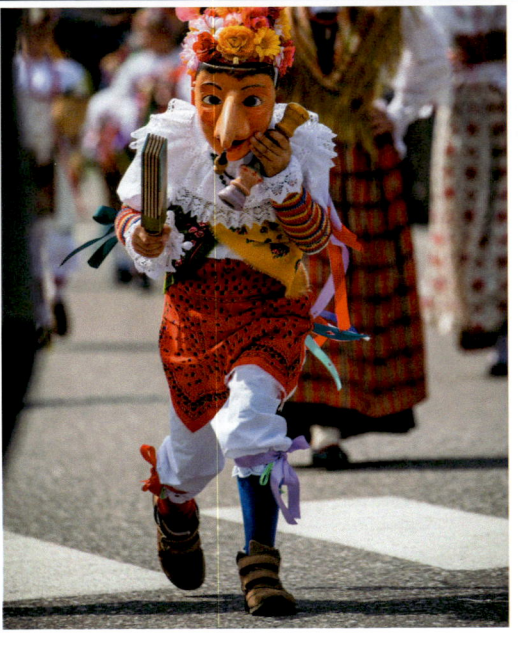

One of the most visible and defining characteristics of the local culture is undoubtedly the language, and first-time visitors to the Dolomites will no doubt be struck by the practice of signing most place names in three languages – Italian, German and Ladin. Ladin is an ancient language dating back to the Roman Empire; when the Alps became part of the Empire, the Rhaetian people began to speak a vernacular variation of Latin spoken by the soldiers and this gradually morphed into Ladin.

Once spoken across the Alps, only pockets of the language remain, yet the unique identity which accompanied the language is still strongly upheld throughout the Dolomites and in parts of the region Ladin is recognised together with Italian and German as an official language. The Ladin culture is characterised by traditional mountain activities and traditions; woodwork in particular is still prized as an important skill and the Val Gardena is renowned for its woodcarving expertise. Alpine agriculture, typically characterised by small-scale subsistence farming, is still prevalent throughout many of the lowlands and meadows below the peaks, with many small dairy farms producing local cheeses to traditional recipes.

Another distinctive feature of the local culture are the many festivals and celebrations held in the towns and villages. Spring and autumn are the liveliest in this respect; in February the locals celebrate Carnevale, dressing up in bright costumes to mark the end of winter, while in October the local farmers adorn their cattle with ornate headdresses and flowers as they drive them down to the lower pastures.

Many aspects of modern culture in the Dolomites resonate with more stereotypically Italian influences: Cortina is well-known for its chic and fashionable appeal and Italian cuisine is naturally very prevalent in the bars and restaurants. Religion still plays a large part in the lives of many local people, with even the smallest villages having at least one church or chapel. Sunday is still observed as a day of rest throughout the Dolomites and almost all local business and shops will close for the entire day. Similarly, long family lunchtimes are still considered an almost obligatory ritual and during the week most shops close for three to four hours from midday onwards.

Above: Gran Festa da d'Istà – Canazei in Val di Fassa. Nikon Z7II, 100–400mm at 400mm, ISO 200, 1/800s at f/7.1, Sep.

Opposite top: The transhumance celebration in Castelrotto as all the livestock are brought down from the mountains. Nikon D810, 80–400mm at 400mm, ISO 160, 1/400s at f/5.6, Oct. **Bottom**: During the event, the various districts decorate the cows with elaborate headdresses. Nikon D810, 80–400mm at 185mm, ISO 100, 1/320s at f/5.3, Oct.

DOLOMITES CUISINE

Italy has long been celebrated for its delectable food and drink and the Dolomites is no different, with quality food a welcome characteristic in the restaurants, bars and mountain rifugios. However, just as the complex history of the area has left its mark on the language and culture, so too has it had an effect on the cuisine and the dishes are characterised by a unique fusion of Italian, Austrian and Ladin influences.

Italian food is often pigeonholed into the ubiquitous pizza and pasta and these are of course prevalent throughout the region's restaurants. In many establishments, pasta is made by hand according to traditional methods and Casunzei (a close relative of the Austrian Schlutzkrapfen), a half-moon shaped ravioli typically filled with potato or spinach and served in a butter and sage sauce, is a popular Ladin dish. Pizza is cooked traditionally in wood-fired ovens and most pizzerias have a very extensive menu of toppings, the classics often accompanied by more inventive choices and a selection of "Pizze Bianche", white pizzas with no tomato sauce.

As in many mountainous regions, before the arrival of the ski and tourist industries the Dolomites was a relatively poor agricultural area and meals typically consisted of few ingredients which could be sourced cheaply and locally. Canerdeli, bread dumplings made with speck, cheese or spinach, are often served in a light vegetable broth, and zuppa d'orzo, barley soup with speck, is accompanied by "tutres", pastry fritters filled with sauerkraut or spinach.

There are numerous small dairies producing excellent alpine cheeses throughout the region and this is often served on a platter accompanied by speck, a cured meat similar to Parma ham, and local salami.

For those with a sweet tooth, apple strudel is served throughout the region, the traditional South Tyrolean style favouring a thicker, almost biscuit-style pastry rather than filo. Custard or vanilla sauce are common apple strudel accompaniments.

As both Austria and Italy have thriving coffee cultures, it is unsurprising that this tradition continues in the Dolomites and the morning "caffe", meaning simply an espresso, is a morning ritual for many locals, traditionally taken on foot at the bar. Latte macchiato, literally translated as stained milk, is the Italian equivalent of a latte and is usually a warm, very milky coffee, while cappuccino is an espresso topped with steamed milk (in Austria, cappuccinos are often topped with whipped cream but this would be sacrilege in Italy, as would the thought of drinking this traditionally morning coffee any time in the afternoon).

Grappa, Italy's answer to Schnapps, is produced in local distilleries throughout the region; the white grappa is the simplest (and strongest) variant and is an acquired taste, but the fruit grappas are much more palatable to the uninitiated and are often served as a "digestivo" at the end of the meal. Trentino is well-known for its wine-making heritage and local wines include blended and varietal wines such as Casteller DOC and Trentino DOC; "DOC" represents the Controlled Designation of Origin and serves as a quality assurance for Italian wine.

Recently, the Dolomites has acquired something of a gourmet reputation and the area boasts a higher concentration of Michelin-starred chefs than anywhere else in Italy. The restaurants pride themselves on their rich culinary heritage and the menus often feature new interpretations on traditional local dishes. Alternatively, for a more down-to-earth (and cheaper) local experience seek out one of the many agriturismos; small independent farm restaurants, to gain agriturismo status these establishments must use ingredients produced or grown on the premises and consequently are an excellent way of sampling true local cooking.

Opposite top: Pasta is often made according to traditional methods. Nikon D810, 105mm, ISO 100, 1/15s at f/3, tripod.
Middle & bottom: The various stages of traditional Tyrolean strudel. Nikon D810, 105mm, ISO 100, 1/30s at f/3, tripod.

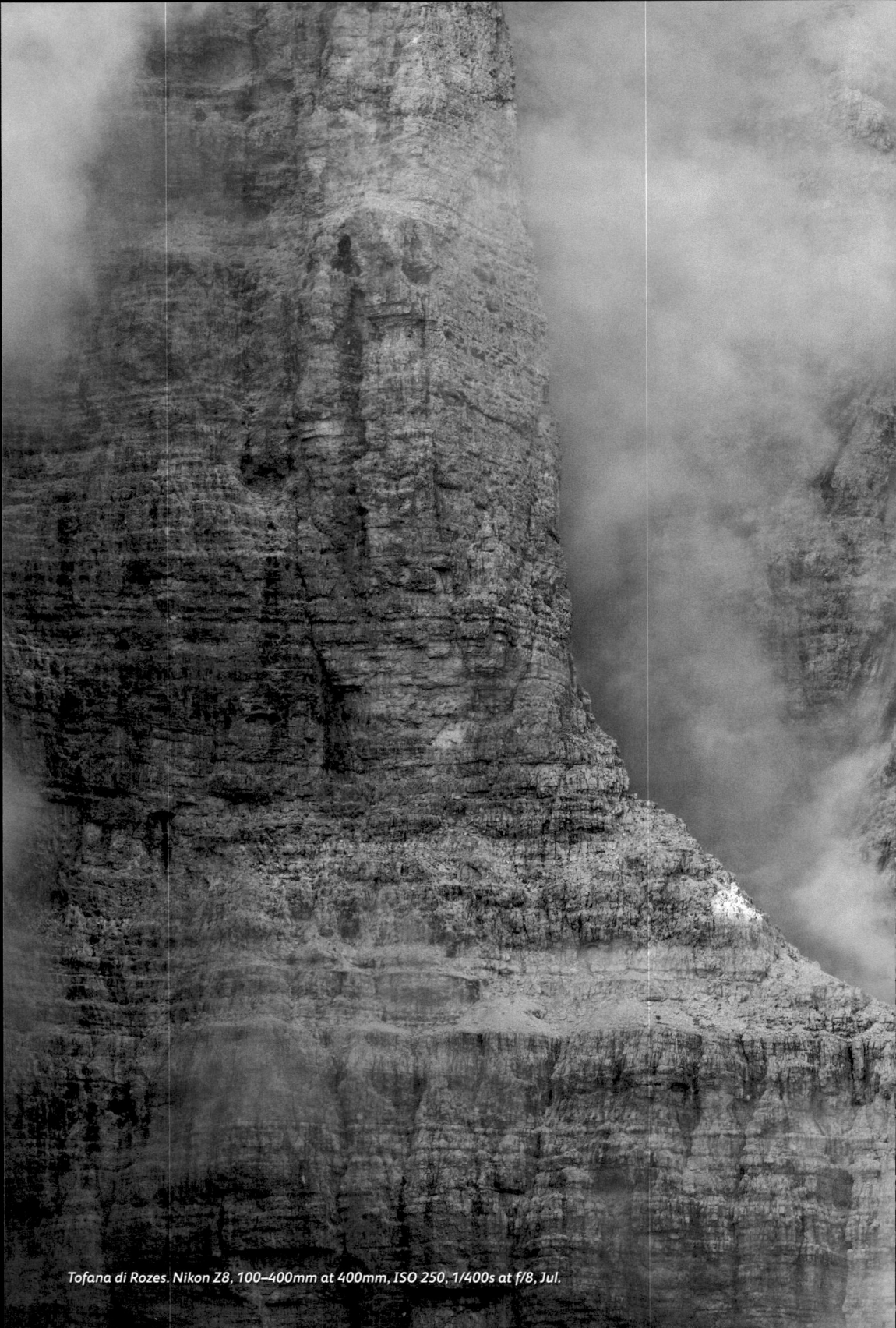
Tofana di Rozes. Nikon Z8, 100–400mm at 400mm, ISO 250, 1/400s at f/8, Jul.

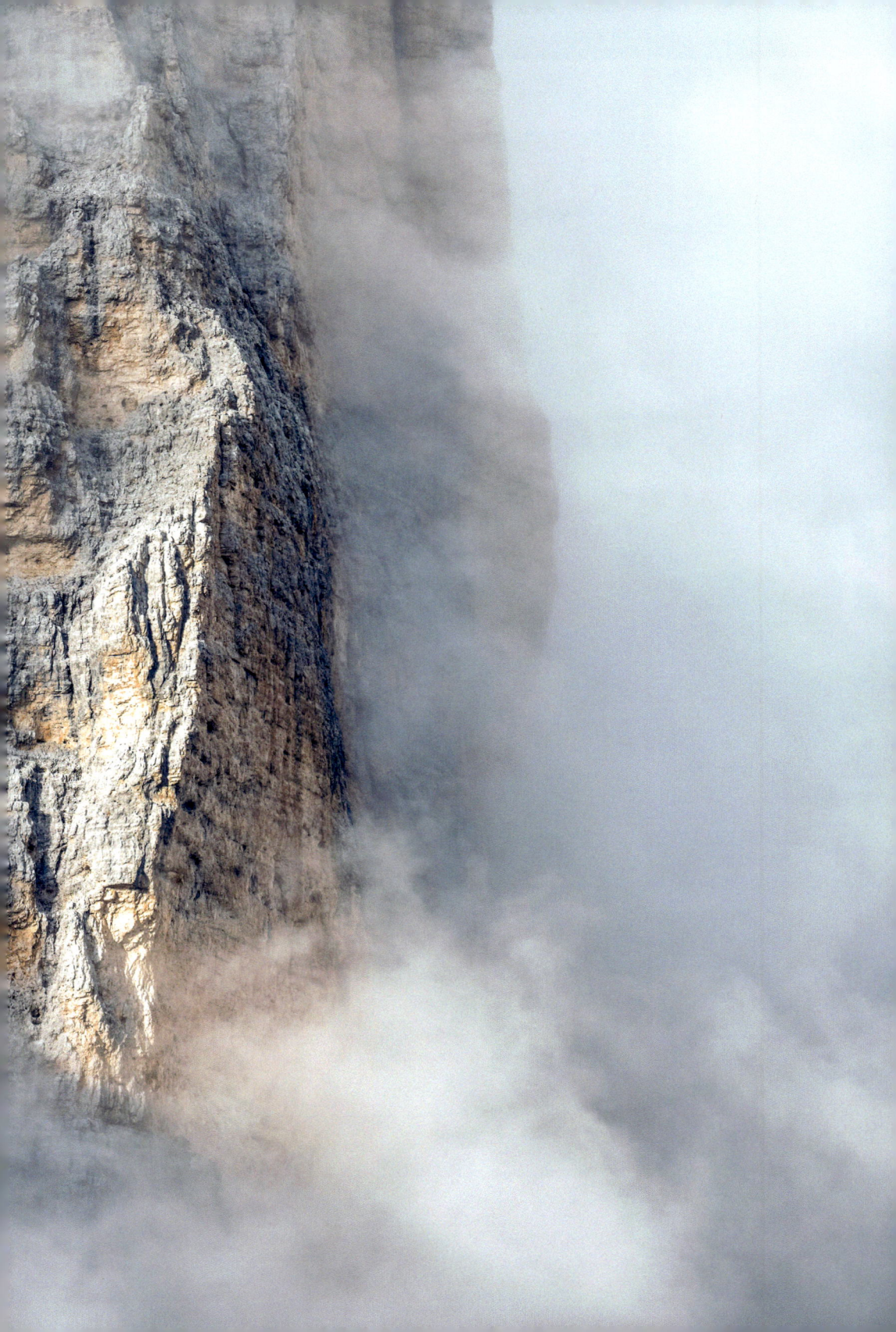

VAL PUSTERIA

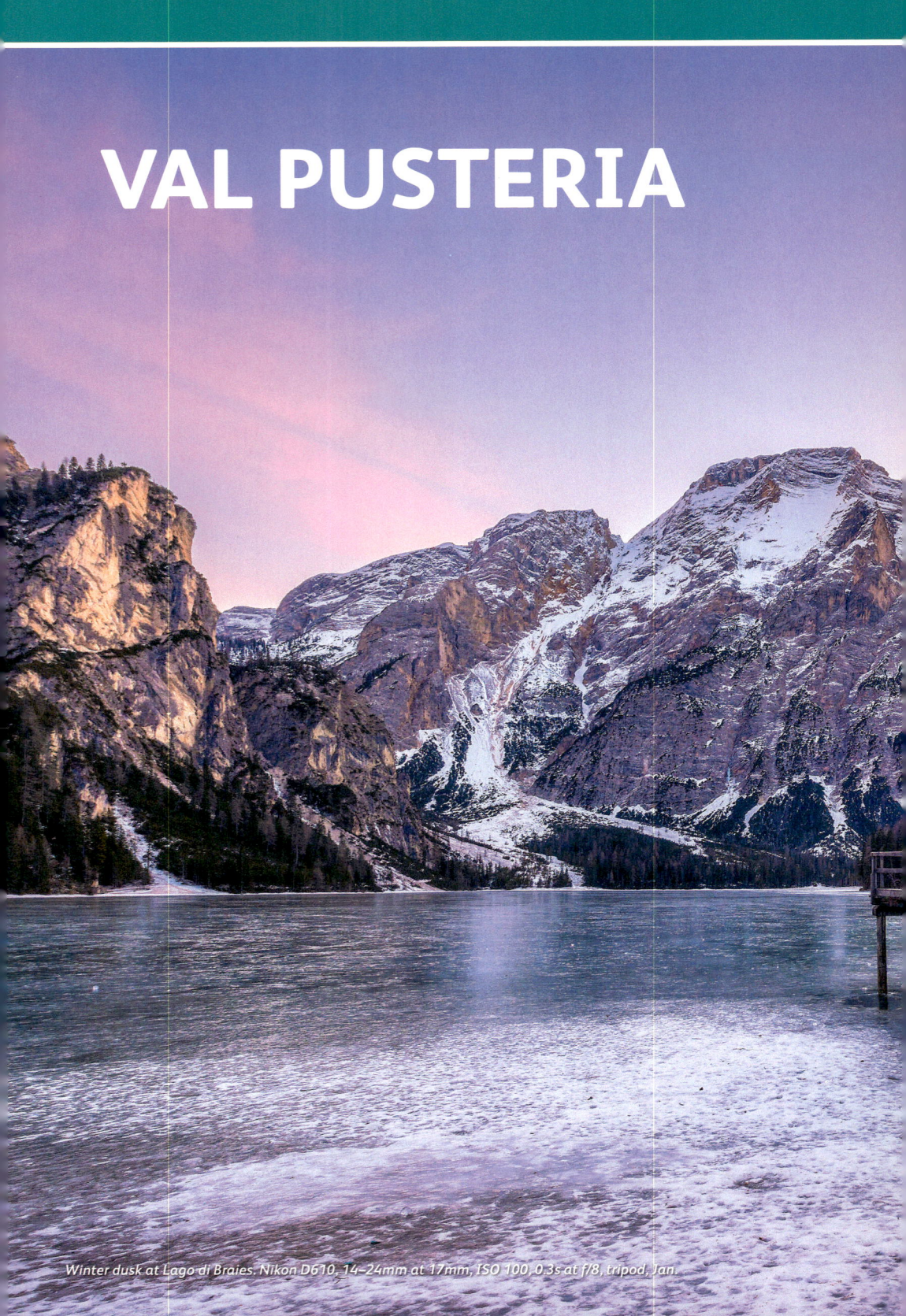

Winter dusk at Lago di Braies. Nikon D610, 14–24mm at 17mm, ISO 100, 0.3s at f/8, tripod, Jan.

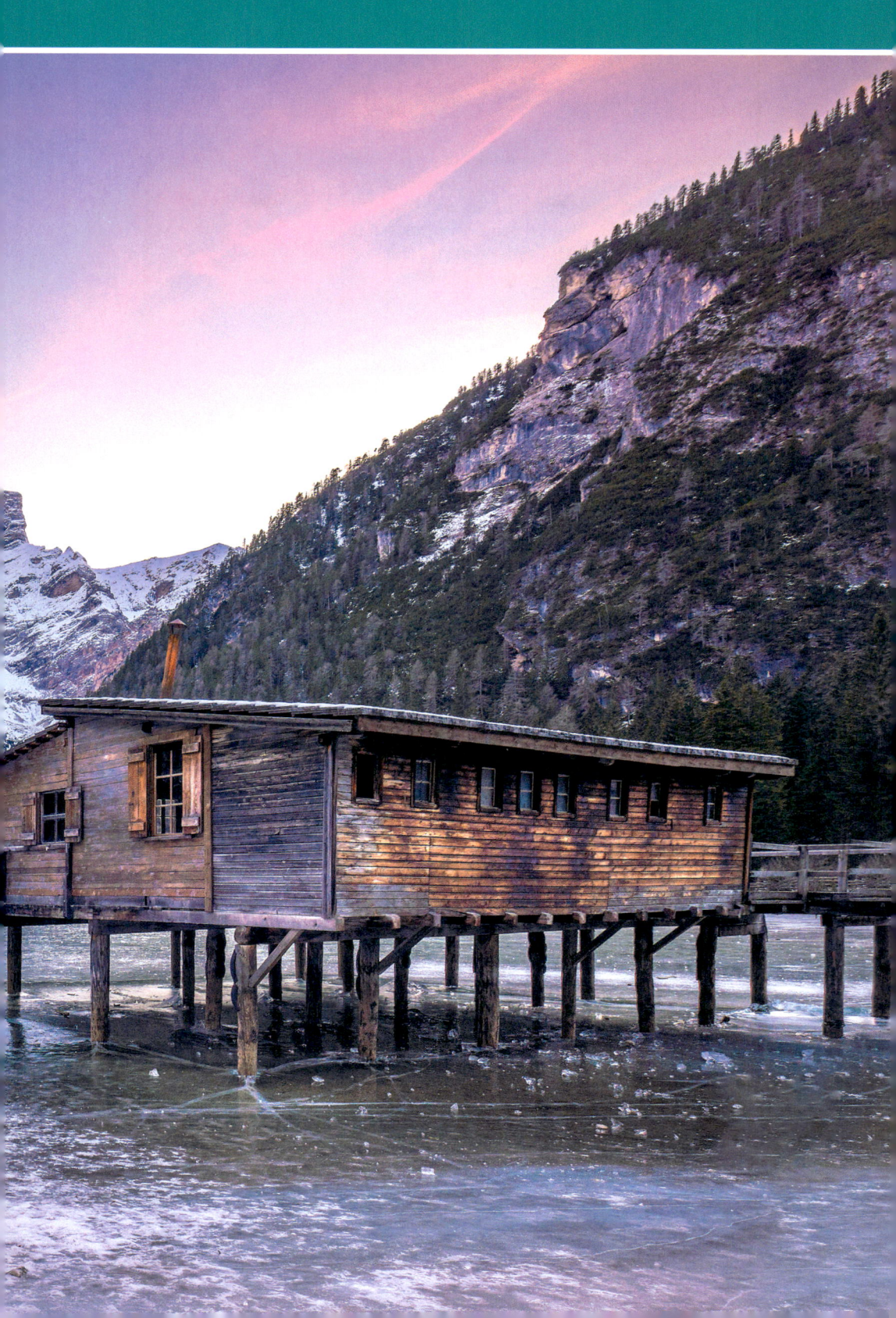

VAL PUSTERIA – INTRODUCTION

The broad valley of the Val Pusteria runs east to west, forming part of the Periadriatic Seam which separates the Southern Limestone Alps from the Central Eastern Alps. One of the principal valleys surrounding the northern Dolomites, it marks the edge of the group and extends from Rio di Pusteria in the west to the town of Lienz in Austria to the east. Given its location, the valley is profoundly Tyrolean both geographically and culturally and the local population is almost entirely German speaking. The valley's superb position has other benefits too; its efficient public transport network has earned it the epithet of 'the gateway to the Dolomites' and the valley provides convenient access to the Sesto, Fanes-Sennes-Braies and Puez-Odle natural parks.

The largest town in the valley is Brunico. Dominated by its medieval castle, it has a population of just over 15,000 and while the outskirts are undeniably industrial, the historic and lively centre is a beautiful example of its Tyrolean heritage. Brunico also has a proud artistic legacy, with late Gothic masters such as Hans von Bruneck and the sculptor Michael Pacher originating from the town.

To the east lies the much smaller town of Dobbiaco. Enjoying an arguably more scenic location than Brunico, Dobbiaco also has its fair share of cultural interest; the somewhat divisive late-Romantic composer Gustav Mahler took refuge here following the death of his beloved daughter Maria Anna in 1907 while he worked on his disturbing but seminal Ninth Symphony, while in a more recent accolade, in 2005 the town was heralded as a 'perfect example of clean energy' following the completion of an internationally acclaimed project to construct a power plant that burns waste shavings from local sawmills. However, the town is arguably best known for providing access to the Sesto Dolomites, home to the world-famous and much-photographed Tre Cime di Lavaredo.

The Val Pusteria receives a lot of sunlight and despite the absence of a quintessentially Dolomitic backdrop, the gentle meadows, grassy plateaus and beautiful woodlands which characterise the valley are very photogenic in their own right. Perhaps the jewel of the region is Lago di Braies (Pragser Wildsee), the so-called 'pearl of the Dolomites' and start of the famous long-distance walking trail 'Alta Via 1'. This spectacular lake provided the setting for the Italian TV series 'Un passo dal cielo' and is a must for anyone in the area, particularly during low season when the crowds have abated.

Traditional dress in Brunico. Nikon D810, 105mm, ISO 100, 1/320s at f/2.8.

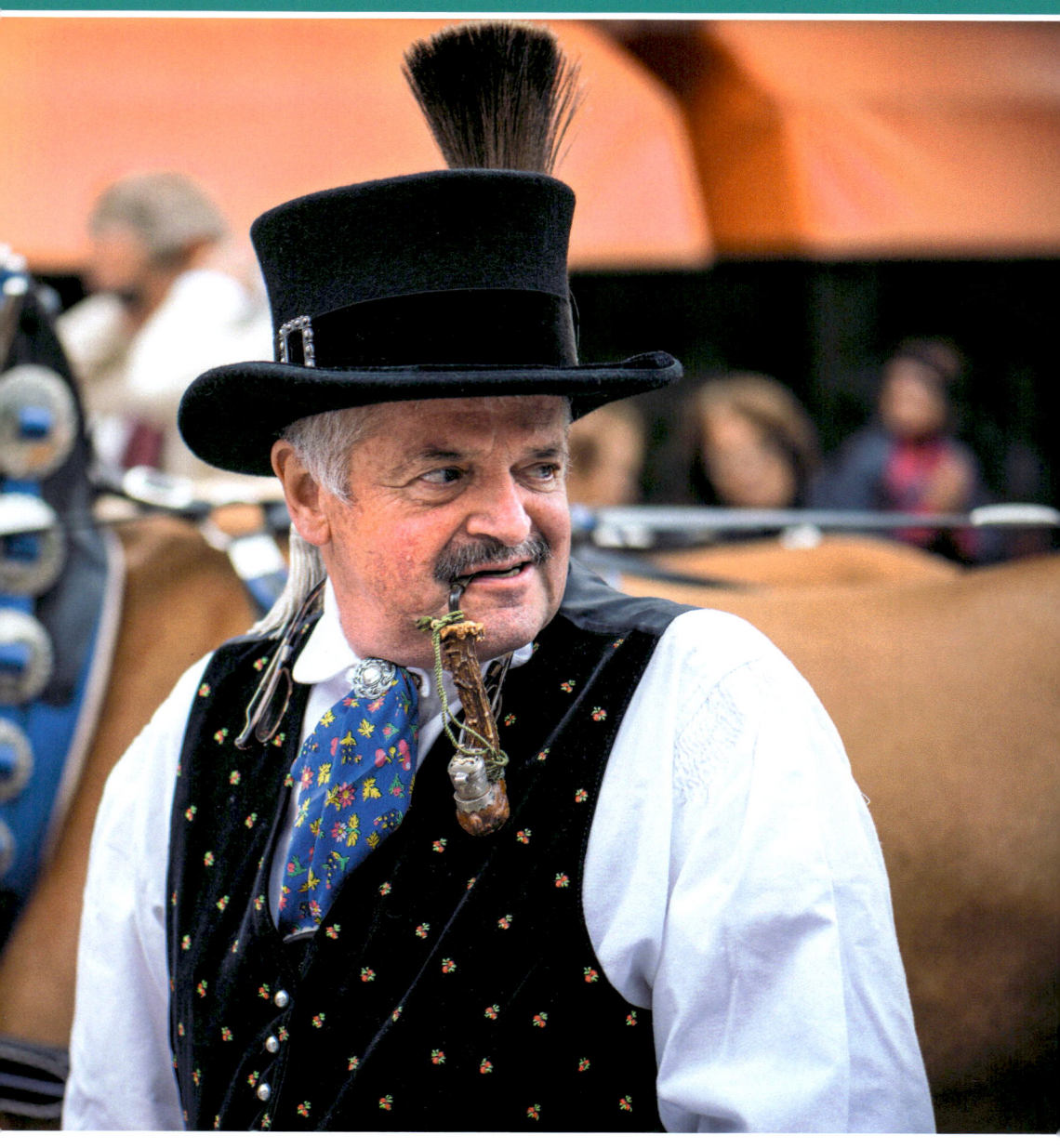

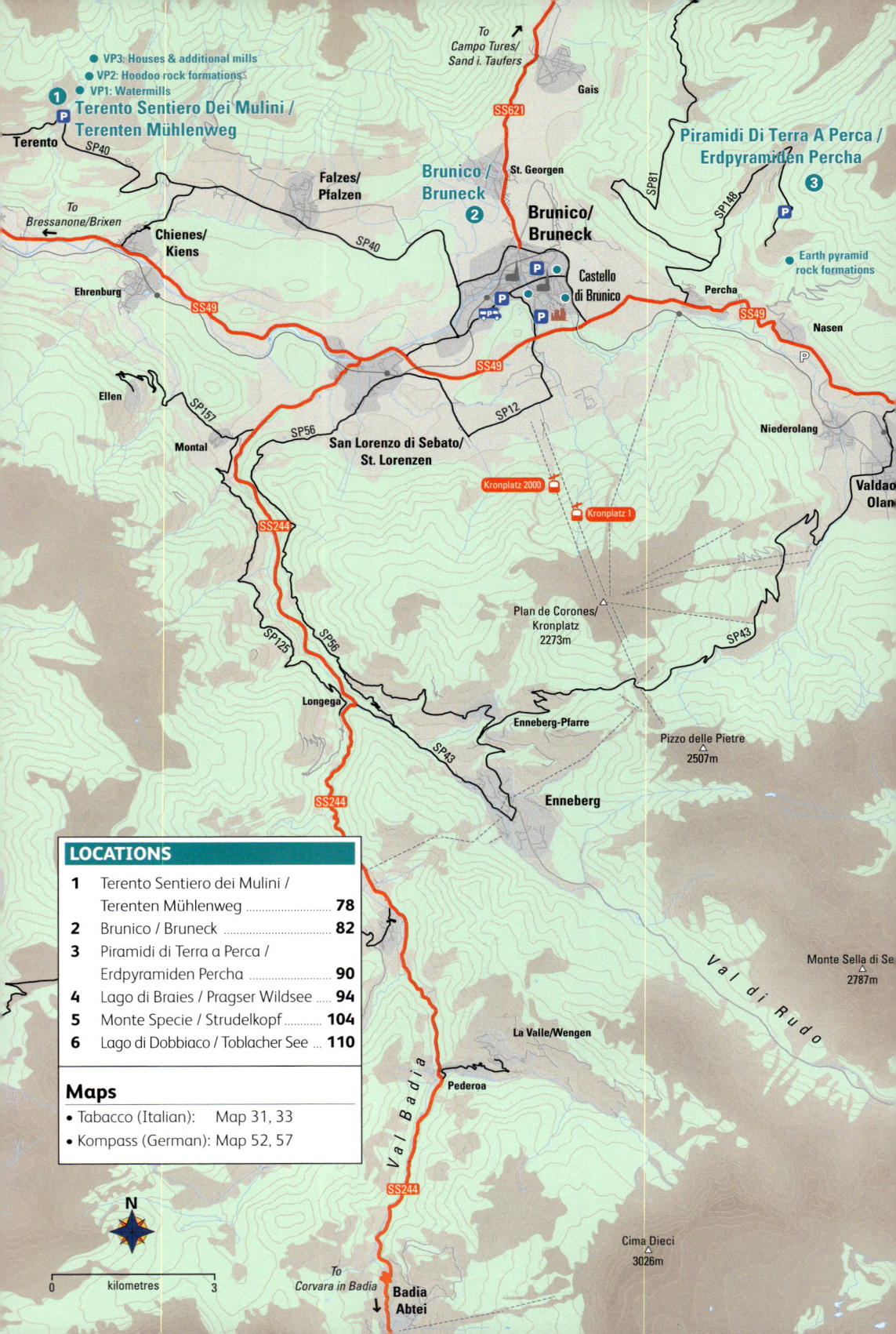

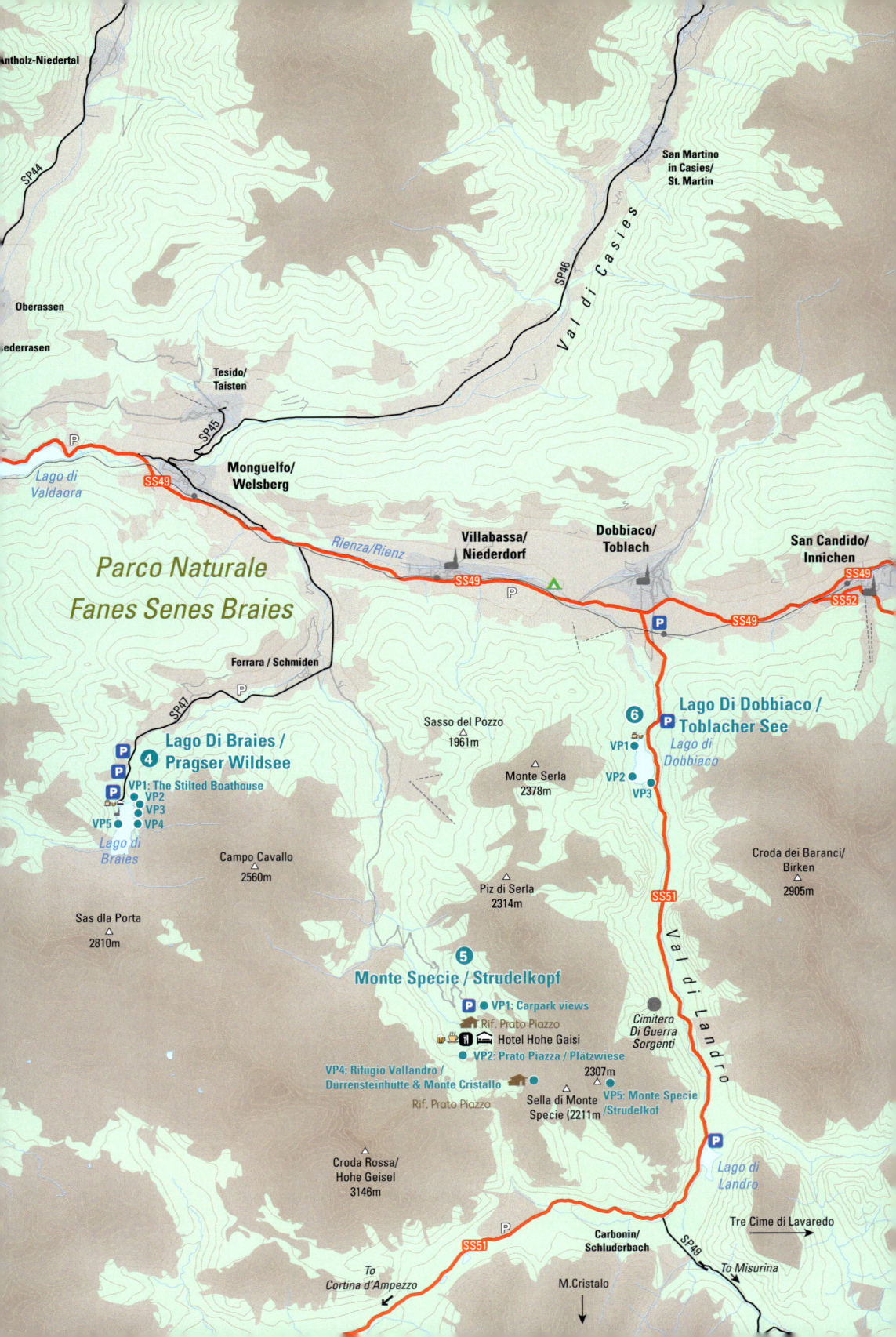

1. TERENTO SENTIERO DEI MULINI / TERENTEN MÜHLENWEG

This historical hike starts at Terento – a small village on the outskirts of the Dolomites once known 'as the granary' of the Val Pusteria. The trail follows the eponymous stream past seven restored mills and a small earth pyramid outcropping. This location will appeal to photographers with a historical interest.

What to shoot and viewpoints

The complete 5.5km circuit takes approximately 90 minutes to complete without breaks and photographers should definitely budget a little more time to fully take advantage of this very enjoyable location. For those not wishing to complete the full circuit reaching the Hoodoo rock formations takes approximately 30 minutes.

From the carpark follow the main road (SP40) downhill to the west for 150m. At the first hairpin leave the main road and join a path on the right, where an information board and map describes the proposed circuit. Ascend the well marked trail, following signposting towards Sentiero dei Mulini and the Piramidi di Terra to reach the first mill in 10 minutes of uphill walking, shortly after crossing a bridge.

Viewpoint 1 – Watermills

There are seven mills in all, two in the lower valley and then five above the hoodoo rock formations. Each has their own unique characteristics and there isn't really a best classic perspective. Instead try experimenting, wider shots to include the whole building – or picking out some of the wonderful details with a longer lens. The historic nature of the valley lends itself well to black and white photography.

How to get here

Parking for the Sentiero dei Mulini is found in the main Terento carpark. From Brunico take the SP40 west for 16km to reach the town of Terento. Follow the SP40 through town, following signposting towards 'Parcheggio Centro'. The large carpark can be found on the left, adjacent to the tourist information office.

- **Lat/Long:** 46.8297, 11.77662
- **what3words:** ///shutting.humble.cavern
- **Tabacco:** Map 33 (1:25.000)
- **Kompass:** Map 52 (1:50.000)

Accessibility

Approach: 30 minutes, 3km, 230m of ascent.

Well maintained gravel paths make up the majority of the circuit, with occasional short sections on tarmacked roads. Be aware the path goes uphill for 230m of ascent, albeit never too steeply.

Disabled access: Whilst it would be possible to access some of the viewpoints following the gravel path with a wheelchair it would be difficult and is not recommended.

Best time of year/day

This is an ideal venue in the spring, summer and autumn once the winter snows have melted. The easy access and close up nature of the photography here makes it a good location in bad weather when it is best to avoid the higher mountains.

There is a culinary festival here in October and several of the mills are used to grind flour.

A wonderful garden on the walking trail. Nikon Z7II, 24–120mm at 55mm, ISO 125, 1/60s at f/11, Sep.

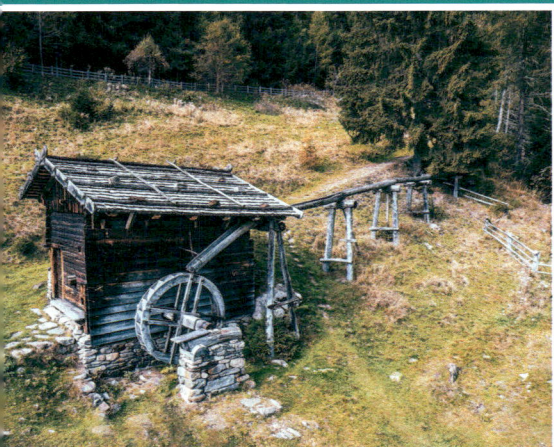
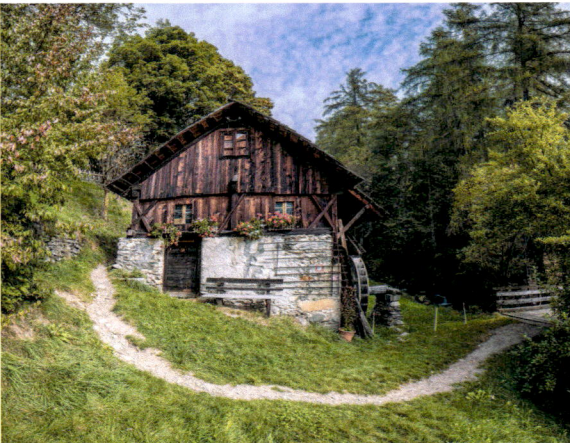

The penultimate mill on the Sentiero dei Mulini. DJI Mavic Pro 3, 24mm, ISO 100, 1/1000s at f/2.8, Oct.

A cropped six photo mill panorama. Nikon Z7II, 24–120mm at 24mm, ISO 64, 1/60s at f/11, Aug.

Viewpoint 2 – Hoodoo Rock Formations

After following the trail for 30 minutes the hoodoo rock formations – or 'earth pyramids' are clearly visible on the right across the Terento river. Formed after a dramatic storm in 1837 which destroyed many of the buildings populating the valley, the earth pyramids make for an interesting subject with a medium zoom lens.

Viewpoint 3 – Houses & Additional Mills

Continuing uphill for another few minutes first leads to some picturesque houses with beautiful gardens and then to the remaining mills. Photographers can then retrace their steps back to the car or cross the bridge leading onto the east side of the river. A good track and then small road leads back down into Terento, with good views over the surrounding landscape on the descent.

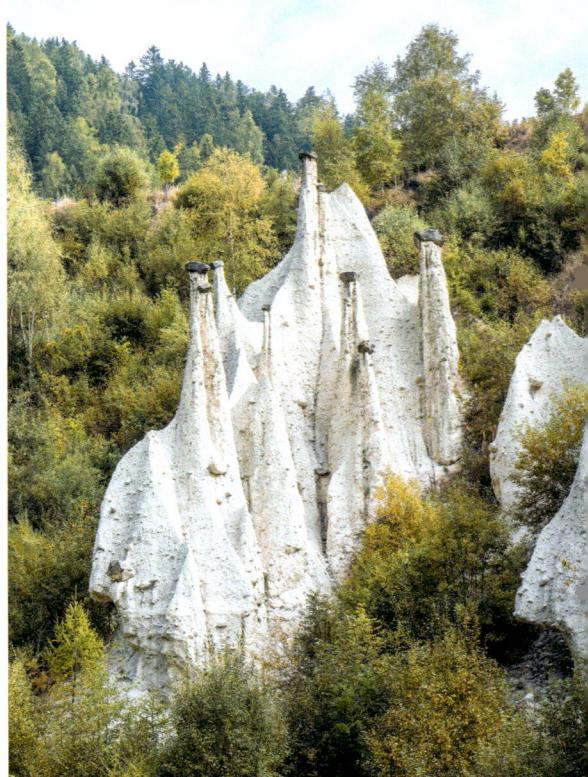

The Hoodoo formations are clearly visible whilst ascending the trail. Nikon Z7II, 24–120mm at 75mm, ISO 100, 1/80s at f/11, Oct.

2. BRUNICO / BRUNECK

Styling itself as the 'pearl of the Val Pusteria' and with a population of just over 15,000, Brunico is the largest town in the valley. Voted in 2009 as the best small town in Italy to live in, it is well-known for its modern approach to traditional South Tyrolean characteristics. This is perhaps best reflected in the architecture, with the street of Via Dante Alighieri providing a dramatic contrast between old and new. From a photographer's perspective, the castle, forest cemetery, Rainkirche church and the old town all present some superb photo opportunities and are recommended for those with a keen cultural interest or as a wet weather option.

It is thought that Brunico was named after its founder Bruno von Kirchberg, Prince-Bishop of Bressanone, with records first citing the settlement as 'Bruneke' in a deed issued on 23 February 1256AD. Located on the confluence of the rivers Ahr and Rienz and the junction between the Aurina, Tures, Badia and Pusteria valleys, the town represented a historically strategic position and the castle was built in the mid 13th century, commissioned by the Prince-Bishop to protect his lands in the Val Pusteria.

The 14th and 15th centuries saw increased trade between Augsburg in Bavaria and the Republic of Venice, with many merchants bringing goods through the Val Pusteria for storage in Brunico. Despite setbacks including floods, fires and the plague, the town prospered and earned a reputation as a centre of artistic mastery, perhaps most famously for the tutelage of Renaissance artists Michael and Friedrich Pacher. In 1871 a railway was constructed along the valley, marking the first step towards the town's development as a mountain holiday destination. Following World War I and the collapse of the Austro-Hungarian Empire, Bruneck became part of the Italian state and was renamed 'Brunico', although the Bruneck name is still widely used.

Castello di Brunico.

Today, the impressive town gates lead into a bustling and lively centre; there is a refreshing number of independent and artisan traders particularly in the old part of town, while the Brunico campus of the Free University of Bolzano brings a young and vibrant aspect to the town's contemporary culture.

Previous spread: The morning mist slowly burns off Brunico Castle – as seen from Santa Caterina. Nikon D810, 80–400mm at 400mm, ISO 180, 1/400s at f/5.6, Oct.

How to get here

Brunico is located equidistant between Rio di Pusteria and Dobbiaco in a central position in the Val Pusteria. As the main town of the region, it is well signposted off the SS49 which runs the length of the valley. There are numerous designated car parks in the town, although for the photo locations described here the official castle car park is the most logical. As you approach the town centre, the castle is well signposted as 'Bruneck Schloss', denoted pictorially with a battlement symbol. The car park is located adjacent to the castle on Via Riscone, directly below a pedestrian suspension bridge.

- **Lat/Long**: 46.79344, 11.93946
- **what3words**: ///detonator.swept.faxed
- **Tabacco**: Map 33 (1:25.000)
- **Kompass**: Map 52 (1:50.000)

Accessibility

Approach: 5 minutes, 0.2km, 20m of ascent.

The tracks leading up to the castle and forest cemetery are both steep but well surfaced. For those with reduced mobility, it is better to focus your visit on the old town, parking in one of the underground car parks in the centre rather than attempting to descend the steep cobbles leading through the castle ground.

♿ **Disabled access** throughout Brunico town centre is good.

Best time of year/day

Thanks to the vast and varied potential offered by a town of this size, Brunico can be recommended throughout the year and at all times, be it day or night. The town also makes for an excellent wet weather option if the higher ranges are affected by adverse conditions.

 # BRUNICO / BRUNECK

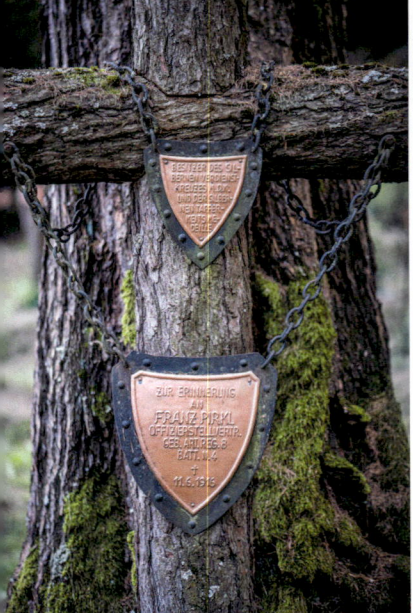

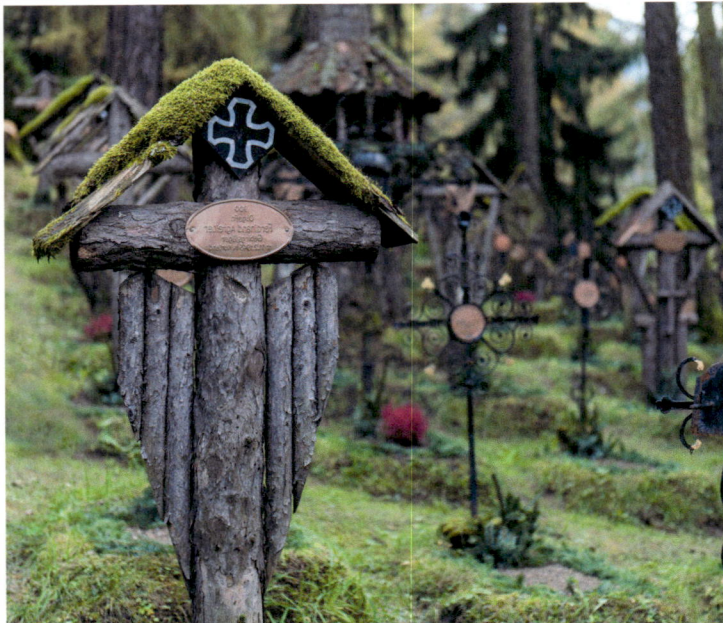

Remembrance plaques. Nikon D810, 105mm, ISO 500, 1/125s at f/2.8, Jun.

Using a shallow depth of field to draw the eye to the foreground. Nikon D810, 24–70mm at 70mm, ISO 100, 1/160s at f/2.8, Sep.

What to shoot and viewpoints

Viewpoint 1 – Cimitero di Guerra

The soldiers' cemetery in Brunico is a unique, moving and fascinating photo location which should treated with the utmost respect. Designed by the Austrian Lieutenant Colonel Berchtold and then opened by the town's mayor, Josef Schifferegger, on the 3rd July 1915, this cemetery is the final resting place of many soldiers who fell serving on the front lines of the Dolomites during the First World War. Directed by the mayor's wife, a ladies' committee was established in June 1921 to oversee the upkeep of the cemetery, and this tradition has been upheld by the women of Brunico to this day. Please be respectful and refrain from taking photos here on a Sunday.

From the car park walk uphill, crossing the main road and taking a well-marked track off to the right signposted to 'Cimitero di Guerra'. Follow the track gently uphill for 5 minutes to reach the forest glade.

Here the woodland setting, vibrant moss, flowers and well-maintained wooden graves provide innumerable photo opportunities. There is no 'main' viewpoint as such, so feel free to be creative; try a macro or zoom lens to capture some of the fascinating and intricate details, or experiment with a wide-angle to portray the scale of the site.

The graves can be effectively photographed from the front or back, and early in the morning and evening there is ample opportunity for sunstars through the surrounding trees (make sure you use a narrow aperture to allow the light diffraction to occur).

The location has a very evocative, fairytale feel and it is an ideal spot to let your imagination run wild. Just remember to be sensitive to the environment at all times.

Above: *The sun illuminates a grave. Nikon D810, 24–70mm at 48mm, ISO 100, 1/160s at f/6.3, Sep.*
Below: *Using a narrow aperture to create a sun star. Nikon D810, 14–24mm at 20mm, ISO 560, 1/25s at f/18, Oct.*

2 BRUNICO / BRUNECK

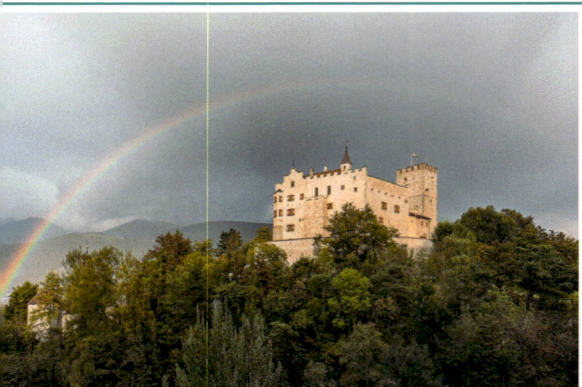

Stormy weather over Brunico castle. Nikon D810, 14–24mm at 20mm, ISO 100, 1/250s at f/8, May.

The clock face of Rainkirche church. Nikon D810, 80–400mm at 250mm, ISO 100, 1/250s at f/7.1, Oct.

Viewpoint 2 – Castello di Brunico ♿

In July 2011, Brunico Castle became one of six 'Messner Mountain Museums' dedicated to exploring the geomorphology, history and culture of mountainous environments, with particular focus on the relationship between mountains and humankind. Each museum explores a unique theme and MMM Ripa presents a study of the mountain civilizations of Asia, Africa, South America and Europe, exploring their culture and offering an exploration into their regions and tourism activities.

The castle provides several good photo opportunities, though arguably the best views are from the pedestrian suspension bridge above the car park and a viewpoint just over the bridge (the opposite side of the road to the castle) and 30m to the right. If you are accessing this viewpoint from the cemetery, you can reach the suspension bridge by following good signposting towards the castle.

The viewpoint allows a relatively tree-free view of the south-west side of the castle, making it an ideal late afternoon and early evening location when the white of the perimeter walls glows a beautiful pink colour. The stark functional design of the castle also lends itself to wintry and stormy days, when the pale walls contrast nicely with a stormy sky to create a dramatic composition.

The suspension bridge leads to the south-facing walls and can be included in the right of the frame to provide a nice set of leading lines towards the castle.

Viewpoint 3 – The Old Town ♿

The old town, Rainkirche church and Santa Maria Assunta are best approached through the castle grounds. From the castle entrance, turn right onto a gravel path that circumnavigates the right-hand side of the castle. Follow the path for 50m, passing through the lower of two archways that breach the castle wall. Continue on this path as it traverses down towards the left-hand side of Rainkirche church – there is a good opportunity here to isolate the impressive clock face with a zoom lens as you begin the descent.

Once you reach the church, it is well worth taking some time to explore the interior before joining a path behind the building. Turn right, following the path as it descends down a cobbled street to join with Brunico's high street. Turn right here (left through the archway leads into the main shopping area – also worth a visit) and follow the road to a small square. Continue straight across onto street 'Oberragen Ragen di Sopra', easily identified by its row of exceptionally photogenic brightly coloured buildings.

At the end of the street lies the parish church of Santa Maria Assunta, initially established in the 13th Century. While the building isn't particularly impressive from the outside, the lavish interior definitely merits a look. Pay particular attention to the elaborate ceiling and intricate paintings.

Opposite: The lavish interior of Santa Maria Assunta. Nikon D810, 14–24mm at 14mm, ISO 250, 1/15s at f/2.8.

A panorama of the beautiful houses along Oberragen Ragen di Sopra with deliberate perspective distortion. Nikon D810, 14–24mm at 14mm, ISO 100, 1/320s at f/9, Aug.

3. PIRAMIDI DI TERRA A PERCA / ERDPYRAMIDEN PERCHA

Whilst not as easy to access as the earth pyramids at Longomoso (p.124), the hoodoo rock formations at Perca are probably the most photogenic in the Dolomites. Formed due to the capstone preventing erosion to the softer material underneath, these bizarre formations create an extremely photogenic and otherworldly scene.

Opposite: If possible misty weather works the best here. Nikon Z8, 20mm, ISO 800, 1/500s at f/13, tripod, Nov.

Next spread: Using the surrounding pines to frame the image. Nikon Z8, 20mm, ISO 64, 1/30s at f/14, tripod, Nov.

Whilst it used to be possible to access the site from a paved road, this has now been closed to all but local traffic. Visitors can approach the rock formations via a very pleasant forest path that departs from a large parking area above the hamlet of Vila di Sopra.

What to shoot and viewpoints

A well-signposted single-file path leads uphill from the middle of the parking area, ascending steeply through the forest. Keep following the path uphill for 20 minutes, following signposting towards the earth pyramids until you reach a tarmac road. Turn left here, ascending the road for 150m to reach a sharp hairpin to the left. Turn right off the road here, following more signposting to reach a series of viewing platforms overlooking the earth pyramids in a further five minutes of walking.

Viewpoint 1 – Earth Pyramid Rock Formations

A good path with several viewing platforms runs alongside the rock formations. Take some time to explore as there are many different angles and potential compositions. The surrounding trees can be used to frame the hoodoos and there are some good foreground rocks, branches and vegetation. Three trees perched on a particularly unlikely outcropping make for a good focal point when combined with the surrounding formations. These need to be positioned in the sky if there is no mist to provide some separation and make them stand out.

A long lens can also be used to pick out areas of interest or the capstones on top of the rocks.

To return retrace your steps back to the carpark.

How to get here

From Brunico take the SS49 east for 3km, following signposting towards Dobbiaco and Cortina. Just before entering the town of Perca turn left onto Via St. Nikolaus, now following for Via Plata / Platten. Follow this road for 6km to reach the well signposted Parkplatz Erdpyramiden on the right, 1.5km before reaching the hamlet at Plata / Platten. Please do not attempt to drive past the parking area to Plata itself as this is access only for local residents.

Lat/Long:	46.81231, 12.00595	
what3words:	///persuaded.responsibly.spices	
Tabacco:	Map 33 (1:25.000)	
Kompass:	Map 57 (1:50.000)	

Accessibility

Approach: 30 minutes, 2.5km, 160m of ascent.

A forest path leads uphill through the woods and can be steep in places. Be careful of the tree roots which are slippery when wet.

Disabled access: The forestry path is not suitable for disabled access without getting permission to drive up the access only road.

Best time of year/day

This is a superb location that can usually be accessed year round (snowshoes or skis may be required during the winter).

Undoubtedly the best conditions are on misty mornings when the fog and low visibility adds additional atmosphere to an already surreal scene. The hoodoos look excellent with a snowy cap and the autumn colours of the surrounding vegetation are also excellent.

Try and avoid bright and sunny days when the shadows can be very harsh, particularly towards mid day.

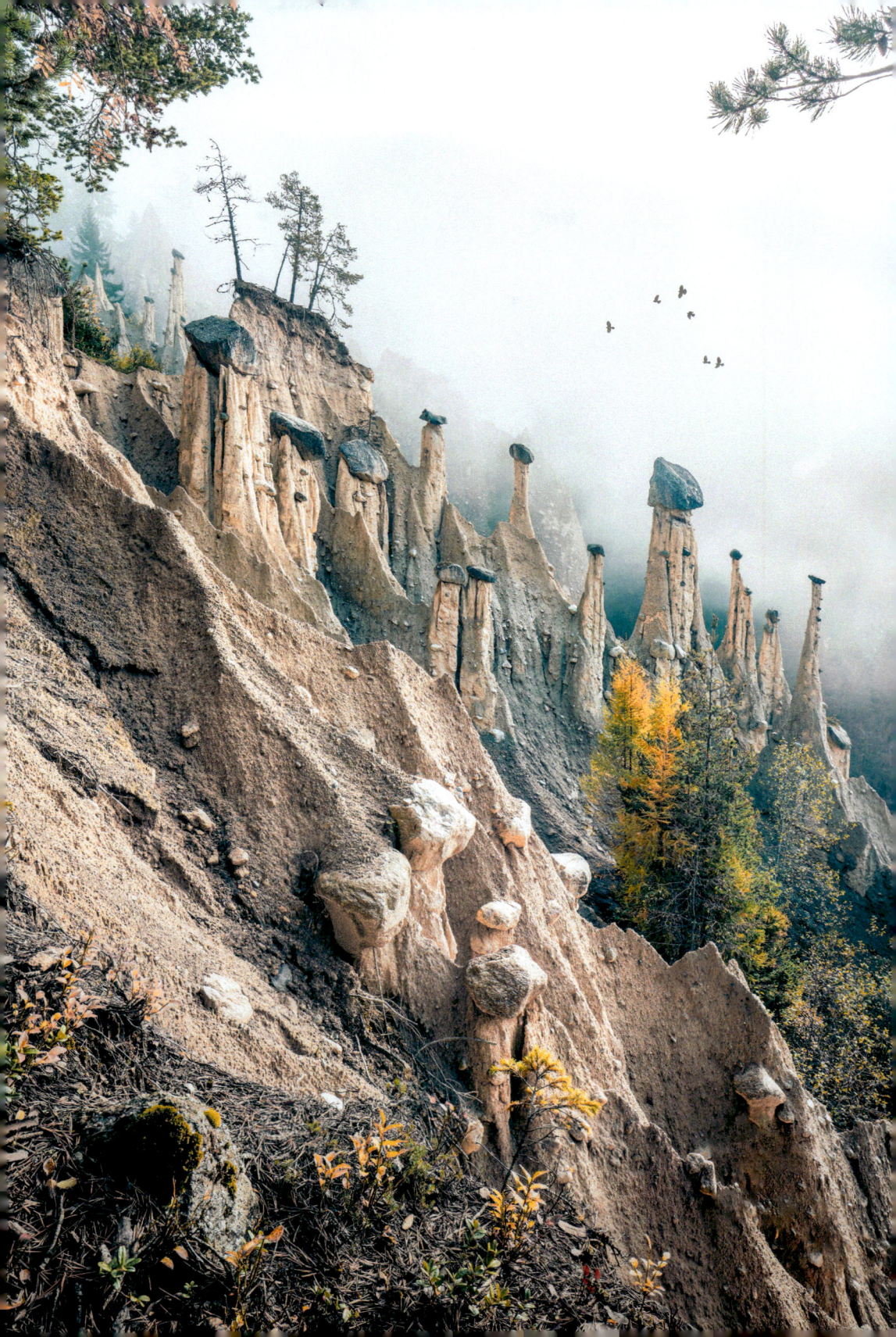

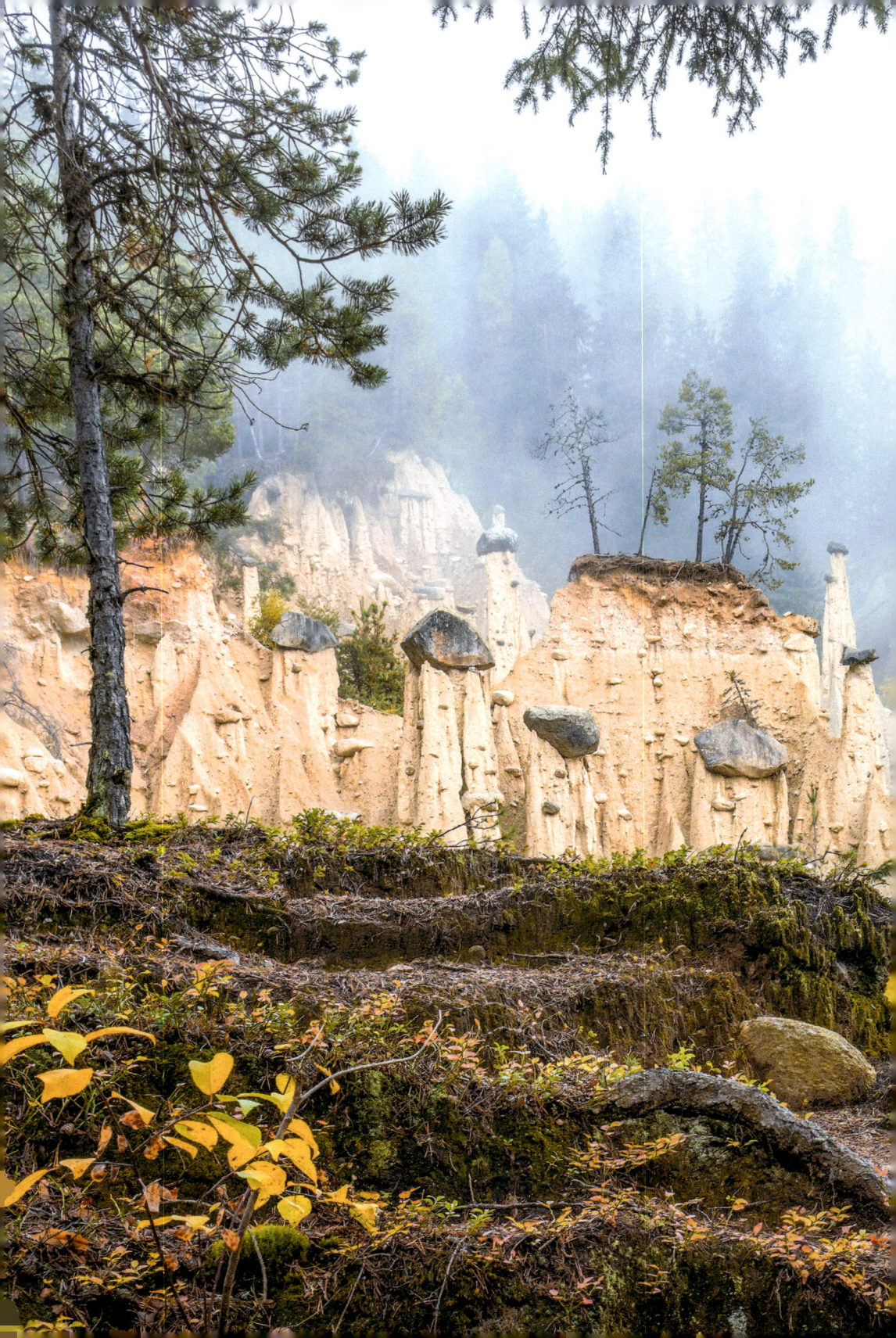

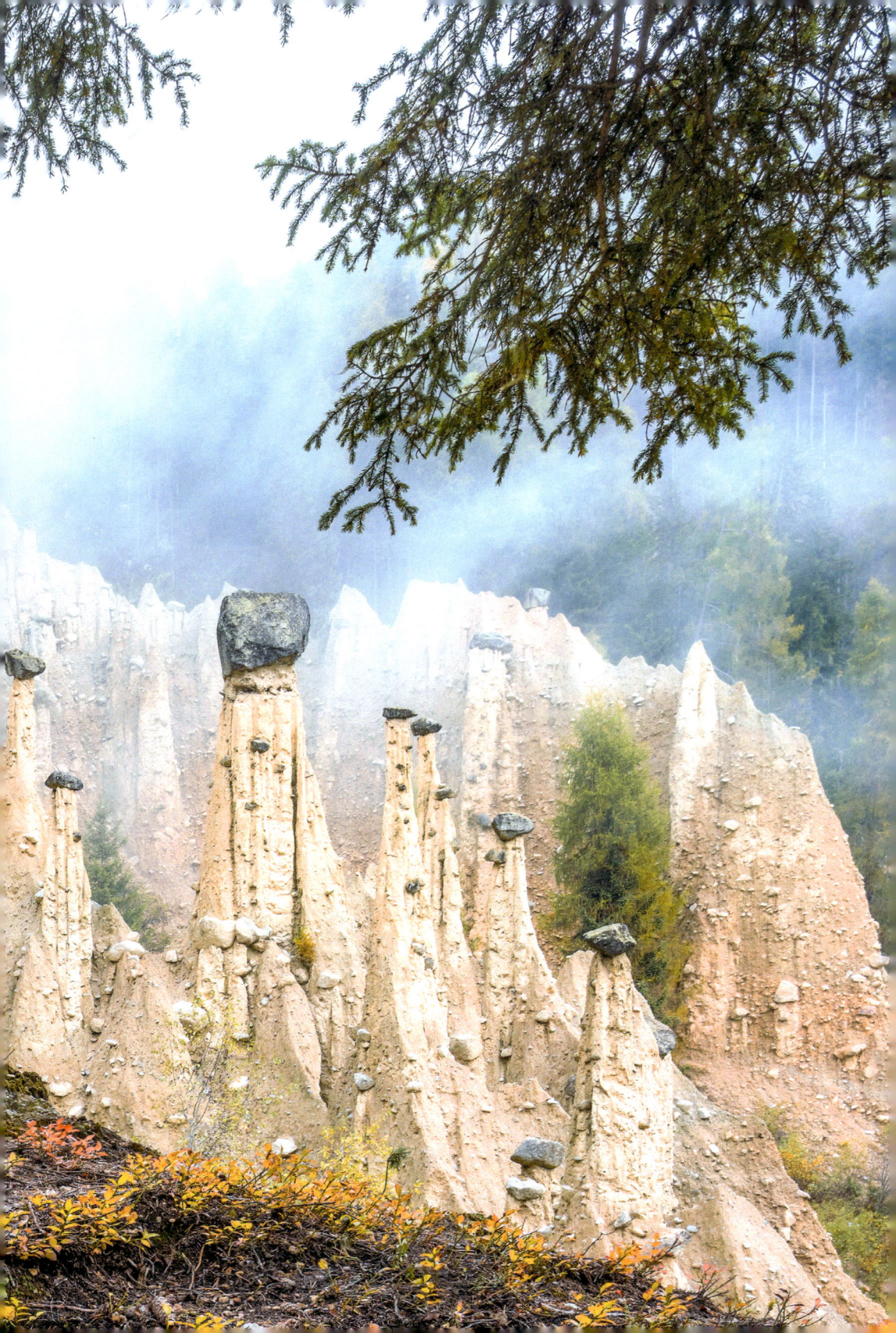

4 LAGO DI BRAIES / PRAGSER WILDSEE

Lago di Braies is undoubtedly one of the most beautiful lakes in the Dolomites, particularly when viewed from its north end overlooking an idyllic and characteristic stilted boathouse. The location was dramatic enough to form the setting of the Italian television series 'Un passo dal cielo', and according to legend the Croda del Becco mountains to the south are said to house a gateway to the underworld, hence the Ladin name 'Sass dla Porta' (gate rock).

Access is quick, easy and convenient thanks to a number of large car parks close at hand and an excellent path encircling the perimeter of the lake shore. Unfortunately, the above factors often mean that area is very busy, particularly in peak season when the ambiance can be somewhat commercial. However, when visited out of season, early in the morning or late in the evening, the location becomes truly halcyon. Just remember to bring a neutral density filter to experiment with longer exposures to remove the many onlookers.

What to shoot and viewpoints

Viewpoint 1 – The Stilted Boathouse ♿
Located at the northern end of the lake within 200m of the road and Hotel Lago di Braies, this is the most obvious and arguably best viewpoint. The stilts, beautiful colour of the water, mountain backdrop and moored wooden boats create a scene so magical that it almost feels like a film (or indeed TV series) set. The boathouse is exceptionally photogenic from all angles, although the best viewpoint is probably from the left (east) side.

With a wide-angle, you can get the walkway, hut, a good proportion of the lake and Croda del Becco into the frame. If there is any wind rippling the water, consider using a tripod in conjunction with a neutral density filter for a longer exposure to smooth out the surface, creating a 'tranquil' look that suits the scene.

With a zoom lens you can pick out individual moored boats and stilts, creating some artistic effects when combined with a long exposure.

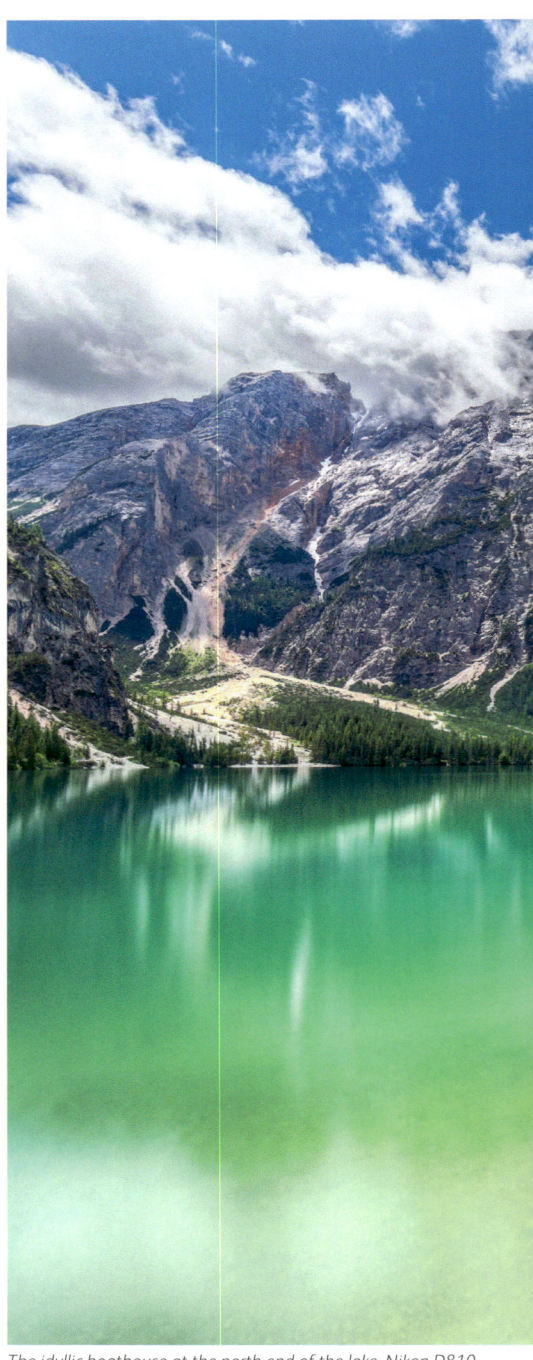

The idyllic boathouse at the north end of the lake. Nikon D810, 16–35mm at 16mm, ISO 50, 30s at f/22, tripod, Jun.

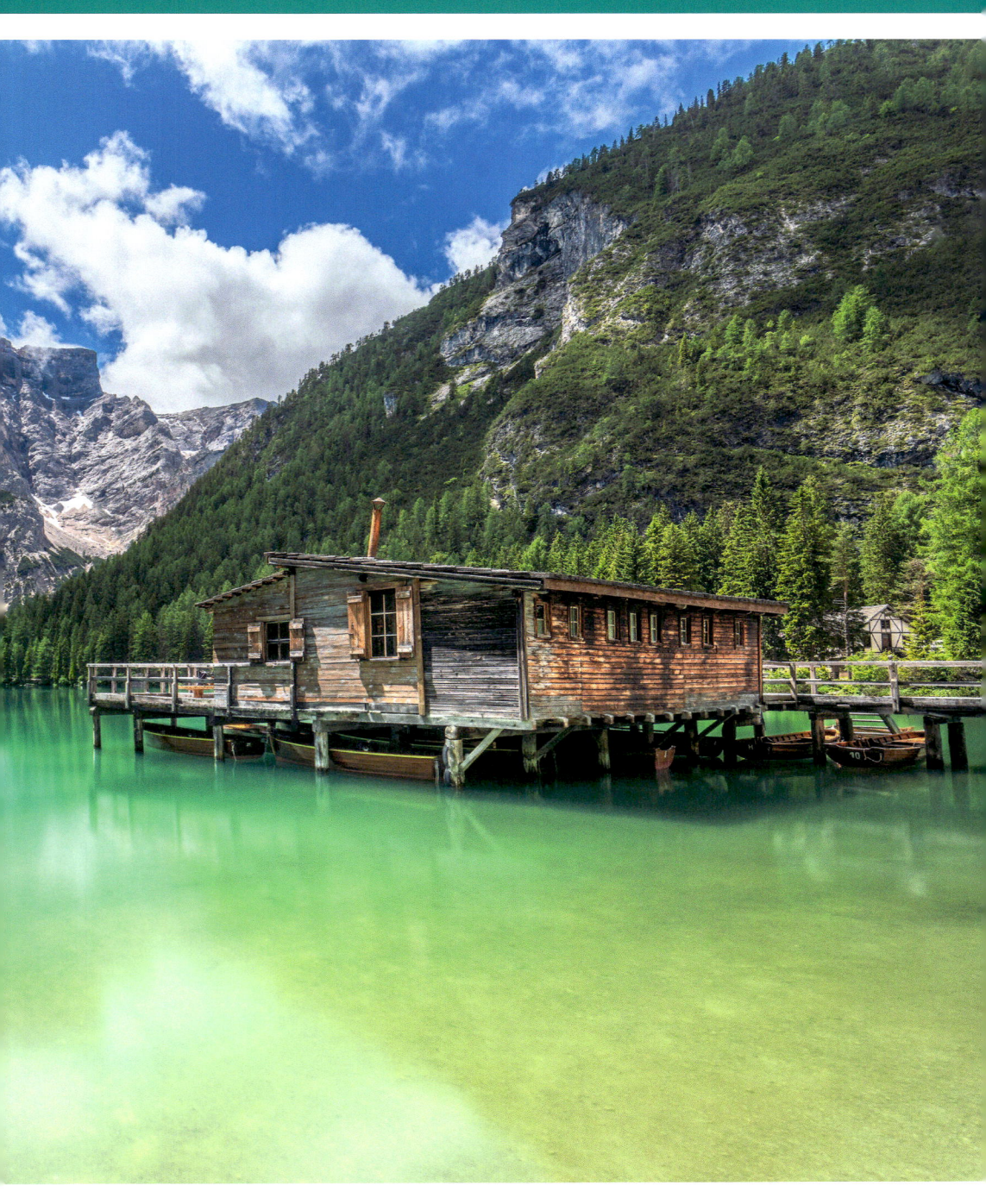

[4] LAGO DI BRAIES / PRAGSER WILDSEE

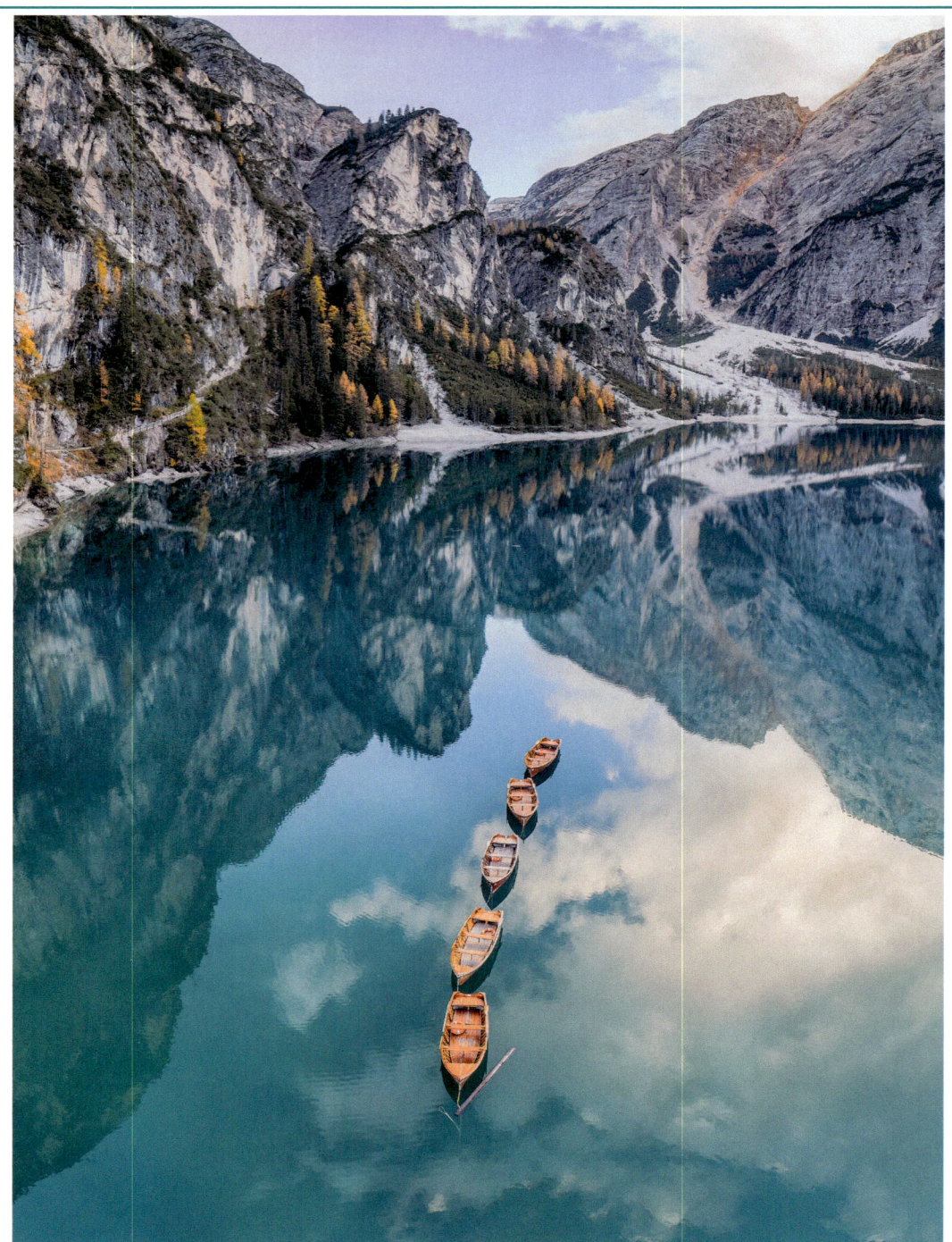

Climbing the northern bank provides a more top down perspective. Nikon Z8, 24–120mm at 50mm, ISO 64, 1/200s at f/8, Oct.

Above: *The moored up boats make for a superb foreground. Nikon Z7II, 24–120mm at 50mm, ISO 100, 1/200s at f/9, Oct.*
Below: *Helicopter and sightseeing flights are available from Olang. Nikon Z8, 24–120mm at 100mm, ISO 800, 1/1000s at f/10, Oct.*

LAGO DI BRAIES / PRAGSER WILDSEE

Viewpoint 2 – Boat House Steps ♿

Visitors are allowed onto the boathouse decking, providing a superb wide-angle opportunity to photograph either of the two sets of wooden steps leading down into the lake. Both landscape and portrait orientations work well here, centring the steps in the middle of the frame. Try isolating just the steps for a 'less is more' shot or experiment with some strong portrait leading lines combined with the mountain backdrop. While the best viewpoints are undoubtedly located at the northern end, it is worth taking the time to complete a full circuit of the lake; the walk on the well-maintained and obvious path takes around an hour at a steady pace. The subsequent viewpoints are described making a clockwise circuit of the lake.

How to get here

Located in the Parco Naturale Fanes-Senes-Braies, Lago di Braies nestles at the head of the eponymous valley that branches off the Val Pusteria between Villabassa and Monguelfo. Follow the SS49 along the Val Pusteria from either the west or east to roughly midway between the two villages, where a small road branches off to the south and is clearly signposted for 'Lago di Braies'. Follow the road for 8km to reach the lake at the end of the road.

There are four pay and display car parks which become progressively more expensive the closer you get to the lake.

Please note that a pre-paid parking reservation is required to drive the road between the first week of July and September, from 9am until 4pm. For more information on the current access restrictions please visit *www.prags.bz*.

🅿 **Lat/Long**:	46.70135, 12.08502
🅿 **what3words**:	///familiarity.lullabies.unfasten
🅿 **Tabacco**:	Map 31 (1:25.000)
🅿 **Kompass**:	Map 57 (1:50.000)

Accessibility

Approach: 5 minutes, 0.2km, 5m of ascent.

An excellent path circumnavigates the majority of the lake; the only obstacle is a short section on the eastern shore which traverses a series of rock bands equipped with steep steps. Take care as these can be slippery when wet and are moderately exposed.

♿ **Disabled access** to the south and east side of the lake is generally good on well-maintained paths.

Best time of year/day

Because of the idyllic nature of the surroundings, the lake usually looks best in good weather during spring and summer, when direct sunlight on the lake surface shows off the emerald green water to its fullest. The rowing boats are available to hire from 10am and change the scene dramatically.

As the lake is surrounded by a protective ring of mountains, there is a lack of foreground light early in the morning and at sunset; consequently it is hard to take advantage of the 'golden hours' without resorting to some composite trickery.

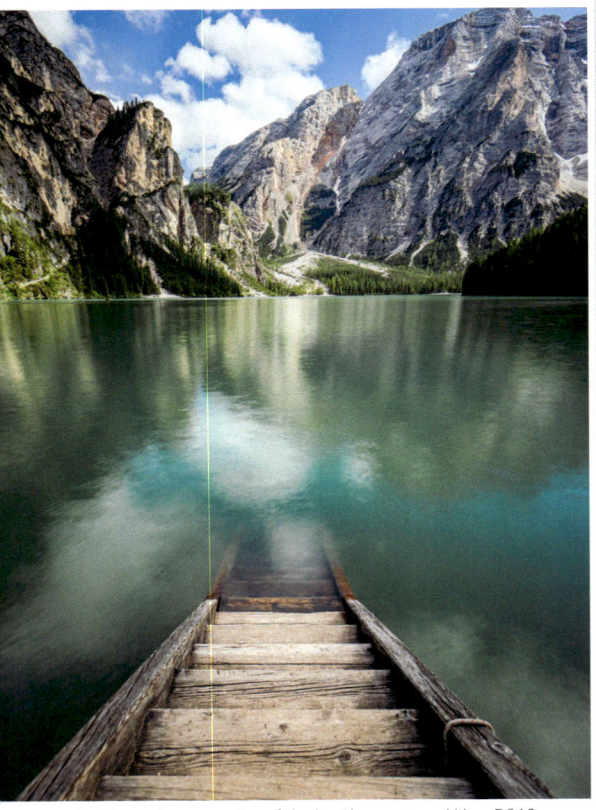

A wide-angle perspective of the boathouse steps. Nikon D810, 16–35mm at 16mm, ISO 100, 0.6s at f/4, tripod, Jul.

***Opposite**: Autumn colours on the western shore. Nikon Z7II, 100–400mm at 200mm, ISO 400, 1/200s at f/5.6. Oct.*

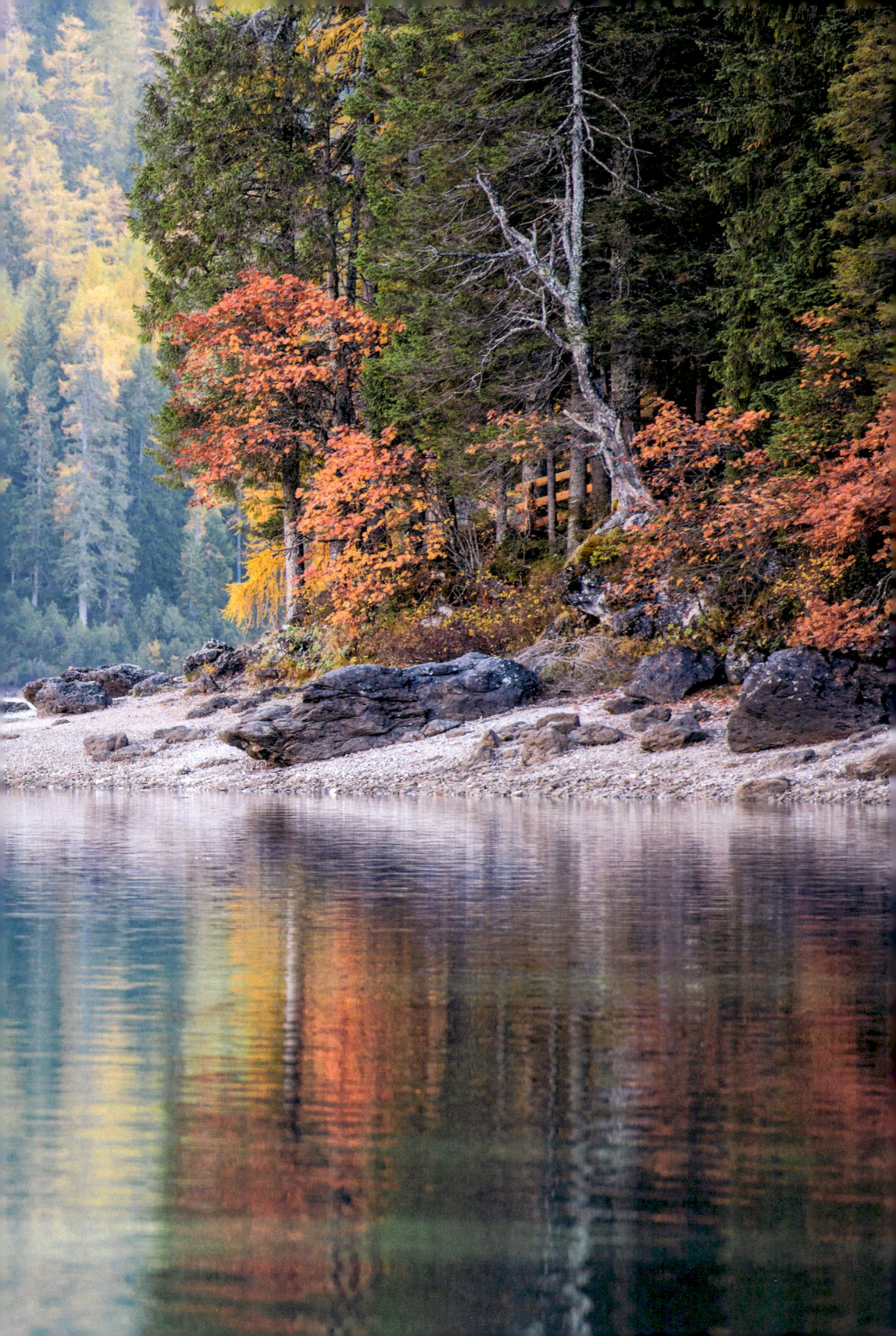

4 LAGO DI BRAIES / PRAGSER WILDSEE

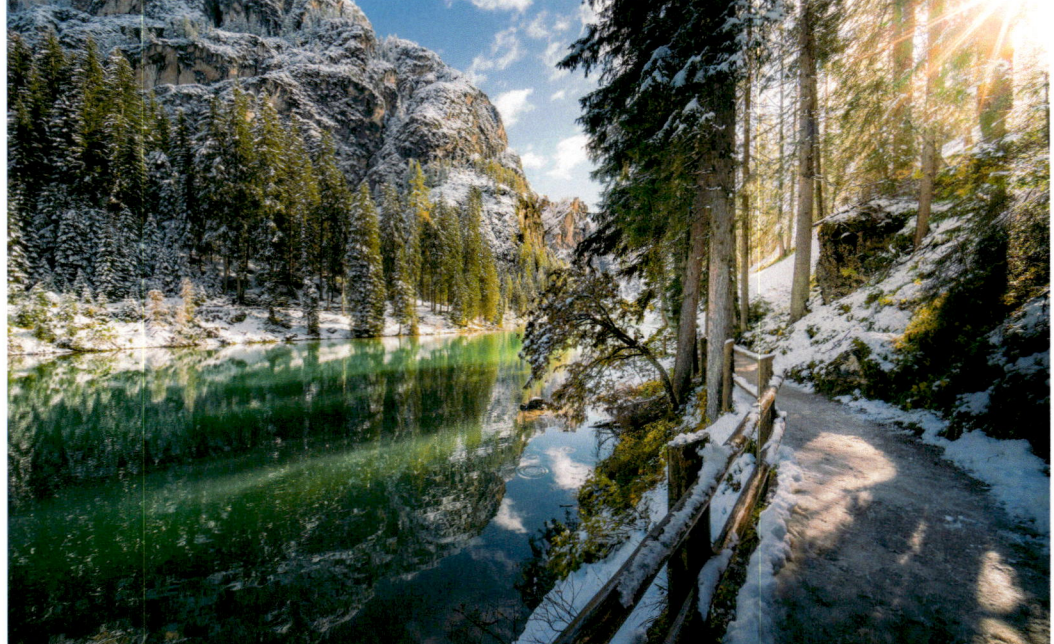

The path around the western side of the lake. © Daniel Seßler.

Viewpoint 3 – Wooden Bridge ♿
Some 200m past the boathouse there is a little wooden bridge crossing the north-east corner of the lake. This viewpoint only works in spring and autumn when the water level in the lake is high enough to flow under the bridge itself. The aquamarine colour of the water combined with a subject sat on the bridge makes for an excellent portrait photo shoot location. If you want to use a wide-angle lens to capture the bridge, there is a well-placed boulder in the water 80m before the bridge itself that can be used as a foreground.

Viewpoint 4 – Cappella Lago di Braies ♿
Once you cross the bridge onto the eastern shore there is an excellent view of the chapel to the west. You need a long lens (at least 200mm ideally) to pick out the chapel using the water and fence as a foreground. The many passing rowing boats also provide interesting subjects with the chapel as a backdrop; try using the trees surrounding the building to aid the composition.

Viewpoint 5 – Rocks & Reflections ♿
Once you have circled the lake (or doubling back if you're pressed for time), head for the chapel on the opposite shore; just beyond this there is a cluster of photogenic rocks in the water where the shore turns slightly. While it isn't possible to get everything into the frame even with an extreme wide-angle, you can create a great portrait shot looking south, using the trees on the shore combined with the rocks as a foreground. The shot works best on a still morning when the background peaks are illuminated and the lake water is still in the shade, providing a dramatic reflection of the trees and the Croda del Becco mountains.

__Opposite Top__: Dusk at the boathouse. Nikon D810, 14–24mm at 14mm, ISO 500, 30s at f/2.8, tripod, Jul. __Bottom Left__: Rowers and Cappella Lago di Braies. Nikon D810, 80–400mm at 350mm, ISO 200, 1/400s f/5.6, Jun. __Bottom Right__: Rocks on the western shore. Nikon Z7II, 14–24mm at 14mm, ISO 64, 1/800s at f/8. Sep.

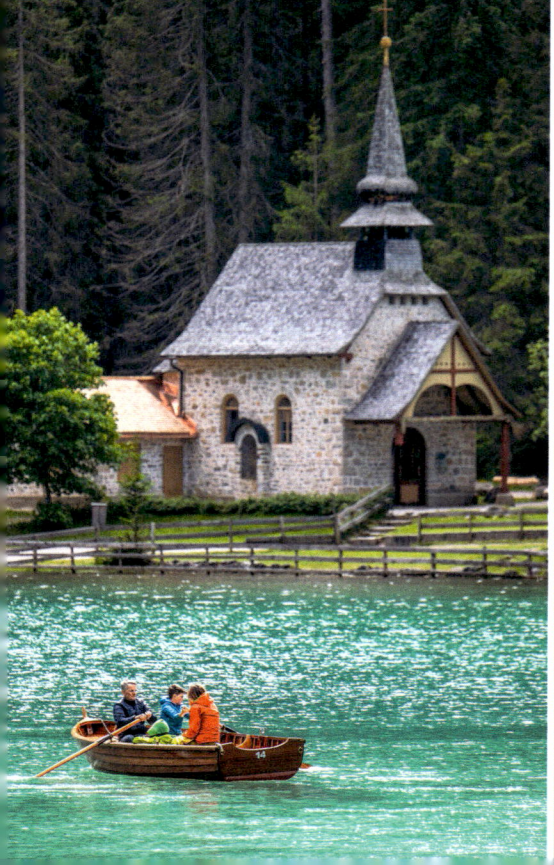
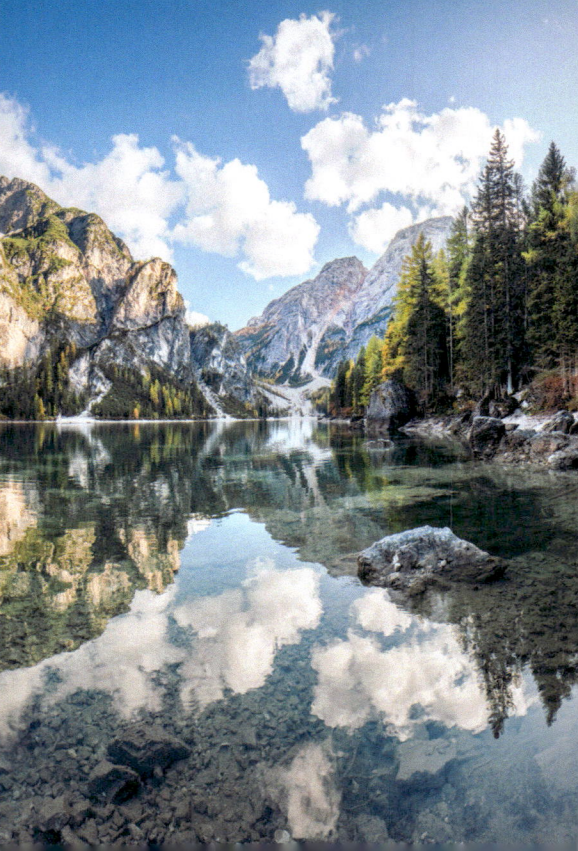

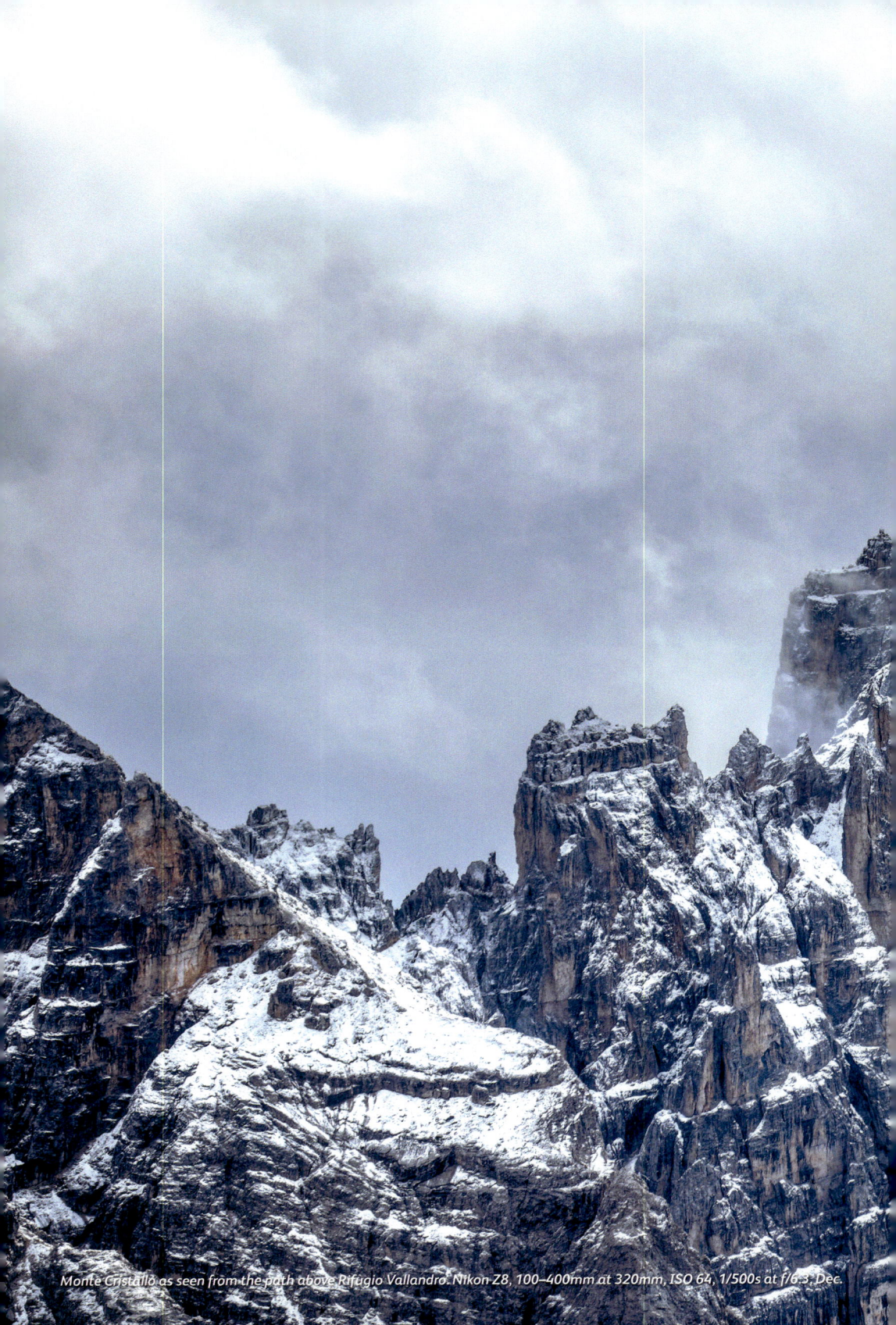

Monte Cristallo as seen from the path above Rifugio Vallandro. Nikon Z8, 100–400mm at 320mm, ISO 64, 1/500s at f/6.3, Dec.

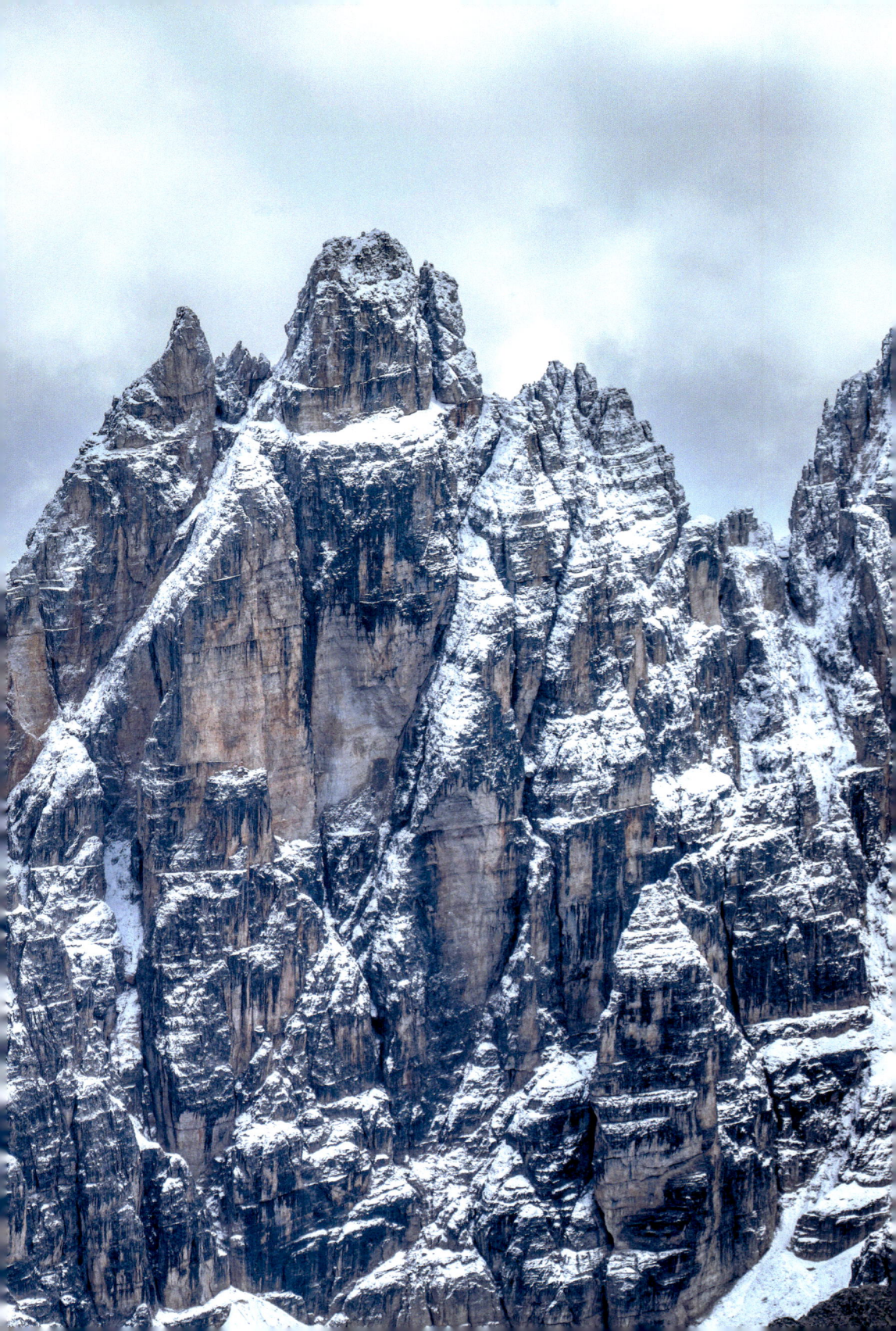

5. MONTE SPECIE / STRUDELKOPF

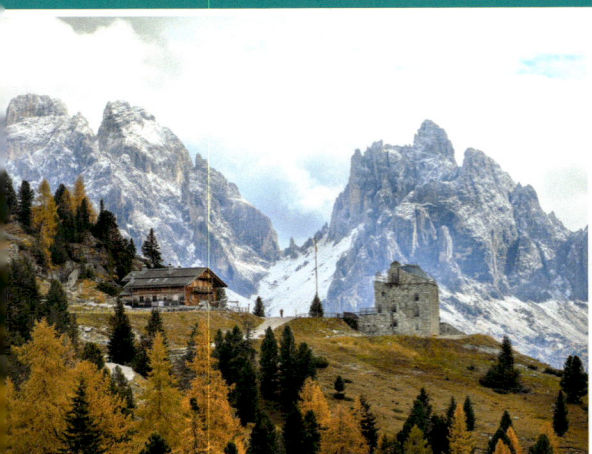

Rifugio Vallandro backdropped by the Cadini di Misurina. Nikon Z7II, 100–400mm at 240mm, ISO 90, 1/250s at f/8, Oct.

An impressive rock arch on a subsidiary buttress of Croda Rossa. Nikon Z7II, 100–400mm at 400mm, ISO 160, 1/400s at f/8, Nov.

Monte Specie or Strudelkopf (great name) is an isolated peak in the Fanes-Sennes-Braies Nature Park. Reaching 2307m the summit enjoys spectacular views over the Tre Cime, Cadini di Misurina, Sexten Dolomites and Monte Cristallo.

Accessible year-round with the right equipment, the proposed itinerary ascends Monte Specie from the parking area at Prato Piazza high above the Valle di Braies. With 400m of elevation gain the round trip of 10km takes approximately four hours to complete without photographic distractions.

For those not wishing to complete the full itinerary an out-and-back trip along the gravel vehicle track to Rifugio Vallandro is recommended. This takes 40 minutes in each direction on easy terrain and allows photographers to enjoy the first three viewpoints.

What to shoot and viewpoints

Viewpoint 1 – Carpark Views ♿
There are excellent views straight out of the parking area looking north-west towards an outcropping of impressive rock towers, north-east to Picco di Vallandro and south-west to the distinctive red rock of the aptly named Croda Rossa. To begin the hike follow the vehicle track south-east, following signs towards Rifugio Vallandro on path 37.

Viewpoint 2 – Prato Piazza / Plätzwiese ♿
After 15 minutes of walking you enter the Prato Piazza proper, a vast alpine plateau covered with small wooden huts, wildflowers and sometimes grazing livestock. The former make excellent subjects, especially when combined with the impressive mountain backdrop.

Those with sharp eyes will notice an impressive rock archway on one Croda Rossa's buttresses to the left of the main summit, though a long lens is required to capture it.

Viewpoint 3 – Rifugio Vallandro / Dürrensteinhütte & Monte Cristallo ♿
After 10 minutes of walking, pass Rifugio Prato Piazza and Hotel Hohe Gaisl on their right side (nice little chapel on the left), continuing on the vehicle track and ignoring any path junctions. Shortly after you will see Rifugio Vallandro straight ahead with the distinctive WW1 fort opposite. This makes a good telephoto shot, the longer focal length allowing impressive rock towers of the Cadini di Misurina group to fill the frame in the background.

It will take another 30 minutes of walking to reach the rifugio properly, where you now get an excellent view across to Monte Cristallo with its many buttresses and jagged ridge line. After refreshments, take the path which starts on the left side of Rifugio Vallandro, following path 34/40A signposted towards Monte Specie.

Above: An isolated group of larches catch the light on the approach. Nikon Z7II, 100–400mm at 400mm, ISO 160, 1/400s at f/6.3, Oct.

Below: Croda del Becco as seen from Monte Specie. Nikon Z7II, 100–400mm at 400mm, ISO 250, 1/400s at f/9, Nov.

How to get here

Turn off the SS49 onto Strada Ponticello between the villages of Villabassa and Monguelfo, following signposting towards the Valle di Braies. At the hamlet of Segheria turn left at the initial roundabout, now following for Prato Piazza. Continue for 5km to reach a pay and display carpark and toll gate at Ponticello / Brückele.

The final 6km is a tolled and controlled road. There are driving restrictions in place between early July and early September (check www.prags.bz/en/plaetzwiese for the exact dates). During this period traffic is charged €10 per vehicle and driving is only permitted before 10am and after 3pm. Outside of these times, bus 443 can be taken up to the plateau. If permitted, drive the final 6km to the Prato Piazza carpark at the end of the road.

Lat/Long:	46.65673, 12.17512
what3words:	///reviewing.unknowns.requirement
Tabacco:	Map 31 (1:25.000)
Kompass:	Map 57 (1:50.000)

Accessibility

Approach: 120 minutes, 5km, 400m of ascent.

Whilst Monte Specie is one of the more accessible peaks in the Fanes-Sennes-Braies Park it should not be underestimated. Be sure to take one of the topographic walking maps listed above.

Disabled access: There is good disabled access along the track from Prato Piazza to Rifugio Vallandro.

Best time of year/day

This location is ideal during the autumn when the toll road is free from restrictions and the first snows have started to fall on the higher surrounding peaks. For early risers watching the sun come up from the summit of Monte Specie is a special experience.

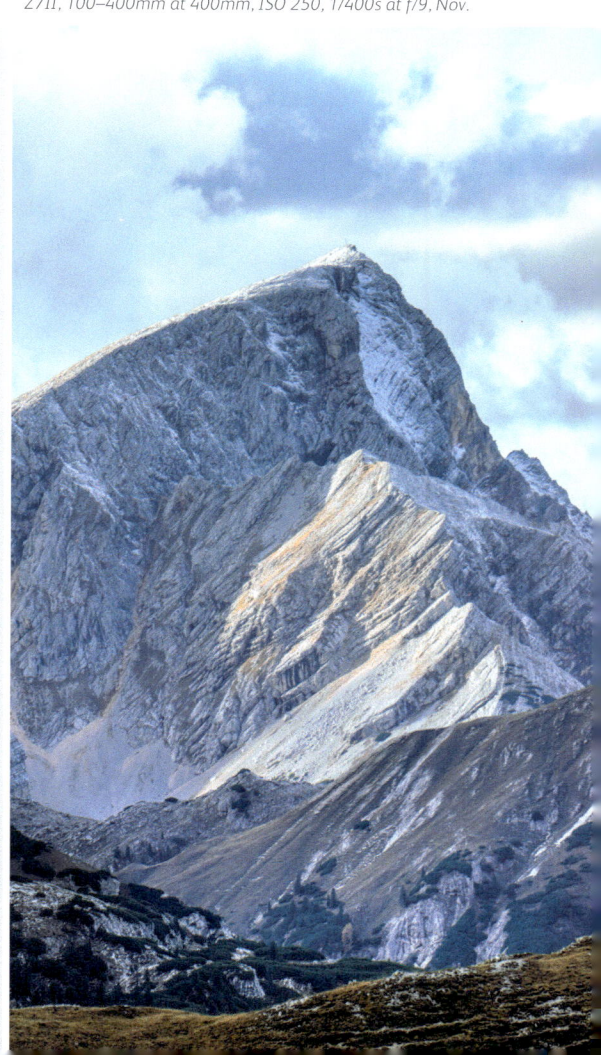

5 MONTE SPECIE / STRUDELKOPF

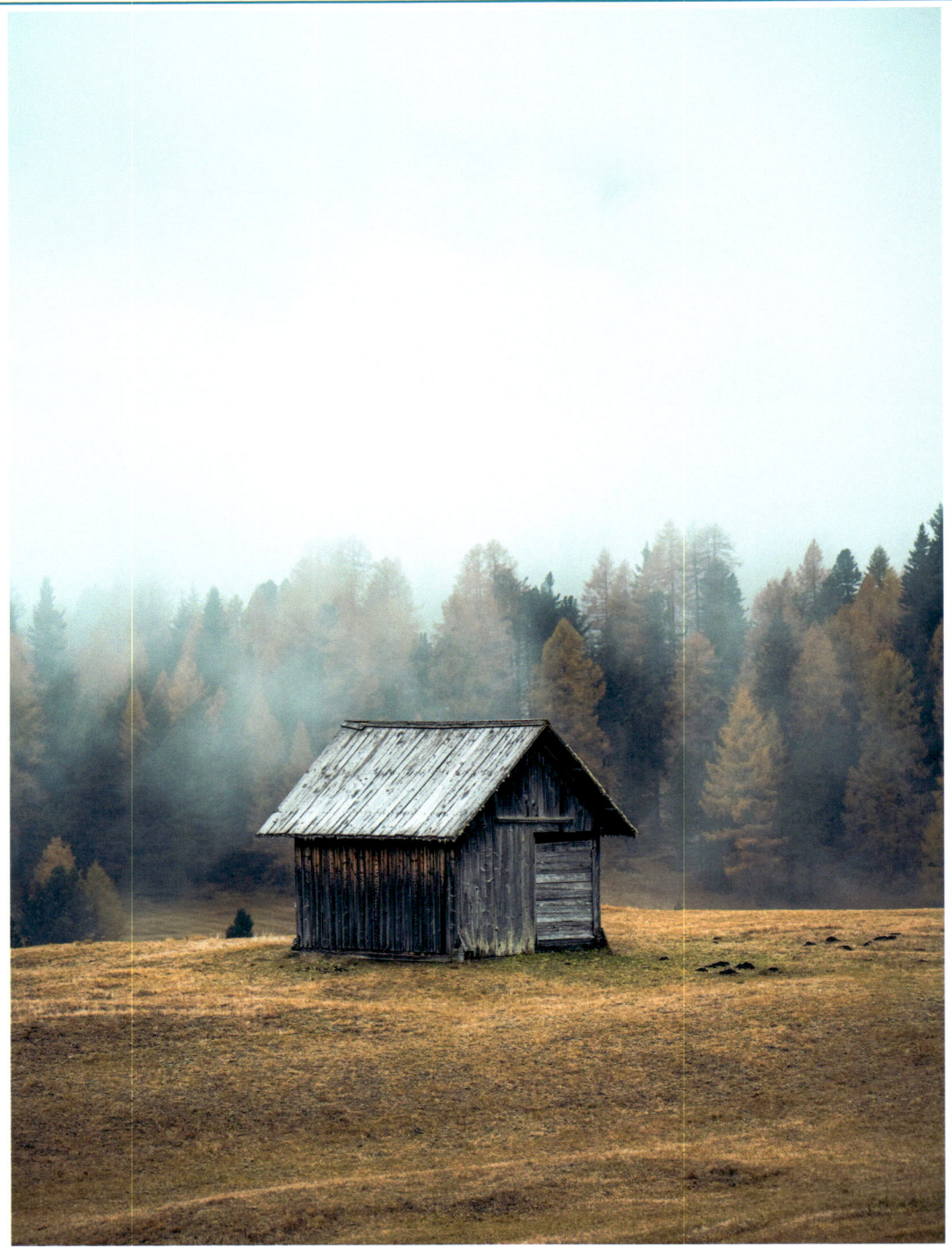

One of the many huts on Prato Piazza. Nikon Z7II, 24–120mm at 120mm, ISO 500, 1/50s at f/4, Nov.

Above: Looking south-east towards the Tre Cime from Monte Specie. Nikon Z7II, 24–120mm at 60mm, ISO 64, 1/400s at f/8, Oct.

Below: Interlocking layers and Picco di Vallandro / Dürrenstein. Nikon Z7II, 100–400mm at 400mm, ISO 80, 1/400s at f/8, Sep.

Follow the path as it traverses and ascends the hillside to reach the col at Sella di Monte Specie (2211m) where many smaller paths converge. A final 20 minute ascent up the west flank of Monte Specie on path 34 leads to the summit.

Viewpoint 4 – Monte Specie / Strudelkopf

A panoramic viewpoint with the various peaks marked is found at the summit, with spectacular views in every direction. Whilst the Tre Cime to the south-east undoubtedly steals the show there are still excellent views of the Sesto Dolomites, Monte Piana, the Cadini di Misurina, Cristallo and even the Tofane high about the Passo Falzarego.

Looking north-west Crepe do Val Chiara and Picco di Vallandro make a lovely portrait composition, as does Croda del Becco above Lago di Braies. To the north it is possible to see the Austrian Alps on a clear day – the distinctive glacial peak of the Rötspitze (3495m) makes an excellent subject with a long lens.

To return retrace your steps back down the last section, before following path 40A above Rifugio Vallandro, following signs to Malga Prato Piazza. Descend back to path 37 to join the initial track back to the parking area.

Next spread: A rain storm passes the Tre Cime as seen from the summit of Monte Specie. Nikon Z7II, 24–120mm at 64mm, ISO 64, 1/320s at f/8, Nov.

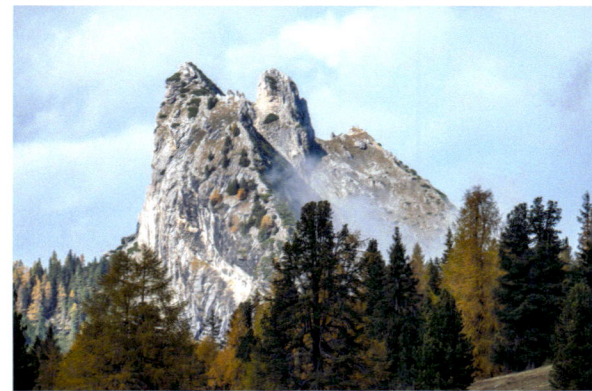

Looking north-west from the parking area. Nikon Z7II, 100–400mm at 400mm, ISO 160, 1/400s at f/8, Oct.

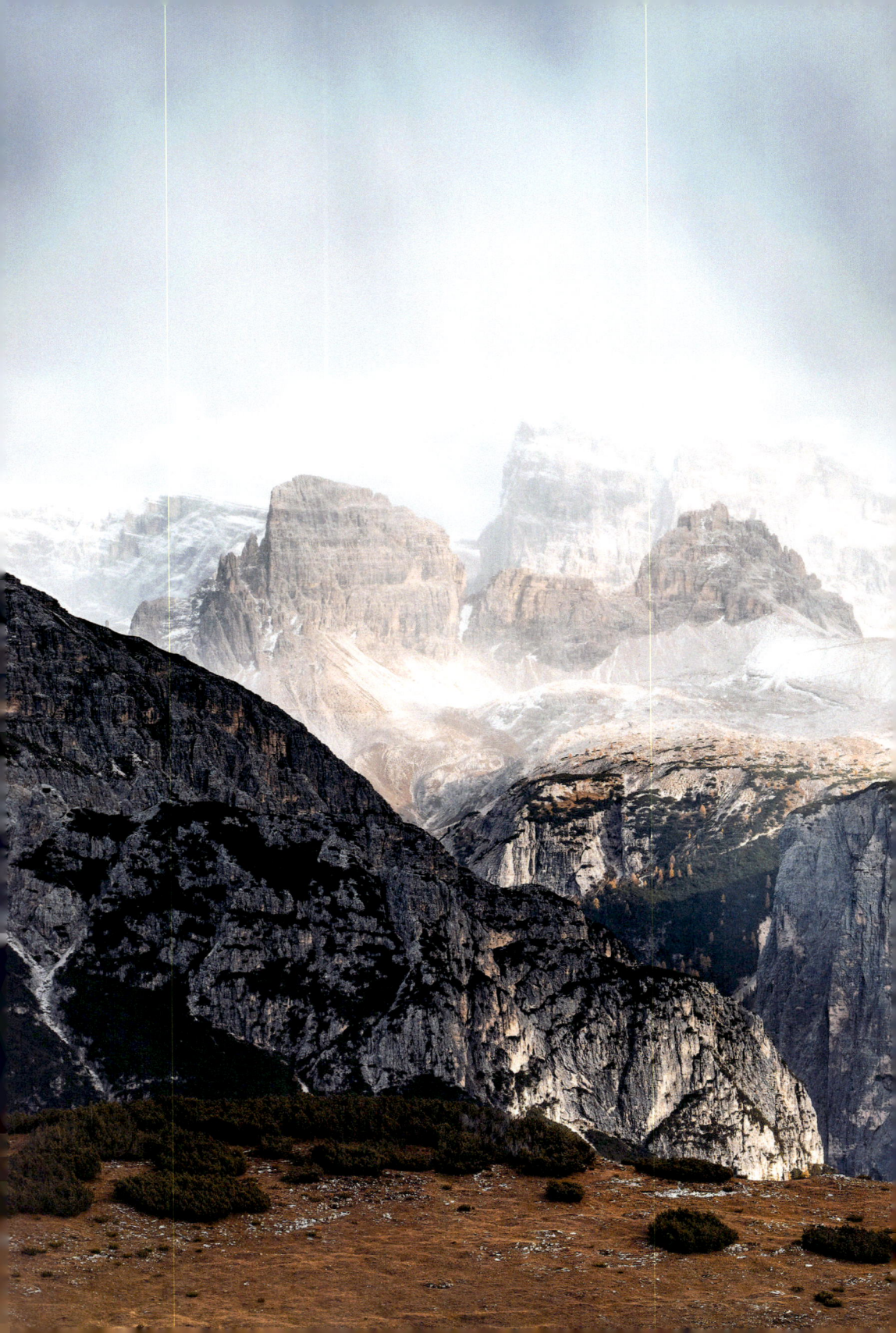

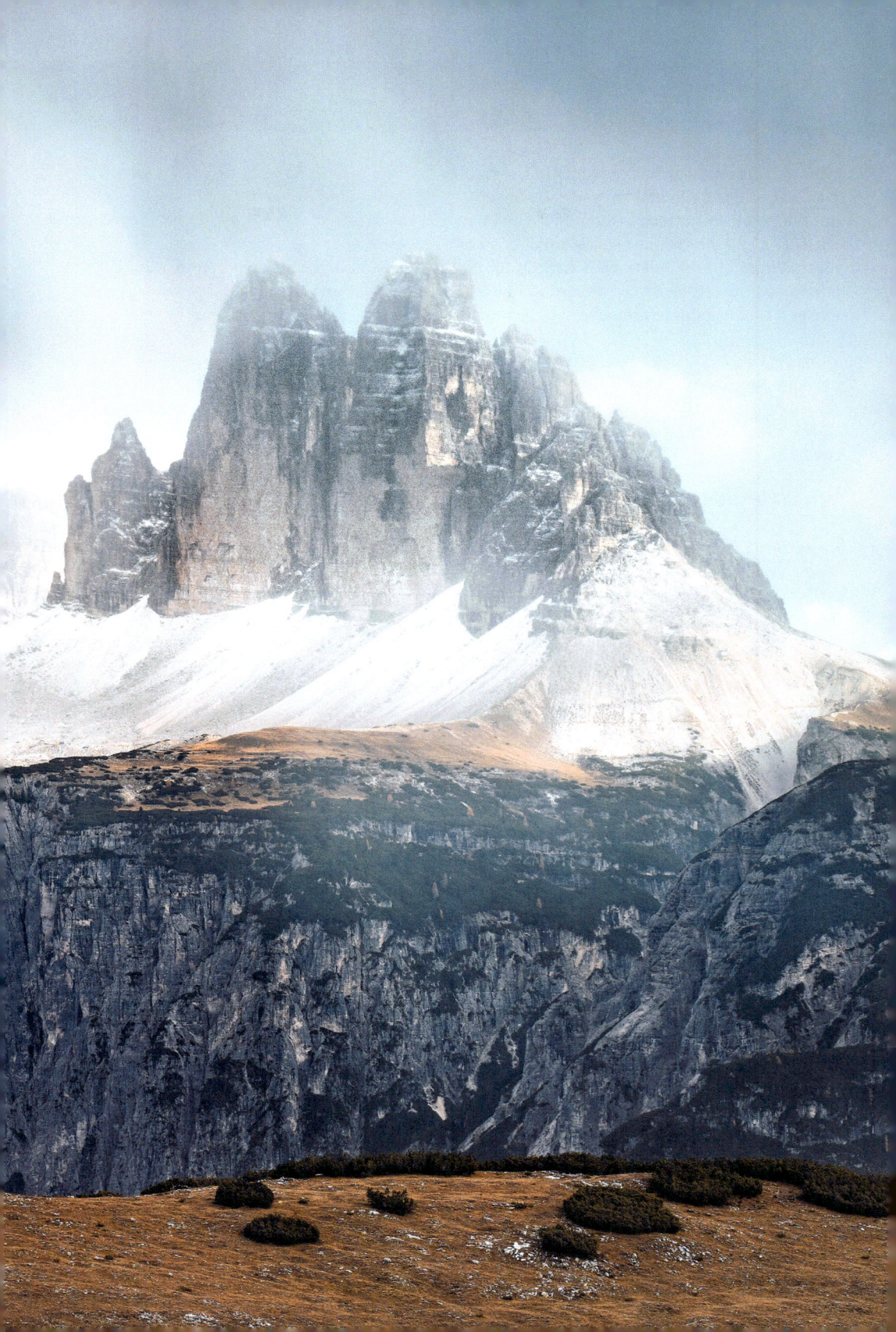

6. LAGO DI DOBBIACO / TOBLACHER SEE

Lago di Dobbiaco marks the border between the Tre Cime di Lavaredo and Fanes-Senes-Braies national parks, situated 3km south of the town itself. The lake was formed following a massive rockfall from Monte Serla and is famous for its blue-green hue, while its convenient road access makes it an exceptionally popular spot year-round.

While the location is undoubtedly commercial along the north shore, things do improve as you approach the wildlife reserve on the south side, where a diverse range of aquatic and marsh-dwelling birds can be found.

What to shoot and viewpoints

Viewpoint 1 – Croda dei Baranci & Cima Nove ♿

The classic shot of Lago di Dobbiaco is taken from its northern shore and the view graces many posters and national park signs around the region. From the car park, follow the road down to the lakeside and turn right, walking for 200m to reach a bridge crossing the river Rienza adjacent to a small waterfall on the left.

Looking down the length of the lake you will see a striking, canyon-like gap created by Croda dei Baranci and Cima Nove on the left and the flanks of Monte Serla to the right. Take full advantage of the reflections on the lake to create some aesthetic symmetry at a variety of focal lengths, with a multitude of possible compositions.

The waterfall makes for an attractive foreground if you have a suitably wide-angle, while ducks and other water fowl can often be captured with a mid range zoom. The stilted 'Seerestaurant' on the right, which doubles up as a boat house, can also be used as a foreground; just be careful to avoid straying onto the private grassland on the north side of the building.

Viewpoint 2 – Nature Reserve

Continue past the Seerestaurant, entering the woods and following a good path alongside the water's edge to reach a large wooden viewing platform at the south-west end of the lake. Unfortunately landscape shots are limited here but with some patience (and luck) you can often get some great wildlife shots with a long lens. If time allows, it is also worth continuing along the path, turning left at a junction to circle the lake and return along the opposite shore.

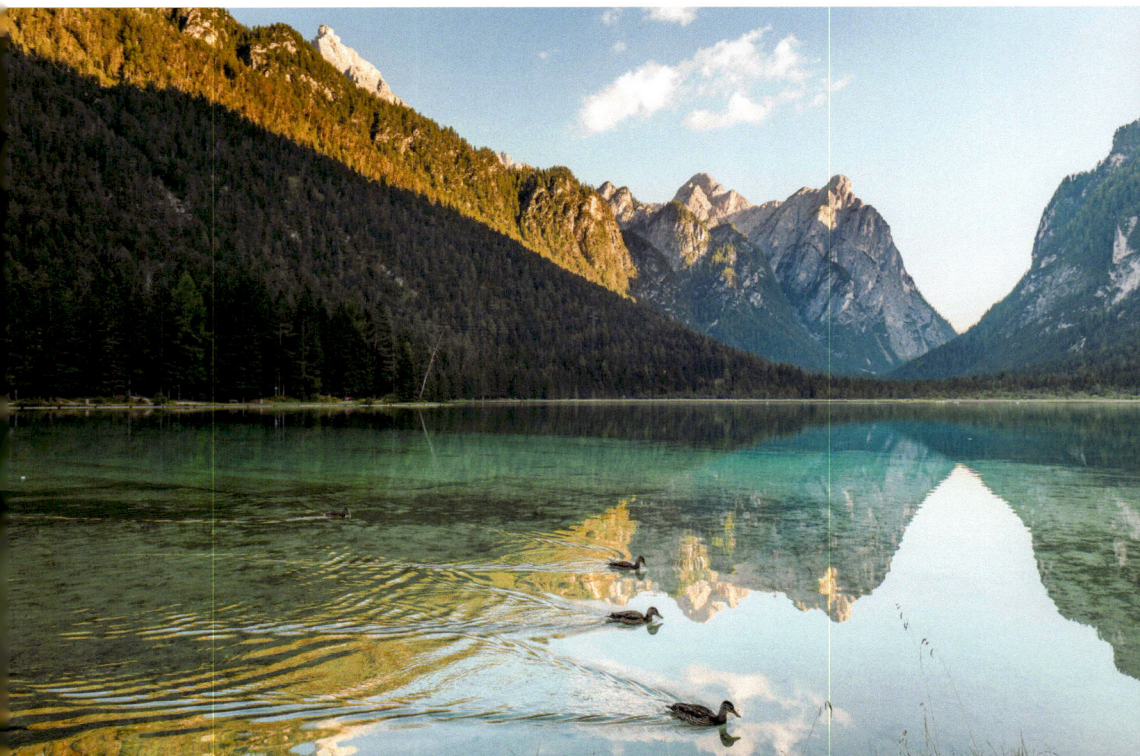

A 6 image panorama taken from the wooden road bridge on the northern shore. Nikon Z7II, 20mm, ISO 64, 1/60s at f/8, Oct.

How to get here

The lake is easily accessed from the town of Dobbiaco, situated just off the SS49 which runs east-west along the Val Pusteria. From Dobbiaco, turn onto the SS51, signposted towards Cortina d'Ampezzo and Misurina, and follow the road for 3km to reach a large car park next to the lake.

	Lat/Long:	46.70502, 12.22035
	what3words:	///loving.trots.clearcut
	Tabacco:	Map 31 (1:25.000)
	Kompass:	Map 57 (1:50.000)

Accessibility

Approach: 2 minutes, 0.1km, 0m of ascent.

A road leads from the car park to the northern end of the lake, from where a good footpath encircles the remaining lake shore. The classic viewpoint is in close proximity to the car park and can be accessed by vehicle, making for an extremely accessible location.

 Disabled access to the northern side of the lake is very good.

Opposite: *The classic view of Lago di Dobbiaco looking south. Nikon D810, 24–70mm at 24mm, ISO 100, 1/160s at f/6.3, Sep.*

Best time of year/day

The lake is photogenic throughout the year, although the area can get very crowded in peak season and is best avoided. Spring and early summer can provide some spectacular flower displays along the lake shore while the surrounding larches take on beautiful autumnal colours later in the year.

If you're planning a trip during the winter, the lake is best photographed from the northern shore as the moving water helps to keep the ice at bay, providing some reflections.

The surrounding mountains shadowing the lake combined with its north–south orientation mean that sunrise and sunset shots are difficult to achieve consistently. Instead, the blue and green hues of the lake are best captured when bathed in light; consequently this is an ideal late morning or early afternoon venue.

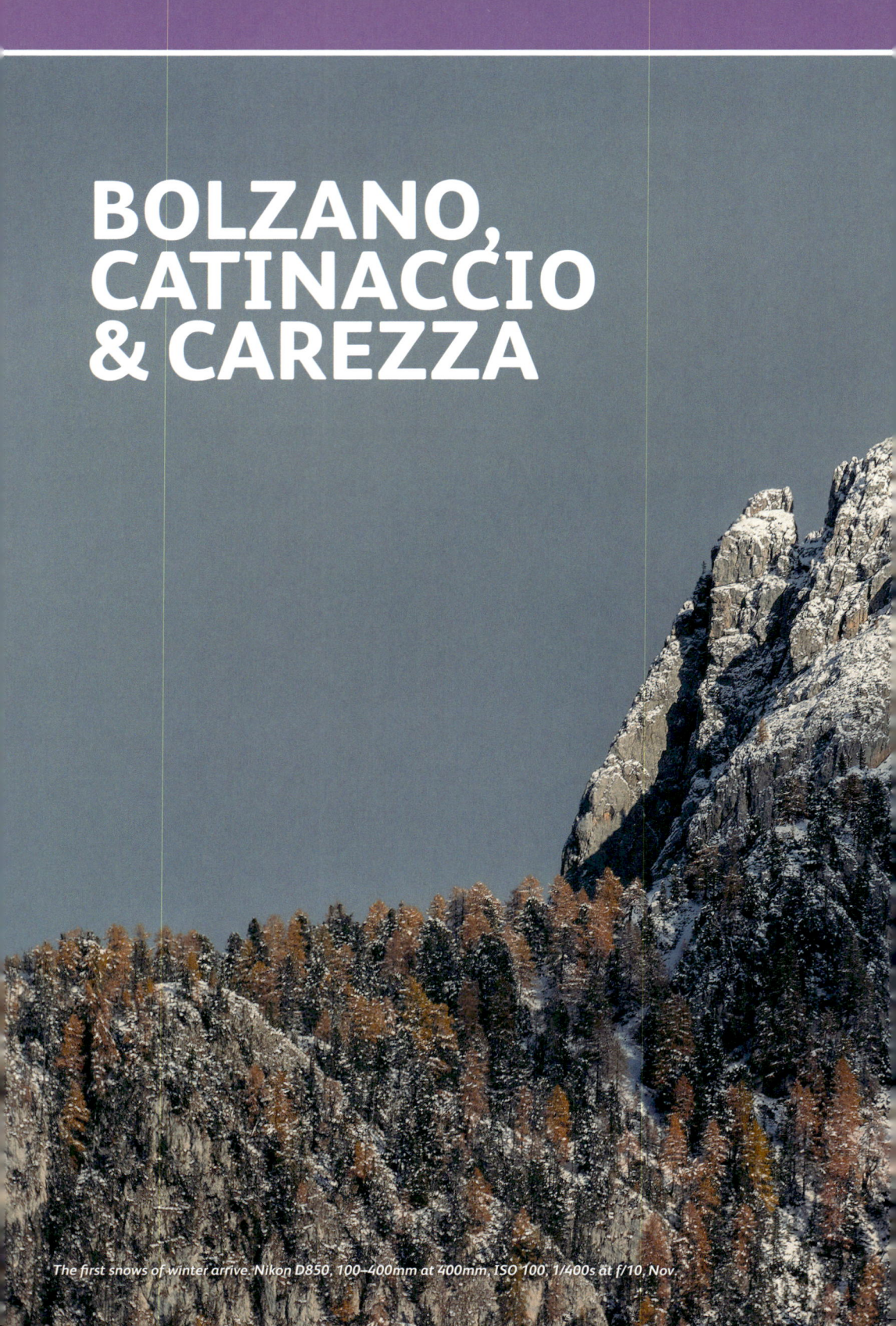

BOLZANO, CATINACCIO & CAREZZA

The first snows of winter arrive. Nikon D850, 100–400mm at 400mm, ISO 100, 1/400s at f/10, Nov.

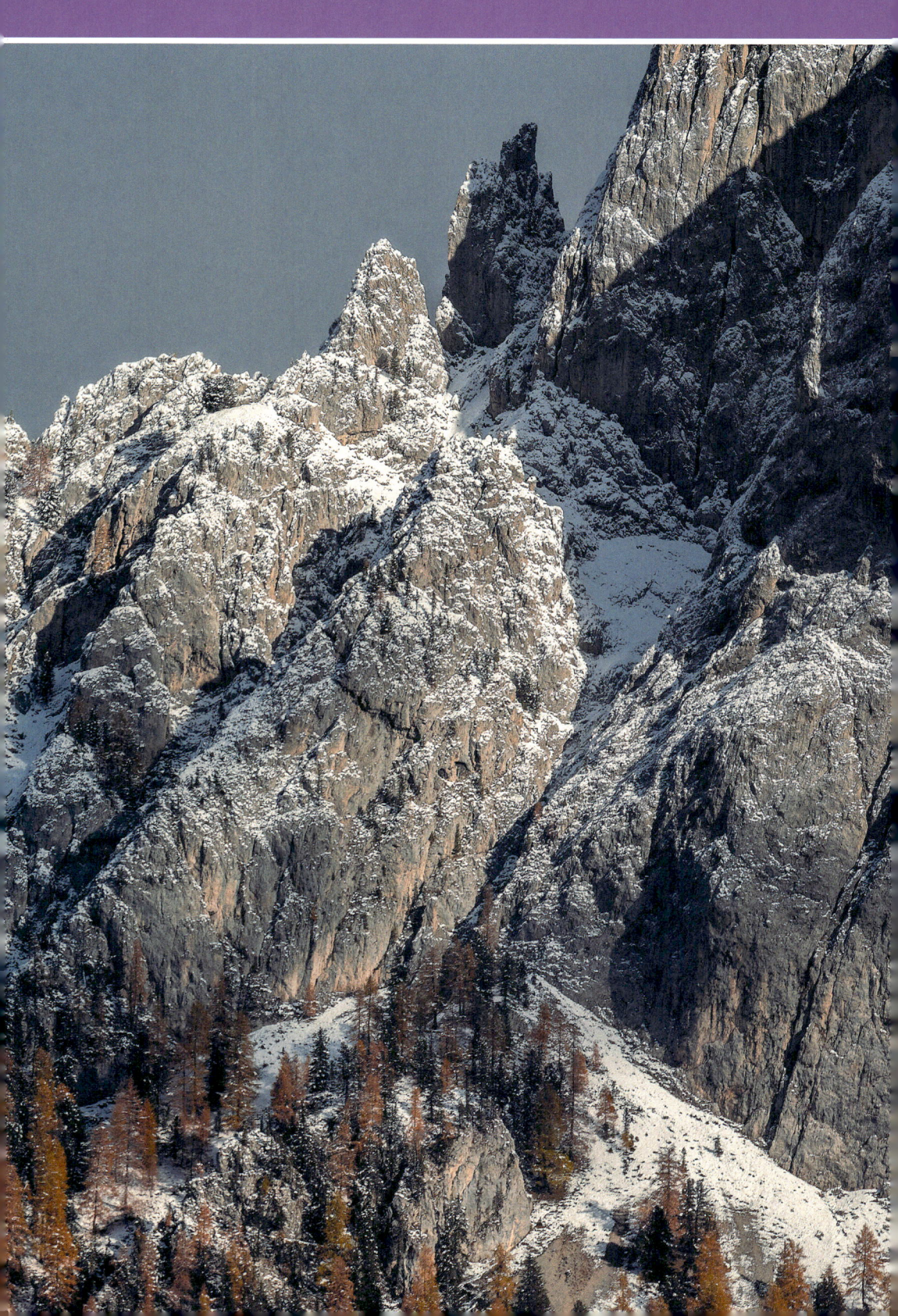

BOLZANO, CATINACCIO & CAREZZA – INTRODUCTION

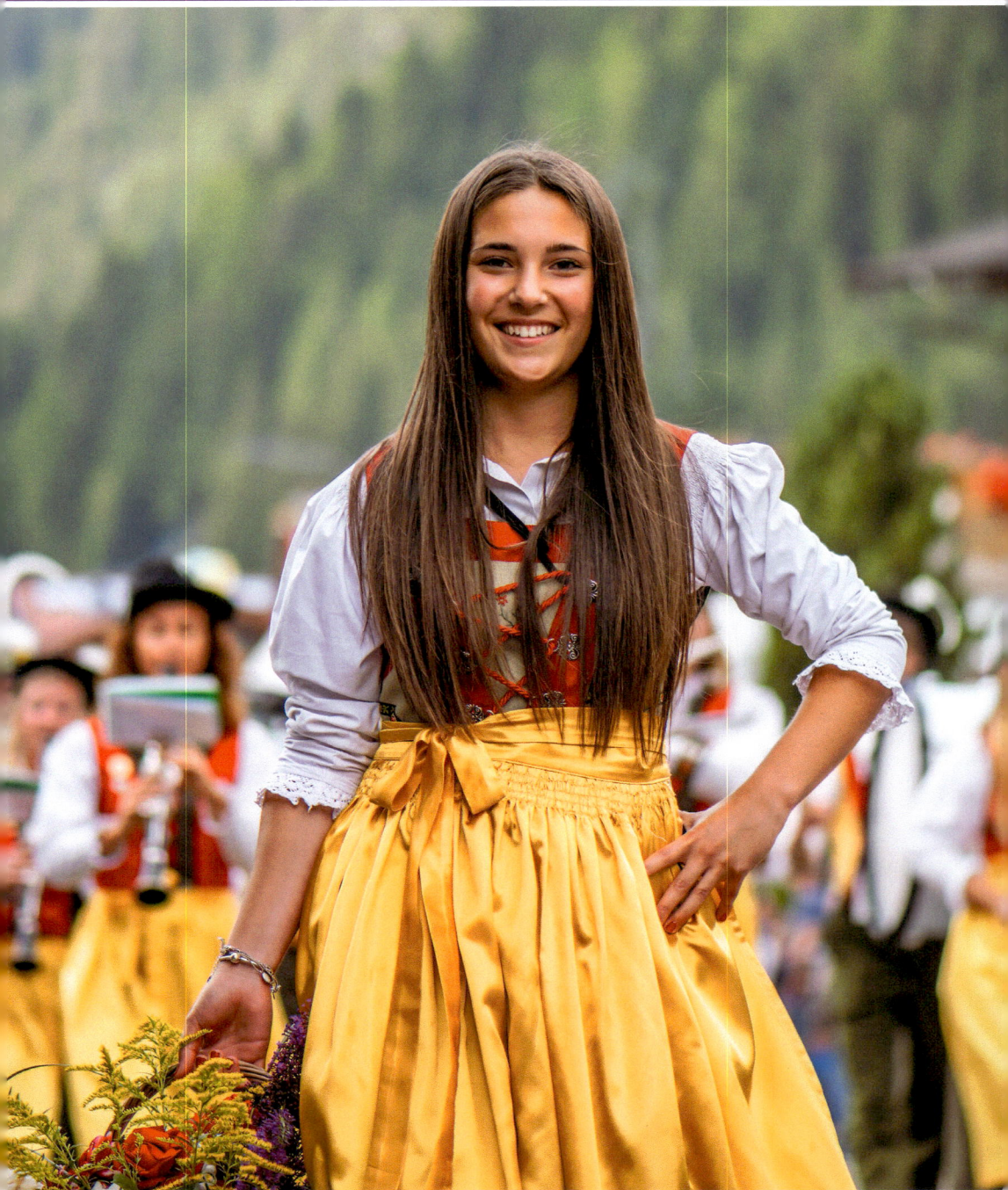

Passo Carezza (also known as Passo di Costalunga & Karerpass) provides a vital east-west link between Bolzano, the provincial capital of the Alto Adige, and the Val di Fassa, one of the preeminent valleys of the region. Reaching a height of 1745m, the pass carves through the d'Ega and Nova Levante valleys and is shrouded in folklore, often centred on the idyllic Lago Carezza, one of the must-see sights of the Dolomites. Famous for its ever-changing emerald hues, this beautiful lake is backed by the impressive Bambole di Latemar (Latemar Dolls) which provide a stunning and quintessentially Dolomitic scene. The pass joins the Val di Fassa on the eastern side, entering the quaint village of Vigo as the valley runs perpendicularly from Moena in the south to Alba in the north. The Val di Fassa is Trentino's only Ladin-speaking valley and is famous for its cross-country skiing during the winter months. The riverside town of Moena is the residence of Italian cross-country ski champion Christian Zorzi and also hosts the 'Marcialonga', a huge cycling, skiing and running event.

Both Bolzano and the Val di Fassa are well-developed tourist destinations, boasting a huge array of accommodation options and amenities. The so-called 'gateway to the Dolomites', Bolzano is a cultural gem, perfectly showcasing the unique blend of Tyrolean and Italian cultures so characteristic of the Dolomites. The medieval streets, Gothic Cathedral and esteemed South Tyrol Museum of Archaeology – home to Ötzi the Iceman, all make for excellent wet weather options. In the Val di Fassa the town of Canazei in the north is arguably the best situated, located at the base of the Pordoi, Sella and Fedaia Passes and so offering excellent access to many of the other areas within this guide.

Bordering the region sits the mighty Catinaccio (Rosengarten) group, home to the much-coveted Vajolet Towers and Torre Delago, the latter of which hosts one of the most famous rock climbing routes in the world – the Piaz Arete/Delagokante. The towers provided the on-set location for the now infamous opening scene of Sylvester Stallone's Cliffhanger, a movie which despite being set in the North American Rocky Mountains was largely filmed in the Dolomites. This vertiginous labyrinth of peaks and spires is best accessed using the cablecar that ascends from Vigo di Fassa as there is no public vehicle access. The remote nature, combined with the sheer scale of the Catinaccio group, will appeal to photographers looking to shoot the Dolomites from rarely captured perspectives.

The procession at the Festa d'Istà in Canazei to celebrate the end of summer. Nikon D810, 105mm, ISO 100, 1/320s at f/2.8, Sep.

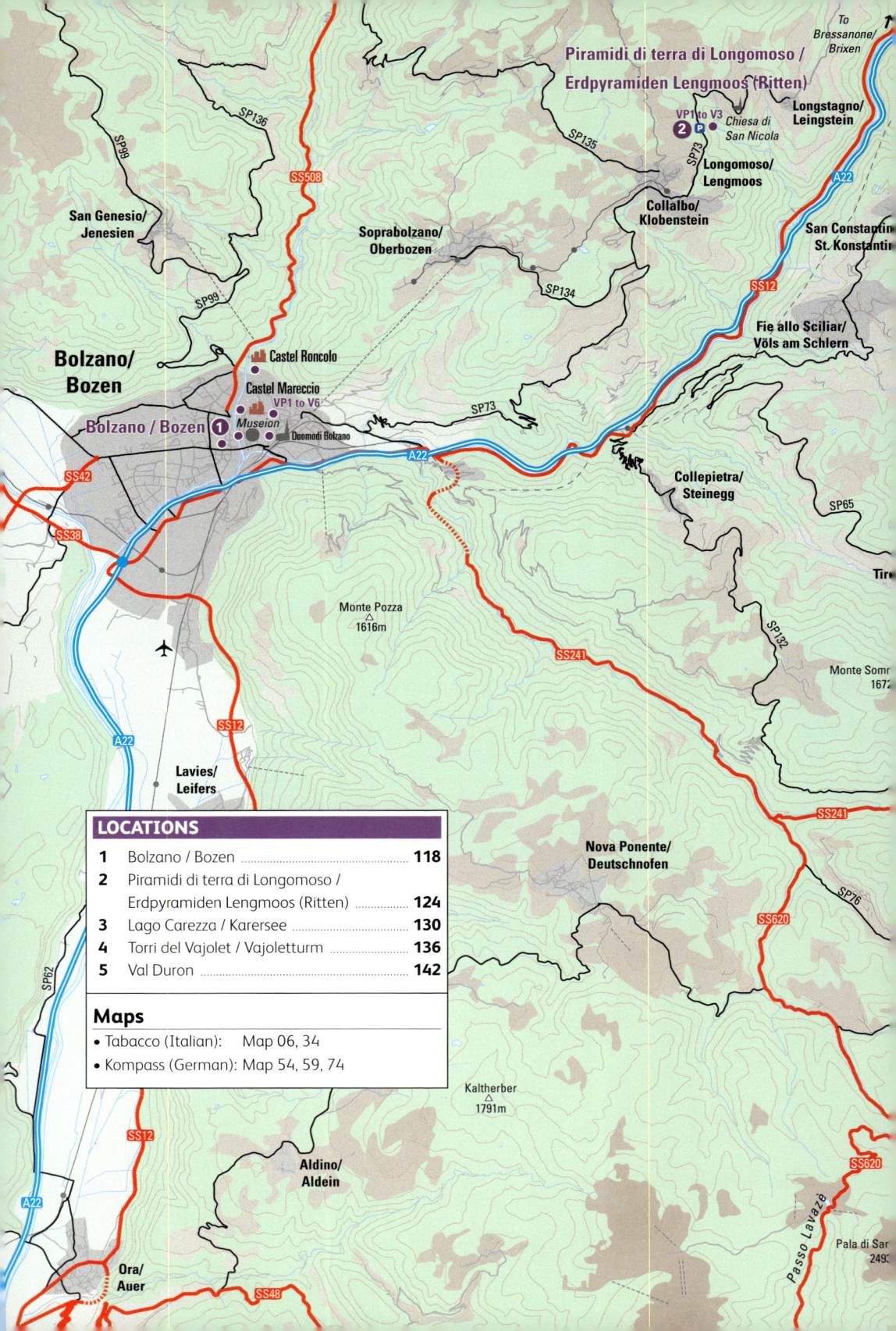

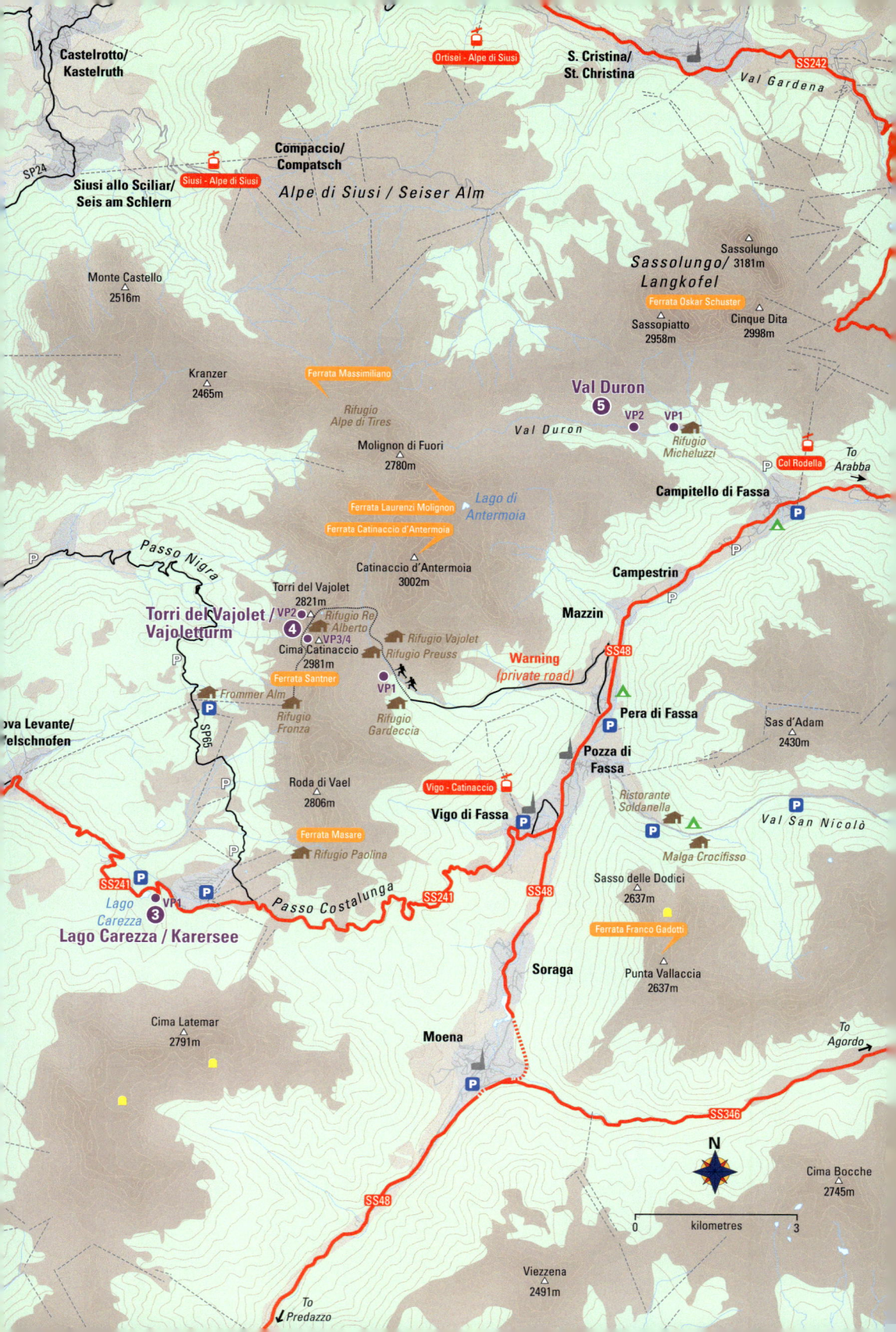

1. BOLZANO / BOZEN

Once an important stop between Venice and the prospering Austro-Hungarian Empire, Bolzano is now the provincial capital of the South Tyrol (Alto Adige / Südtirol) and a vibrant melange of mountain and city culture. Despite its location on the very periphery of the Dolomites, the unmistakable silhouettes of the world's most jagged peaks can clearly be seen from the old town centre as you look east towards the Catinaccio group, a sight especially recommended at sunset. Bolzano itself is surrounded by a network of green hills and rolling agricultural terraces that contrast sharply with the city outskirts as the mountains meet industry.

Although German is the first language of the South Tyrol, the city of Bolzano remains something of an anomaly, boasting an Italian-speaking majority dominated by a strong university and education-led culture. In the 2014 annual ranking of Italian cities, Bolzano was cited as offering the best quality of life in Italy and won the Alpine Town of the Year in 2009 for its sustainable development projects within the alpine arc.

Culturally, Bolzano is perhaps most famous for Ötzi 'the iceman', a glacial mummy dating to the copper age found on the Schnalstal/Val Senales glacier on the border between Austria and Italy. Ötzi is over 5300 years old, making him Europe's oldest natural human mummy – he was crossing the Tisenjoch / Giogo di Tisa glacier before the pyramids were built. His body and belongings are displayed in the South Tyrol Museum of Archaeology, found in the centre of Bolzano.

While Bolzano doesn't perhaps merit a photography trip in its own right, it does however provide some excellent opportunities if the weather is bad in the mountains, if you fancy exploring some of the town's considerable cultural offerings or for those who simply want to do some shopping and enjoy a larger town.

What to shoot and viewpoints

The sprawling and unpredictable nature of Bolzano suits a more impromptu photographic approach as you explore the sights and sounds of the winding streets. With that said, here are a few ideas:

Viewpoint 1 – Duomo di Bolzano ♿
Dedicated to Saint Mary of the Assumption and restored in Gothic style following allied bombing in 1944, the cathedral of Bolzano is an impressive sight inside and out.

Viewpoint 2 – Via Casa di Risparmio ♿
The bright façades of this Neo-Gothic street with Baroque Bavarian and Romanic-Renaissance influenced elements are well worthy of attention.

Viewpoint 3 – Museion ♿
Designed by the architecture firm Krueger, Schuberth, Vandreike of Berlin in 2008, Bolzano's museum of modern and contemporary art is an impressive installation. Experiment with including the new cycle and pedestrian bridges crossing the Talvera to the west to create an effective sci-fi scene, especially once night has fallen.

Viewpoint 4 – Castel Mareccio ♿
Dating back to the early 13th century and surrounded by vineyards, this riverside castle was inhabited by the Lords of Mareccio who represented the Count of the Tyrol.

Viewpoint 5 – Piazza delle Erbe Market ♿
The fruit and vegetable market in Piazza delle Erbe is held every day with the exception of Saturday afternoons and Sunday. Established in 1277 by the Count Meinhard II, the ancient market is located on the site of the city's high gate and houses the Fountain of Neptune built in 1777. The bustling market sells a wide range of Tyrolean delicacies and offers a host of opportunities for street photography.

Viewpoint 6 – Castel Roncolo ♿
Accessible with a 35 minute walk north along the river Adige following the Lungo Talvera path from the town centre, the medieval castle dates back to 1237 and presents a spectacular focal point.

Looking down the long central nave of the Duomo di Bolzano. Nikon D810, 14–24mm at 14mm, ISO 560, 1/15s at f/2.8.

The brightly coloured buildings found along Via Casa di Risparmio. Nikon D810, 14–24mm at 24mm, ISO 100, 1/500s at f/11, Aug.

Artistic graffiti surrounding the Museion. Nikon D810, 28–300mm at 300mm, ISO 360, 1/320s at f/5.6.

Using a long lens to created a tiled roof abstract. Nikon D810, 100–400mm at 400mm, ISO 220, 1/320s at f/6.3.

1 BOLZANO / BOZEN

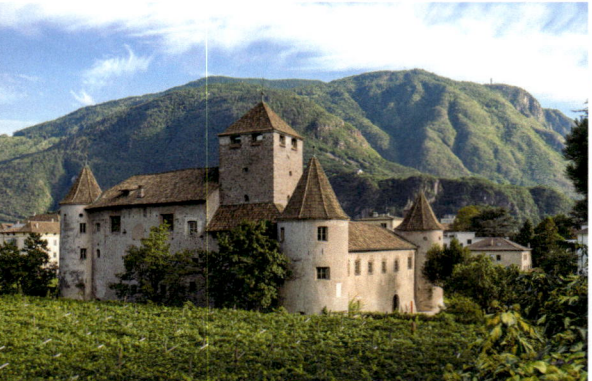

How to get here

Bolzano is situated directly on the A22 motorway and has two junctions – Bolzano Nord and Sud. The town centre is well signposted and there is a wide variety of car parks to choose from. If in doubt, the railway station just south of the city centre is a good place to start as there are numerous parking areas in the vicinity. If travelling with a camper van beware: many of these are height-restricted or multi-storey, as indicated by the hat symbol over the parking sign.

🅿 Lat/Long:	46.50298, 11.3514
🅿 what3words:	///levels.destined.pouting
🅿 Tabacco:	Map 34 (1:25.000)
🅿 Kompass:	Map 54 (1:50.000)

Accessibility

Approach: There are many car parks within a 15 minute walking distance from the city centre. The path along both sides of the river Adige provides a convenient link up between the parking areas and the centre.

 Disabled access: Disabled access throughout the town is good and most car parks offer a number of disabled parking spaces.

Best time of year/day

As befits a city of this size, Bolzano offers a range of shooting possibilities throughout the four seasons. The city has a vibrant cultural scene and hosts a number of events and festivals:

- December – Christmas markets
- February – Family festival (puppet and theatre displays)
- April, May – Primavera a Bolzano (spring flower festival)
- June – Castelrona (historical exhibitions in the castles of Bolzano)
- June, July, – Jazzfestival Alto Adige
- July – Bolzano danza (very popular dance festival)

Top left: Castel Mareccio. Nikon D810, 16–35mm at 35mm, ISO 100, 1/200s at f/7.1, Sep. **Top right**: The outdoor market in Piazza delle Erbe. Nikon Z7II, 14–24mm at 20mm, ISO 64, 1/50s at f/4, Sep.

Middle: A horse-drawn carriage. Nikon D810, 105mm, ISO 100, 1/500s at f/2.8, Aug.

Above: One of the many patisseries in the city. Nikon D810, 14–24mm at 24mm, ISO 100, 1/50s at f/3.5.

Opposite: Live traditional music is a common sight on the streets. Nikon D810, 105mm, ISO 100, 1/800s at f/2.8, Aug.

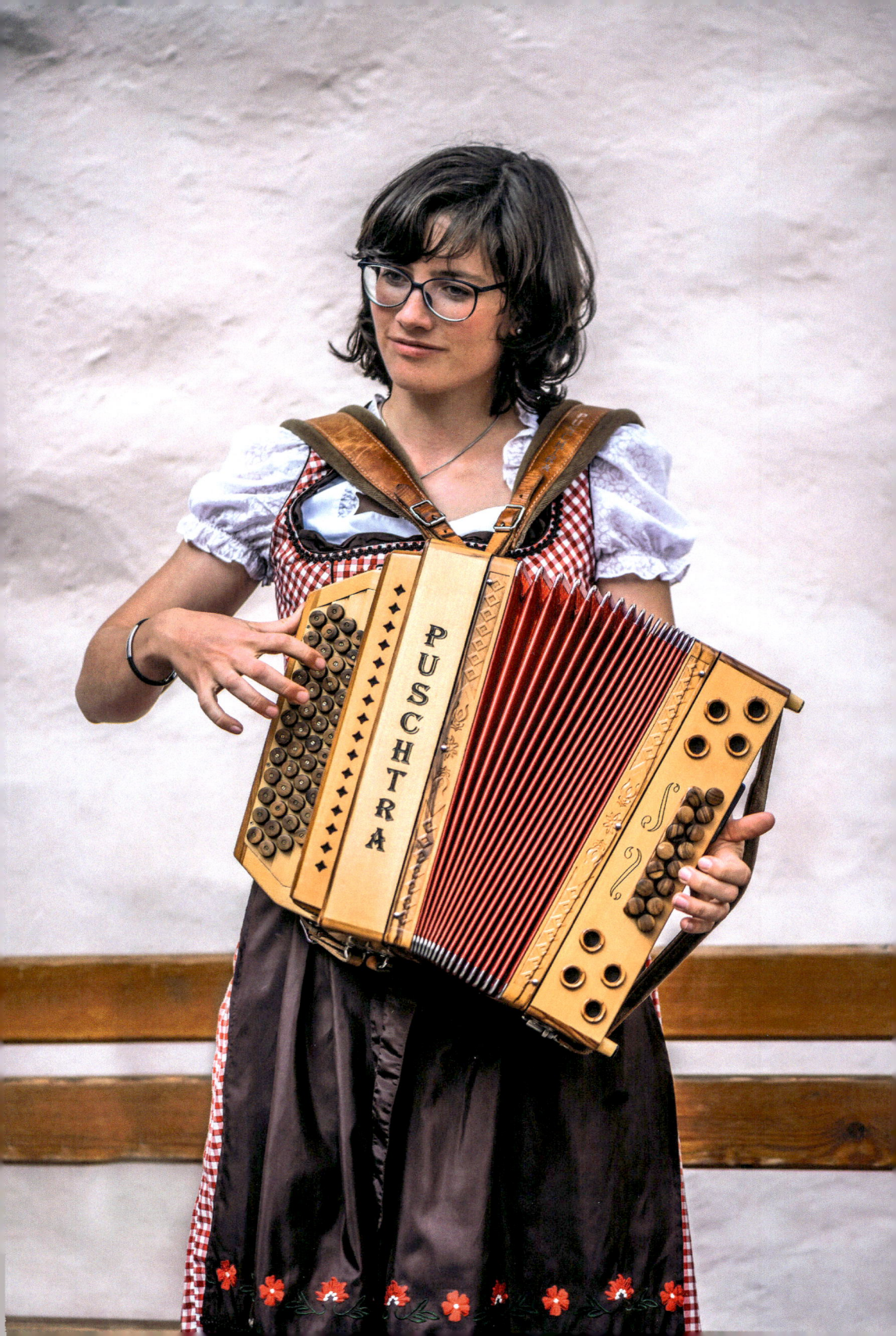

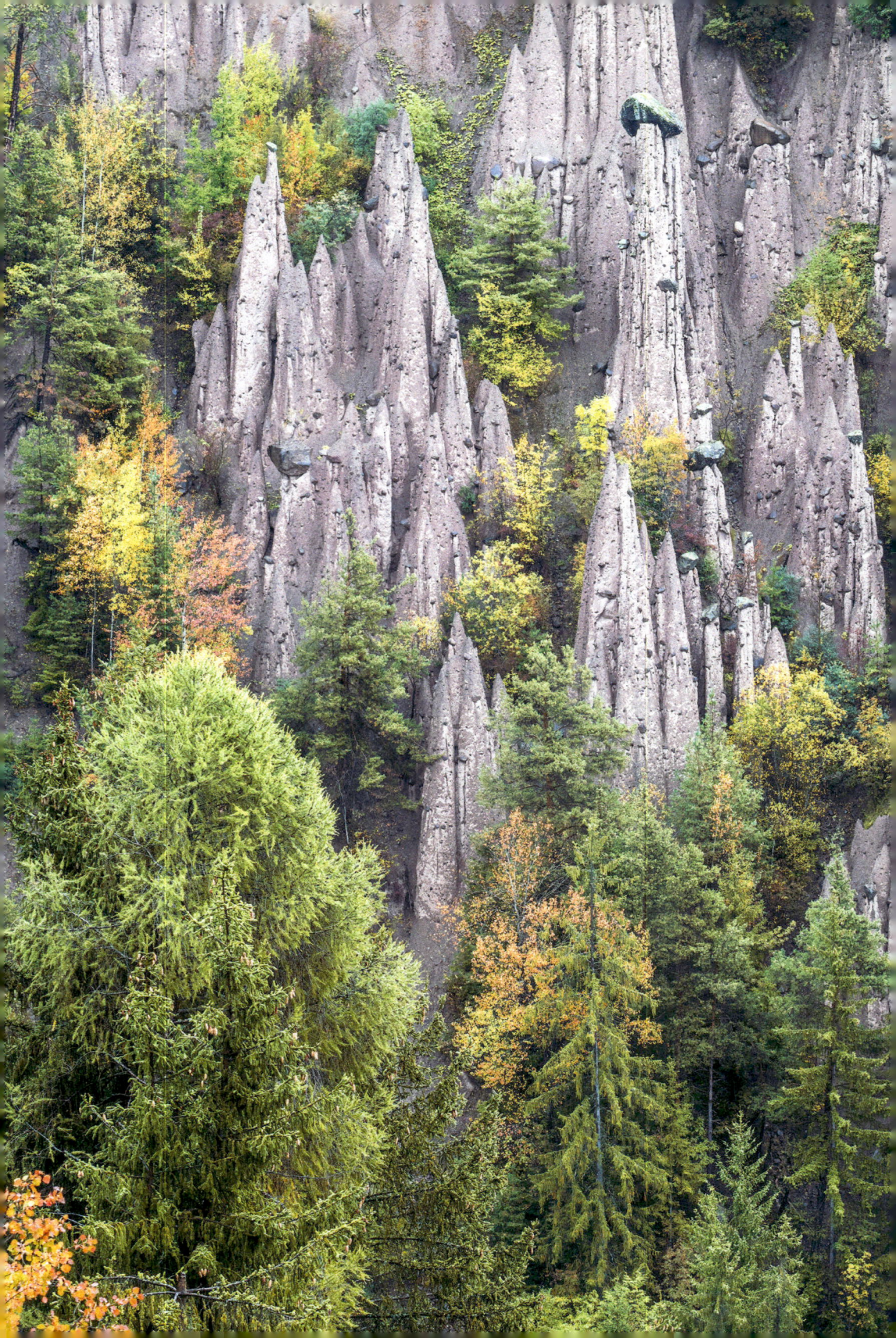

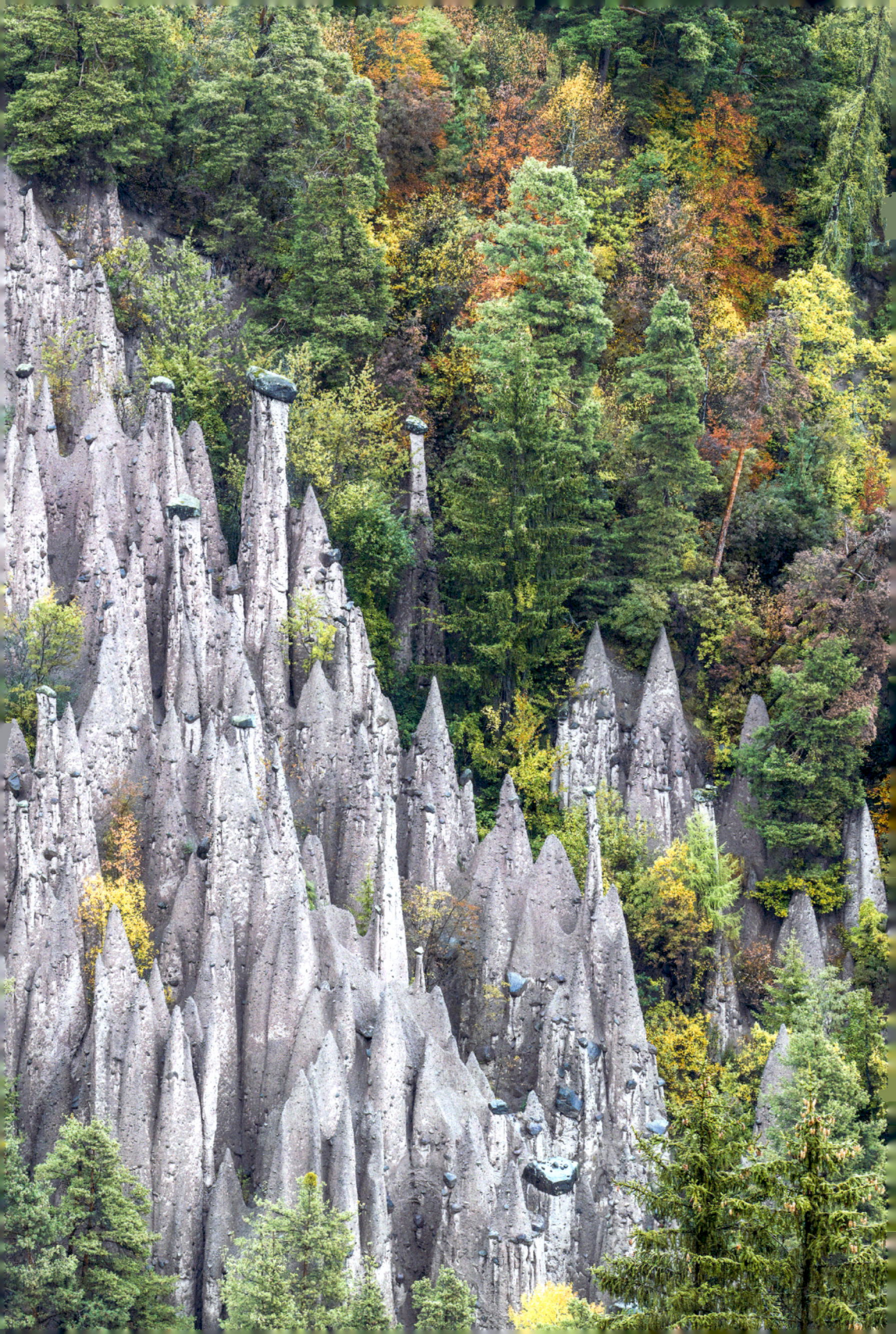

2 — PIRAMIDI DI TERRA DI LONGOMOSO /

Formed by prolonged water erosion of a fine clay substrate containing large boulders, the earth pyramids or Hoodoos at Longomoso are some of the finest and best-preserved examples of their kind in Europe. Easily accessed, these wonderful rock formations make for an excellent photo location throughout the year.

What to shoot and viewpoints

From the parking area follow the main road (Via Principale) north for 350m to reach Cafe Erdpyramiden. Turn right off the road onto a good walking track, clearly signposted towards the earth pyramids. Follow this flat track through the forest for a further 500m to reach the first viewpoint overlooking the rock formations.

Viewpoint 1 – Earth Pyramids ♿
There are three good viewpoints overlooking the earth pyramids, each offering a slightly different perspective and backdrop. The church – Chiesa di San Nicola, makes for a lovely backdrop with a wide-angle, whilst a longer lens is ideal for picking out key points of interest.

Viewpoint 2 – Chiesa di San Nicola ♿
Rock formations aside the church makes for a lovely subject in its own right. With a telephoto it is possible to get in close, taking advantage of the perspective distortion to frame the impressive walls of the Odle group in the background.

Viewpoint 3 – Other Ideas
There are some more earth pyramids nearby at Auna di Sotto and Soprabolzano for those wishing to do some additional research. However, these at Longomoso are the easiest to access and arguably the most photogenic.

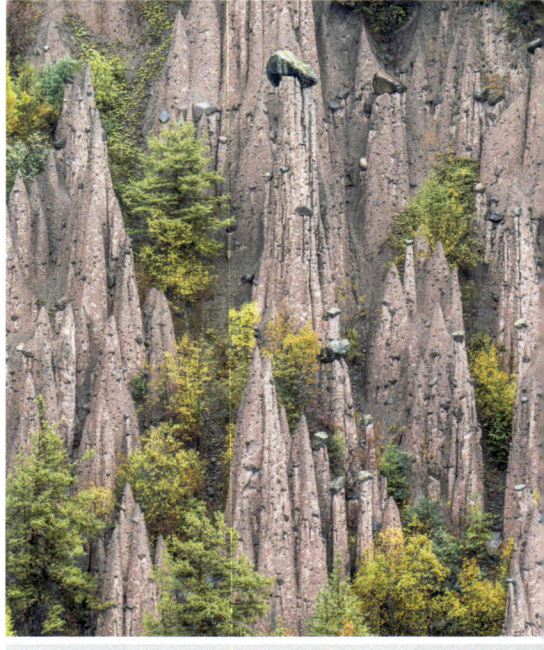

How to get here

Longomoso can be accessed in 30 minutes of driving from Bolzano. Please note that for those approaching from Ponte Gardena to the north-east, the road is very narrow in places.

From Bolzano take the SP22 east for 3km before turning left onto the Via Principale signposted towards Renon. Follow this for 16km to reach the town of Longomoso. There are many carparks along the main road, the closest found just past apartments Waldquell. If this is full there is another large carpark by Sporthotel Spoegler.

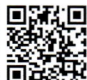

- **🅿 Lat/Long**: 46.54504, 11.46881
- **🅿 what3words**: ///stews.campers.submissions
- **🅿 Tabacco**: Map 34 (1:25.000)
- **🅿 Kompass**: Map 54 (1:50.000)

Accessibility

Approach: 15 minutes, 1km, 10m of ascent.

Access is via the main road, a good path and then a boardwalk.

♿ **Disabled access**: There is good disabled access to the viewpoint overlooking the earth pyramids with a good track and then boardwalk.

Best time of year/day

Due to the easy access, the earth pyramids at Longomoso can confidently be recommended year round. The rock formations look particularly beautiful in the snow and through October when much of the surrounding vegetation takes on lovely autumn hues.

The easterly aspect makes this a good sunrise or afternoon venue.

Previous spread: Piramidi di terra di Longomoso looks beautiful throughout the autumn. Nikon Z7II, 100–400mm at 100mm, ISO 200, 1/8s at f/8, tripod, Oct.

Above right: Using a long lens to pick out an area of interest. Nikon Z8, 100–400mm at 180mm, ISO 200, 1/10s at f/8, Oct.

Opposite: Chiesa di San Nicola makes a wonderful backdrop to the earth pyramids. This is a cropped 16 image panorama. DJI Mavic Pro 3, 24mm, ISO 100, 1/1000s at f/2.8, Sep.

ERDPYRAMIDEN LENGMOOS (RITTEN)

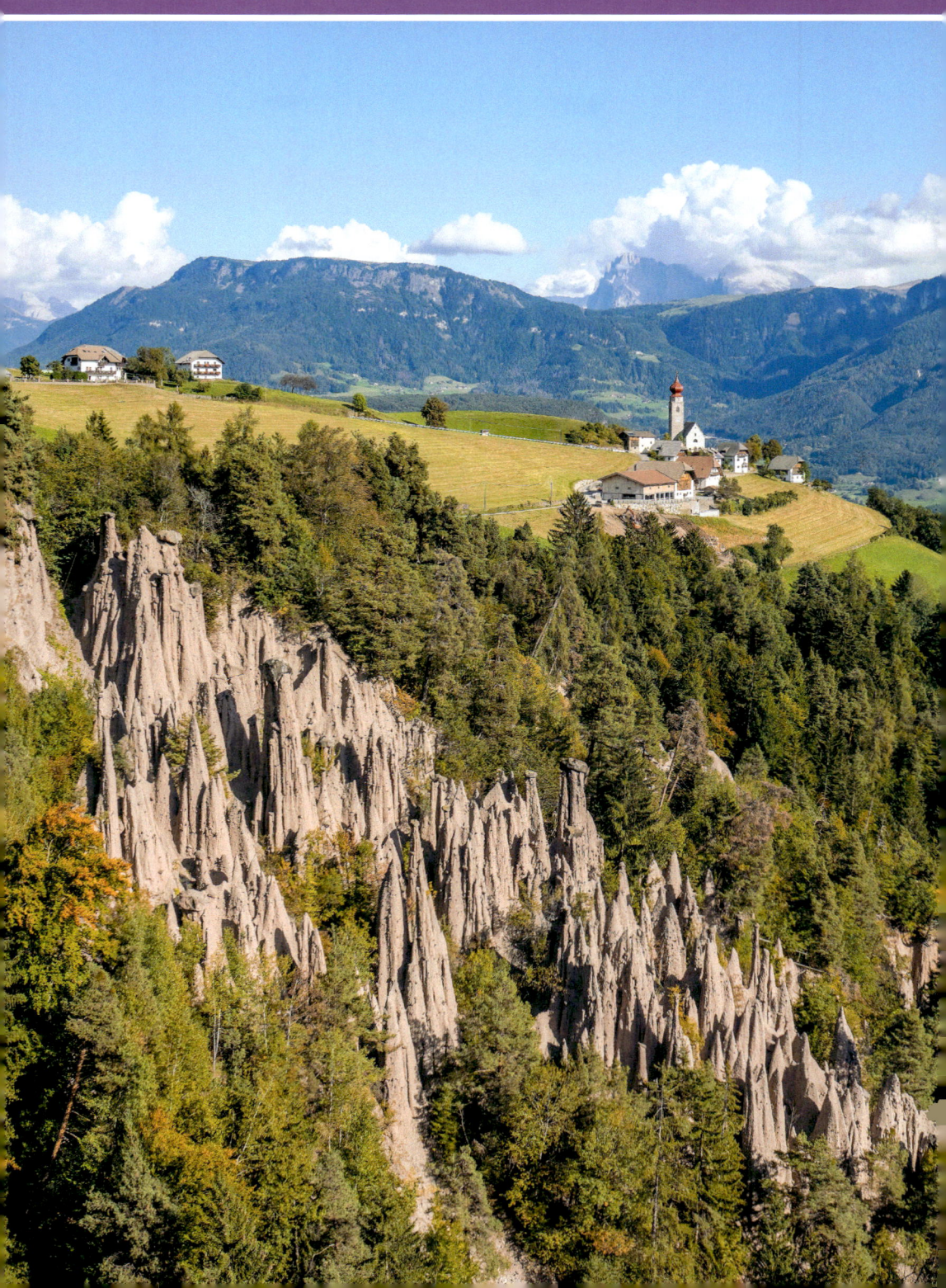

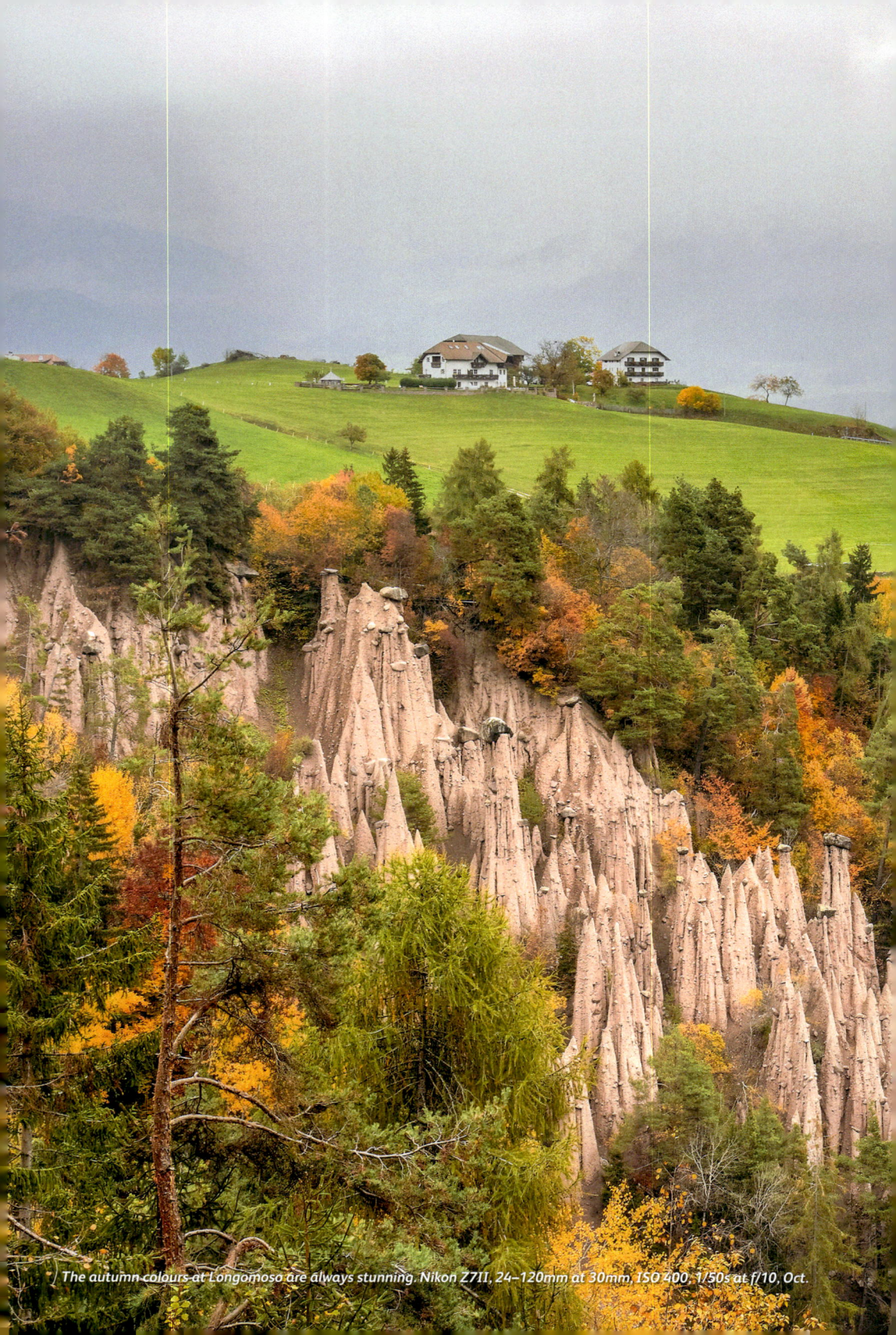
The autumn colours at Longomoso are always stunning. Nikon Z7II, 24–120mm at 30mm, ISO 400, 1/50s at f/10, Oct.

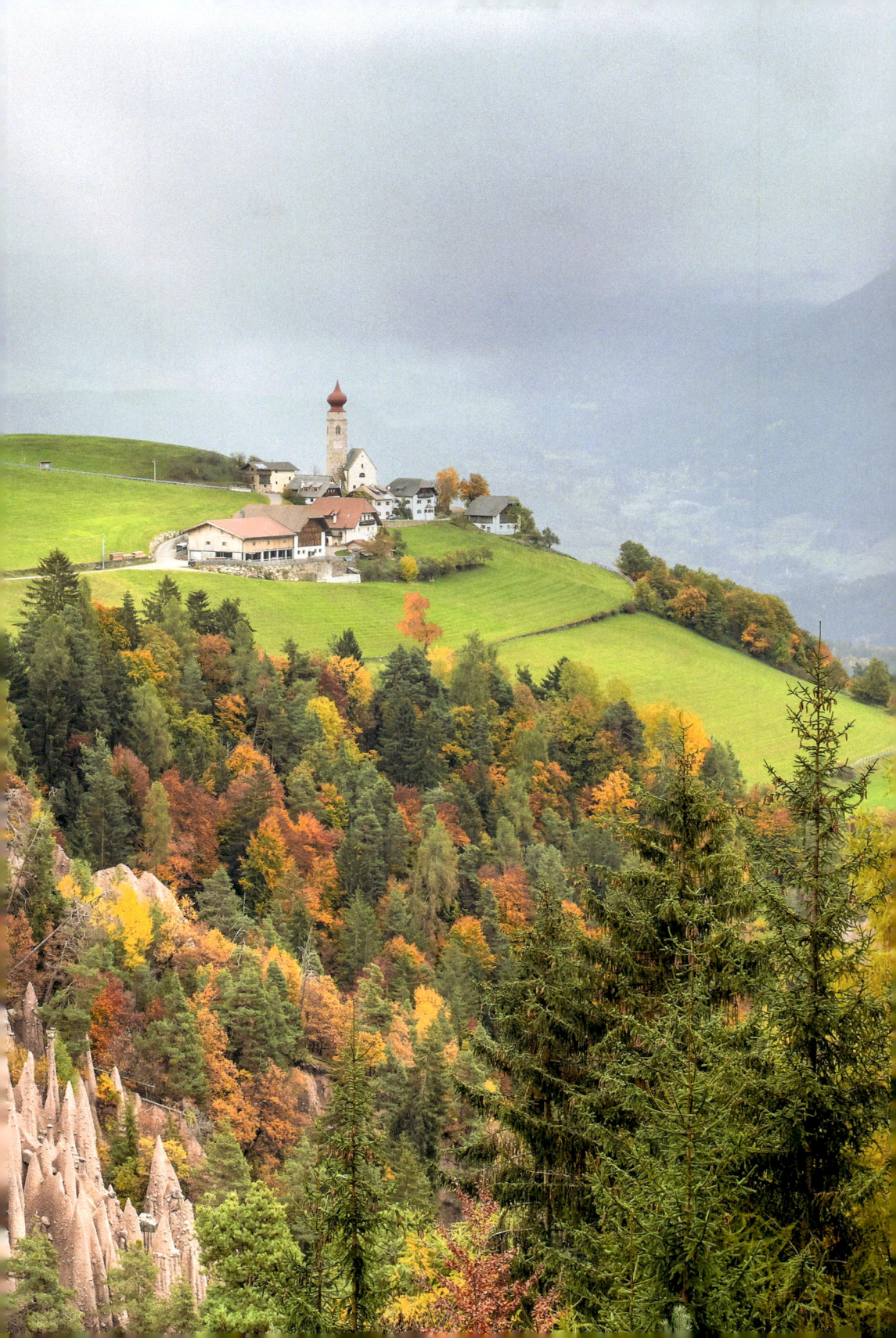

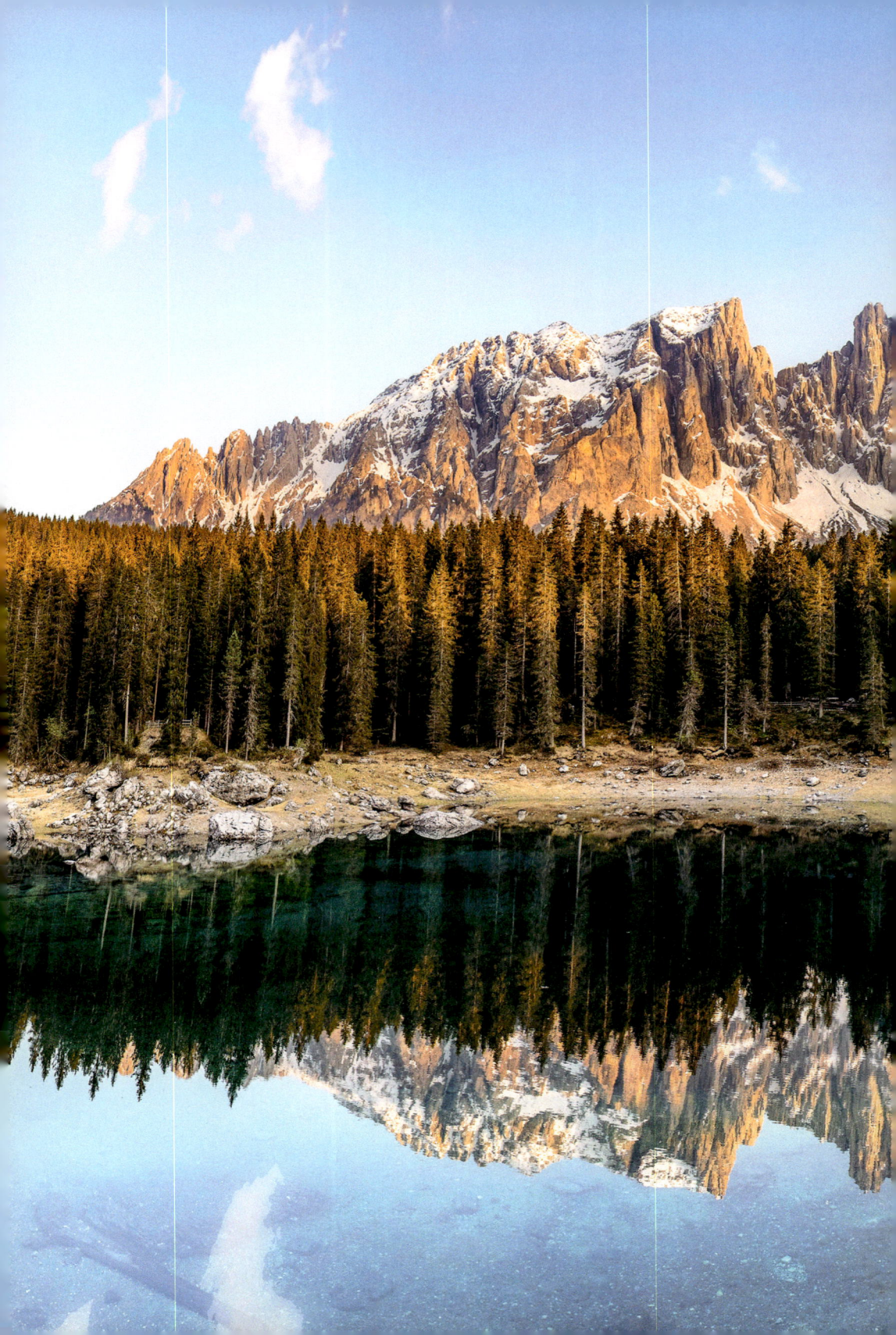

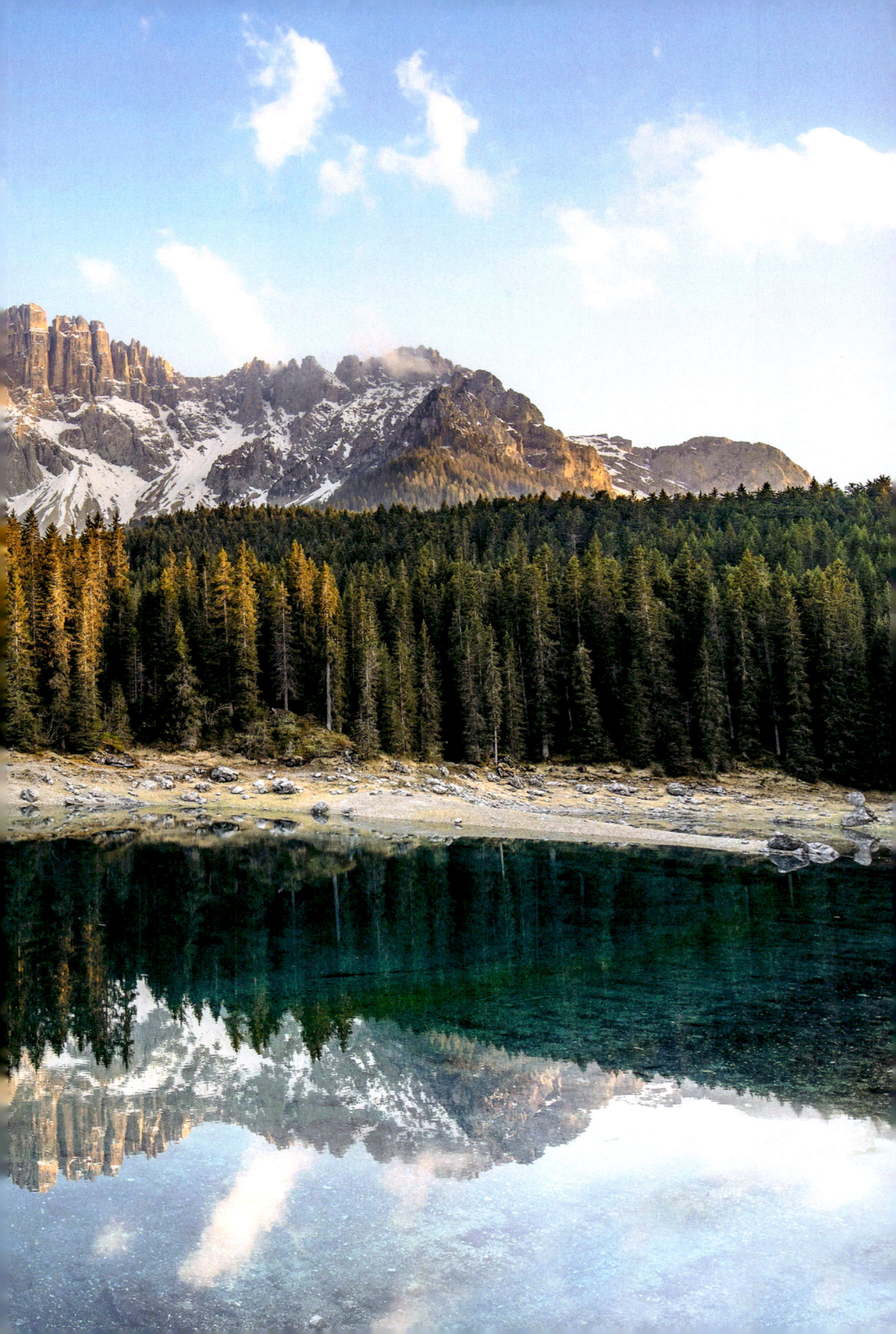

LAGO CAREZZA / KARERSEE

The emerald lake of Lago Carezza backdropped by the north faces of the Latemar group is one of the iconic spectacles of the Dolomites. Although undoubtedly a little cliché, the view never fails to impress (despite the recent storm damage) and the easy access makes it a firm favourite amongst photographers year round.

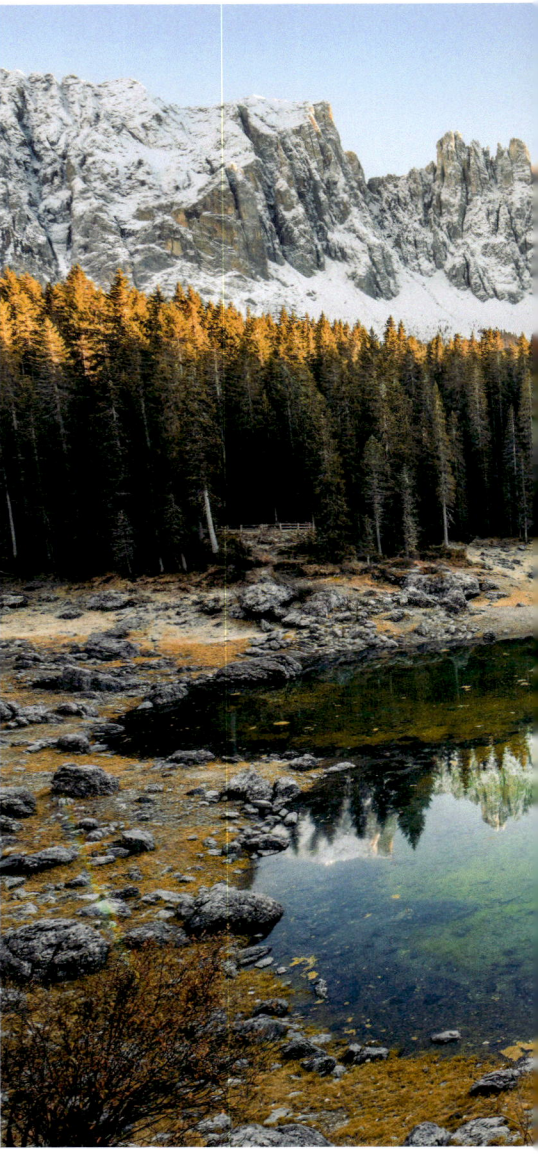

Legends tell of Undine, a shy nymph who lived in the waters of Lago Carezza, infatuating passersby with her singing but never revealing herself. A local sorcerer who lived in the nearby Catinaccio mountains was captivated by the nymph's song but every time he approached, she dived down into the waters. Frustrated, the sorcerer sought the help of a witch, Masaré, who suggested he build a rainbow bridge from the Latemar group to the Catinaccio in order to attract her attention, dressing up as a jewellery merchant to stop her from recognising him. The sorcerer complied and built the most spectacular rainbow of vibrant colours, taking many different jewels down to the lake edge.

Fascinated by the rainbow and sparkling jewels, Undine appeared and swam over to the sorcerer. However, as she drew closer she recognised the sorcerer who in his haste had forgotten to dress up as a jewellery merchant. Feeling tricked, Undine dove back into the water, staying forever submerged and refusing to come back to the surface. In anger, the sorcerer broke up his magnificent rainbow and cast the fractured pieces along with the jewels into the lake. The nymph Undine has never been seen again, but there is now a bronze statue of her on the eastern shore and the lake continues to sparkle magically with all the colours of the rainbow, earning it the Ladin name 'Lec de Ergobando or 'Rainbow Lake'.

There are no tributaries flowing into the lake and the water level which fluctuates dramatically between spring (when it is highest) and October (when it is lowest) is controlled by a series of underground springs which bubble into the lake from the nearby Latemar catchment. The crystal clear waters harbour Arctic char which thrive in the lake, despite the surface freezing throughout the winter months.

Unfortunately Storm Vaia toppled many of the surrounding trees during 2018, though the forest is now showing good signs of recovery.

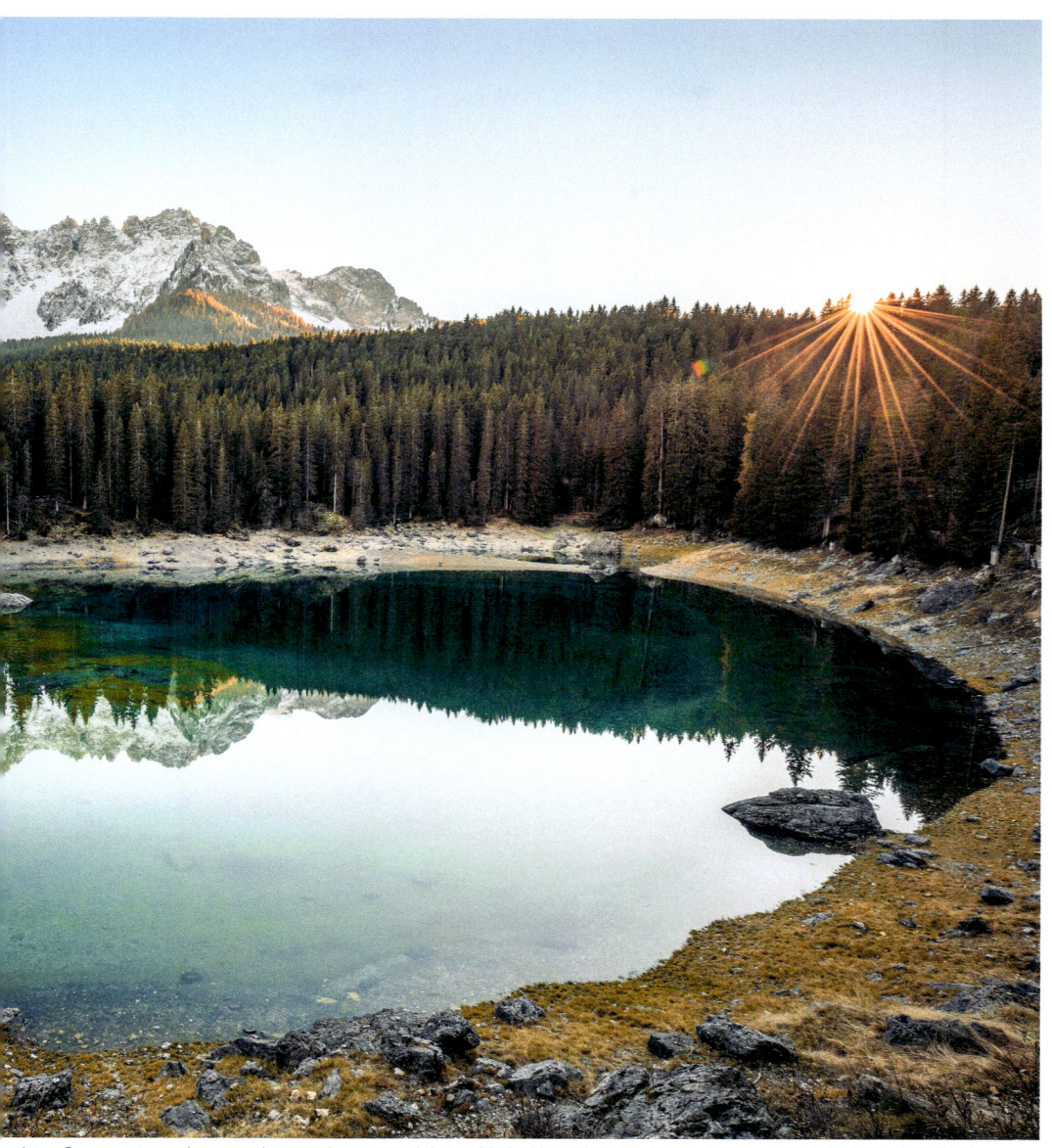

Lago Carezza prior to the storm damage that occurred during 2018. Nikon D810, 14–24mm at 16mm, ISO 200, 1/50s at f/18, Oct.

Previous spread: *A 4 photo panorama of Lago Carezza taken from the viewing platform. Nikon D810, 16–35mm at 16mm, ISO 100, 1/100s at f/6.3, May.*

[3] LAGO CAREZZA / KARERSEE

The north-eastern lake shore in early autumn. Nikon D810, 16–35mm at 20mm, ISO 100, 1/60s at f/8, Oct.

What to shoot and viewpoints

The land immediately surrounding the lake is privately owned and is cordoned off with a wooden perimeter fence – please respect these boundaries. While the quintessential and classic viewpoint is from the viewing platform on the north side, there is a path encircling the lake which provides a beautiful if short stroll.

Viewpoint 1 – Lago Carezza & Latemar Group ♿

Looking south towards the Latemar from the viewing platform, it is easy to see why photographers keep returning to this spot. The reflections create some beautiful symmetry at a range of focal lengths and the water colour seems to change every time you shoot it. The path that leads right (west) from the platform provides the same viewpoint but allows you to shoot the lake more centrally, creating a more 'head on' composition. A panorama of several photos works well from either perspective.

Opposite: The classic perspective of Lago Carezza. Nikon D810, 16–35mm at 16mm, ISO 100, 1/20s at f/9, Oct.

How to get here

Lago Carezza is located 2.5km below the top of the Passo Carezza on the west side. The pass can be approached using the SS241 from the north-west and Bolzano or from the Val di Fassa to the east. The lake is well signposted from either direction and there is a large car park and visitors' centre just off the road.

🅿 Lat/Long:	46.41132, 11.57499
🅿 what3words:	///fezzes.seat.adjusted
🅿 Tabacco:	Map 06 (1:25.000)
🅿 Kompass:	Map 74 (1:50.000)

Accessibility

Approach: Roadside access.

♿ **Disabled access**: There is a good path leading from the visitors' centre on the north side of the road through a subway to the main viewing platform.

Best time of year/day

The lake looks particularly striking during spring and autumn when the Latemar group is highlighted with snow but the water surface remains unfrozen, reflecting the scene. Due to the north-facing aspect of the mountain backdrop, light only touches the peaks during sunrise and sunset. At midday the sun hangs directly over the pinnacles, silhouetting everything and generally making shooting difficult.

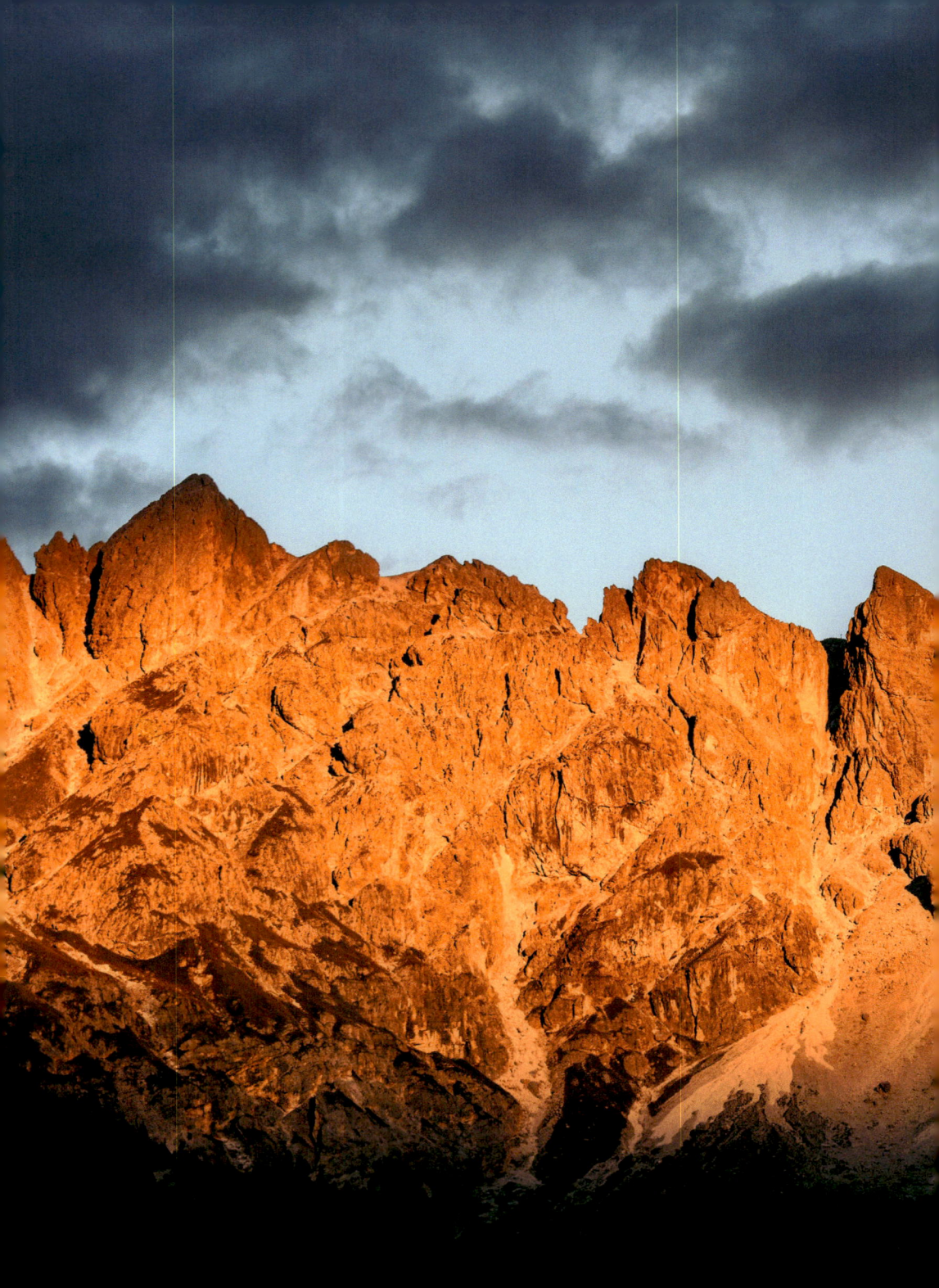
Last light on the Torri del Vajolet as seen from the village of Tires. Nikon D810, 80-400mm at 160mm, ISO 100, 1/100s at f/8, tripod, Oct.

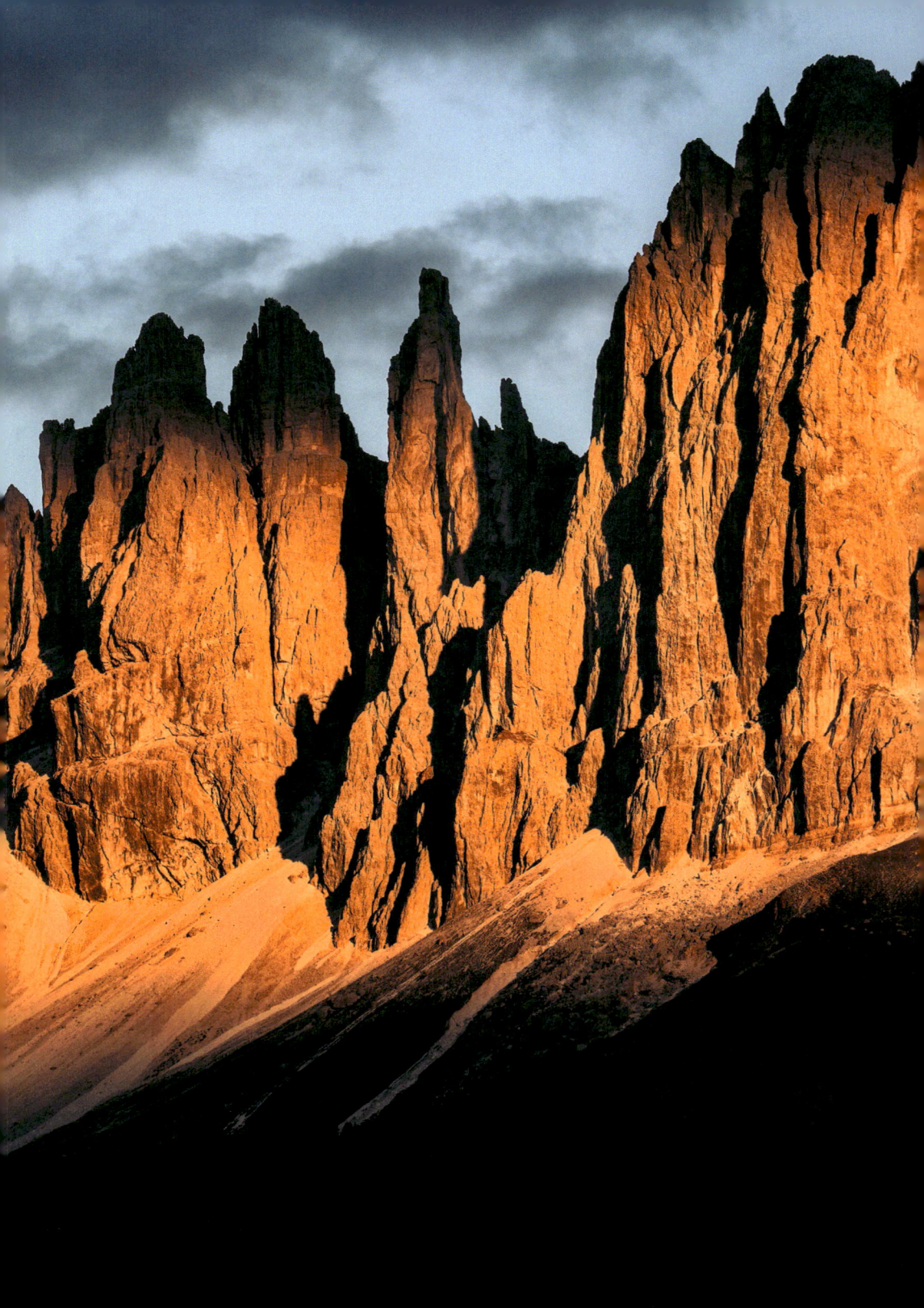

4. TORRI DEL VAJOLET / VAJOLETTURM

The location for the infamous opening scene of the movie 'Cliffhanger', home to one of the most famous climbs in the world and a much-used symbol of the Catinaccio group, the Vajolet Towers are one of the most iconic rock formations in the Dolomites.

Despite being comprised of seven individual towers, the southernmost three – Torre Delago, Torre Stabeler and Torre Winkler – are the most famous and photogenic. All three are highly coveted by climbers due to their excellent rock, logical lines, exposed position overlooking Tires and modest technical difficulties. Of these routes, the Piaz Arête/Delagokante on Torre Delago, first climbed by Giovanni Battista Piaz, Francesco Jori and Irma Glaser in August 1911, is the most popular.

The towers can be accessed from Rifugio Gardeccia to the south-east or by climbing Via Ferrata Santner from the Passo Nigra. However, the approach is long from either direction and both routes, especially Santner, require scrambling experience. Despite the difficult access, the area can get exceptionally busy during peak season and consequently, an overnight stay in Rifugio Re Alberto at the base of the towers is recommended, allowing you to take advantage of sunset and sunrise once the crowds have diminished.

What to shoot and viewpoints

The following details the recommended approach from Ciampedie. After ascending the Catinaccio cablecar take path 540 north-west, following signposting towards Rifugio Gardeccia to reach the hut in 50 minutes.

How to get here

Unusually for the Dolomites, there is no direct vehicle access to the Catinaccio group so some thought must be given to logistics, particularly for those planning a sunrise or sunset shoot. There are two possible approaches to the Torri del Vajolet – the most common is via the Catinaccio cablecar which ascends to Rifugio Ciampedie from Vigo, a small town in the Val di Fassa. It is then possible to walk on foot, following path 540 to Rifugio Gardeccia and then taking path 546 to Rifugio Vajolet. Finally, path 542 can be ascended to Rifugio Re Alberto (Gartlhutte) and the Vajolet Towers.

Alternatively, it is possible to reach the Torri del Vajolet using Via Ferrata Santner which departs from the Laurin chairlift on the Passo Nigra. Whilst shorter in distance, this ascent requires mountaineering experience as this is a technical climbing route.

Both approaches take between two and three hours, have a significant amount of ascent and should not be underestimated.

Catinaccio Cablecar to Ciampedie from Vigo di Fassa

- **Lat/Long**: 46.42116, 11.67152
- **what3words**: ///illustrated.probable.foams
- **Tabacco**: Map 06 (1:25.000)
- **Kompass**: Map 74 (1:50.000)

Laurin Chairlift to Via Ferrata Santner

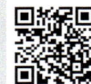

- **Lat/Long**: 46.444369, 11.588163
- **what3words**: ///untold.thrills.teaching
- **Tabacco**: Map 06 (1:25.000)
- **Kompass**: Map 74 (1:50.000)

Accessibility

Approach: 2 hrs 30 mins, 5.5km, 800m of ascent.

The approach from Ciampedie requires good fitness and there are several steeper sections protected by wire that require confidence.

Those choosing to ascend Via Ferrata Santner should have suitable climbing experience and the correct safety equipment (harness, via ferrata lanyards and helmet). The technical difficulty is moderate but there are several exposed sections with no wire for protection.

Disabled access: There is no disabled access to the towers.

Best time of year/day

Due to the remote location and long approach, it is best to wait for the summer months to ensure the snow has cleared.

Despite the easterly orientation, the towers don't get much direct light at sunrise due to the bulky form of Cima Catinaccio shadowing the peaks for much of the year. The location then receives good light throughout the day, with the sun finally setting on the summits and the west face of Torre Delago.

A visit during the afternoon and evening are particularly recommended in conjunction with an overnight stay in Rifugio Re Alberto to fully appreciate the spectacular landscape once the crowds have retreated. This also allows for sunset, night and sunrise sessions, whilst preventing the need for a return in darkness.

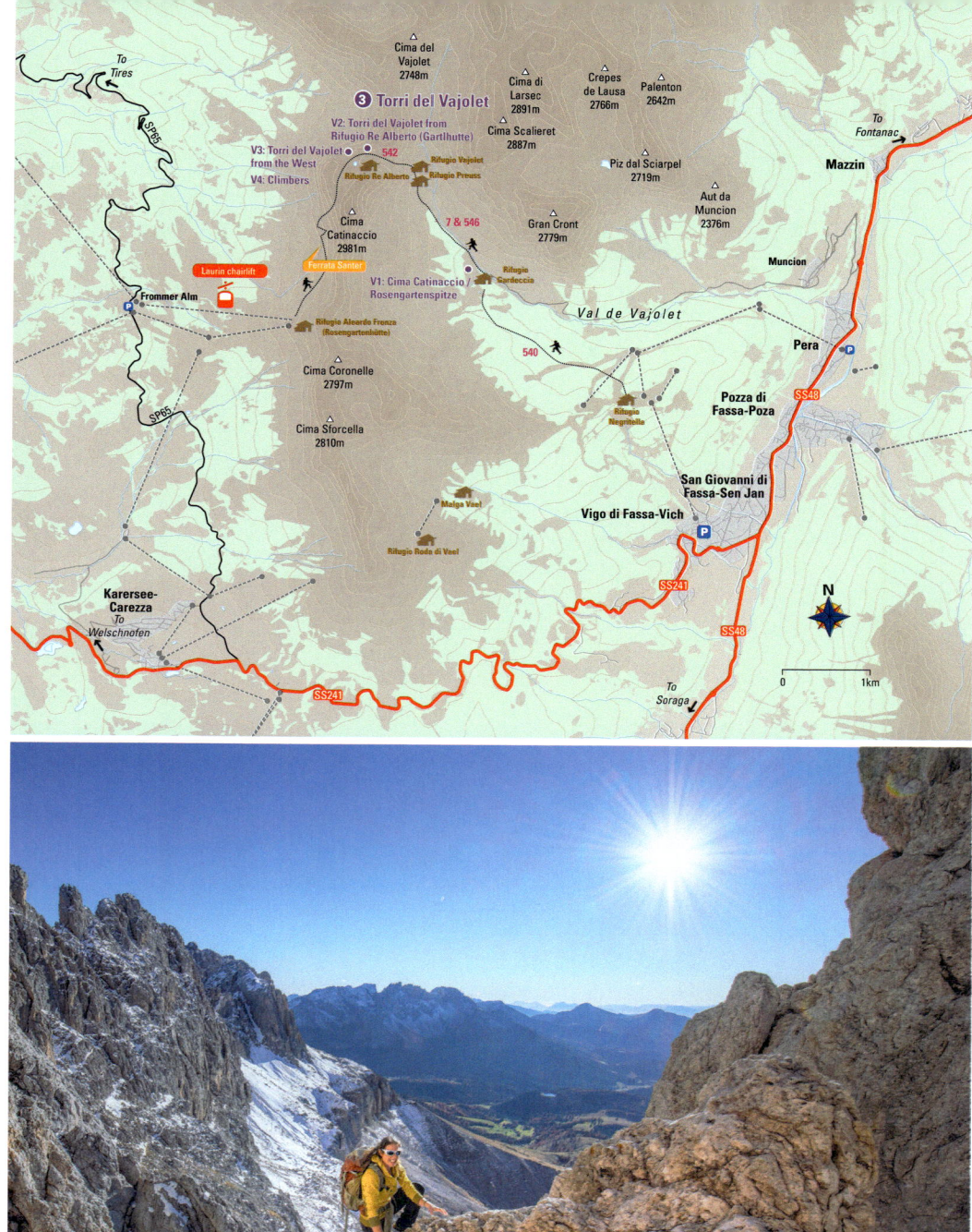

Using Via Ferrata Santner to approach the Torri del Vajolet from the Passo Nigra. Nikon D810, 14–24mm at 14mm, ISO 100, 1/500s at f/10, Nov.

[4] TORRI DEL VAJOLET / VAJOLETTURM

The wonderfully situated Rifugio Re Alberto sits directly under the Vajolet Towers. © Ruud Luijten.

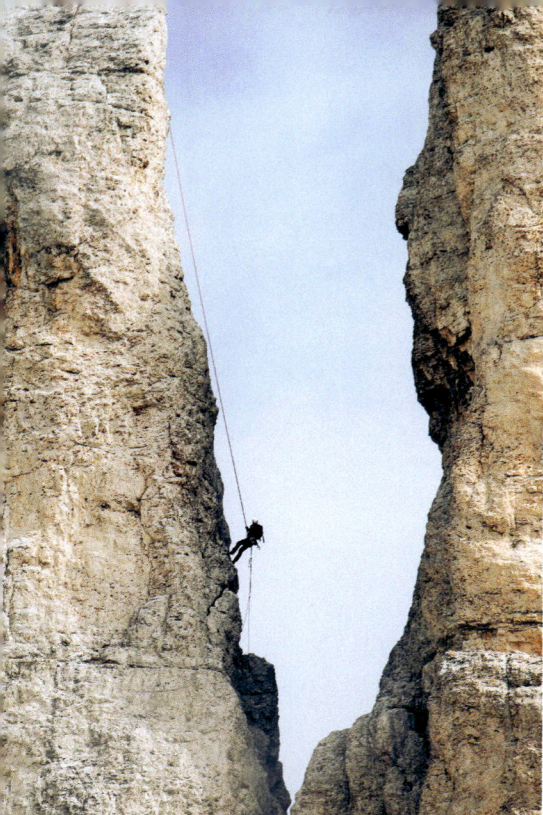
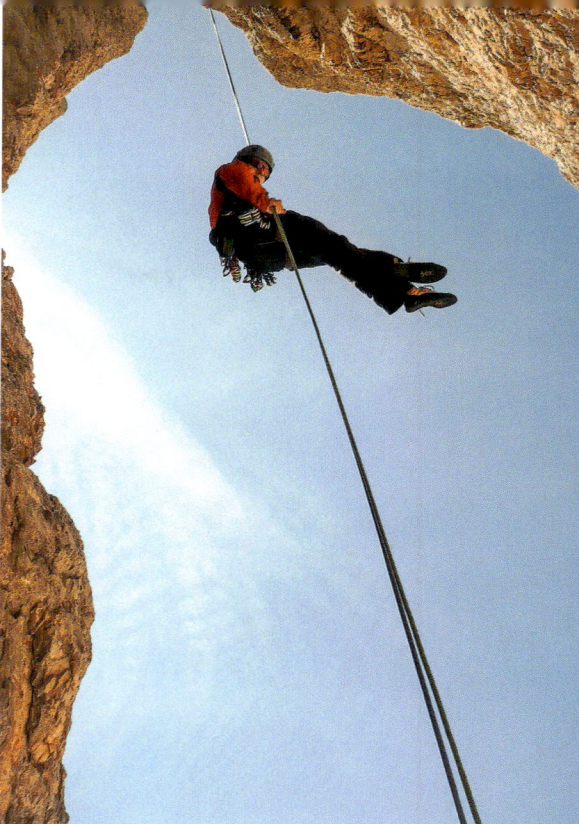

Climbers abseiling off Torre Delago. Canon 6D, 70–300 at 300mm, ISO 100, 1/400s at f/7.1, Aug.

Making the Torre Delago abseil. Nikon D610, 14–24mm at 14mm, ISO 100, 1/800s at f/7.1, Jul.

What to shoot and viewpoints

Viewpoint 1 – Cima Catinaccio / Rosengartenspitze

On reaching Rifugio Gardeccia, there is immediately a good view of the Cima Catinaccio's dramatic east face. This triple-peaked bastion of rock makes for an interesting subject while the rolling meadows at the base offer a broad range of foreground possibilities.

If you happen to be carrying a very long lens you can often make out climbers ascending the series of parallel cracks in the centre of the face, first climbed by Steger in 1929. The brooding and somewhat intimidating rock face suits a high contrast black and white scene, particularly in moody and atmospheric weather conditions.

To continue to the Vajolet Towers from Rifugio Gardeccia, take the large track 546/7 north for 40 minutes to reach Rifugios Preuss and Vajolet. Just past Rifugio Vajolet, turn left (west) onto path 542, signed towards the Torri del Vajolet and Rifugio Re Alberto (Gartlhütte). Follow the path, taking care on several scrambling sections protected by wire, to reach the rifugio and towers in 50 minutes. There are good views throughout the ascent and it is worth keeping your camera accessible.

Viewpoint 2 – Torri del Vajolet from Rifugio Re Alberto (Gartlhutte)

This is the classic viewpoint and looks directly up at the towers with Torre Delago on the left, Torre Stabeler in the centre and Torre Winkler to the right. The small triangular form of Torre Piaz sits just in front of Delago but can be hard to distinguish from this angle.

A small shallow pool often forms just behind Rifugio Re Alberto in late spring and early summer when the snow starts to melt. This creates a very effective foreground as it can be used to reflect the rifugio and towers, creating a perfect portrait-orientated composition. If the pool hasn't formed, it is worth moving further back to use the jagged rocks as a foreground instead.

4 TORRI DEL VAJOLET / VAJOLETTURM

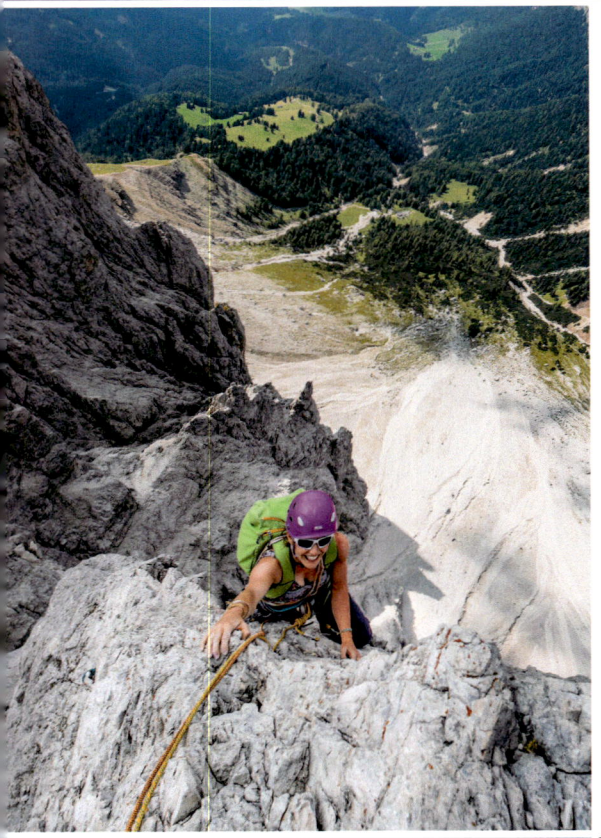

Viewpoint 3 – Torri del Vajolet from the West

Just above and west of the rifugio you will see a viewpoint ringed with stones, overlooking the west face of Torre Delago and the Passo Nigra below.

This perspective better demonstrates the precipitous nature of the towers as the ground plunges away. Using a wide-angle lens it is possible to capture the significant amount of air between the rock walls and valley floor below. Just take care near the edge which is loose in places.

This spot also serves as an excellent vantage point for night sky photography. Using an extreme wide-angle lens (14mm or wider on a full frame), you can place Polaris just left of the towers to create some well-composed startrails.

Viewpoint 4 – Climbers

During stable weather, the Torri del Vajolet are positively crawling with climbers in the summer months. Use a long lens to isolate parties, trying to keep the belayer in the shot as well. The arête of Torre Delago is the obvious choice as the climbers stand out well when framed against the sky. The gap between Torre Delago and Torre Stabeler is also worthy of note as you can capture alpinists as they abseil into the notch when descending from the towers.

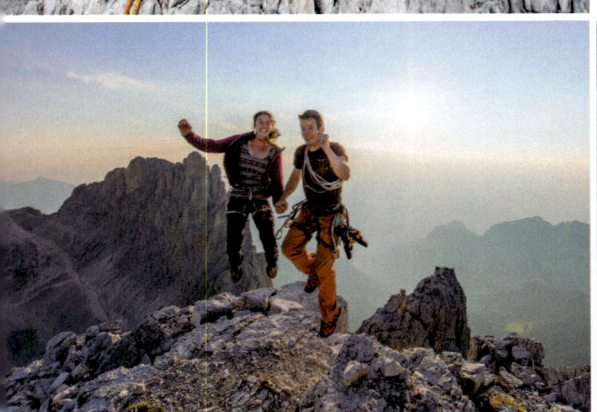

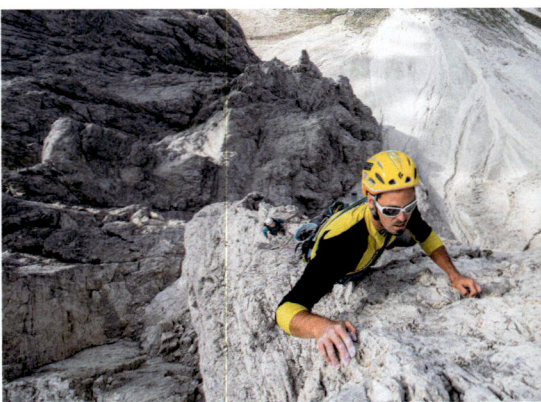

Top: Looking down the Piaz Arête/Delagokante. Nikon D810, 14–24mm at 14mm, ISO 100, 1/500s at f/8, Aug. **Above**: Jumping for joy on the summit of Torre Stabeler. Nikon D810, 14–24mm at 14mm, ISO 400, 1/800s at f/8, Aug.

On the exposed 3rd pitch of the Piaz Arête/Delagokante. Nikon D810, 14–24mm at 14mm, ISO 200, 1/500s at f/7.1, Aug.

Opposite: During spring snow melt-water often forms a beautiful pool outside Rifugio Re Alberto. © Enrico Grotto.

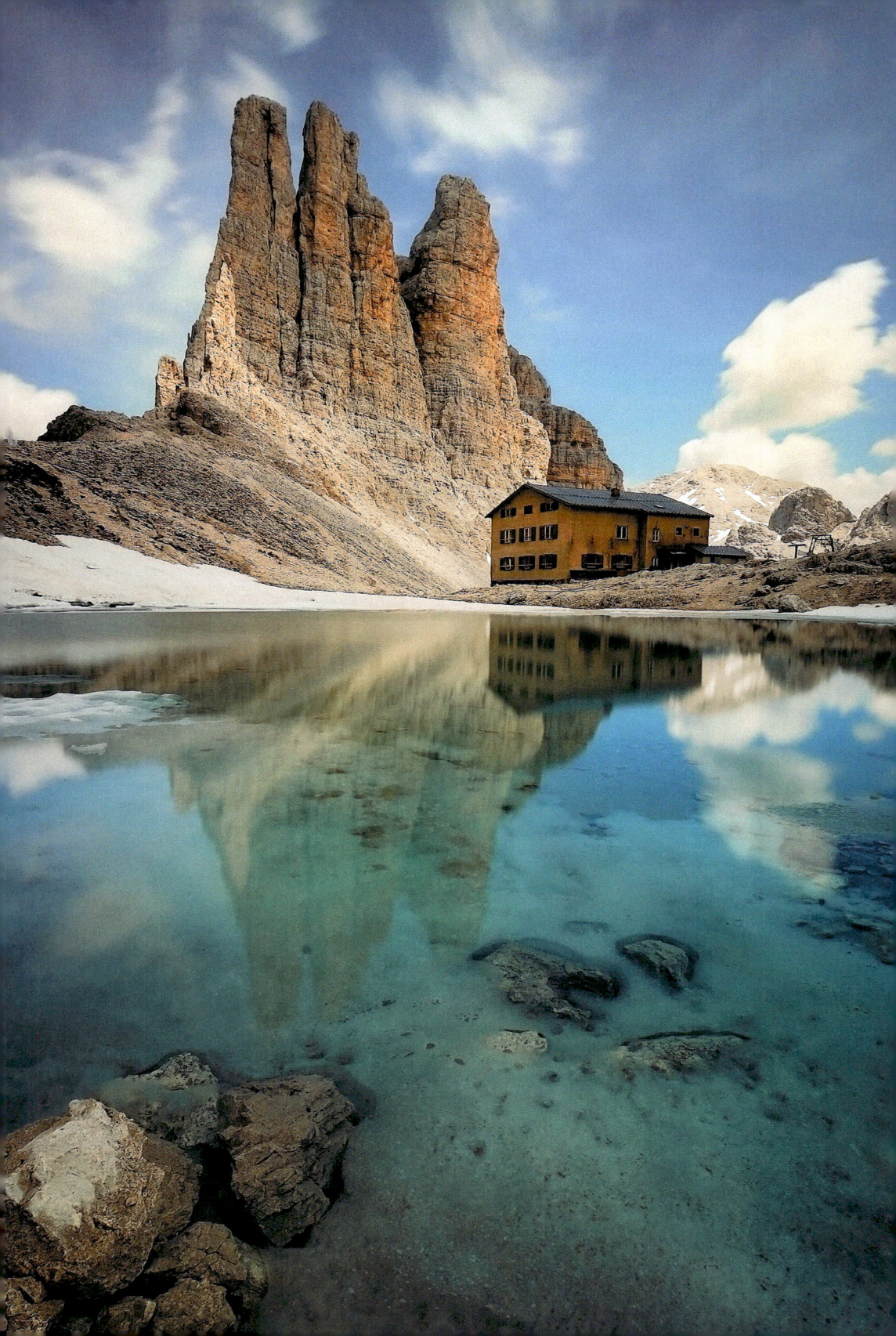

5 VAL DURON

The Val Duron is a beautiful and unspoilt alpine valley that carves its way between the Sassolungo and Catinaccio groups. Now declared as a Site of Community Importance, Special Area of Conservation and Special Protection Area, the broad valley remains a perfect example of traditional alpine culture. The green meadows which are still traditionally farmed are dotted with livestock and ancient buildings, creating some fantastic photo opportunities, especially during harvest.

During the summer months the valley can be easily accessed using a jeep taxi service that departs from the outskirts of Campitello and ascends to Rifugio Micheluzzi.

What to shoot and viewpoints

Viewpoint 1 – Rifugio Micheluzzi ♿
The valley immediately opens out at Rifugio Micheluzzi to offer a great view looking west towards the Dente di Terrarossa peaks at the head of the valley. The rifugio and outhouses are very photogenic and can be framed nicely by reversing the approach route slightly before walking 20m up the gravel track that overlooks the buildings. An out-and-back walk up the valley following path 532 west for 30 minutes past the rifugio is recommended.

Viewpoint 2 – Farmhouses & Fields ♿
As you ascend the valley you will notice a number of picturesque farm buildings, homes and farmhouses that can be used as a foreground to the Molignon mountains which dominate the view to the west. Alternatively, these make interesting subjects in their own right with a wealth of superb craftsmanship to be found. Farmers working the fields is a common sight and it's not unusual to see traditional farming methods still being practiced, especially during hay-making season.

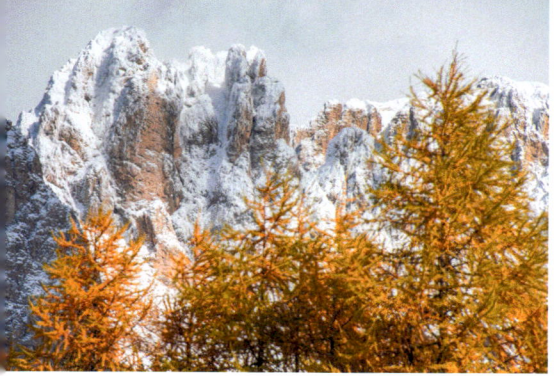

Opposite top: An Alsatian lounges on the porch of one of the farmsteads. Nikon D810, 28–300mm at 300mm, ISO 640, 1/320s at f/5.6, Oct. *Opposite*: A black redstart seeks sanctuary in some dry timber. Nikon D810, 28–300mm at 300mm, ISO 180, 1/320s at f/5.6, Oct.

Top: Traditional Tyrolean housing and architecture can be found throughout the valley. Nikon D810 28–300mm at 125mm, ISO 100, 1/250s at f/8, Oct.

Above: The first snow of the season clings to Sassolungo. Nikon D810, 28–300mm at 300mm, ISO 100, 1/400s at f/10, Oct.

How to get here

The Val Duron branches west from the Val di Fassa at Campitello. Situated just below Canazei, the village is easily accessed using the SS48 which runs the length of the valley. On entering Campitello, follow signs for the Val Duron/Rifugio Micheluzzi to reach a parking area at 1500m (the unsurfaced road beyond this point is closed to private vehicles). Several taxi shuttles serve Rifugio Micheluzzi from late June until early September.

Alternatively it is possible to walk up to Rifugio Micheluzzi, initially following the road and then branching off onto a well-signposted path that leads through the forest to reach the hut in one hour.

Lat/Long:	46.48203, 11.73733	
what3words:	///writers.saturdays.flaky	
Tabacco:	Map 06 (1:25.000)	
Kompass:	Map 59 (1:50.000)	

Accessibility

Approach: 3 minutes, 0.3km, 5m of ascent.

♿ **Disabled access**: The taxi service and large private track that lead up the valley offer excellent disabled access. However, some of the taxi vehicles are not suitable for wheelchairs so it can be worth ringing up to check beforehand.

Best time of year/day

The valley is most photogenic throughout the summer and is to be particularly recommended during the farming season.

The east – west aspect of the valley means an early start is advantageous if you wish to shoot looking up the valley. However, there are sufficient viewpoints to photograph throughout the day.

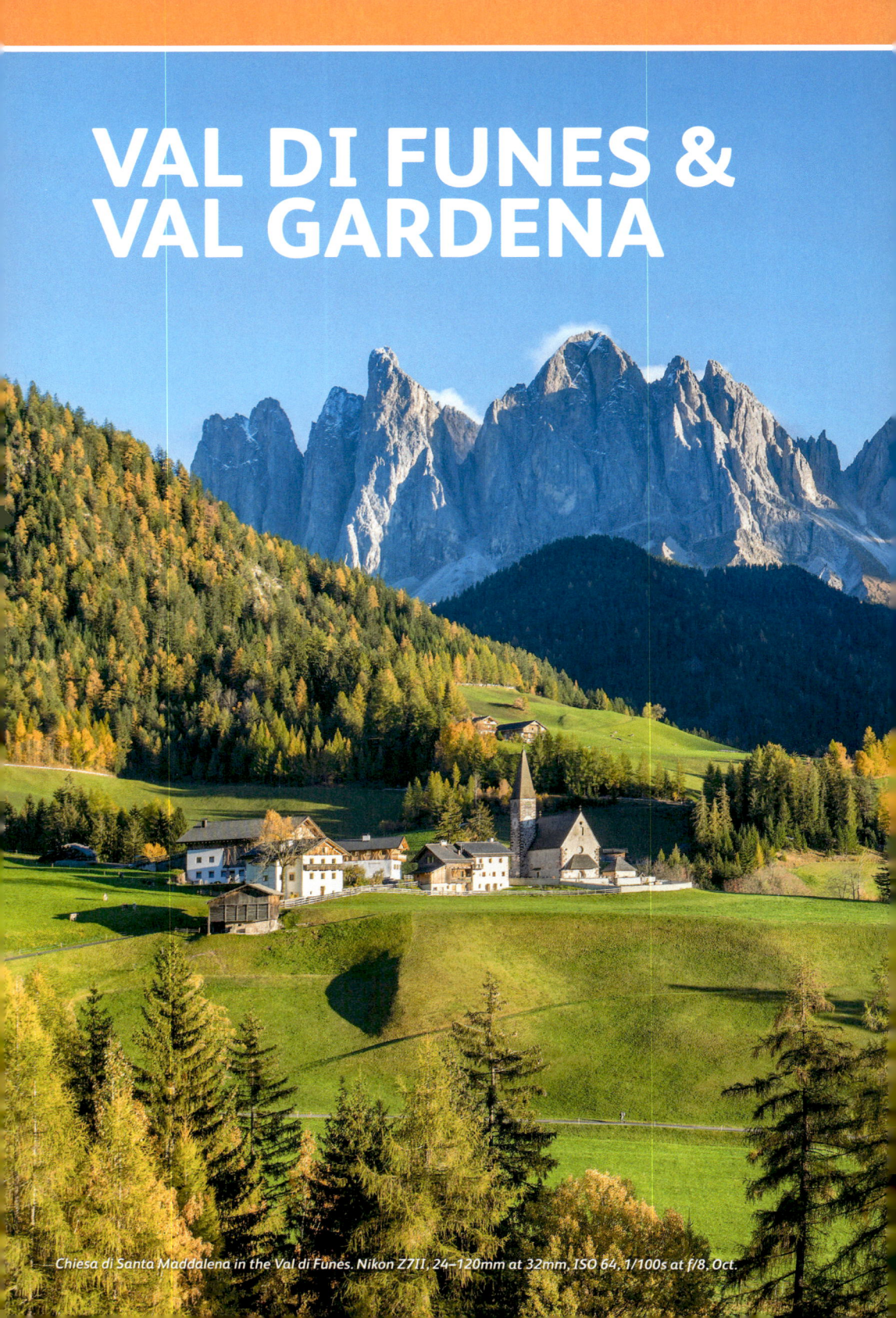

VAL DI FUNES & VAL GARDENA

Chiesa di Santa Maddalena in the Val di Funes. Nikon Z7II, 24–120mm at 32mm, ISO 64, 1/100s at f/8, Oct.

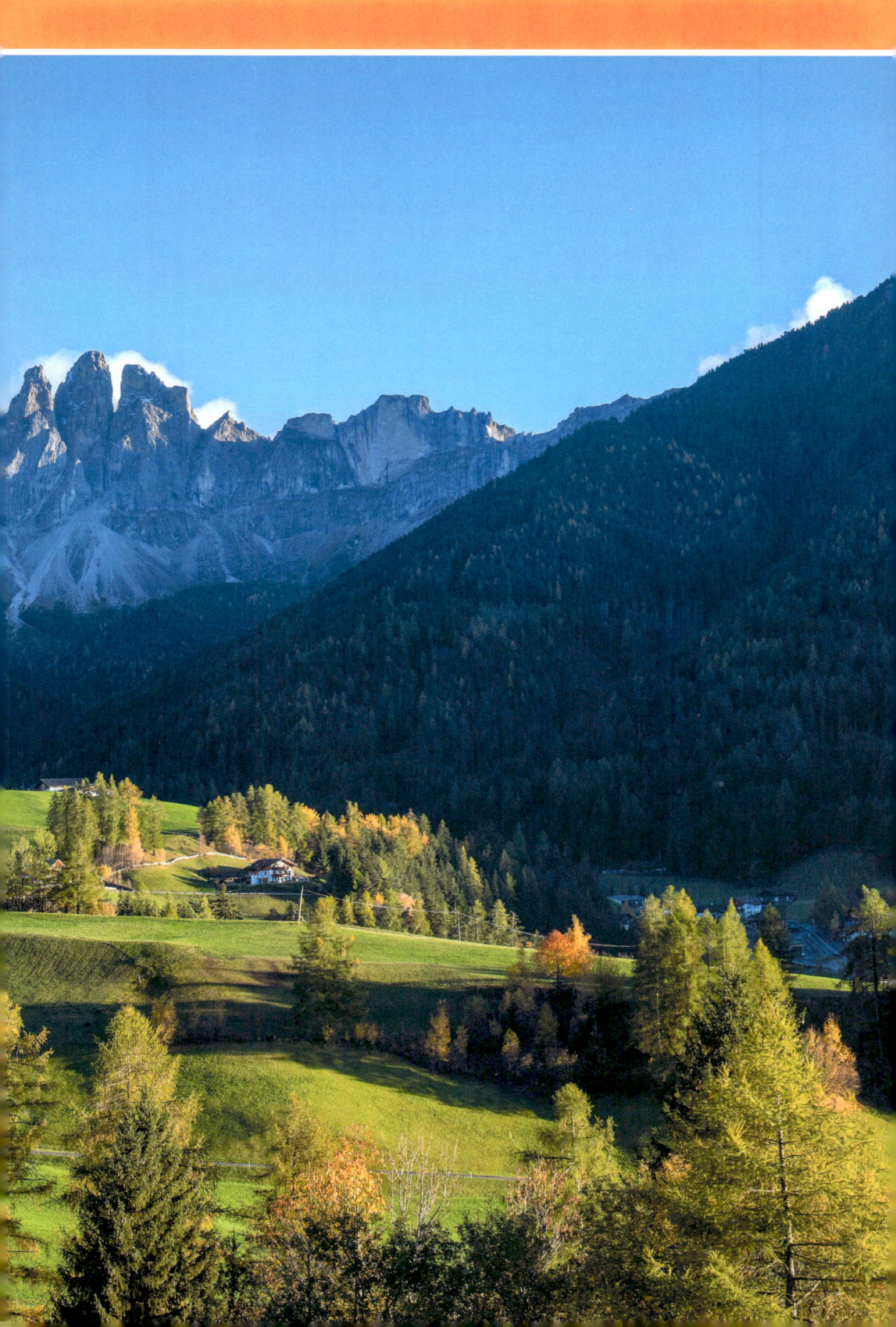

VAL DI FUNES & VAL GARDENA – INTRODUCTION

The Val di Funes and Val Gardena run parallel to one another from east to west, separated by the Puez / Geisler peaks and the adjoining uplands. Both valleys branch off the larger Valle Isarco, a region famous for its white wine; a favourable microclimate comprised of hot summer days and cool nights at vintage time ensures the grapes reach maturity with a high sugar content. The medieval town of Chiusa, dominated by the Benedictine nunnery 'Monastero di Sabiona' and a member of 'I borghi più belli d'Italia', a private association promoting the most beautiful villages in Italy, makes for a logical and worthwhile stop for anyone travelling between the two areas. Despite their close proximity, the two valleys display very diverse characteristics. The Val di Funes has a secluded and remote feel, with limited facilities but a rustic charm, while the hamlet of Santa Maddalena is famous among photographers as it offers several beautiful foregrounds to the spectacular north-west faces of Sass Rigais (3025m) and Furchetta (3025m), the two highest peaks of the Puez Odle.

By contrast, the Val Gardena is one of the principle valleys of the Dolomites and is well developed. Still considered the heartland of Ladin culture, the Val Gardena comprises three principal towns: Ortisei to the east, providing easy access to the city of Bolzano; Santa Cristina in the centre; finally Selva, the highest and most westerly of the towns, forming the junction between the Passo Sella and Passo Gardena. While much of the Val Gardena's economy is now dependent upon the tourism brought in by mountain sports, local craftsmen continue to uphold their long heritage of handicraft and woodwork.

The valley's wood carving industry has flourished since its beginnings in the 17th century, when religious statues and alters were shipped to Catholic churches all over the world. Later, the woodcarvers diversified their work to focus on toys and this became the principle occupation of many families in the valley throughout the 19th century, earning Ortisei the epithet of 'the capital of Toyland'.

Another characteristic unique to the region is the traditional outfits donned during local parades and important church festivities. One such example is the Almabtrieb festival held at the end of September, when herds of alpine cattle are paraded along the Vallunga valley into Selva. Adorned with garlands of flowers and enormous bells, this colourful, jangling procession provides an interesting and original opportunity to photograph traditional valley life.

To the north, the Val Gardena is dominated by the Odle/Geisler peaks, a jagged ribbon of summits that rise up from the very heart of the Puez-Odle Park.

Sassolungo as viewed from Baita Sanon on the Alpe di Siusi. Nikon D850, 24–70mm at 28mm, ISO 100, 1/200s at f/8. Jun.

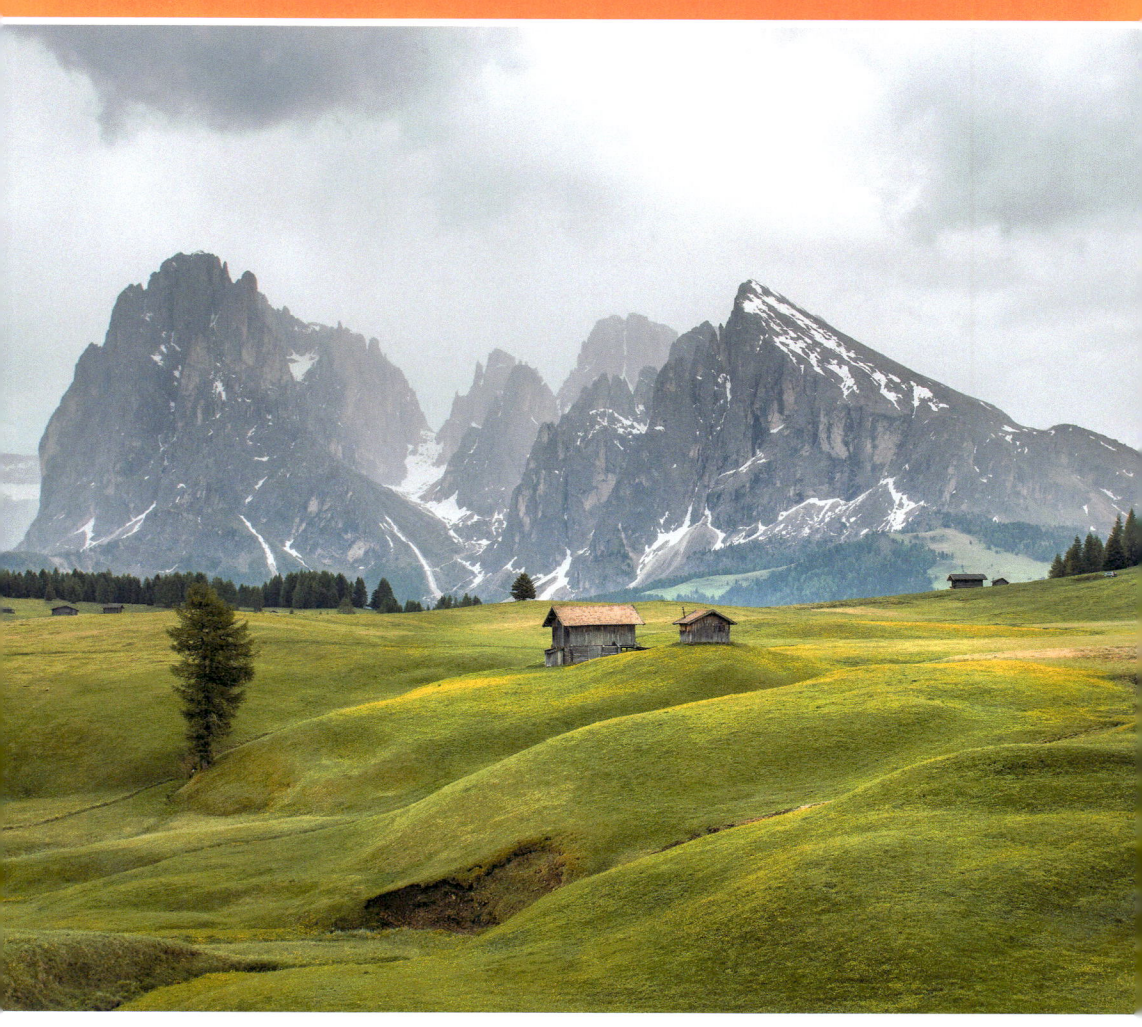

Forming the border ridge between the Gardena and Funes valleys, these can be accessed from Ortisei via the Seceda gondola and cable car that ascend to Rifugio Seceda (2456m) on the Alpe di Cisles plateau. Here, the ground plunges away for hundreds of metres to the Val di Funes below, presenting a photographic composition that looks like you're standing on the edge of the world.

On the opposite side of the valley to the south sits the Alpe di Siusi (Seiser Alm in German), the largest high alpine meadow in Europe. Easily accessible by cable car from Ortisei and scattered with a vast array of wooden huts, rustic rifugios and derelict shacks, this plateau makes for a stunning photo location. From May to July the gently undulating hills are illuminated with a vibrant display of alpine flowers, from tiny vanilla orchids to lady slippers found in the scattered woodland and stone-strewn slopes.

Hemmed in by the jagged peaks of the Sciliar and Sassolungo, the meadows are criss-crossed with easy walking paths and provide a lifetime's worth of photo opportunities in their own right. The Transhumance moving of the cattle from the meadows down to Castelrotto at the start of October is not to be missed.

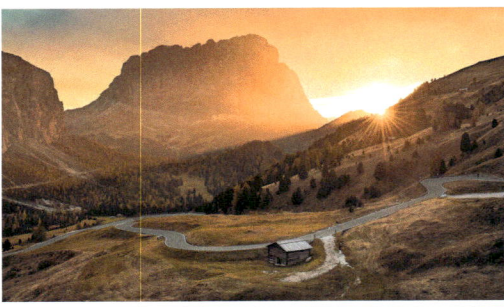

LOCATIONS

1	Chiusa / Klausen	150
2	Monastero di Sabiona / Säben Viewpoint	154
3	Santa Maddalena / Magdalena	158
4	Chiesetta di San Giovanni in Ranui / St. Johann	162
5	Chiesa di San Valentino / St. Valentino Kirche	166
6	Alpe di Siusi / Seiser Alm	172
7	Chiesa di San Giacomo / St. Jakobs Kirche	184
8	Puez Odle / Geisler – Seceda & Col Raiser	186
9	Passo Gardena Prato / Grödner Joch Wiese	192
10	Passo Gardena / Grödner Joch	194

Maps
- Tabacco (Italian): Map 05, 30
- Kompass (German): Map 56, 76, 627

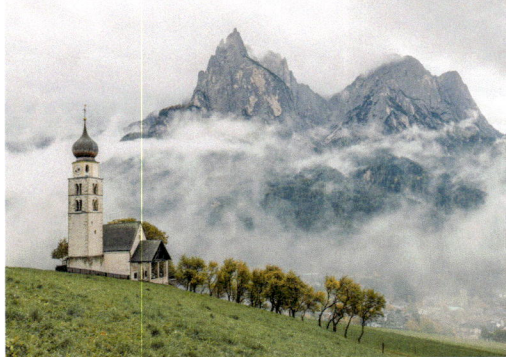

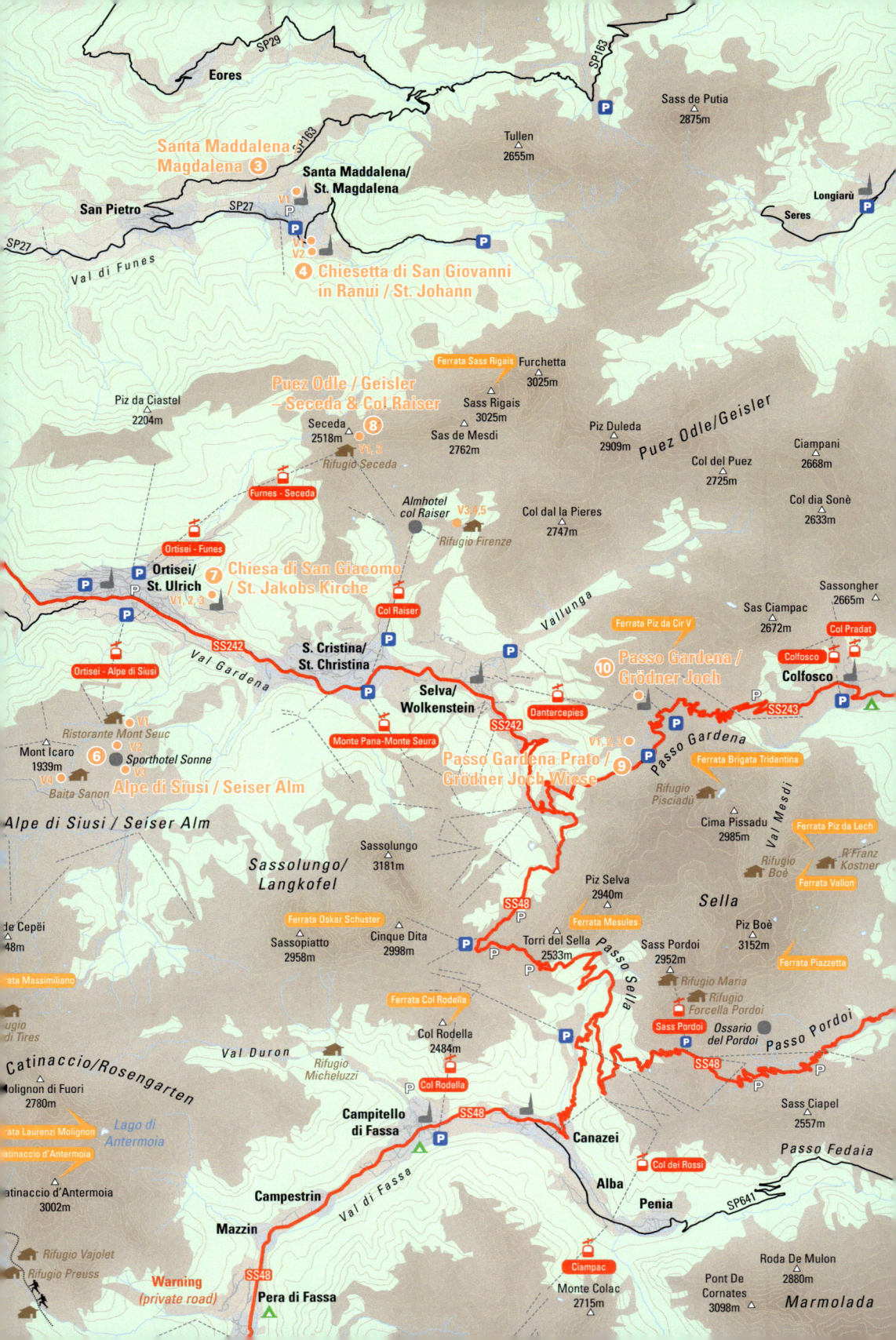

1 CHIUSA / KLAUSEN

Surrounded by beautiful terraces, vineyards and chestnut forests, the medieval city of Chiusa sits in the heart of the Val Isarco. Often referred to as the 'City of Artists', the region became synonymous with art and literature during the late 19th century when the rustic surroundings, old stone walls and artistic heritage drew some 300 painters to the town. During this period the Klausner Art Colony flourished, represented by influential figures such as Alexander Koester and transforming the streets of Chiusa into open-air workshops. The town continues to inspire and recently became the setting for Andreas Maier's fictional crime novel 'Klausen'. The Benedictine monastery of Sabiona sits above the town and is the principle destination of an ancient Ladin pilgrimage which takes place each June.

What to shoot and viewpoints

Viewpoint 1 – Town Centre / Collina dei Frati ♿

The town centre is full of quaint cobbled streets, faded pub signs and artisan shops that all make for excellent photo opportunities. For a good bird's eye view of the buildings, a walk up to the viewpoint on Collina dei Frati (Friars' Hill) is highly recommended. To access the viewpoint, from the Museo Civico Chiusa located on the south-west side of town follow the signs for 'Punto panoramico'. The steps are steep and are unsuitable for those with limited mobility.

Above: A panorama of Chiusa as seen from Collina dei Frati. Nikon Z7II, 24–120mm at 24mm, ISO 100, 1/160s at f/10, Oct.

Right: The high street is exceptionally photogenic when quiet. Nikon Z7II, 24–120mm at 30mm, ISO 64, 1/200s at f/8, Apr.

How to get here

Chiusa is located between Bressanone and Bolzano in the centre of the Val Isarco and can be easily accessed from the A22 motorway; the town is well signposted and has its own junction. There are several large car parks on the outskirts of the town which are regulated by parking attendants during peak season.

	Lat/Long:	46.642074, 11.569131
	what3words:	///grades.relives.staffers
	Tabacco:	Map 30 (1:25.000)
	Kompass:	Map 56 (1:50.000)

Accessibility

Approach: From the large car parks on the north-east side of town, the centre can be accessed via a short scenic walk along the banks of the river Eisack.

 Disabled access: Disabled access throughout the town is good and the car parks offer a number of designated disabled parking bays. Due to the steps, access to the monastery is unfortunately rather limited.

Best time of year/day

As one might expect, the medieval environment of Chiusa is home to enough nooks, crannies and artistic potential to offer a range of photogenic opportunities throughout the year. Even in bad weather, the cobbled streets provide a suitably atmospheric environment for some moody monochrome landscapes.

However, the town quite literally shines during the summer when the flower boxes are resplendent with vibrant colours, and really comes into its own on bright autumnal days. Towards the end of October, the many terraced vineyards surrounding the town and monastery turn a fantastic sunshine yellow, creating a wonderful display of colour when set against a blue sky.

Although the area's prestige can lead to crowds in high summer, particularly during Ferragosto in mid August, these quickly abate come September when the town returns to peace and tranquillity.

Thanks to the south-facing aspect, both Chiusa and the monastery are well lit throughout the day, although the surrounding mountains cast the town into shadow at dawn and dusk.

1 CHIUSA / KLAUSEN

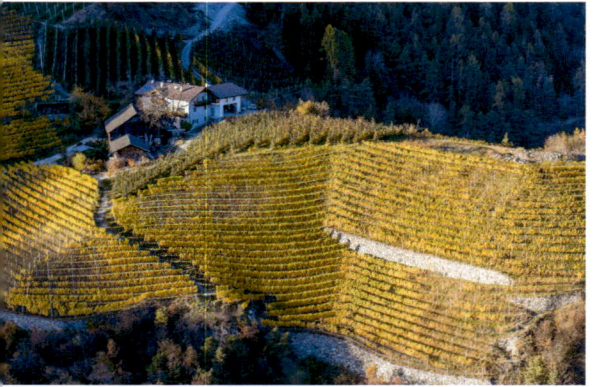

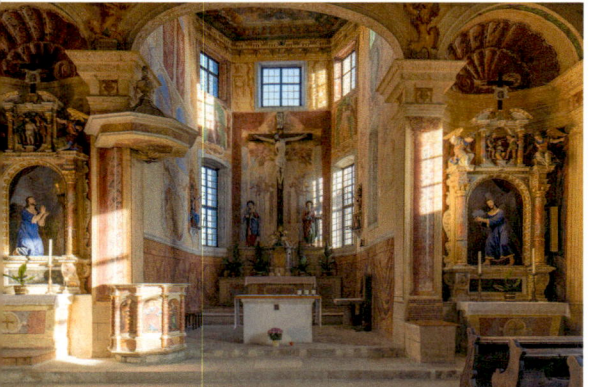

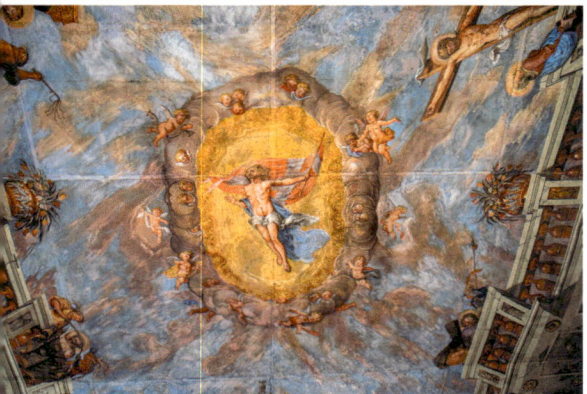

Viewpoint 2 – Monastero di Sabiona

No trip to Chiusa would be complete without taking the 30 minute walk up the Säbner staircase to Monastero di Sabiona. The walk departs from the town centre and is well signposted towards 'Kloster Säben / Convento Sabiona', leading past the fourteen stations of the cross. While some parts of the monastery are closed to the public (the site still operates as a working nunnery), it is possible to access Chiesa di Nostra Signora, Chiesa del Convento and Chiesa della Santa Croce.

The views from the top are superb and it is well worth taking the time to study the elaborate architecture of the three churches adjoined to the monastery.

Opposite: The start of the Säbner staircase that leads past the Stations of the Cross to Monastero di Sabiona. Nikon Z7II, 24–120mm at 35mm, ISO 64, 1/50s at f/8, Sep.

Top: Terraced vineyards displaying their autumn colours. Nikon Z7II, 24–120mm at 70mm, ISO 100, 1/160s at f/6.3, Oct.

Middle: The interior of Chiesa della Santa Croce at Monastero di Sabiona. Nikon D810, 24–70mm at 24mm, ISO 100, 1/100s at f/5.

Bottom: The beautiful murals found on the ceiling of Chiesa della Santa Croce. Nikon D810, 24–70mm at 24mm, ISO 160, 1/25s at f/2.8.

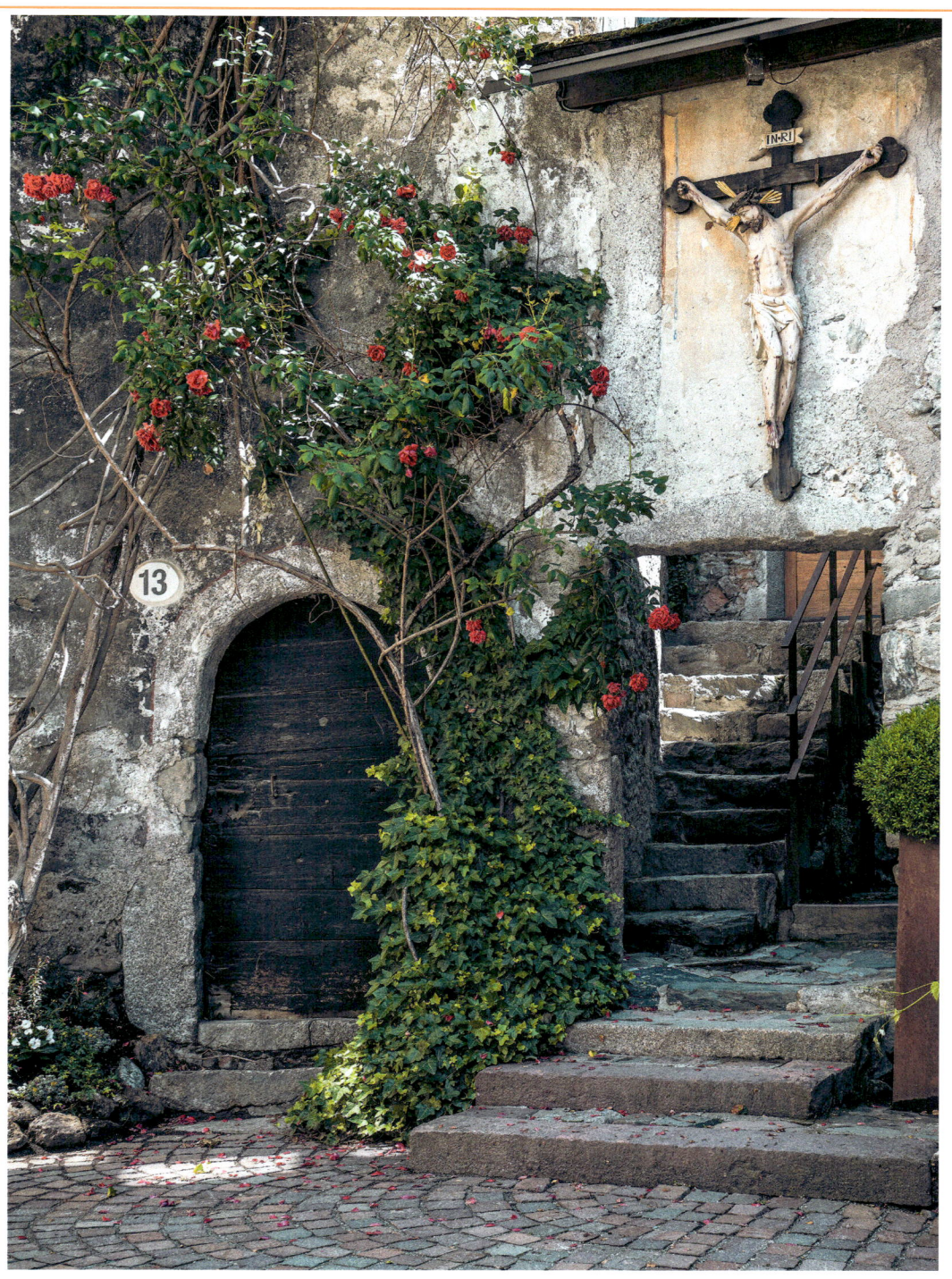

MONASTERO DI SABIONA / SÄBEN VIEWPOINT

Situated atop the 'holy mountain', the Benedictine monastery of Sabiona is one of the South Tyrol's most important spiritual sites and the emblem of the Val Isarco. First settled during the Neolithic Age, the mountain was later occupied by the Romans and was a bishopric seat between the 6th and 10th centuries. The stone building was constructed in its current form during the 14th and 15th centuries as a fortress and later supported a community of Benedictine nuns established by a local priest in 1686. The site sustained significant damages and was heavily looted during the Napoleonic wars before being stripped of its assets in the early 19th century. The nunnery began to flourish again towards the turn of the century following significant investment, yet it wasn't until 1974 that the abbey was formally accepted into the Beuronese Congregation of the Benedictine Confederation.

The best place to view the monastery is from the tiny hamlet of Lusenegg on the south side of the valley. Situated at the same height as Monastero di Sabiona itself, the location provides the perfect vantage point from which to capture this little piece of history. The road access can be difficult to navigate but the resulting views out over Chiusa and the surrounding terraces are well worth the effort.

What to shoot and viewpoints

Viewpoint 1 – Monastero di Sabiona ♿
From the parking area, the monastery can clearly be seen to the north. If you wish to isolate just the monastery and grounds you will need a long telephoto lens. Try to include the steep cliffs below to give a sense of scale. With a standard zoom you can capture a wider landscape, although it can be difficult to create a pleasing composition because of the trees surrounding Lusenegg and the parking area. From the high vantage point and equipped with a suitably long lens, you can also capture some cultural details in the surrounding fields and terraces: labourers at work, agricultural vehicles, chestnut forests, hamlets and farm buildings all create interesting subjects. The paths weaving between the vineyards also offer the potential for some excellent symmetry if you are able to isolate them with a telephoto lens.

Viewpoint 2 – Ansitz Lusenegg ♿
The parking area lies adjacent to the 13th century noble house of Ansitz Lusenegg, which proves an interesting photographic subject in its own right. Featuring a stone curtain wall and a crenellated gable, the mansion has a defiant feel akin to a small castle. The house is open year round and boasts a highly decorative interior that is well worth taking the time to explore. The wood panelled room is of particular photographic interest.

How to get here
From Chiusa, take the SS242 south for 1.5km, passing through a tunnel. Continue beyond the tunnel for a further 500m to reach a sharp turn left signposted towards Lusenegg. The turning is small and easy to miss so keep an eye out. Turn left and ascend the road for 1km to reach the easily recognisable 13th century manor of Ansitz Lusenegg on the right. Park in a small lay-by just beyond the building on the right.

🅿 **Lat/Long**:	46.63396, 11.56961	
🅿 **what3words**:	///manifested.anteater.dismissive	
🅿 **Tabacco**:	Map 30 (1:25.000)	
🅿 **Kompass**:	Map 56 (1:50.000)	

Accessibility
Approach: Roadside access.

♿ **Disabled access**: Excellent; the classic shot of Monastero di Sabiona can be taken from the car window if required.

Best time of year/day
As with Chiusa, the surrounding vineyards look their best in summer and autumn. Late October is particularly photogenic as the vines begin to turn a vibrant yellow colour. If you manage to capture the transformation early enough, you often get a lovely transition gradient throughout the fields as the vines turn from green to gold.

Fresh snowfall offers a range of new photographic opportunities, creating a fairytale winter scene. However, the steep approach road becomes difficult to negotiate with a vehicle and it may be necessary to walk up on foot.

The light on Monastero di Sabiona is most dramatic during late morning and early afternoon when both the east and south-facing walls of the monastery are well lit.

Ansitz Lusenegg is open year round to visitors.

Above: Autumnal colours surround Monastero di Sabiona. Nikon D810, 80–400mm at 320mm, ISO 100, 1/320s at f/9, Nov.
Below: A small track weaves between terraces and forest. Nikon D810, 80–400mm at 300mm, ISO 100, 1/320s at f/6.3, Nov.

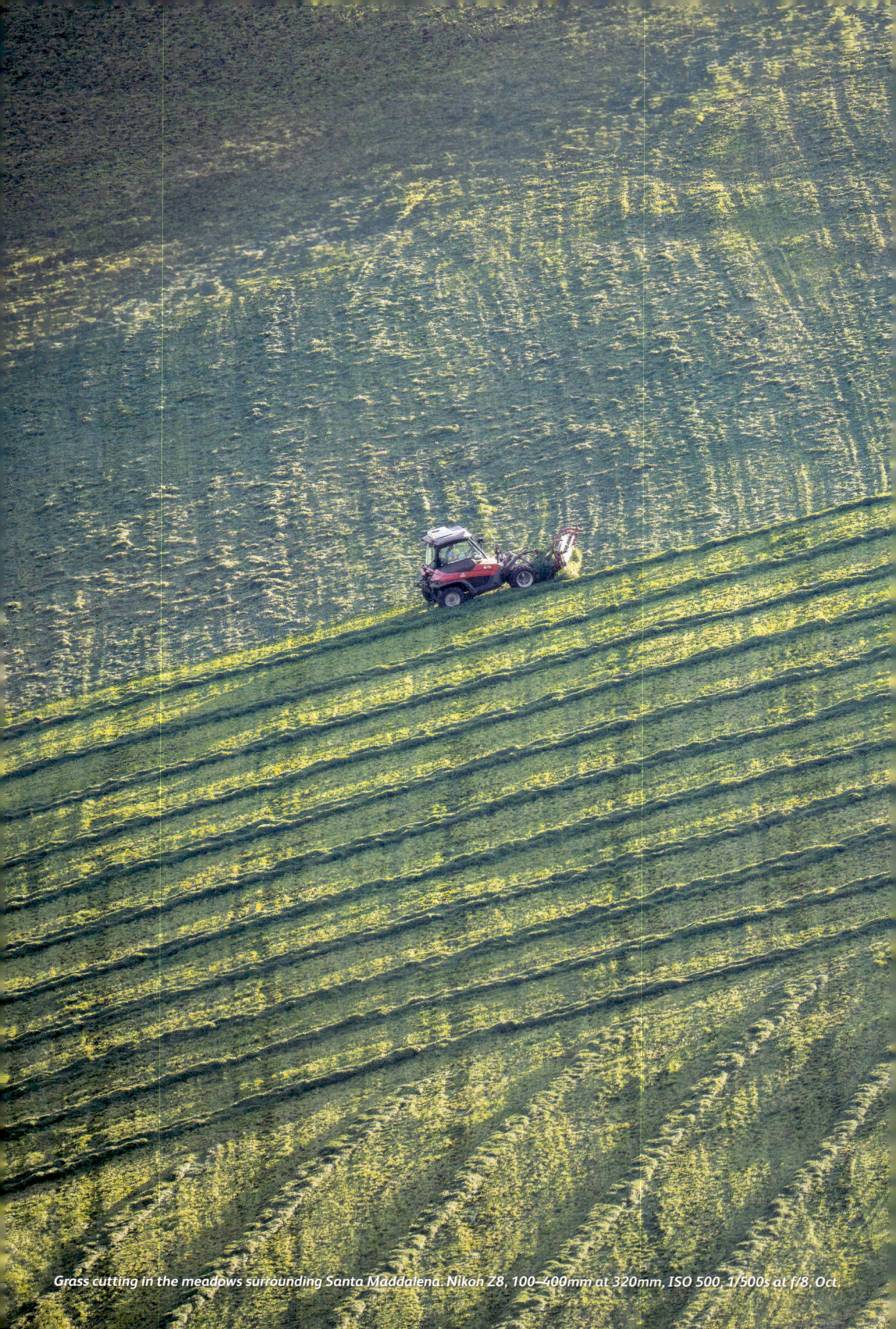
Grass cutting in the meadows surrounding Santa Maddalena. Nikon Z8, 100–400mm at 320mm, ISO 500, 1/500s at f/8, Oct.

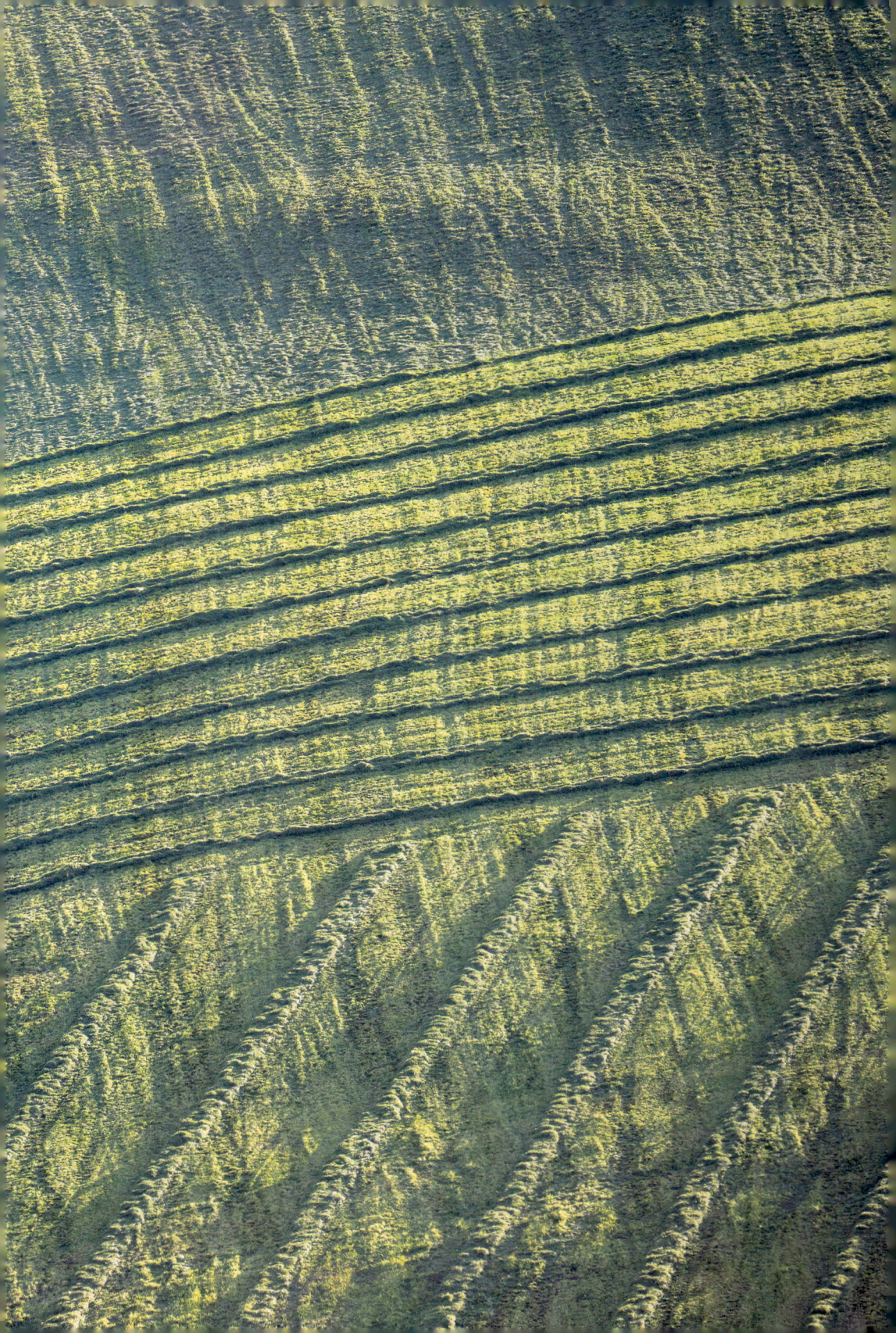

3. SANTA MADDALENA / MAGDALENA

The classic view of Chiesa di Santa Maddalena surrounded by traditional farmsteads, rolling meadows and woodland against the backdrop of the dramatic north-west faces of the Odle / Geisler peaks is one of the most iconic and frequented views in the Dolomites. Due to the locations popularity the approaching road is now access only and visitors are required to walk up on foot from the outskirts of Santa Maddalena. Please be respectful of the local residents in this politically sensitive area.

What to shoot and viewpoints

From the parking area, head north on the Kirchweg following good signposting towards the church. Follow the signposts right just before reaching Hotel Tyrol Dolomites Slow Living, and ascend the now steeping track up past the Fallerhof farmhouse to reach the church in 10 minutes of uphill walking. Continue on the road past the church (public toilets on the left), descending and then traversing around the opposite hillside with excellent views back towards the church.

Viewpoint 1 – Chiesa di Santa Maddalena ♿

Looking back to the south-east, you now get an excellent view of Chiesa di Santa Maddalena backed by the Odle group. A variety of focal lengths work well here, depending on how much of the foreground and surrounding scenery you wish to capture. There is no best vantage-point and it is worth exploring higher up the road, where there are several trees that provide excellent foregrounds.

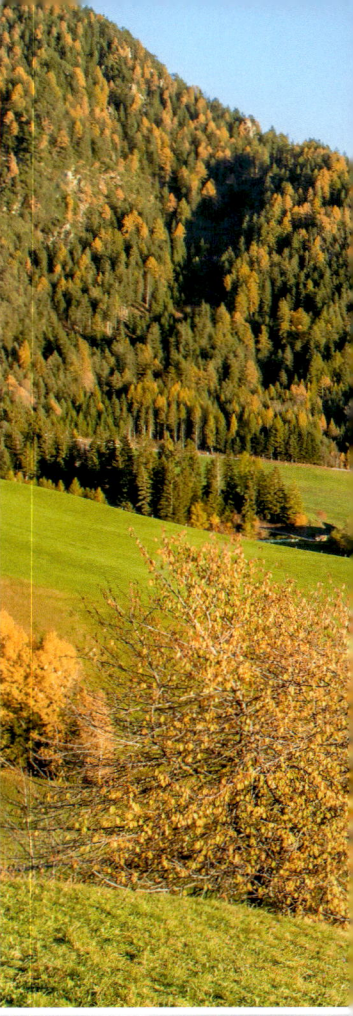

Santa Maddalena backdropped by the Odle. **Right**: *Nikon Z7II, 24–120 at 24mm, ISO 64, 1/60s at f/9, Oct.* **Below**: *Nikon D810, 24–70mm at 38mm, ISO 100, 1/320s at f/8, Nov.*

How to get here

The Val di Funes is usually approached from the A22, exiting the motorway at Chiusa. Turn left, following signs north-east towards Bressanone/Brixen for 2km before turning right into the well-marked Val di Funes. Drive up the SP163 as it ascends the valley for 11km to reach the village of Santa Maddalena. Turn left into the village and immediately right, with roadside parking to either side of the Kirchweg.

Please do not try and drive up to the church. This is a private and access only road with a barrier.

Alternatively, it is possible to approach the Val di Funes from the Val Badia via the Passo delle Erbe. This is a particularly scenic drive and is recommended for anyone approaching from the Alta Badia or Val Pusteria.

P Lat/Long:	46.640513, 11.716619	
P what3words:	///gymnastic.aliases.monsoons	
P Tabacco:	Map 30 (1:25.000)	
P Kompass:	Map 627 (1:25.000)	

Accessibility

Approach: 20 minutes, 2km, 50m of ascent.

♿ **Disabled access**: For disabled access it is best following the Magdalenaweg in its entirety, staying on the surfaced road which is closed to all but local traffic.

Best time of year/day

While Chiesa di Santa Maddalena is superbly photogenic at any time of year, it arguably looks best during spring when the flower meadows come into bloom, and autumn when the larches and surrounding deciduous trees change colour. The shoulder seasons are also quieter at this now very popular location.

Beware of the annual Speckfest event (yes, there really is a festival about bacon) that sometimes takes place right in front of the church during early October.

The north-westerly aspect of the Odle peaks and the church makes the setting a perfect late afternoon and sunset location.

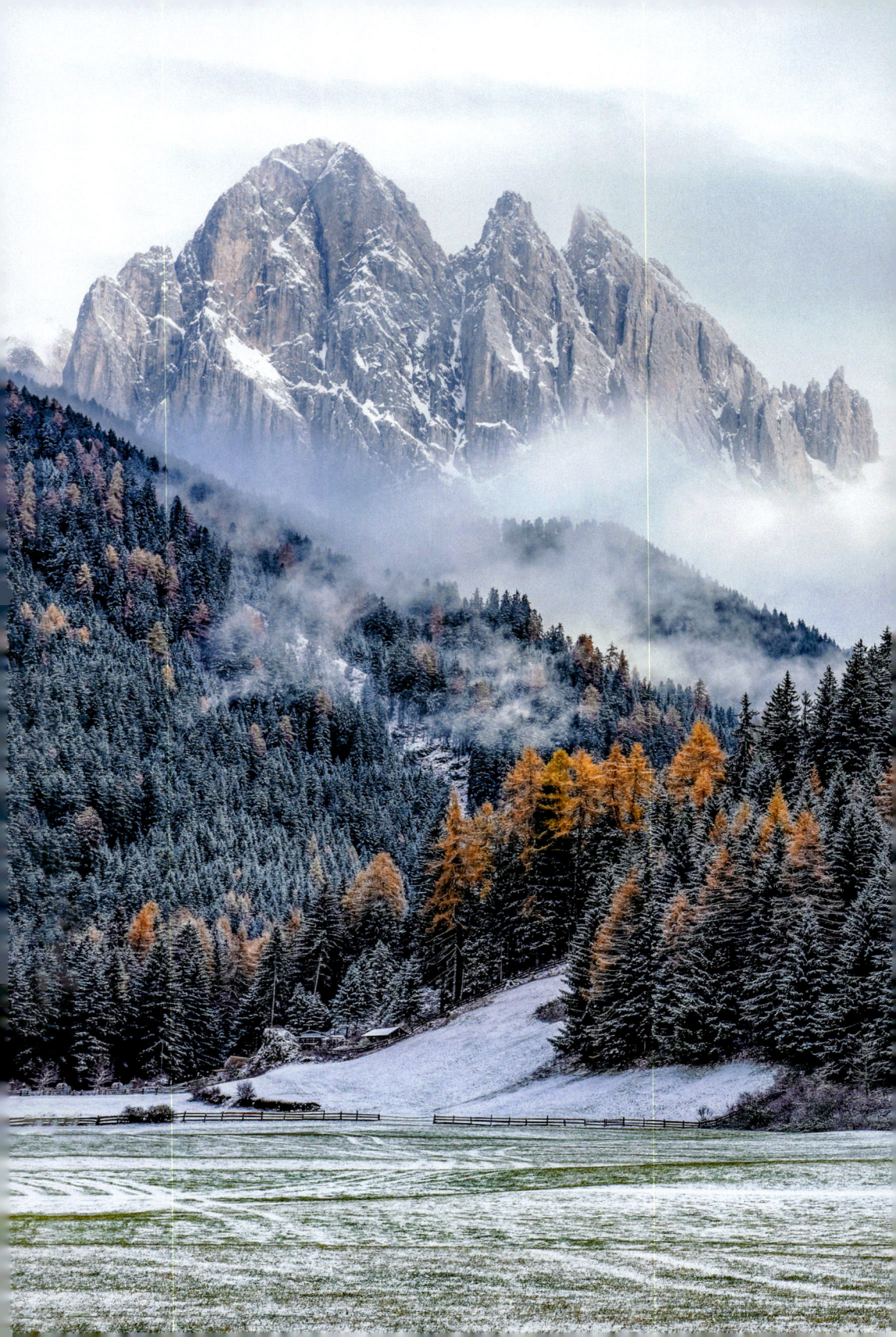

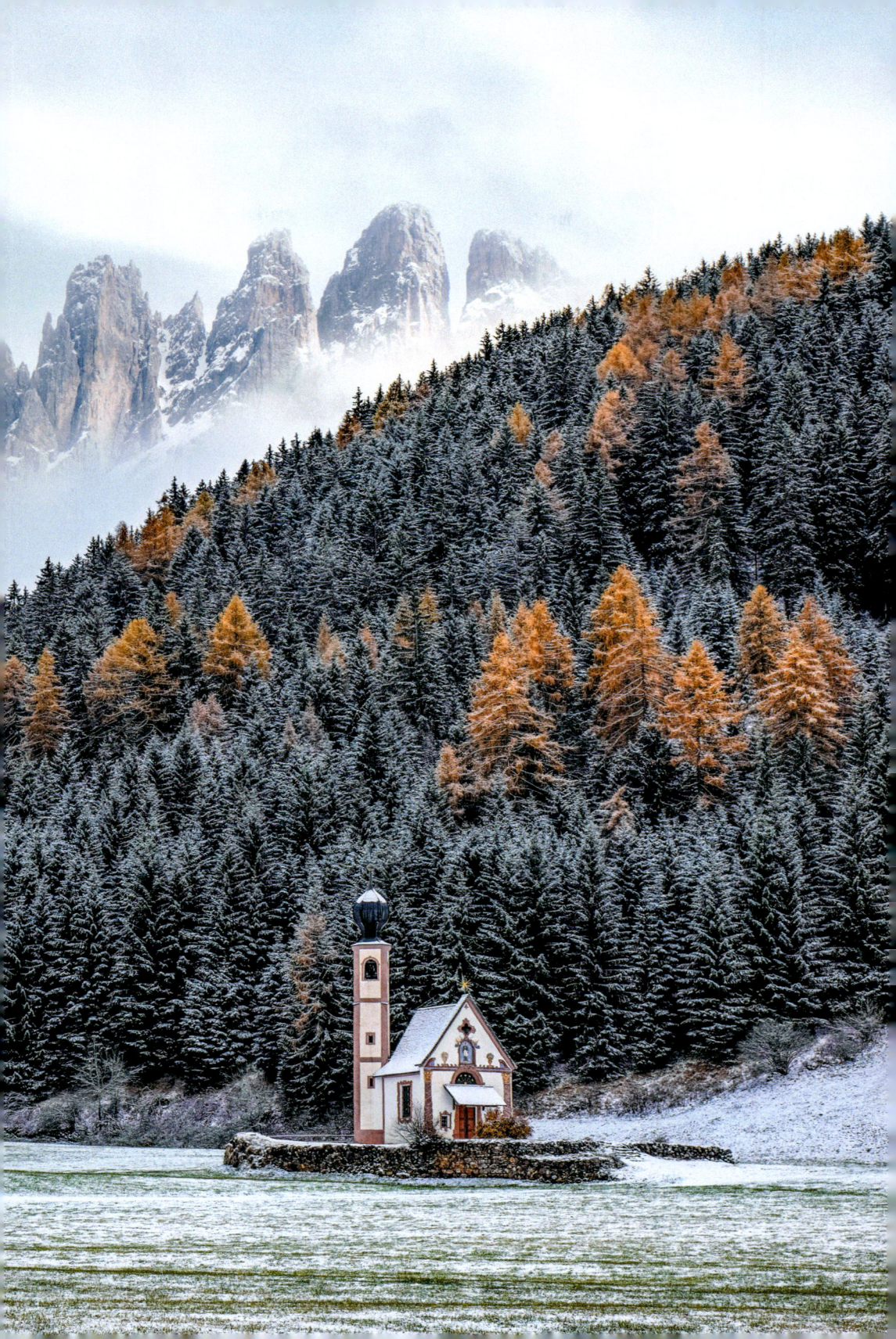

4 CHIESETTA DI SAN GIOVANNI IN RANUI / ST. JOHANN

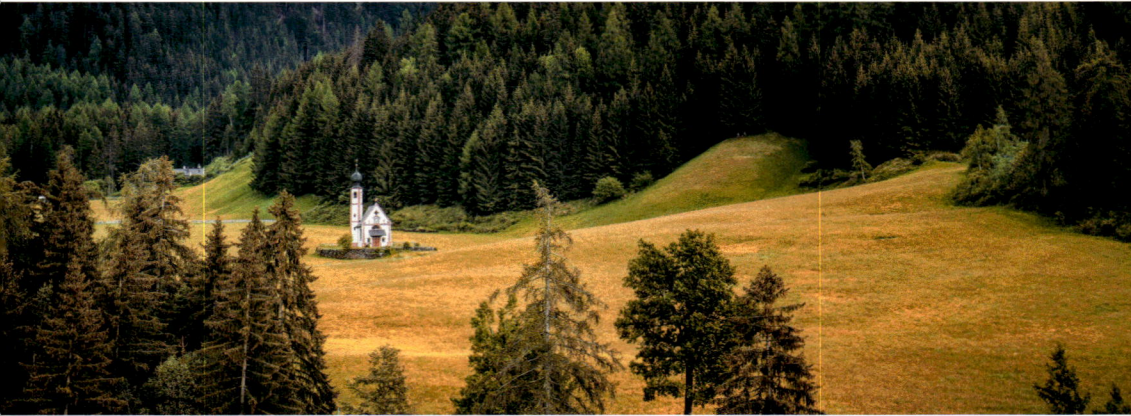

Chiesetta di San Giovanni in Ranui. © Julien Riedel.

Despite its modest proportions, the small onion-domed chapel of San Giovanni is perfectly formed and enjoys a spectacular setting beneath the Odle group. Commissioned in 1744 by mine owner Michael von Jenner and built in the Baroque style, this small church has become an iconic symbol of the Val di Funes.

What to shoot and viewpoints

Viewpoint 1 – San Giovanni from the Viewpoint

From the parking area walk up Via San Giovanni to reach the obvious wooden viewing platform. Please don't cross the wooden fence as the land is privately owned.

Viewpoint 2 – San Giovanni from up Close ♿

From the viewing platform, follow the road uphill to reach a signposted path leading past a farmhouse and through the field to the chapel itself. There is an entrance fee through a paid turnstile. The stone steps present some aesthetic leading lines to the front of the building which is decorated with numerous frescos.

Previous spread: The morning mist clears. Nikon D810, 24–70mm at 58mm, ISO 100, 1/640s at f/8, Nov.

How to get here

The Val di Funes is usually approached from the A22, exiting the motorway at Chiusa. Turn left, following signs north-east towards Bressanone/Brixen for 2km before turning right into the well-marked Val di Funes. Drive along the SP163 as it ascends the valley for 11km to reach the village of Santa Maddalena. Continue past the village for 750m to reach a bus turning circle and carpark just before the right turn onto Via San Giovanni. Park in the pay and display parking area. Please do not drive up Via San Giovanni.

- **Lat/Long**: 46.636978, 11.720794
- **what3words**: ///acquire.flatland.fishing
- **Tabacco**: Map 30 (1:25.000)
- **Kompass**: Map 627 (1:25.000)

Accessibility

Approach: The viewing platform is situated 20m above the parking area, whilst a short 5 minute walk leads to the chapel.

♿ **Disabled access**: Unfortunately the high fence prevents easy viewing from the platform for wheelchair users. However the chapel can be viewed up close.

Best time of year/day

As with Chiesa di Santa Maddalena, the church is best shot during spring and autumn.

The light is best during late afternoon and early evening when the sun sets on the north-west faces of the Odle group.

Opposite: Afternoon and evening light is perfect during the summer. © Daniel Seßler.

Next spread: Hiking up past Malga Zannes in the Val di Funes during winter. © Daniel Seßler.

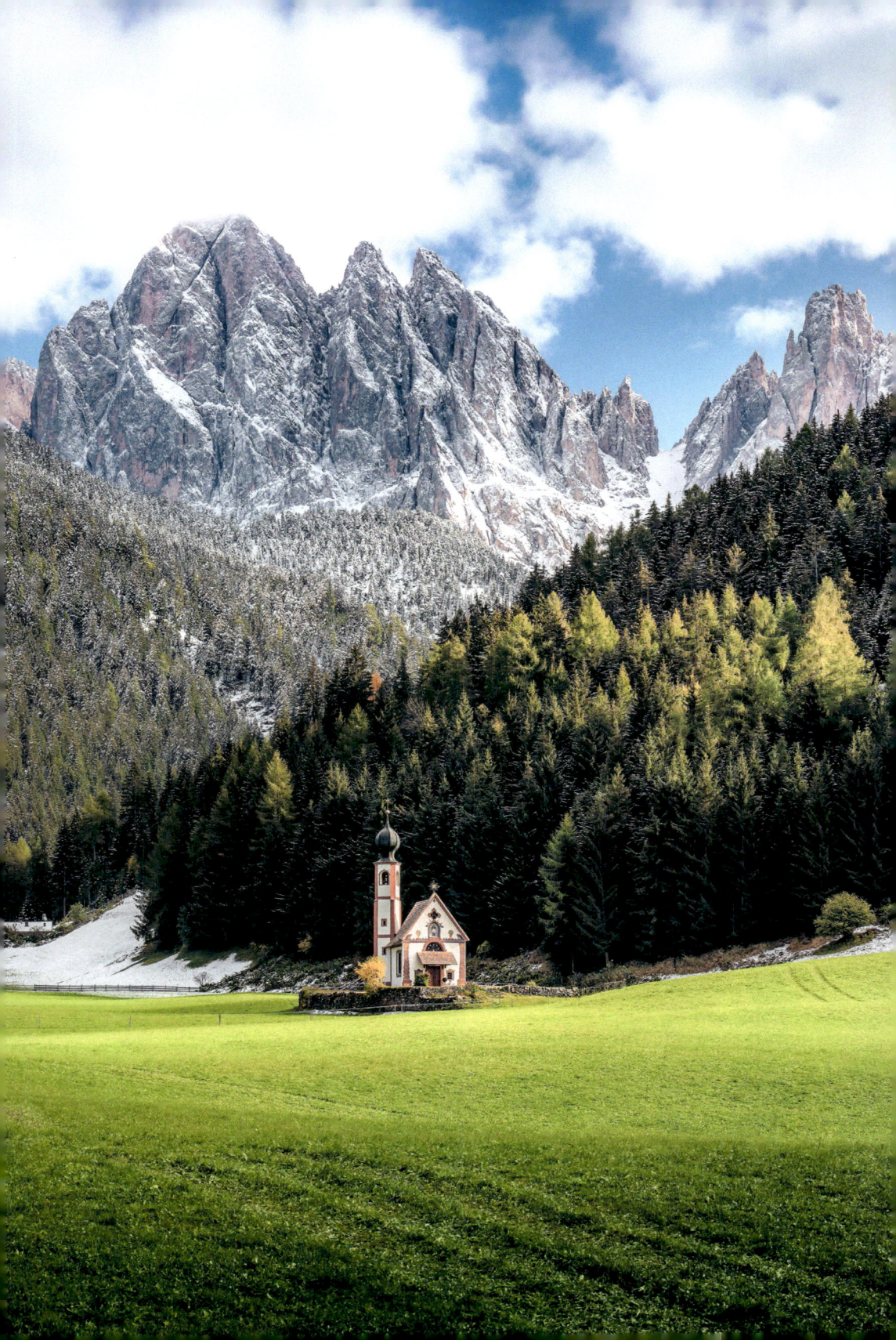

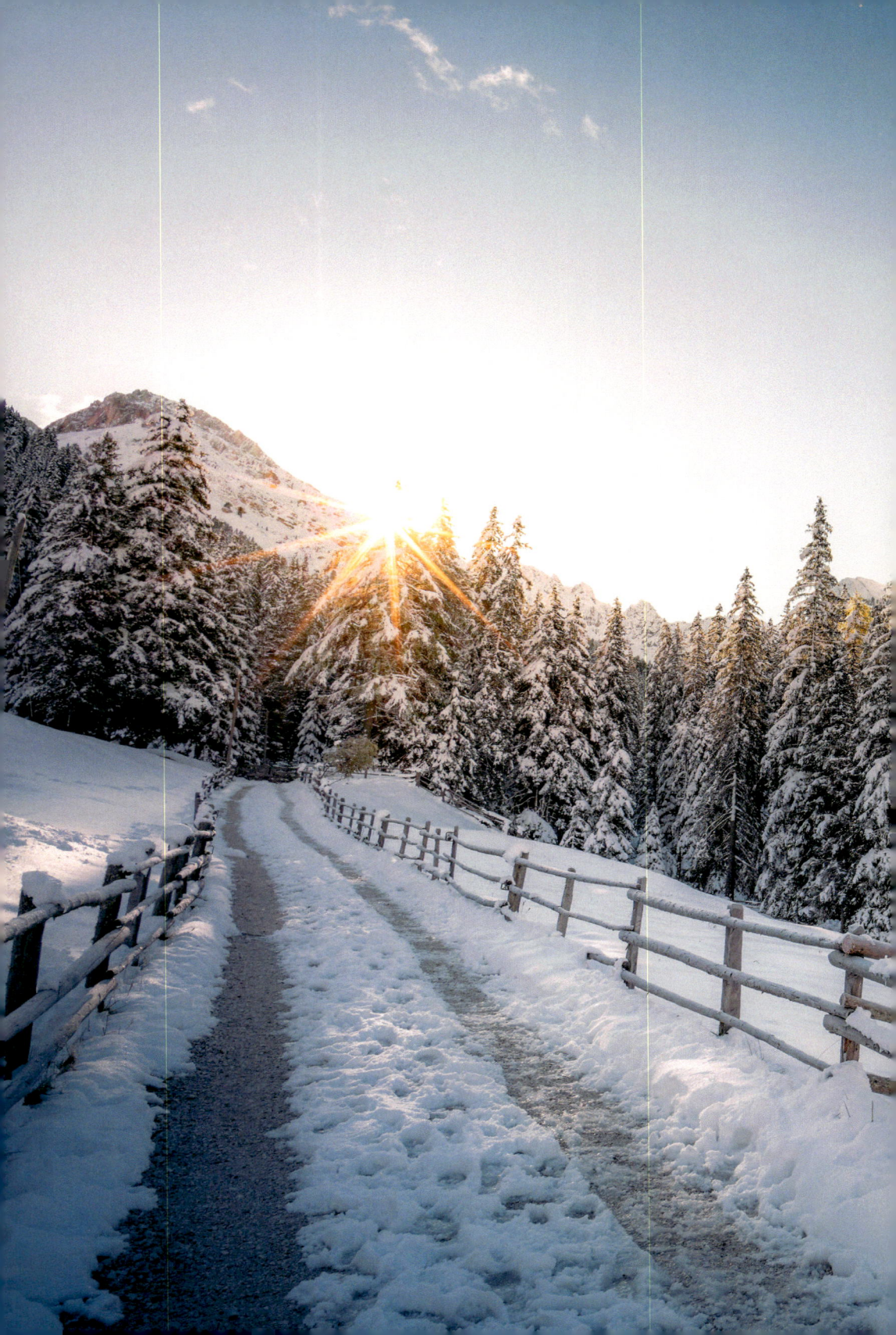

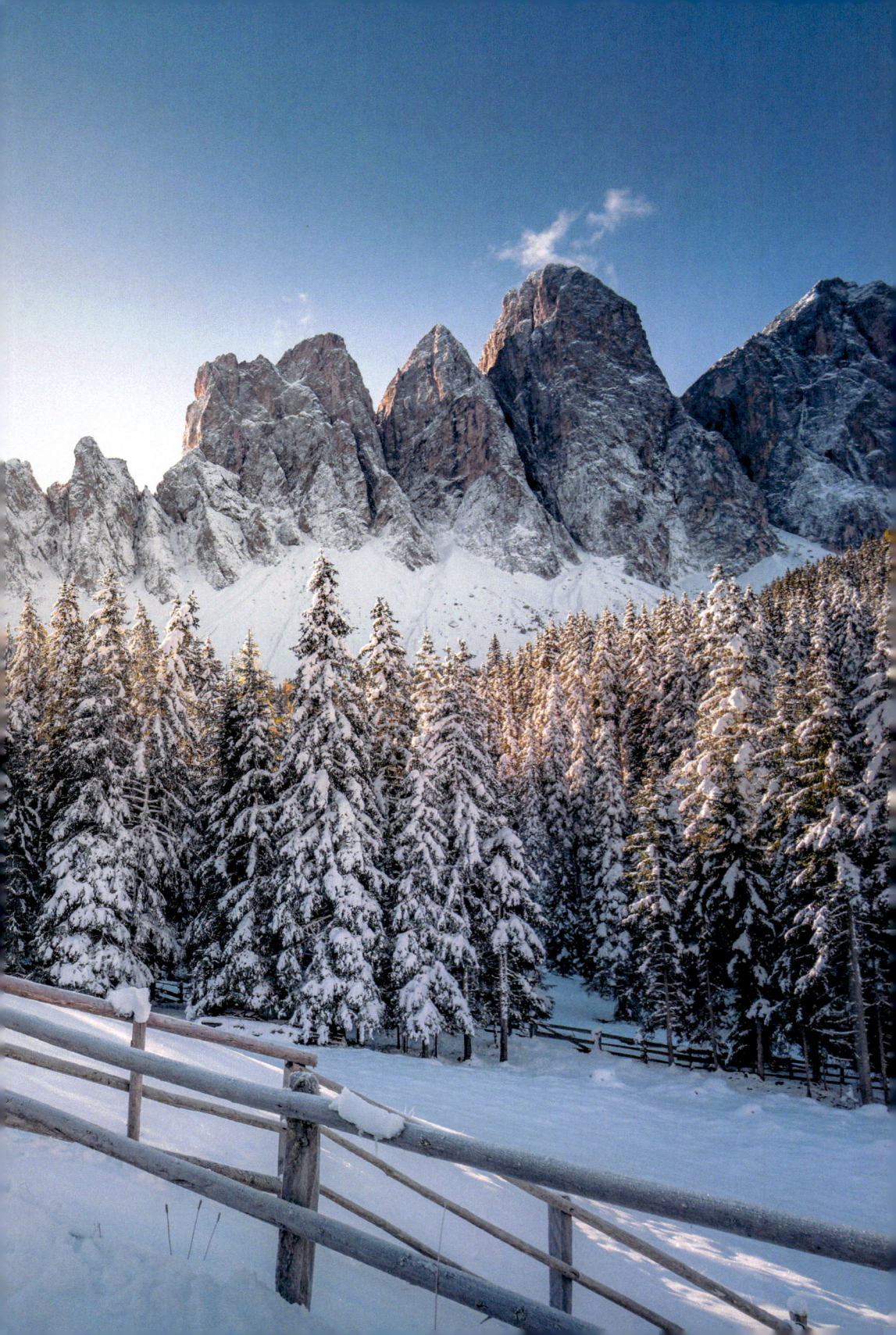

5 CHIESA DI SAN VALENTINO / ST. VALENTINO KIRCHE

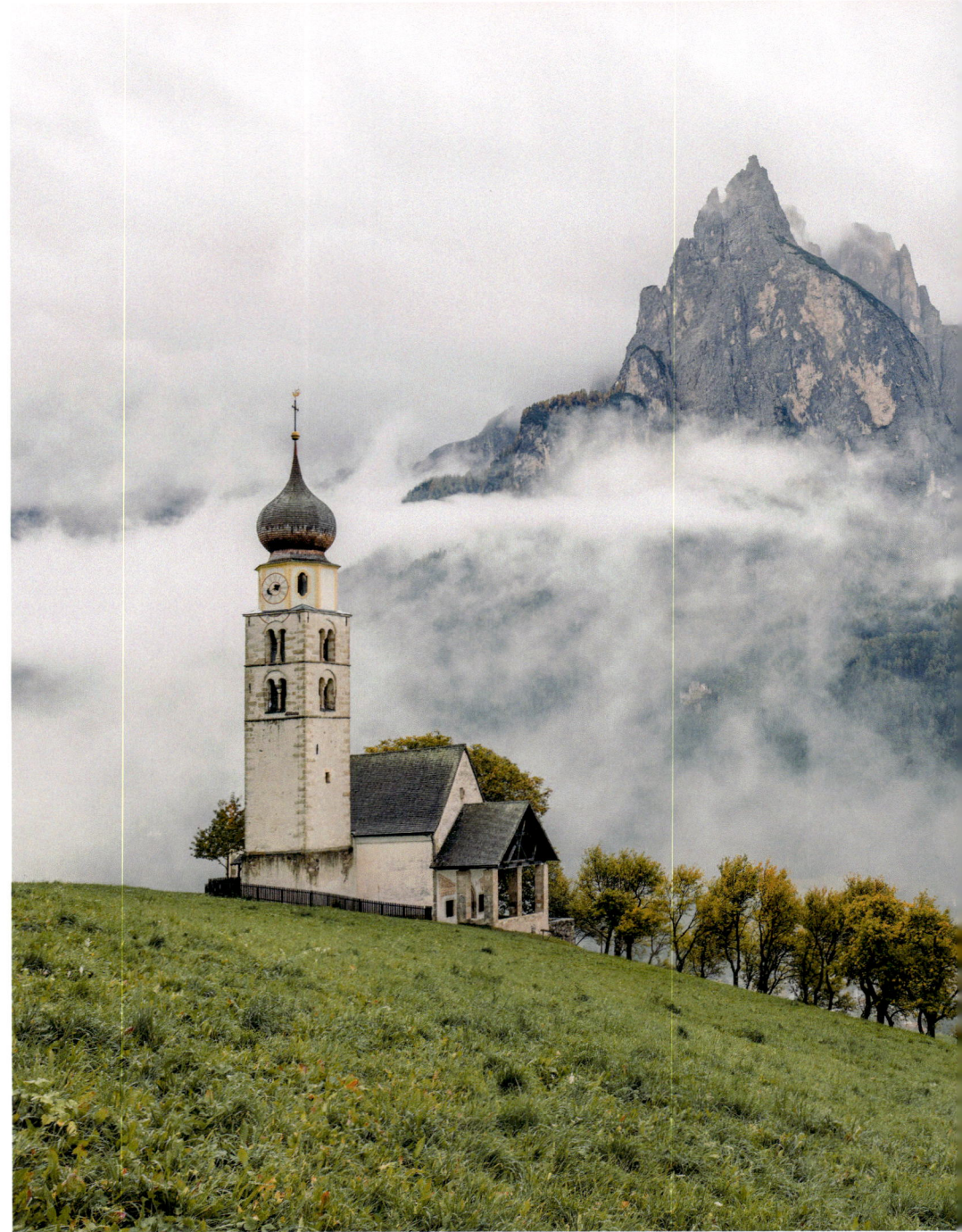

Chiesa di San Valentino. Nikon Z7II, 24–120mm at 28mm, ISO 64, 1/250s at f/8, Sep.

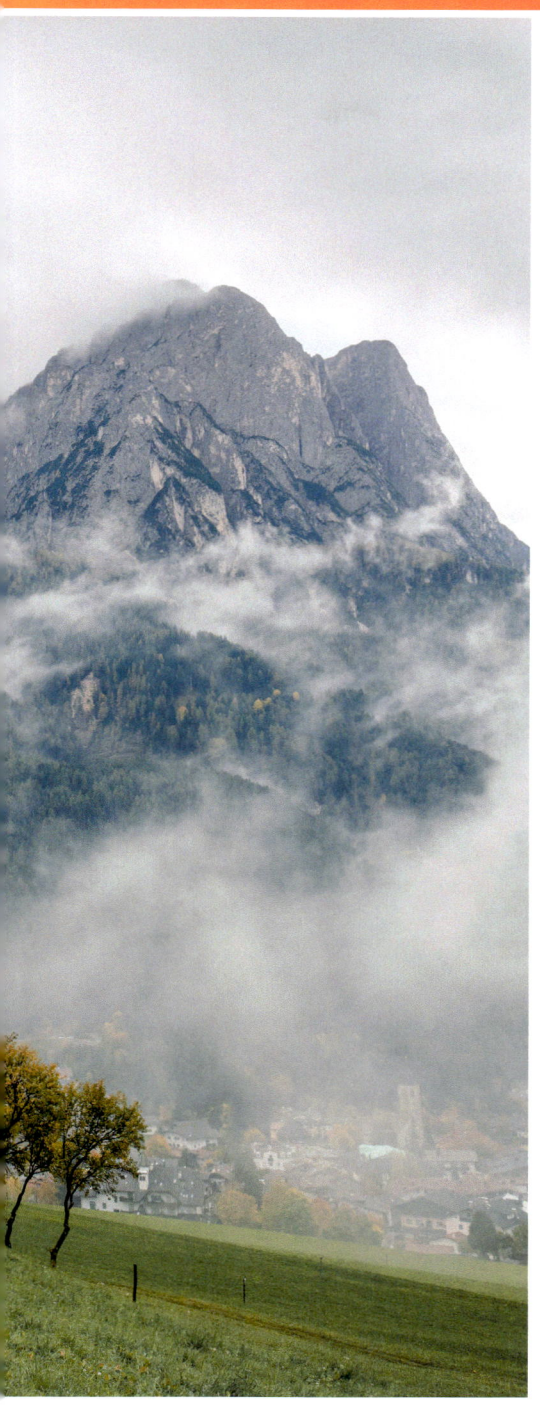

Previously seldom frequented, this little chapel on the approach road to the Alpe di Siusi has become popular with photographers in recent years. Backdropped by the steep walls of the Sciliar group and Punta Santner it is easy to see why – the characteristic onion dome providing a perfect foreground to the dramatic peaks.

Dating back to the 14th and 15th Century, the church is adorned with numerous impressive frescos that will provide additional interest for photographers with a love of art and history. Access has been a recent point of contention and visitors should approach on foot following the public footpath from the town of Seis below. Please do not attempt to park on the main road above the church.

What to shoot and viewpoints

Leaving the underground parking it is just possible to see the chapel up on the hillside to the north. Follow the main road (Via Catinaccio) uphill past the bus station for 50m until Via Henrik Ibsen branches off to the right. Here you have a choice – you can take path 11A to the right, or continue following signposting towards the chapel along Via Catinaccio until path 7 turns right uphill in a further 150m. In either case, it is easy to spot Chiesa di San Valentino once you leave the village buildings behind. Both paths are quite steep on the approach so take your time.

Viewpoint 1 – Chiesa di San Valentino from Afar
Both paths offer good views of the church on the approach – these make for excellent leading lines. There are also several photogenic trees that can be used to frame the chapel. Livestock in the surrounding fields can also provide good foreground interest. If the fields are fenced off for growing crops please stick to the designated path.

Viewpoint 2 – Chapel Frescos
The south and west walls of Chiesa di San Valentino have some beautiful and intricate frescos dating back to the 14th and 15th centuries.

It is worth completing a circuit using the other path on the return to gain some different perspectives of the chapel.

5 CHIESA DI SAN VALENTINO / ST. VALENTINO KIRCHE

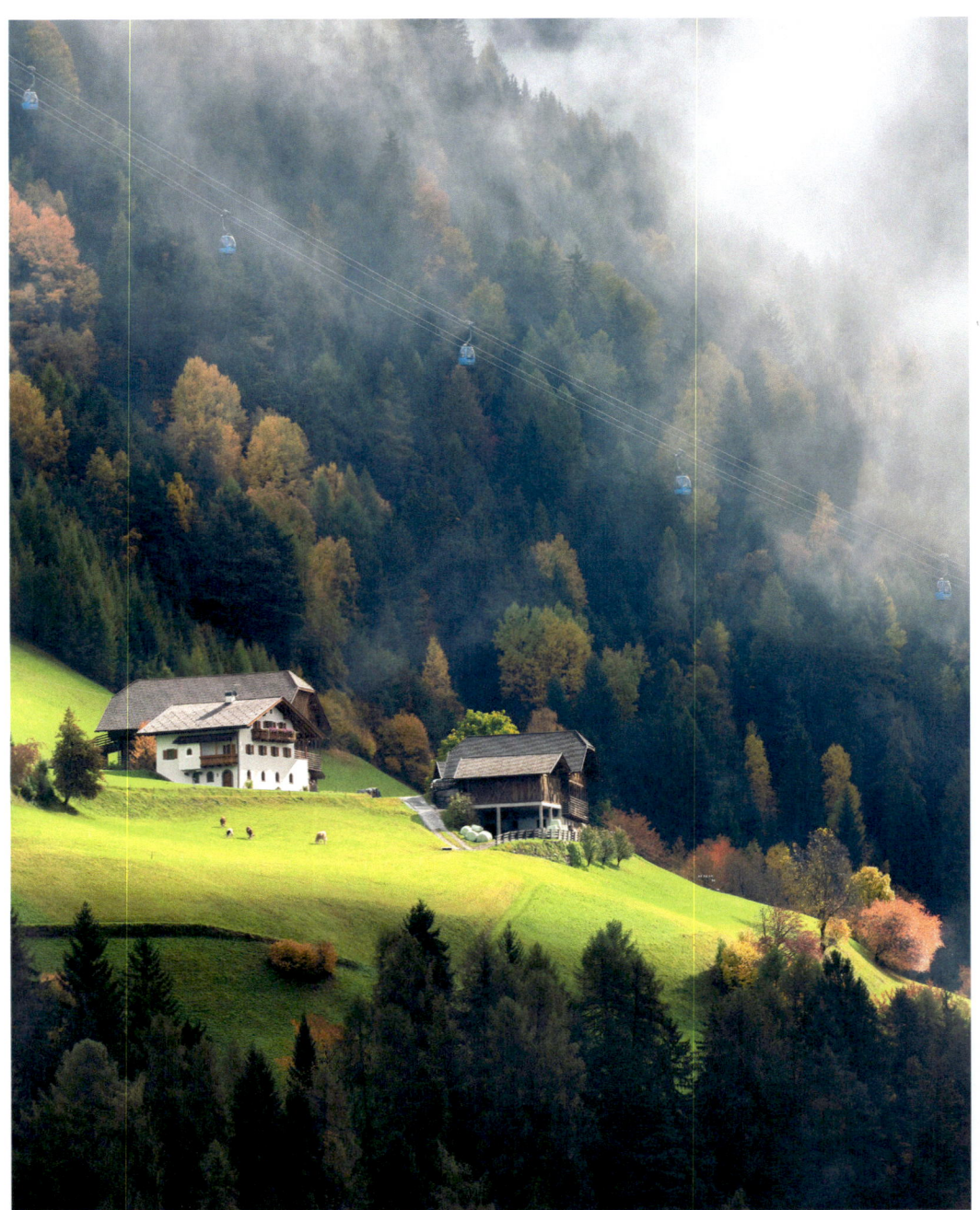

Looking south towards Cabinovia Alpe di Siusi from San Valentino. Nikon Z7II, 100–400mm at 200mm, ISO 100, 1/200s at f/8, Oct.

Above: A spectacular autumn day. Nikon D850, 24–70mm at 28mm, ISO 100, 1/200s at f/11, Oct.

Below: Contrasting fields make for an interesting foreground. Nikon D810, 24–70mm at 24mm, ISO 100, 1/500s at f/11, Sep.

How to get here

Situated on the west side of the Alpe di Siusi plateau, the town of Siusi is easily approached from Castelrottoand and the A22. There is a large underground carpark behind the bus station in the centre of town that is well signposted. If this is full there is additional parking at the Seiser Alm gondola lift station.

Lat/Long:	46.5446, 11.56279	
what3words:	///unfounded.teddies.brimmed	
Tabacco	Map 05 (1:25.000)	
Kompass	Map 76 (1:25.000)	

Accessibility

Approach: 20 minutes, 1km, 120m of ascent.

Path 7A is a surfaced track whilst path 11A is a small gravel footpath leading through the fields. Both are steep.

 Disabled access: Whilst it would be possible to ascend path 7 as the track surface is good, it is not recommended as the gradient is very steep.

Best time of year/day

Chiesa di San Valentino can be visited year round and looks excellent throughout the year. Snow, contrasting fields, flowers, crops, livestock – there is something different in every season.

The classic view back towards Punta Santner looks south and is best at either end of the day to avoid looking directly at the sun.

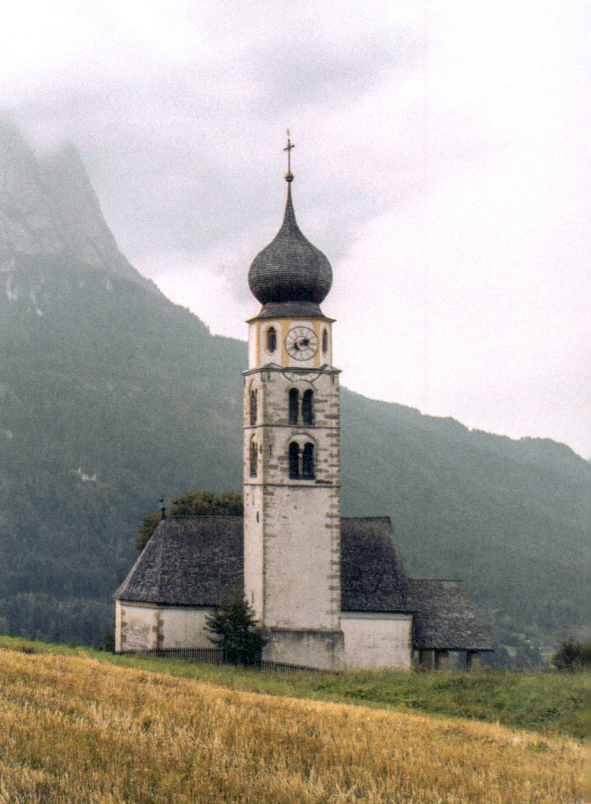

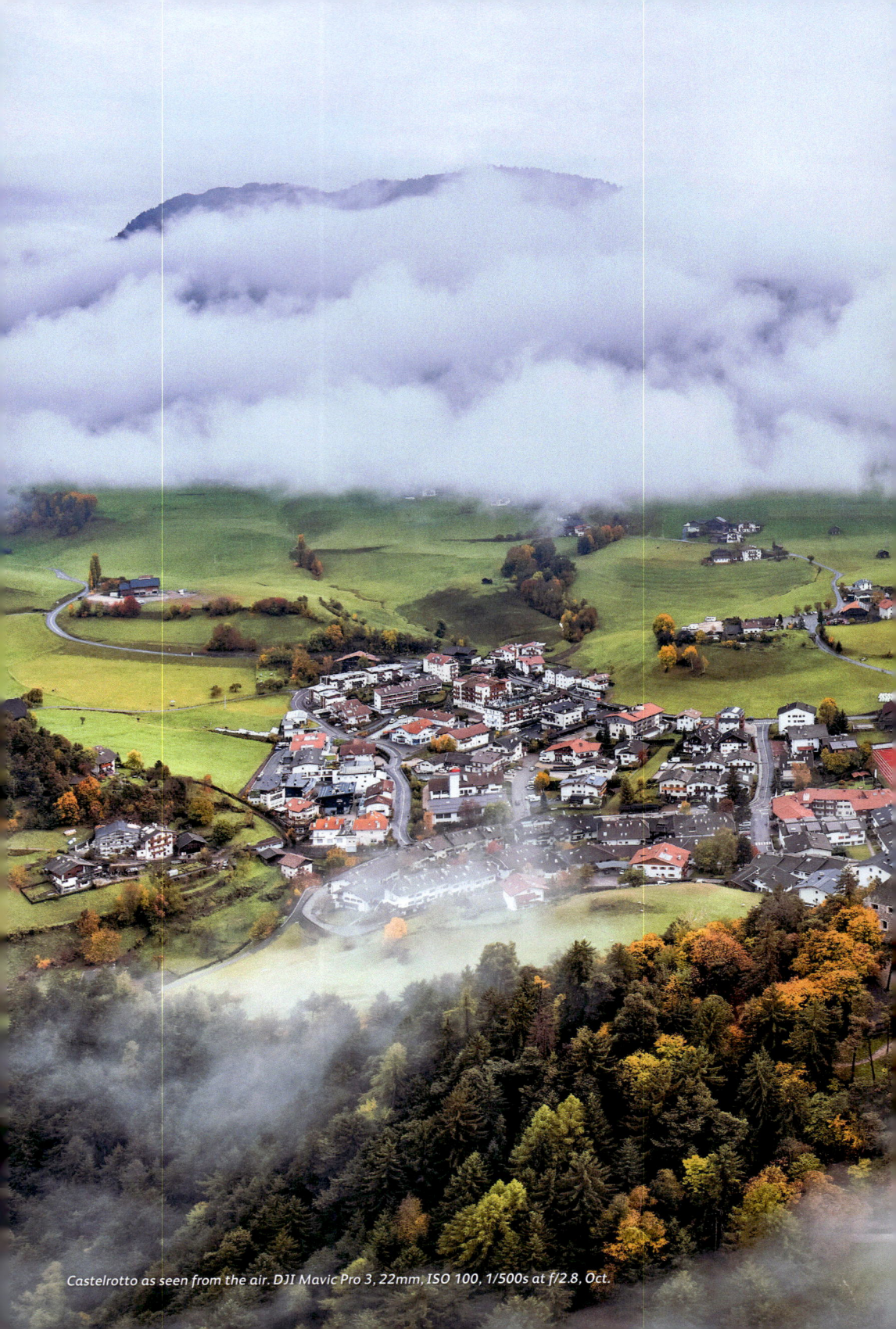
Castelrotto as seen from the air. DJI Mavic Pro 3, 22mm, ISO 100, 1/500s at f/2.8, Oct.

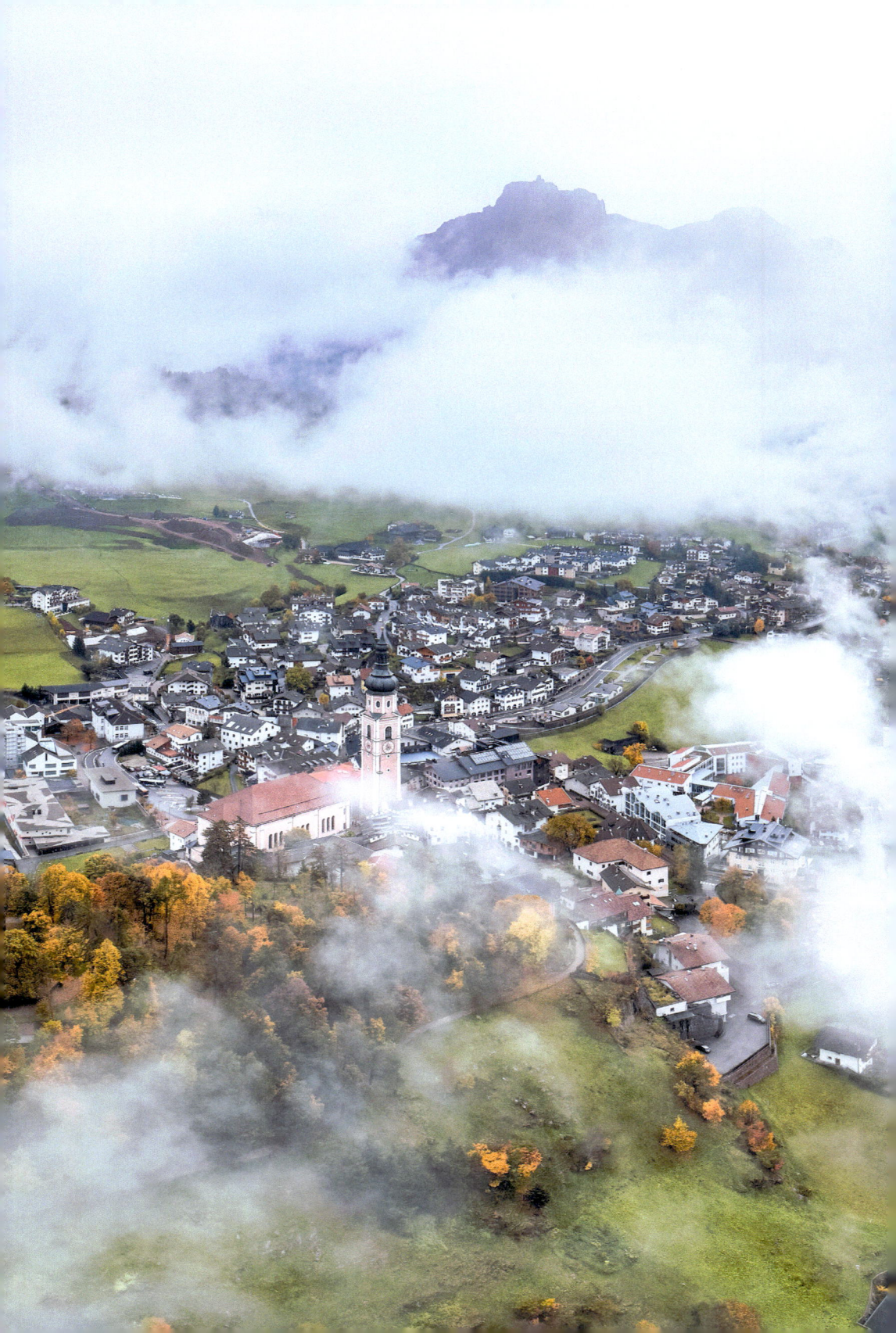

6 ALPE DI SIUSI / SEISER ALM

Spanning an area of 6000 hectares (or 56 square kilometres), the Alpe di Siusi is Europe's largest high-altitude alpine meadow. The vast plateau harbours some 800 different species of wildflower and is liberally studded with rustic wooden huts, babbling streams and small ponds. Set against the superbly proportioned Sassolungo group, an epitome of the Dolomitic ideal of what a mountain should look like, there is a nearly infinite number of creative photo opportunities to be had here. To take full advantage of the scale of this landscape, a stay in one of the many hotels and rifugios atop the plateau itself is highly recommended.

Road access to the Alpe di Siusi is restricted and the plateau is best approached via gondola from Ortisei to the north or Siusi to the west. The meadows are bisected by a number of small but well-maintained paths which make the area incredibly accessible. Despite the area's popularity, the scale is such that it is always possible to find a quiet corner.

The plateau is renowned amongst botanists and enjoys an excellent reputation for harbouring many rare orchids, including the elusive lady's-slipper (Cypripedium calceolus). With fields awash with globeflowers, blue gentians and wild rhododendrons, the meadow is perfect for macro photographers.

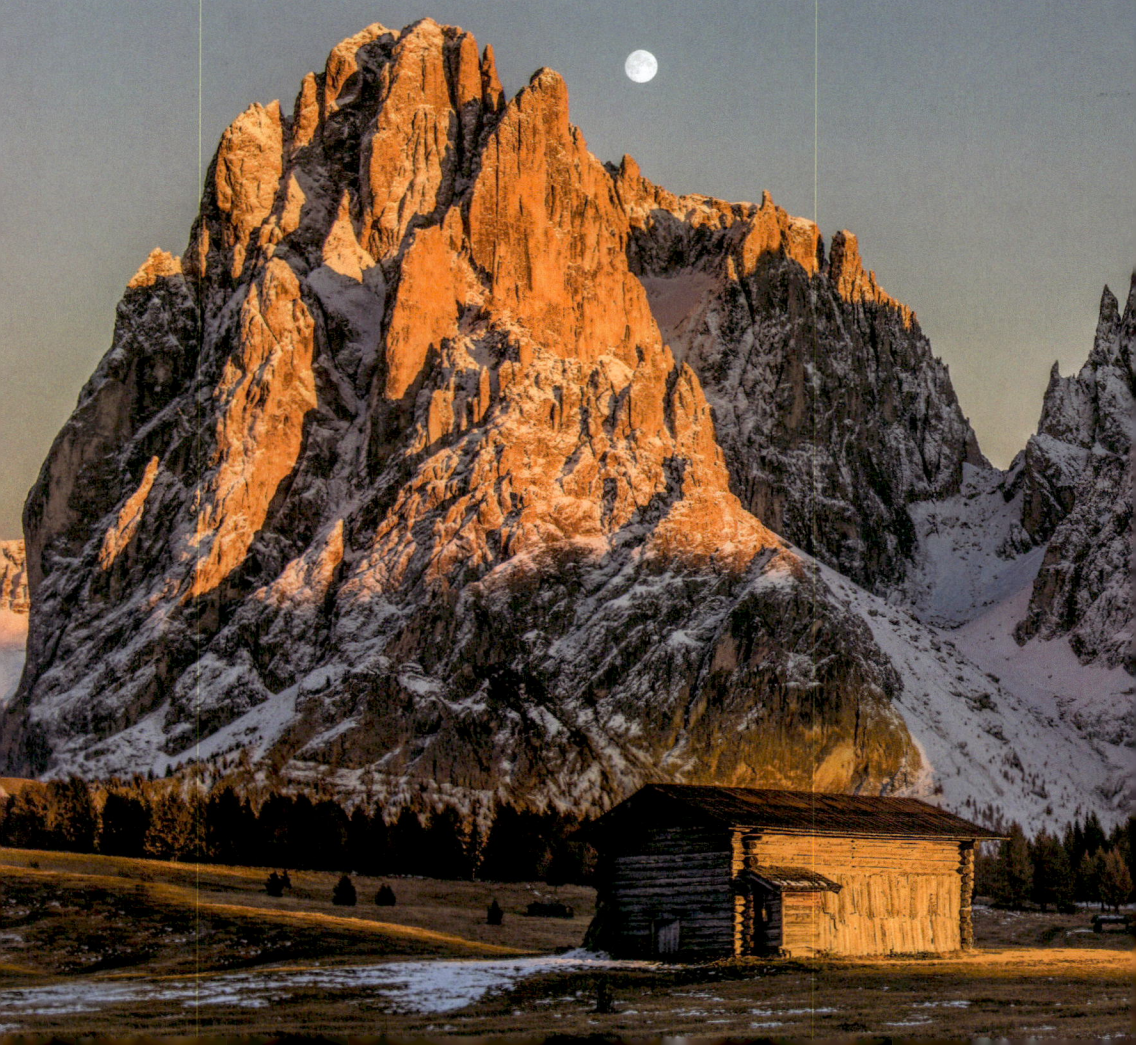

What to shoot and viewpoints

The scale of the Alpe di Siusi gives plenty of scope for exploration, originality and new perspectives of the classic Sassolungo backdrop. Recommending individual viewpoints is difficult as there is so much potential; instead, take the time to discover your own favourite compositions in this fascinating area. The following circuit provides a good starting point and will take roughly two hours.

Viewpoint 1 – Sassolungo ♿
The decking of Ristorante Mont Seuc at the top of the Ortisei gondola immediately provides a superb vantage point from which to view the Alpe di Siusi meadow.

Looking south-east, the unfolding panorama is dominated by the Sassolungo / Langkofel group, a distinctive mountain comprised of three prominent rock formations; Sassolungo (long rock) on the left, Cinque Dita (five fingers) in the middle and Sasso Piatto (flat rock) to the right. The Sciliar peaks encircle the plateau to the south-west, capped by the characteristic spire of Punta Santner, the emblem of the Alpe di Siusi.

The best composition is undoubtedly towards Sassolungo, although a variety of focal lengths all prove effective depending on how much foreground you wish to include.

The sun sets in the Alpe di Siusi. Nikon D810, 24–70mm at 70mm, ISO 100, 1/50s at f/10, tripod, Oct.

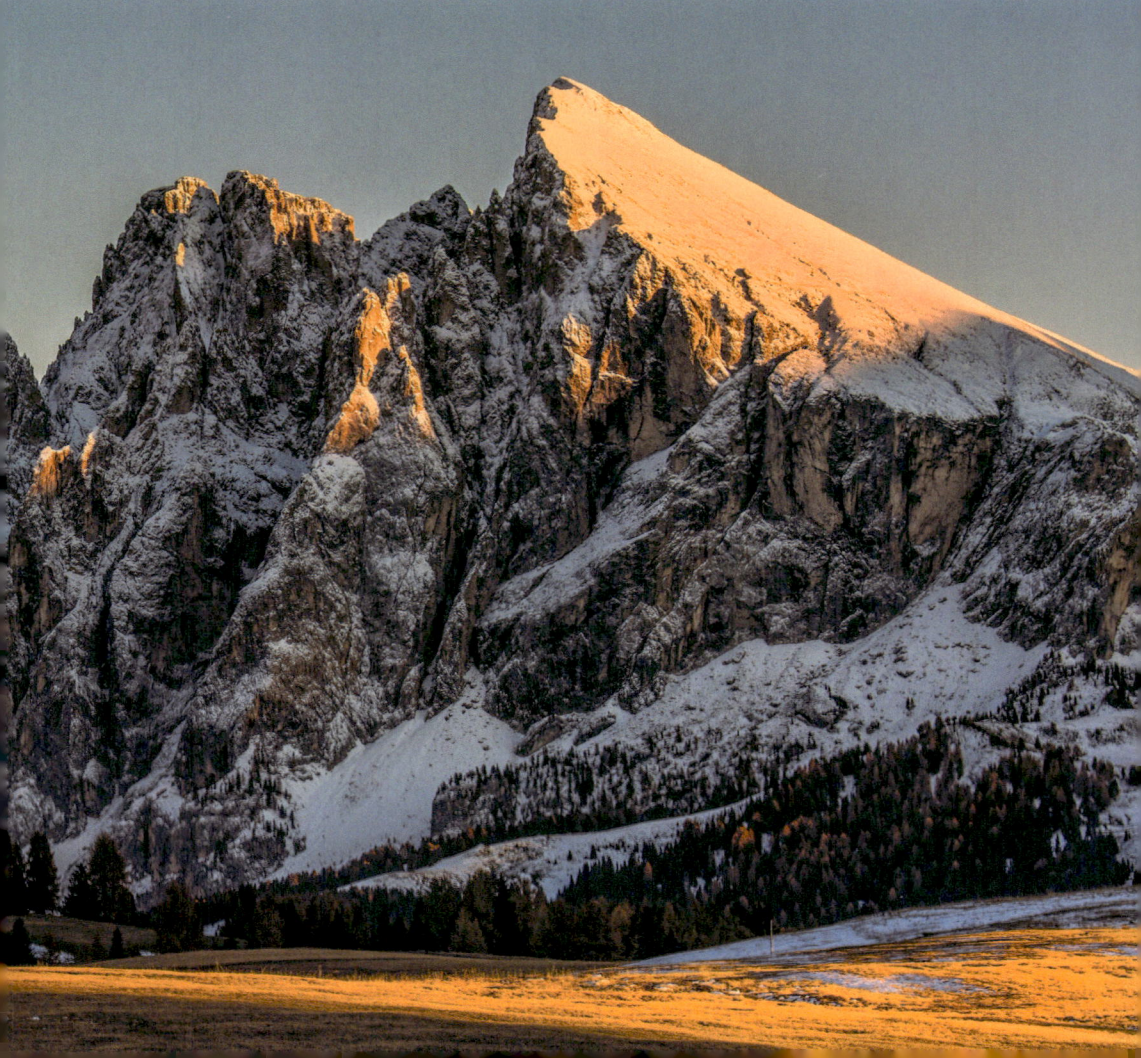

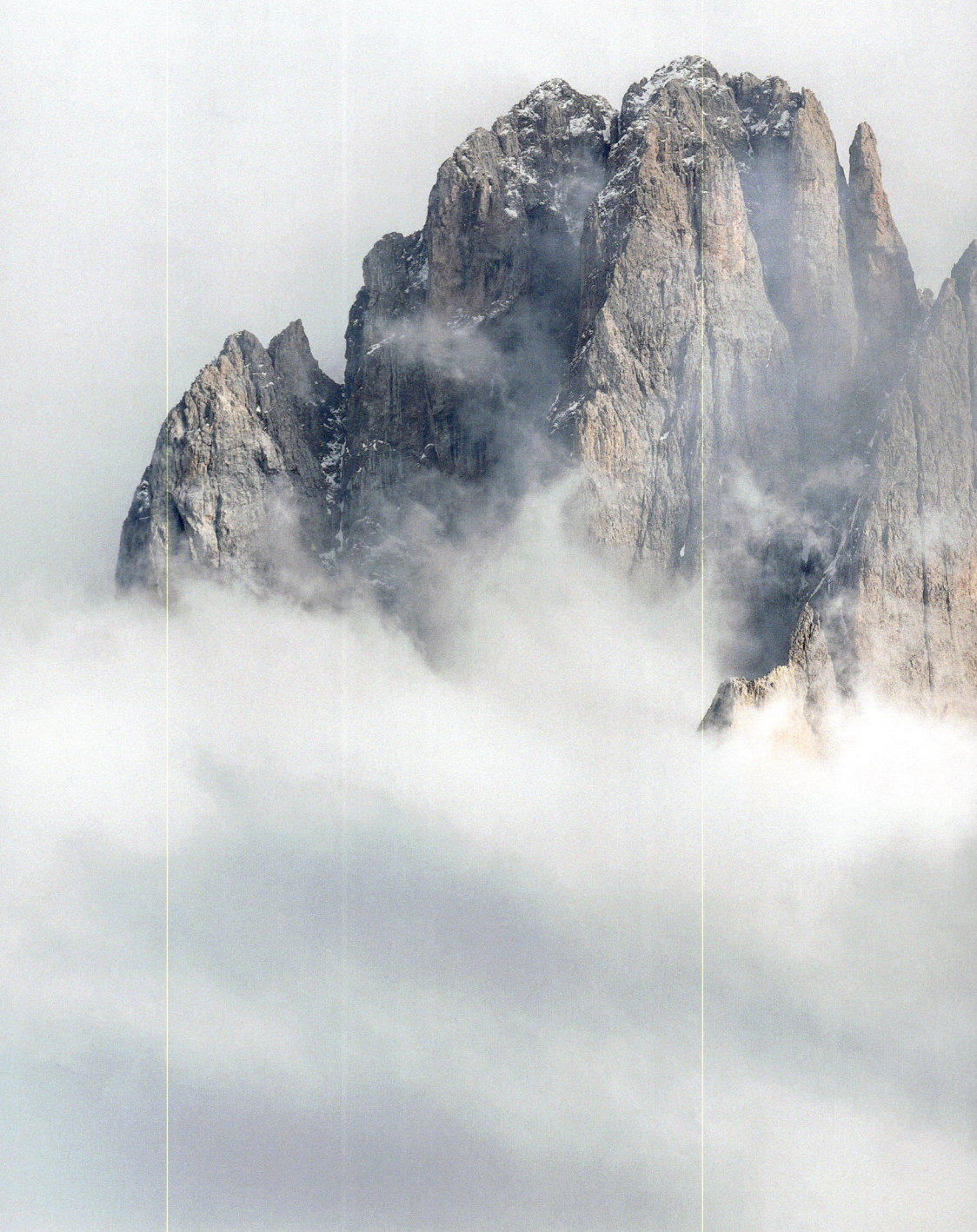

Sassolungo emerges from the clouds. Nikon Z7II, 100–400mm at 200mm, ISO 100, 1/400s at f/8, Jul.

ALPE DI SIUSI / SEISER ALM

To begin the circuit, descend east along the vehicle track just below Ristorante Mont Seuc, following signs for paths 8 and 9. The track soon makes a sharp turn to the right to face west. Continue descending for 10 minutes to reach the newly built Adler Mountain Lodge then turn left to arrive at Sporthotel Sonne. (During peak season the Sonne chairlift can be taken directly to and from the hotel).

Viewpoint 2 – Sporthotel Sonne Lake ♿

The east side of Sporthotel Sonne is home to a small but superbly situated lake which provides an excellent foreground to Sassolungo. A good path encircles the banks and provides easy access to many possible compositions. Getting low to the waters surface results in a larger reflection. Again, a number of focal lengths work here, although a standard zoom generally strikes a nice balance between capturing enough foreground and ensuring the backdrop doesn't look too small.

In July, it is not uncommon to see spectacular blue dragonflies hovering over the water's surface, providing an excellent opportunity for some macro work.

You can also get a pleasing composition from the far shore without including the lake at all, instead making use of two wooden huts just in front of a small copse.

Viewpoint 3 – Wooden Huts & Sassolungo ♿

To continue, briefly retrace your steps back towards the Adler Mountain Lodge and then turn left onto path 6b, following signposting towards Baita Sanon. The path weaves through the meadows and is exceptionally photogenic, leading across a small stream (sometimes dry) to reach two superbly positioned wooden huts on the left.

Easily identified by the faded orange roofs that contrast beautifully with the dark wood, the huts create an excellent foreground when framing Sassolungo. The huts can be placed directly below Cinque Dita in a landscape composition, a shot that looks particularly striking when there is some good foreground light to highlight the roofs.

By moving slightly further right and shooting in a portrait orientation, you can position the huts as an effective foreground for Sassolungo, cropping out the other peaks.

The lake outside Sporthotel Sonne. Nikon D810, 24–70mm at 44mm, ISO 100, 1.3s at f/13, tripod, ND filter, Jul.

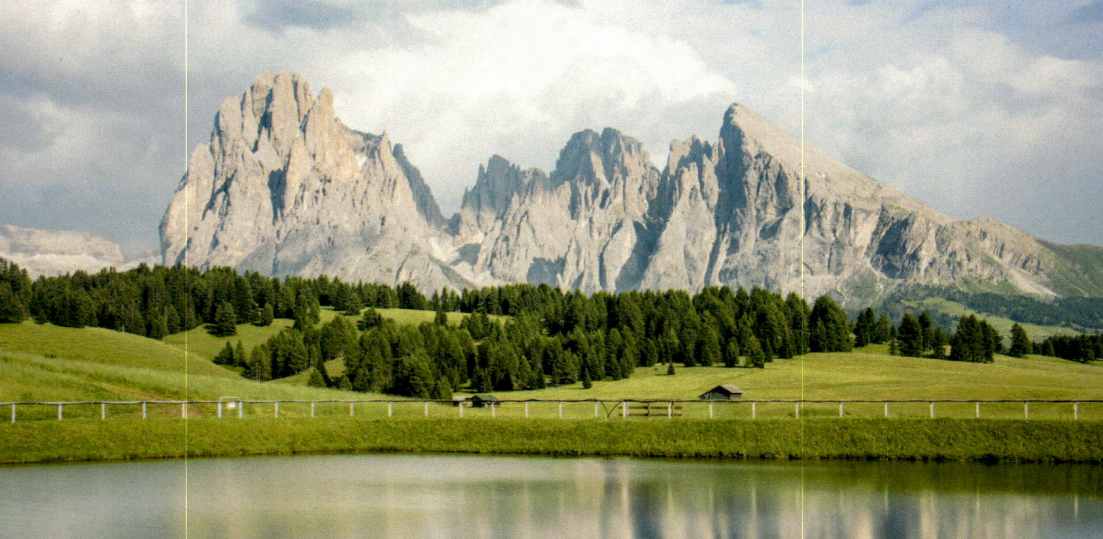

Above: *The rare and much-coveted lady's-slipper orchid (Cypripedium calceolus) cropped to three different sizes. Nikon D810, 105mm, ISO 100, 1/160s at f/16, tripod, May.* ***Below***: *Using a drone to gain a slightly higher perspective over two of the mountain huts near Baita Sanon. DJI Mavic Pro 3, 22mm, ISO 100, 1/1000s at f/2.8, Oct.*

6 ALPE DI SIUSI / SEISER ALM

Above: Larches in autumn. Nikon Z7II, 100–400mm at 200mm, ISO 180, 1/200s at f/5.6, Oct.
Below: There are many aesthetic trees scattered about the meadows. Nikon D810, 16–35mm at 16mm, ISO 100, 1/200s at f/7.1, Jul.

Above: Sassolungo and the moon. Nikon D810, 28–300mm at 300mm, ISO 100, 1/50s at f/10, tripod, Oct.
Below: One of many huts found dotting the Alpe di Siusi plateau. Nikon Z7II, 24–120mm at 35mm, ISO 64, 1/5s at f/9, tripod, Aug.

6 ALPE DI SIUSI / SEISER ALM

A further 10 minutes of walking along path 6b brings you to Baita Sanon, owned by the Kostner family.

Viewpoint 4 – Baita Sanon
The farmhouse rifugio serves traditional Tyrolean dishes in a spectacular environment, providing an excellent excuse for some food photography. Make sure you take a look inside to admire the beautiful wooden architecture so characteristic of the region. Once again, the view from the decking towards Sassolungo is wonderful.

Viewpoint 5 – Punta Santner
To complete the circuit, stay on path 6b and follow this west to reach a junction with a larger track. Turn right onto this, now following signs for path 8 and then 6 as you pass between Hotel Icaro and Monte Icaro. Either stay on the large track to return to the Adler Mountain Lodge, or for an arguably more scenic route turn left onto path 6a shortly after passing Hotel Icaro.

As you ascend back towards the gondola station, there is a good view of Punta Santner (formerly Punta del Diavolo – the Devil's Tower) to the south-west. A longer lens is required to do this shot justice, framing the aesthetic mountain against one of the many huts.

To return, stay on path 6a, passing Malga Contrin to reach the top station of the Ortisei gondola in 25 minutes.

Viewpoint 6 – Flora & Fauna ♿
The diverse range of plant life, flowers and insects found throughout the Alpe di Siusi makes the plateau perfect for some close-up macro photography. Use the lens aperture to try to strike a nice depth of field compromise, aiming for a wide enough angle to remove any distracting background elements while keeping enough of the foreground in focus. A tripod and ring or off-camera flash setup can greatly improve the effectiveness of macro work.

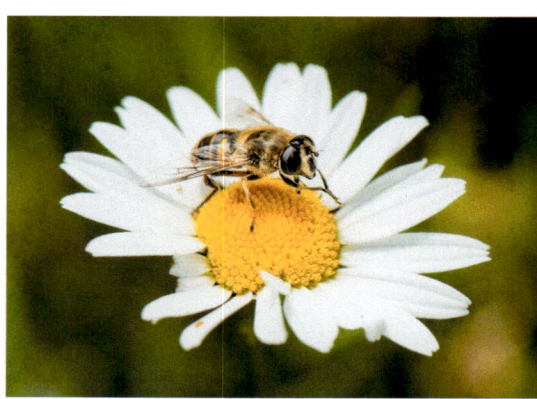

How to get here

The Alpe di Siusi is most easily accessed using the gondola that departs from Ortisei in the Val Gardena. Ortisei can be approached from the east via the Passo Gardena or Passo Sella, or from the Val Isarco along the SS242 or SP64.

Alternatively, it is also possible to take a gondola from just outside the village of Siusi to reach to Compaccio on the west side of the plateau. Finally, there is also an access road that leads up to Compaccio from Siusi, although this is closed to private vehicles between 9am and 5pm.

	Lat/Long:	46.57304, 11.6706
	what3words:	///complaining.genuine.persuade
	Tabacco:	Map 05 (1:25.000)
	Kompass:	Map 76 (1:25.000)

Accessibility

Approach: There are excellent views straight out of the Ortisei gondola with the opportunity for many hours of walking as desired.

 Disabled access: The Ortisei gondola is wheelchair-accessible and there are a number of well-surfaced paths and roads on the plateau, making it an ideal venue for those with limited mobility.

Best time of year/day

The huge scale of the area ensures there are excellent photo opportunities year round, although the plateau undoubtedly looks best in June and July when the meadows are carpeted in flowers of every conceivable shape, size and colour.

During the summer the sun sets on the north-west faces of Sassolungo, making it an ideal late afternoon and sunset location.

Opposite top: A bee harvests a false aster (Aster bellidiastrum). Nikon D810, 105mm, 1/250s at f/10, Jul.

Opposite: The distinctive tower of Punta Santner. Nikon Z7II, 100–400mm at 200mm, ISO 100, 1/500s at f/8, Aug.

Top: It's hard not to love the spires of Sassolungo. The viewpoint is found just outside Baita Sanon. Nikon D810, 16–35mm at 16mm, ISO 100, 1/320s at f/8, Jul. **Above**: Centaurea nervosa. Nikon D810, 105mm, ISO 100, 1/250s at f/4.5, Jul.

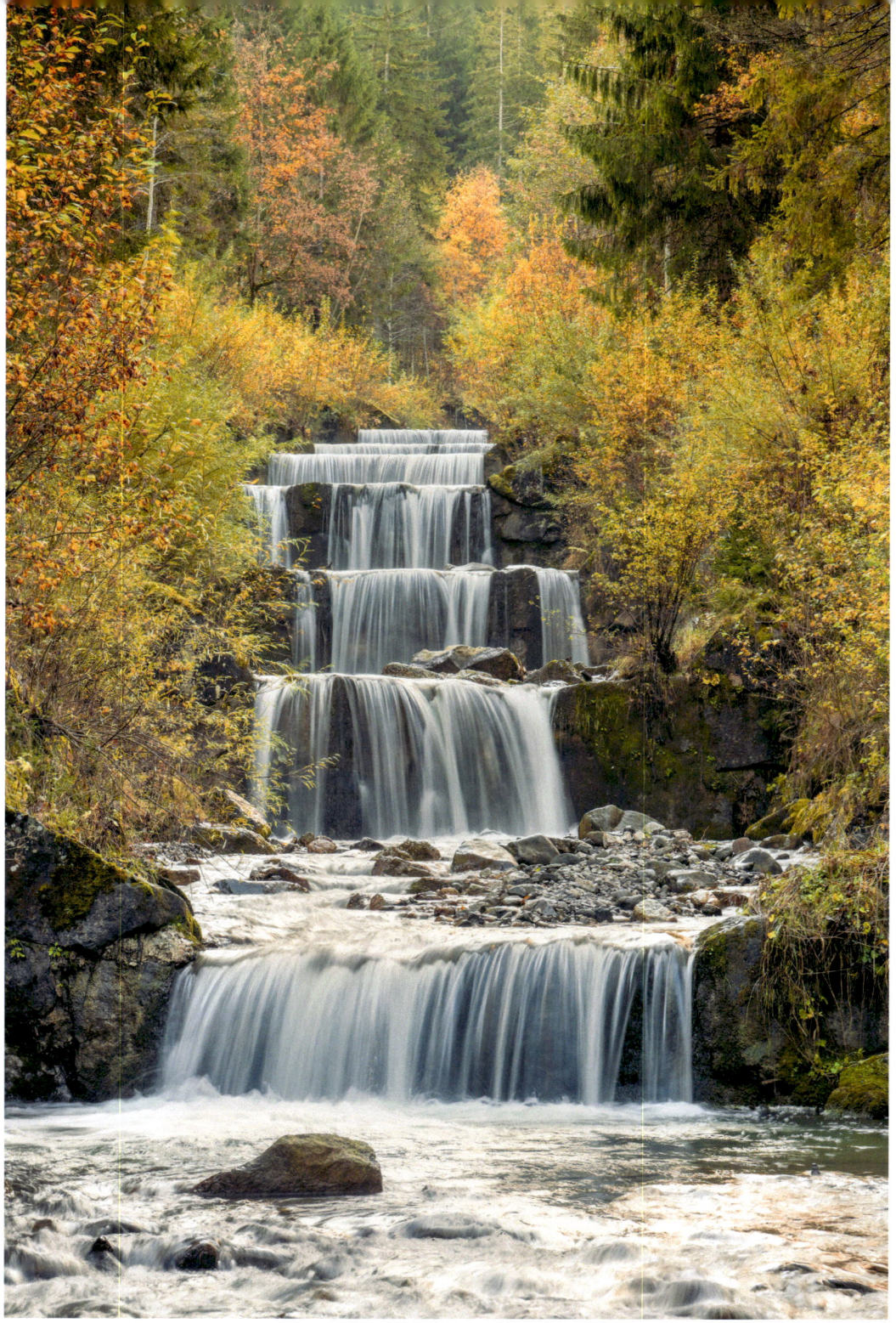
The stepped waterfalls at Puflerbachbrücke. Nikon Z8, 24–120mm at 80mm, ISO 64, 1/13s at f/14, tripod, Oct.

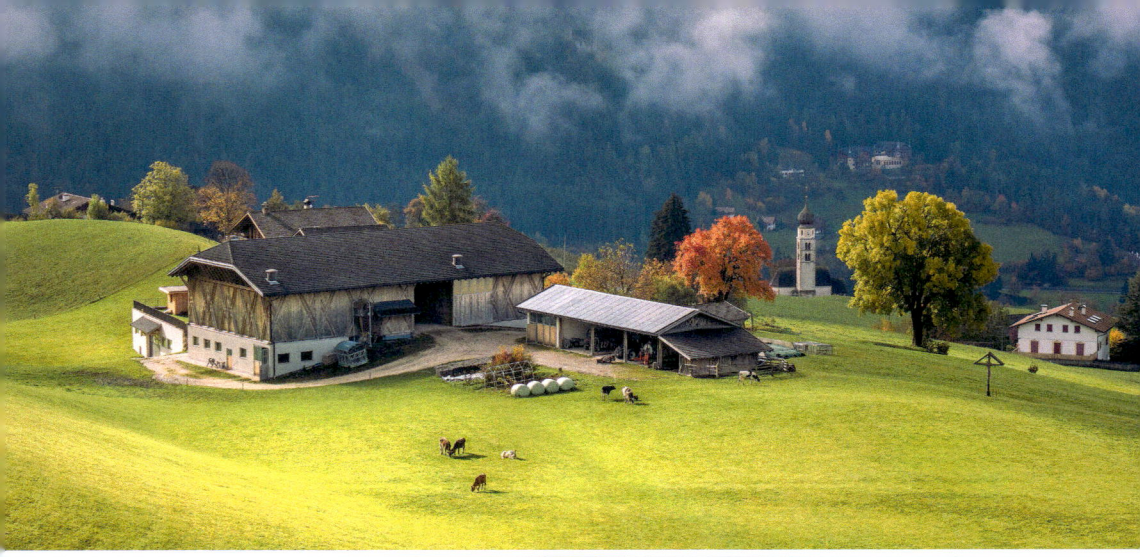

Idyllic scenes in the meadows surrounding Castelrotto. DJI Mavic 3 Pro, 166mm, ISO 100, 1/160s at f/4, Oct.

7. CHIESA DI SAN GIACOMO / ST. JAKOBS KIRCHE

Dedicated to Saint James the Greater, patron saint of pilgrims, Chiesa di San Giacomo is the oldest religious building in the Val Gardena and dates back to the early 11th century. Located on the Troi Paian, an ancient high altitude trade route linking the Val Isarco to the Venetian plains, the church was originally erected in the Romanesque style but was later adapted to a Gothic design during the 17th Century.

Located in a beautiful copse above the village of Ortisei, the church enjoys spectacular views of Sassolungo's north-west faces and the Val Gardena. Thanks to its secluded location away from the traditional tourist destinations, this hidden gem is rarely busy and as such is a highly recommended photographic location.

What to shoot and viewpoints

Viewpoint 1 – San Giacomo & Sassolungo ♿

Because of the dense trees surrounding the church, this is the only viewpoint offering a far-reaching view. Thankfully though, it forms a perfectly composed natural scene with the main church on the left, Sassolungo in the centre and a very photogenic outhouse on the right. You will need an extreme wide-angle to fit it all into a single frame; just be mindful of distortion on the converging verticals which will need fixing when you process your image, otherwise the church will have a distinctly leaning appearance.
A panorama works equally well here, particularly if you have access to a tilt-shift lens.

Viewpoint 2 – Church Grounds ♿

During the spring there are several well-tended flower beds that look out over the Val Gardena, while the graveyard enjoys a spectacular view of Sassolungo.

Viewpoint 3 – Church Interior ♿

Featuring Gothic frescos, an elaborate altar and several famous statues, the small but beautifully crafted interior is worthy of attention.

How to get here

From Selva, drive north-west along the Val Gardena to reach Ortisei. Stay on the main road to bypass the town, passing through a short tunnel to reach a roundabout. Turn right here, following signs for San Giacomo to reach a second roundabout in 100 metres. Turn right again, still following signs for San Giacomo and driving over cobbles towards the village centre. In 50 metres the village becomes a pedestrian-only zone and the road swings to the left. Continue along this, passing in front of the church and following the road for 1.5km as it begins to ascend steeply to reach Hotel Ansitz Jakoberhof on the left in the tiny hamlet of Sacun. There is very little space for parking and it is worth asking the hotel for permission to use their car park.

Alternatively, it is possible to park in the centre of Ortisei and then ascend on foot using paths 4 or 6 to reach the church in one hour.

Lat/Long:	46.57075, 11.69089	
what3words:	///financier.scuba.wavelengths	
Tabacco:	Map 05 (1:25.000)	
Kompass:	Map 76 (1:25.000)	

Accessibility

Approach: 10 minutes, 0.5km, 70m of ascent.

♿ **Disabled access**: There is a well defined gravel path that leads from Sacun to the church itself. The path ascends the whole way but the steeper sections are well negotiated with switch backs.

Best time of year/day

The church is exceptionally photogenic throughout the year and the viewpoint isn't seasonally dependant. Although the church looks particularly striking during the winter after fresh snowfall, the drive up to Sacun can be a difficult undertaking without a four wheel drive vehicle and snow chains.

Due to the west-facing aspect of the church, the location is typically best shot during the late afternoon when the sun has moved round to illuminate the front of the building. Unfortunately, due to the surrounding trees you lose the light on the church as the sun sets on the Sassolungo group.

Opposite top: The location is perfect for capturing the afternoon sun. Nikon D810, 14–24mm at 14mm, ISO 100, 1/40s at f/8, Sep.
Bottom left: The graveyard has lovely views towards Sassolungo. Nikon D810, 16–35mm at 35mm, ISO 100, 1/320s at f/9, Mar.
Bottom right: The church is photogenic throughout the year. Nikon D810, 16–35mm at 18mm, ISO 100, 1/320s at f/9, Mar.

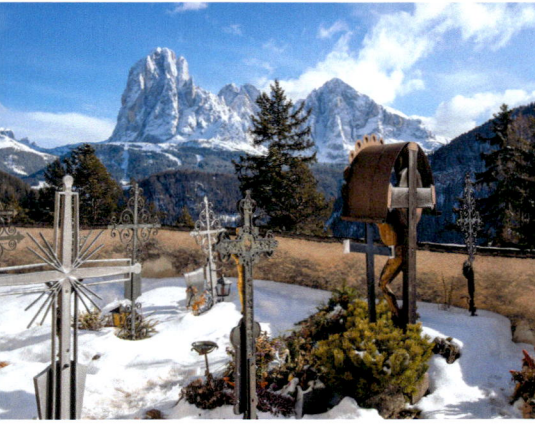
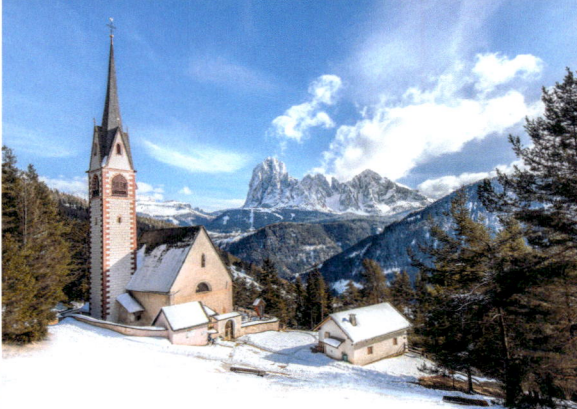

PUEZ ODLE / GEISLER – SECEDA & COL RAISER

Comprised of nine individual towers, the Odle group forms a dramatic line of peaks rising above the Alpe di Cisles plateau. Sass Rigais and Furchetta are the highest in the chain and the Puez Odle massif, both sharing a height of 3025m. From the summits, the ground then plunges away for a vertical kilometre into the beautiful Val di Funes, giving one the impression of standing quite literally on the edge of the Dolomites.

Approached via the Seceda gondola – this location is incredibly accessible to both photographers and hikers alike. There is also accommodation near the lift station for those wanting to stay late or make an early start the following morning.

To the south-east lies the Col Raiser plateau. This superb hiking area can be accessed on foot from Seceda or by taking the Col Raiser gondola from Santa Cristina in the Val Gardena.

What to shoot and viewpoints

Take the Ortisei – Furnes gondola and subsequent Furnes – Seceda cable car. From the top station, ascend north-east to reach the summit of Seceda after 10 minutes of easy walking. There are excellent views from the summit and alternative compositions can be found further east along the ridgeline towards the top of the Fermeda chairlift.

Viewpoint 1 – Odle Ridge Line ♿

The spectacular ridgeline works well framed on the left or right, offering views of the Val di Funes or Alpe di Cisles. The exposed bedding planes make for an interesting foreground, especially if there is a subject walking on the path towards Piccola Fermeda.

Viewpoint 2 – Seceda Summit Cross

The highly detailed crucifix at the summit of Seceda makes for a somewhat melodramatic but striking subject, especially when the sun is low in the sky creating a stark silhouette. The summit also offers far-reaching views over much of the Dolomites and the Austrian Alps.

The summit cross at Seceda. Nikon D810, 80–400mm at 185mm, ISO 100, 1/200s at f/7.1, Sep.

How to get here

Both Ortisei and Santa Cristina are principal towns of the Val Gardena and are easily accessed via the SS242 that runs the length of the valley. The Ortisei – Furnes gondola is located on the north-east side of the town and is well signposted from the main road. The Col Raiser Gondola is found at Plan de Tieja also north-east of Santa Cristina.

Viewpoint 1 & 2 – Seceda

Lat/Long:	46.57671, 11.6751
what3words:	///passing.intros.varnish
Tabacco:	Map 05 (1:25.000)
Kompass:	Map 76 (1:25.000)

Viewpoint 3, 4 & 5 – Col Raiser

Lat/Long:	46.56508, 11.73643
what3words:	///heave.entertainer.lengthening
Tabacco:	Map 05 (1:25.000)
Kompass:	Map 76 (1:25.000)

Accessibility

Approach: 10 minutes, 0.5km, 60m of ascent.

A series of well-maintained and signed paths crisscross the Seceda and Col Raiser plateaus. Be aware that the walking area is huge and complex once away from the main viewpoint overlooking the ridge.

♿ **Disabled access**: Both gondolas and cable cars offer wheelchair access. From the top station, a newly installed boardwalk and viewing deck look out over the Odle ridge.

Best time of year/day

Given the rocky nature of this viewpoint, the scene is not seasonally dependent, although Seceda is most easily accessed when the lift system is running (June – October and December – April).

The area forms part of an extensive lift and ski piste network during the winter season. Competent skiers can return after sunset via the 'La Longia' ski piste, a 10km red run that leads back to Ortisei.

Looking along the Seceda ridge line to Grande Fermeda and then Sass Rigais in the distance. © Guillaume Briard.

8 PUEZ ODLE / GEISLER

COL RAISER

To reach the Col Raiser plateau and meadows from Seceda it is best to follow path 1 and then 4 as this provides lovely views on the descent. Please note that this is a very large walking area and good hiking experience is essential. Bring a detailed topographic map as the sheer number of trails makes navigation difficult. Allow three to four hours for this hike, particularly if you're planning on making a loop to descend via Rifugio Firenze. Don't forget to plan your return – either by hiking, or descending the Col Raiser gondola and then taking public transport back to the Seceda lift station.

Alternatively, it is possible to take the Col Raiser gondola from Santa Cristina to arrive directly on the plateau (details in the grey box on the previous spread).

Viewpoint 3 – Col Raiser ♿

Arriving at Col Raiser via the gondola provides immediately impressive views from the lift decking, with excellent compositions in nearly every direction. From here is it possible to see the Sella, Sassolungo, Stevia, Odle, Molignon and Sciliar peaks.

Viewpoint 4 – Rifugio Firenze & Surroundings

A walk to Rifugio Firenze takes just under 30 minutes following path 4 from the top of the Col Raiser lift and is recommended for those who want to explore this beautiful area further. The rifugio is stunningly situated and there is a particularly photogenic outbuilding to the north. It is possible to return to the lift station via path 2, creating a small loop that will take approximately two hours.

Viewpoint 5 – Other Ideas

For adventurous photographers with suitable experience and equipment Via Ferrata Sass Rigais offers a lovely birds-eye perspective down over the surrounding area and warrants further research.

Above: An outbuilding at Rifugio Firenze. Nikon Z8, 24–120mm at 40mm, ISO 64, 1/100s at f/9, Aug. **Opposite**: Clouds roll over the jagged peaks of the Odle. Nikon D810, 16–35mm at 35mm, ISO 100, 30s at f/9, tripod, ND filter, Sep.

A black redstart surveys the area. Nikon D810, 28–300mm at 300mm, ISO 160, 1/320s at f/5.6, Oct.

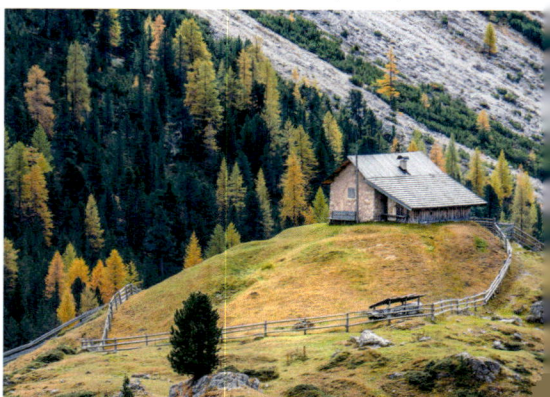

An alternate perspective on the Rifugio Firenze farmhouse. Nikon Z8, 100–400mm at 180mm, ISO 64, 1/200s at f/7.1, Sep.

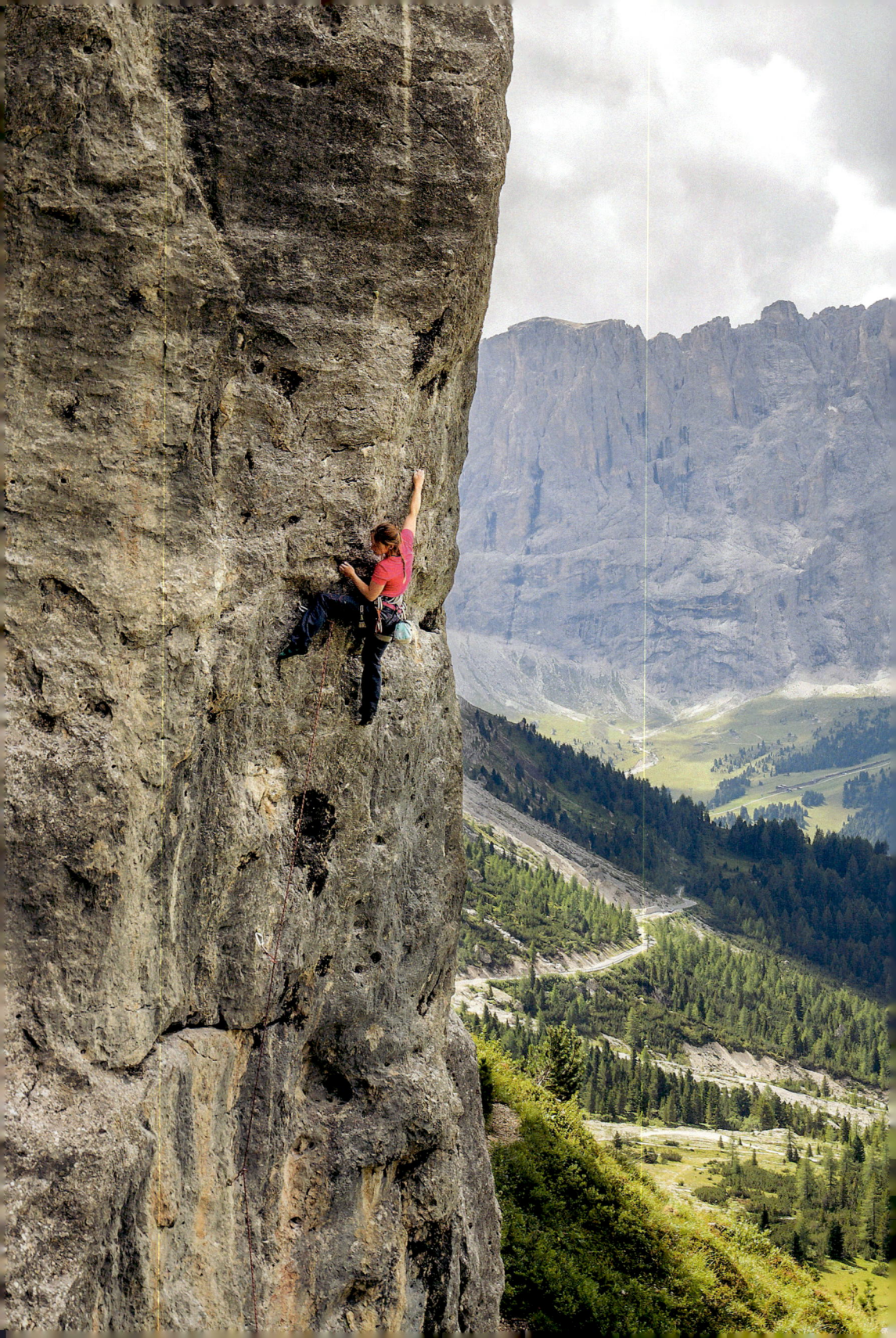

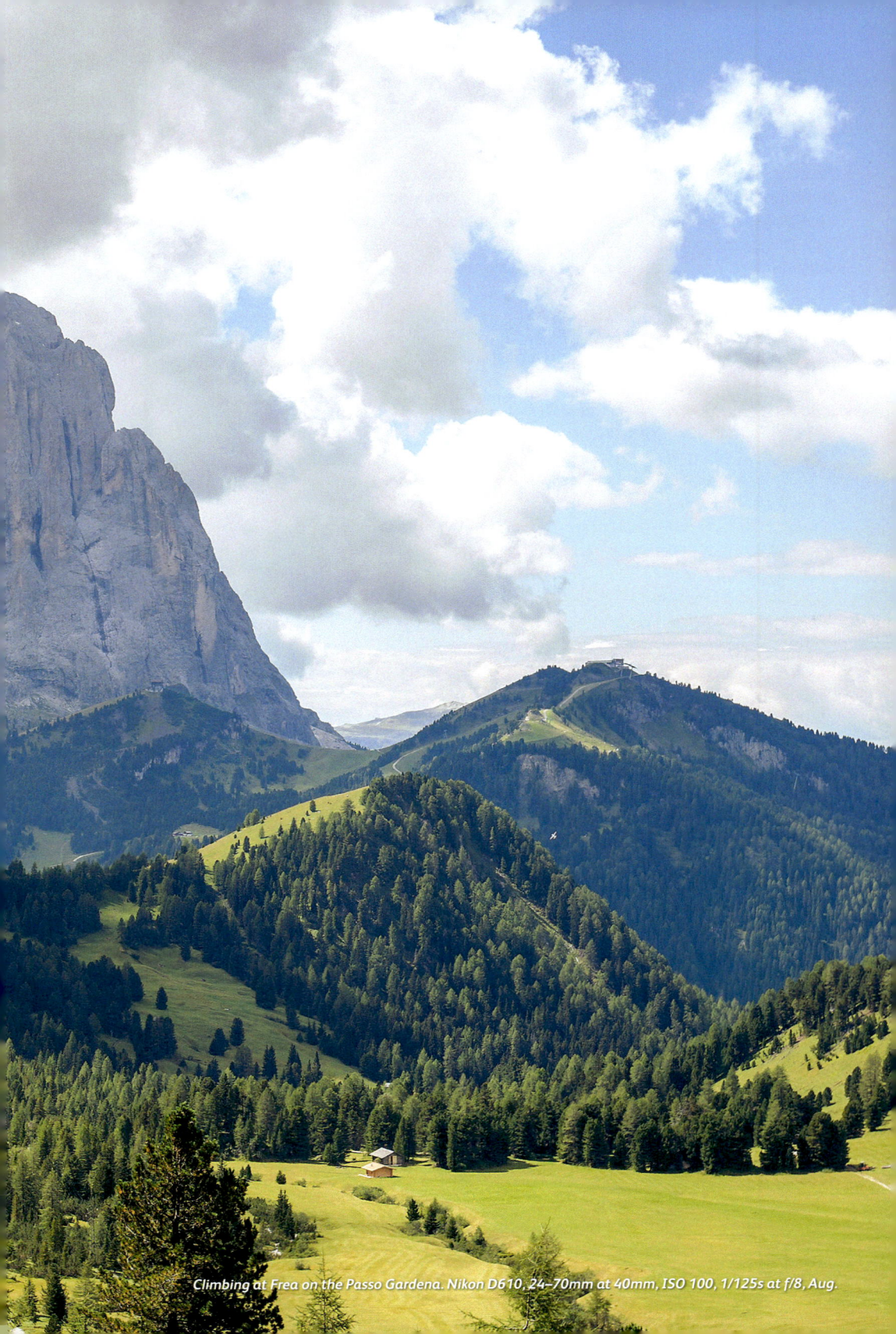
Climbing at Frea on the Passo Gardena. Nikon D610, 24–70mm at 40mm, ISO 100, 1/125s at f/8, Aug.

9 PASSO GARDENA PRATO / WIESE

Tucked below the Passo Gardena summit lies a beautiful open meadow that enjoys terrific views towards the huge north-east face of Sassolungo. Liberally studded with picturesque wooden huts this location is often overlooked and it is easy to find solitude here despite the close proximity to the Passo Gardena.

What to shoot and viewpoints

A gravel vehicle track leads north-west from the parking area, leading down onto the meadow in five minutes.

Viewpoint 1 – Huts & Sassolungo ♿
The many huts dotting the area provide the most obvious foreground looking towards the prominent east face of Sassolungo. Path 654 runs through the meadow and makes for an excellent leading line. During June and July, the many wildflowers add additional interest and can be used as a foreground by getting down low and then focus-stacking the image.

Viewpoint 2 – The Sella & Cir Groups ♿
Whilst Sassolungo provides the most obvious focal point, the Sella group to the south and Cir group to the north also feature several impressive rock towers that can be picked out with a longer lens.

Viewpoint 3 – Frea Climbing Crag
Looking south towards the Sella massif from the parking area you will Frea – a sports climbing crag with over 150 routes, both single and multi-pitch. If the weather has been dry (it does suffer from seepage) you will see lots of climbers ascending the dark rock, these can be framed using a long lens.

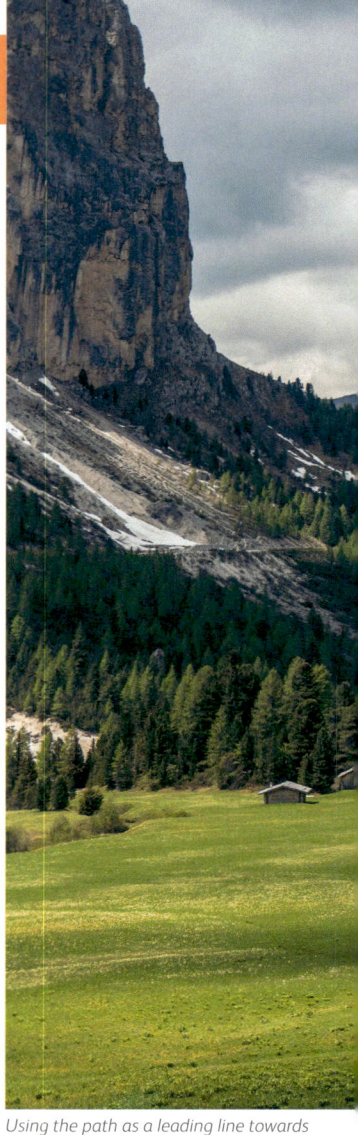

Using the path as a leading line towards Sassolungo. Nikon Z8, 24–120mm at 45mm, ISO 64, 1/500s at f/8, Aug.

Autumn colours of the surrounding larches. Nikon Z7II, 100–400mm at 180mm, ISO 64, 1/200s at f/7.1, Oct.

There are wonderful patterns and textures on many of the huts. Nikon D850, 24–70mm at 55mm, ISO 900, 1/160s at f/10.

How to get here

The wild flower meadow is situated just west and below the highest point of the Passo Gardena. It is accessed from the Val Gardena to the west or the Alta Badia to the east via the SS243. Travelling west the small parking area is found on the right just before Falesia Frera / Frea, 1km before the top of the pass. The parking has space for four vehicles and is found opposite a short gravel track which leads down onto the meadow – using the coordinates below is recommended.

P Lat/Long:	46.54287, 11.80434
P what3words:	///unrepeatable.whilst.copiers
P Tabacco:	Map 05 (1:25.000)
P Kompass:	Map 76 (1:25.000)

Accessibility

Approach: 5 minutes, 300m, 5m of descent.

♿ **Disabled access**: Though not particularly well surfaced the descent to the meadow would be possible in dry conditions providing the ground was not saturated.

Best time of year/day

Whilst this location is photogenic year round, a visit during late June and July is recommended as the wildflowers are spectacular.

The east / west orientation makes this an excellent sunrise and sunset location throughout the year.

VAL DI FUNES & VAL GARDENA – PASSO GARDENA PRATO / GRÖDNER JOCH WIESE

10. PASSO GARDENA / GRÖDNER JOCH

Reaching 2021m above sea level, the Passo Gardena is one of the four passes that make up the Sella Ronda – connecting the Val Badia and Val Gardena. Slicing its way between the Cir group and Sella massif for 15km, the scenery is spectacular throughout and none more so than at the top of the pass itself.

Built and consecrated in spring 2004 by the Selva Gardena branch of the Associazione Nazionale Alpini, the Cappella di San Maurizio chapel dominates the skyline. The interior houses a statue of Saint Maurice and Saint Christina, carved in wood as is the valley's tradition. The Alpini corps was first established in 1872 to prepare military troops for mountain warfare. During the First World War the corps was expanded to 88 battalions and then all but disbanded following the Cold War. Founded in 1919, the Associazione Nazionale Alpini aims to support and preserve the history and traditions of the Alpini soldiers. The Val Gardena branch which funded the chapel was formed in 1957.

What to shoot and viewpoints

There are viewpoints in all directions from the summit of the Passo Gardena, all with good convenient access.

Viewpoint 1 – Cappella di San Maurizio ♿

Visible from the road and presenting a choice of equally impressive backdrops, the chapel offers a number of compositions. The path can be used as an effective leading line in both landscape and portrait orientations.

There are several trees to the left of the chapel that offer an effective foreground with a wide-angle lens, framing the chapel on the right with the north-west faces of the Sella providing a dramatic backdrop. Try to include Torre Murfreit, the distinctive pillar protruding from the Sella.

If you don't have a wide-angle lens it can be difficult to create a nice composition up close; in this case, it is possible to shoot from further back by Hotel Cir.

Viewpoint 2 – East towards the Fanes & Tofane ♿

A short walk east along the road towards Rifugio Frara soon reveals far-reaching views over the Alta Badia, Fanes and Falzarego. There is a small hill with several benches just above the rifugio that offers a slightly higher perspective.

With a long lens, it is possible to isolate any number of the striking peaks on the skyline; the distinctive dome shape of Tofana di Rozes and the triangular outline of Monte Antelao are particularly photogenic.

Afternoon light illuminates Cappella di S.Maurizio. Nikon D610, 14–24mm at 14mm, ISO 100, 1/200s at f/9, Sep.

How to get here

The Passo Gardena can be approached from the Val Gardena to the west or the Alta Badia to the east via the SS243. There are several small dedicated car parks at the top of the pass, all of which impose a substantial parking fee during peak season. There is also a larger carpark at Rifugio Frara.

🅿 Lat/Long:	46.54988, 11.80659	
🅿 what3words:	///cobbles.listen.ringtones	
🅿 Tabacco:	Map 05 (1:25.000)	
🅿 Kompass:	Map 76 (1:25.000)	

Accessibility

Approach: 2 minutes, 0.1km, 10m of ascent.

♿ **Disabled access** at the top of the pass is generally good with well mainted paths surrounding the summit.

Best time of year/day

There is something to photograph in every direction from the top of the Gardena, making this a reliable location throughout the year and day. The easy access also makes this an excellent sunrise and sunset location either looking towards Sassolungo or the Tofane.

Due to the easterly orientation of Cappella di San Maurizio, the front of the chapel receives the best light in the morning. The sun sets just to the right of Sassolungo, often creating some dramatic skies behind the chapel at dusk.

Cappella di San Maurizio also makes for a convenient and easily accessible night-time foreground, especially in the summer months when the Milky Way is often positioned above the Sella.

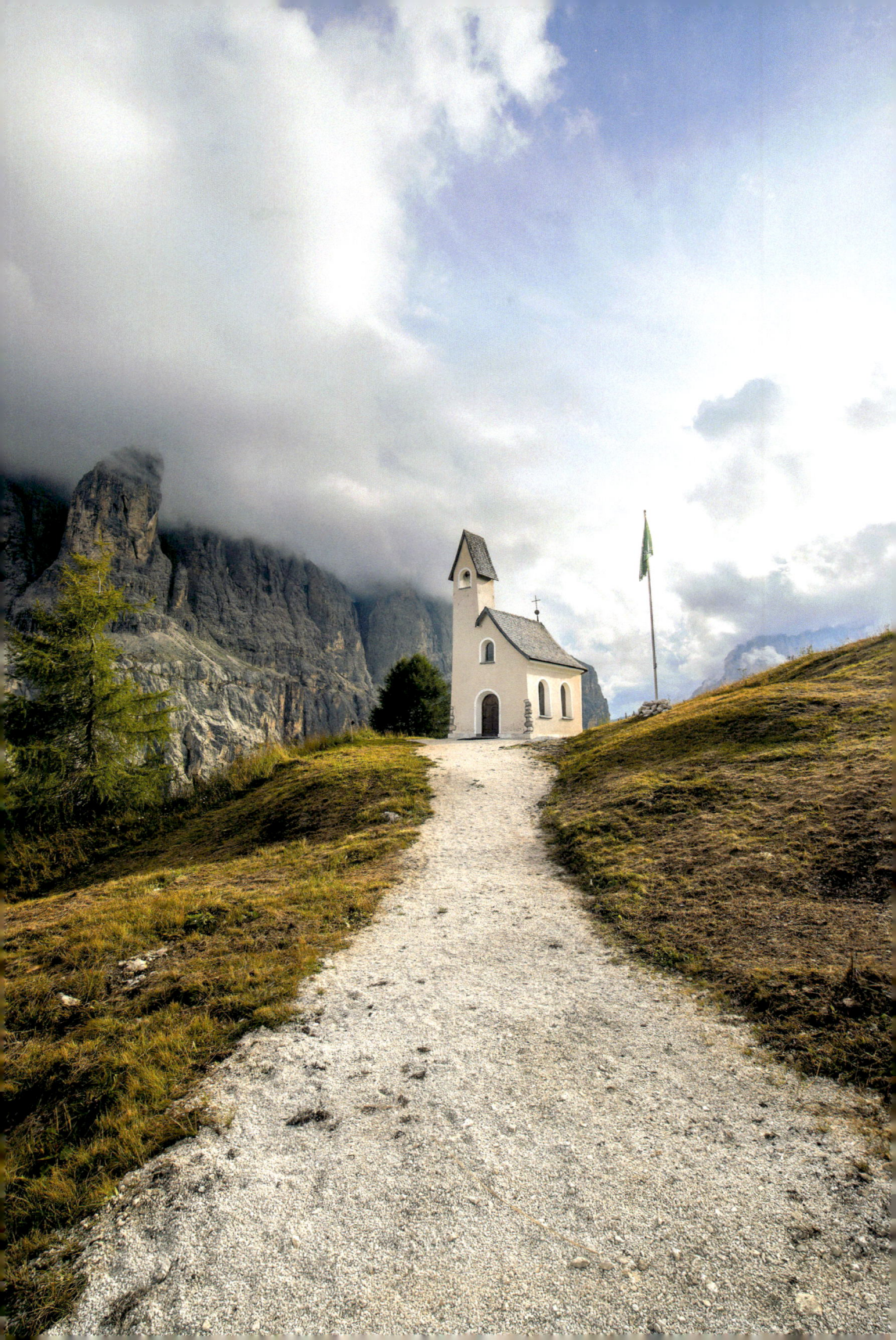

10 PASSO GARDENA / GRÖDNER JOCH

Viewpoint 3 – Sella Massif
Looking south from Rifugio Frara, a grassy ridgeline can be seen descending from the Sella to the top of the Passo Gardena. This can be used to create some attractive symmetry as the two valleys drop away to either side.

Viewpoint 4 – West towards Sassolungo
From the same vantage point above Rifugio Frara there are also excellent views south-west towards Sassolungo, looking down the pass. The road makes for an excellent leading line and there are several photogenic hairpins. Some old wooden huts complete the composition and provide additional foreground interest.

This easy-to-access location works particularly well at sunrise and sunset.

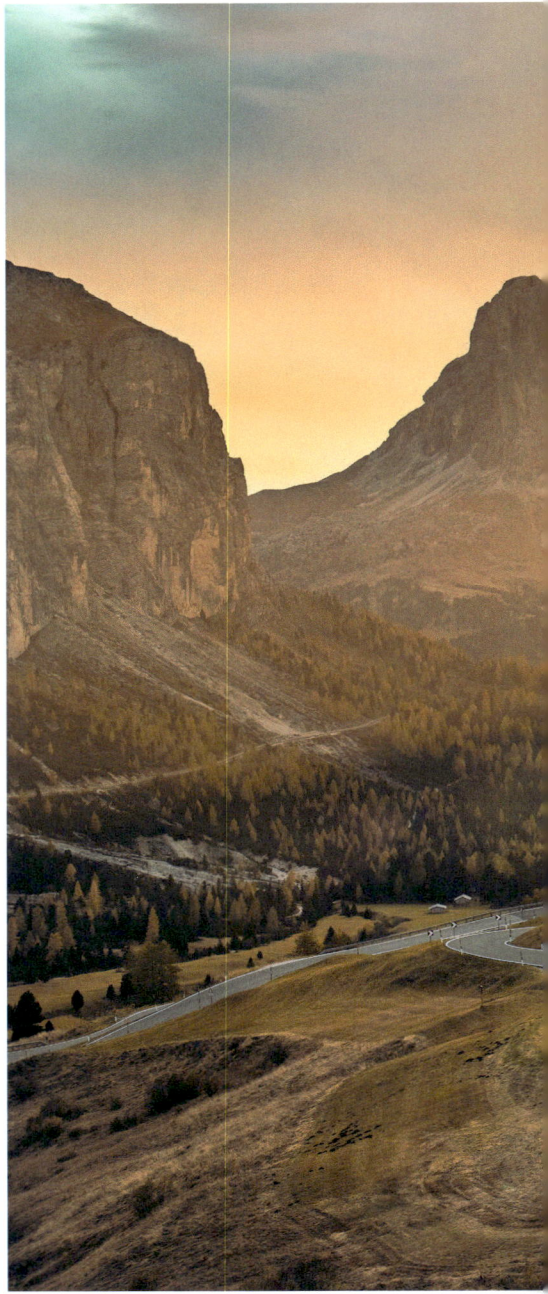

A cropped, 15 image exposure bracketed panorama of the Passo Gardena at sunset. Nikon Z7II, 24–120mm at 40mm, ISO 64, various at f/16, tripod, Oct.

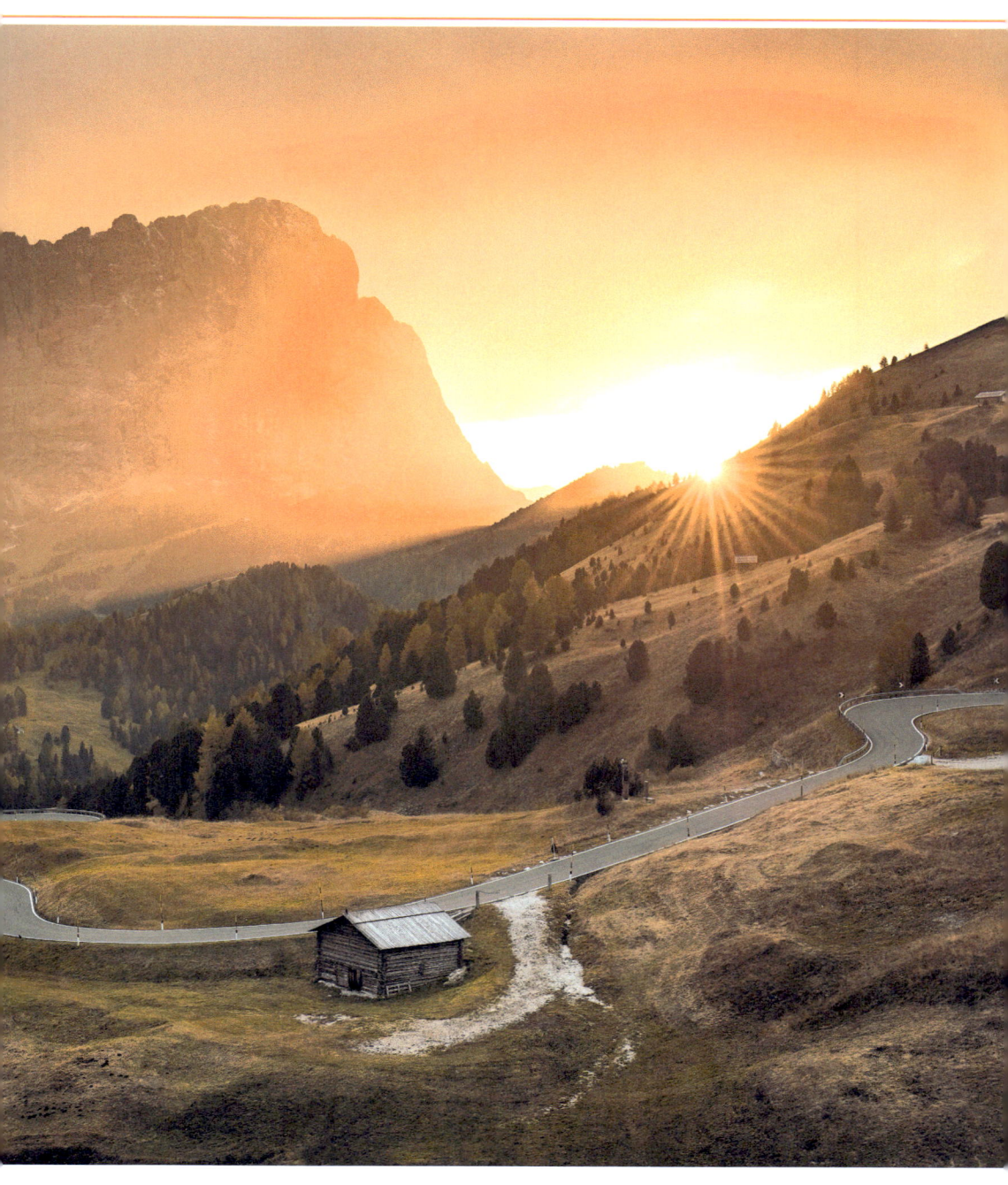

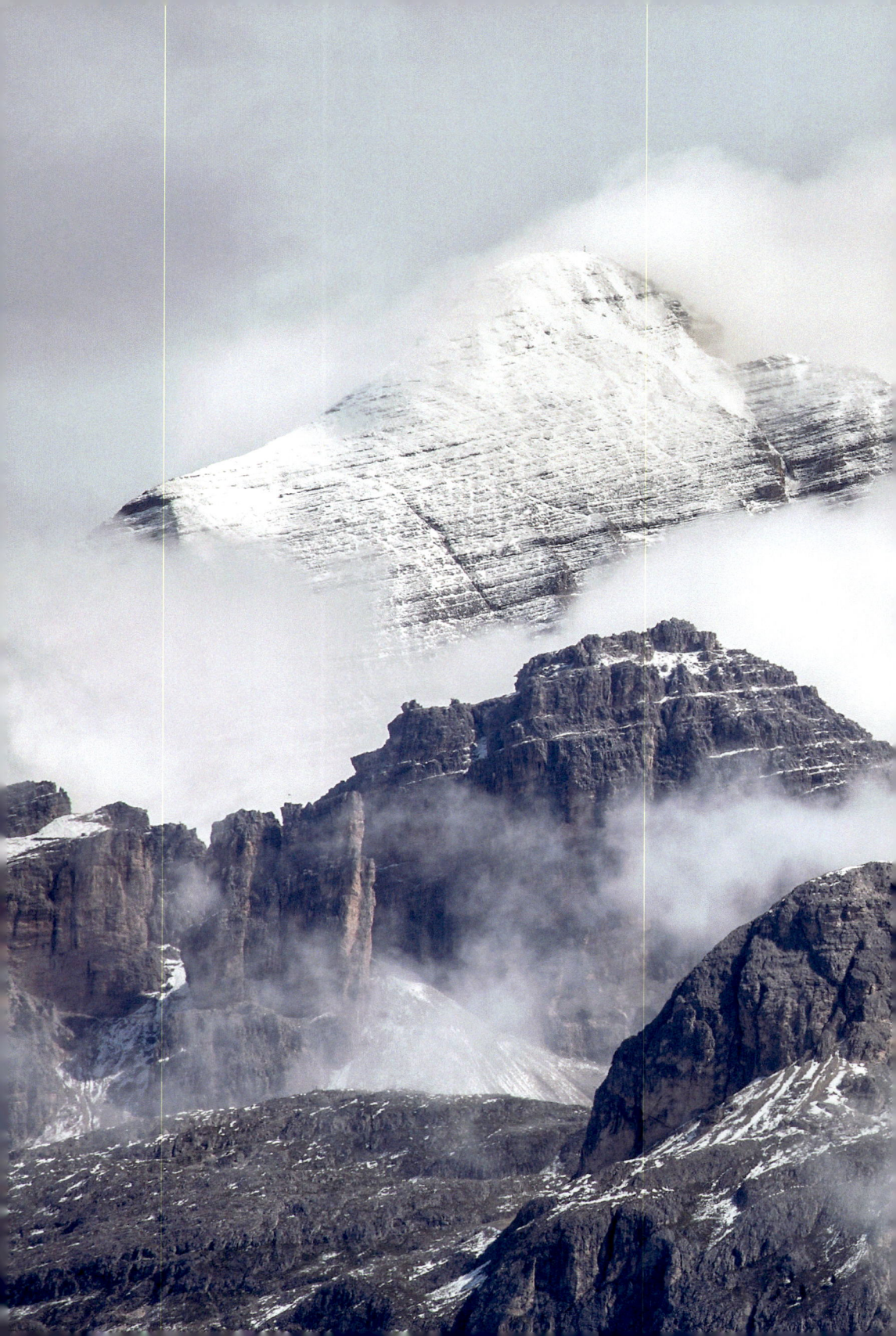

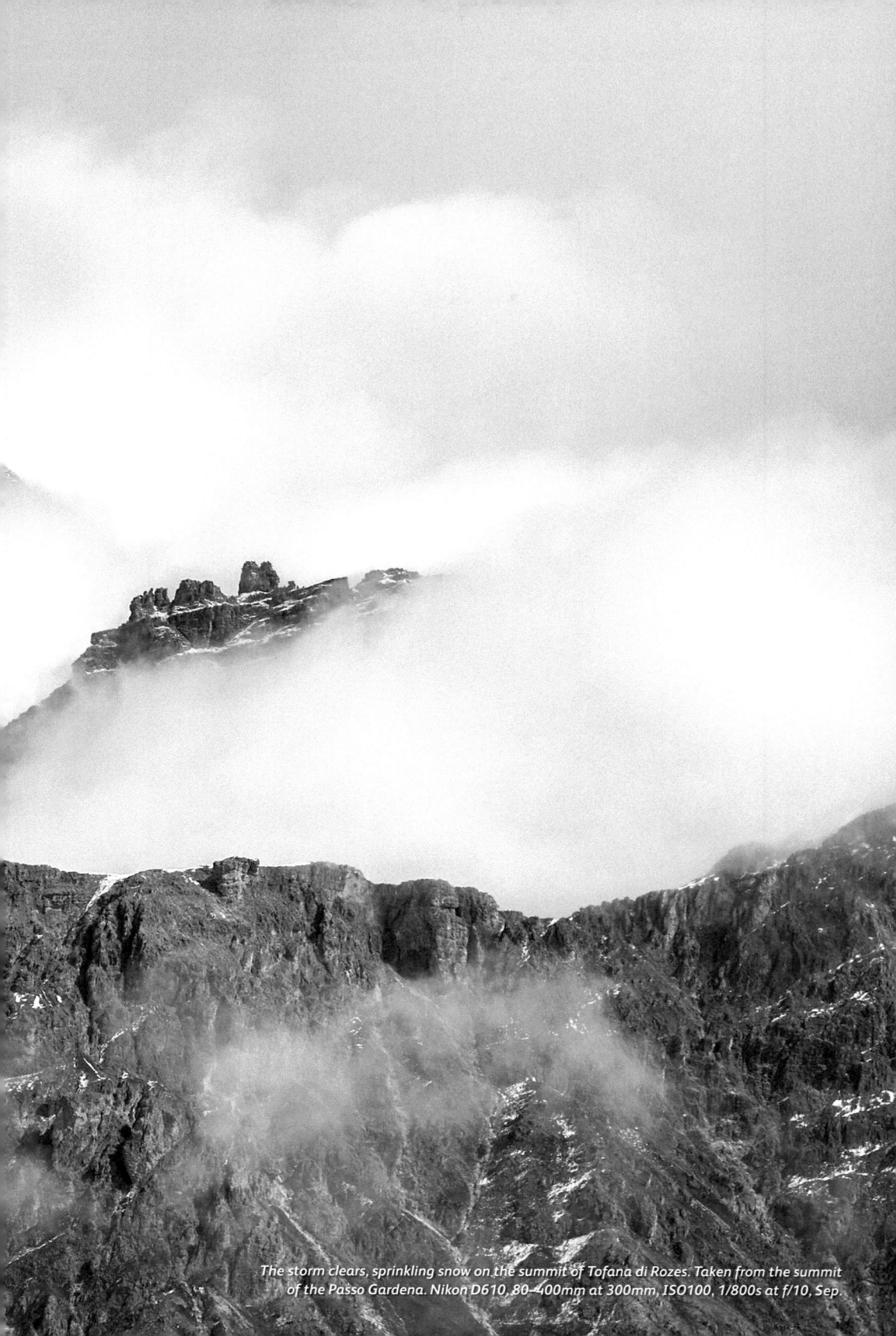

The storm clears, sprinkling snow on the summit of Tofana di Rozes. Taken from the summit of the Passo Gardena. Nikon D610, 80–400mm at 300mm, ISO100, 1/800s at f/10, Sep.

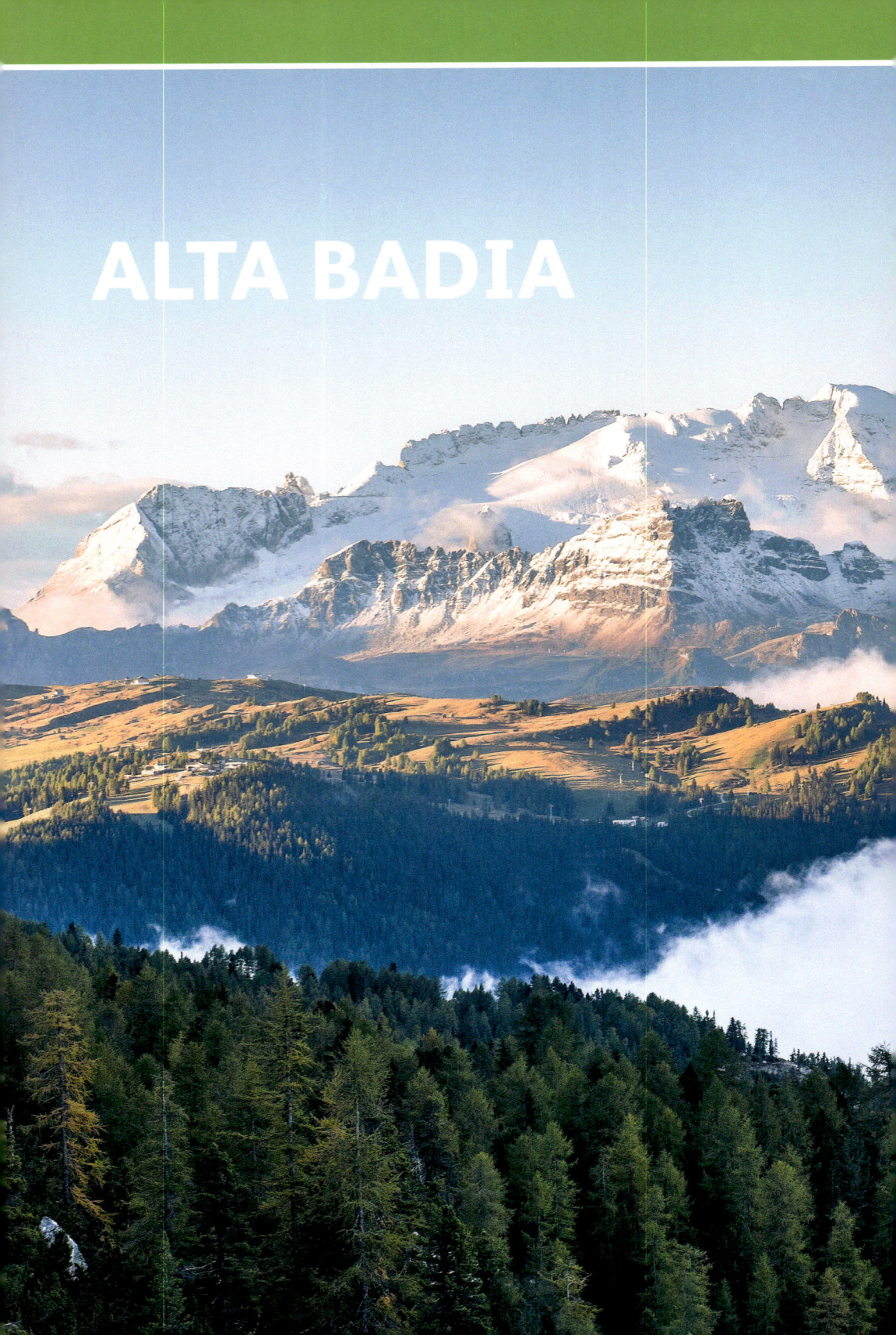

ALTA BADIA

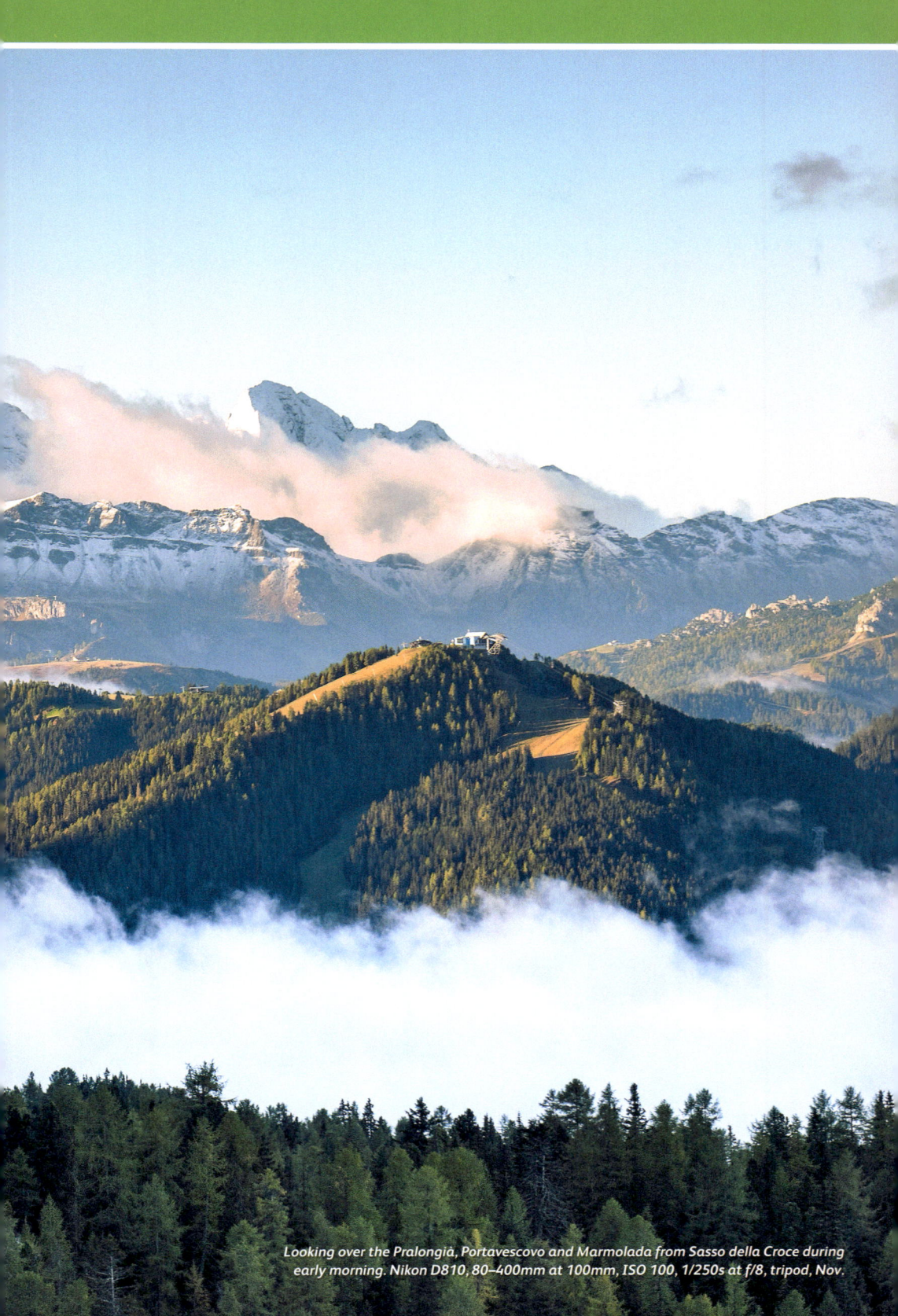

Looking over the Pralongià, Portavescovo and Marmolada from Sasso della Croce during early morning. Nikon D810, 80–400mm at 100mm, ISO 100, 1/250s at f/8, tripod, Nov.

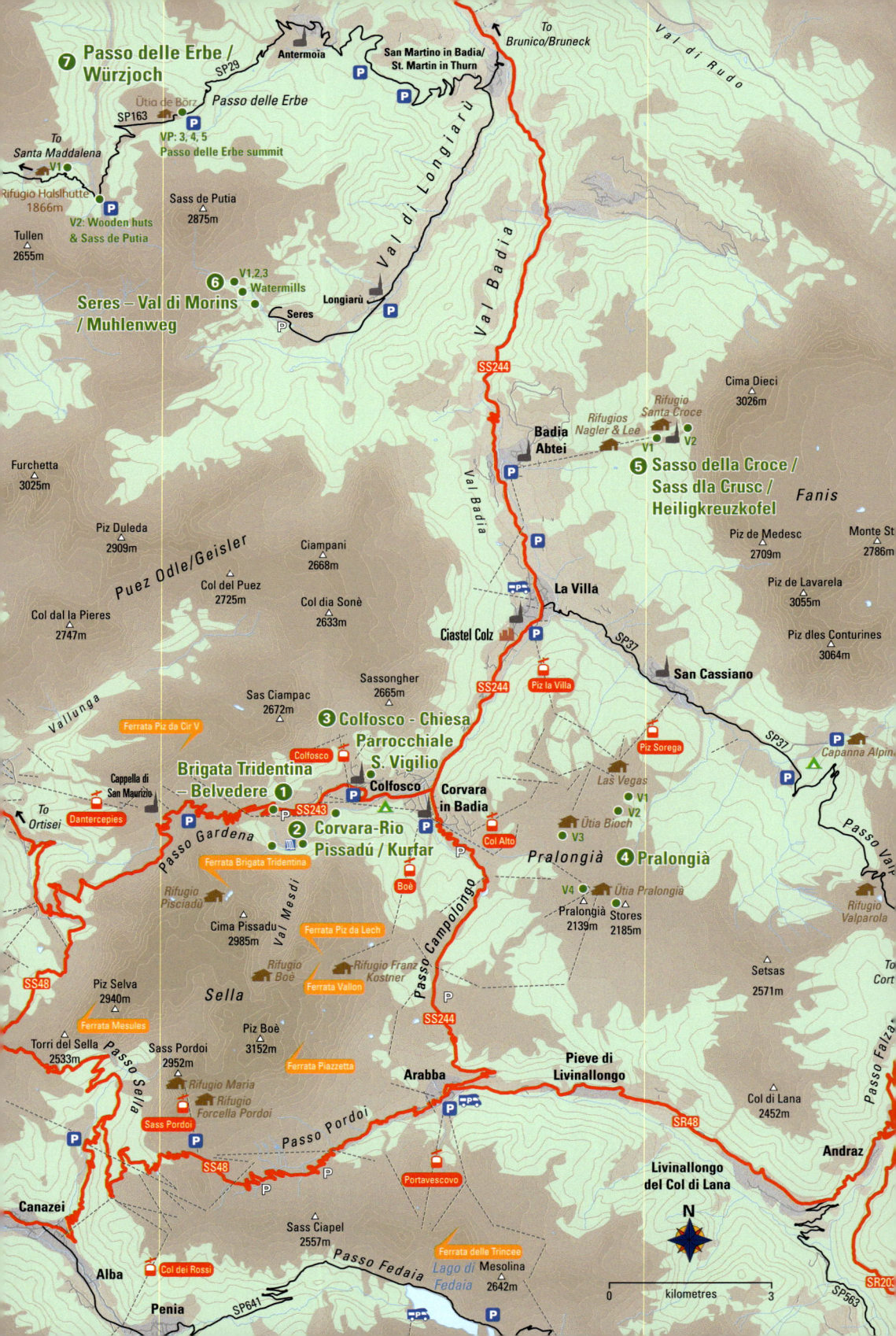

ALTA BADIA – INTRODUCTION

The Val Badia is the largest of the four Ladin valleys that diverge from the Sella massif, extending northwards and descending to meet the Val Pusteria just west of Brunico. The Alta Badia refers to the upper part of the valley, an area which has rapidly become the nucleus for tourism in the Dolomites, particularly during the winter months. With just over two-thirds of the local populace working in the service sector and boasting a higher concentration of Michelin stars than any other valley in the Alps, the Alta Badia is exceptionally well equipped for the travelling sightseer.

The area has an excellent road network and is perfectly situated on the Sella Ronda, a 48km tour of the Sella Massif, providing easy access to Arabba, Selva, the Falzarego, Cortina d'Ampezzo and the Val di Funes via the Campolongo, Gardena, Valparola and Erbe passes.

Despite its extensive tourist infrastructure, the Alta Badia somehow manages to retain an enchantingly authentic feel, primarily thanks to its efforts to preserve, protect and promote the strong Ladin heritage so associated with the region. The language of Ladin exhibits similarities to the traditional Swiss language of Romansch and is still widely spoken throughout the valley.

Predominantly an agricultural society, the Alta Badia began attracting its first tourists during the early 19th century, as alpine pioneers were drawn to the rock faces lining the valley. Winter tourism, specifically skiing, arrived to the valley in winter 1947 with the installation of Italy's first chairlift at Col Alto above Corvara, and since then the region has evolved into a thriving ski resort, attracting thousands of skiers each year and hosting the men's world cup slalom event on the 'Gran Risa' piste above La Villa.

At the northern end of the valley, nestled against the Sella Massif and under the watchful gaze of Sassongher (2665m), a mountain known affectionately by the locals as 'La Madonna' (the mother), the town of Corvara is the largest of the 14 villages found within the Val Badia. Keen cyclists flock here in their thousands, drawn to the challenge of high mountain passes, alluring views and the notorious Maratona dles Dolomites, a gruelling 138km road race that starts from the town centre.

The Alta Badia is not just for the super fit however, and there are a number of lifts that run throughout the summer months. The Pralongia plateau can be accessed via gondola from Corvara, La Villa or San Cassiano, another gondola leads onto the Sella from Corvara and a double chairlift above the village of Badia accesses the beautiful Santa Croce church beneath the imposing west face of Sasso della Croce.

LOCATIONS

1	Brigata Tridentina Viewpoint	206
2	Corvara – Rio Pissadú / Kurfar	210
3	Parrocchia di Colfosco / Pfarrkirche Kolfuschg	212
4	Pralongià	216
5	Sasso della Croce / Sass dla Crusc / Heiligkreuzkofel	222
6	Seres – Val di Morins / Muhlenweg	226
7	Passo delle Erbe / Würzjoch	230

Maps

- Tabacco (Italian): Map 05, 07, 30
- Kompass (German): Map 624, 627

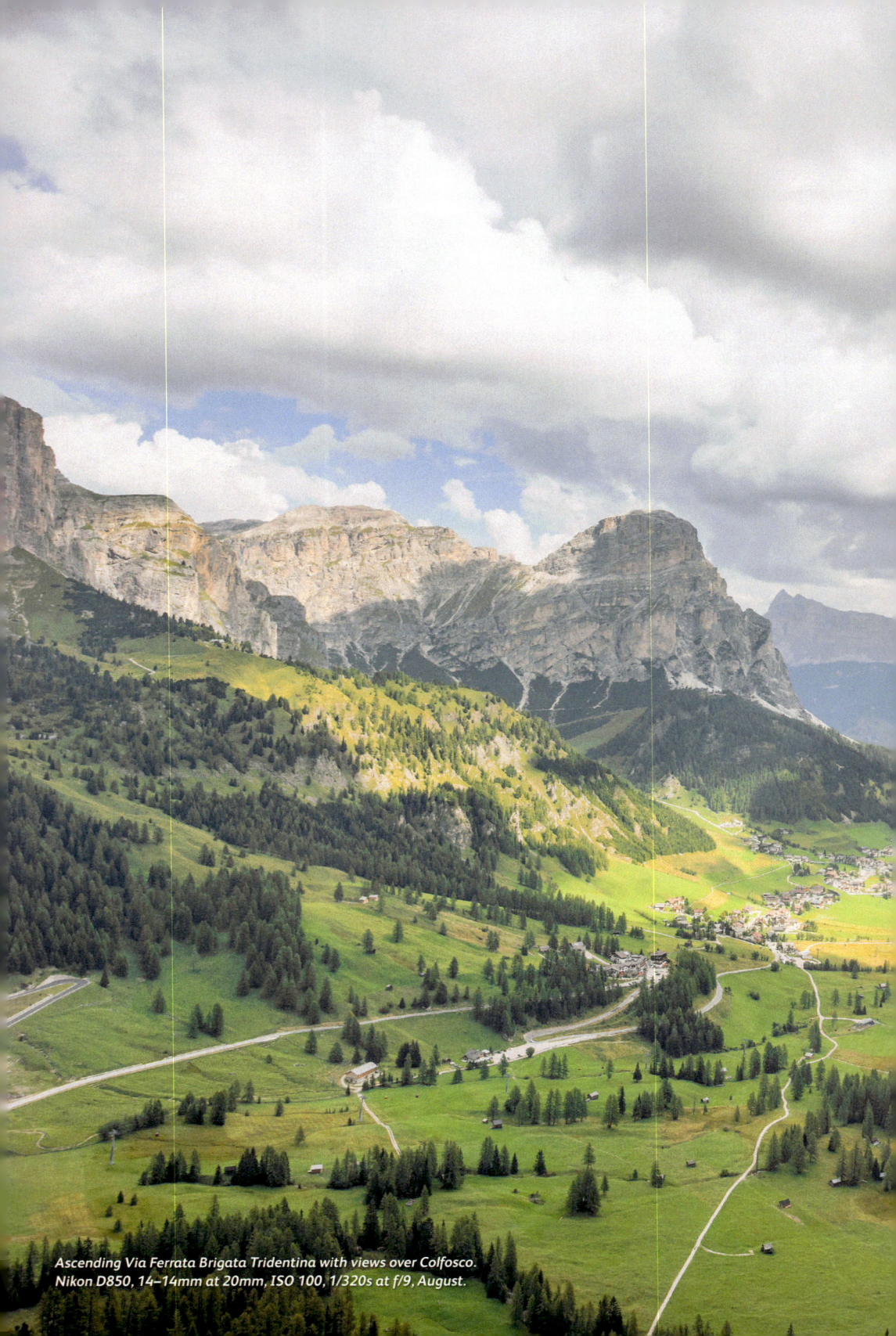

Ascending Via Ferrata Brigata Tridentina with views over Colfosco.
Nikon D850, 14–14mm at 20mm, ISO 100, 1/320s at f/9, August.

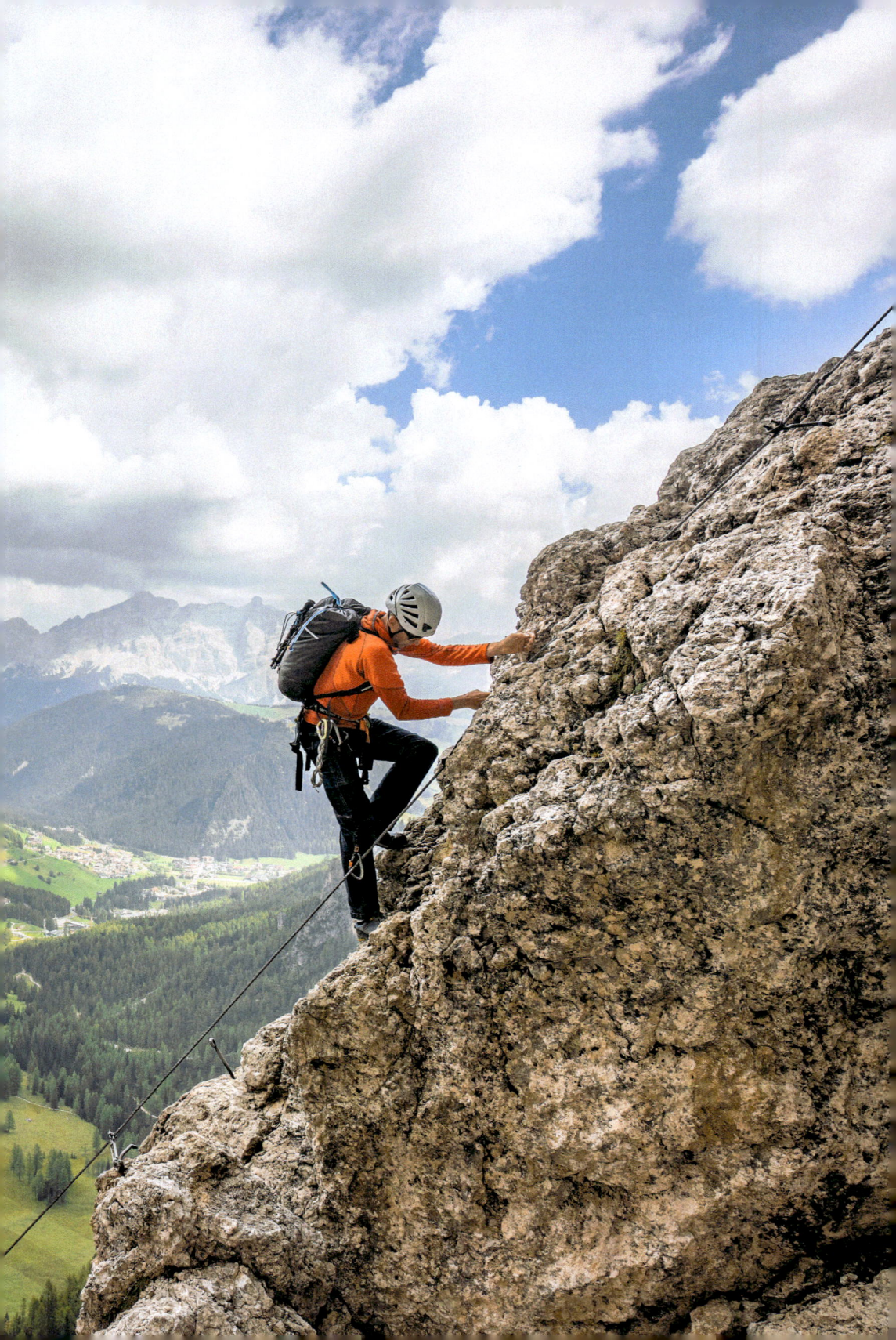

1. BRIGATA TRIDENTINA VIEWPOINT

Constructed in 1960 by the Italian army with help from Germano Kostner, the then custodian of Rifugio Pisciadù, Brigata Tridentina is the most famous and well-travelled via ferrata in the Dolomites. The route owes much of its fame to the dramatic suspension bridge which was added during 1967 to span the gap between Torre Exner and Mur de Pisciadù. The bridge is visible from the roadside on the road up towards the Passo Gardena and creates an excellent photo opportunity for anyone travelling over the pass.

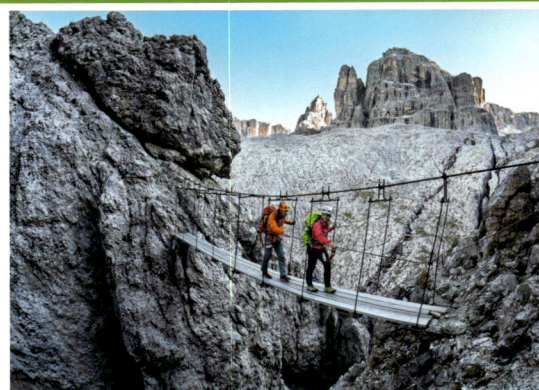

Crossing the bridge between Torre Exner and Mur de Pisciadù.
© Dan Patitucci.

What to shoot and viewpoints

Viewpoint 1 – Brigata Tridentina Bridge

There are so many spires and towers on the north faces of the Sella massif that the bridge can be difficult to spot at first. Looking south from the lay-by, try to pick out the square silhouette of Torre Exner located just left of the characteristically black wall of Mur de Pisciadù. The bridge is located halfway down the characteristic gap.

A long telephoto lens is required if you wish to isolate just the bridge itself. This shot works well as a portrait composition to help provide a sense of scale and height. Alternatively, it is possible to create an effective landscape photo by placing the bridge on the right and using the distinctive outline of Cima Pisciadù to fill the frame on the left. In either case, it's best to underexpose the bridge to create a more dramatic and striking silhouette.

Viewpoint 2 – Tofana di Rozes

Looking east from the lay-by you also get an excellent view of the photogenic Tofana di Rozes flanked by Lagazuoi Piccolo and Lagazuoi Nord. Once again, you will need a long telephoto lens to do the shot justice, bringing the mountains closer for a more dramatic effect. Tofana di Rozes holds snow on the summit for much of the year, helping to emphasise the peak's impressive height. Additionally the snow helps to highlight and define the distinctive shield profile of this beautiful peak. With a lens of at least 300mm, it is actually possible to make out climbers and mountaineers on the summit.

How to get here

From Corvara, take the SS243 west following signs for the Passo Gardena. Pass through the village of Colfosco and continue to reach the third hairpin bend. Follow the hairpin round to the right (an access track continues straight on) and park immediately on the right in a small roadside lay-by. The correct hairpin is found two hairpins after Ristorante Bar Mesoles.

- **Lat/Long:** 46.549236, 11.830906
- **what3words:** ///swims.gets.proceedings
- **Tabacco:** Map 05 (1:25.000)
- **Kompass:** Map 624 (1:25.000)

Accessibility

Approach: Roadside access.

Disabled access: Excellent; the classic shot of the Brigata Tridentina bridge crossing can be taken from the car window.

Best time of year/day

The best time of year to capture climbers crossing the bridge is between early July to mid September, when the route generally sees the most traffic. Most parties opt for a relatively early start and climbers can normally be spotted from mid morning through to early afternoon when the weather forecast is good.

Opposite: A climber crosses the suspension bridge on Via Ferrata Brigata Tridentina. Nikon D810, 80–400mm with 1.4x teleconverter at 560mm, ISO 800, 1/640s at f/8, Aug.

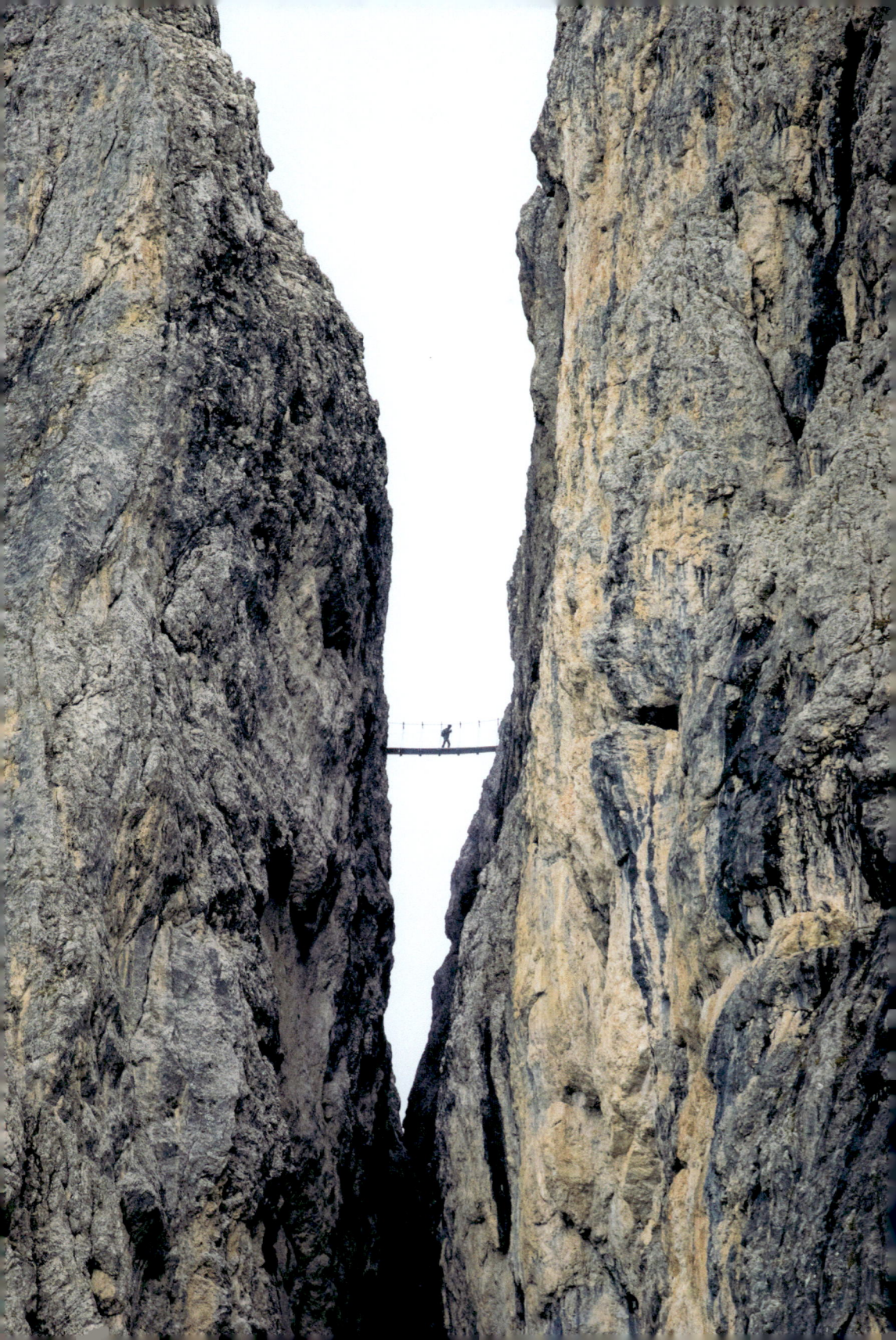

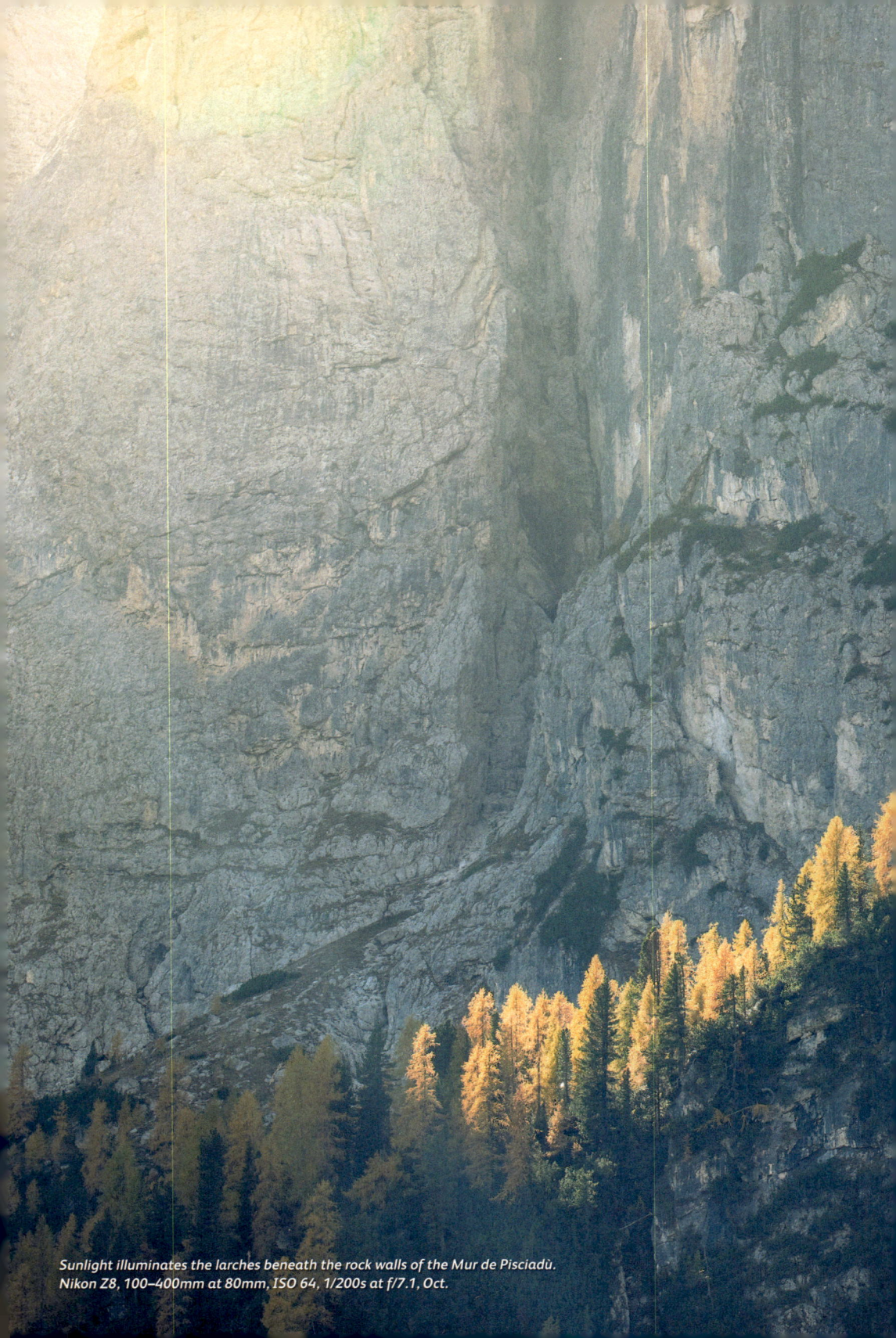
Sunlight illuminates the larches beneath the rock walls of the Mur de Pisciadù. Nikon Z8, 100–400mm at 80mm, ISO 64, 1/200s at f/7.1, Oct.

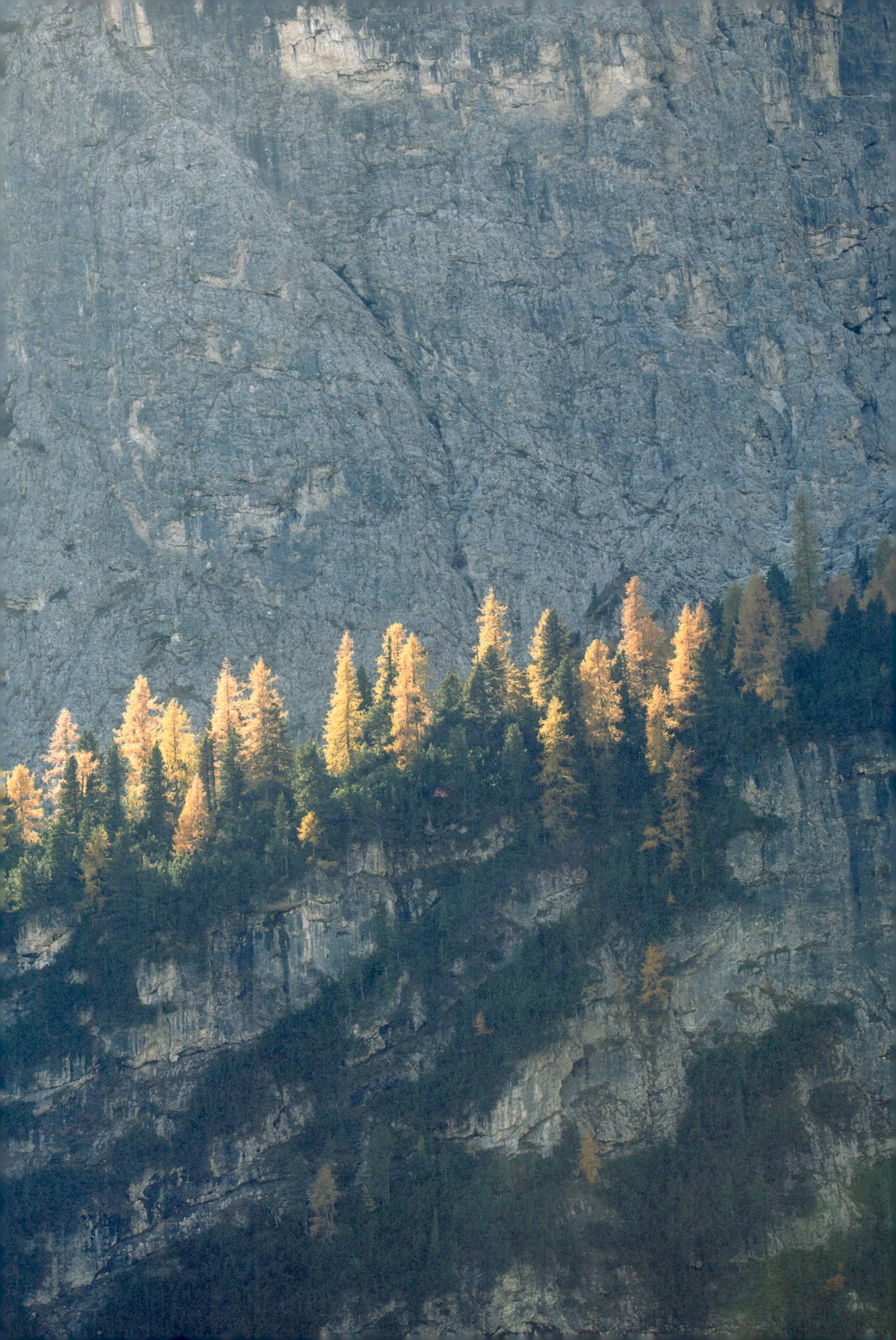

② CORVARA – RIO PISSADÚ / KURFAR

Rio Pissadú flows down from the Sella massif in a series of impressive cascades that run parallel to Via Ferrata Brigata Tridentina before joining Rio Torto in Corvara. The rocky stream is a good size and offers enough white water to provide some photogenic interest while remaining accessible from Corvara and Colfosco.

While the proposed circuit wouldn't be considered a classic of the Dolomites, it does provide an excellent wet weather option or a good afternoon stroll from the popular town of Corvara. The walk takes roughly three hours to complete and there are several options for returning early.

What to shoot and viewpoints

From the Boè gondola lift station car park in Corvara, take path 28 west through the Borest forest, following signs for 'Cascades'. The track ascends gently before levelling out, passing Camping Colfosco on the left. After another 10 minutes of walking you will see a nature trail signposted off to the right. Turn right here onto the little path that leads down to the stream.

Viewpoint 1 – Rio Pissadú ♿
With its rich vegetation and varied stream bed, the small stream provides a number of photo opportunities throughout the year. Just below the nature trail turn-off there is a photogenic wooden bridge leading towards Colfosco with a small waterfall directly beneath it.

Viewpoint 2 – Cascate del Pisciadù
Continue westwards along the main track (path 28), still following signs for 'cascades'. Shortly after, the dramatic rock walls of the Val Mesdi (valley of the midday sun) come into view on the left. Continue straight ahead for around 30 minutes to reach a beautiful picnic area beneath the falls. Turn left and ascend a rocky path to a bridge and viewing platform directly below the waterfalls. The narrow gorge and substantial fall height of the main cascade suit a portrait composition; the hard part is keeping your lens dry if the water volume is high.

To return, retrace your steps back to the picnic area and then turn on path 651 signposted towards Colfosco. Cross through a series of beautiful meadows (some good macro opportunities to be had here) to reach the village, then continue following good signposting to return to Corvara.

How to get here

Corvara sits at the head of the Val Badia and can be approached from the west via the Passo Gardena, the south via the Passo Campolongo, or from the Val Badia itself via the SS244. The circuit described here departs from the Boè gondola lift station car park which is well signposted throughout the village.

Rio Pissadú can also be approached from Colfosco to create a shorter circuit. Park in the large car park adjacent to the Colfosco ski pass office and high ropes course on the south side of the village. The first viewpoint can then be accessed following the path west to the Colfosco gondola lift station before turning left to cross a wooden bridge to join with path 28.

📍 Lat/Long:	46.5489, 11.87096
📍 what3words:	///sizzle.suffix.lighted
📍 Tabacco:	Map 05 (1:25.000)
📍 Kompass:	Map 624 (1:25.000)

Opposite: The bridge on the nature trail is very photogenic. Nikon Z7II, 20mm, ISO 64, 1s at f/22, tripod, May.

Accessibility

Approach: 20 minutes, 2km, 50m of ascent.

♿ **Disabled access**: Good paths are found throughout this circuit with the exception of the access to the Rio Pissadú stream bed itself. The Cascate del Pisciadù viewing platform is not suitable for disabled access as it requires ascending a narrow and rocky path. The complete circuit is 8km and takes roughly 3 hours.

Best time of year/day

The circuit can be completed throughout the year but the stream does freeze during the winter period. The Cascate del Pisciadù waterfalls transform into a spectacular icefall during the coldest months, although during this period the final approach to the viewing platform requires crampons and mountaineering experience.

Winter aside, the Cascate del Pisciadù are at their most dramatic after heavy rainfall and during the spring when snow melt elevates the water levels.

The nature of stream photography suits flat light conditions to remove harsh shadows, making it a good poor weather destination.

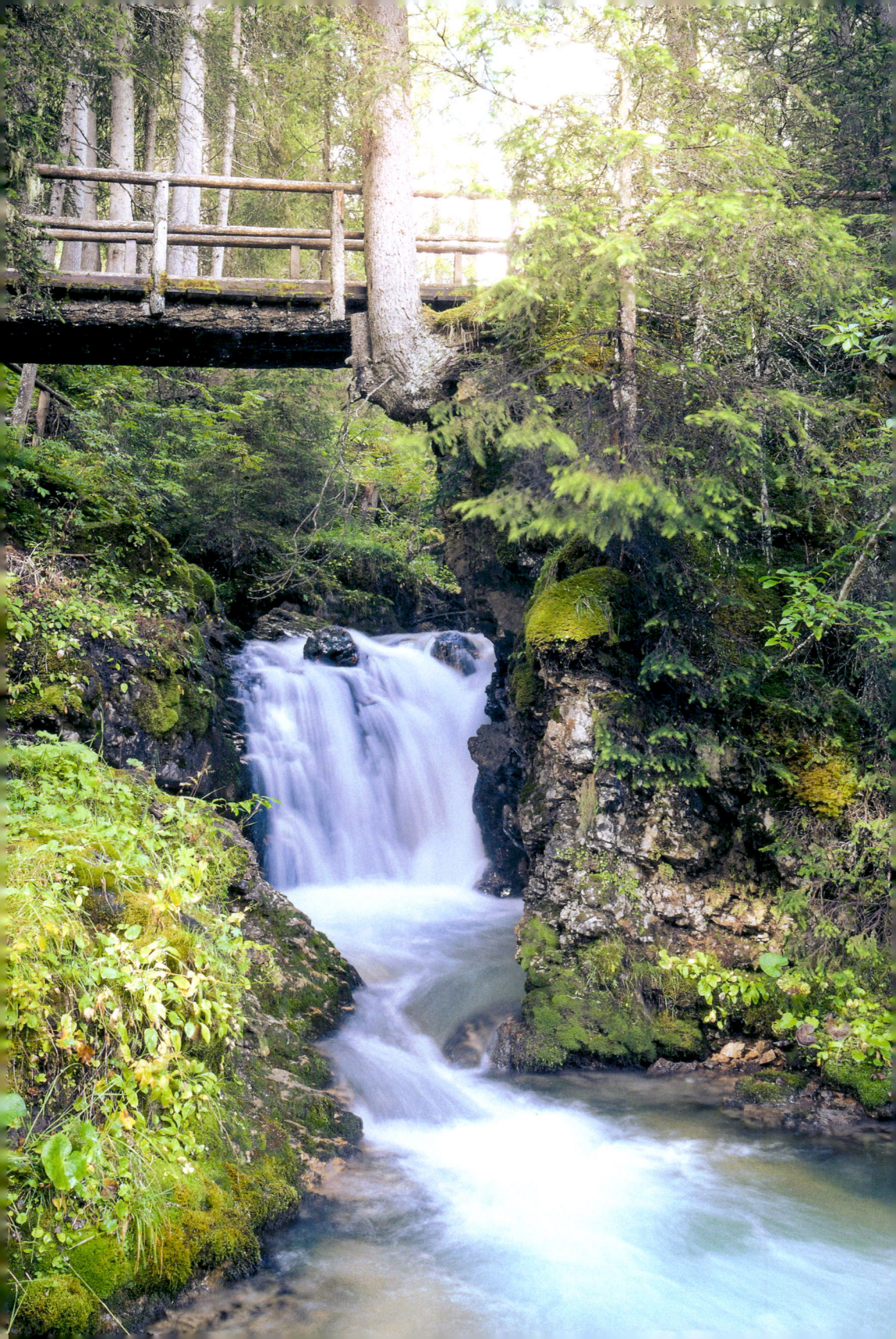

PARROCCHIA DI COLFOSCO / PFARRKIRCHE KOLFUSCHG

Constructed in late Gothic style, the onion-domed parish church of San Vigilio is renowned for its fairytale location backed by the dramatic north faces of the Sella Group and the famous Val Mesdi. The easy and convenient access provided by the nearby Passo Gardena ensures that this is one of the most photographed churches in the Dolomites.

The exact age of the original church is contested, although documents mention the building as early as 1419. Accounts indicate that the building underwent major restoration between 1629 and 1869 as a new Gothic narthex and bell tower were added. Consecrated to San Vigilio and the Archangel Michael, there are numerous figurines depicting the two, although the original statue of San Vigilio has been replaced by a replica due to the historical value of the original piece.

What to shoot and viewpoints

Viewpoint 1 – Parrocchia di Colfoscoo

Despite the beauty of the scene, the possibilities for different compositions are somewhat limited, especially given that the view looking south-west is so undeniably spectacular. While the aspect is restricted, a pleasing composition can be attained at a variety of focal lengths. Using a wide-angle it is possible to include the perimeter fence and even the trees as foreground interest. Using a tripod in conjunction with a narrow aperture will help to keep the majority of the scene in focus. Alternatively, it is possible to focus blend during post processing or utilise focus stacking software. Indeed, you may not want everything in focus and may wish to use a wide aperture and shallow depth of field to keep the church in focus while softening the foreground.

During the winter season, a series of four spectacular icefalls form consistently to the east of the Val Mesdi, adding significant interest to the left of the frame.

With the aid of a longer focal length you can crop closer, isolating the church and removing some of the distracting buildings surrounding the area.

Viewpoint 2 – Church Grounds

The church grounds are immaculately tended and the graveyard overlooking the Sella is particularly worthy of exploration. The intricate memorials, flowers and decorations are beautifully arranged facing the dramatic panorama. Light rays, sunbursts and reflections can be used to good effect in the early afternoon once the sun has passed over the Val Mesdi.

In the evening, a mix of electric and natural candles are lit, creating a peaceful and thought-provoking scene in front of the Sella massif. Cameras are permitted but please be respectful and refrain from taking photographs on a Sunday and during religious celebrations.

Opposite top: Chiesa di S.Vigilio in summer. Nikon D810, 16–35mm at 35mm, ISO 100, 1/400s at f/10, Jul.
Bottom: Chiesa di S.Vigilio in winter. Nikon D810, 16–35mm at 32mm, ISO 100, 1/320s at f/9, Jan.

How to get here

Colfosco lies just west of Corvara and can be approached from the south via the Passo Campolongo, from the Val Badia via the SS244 or from Selva driving over the Passo Gardena. The church is well signposted from the centre of the village.

Lat/Long:	46.554587, 11.855525
what3words:	///adaptations.dimension.referee
Tabacco:	Map 05 (1:25.000)
Kompass:	Map 624 (1:25.000)

Accessibility

Approach: Roadside access.

Disabled access: Chiesa Parrocchiale San Vigilio has its own dedicated car park and has good disabled access throughout.

Best time of year/day

With its ease of access and magnificent backdrop of the Sella, Chiesa Parrocchiale San Vigilio makes for an impressive scene year round and as such the location isn't seasonably dependant.

During the spring it is possible to use some of the flowerbeds surrounding the site as a striking foreground. Just be sure to ask permission before stepping into anyone's garden.

The easterly aspect of the church receives the best light during early morning, although it is possible to create some striking sunstars above the Val Mesdi at midday.

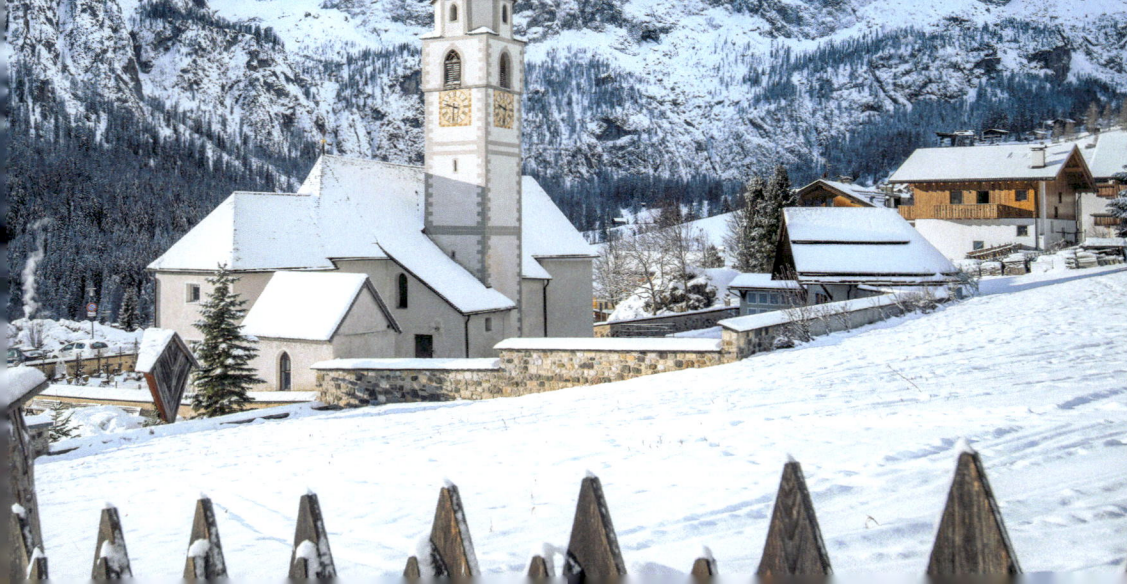

A ski mountaineering day out on Sassongher, descending the Val Scura (Dark Valley) couloir. **Above**: *Nikon D850, 24–70mm at 24mm, ISO 100, 1/250s at f/8, Mar.* **Below left & right**: *Nikon D850, 24–70mm at 24mm, ISO 100, 1/500s at f/8, Mar.*

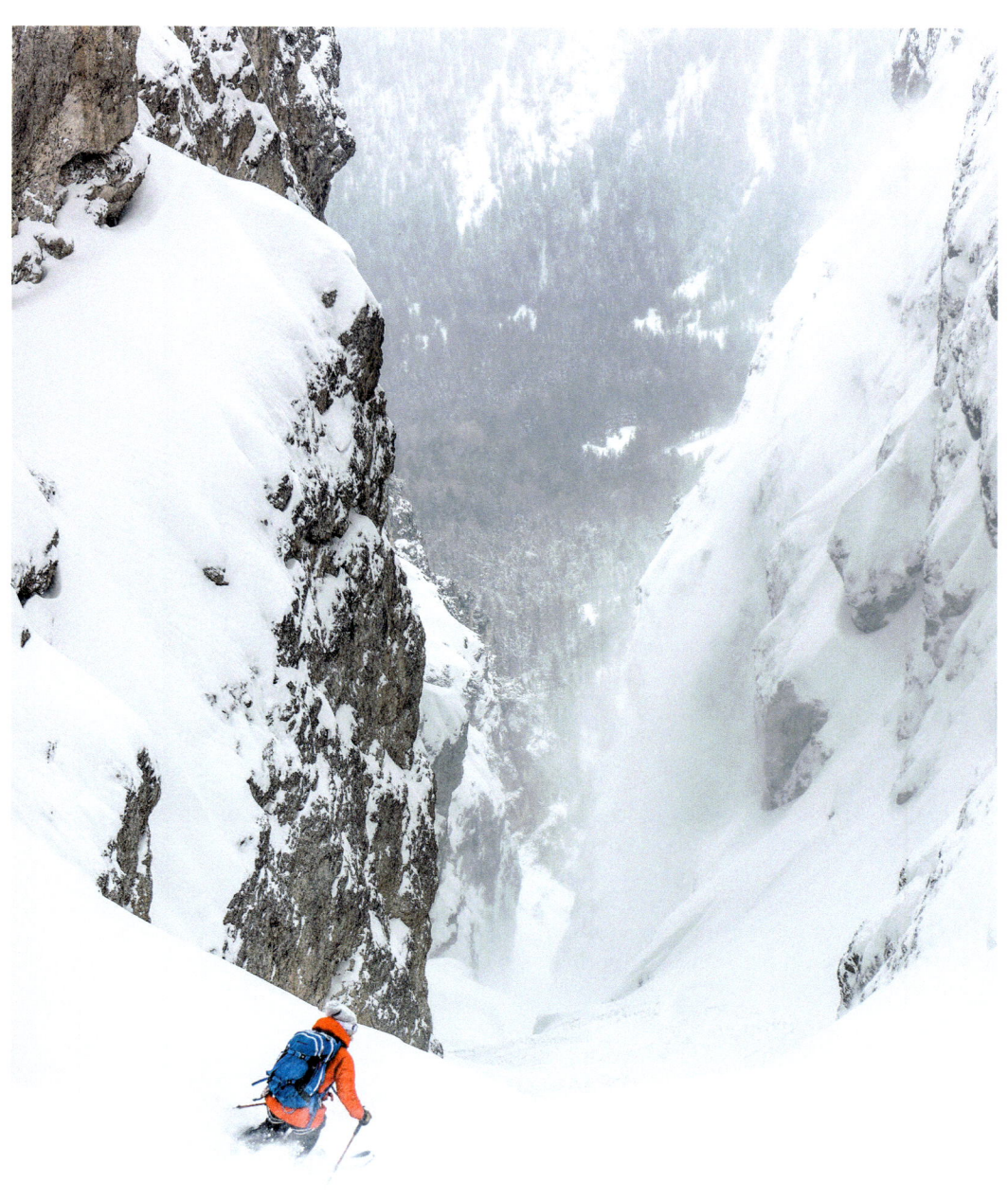

Descending the lower couloir. Nikon D850, 24–70mm at 70mm, ISO 400, 1/800s at f/9, Mar.

4 PRALONGIÀ

The Pralongià, which means 'long grass' in Ladin, is a plateau of high alpine meadows separating the villages of Corvara, La Villa and San Cassiano. Surrounded by the Sella, Puez-Odle, Fanes and Lagazuoi groups, the plateau enjoys wonderful views in all directions. Despite a well-developed ski infrastructure, the area manages to retain a rustic feel throughout the summer, with the numerous huts and wooden rifugios dotted around the meadow bringing a pastoral charm to the dramatic setting.

Much like the larger Alpe di Siusi, this area offers endless potential for viewpoints and so suits a spontaneous style of photography. The suggested hike to the summit of Pralongià from the top of the Piz Sorega gondola takes roughly 3 hours and is just one of many possible ways to explore the plateau.

What to shoot and viewpoints

From the top of the Piz Sorega gondola head south towards Rifugio Las Vegas on path 21A, following signs for Pralongià. Pass the rifugio to reach the top station of the Ciampai chairlift and continue for 300m until a small lake comes into view on the left; access this by a small path.

Viewpoint 1 – Pralongià Pond
This small nameless pond, complete with wooden jetty and the spectacular backdrop of the Fanes and Lagazuoi groups, is a veritable hidden gem. The most striking aspect looks east towards the west faces of the Fanes, making it a perfect late afternoon and sunset location. A variety of focal lengths all prove effective, from the very wide to a tighter frame focusing on the jetty. If the water surface is still, experiment with a subject on the wooden pier, taking advantage of the symmetry created by the reflections.

To continue, retrace your steps uphill back to path 21A.

A southern hawker dragonfly. Nikon D850, 300mm, ISO 500, 1/400s at f/5.6. Aug.

The small pond just south of Rifugio Las Vegas. Nikon D610, 24–70mm at 38mm, ISO 100, 4s at f/10, tripod, ND filter, Jul.

Small wooden huts liberally dot the plateau. Nikon D810, 24–70mm at 38mm, ISO 100, 1/400s at f/10, Oct.

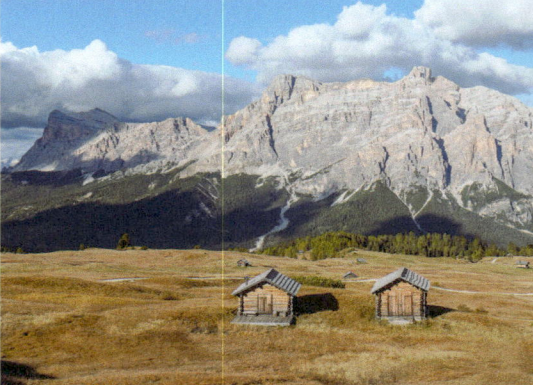

Continue south on the large track for another 300m to reach a giant pair of wooden sun loungers on the left and two beautiful huts in the meadow to the right.

Viewpoint 2 – Sun Lounge Sculptures & Huts

The oversized wooden sun loungers make for some entertaining portrait opportunities if you can find enough willing models. Equally, the two wooden huts just to the west work well up close to capture the impressive craftsmanship and architecture or as a striking foreground when shooting back north-east towards the Fanes and Sasso della Croce.

The track now leads westwards, ascending gently to reach Rifugio Utia de Bioch in a further 15 minutes.

How to get here

San Cassiano can be approached from La Villa in the heart of the Alta Badia via the SS37 or from the south via the Passo Valparola. The Piz Sorega gondola is well signposted from the village and has a large car park adjacent to the lift station.

	Lat/Long:	46.56768, 11.93805
	what3words:	///innovations.vaguest.places
	Tabacco:	Map 07 (1:25.000)
	Kompass:	Map 624 (1:25.000)

Accessibility

Approach: 15 minutes, 1km, 20m of ascent.

Disabled access: Wheelchairs are permitted on the Piz Sorega gondola. With the exception of the short detour to the first viewpoint, the hike described here develops on a large track and is wheelchair-friendly.

Best time of year/day

Summer is the best season to enjoy the Pralongià, especially during June and July when the flowers are in bloom. The Piz Sorega lift system runs from mid June until early September, avoiding the somewhat laborious walk up to the plateau from the valleys.

4 PRALONGIÀ

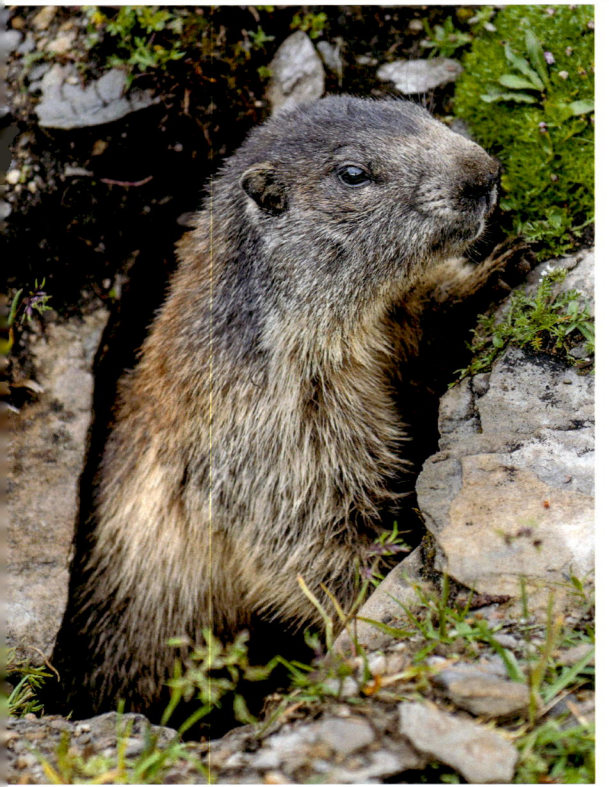

Viewpoint 3 – Rifugio Utia de Bioch ♿
This quaint rifugio opens during the summer and winter seasons and presents an excellent opportunity to sample some traditional food. A small rise with several flags just to the left of the building yields far-reaching views across to the Marmolada, Sella and Puez-Odle massifs.

The eye is quickly drawn to the green Portavescovo and Padon ridgelines contrasting starkly with the white expanse of the Ghiacciaio della Marmolada which can be captured with a mid range zoom. Looking south-east, path 23 creates a nice leading line towards Settsass (2571m) situated just off the Pralongià.

To continue, turn onto path 23, still signposted towards Pralongià and Stores. Follow the undulating but well-surfaced track to reach Rifugio Pralongià, the summit cross and a small chapel.

Viewpoint 4 – Pralongià Summit & Chapel ♿
Sat atop a small rise, the chapel can be effectively shot in almost any direction with a choice of dramatic backdrops. Just to the south, a slight elevation gives good views of the huge north-west face of Monte Civetta and the cratered summit of Col di Lana.

To return, retrace your steps back to the Piz Sorega gondola; alternatively, you can extend the route with a short ascent to the nearby summit of Stores (2181m).

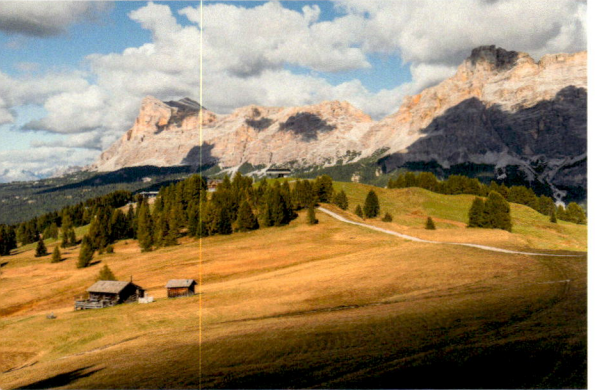

Opposite: Using the fence as a leading line towards Sasso della Croce. Nikon D610, 24–70mm at 40mm, ISO 64, 1/80s at f/14, Jul.

Next spread: Last light on Sasso della Croce after fresh snowfall. Nikon D810, 16–35mm at 35mm, ISO 100, 1/80s at f/8, Jan.

Top: You do not always need a long telephoto lens to capture very tame marmots. Nikon D810, 24–70 at 70mm, ISO 100, 1/320s at f/3.5, Aug.

Above: Light and shadows on the Pralongià. Nikon D810, 24–70mm at 31mm, ISO 100, 1/400s at f/10, Oct.

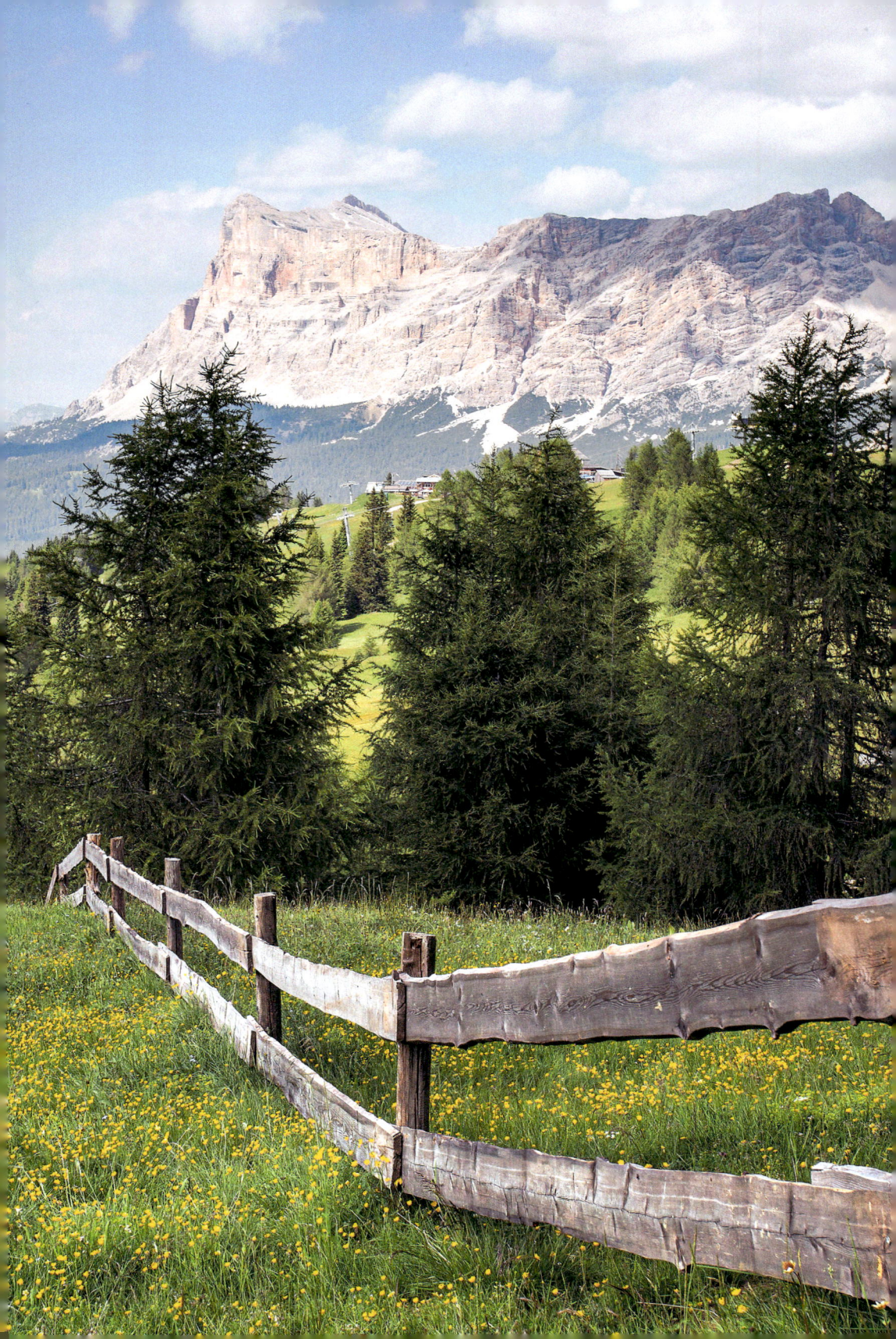

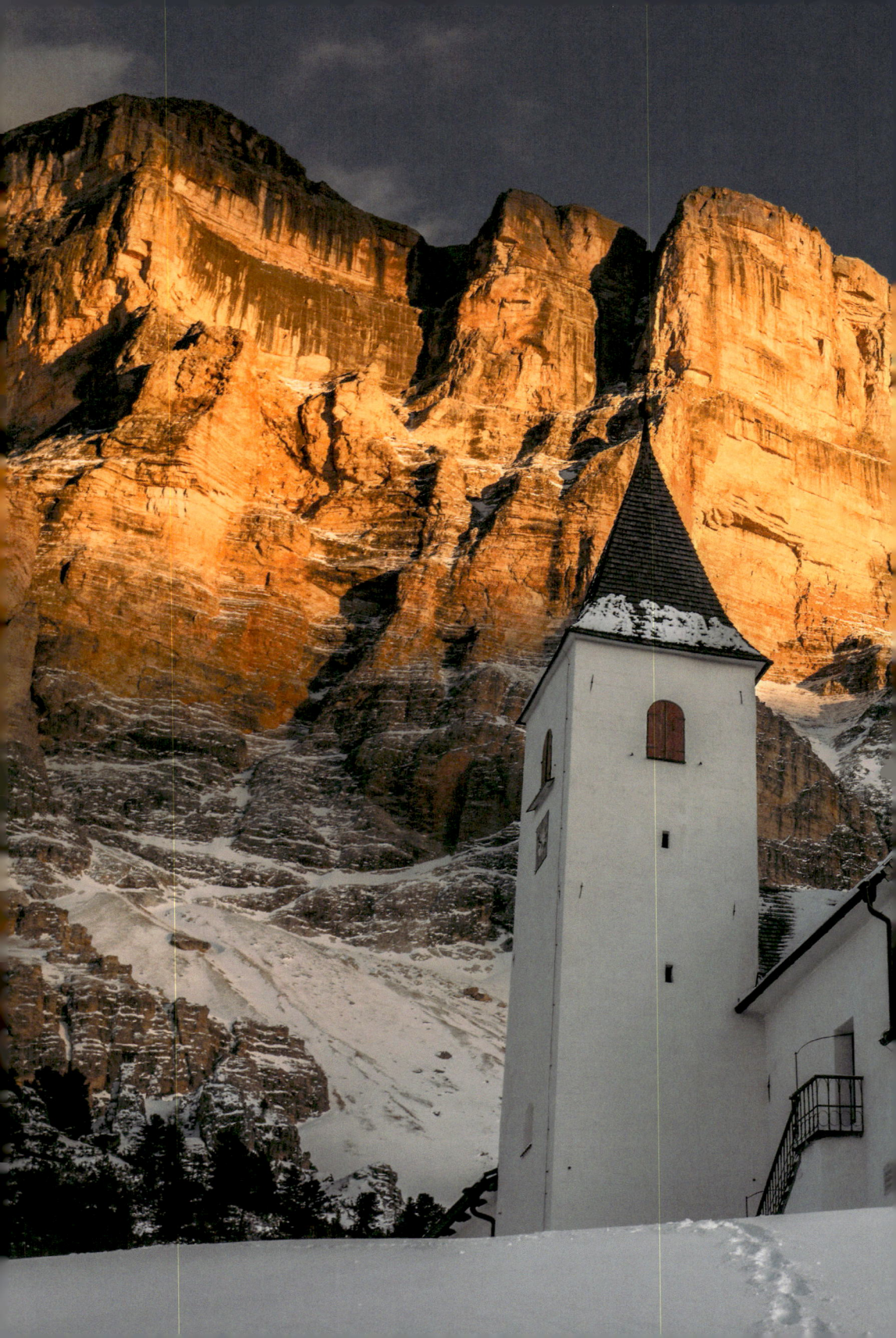

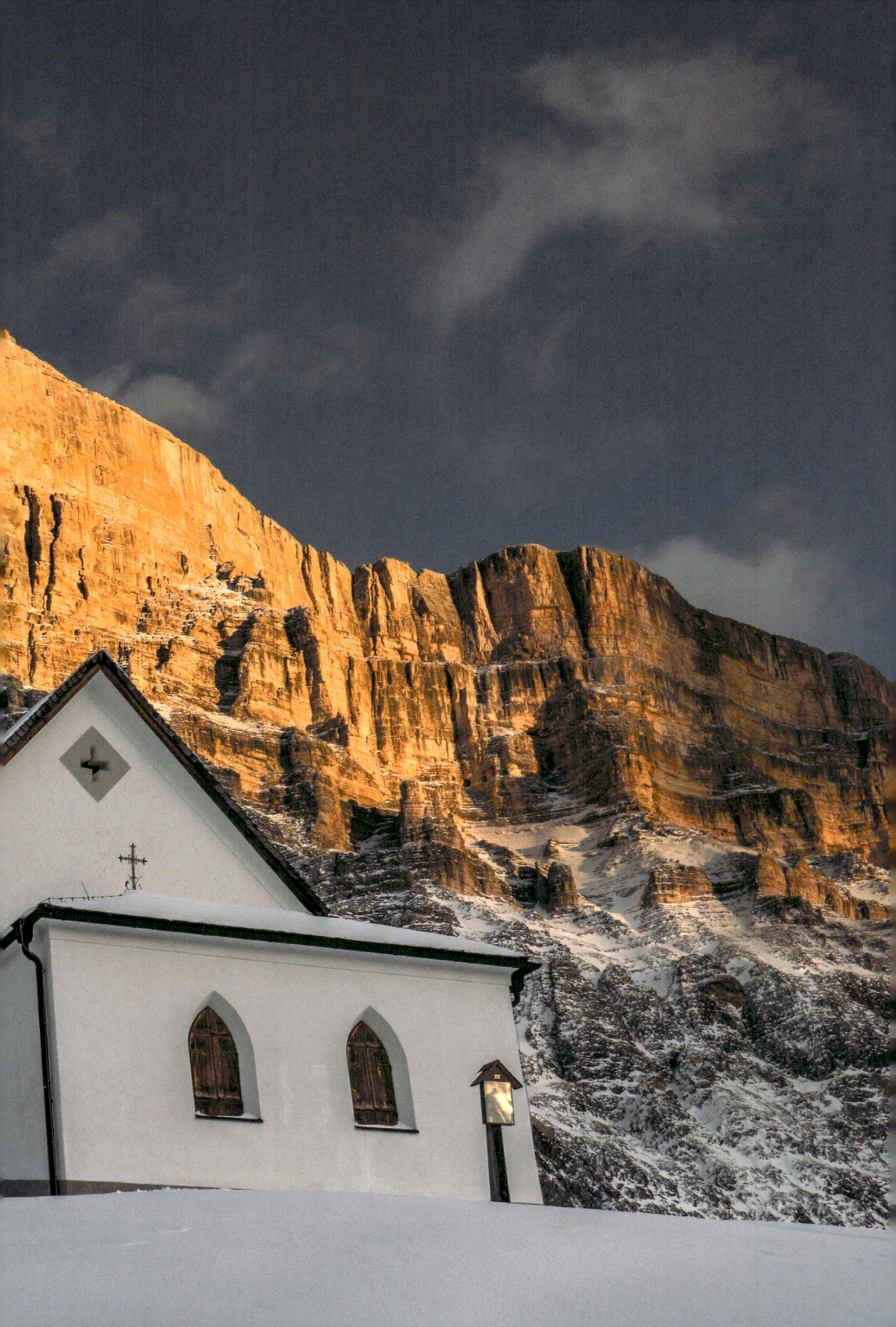

SASSO DELLA CROCE / SASS DLA CRUSC / HEILIGKREUZKOFEL

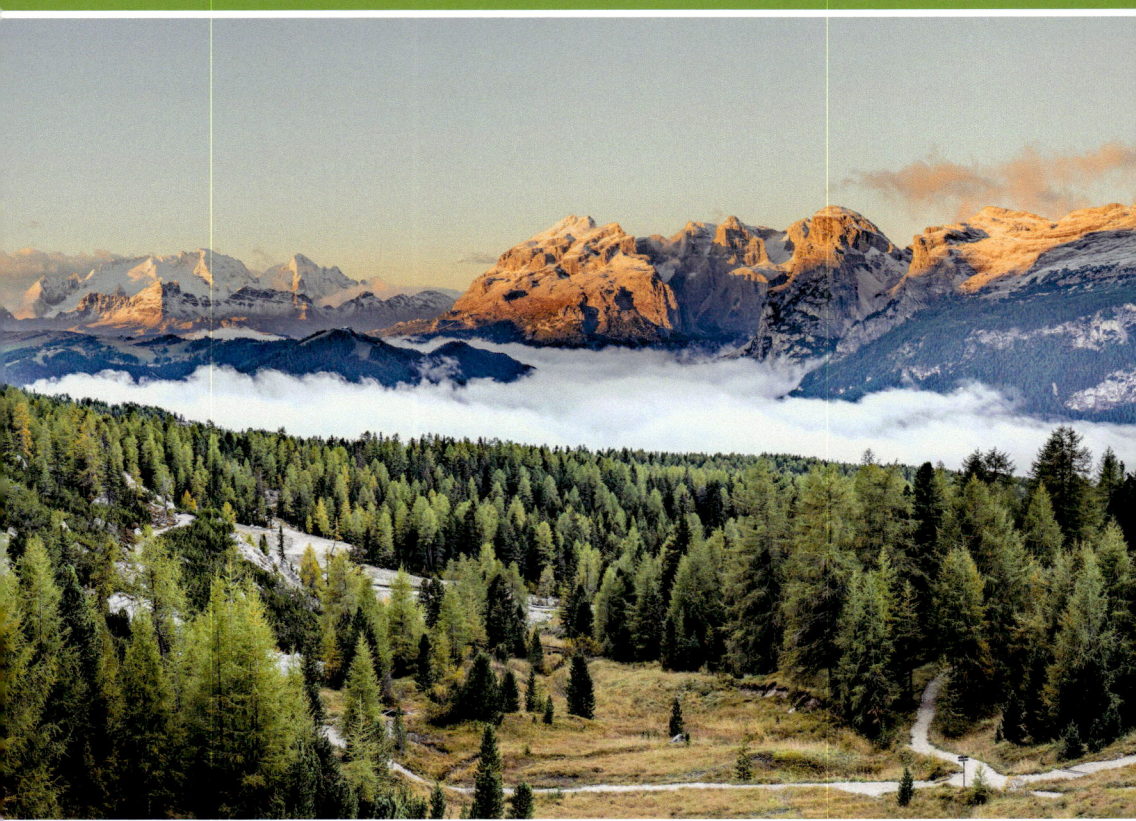

The sheer rock face of Sasso della Croce is a familiar and iconic sight to anyone travelling through the Val Badia. Orientated westwards, this dramatic pale face is infamous for its fantastic pink glow at sunset, the so-called "enrosadira" phenomenon. Nestled at the foot of the cliff, Rifugio Santa Croce and Il Santuario del Santa Croce complete the scene. The small church is over 500 years old; it was consecrated in 1484 by the Auxiliary Bishop of Bressanone and is the source of much local folklore. It is said that after returning from a pilgrimage in the holy land, Count Volkhold della Pusteria decided to donate all of his possessions to the Benedictine nuns of Sonnenburg and live as a hermit at the foot of Sasso della Croce. Here he built the chapel that still stands today, on the pagan site Col dei Paternostri (Col of our Fathers).

From a photographer's perspective, the setting is superb and surprisingly rarely frequented despite the easy access via chairlift from Badia.

What to shoot and viewpoints

Viewpoint 1 – Rifugio Santa Croce & Il Santuario di Santa Croce from the West
The two buildings can be shot from below with a wide-angle lens, using the rock face as a backdrop. This composition is spectacular, particularly with a good sunset.

Viewpoint 2 – Il Santuario di Santa Croce & Rifugio Santa Croce from the East
Moving above to look down to the east, there is a superb panorama overlooking the Val Badia and Puez-Odle group. Conversely this shot favours sunrise, as the light gradually illuminates the mountain backdrop.

How to get here

The lift departs from the village of Badia Abtei, formerly known as Pedraces. The village can be approached from the north or south via the SS244 which runs the length of the Val Badia. Once you reach Badia, follow signposts into the upper hamlet of San Leonardo to reach the Santa Croce chairlifts at the east side of the village. Park in the ample lift station car park and take both the Santa Croce and Sas dla Crusc chairlifts. From the top of the chairlifts, a short but steep five minute uphill walk leads to Rifugio Santa Croce.

If you wish to walk up on foot, from the car park you can follow path 7 all the way up to reach Rifugio Santa Croce in just under two hours. Bear in mind that this involves 700m of ascent; for this reason an overnight stay in the rifugio is recommended if you wish to shoot sunrise or sunset when the lift is closed.

Lat/Long:	46.60937, 11.89649	
what3words:	///advise.proper.encrypt	
Tabacco:	Map 07 (1:25.000)	
Kompass:	Map 624 (1:25.000)	

Accessibility

Approach: 5 minutes, 0.3km, 20m of ascent.

Good paths are found throughout the site, although the initial ascent from the top of the chairlift to the rifugio is quite steep.

Disabled access: The location is approached using two consecutive chairlifts and is not suitable for disabled access.

Best time of year/day

The scene is undeniably spectacular throughout the year and isn't seasonally dependant. However, accessing the location is easiest when the chairlifts and rifugio are open, from December to April in the winter and early June to October during the summer.

Due to the east / west orientation of both major viewpoints, the best light is to be had at sunrise and sunset, but the setting is undeniably spectacular throughout the day.

A 12 photo panorama of Rifugio Santa Croce at sunrise.
Nikon D810, 24–70mm at 50mm, ISO 100, 1/125s at f/7.1, May.

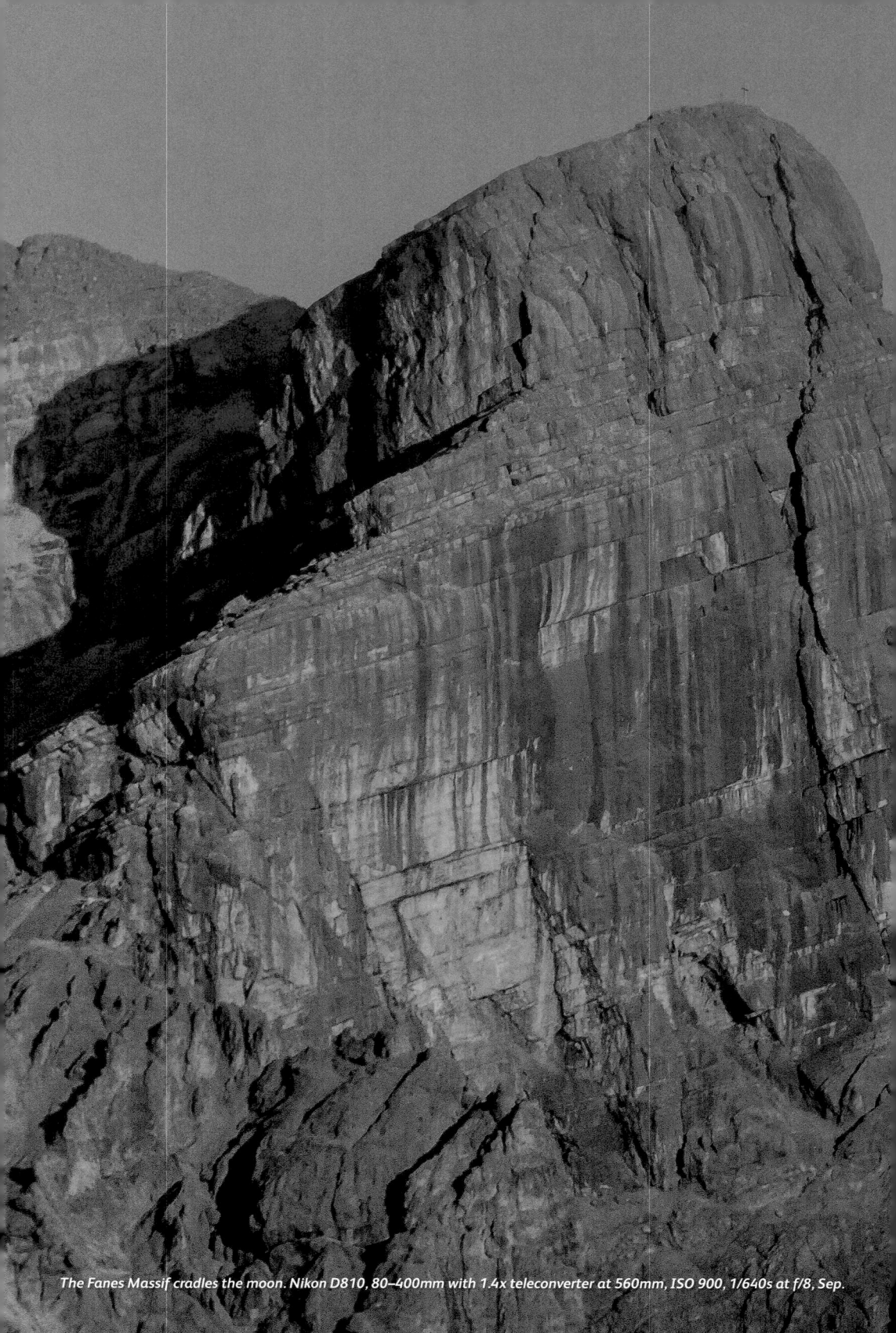

The Fanes Massif cradles the moon. Nikon D810, 80–400mm with 1.4x teleconverter at 560mm, ISO 900, 1/640s at f/8, Sep.

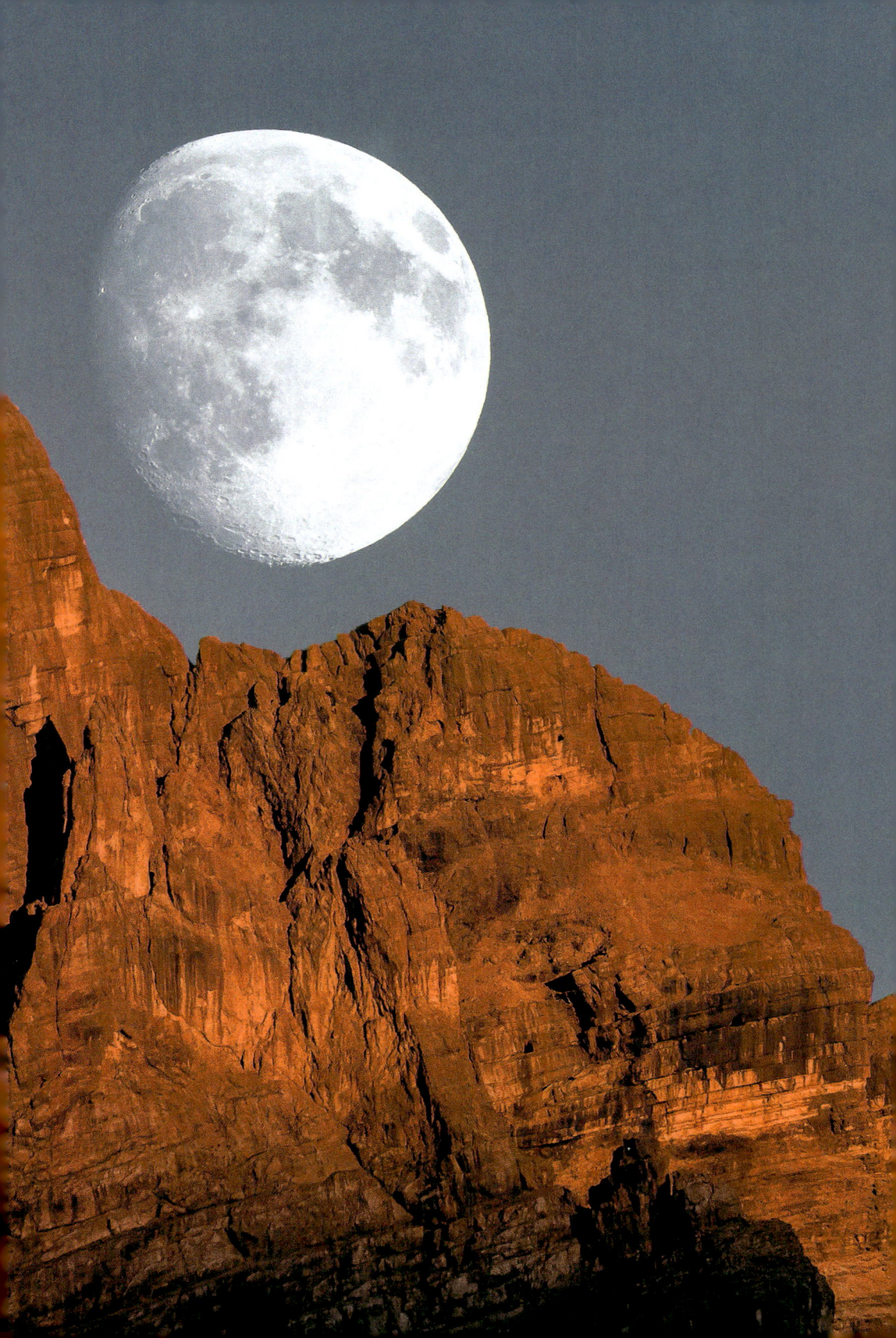

SERES – VAL DI MORINS / MUHLENWEG

The Longiarù region just south-west of San Martino in Badia is famous for its collection of some 30 preserved watermills, a living testament to an ancient rural culture that relied almost entirely on agriculture. Situated equidistant from the hamlets of Seres and Miscì, the Val de Murin or 'valley of the mills' hosts eight recently restored watermills which form part of a small open air museum. Powered by the Seres river which flows down from the flanks of the nearby Sass de Putia, the power of the water is harnessed by an innovative system of channels, gates, wooden aqueducts and wheels.

The short approach, sunny aspect and photogenic surroundings make this an ideal half day venue and is particularly recommended during autumn and the August mill festival.

What to shoot and viewpoints

From the parking area, continue up the road on foot, passing Speck Stube Tlisöra to reach a bridge crossing the Seres river. The first mill is now clearly visible on your left. Cross the bridge and turn left, following signs for path 4 and the Val de Murin.

Viewpoint 1 – Watermills

There are eight watermills along the well-signposted trail, each displaying their own individual characteristics. The first mill is the only one you can go inside unless you coincide your visit with the August festival, when there are several displays demonstrating the milling process.

The riverbank location coupled with a network of intricate man-made water channels makes for some great photo opportunities. If the wheels themselves are in motion, try using a slow shutter speed in conjunction with a tripod to capture the movement as they turn.

The many paths surrounding the buildings combined with the river and several small tributaries make for some great leading lines towards the old structures. The valley has a south-easterly aspect which ensures that there is often good light to be had in late morning and at noon.

Viewpoint 2 – Details & Textures

As well as the ancient wood of the original buildings, the site is scattered with sawn and worked timber and there are countless delightful details and abstract shapes to be captured in the wood grains. Use a small aperture to keep everything in focus, picking out the most striking patterns and areas of symmetry with a longer focal length.

Viewpoint 3 – Paths, Tracks & Meadows

As you reach the highest part of the clearly marked Val de Murin circuit, you will see a number of fields and farm buildings beautifully enclosed by traditional wooden fencing. The meadows, used for hay at harvest time, are home to large numbers of wildflowers and look a picture during the summer months. The surrounding tracks and the fences themselves make for eye-catching features when framed against the old farm buildings.

Occasionally, the fields are populated with photogenic chestnut Haflinger horses, a small species native to Austria and the Dolomites.

How to get here

From Badia follow the SS244 down the Val Badia for 11km to reach San Martino in Badia. Here turn left onto the SP57 and follow this for a further 6km to reach Longiarù. Continue through the town, now following signposts towards Seres, to reach an area of roadside parking on the left just before Speck Stube Tlisöra.

It is also possible to approach Longiarù from the Val di Funes, driving over the Passo delle Erbe.

- Lat/Long: 46.63357, 11.84725
- what3words: ///revisits.depositors.brag
- Tabacco: Map 07 (1:25.000)
- Kompass: Map 627 (1:25.000)

Accessibility

Approach: 5 minutes, 0.5km, 20m of ascent.

Disabled access: While there is a good track throughout the Val de Murin circuit, there are several narrow and uneven sections as the path weaves between buildings and waterways.

Best time of year/day

Despite the lower water level of the river Seres, the mills are often best viewed during August as many of the wheels are used for the festival. The south-easterly aspect ensures good light throughout the morning and early afternoon, although the tranquil setting also works surprisingly well in flat light.

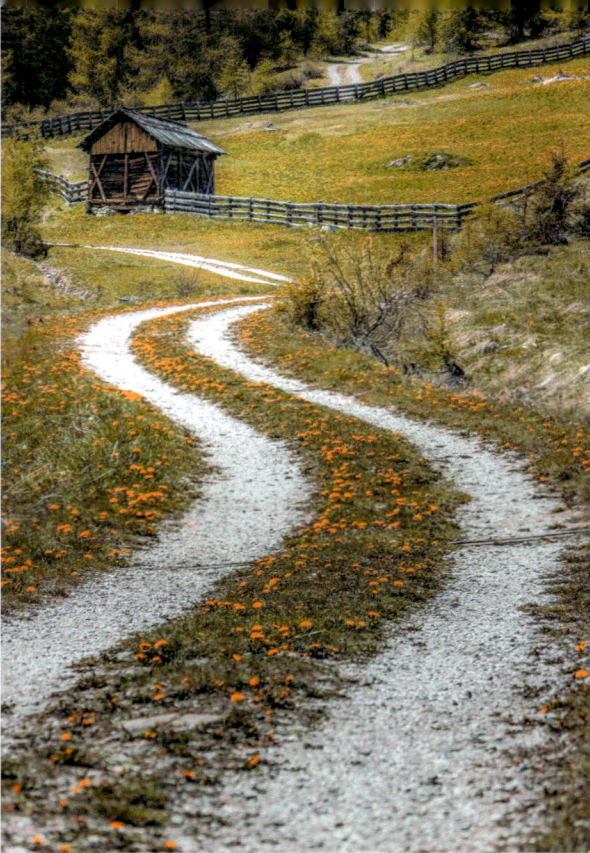

Wood grain abstracts. Nikon D810, 105mm, ISO 100, 1/60s at f/14, tripod.

Using a narrower depth of field to draw the eyes down the road. Nikon D810, 80–400mm at 195mm, ISO 64, 1/800s at f/5.6, May.

One of the many watermills found in the valley. Nikon D810, 16–35mm at 35mm, ISO 100, 5s at f/7.1, tripod, ND filter, May.

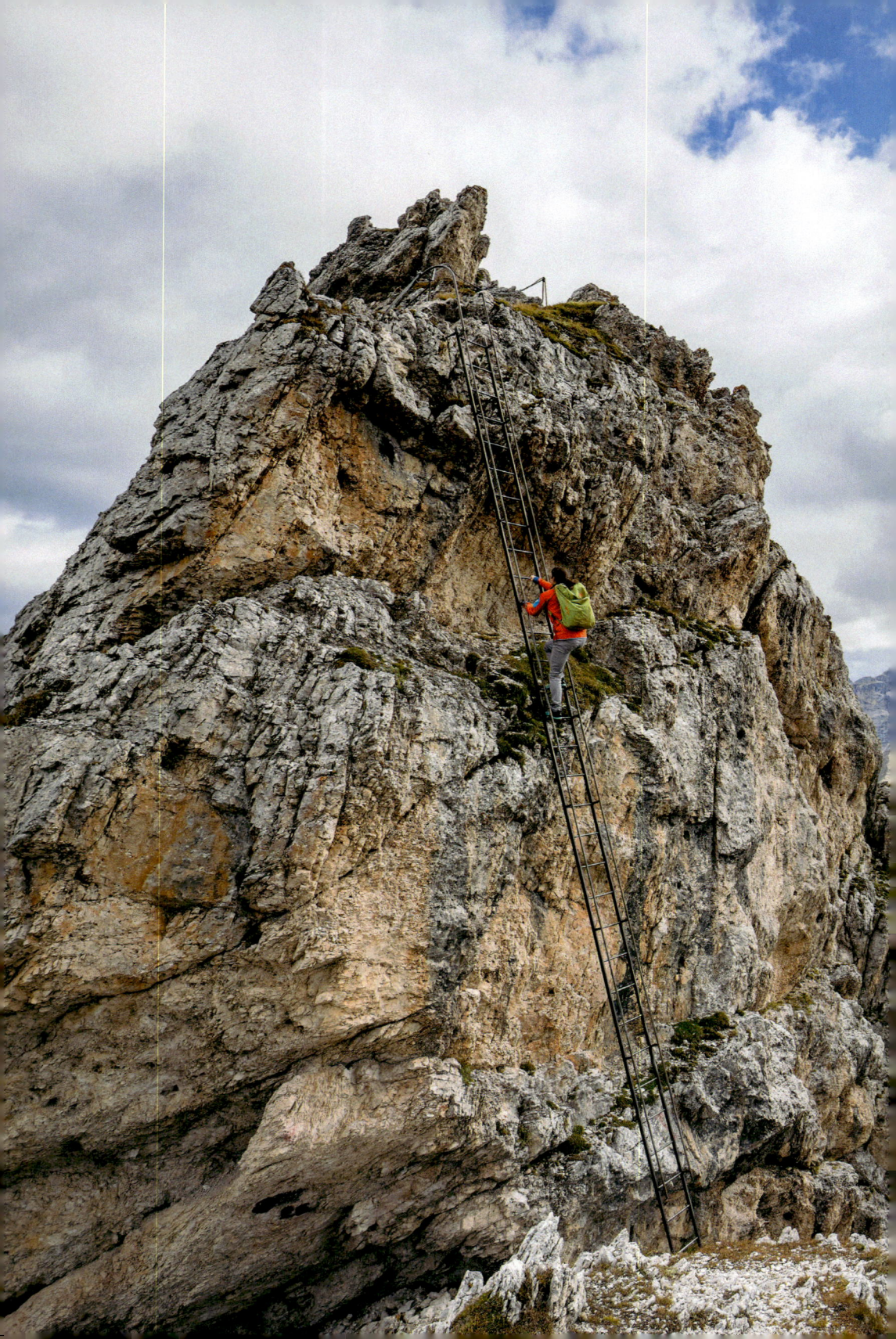

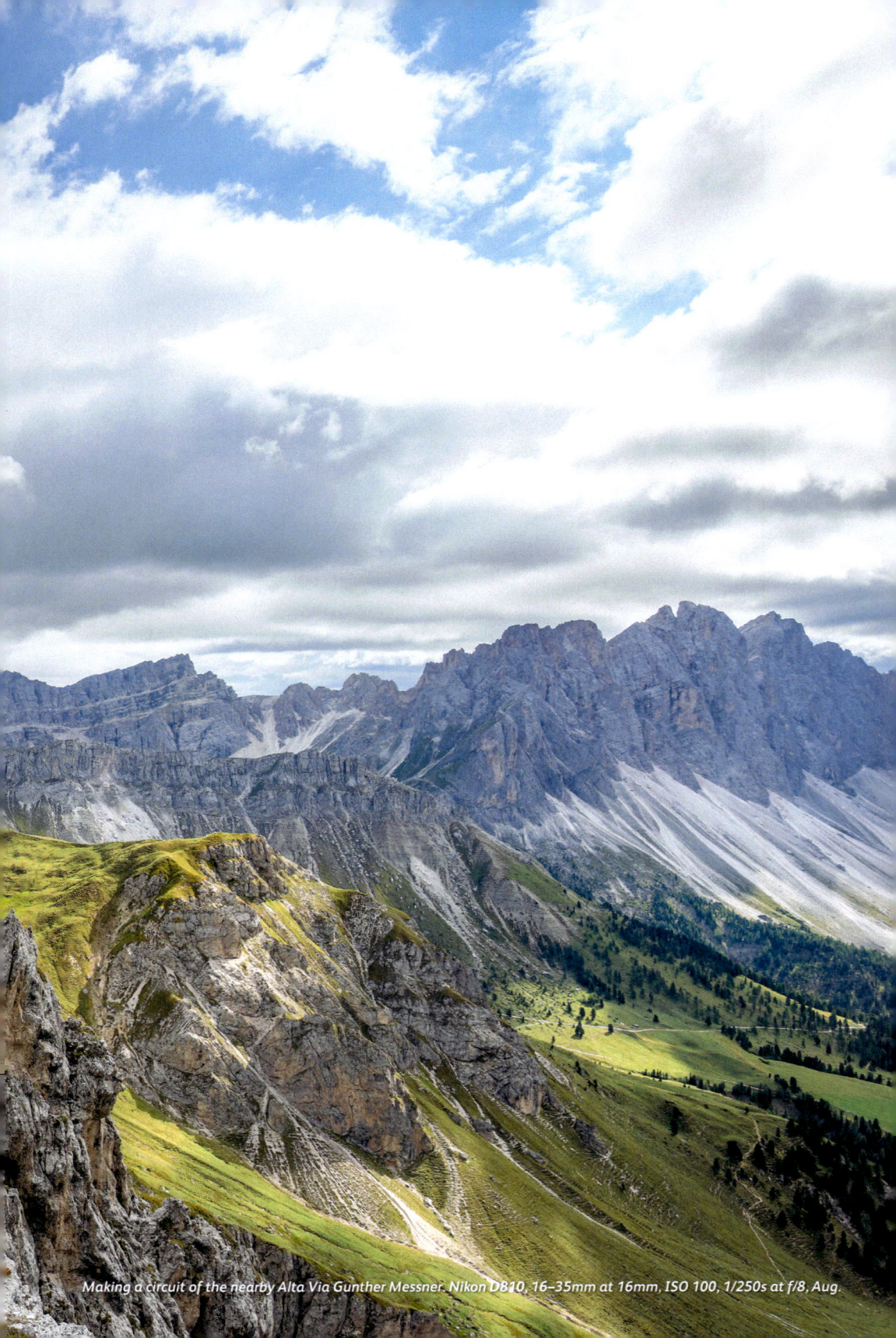

Making a circuit of the nearby Alta Via Gunther Messner. Nikon D810, 16–35mm at 16mm, ISO 100, 1/250s at f/8, Aug.

7 PASSO DELLE ERBE / WÜRZJOCH

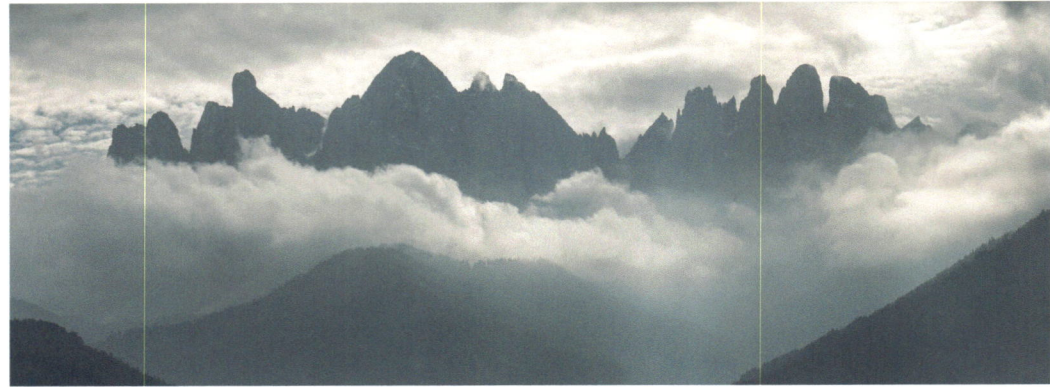

Silhouettes of the backlit north-west faces of the Odle / Geisler peaks. Nikon Z7II, 24–120mm at 70mm, ISO 64, 1/800s at f/8, Aug.

Running east to west for 45km from San Martino in the Val Badia to Bressanone in the Val d'Isarco, the Passo delle Erbe or Würzjoch is a stunning mountain pass that is highly recommended. The route is perfect for photographers looking to traverse between the two regions (it is easy to join the pass from the Val di Funes), or for those who enjoy a scenic drive with ever-changing road-side views.

Be aware that the road is very narrow, steep and single track in places, requiring confident driving. For this reason, it should be avoided in peak season as congestion coupled with limited passing places can make for a frustrating experience.

The road is closed during the winter and can only be driven in its entirety from mid-spring to late autumn.

What to shoot and viewpoints

Driving in either direction is very scenic, though if you had to choose – west to east, from Bressanone or the Val di Funes to the Alta Badia arguably offers the best driving views and that is what will be described here. There is no singularly obvious or classic viewpoint, rather the Passo delle Erbe is perfect for spontaneous stops depending on the light and conditions. The following viewpoints are intended as suggestions only – be careful not to obstruct traffic when pulling over.

How to get here

The Passo delle Erbe is signposted as the SP29 and can be accessed from Bressanone in the Val d'Isarco or from San Martino in the Val Badia. It is also possible to join the pass from the Val di Funes using the SP163 that departs from San Pietro – this is probably the most scenic approach and is recommended.

There are excellent views throughout and the codes below can be scanned for parking and viewpoint suggestions.

Viewpoint 1 – Rifugio Halslhütte & Surroundings

- **Lat/Long**: 46.66676, 11.77003
- **what3words**: ///variant.harder.wriggling
- **Tabacco**: Map 30 (1:25.000)
- **Kompass**: Map 627 (1:25.000)

Viewpoint 2 – Wooden Huts & Sass de Putia

- **Lat/Long**: 46.66102, 11.79415
- **what3words**: ///arch.tacklers.alternatives
- **Tabacco**: Map 30 (1:25.000)
- **Kompass**: Map 627 (1:25.000)

Viewpoints 3, 4, 5 – Passo delle Erbe Summit

- **Lat/Long**: 46.67487, 11.81344
- **what3words**: ///reach.crumpet.despite
- **Tabacco**: Map 30 (1:25.000)
- **Kompass**: Map 627 (1:25.000)

Accessibility

Approach: Roadside access or very short walks from parking areas.

Disabled access: There are good views from the road throughout the drive and the larger parking areas have good paths.

Best time of year/day

The pass is best enjoyed during early and late summer / autumn to avoid congestion. During winter the pass is closed on the west side when sections of the road are used as a cross country ski piste.

Viewpoint 1 – Rifugio Halslhütte & Surroundings

Rifugio Halslhütte is idyllically located in a little valley and is photogenic in its own right. For those wanting to explore a little further afield following Alta Via 2 uphill for 20 minutes before turning right onto path 9 produces some lovely views over the area. Alternatively following Alta Via 2 uphill for 40 minutes leads to the Schatzerhütte and some stunning views over the Odle and Sass da Putia.

Viewpoint 2 – Wooden Huts & Sass de Putia ♿

There is good parking on both sides of the road, just before crossing a small bridge over the stream. In the adjacent meadow, several rustic wooden huts make a lovely foreground to the dramatic rock walls of Sass de Putia. During June and July, this meadow is superb for wildflowers.

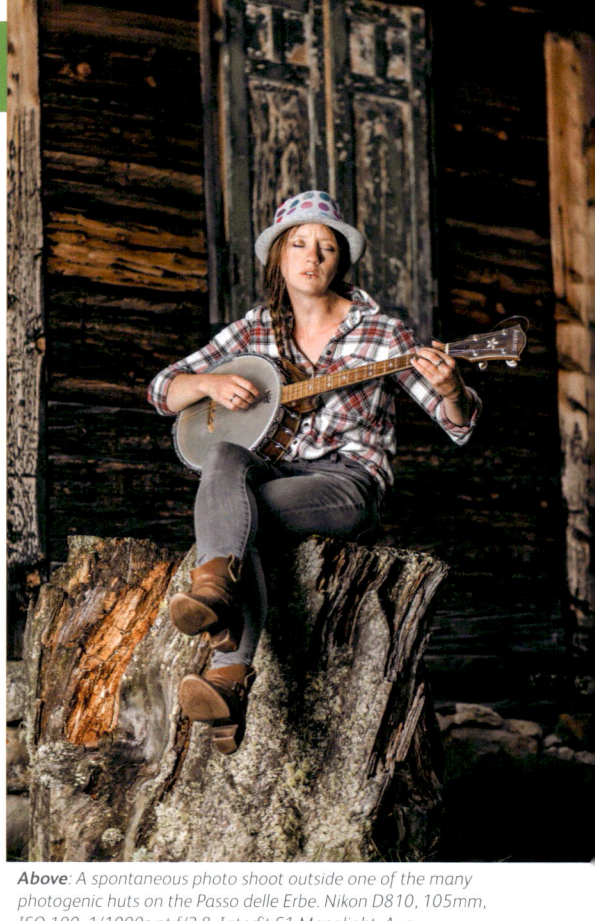

Below: Autumn colours looking over the Val di Funes whilst driving up the SP163 to join the Passo delle Erbe. Nikon Z7II, 24–120mm at 70mm, ISO 100, 1/100s at f/13, Nov.

Above: A spontaneous photo shoot outside one of the many photogenic huts on the Passo delle Erbe. Nikon D810, 105mm, ISO 100, 1/1000s at f/2.8, Interfit S1 Monolight, Aug.

7 PASSO DELLE ERBE / WÜRZJOCH

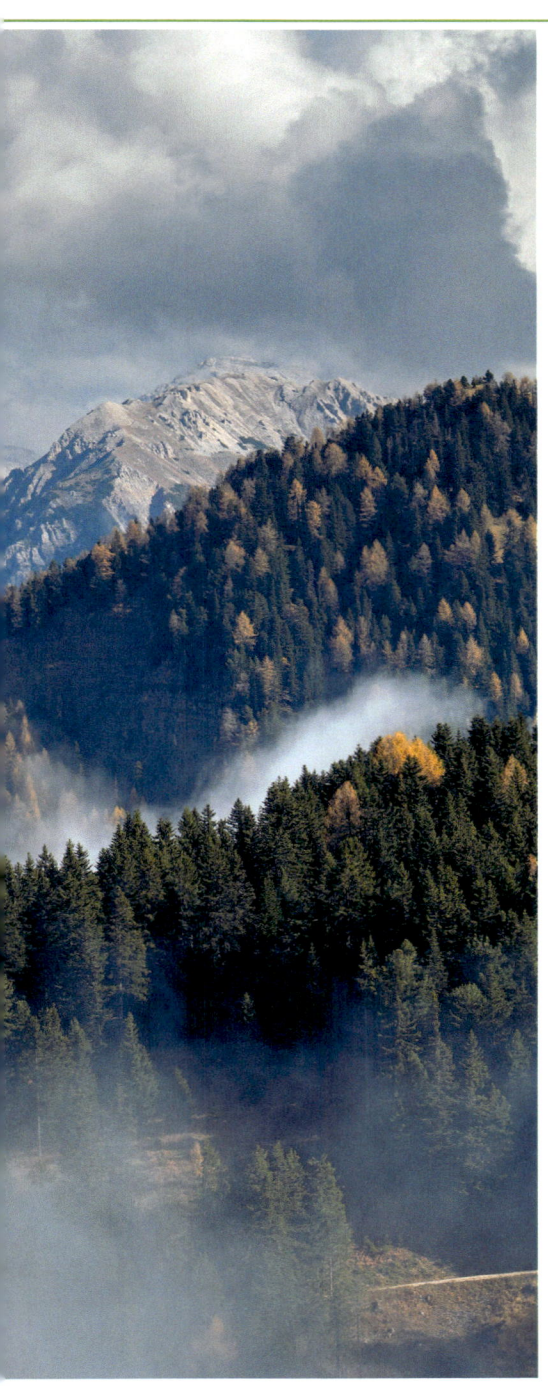

PASSO DELLE ERBE SUMMIT

There is a large parking area opposite the mountain hut Ütia de Börz (a good spot for both accommodation and food). There are then several viewpoints a short walk from the top of the pass.

Viewpoint 3 – East towards the Alta Badia

From the east of the parking area, a small earthy ridge provides far-reaching views across the Alta Badia to the peaks of the Fanes-Sennes-Braies Nature Park beyond. The dense foliage requires a bit of navigating to find a clear spot – or it is possible to frame the scene using the surrounding tree branches.

Viewpoint 4 – Baita Cir, Tree Roots & Sass de Putia

From the south side of the parking area take path 8A signposted for Rundweg Peitlerkofel, following the path for 250m to reach a clearing overlooking an impressive rock bowl backdropped by Sass de Putia. A nearby tree with exposed roots (lat/long: 46.67333, 11.81365) makes for a brilliant foreground to the scene when used in conjunction with a wide-angle lens. The nearby Baita Cir restaurant is also photogenic and makes for a great lunch spot.

Viewpoint 5 – Costaces

Reaching 2119m, Costaces is a small hill just north of mountain hut Ütia de Börz that offers panoramic views over the surrounding area. To reach it follow path 1 to the right of Ütia de Börz for 200m before turning left onto a small path leading to the top of the hill in 30 minutes of consistent uphill walking.

A beautiful cloud inversion looking east towards the Fanes-Sennes-Braies Nature Park from the summit of the Passo delle Erbe. Nikon Z7II, 100–400mm at 130mm, ISO 64, 1/400s at f/8, Oct.

PASSO SELLA, PORDOI & FEDAIA

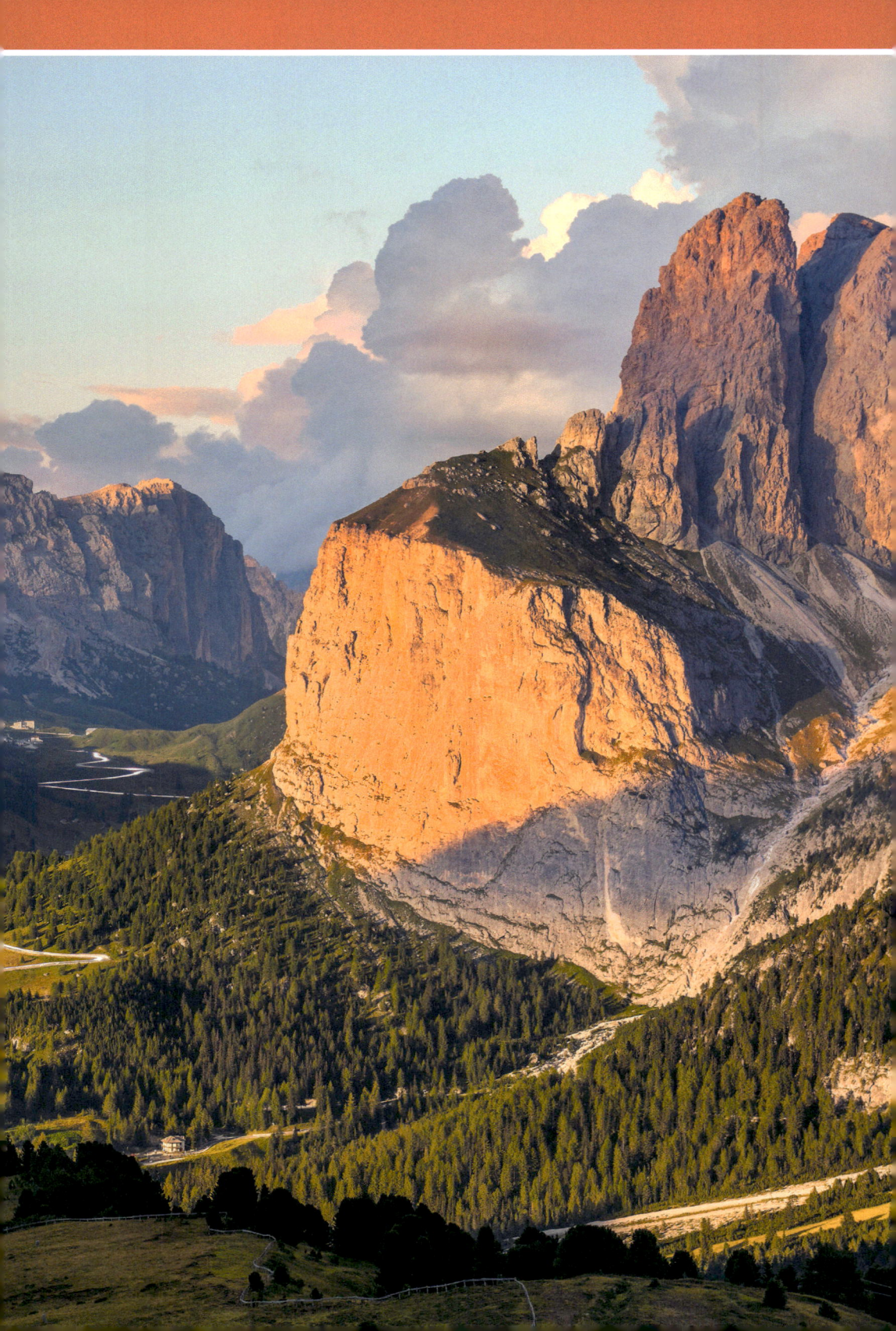

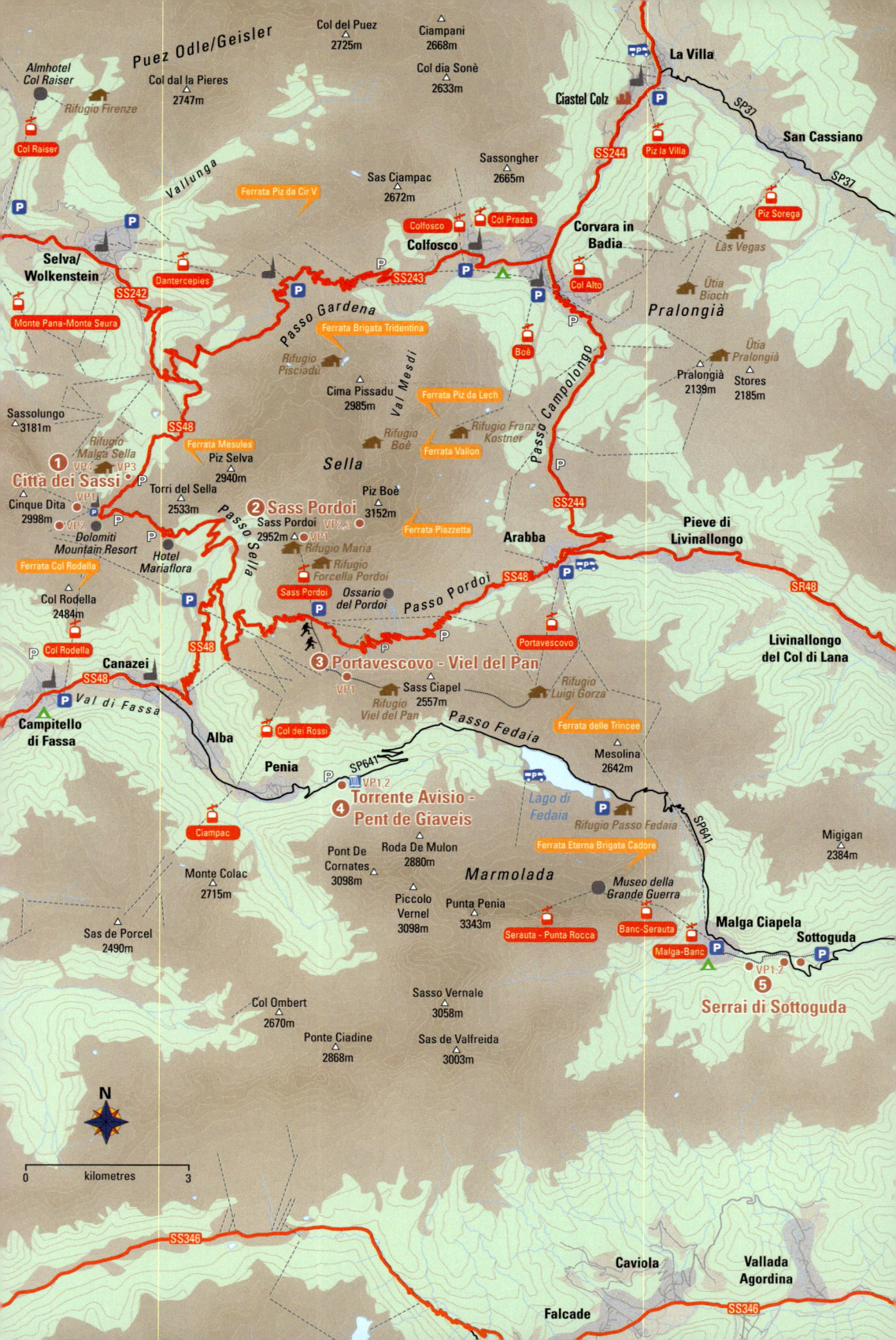

PASSO SELLA, PORDOI & FEDAIA – INTRODUCTION

The Passo Sella is the highest mountain pass in the Dolomites, reaching its summit at 2240m as it winds across the west side of the Sella Massif to link the Val Gardena and Val di Fassa. It is perhaps best known as one of four passes that make up the famous 'Sella Ronda', a network of roads totalling 66km that encircle the Sella. Twice a year the roads are closed to motorised traffic and 20,000 cyclists take to the passes for the biannual Sellaronda bike race, a free and non-competitive event that always proves quite a spectacle. The top of the pass is superbly photogenic, offering fantastic views of the Sella Towers, Marmolada and Sassolungo while also providing access to the Città dei Sassi or 'City of Rocks'. Home to many a sunbathing marmot and Alpine ibex, this sprawling boulder field makes for a unique and exciting photography location which constantly hints at another concealed composition just around the next corner.

As the pass descends south, it joins the Passo Pordoi some 300m above the town of Canazei. Incorporating a staggering 60 hairpins over its 21km, the Pordoi pass is the second highest pass in the Dolomites. It connects Canazei with Arabba in the Livinallongo valley and marks the border between the provinces of Trento and Belluno. Built in the early 20th century to link Bolzano with Cortina and encourage the development of tourism in the Ladin valleys, the Pordoi is part of the 'Strada delle Dolomiti' or 'Great Dolomites Road'. At its summit, the Pordoi cable car shuttles visitors to the top of Sass Pordoi (2952m) in a spectacular four minute ascent. Adjacent to the top station sits Rifugio Maria, host of 'Simposio Top Wine', Italy's highest wine tasting event which takes place each October. From this panoramic viewpoint there are excellent views of Sassolungo ('long rock') and the Marmolada (3343m), the highest peak in the Dolomites.

Often referred to as the 'Queen of the Dolomites', the Marmolada takes its name from the ancient Greek word 'maramairo' (to sparkle), no doubt inspired by the white expanse of the Ghiacciaio della Marmolada, the largest glacier in the Dolomites which dominates the northern slopes. The mountain chain played an integral role during the First World War when vast networks of tunnels were carved into the glacier ice by the Austro-Hungarian soldiers occupying the position. Historians and excavators have since discovered some 12km of tunnels in this veritable 'City of Ice', with chambers large enough to house 300 troops at a time.

The Passo Fedaia provides the most convenient method of accessing the Marmolada. It passes alongside the reservoir of Lago Fedaia, a body of water that may be familiar to anyone who has watched the 2003 film 'The Italian Job'. A three stage cable car then departs from the quaint village of Malga Ciapela, eventually ascending to a viewing platform just below Punta Rocca at 3250m. Although busy in peak season, a clear day up here offers some incredibly panoramic views of the Dolomites and Austrian Alps.

LOCATIONS

1. Città dei Sassi / Steinerne Stadt **238**
2. Sass Pordoi / Pordoi Spitze **250**
3. Portavescovo **258**
4. Torrente Avisio – Pent de Giaveis **262**
5. Serrai di Sottoguda **266**

Maps
- Tabacco (Italian): Map 06, 15
- Kompass (German): Map 59, 616, Map 686

Previous spread: A composite of the Passo Sella using a 15 minute exposure at dusk to capture the car lights. Nikon D810, 24–70mm at 60mm, ISO 100, 1/40s at f/9, tripod, Aug.

1. CITTÀ DEI SASSI / STEINERNE STADT

The sprawling boulderfield of Città dei Sassi (City of Rocks) extends just below the Passo Sella, in the shadow of the famous Sassolungo group. While it is an accepted fact that this vast labyrinth of boulders was created by a huge rockfall from Sassolungo, there is much academic debate as to how and when the event occurred. Some believe the event was triggered by seismic activity; others attribute it to lack of support following the retreat of the glaciers. Either way, the collapse of the rock faces undoubtedly occurred after the last major glacial expansion, around 20,000 years ago, otherwise the boulders would have been carried down to the valleys and there would be no trace of them below their original position.

From a photographer's perspective, the surrounding landscape offers some of the best views in the Dolomites. Sassolungo itself is superbly photogenic, displaying three distinctive and equally impressive towers when viewed from the east – Sasso Levante (3114m), Cinque Dita (2998m) and Spallone del Sassolungo (3081m). Looking in the opposite direction, the west faces of the Sella massif are equally impressive. Città dei Sassi is filled with endless possibilities and presents a multitude of foreground options for both backdrops.

What to shoot and viewpoints

Viewpoint 1 – Cappella di Passo del Sella ♿

Located adjacent to the Passo Sella Dolomiti Mountain Resort, the small roadside chapel is arguably the most logical foreground for capturing the peaks of Sassolungo. Unfortunately, the somewhat unsightly Cabinovia Forcella Sassolungo lift station located behind the chapel rather forces the composition as you need to hide it behind the chapel itself. Try to separate the prominent (and very photogenic) tree to the right from the roof of the building. The front of the chapel receives good light during the early hours of the day and is also well lit by the rifugio once night has fallen.

Cappella di Passo del Sella. Nikon D850, 16–35mm at 16mm, ISO 100, 1/250s at f/8, Jun.

How to get here

Città dei Sassi is located just below and west of the Passo Sella summit, underneath the east faces of Sassolungo. The Passo Sella can be accessed from the Val Gardena and Passo Gardena to the north, or via the Passo Pordoi and Val di Fassa to the south.

The parking areas opposite the newly-built Passo Sella Dolomiti Mountain Resort and alongside the Telecabine Sassolungo are the most convenient. However, both car parks are quite expensive and get very busy during peak season, often necessitating some creative parking in the nearby lay-bys.

If space is short there are some additional parking spaces at the top of the pass, next to Hotel Mariaflora. A brief 10 minute walk alongside the road then leads back to Città dei Sassi.

	Lat/Long:	46.50958, 11.75733
	what3words:	///roomier.footer.peered
	Tabacco:	Map 06 (1:25.000)
	Kompass:	Map 616 (1:25.000)

Accessibility

Approach: 3 minutes, 0.3km, 0m of ascent.

♿ **Disabled access**: While some of the smaller paths that cut through the centre of the boulderfield are not suitable for disabled access, the majority of the paths are wide and well surfaced. There are several disabled parking spaces in the lift car park.

Best time of year/day

The boulderfield is best shot during June, July and August once the snows have cleared and the flowers are in bloom. During peak season the area can get very busy, but the substantial size of the site means it is nearly always possible to find a quiet corner. During the winter the site is less dramatic as the snow blankets many of the smaller boulders, reducing the visual impact of the rocky labyrinth.

Located between dramatic east and west-facing mountain groups, Città dei Sassi is an excellent sunrise and sunset location. However, thanks to the varied aspect of the fallen rocks it is also possible to shoot with good lighting throughout the day.

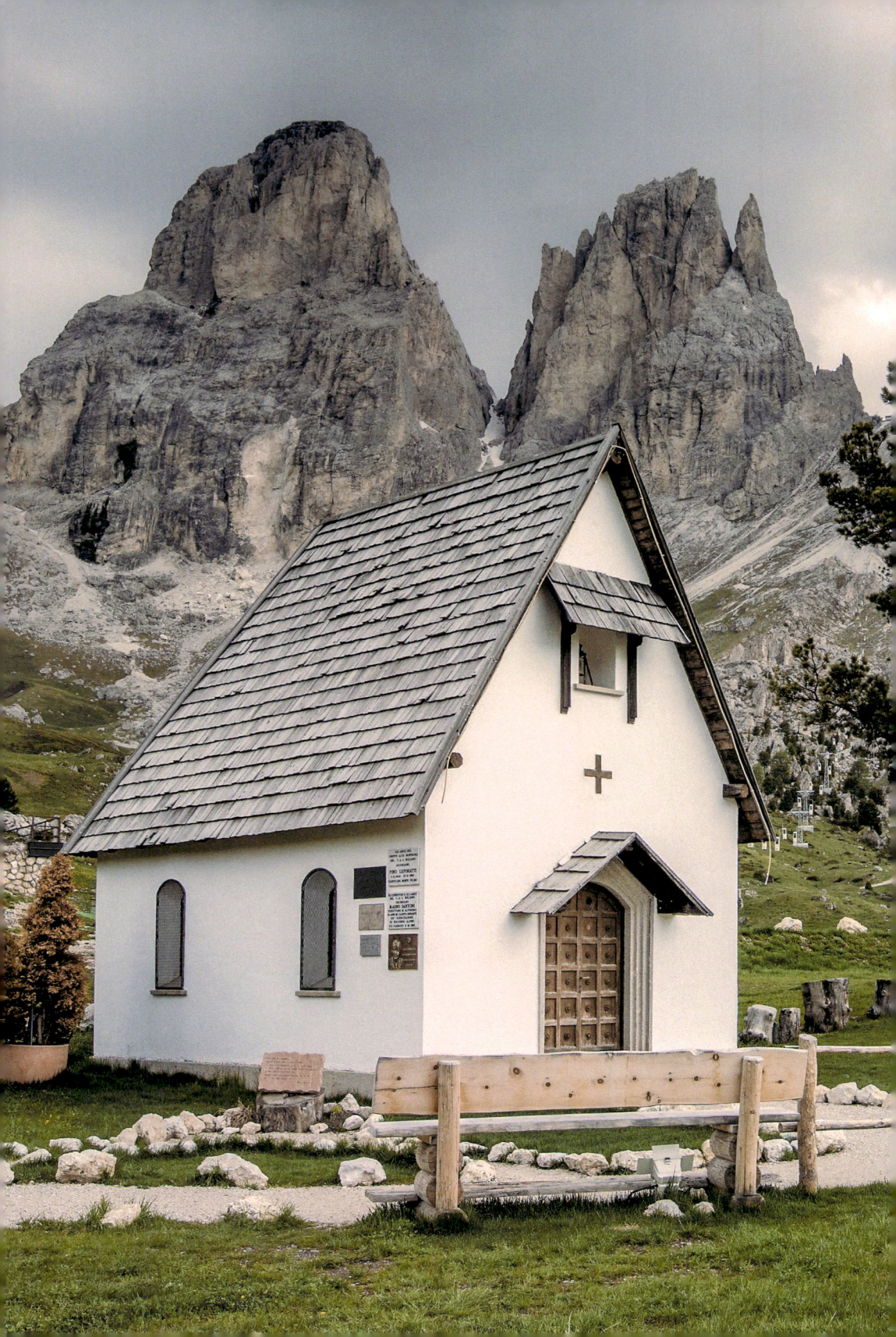

Above: *The track towards Rifugio Malga Sella makes for a great leading line. Nikon Z7II, 20mm, ISO 64, 1/100s at f/11, Sep.*
Below: *Light on the four Sella Towers after a thunderstorm. Nikon D810, 24–70mm at 70mm, ISO 100, 1/400s at f/10, Aug.*

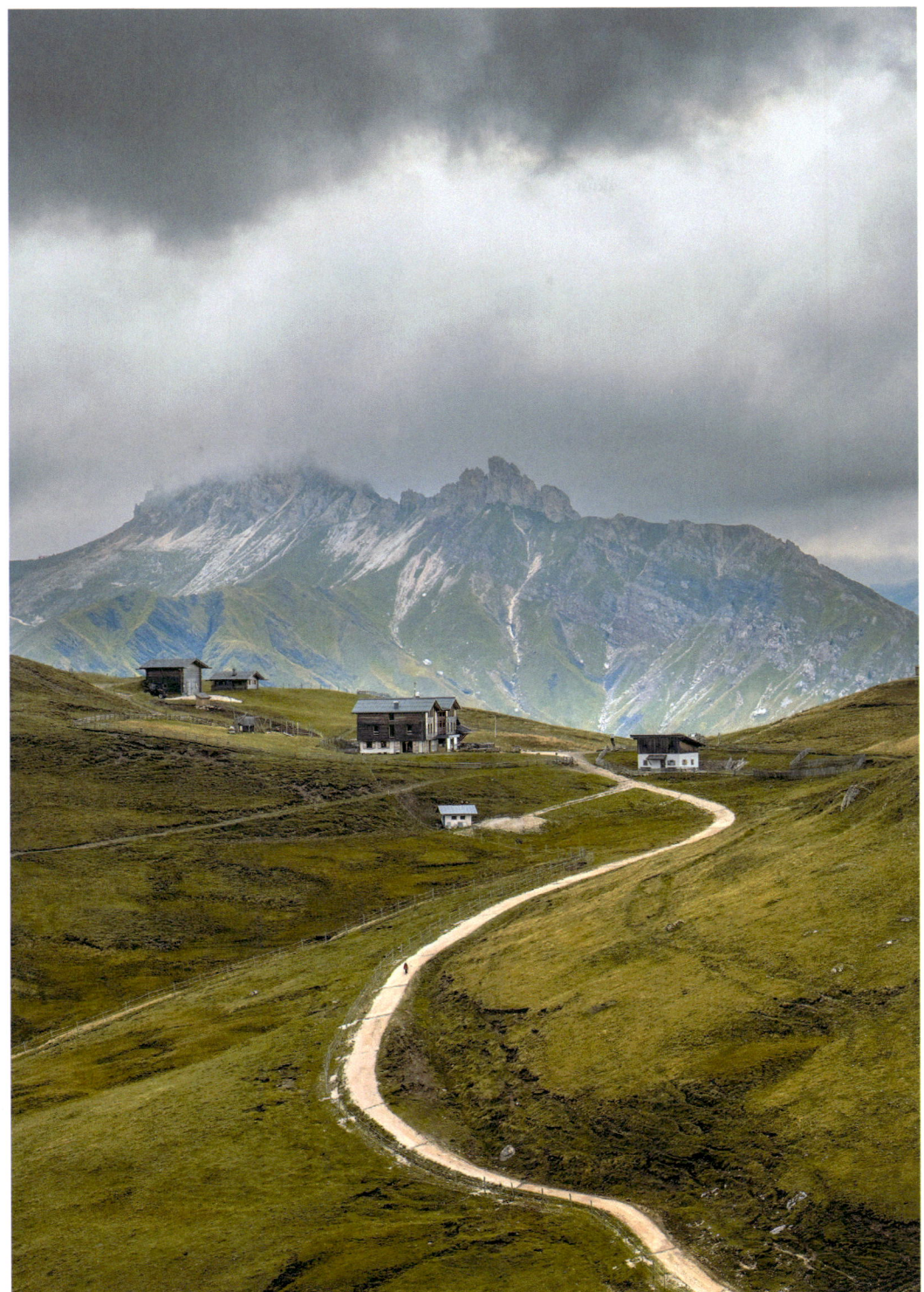

Looking towards Rifugio Sasso Piatto along Alta Via 9. Nikon Z7II, 24–120mm at 80mm, ISO 64, 1/320s at f/8, Aug.

1 CITTÀ DEI SASSI / STEINERNE STADT

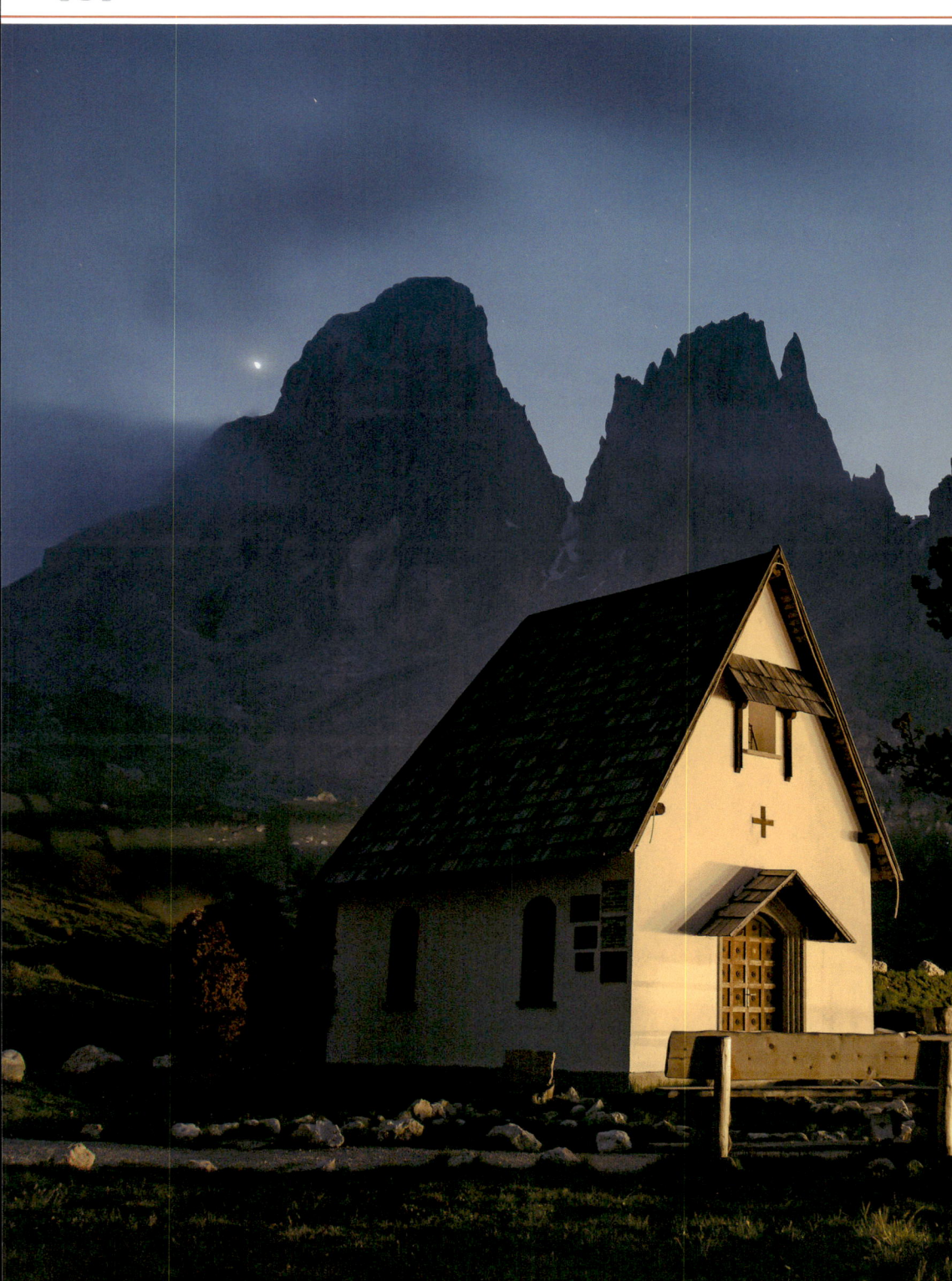

Viewpoint 2 – Naturonda Trail

The Naturonda is a short and well-signposted 1.7km circuit through the boulderfield that offers a great way of exploring the area. There are good photo opportunities throughout, with wildflowers, climbers and many marmots lurking between the rocks.

From the Passo Sella Dolomiti Mountain Resort hotel, follow the large track west underneath the Sasso Levante chairlift (this doesn't run in the summer) for 200m before turning off right, following signs for the Naturonda and Rifugio Comici. The large path then traverses the hillside, giving spectacular views to the east at several logical viewpoints. Eventually reach path 526 and turn right, now following the smaller path back south to the car park.

Viewpoint 3 – Rifugio Malga Sella ♿

Rifugio Malga Sella is a rustic farmhouse to the north-east that sells delicious, locally farmed produce. From Passo Sella Dolomiti Mountain Resort, take path 657 which meanders through the east side of Città dei Sassi to arrive at the farmhouse in 10 minutes. The approach is liberally dotted with wildflowers during the early summer, with a stunning display of dwarf alpenrose (Rhodothamnus chamaecistus) during late July and early August.

The farmhouse enjoys excellent views east towards the Sella Towers which catch the afternoon and evening light throughout much of the year. There are several traditional outhouses surrounding the farm; adorned with a diverse range of scythes, hoes and milk churns, these portray a wonderfully Tyrolean scene, especially once framed against the mountainous backdrop.

*Cappella di Passo del Sella by moonlight.
Nikon D810, 14–24mm at 24mm,
ISO 100, 30s at f/2.8, tripod, Jun.*

① CITTÀ DEI SASSI / STEINERNE STADT

Viewpoint 4 – Rifugio Malga Sella Pond ♿

Continuing past the farmhouse along the vehicle track leading back to the main road, there is a small pond on the left, just beyond a weather station.

This small body of water is often surrounded by flowers for much of the year, making an excellent foreground for shooting towards Sassolungo. With a wide-angle you can capture all three of the peaks, or alternatively use a portrait composition and longer focal length to isolate Spallone del Sassolungo and its reflection.

During early winter, the small stream flowing into the pond prevents the surrounding water from completely freezing, providing the opportunity to capture some beautiful winter reflections long after you're normally able to do so. To return, retrace your steps back to the parking area.

Top: Orange lilies (Lilium bulbiferum) can often be found amongst the rocks. Nikon D810, 105mm, ISO 100, 1/125s at f/11, Jun.

Left: Climbers are a common sight throughout the boulderfield. Nikon D610, 24–70 at 70mm, ISO 100, 1/800s at f/4, Jul.

Next spread: A skier makes the first critical turn on the descent of Canale Joel from Sass Pordoi. Nikon D610, 14–24 at 14mm, ISO 100, 1/500s at f/8, Feb.

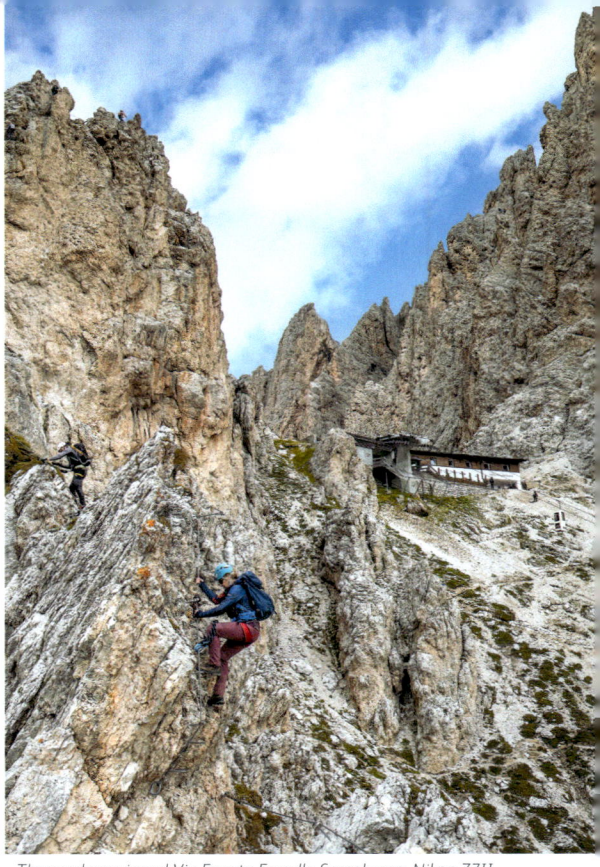

Top: Milk churns at the farm adjacent to Malga Sella. Nikon D610, 14–24 at 14mm, ISO 100, 1/250s at f/8, Jul. **Above**: False aster (Aster bellidiastrum). Nikon D610, 105mm, ISO 100, 1/800s at f/3.5, tripod, Jun.

The newly equipped Via Ferrata Forcella Sassolungo. Nikon Z7II, 24–120mm at 24mm, ISO 220, 1/500s at f/8, Aug.

Sassolungo and Città dei Sassi, shot from the Passo Sella. Nikon D610, 16–35 at 16mm, ISO 100, 1/320s at f/9, Jun.

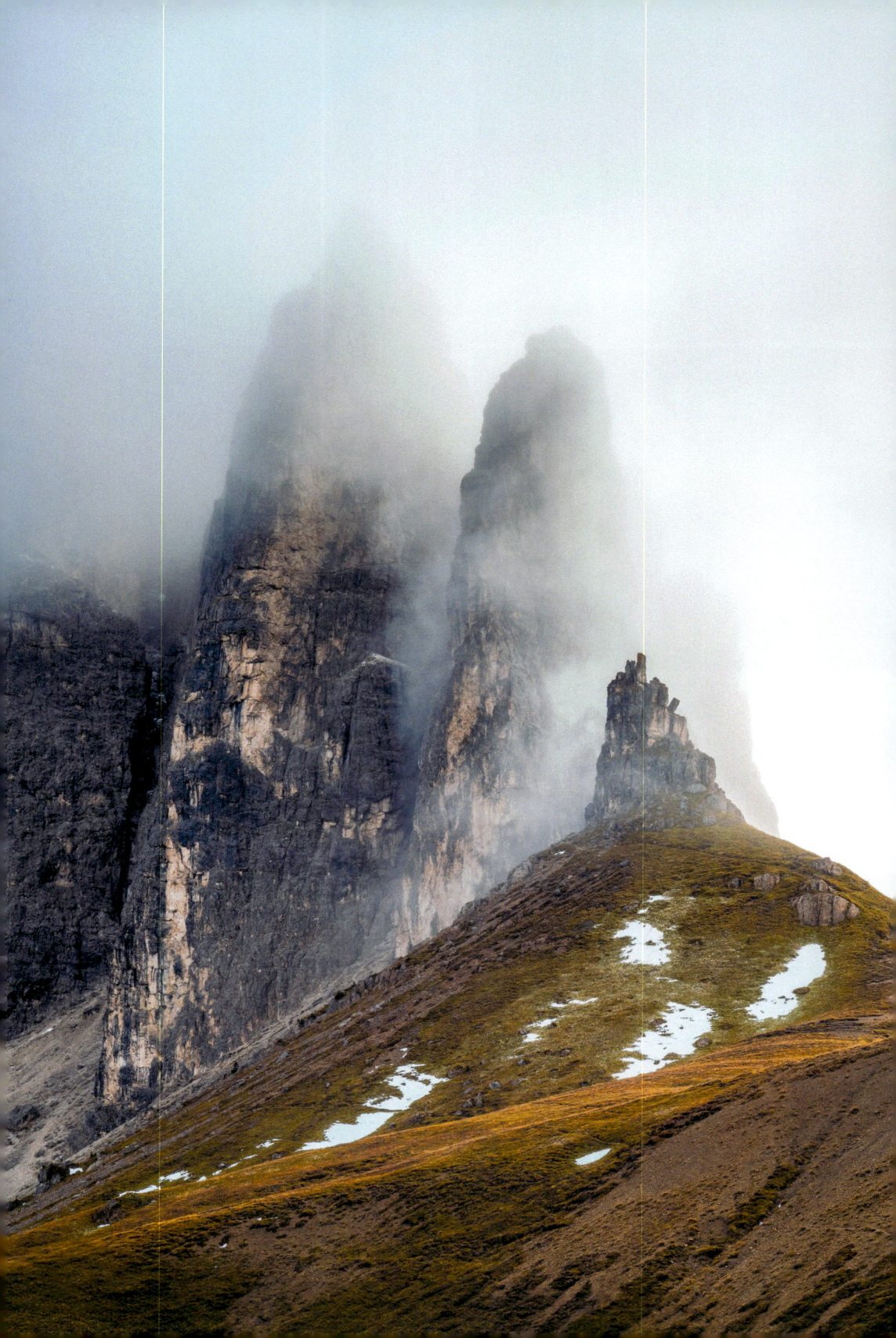

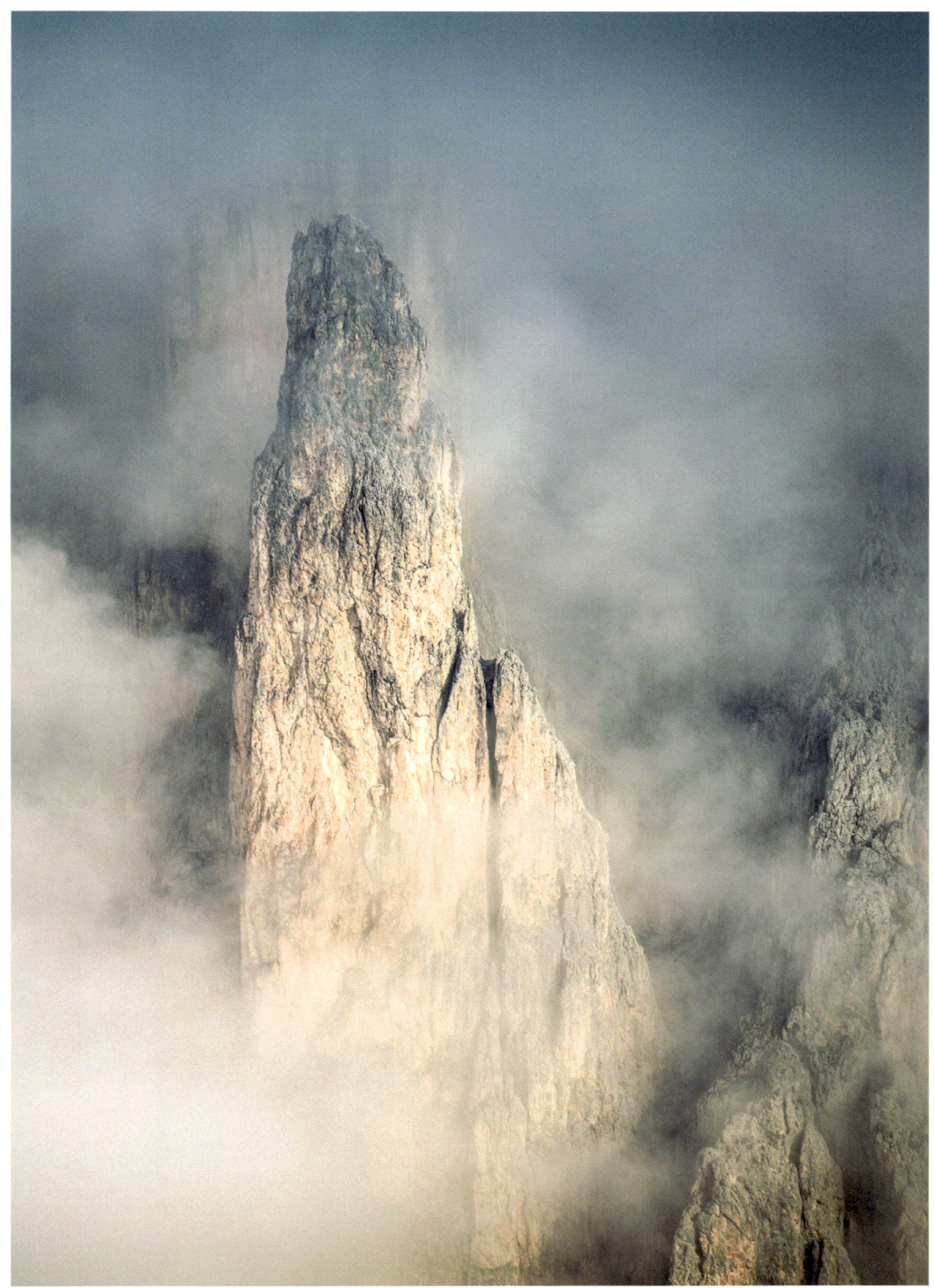

Moody conditions on the Sella. **Above**: *Nikon Z7II, 100–400mm at 320mm, ISO 280, 1/320s at f/9, Sep.*
Opposite: *Nikon Z7II, 24–120mm at 84mm, ISO 64, 1/200s at f/9, Aug.*

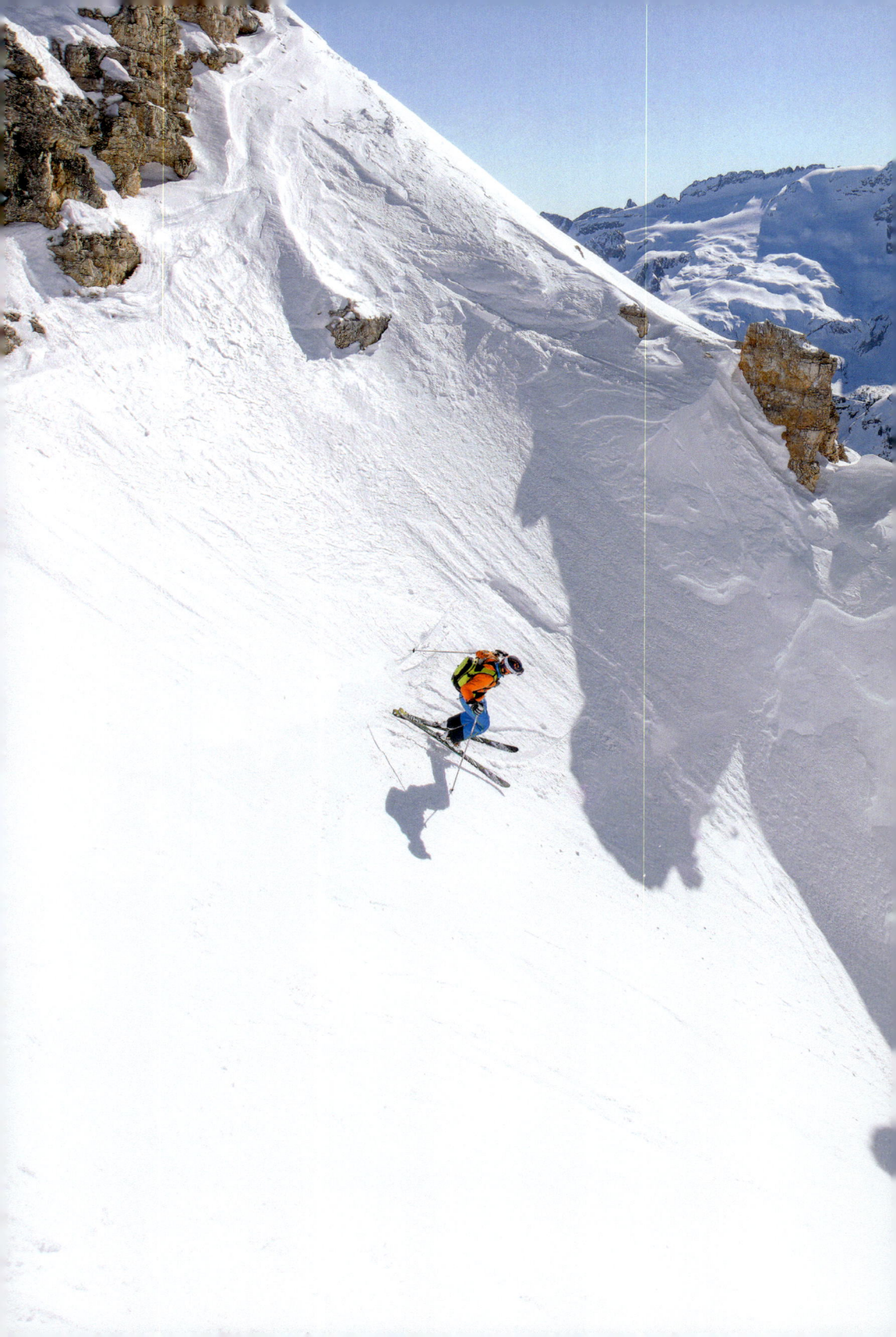

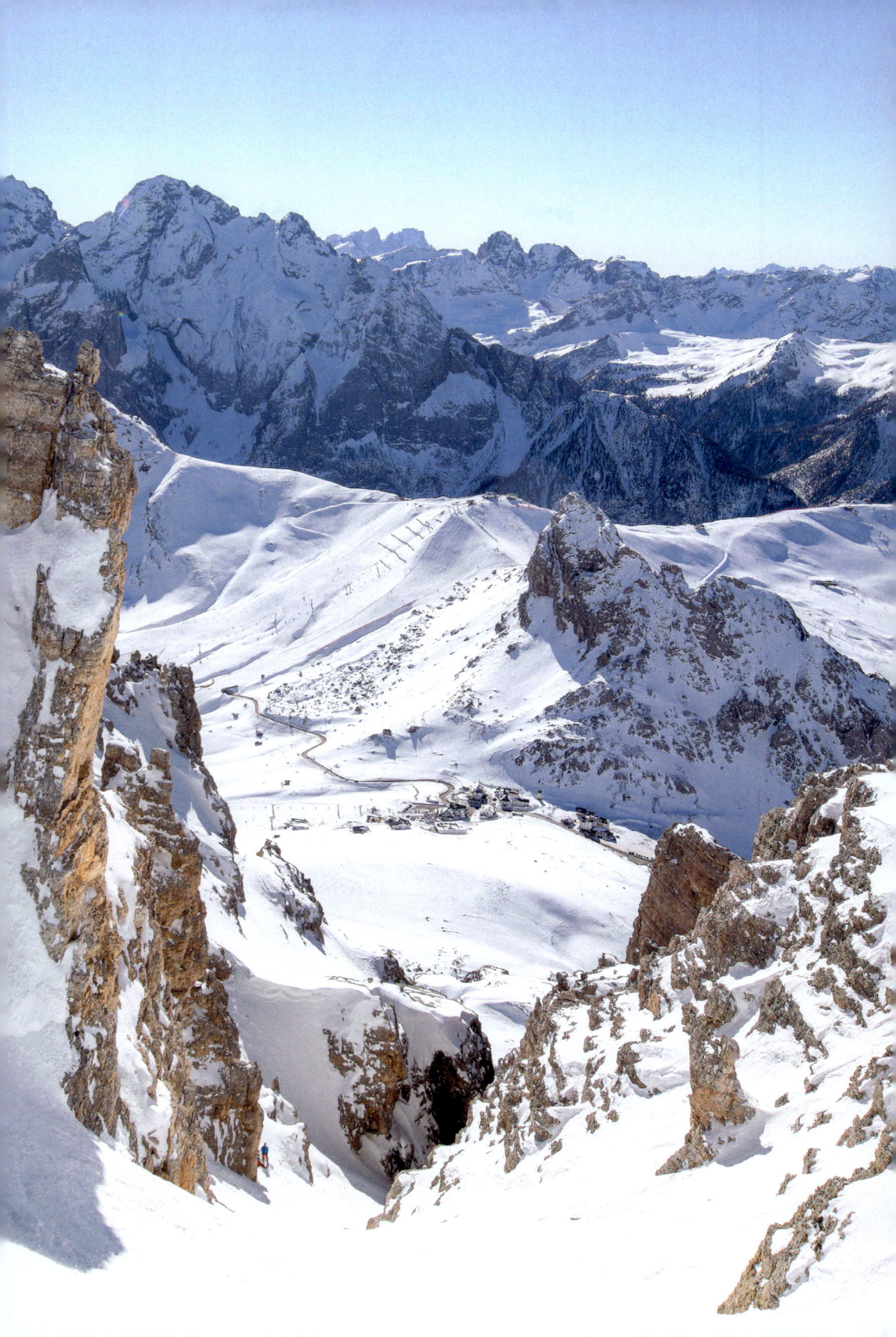

② SASS PORDOI / PORDOI SPITZE

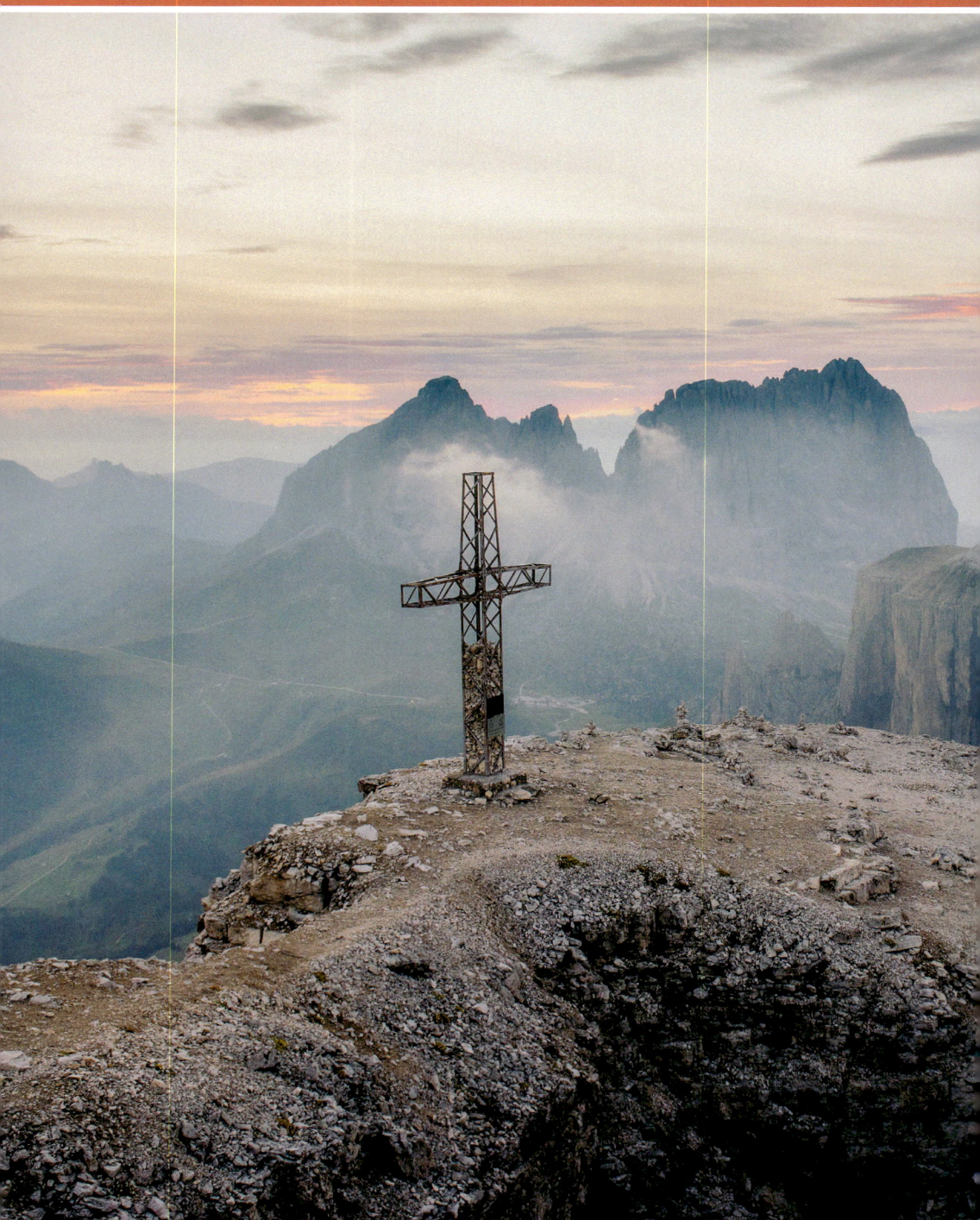

The panoramic summit of Sass Pordoi (2952m) is easily accessed using the Sass Pordoi cable car which departs from the top of Passo Pordoi, making it an ideal location for photographers. The free-hanging cable car has no support pillars over its 800m of ascent and is an experience in itself, depositing you on the vast lunar plateau of the Sella massif. Excellent views of the Marmolada, Sassolungo, Padon ridge and Monte Civetta await.

For those wishing to explore further afield, an out-and-back ascent of Piz Boé (3152m) yields more superb vistas from its conical summit.

What to shoot and viewpoints

Viewpoint 1 – Sass Pordoi Summit ♿

From Rifugio Maria at the top of the Sass Pordoi cable car, a short walk north-west leads to the panoramic summit cross of Sass Pordoi (2952m). The obvious composition looks west towards Sassoungo, using the rock-filled cross as a foreground. Try using a silhouetted subject near the cross for additional interest. This viewpoint works particularly well at sunrise as the light slowly illuminates the east faces.

There are also good views south-west over the Catinaccio group and north over the Sella plateau itself.

Previous spread: A skier makes the first critical turn on the descent of Canale Joel from Sass Pordoi. Nikon D610, 14–24 at 14mm, ISO 100, 1/500s at f/8, Feb.

Left: Whilst Sass Pordoi is a beautiful spot for sunset, it does require staying up on the plateau or a long walk down in the dark. Nikon Z7II, 24–120mm at 24mm, ISO 100, 1/50s at f/6.3, Aug.

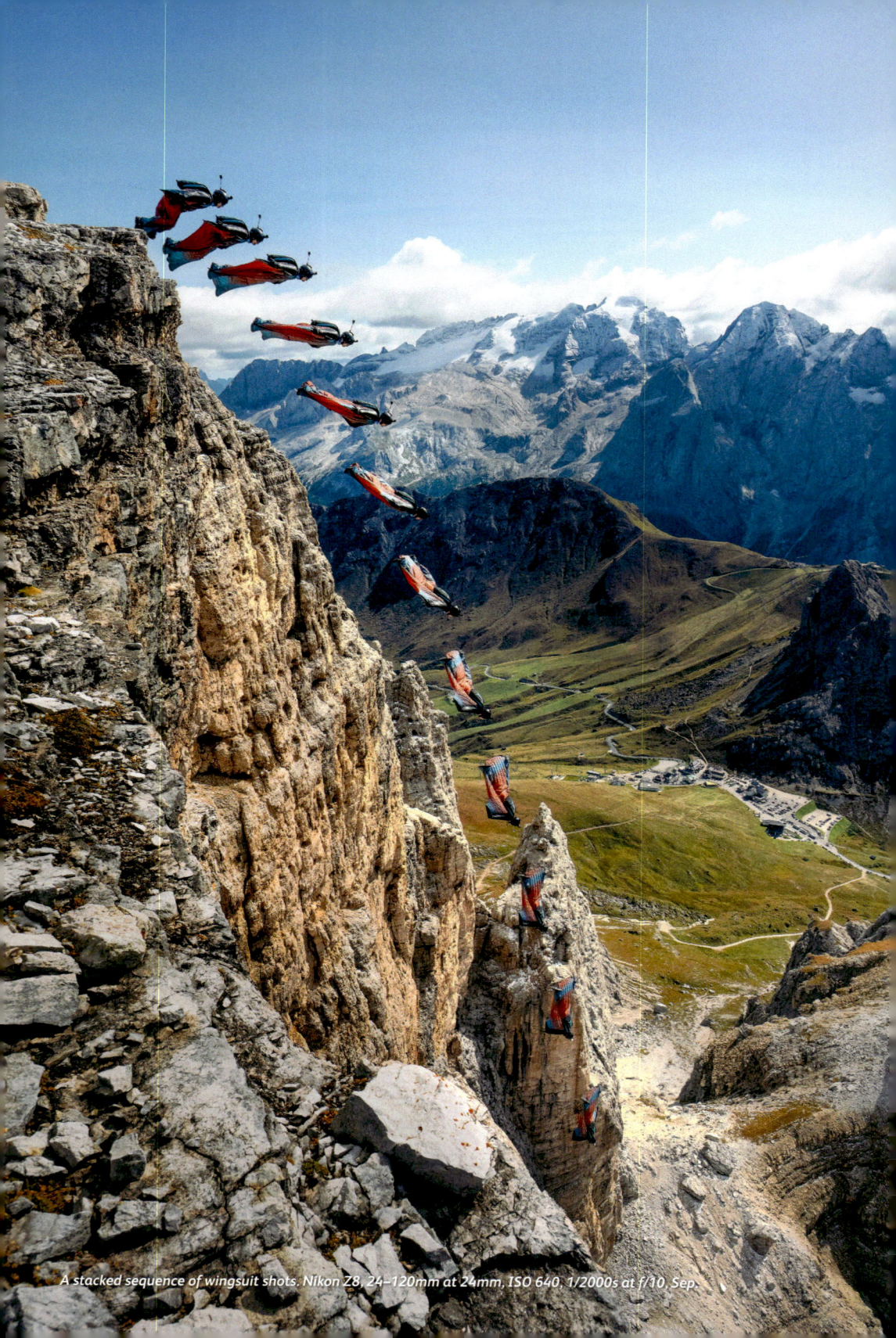
A stacked sequence of wingsuit shots. Nikon Z8, 24–120mm at 24mm, ISO 640, 1/2000s at f/10, Sep.

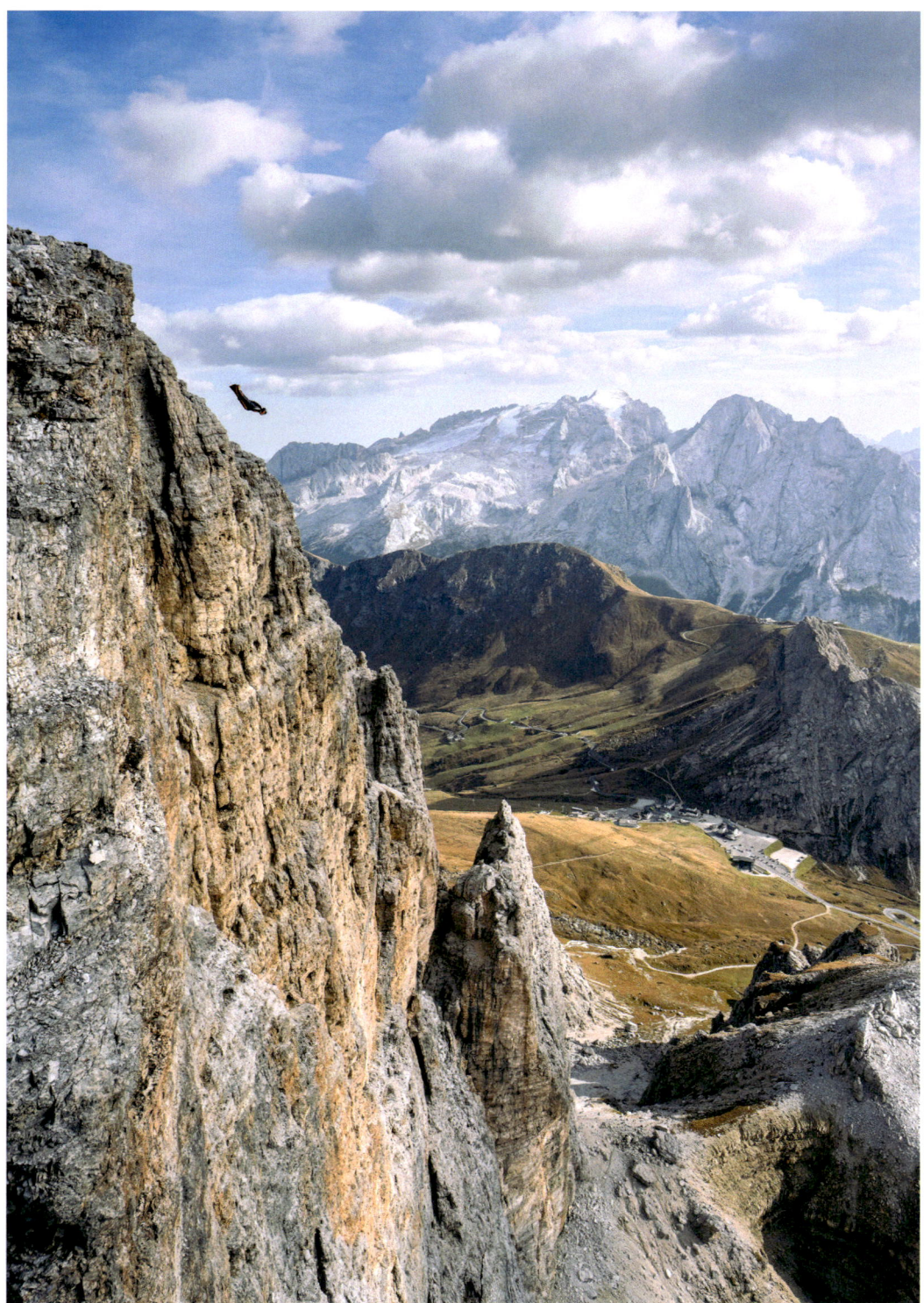
Sass Pordoi is a popular wingsuit jump location. Nikon Z7II, 24–120mm at 24mm, ISO 400, 1/1000s at f/8, Sep.

2. SASS PORDOI / PORDOI SPITZE

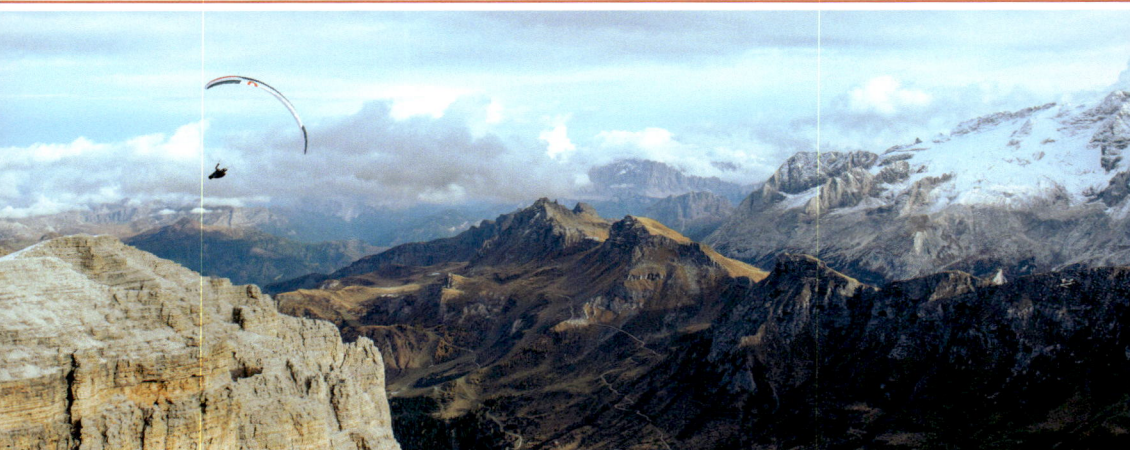

A paraglider makes the most of the ridge lift. Nikon Z7II, 24–120mm, ISO 400, 1/1000s at f/8, Oct.

Viewpoint 2 – Cable Car & Passo Pordoi ♿

Following path 627a north-east for a short distance reveals a number of buttresses situated to the right, providing a series of excellent viewpoints looking south. Take care when approaching and avoid going near the edge – the south face of Sass Pordoi ends in a 300m cliff.

There are now a number of shooting options. Looking south, there are excellent views over the Portavescovo, Padon and Marmolada. This makes for a great panorama, starting with Piz Boè and working all the way back across to the cable car station.

Looking further afield there are far-reaching views over to the north-west faces of Monte Pelmo and Civetta on the Passo Staulanza. Indeed, with a suitably long lens it is possible to isolate any number of dramatic peaks from this high vantage point, taking advantage of the best light. On a good weather day, paragliders can make for interesting subjects and focal points that can really add drama to the already impressive landscapes.

Viewpoint 3 – Cairns

Continue down path 627a for a short distance to reach several stone cairns stacked into perfect pyramids to aid navigation in bad weather conditions. These make for perfect subjects while shooting the bleak and lunar landscape of the Sella plateau.

A broken spectre cast upon the clouds opposite the sun. Nikon D810, 24–70mm at 70mm, ISO 100, 1/250s at f/8, Aug.

How to get here

The Sass Pordoi cable car departs from the summit of Passo Pordoi and is served by several large car parks. The pass can be approached from Canazei to the west or Arabba to the east.

If the cable car isn't running, it is possible to ascend on foot using path 627 to reach Rifugio Forcella Pordoi before turning left onto the 627A to continue to the cable car top station. Allow two hours for the 700m ascent.

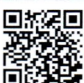

Lat/Long:	46.488161, 11.810587	
what3words:	///decorators.dormant.mismanaged	
Tabacco:	Map 06 (1:25.000)	
Kompass:	Map 616 (1:25.000)	

Accessibility

Approach: 2 minutes, 0.2km, 5m of ascent.

Disabled access: Wheelchair access on the Pordoi cable car is permitted and the views from Rifugio Maria are excellent. The plateau itself is fairly flat but strewn with rocks and boulders of various shapes and sizes.

Best time of year/day

Owing to the rocky nature of the surrounding plateau, the immediate scenery is not seasonally dependant and looks equally impressive during the summer and winter. The cable car is open from early June until late October and then again from December to April.

The range of views in all directions from this 'terrace of the Dolomites' is such that it is generally possible to find a well-lit subject throughout the day if conditions are favourable.

Overnight stays are possible at the nearby Rifugio Forcella Pordoi, offering an good option for those wishing to shoot at sunset, sunrise or through the night when the lift is closed.

Thanks to the height of the viewing terrace, this can be an excellent location if there is a lot of cloud in the valleys, and a good inversion from the top looks spectacular. Keep an eye out for a strong temperature inversion when the peaks are warmer than the valleys. This traps the low pressure at ground level and prevents the cloud from rising. The conditions on the summit can be checked using a variety of webcams accessible on the lift website or by contacting the lift station directly.

Light rays bathe the summit cross with views towards Sassolungo. Nikon D810, 24–70mm at 30mm, ISO 100, 1/800s at f/8, Jul.

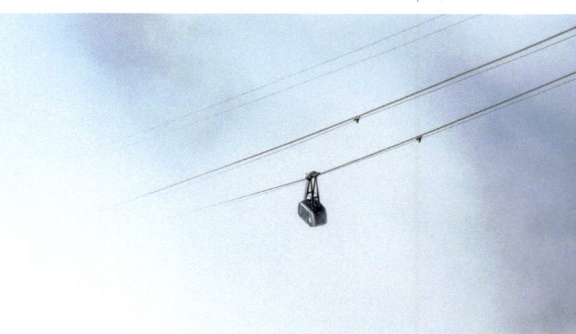

The Sass Pordoi cable car rises from the clouds. Nikon D810, 80–400 at 150mm, ISO 100, 1/800s at f/10, Jul.

A lone paraglider above the Dente di Terrarossa. Nikon D810, 80–400 at 270mm, ISO 100, 1/640s at f/13, Aug.

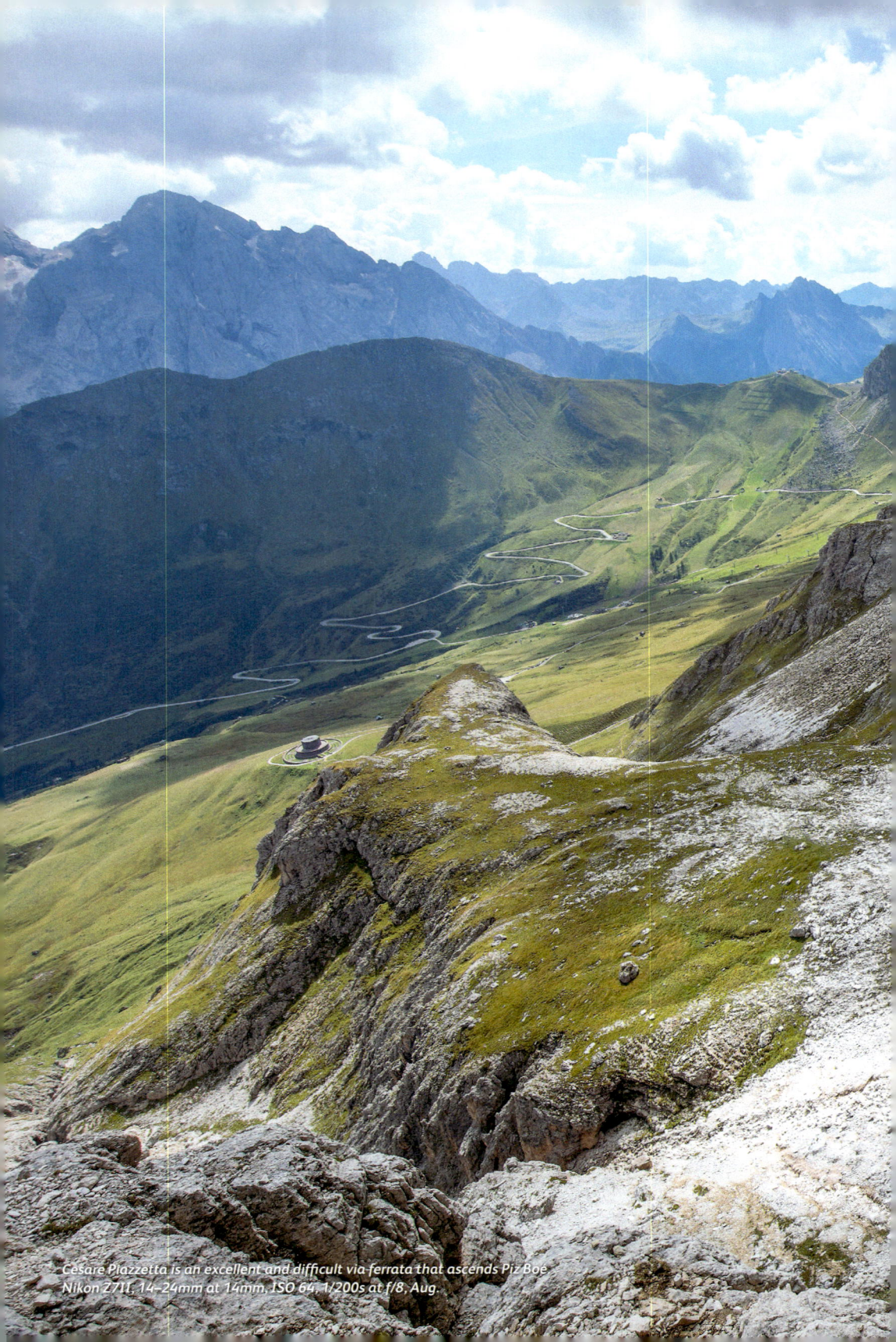

Cesare Piazzetta is an excellent and difficult via ferrata that ascends Piz Boe
Nikon 7/II, 14–24mm at 14mm, ISO 64, 1/200s at f/8, Aug.

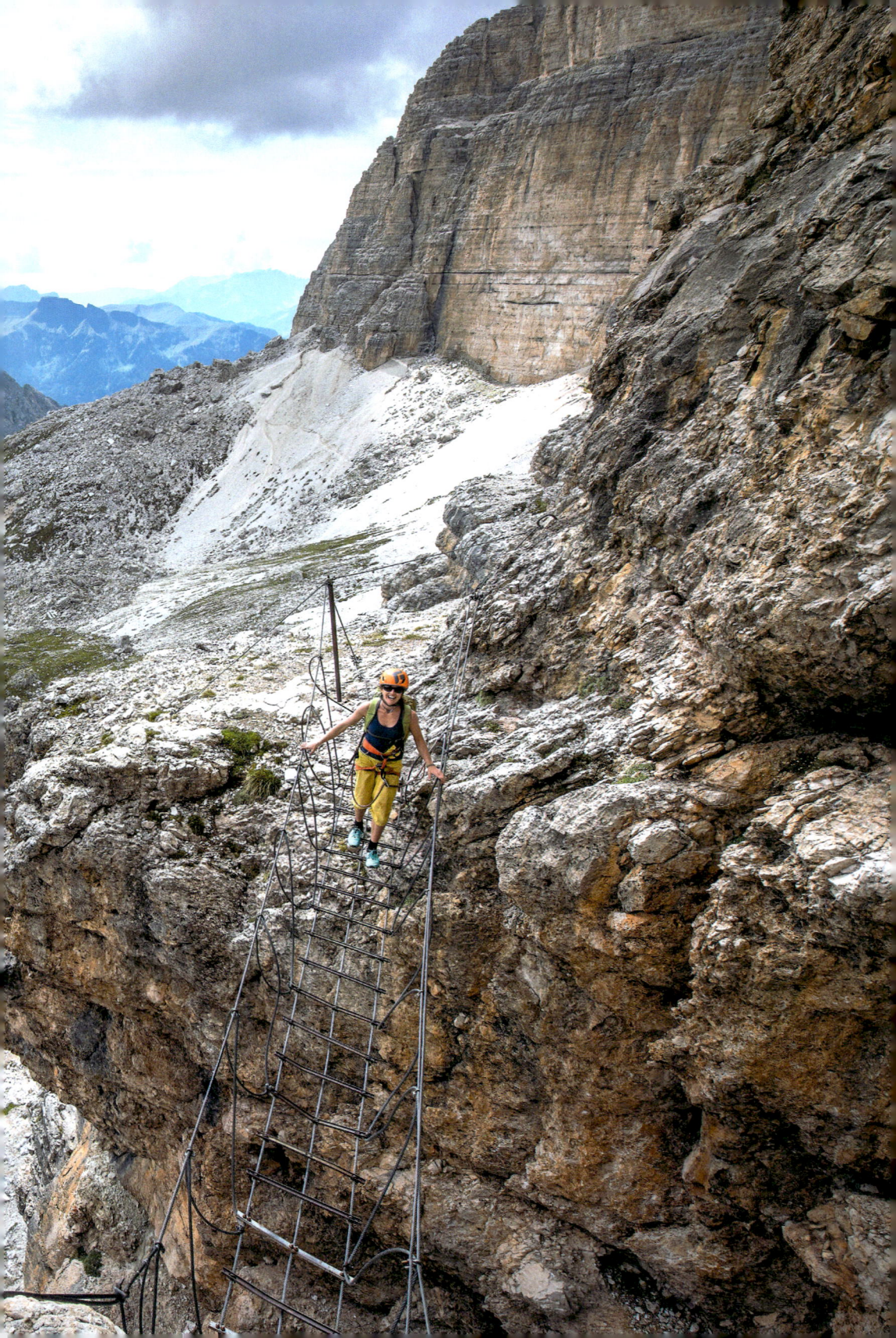

③ PORTAVESCOVO

The volcanic Portavescovo and Padon ridgeline runs east to west, separating the Marmolada, Passo Pordoi and the village of Arabba. The path that runs parallel to the ridge was once used by local grain smugglers to avoid taxes imposed by the Venetian Republic, hence the name 'Viel del Pan' (bread road). Towards the end of the 19th century, the route was rediscovered by German mountaineer Karl Bindel, thus giving rise to its second name, the 'Bindelweg'.

By following the ancient route from the Passo Pordoi to an outcrop just before the perfectly situated Rifugio Viel Dal Pan, photographers can gain an superb view over the Marmolada and the Lago Fedaia reservoir.

What to shoot and viewpoints

From the top of the pass, walk east towards Arabba. Just beyond Hotel Savoia, turn right onto path 601, following signs for the Viel del Pan / Bindelweg. Continue past a small chapel as the path traverses the hillside, passing below Rifugio Sass Bece to arrive at Rifugio Fredarola in 30 minutes. Continue on path 601 as it crosses onto the southern side of the ridgeline, now following for Rifugio Viel del Pan. In a further 10 minutes, the path rounds a prominent corner to give excellent views of Lago Fedaia for the first time. A large flat boulder protrudes from the right-hand side of the path, making for an excellent viewing platform.

Viewpoint 1 – The Marmolada & Lago Fedaia
The ensuing panorama is quite spectacular, with the impressive dam wall separating two distinct landscapes: the dark volcanic rock and lush green of the Portavescovo ridge on the left, and the shattered pale and snow-covered limestone eroded by the Ghiacciaio della Marmolada to the right. The disparity between the two scenes makes a wide-angle landscape or panorama particularly effective when the reservoir is placed in the centre.

Before retracing your steps, it is worth continuing the short distance to Rifugio Viel del Pan for refreshments.

Top: The first light of day illuminates Lago Fedaia. Nikon D810, 24–70 at 60mm, ISO 100, 0.8s at f/8, tripod, Sep. **Above**: Gran Vernel. Nikon Z7II, 24–120 at 120mm, ISO 64, 1/200s at f/8, Jun.

How to get here

The described approach departs from the summit of Passo Pordoi where there are several large parking areas adjacent to the Pordoi cable car. The pass can be approached from Canazei to the west or Arabba to the east.

- Lat/Long: 46.488161, 11.810587
- what3words: ///decorators.dormant.mismanaged
- Tabacco: Map 06 (1:25.000)
- Kompass: Map 616 (1:25.000)

Accessibility

Approach: 40 minutes, 2.5km, 200m of ascent.

 Disabled access: The approach path is narrow and rocky, making it unsuitable for disabled access.

The Portavescovo cable car that departs from the village of Arabba is a good alternative; although slightly further east, this affords similar views and offers good disabled access.

Best time of year/day

The viewpoint looks best during late spring and early summer when the grass of the Portavescovo has greened up but there is still a good covering of snow capping the Marmolada. During midsummer, the retreating snow exposes much of the terminal moraine to give the north face a broken and shattered look.

Because of the easterly orientation of the principal viewpoint, it is easiest to shoot during late afternoon and at sunset when the sun isn't silhouetting much of the scene. That said, if conditions allow sunrise can be spectacular as the first rays strike the Marmolada and the sky is reflected in the clear waters of Lago Fedaia.

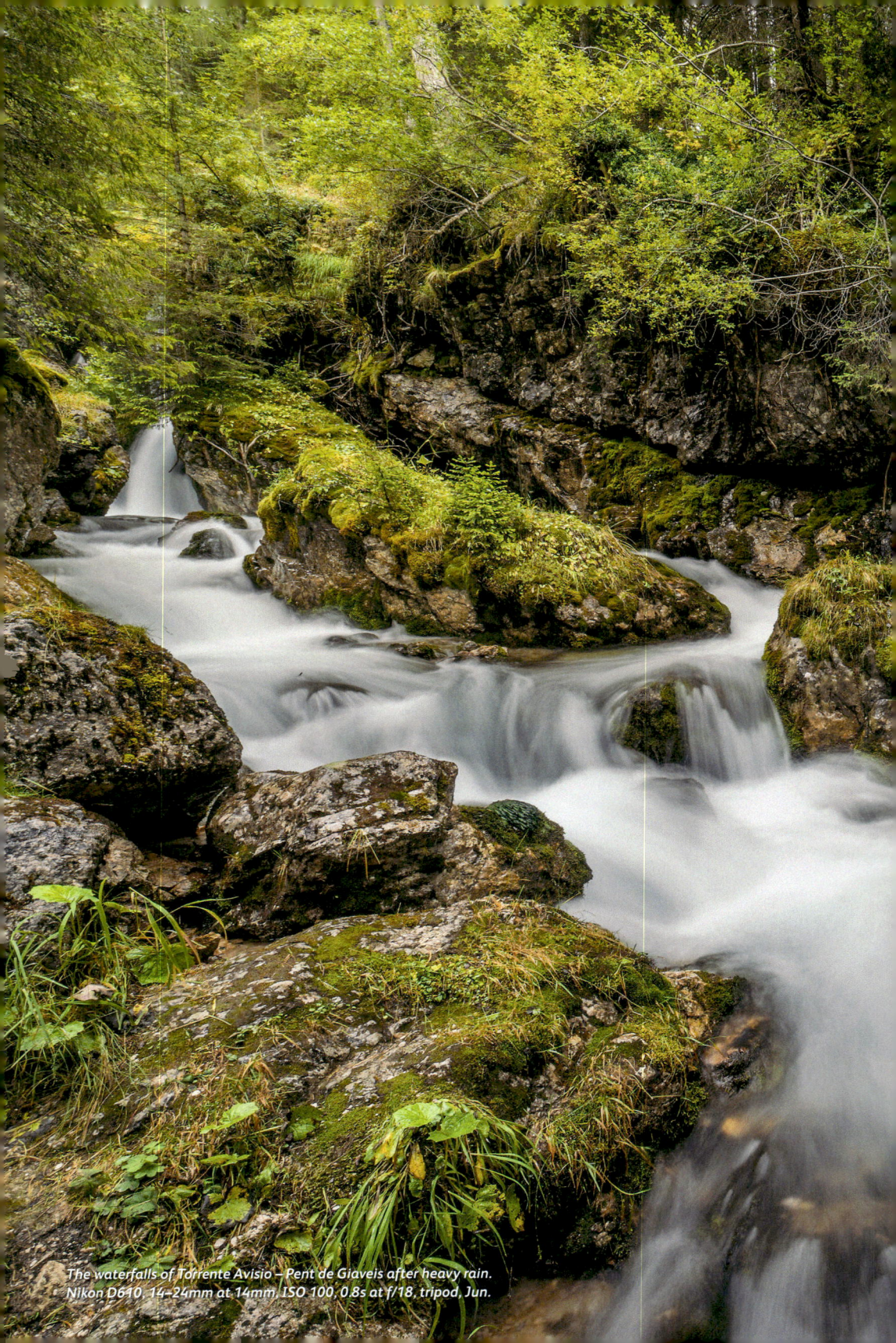
The waterfalls of Torrente Avisio – Pent de Giaveis after heavy rain.
Nikon D610, 14–24mm at 14mm, ISO 100, 0.8s at f/18, tripod, Jun.

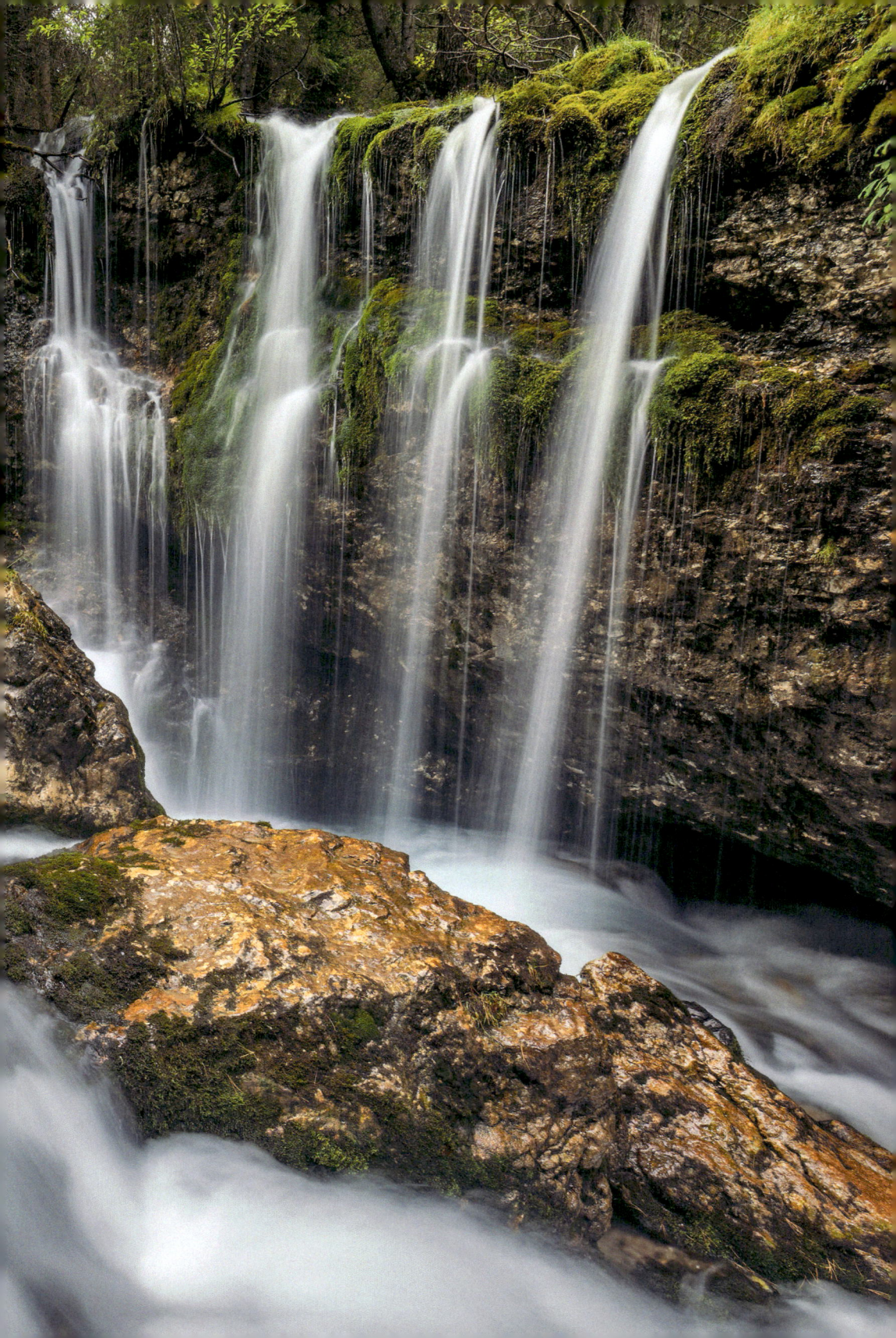

TORRENTE AVISIO – PENT DE GIAVEIS

The Passo Fedaia, a familiar haunt for climbers or skiers scaling the Marmolada, is seldom visited as a scenic or photographic location. Yet concealed behind the dense pines which line the pass and mere metres from the road itself lies the hidden gem of Torrente Avisio. Several tributaries that feed this beautiful stream converge just upstream of the Pent de Giaveis bridge, forming a spectacular little waterfall surrounded by lush green foliage. This is an ideal venue for bad weather days or to seek some solitude away from the crowds.

What to shoot and viewpoints

Viewpoint 1 – Waterfall

Clearly visible some 15m upstream of the Pent de Giaveis bridge and easily accessed by a good path to the left, this is the obvious source for photographic inspiration. Dense foliage prevents a pleasing composition from the bridge itself but there are numerous vantage points to be found following the aforementioned path, both beside and just above the stream. With a wide-angle lens or a panoramic, it is possible to capture both the falls and the main channel. Remember to utilise the line of the stream to draw the viewer's eyes to the cascades. It is also worth isolating the main fall, picking out the lovely detail of the vibrant drenched moss with a longer lens. During the winter months the waterfalls often freeze, creating a beautiful chandelier above the stream which is well worth seeking out when the main watercourse is still flowing.at.

Viewpoint 2 – Tributaries

Cross the bridge and then immediately follow any of a number of ill-defined paths up the right side of the stream to find a number of small tributaries just above the main waterfall. These are very photogenic as they flow straight over moss and superb woodland vegetation, creating their own little drainage basin.

Try getting in close to these mini falls; flowing over sticks, rocks, plants and anything else that gets in their way, the little runnels are constantly changing course, creating the potential for a unique shot every time you visit. During late autumn and very early spring, ice forms around the channels and creates spectacularly intricate formations.

An extreme wide-angle works well at the falls. Nikon D610, 14–24mm at 14mm, ISO 100, 0.4s at f/13, tripod, Jun.

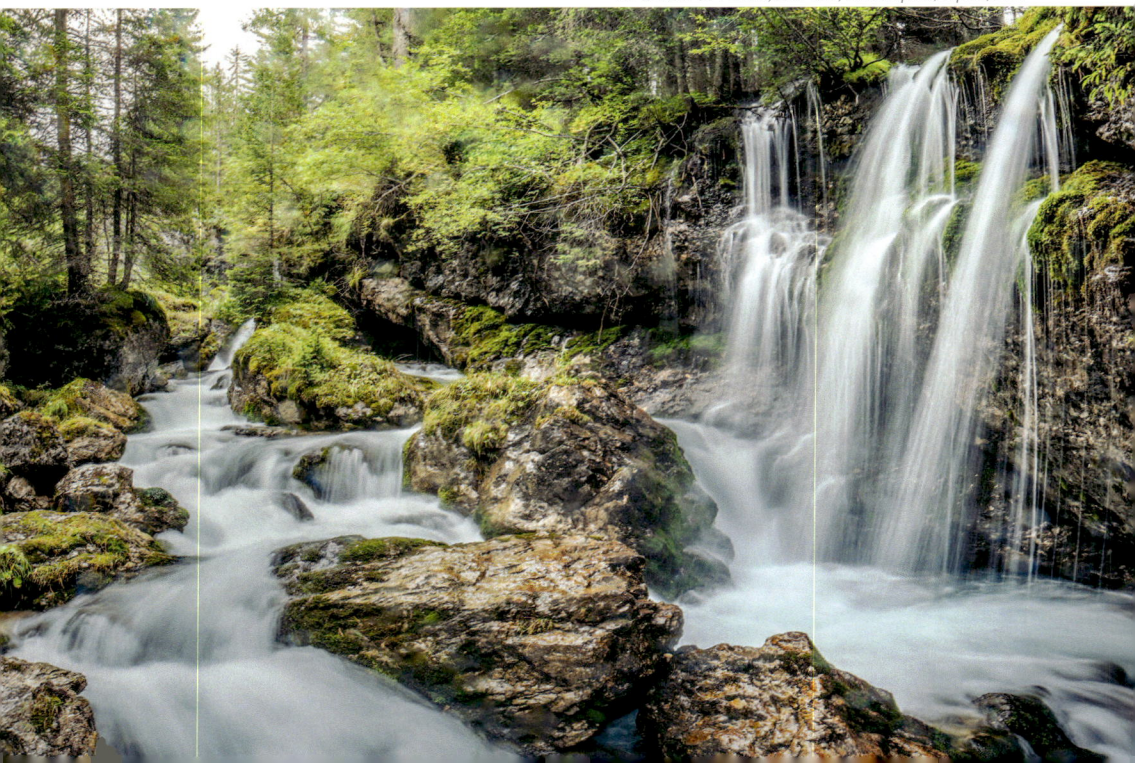

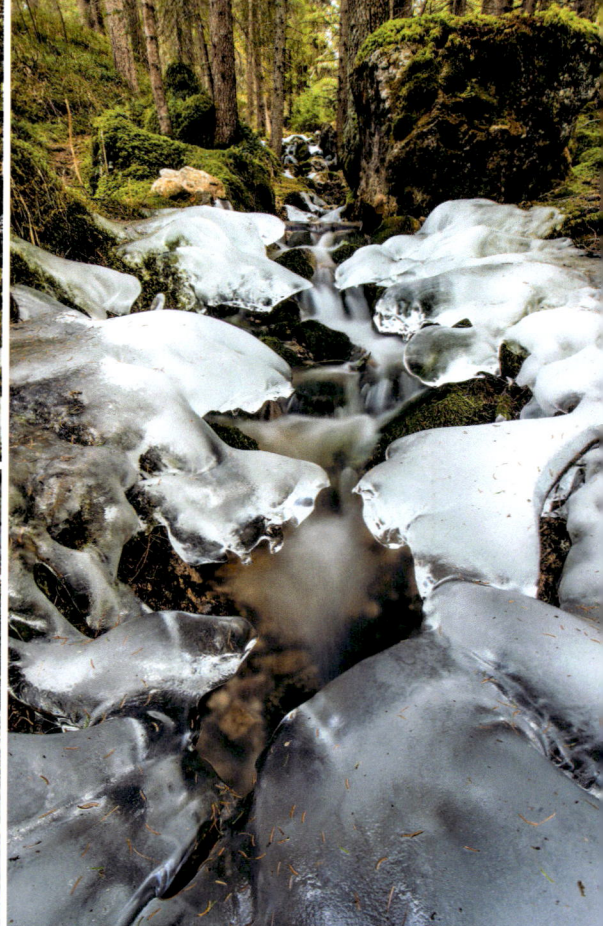

How to get here

The Pent de Giaveis bridge is located on the west side of Passo Fedaia and is accessible from Canazei in the Val di Fassa or from Caprile by driving over the Fedaia pass itself.

From Canazei in the Val di Fassa, follow the SS641 south-east for 3km, signed for the Passo Fedaia, to pass through the villages of Alba and Penia. As you leave Penia the road enters woodland and there is a small lay-by on the right (first parking option). This is followed by another, smaller one 50m further up, also on the right just before the road crosses the clearly marked Pent de Giaveis Bridge.

- **Lat/Long:** 46.457957, 11.807576
- **what3words:** ///exteriors.level.scram
- **Tabacco:** Map 06 (1:25.000)
- **Kompass:** Map 686 (1:25.000)

Accessibility

Approach: Roadside access.

The cascade is only 50m from the nearest parking area, but the surrounding paths are rocky and very slippery when wet. Very occasionally water is released from the Lago Fedaia reservoir, resulting in a sudden and dramatic increase in stream water level.

Disabled access: While it is possible to photograph the stream from the bridge, the best viewpoint is from the stream banks and is not suitable for disabled access.

Best time of year/day

The stream is photogenic year round, although it is generally more interesting after a period of persistent heavy rain. In midwinter the stream is often lost to ice and snow; however, during early and late winter ice often forms on the sides of the channel to create some magnificent and intricate patterns.

The location is perfect for shooting on an overcast or bad weather day when the light is flat, reducing the contrast and enabling you to create a softer image.

Top left: Intricate ice patterns. Nikon D610, 80–400mm at 155mm, ISO 100, 0.6s f/9, tripod, Sep.

Above left: There are many tiny falls flowing amongst the rocks. Nikon D610, 28–300mm at 300mm, ISO 100, 0.4s at f/5.6, tripod, ND filter, Sep. *Right*: Escaping winter's grasp. Nikon D610, 14–24mm at 14mm, ISO 100, 2s at f/18, tripod, Jan.

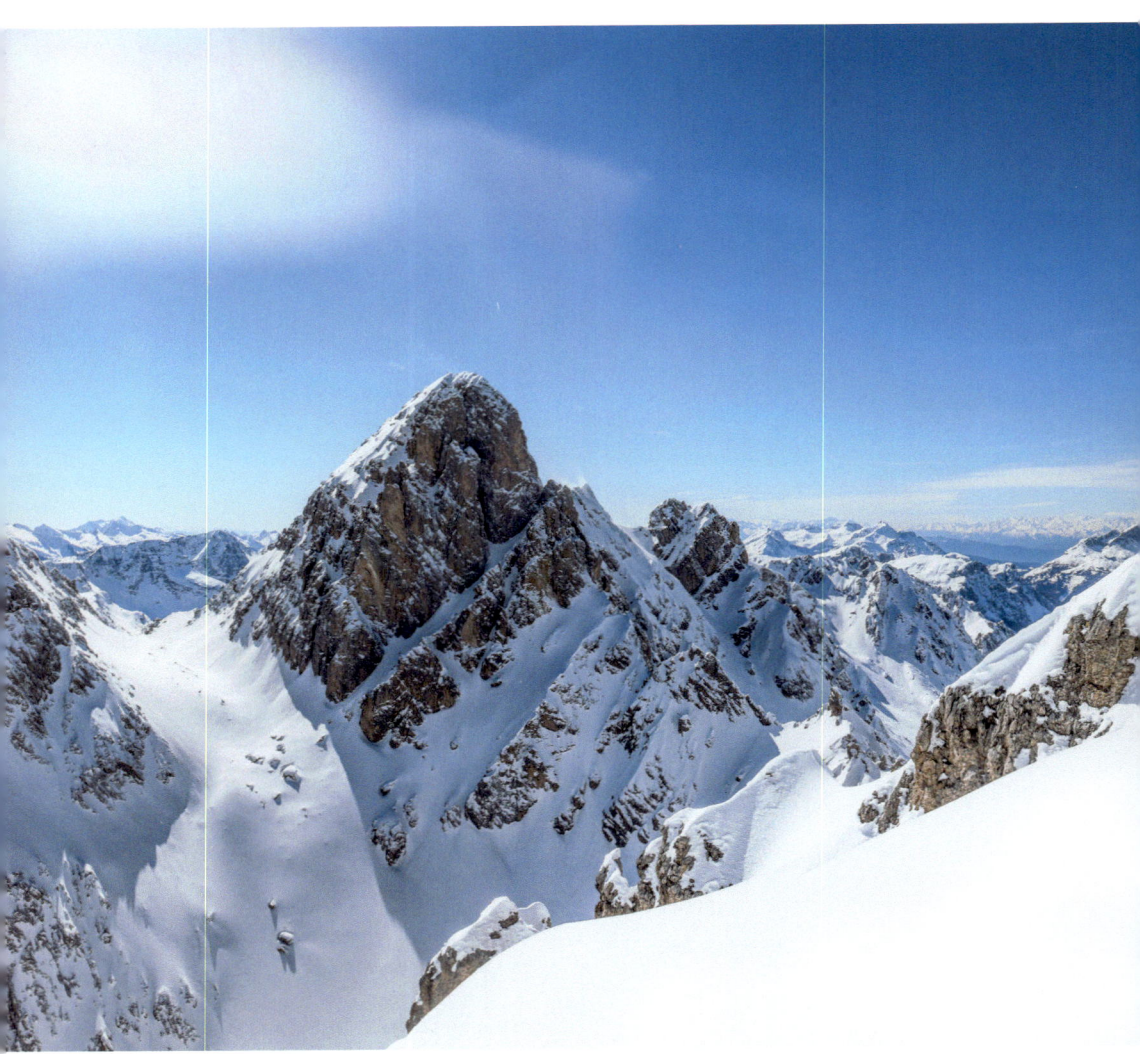

A 6 image panorama as Katie approaches the summit of Cime Cadine. Nikon Z8, 24–120mm at 24mm, ISO 64, 1/500s at f/10, Mar.

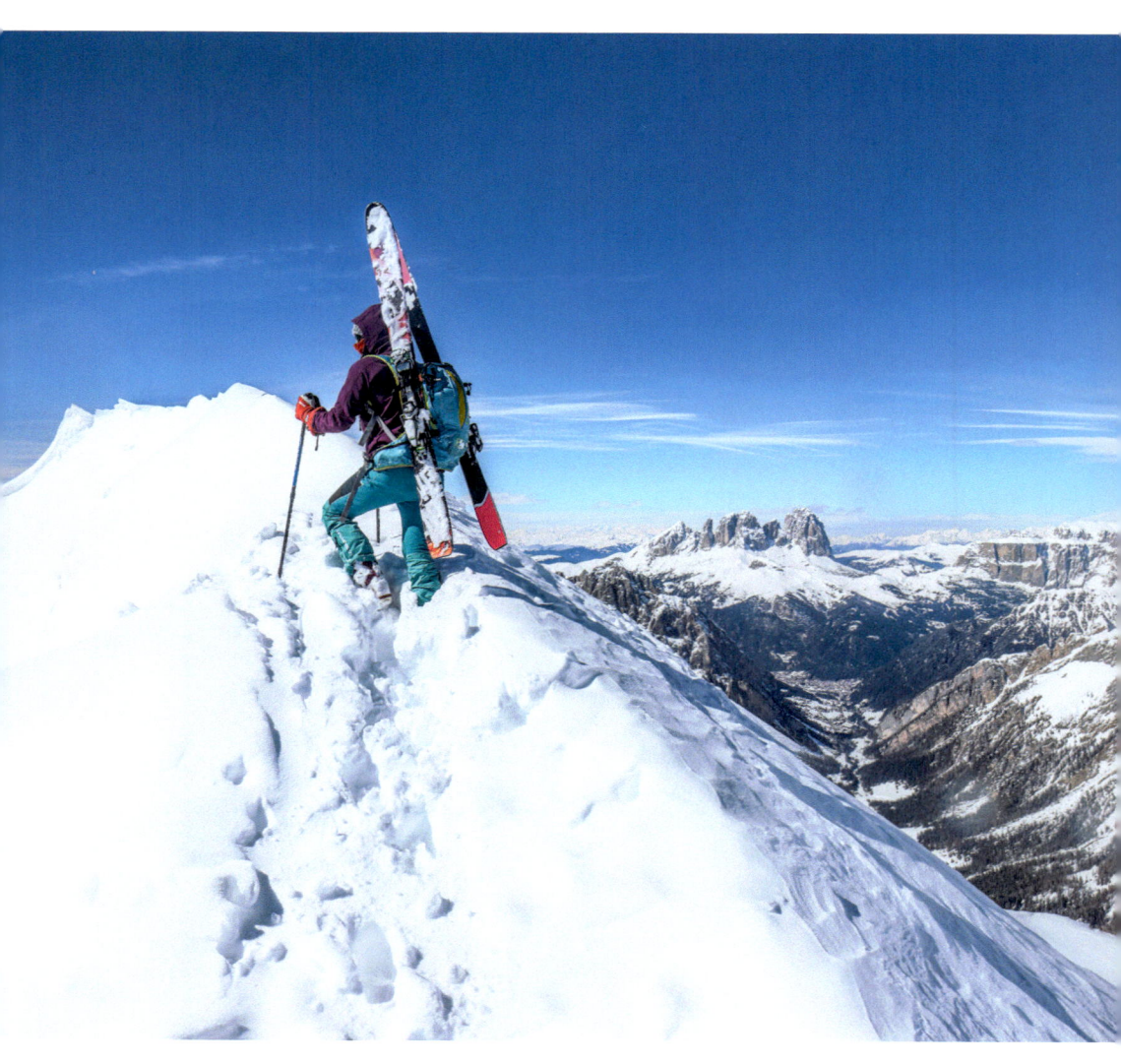

5. SERRAI DI SOTTOGUDA

Cutting a trench between the small hamlets of Sottoguda and Malga Ciapela lies the beautiful Serrai di Sottoguda gorge. While pleasant in the summer months, it is during the winter that the gorge becomes truly spectacular; the trickling water flowing down the walls freezes to create icefalls of every conceivable shape and size. Between January and March this sleepy valley transforms itself into one of Italy's premier ice climbing venues outside of Cogne and is a must-visit for anyone visiting the area in winter.

Note: unfortunately the path leading through Serrai di Sottoguda was badly damaged during Storm Vaia in 2018 (see page 60). Extensive work is currently being carried out on the gorge and it is due to be reopened in the near future.

What to shoot and viewpoints

From the car park, walk uphill following good signposting to reach the entrance to the gorge after 100m. If you're visiting during the summer there is a charge to enter the gorge; in winter just check to make sure the gorge isn't closed for avalanche or high temperature risk.

Viewpoint 1 – Icefalls & Climbers

With so many icefalls in the gorge in a good winter season, it is difficult to recommend individual locations. Be prepared to improvise depending on which routes are being climbed. You will need a mid range or long zoom for the majority of shots, ideally with a large maximum aperture as the gorge gets very little light and you will want a fast enough shutter speed to freeze the action.

Shortly after entering the gorge you will (hopefully – as it doesn't always form) see 'La Spada nella Roccia' (the Sword in the Stone) on the left. Back in the 80s this was considered the hardest icefall in the world, although these days it gets climbed fairly frequently. The icefall is extremely photogenic due to its slender nature and wonderfully dark and contrasting surrounding rock. Continue beyond this for 5 minutes, crossing a wooden bridge onto the left side of the stream where 'La Cattedrale' (The Cathedral), the largest icefall in the gorge, awaits.

Even free of climbers, this beautiful fall covered in chandeliers, shards and drips is a spectacular sight when fully formed and is undoubtedly the highlight of the ravine. To continue, another 5 minutes of gentle uphill walking leads to Excalibur, a 110m high icefall that forms reliably every year on the left-hand side of the stream. This marks the end of the major icefall interest within the gorge.

A climber on the first pitch of La Spada nella Roccia (the Sword in the Stone). Nikon D810, 80–400mm at 260mm, ISO 800, 1/200s at f/7.1, Jan.

How to get here

Serrai di Sottoguda can be accessed from the village of Sottoguda or from Malga Ciapela to the west. During the winter however, the Passo Fedaia is usually closed on the Canazei (west) side and consequently access is usually easier from Sottoguda and Caprile.

From Caprile follow the SP563 north-west, following signs for Malga Ciapela and merging onto the SP641. Continue through the Val Pettorina for 5km to reach the village of Sottoguda and a sharp hairpin to the left. Turn right into the village here, taking care on the narrow and often busy roads. Good signposting towards Serrai di Sottoguda directs you to a car park on the right, just below the entrance to the gorge.

Lat/Long:	46.42506, 11.93588	
what3words:	///lament.feasibly.gratefully	
Tabacco:	Map 15 (1:25.000)	
Kompass:	Map 59 (1:50.000)	

Accessibility

Approach: 10 minutes, 0.2km, 10m of ascent.

The gorge should not be underestimated as snow and in particular ice covers much of the ground. Ice grips (such as micro spikes) or crampons are recommended for negotiating the path. Be wary of skiers descending the gorge and take extreme care when passing underneath ice climbers as they often knock off large pieces of ice. The gorge closes in early spring or during warm weather periods due to the potential hazard of collapsing ice falls.

♿ Disabled access: During the summer months there is a large, well-surfaced path throughout the length of the gorge. The area is not suitable for disabled access throughout the winter.

Best time of year/day

While the gorge is pleasant during the summer, it really shines (quite literally) during the ice climbing season which runs from January to early March. The shady nature of the ravine means the light is generally consistent throughout the day.

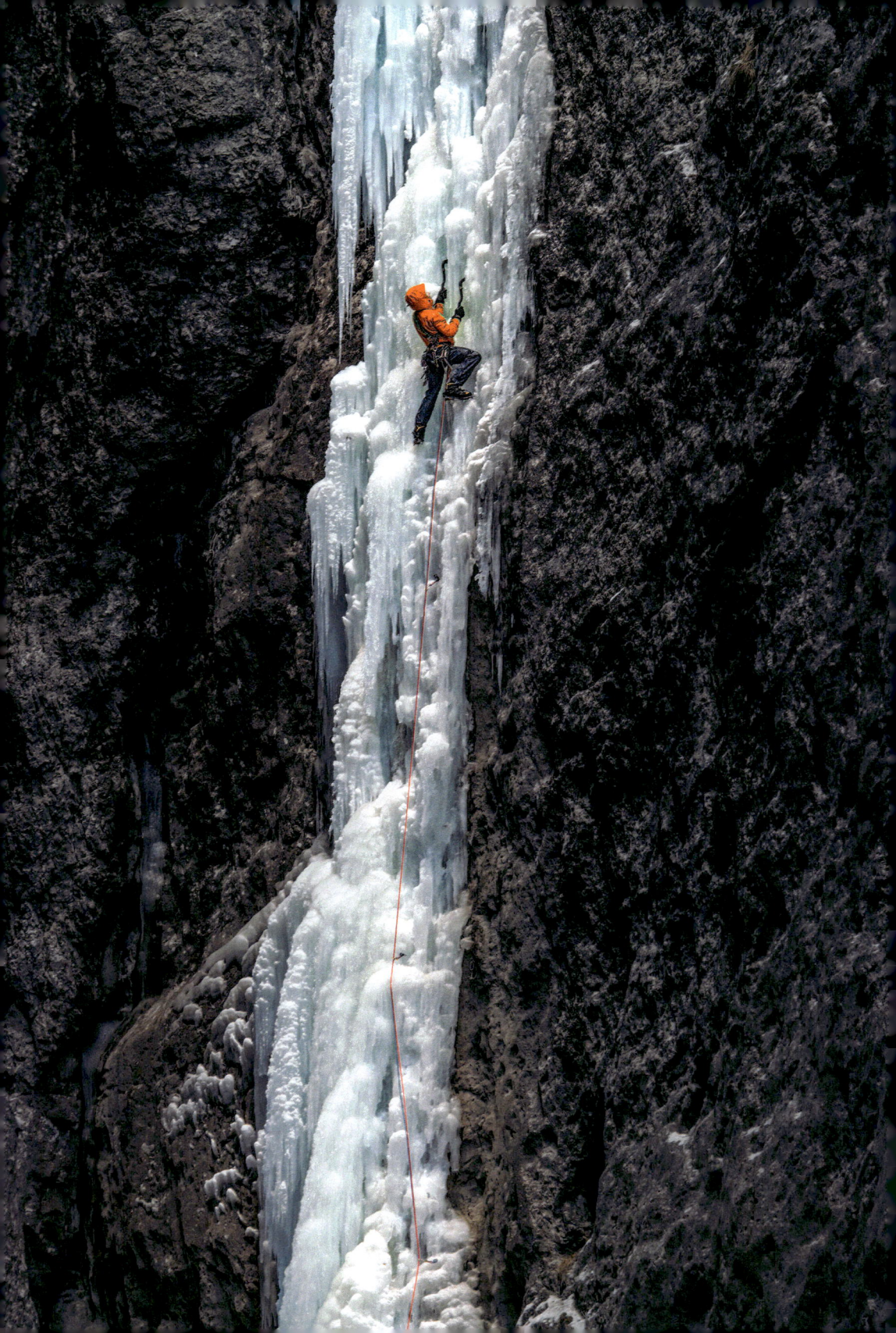

 SERRAI DI SOTTOGUDA

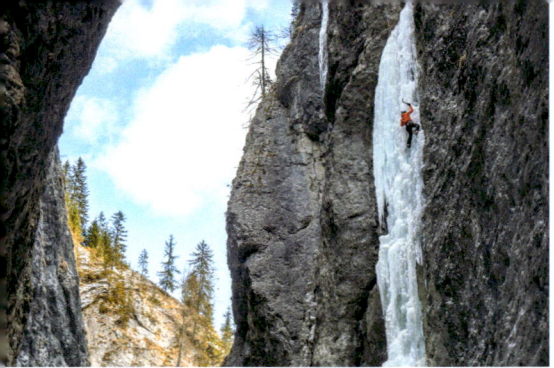
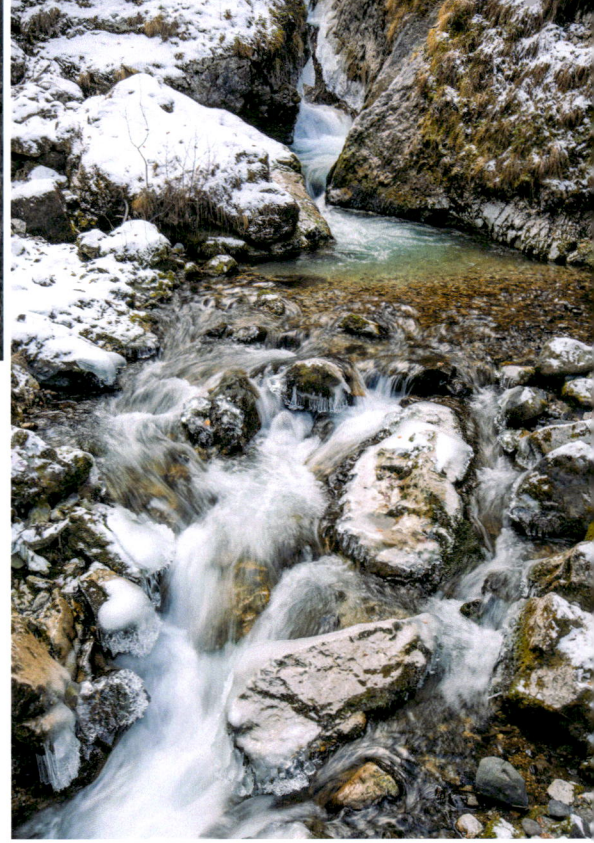

Above: Serrai di Sottoguda. Nikon D810, 24–70mm at 50mm, ISO 400, 1/500s at f/8, Jan. Opposite: Climbing thin ice on the second pitch of Cattedrale di Sinistra. Nikon D810, 80–400mm at 240mm, ISO 560, 1/250s at f/7.1, Jan.

Viewpoint 2 – Torrente Pettorina

The Pettorina stream that flows through the gorge is also worthy of attention during the winter months provided that the surface has not frozen over completely. Keep an eye out for any faster flowing sections where the spray often creates delicate ice sculptures on the surrounding rocks. The bridge that crosses the stream just before the Cattedrale icefall is often a perfect location as it allows you to position yourself directly over the water.

There is also a faster flowing section visible from the path as you first enter the gorge, just below a series of a caves used by troops during the First World War.

A partially frozen Torrente Pettorina as seen from the bridge below the Cattedrale icefall. Nikon D810, 16–35mm at 35mm, ISO 100, 30s at f/6.3, tripod, ND filter, Dec.

Ice stalactites often form in areas prone to seepage. Nikon D810, 80–400mm at 250mm, ISO 100, 210s at f/9, tripod, ND filter, Dec.

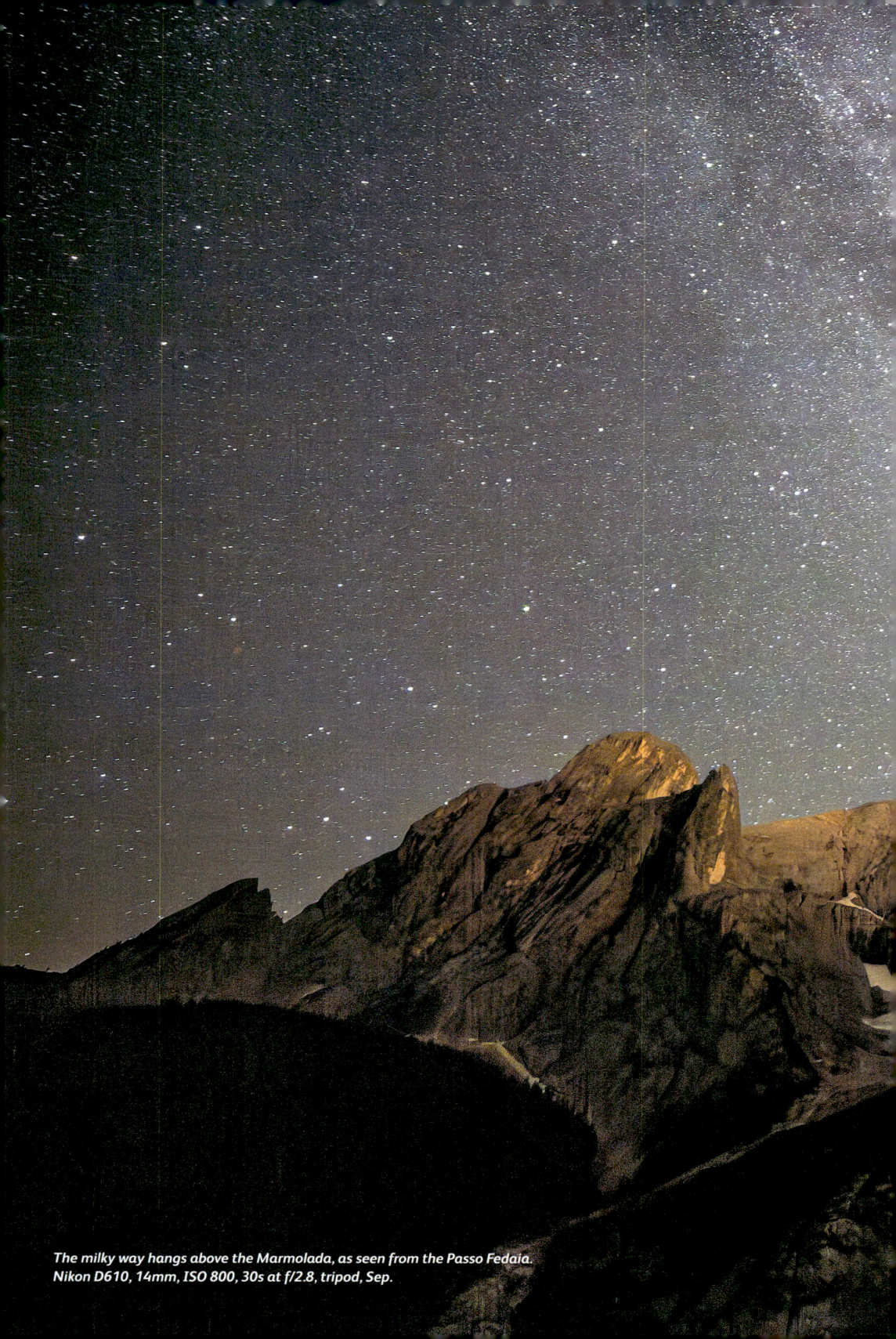
*The milky way hangs above the Marmolada, as seen from the Passo Fedaia.
Nikon D610, 14mm, ISO 800, 30s at f/2.8, tripod, Sep.*

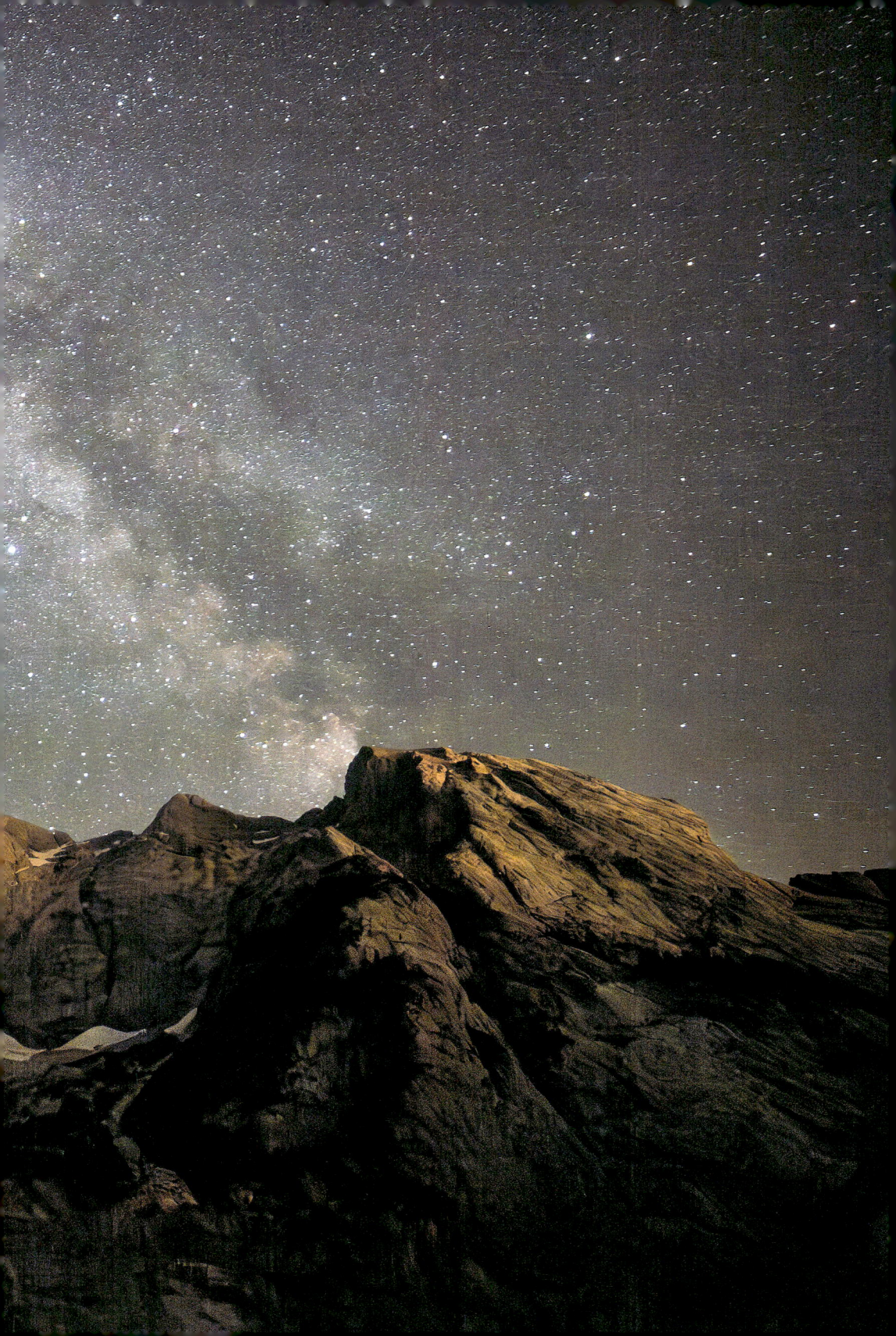

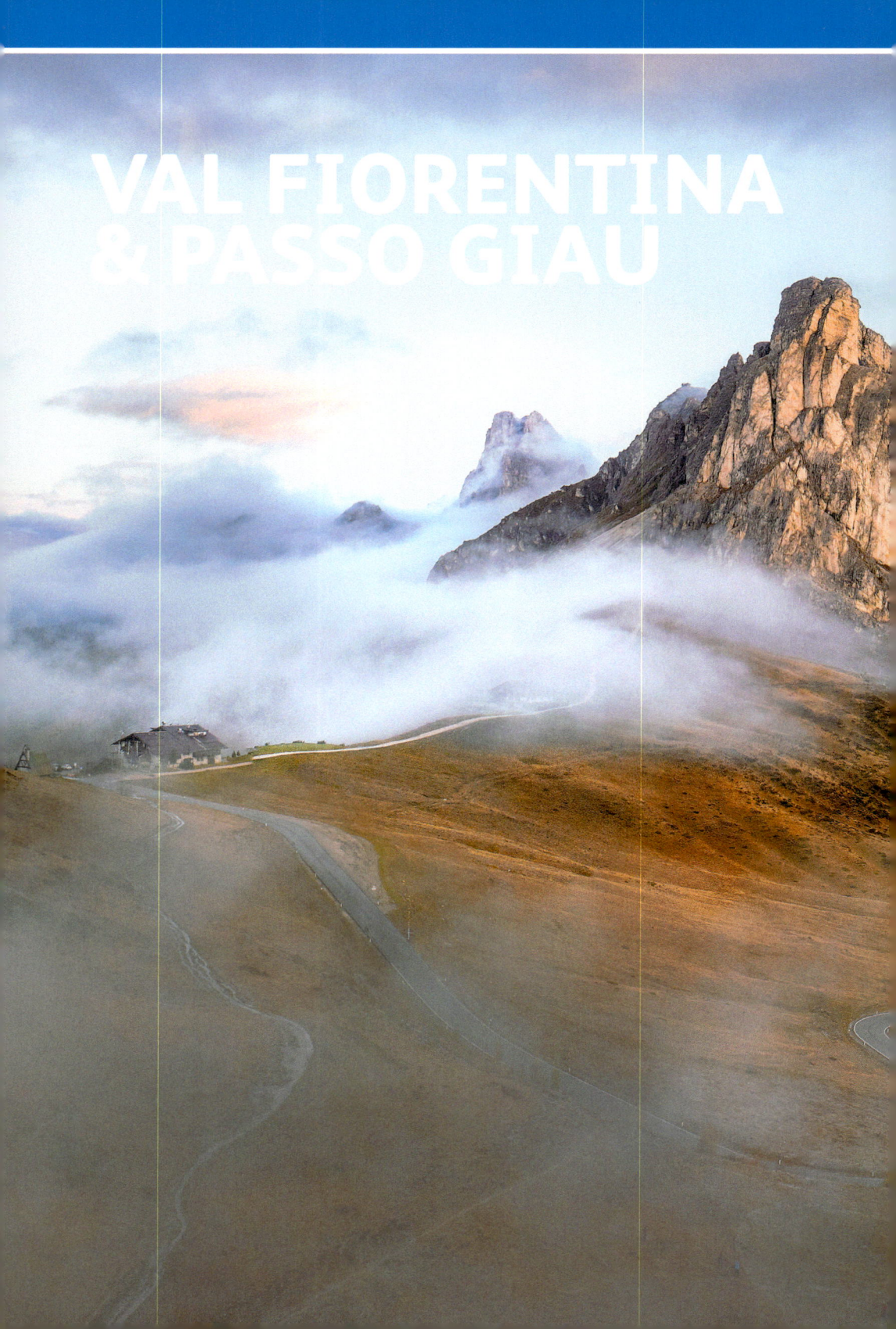

VAL FIORENTINA & PASSO GIAU

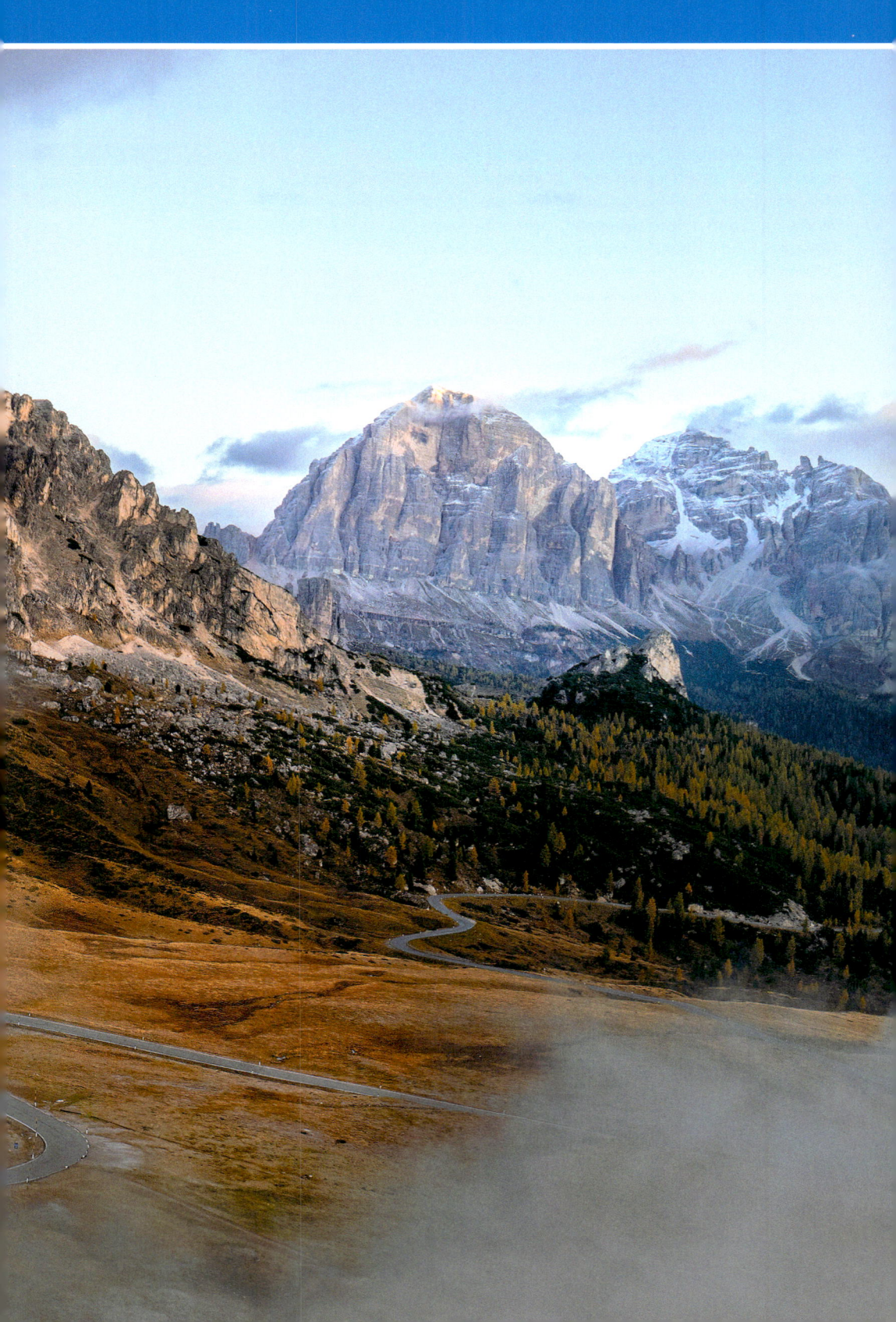

VAL FIORENTINA & PASSO GIAU – INTRODUCTION

The Val Fiorentina is a ten kilometre-long valley located just north of Alleghe and is home to a number of small Ladin villages. Rich in natural resources, the valley was colonised during the middle ages and quickly prospered, primarily due to the iron deposits found within the region. Some claim 'Ferentina', the old word for iron, was the origin of the valley name, while other sources maintain the valley was named after a popular Cadorian noblewoman named Fiorentina who lived in the area. Either way, the Val Fiorentina is famous for its historical past, boasting a series of dinosaur footprints on Monte Pelmo believed to be 200 million years old, the 'Mondeval Man', the skeleton of a Mesolithic hunter recovered from Mondeval de Sora, and two archaeological sites at Mandriz and Casera Staulanza.

Despite its close proximity to the more famous Cortina d'Ampezzo and Passo Falzarego, the Val Fiorentina enjoys an off the beaten track feel during the summer months, before Selva di Cadore turns into a popular ski resort once winter arrives. The valley vista is dominated by two of the most distinctive peaks in the Dolomites; the bastille of Monte Pelmo (3168m) to the east, first climbed by Irishman John Ball, and the intimidating Monte Civetta (3220m) to the south. As early as the 19th century these two mountains in the heart of the Dolomites have drawn writers, poets, photographers and mountaineers from around the globe. In 1866, summer visitor and Italian poet Giosuè Carducci wrote, "In the evening, when the sun is already set in our world, it has its needles and pinnacles still illuminated with a pink light. The mountain seems like a great citadel of the Titans, lit up to receive the pacific gods".

Monte Civetta, so-called because of its resemblance to a little owl taking flight (you need a lot of grappa to see it) is anything but small, presenting a north-west face that rises for just over a vertical kilometre, making it one of the largest in Europe. After rebuffing a host of strong alpinists, the face was eventually climbed on August 9, 1925 by Emil Solleder and Gustav Lettenbauer, marking the first grade VI alpine rock climb.

Extending northwards from Selva di Cadore and Colle Santa Lucia, the Passo Giau rises to 2236m, passing below Nuvolau before descending towards Cortina d'Ampezzo. Due to dense forest and irrigation work, the pass isn't particularly photogenic as it ascends the Val Codalunga. However, at the top of the pass the terrain opens out and quickly becomes spectacular, with far-reaching views over the Tofane, Cristallo, Sorapiss and Croda da Lago. The pass is amongst the youngest in the Dolomites and was only paved in 1986, following the line of an old mule and forestry track mainly used by farmers. Featuring 10km of ascent with an average gradient of 9.4%, the road is infamous amongst cyclists as a relentless test piece and brutal 6th leg of the Maratona dles Dolomites.

LOCATIONS

1	Monte Civetta Viewpoint	276
2	Colle Santa Lucia	280
3	Passo Giau	282
4	Lago delle Baste	290
5	Tornanti al Passo Giau	292
6	Lago Federa – Croda da Lago	296

Maps
- Tabacco (Italian): Map 03, 25
- Kompass (German): Map 654

Previous spread: Ra Gusela dominates the Passo Giau summit. DJI Mavic Pro 3, 70mm, ISO 200, 1/200s at f/2.8, Oct.

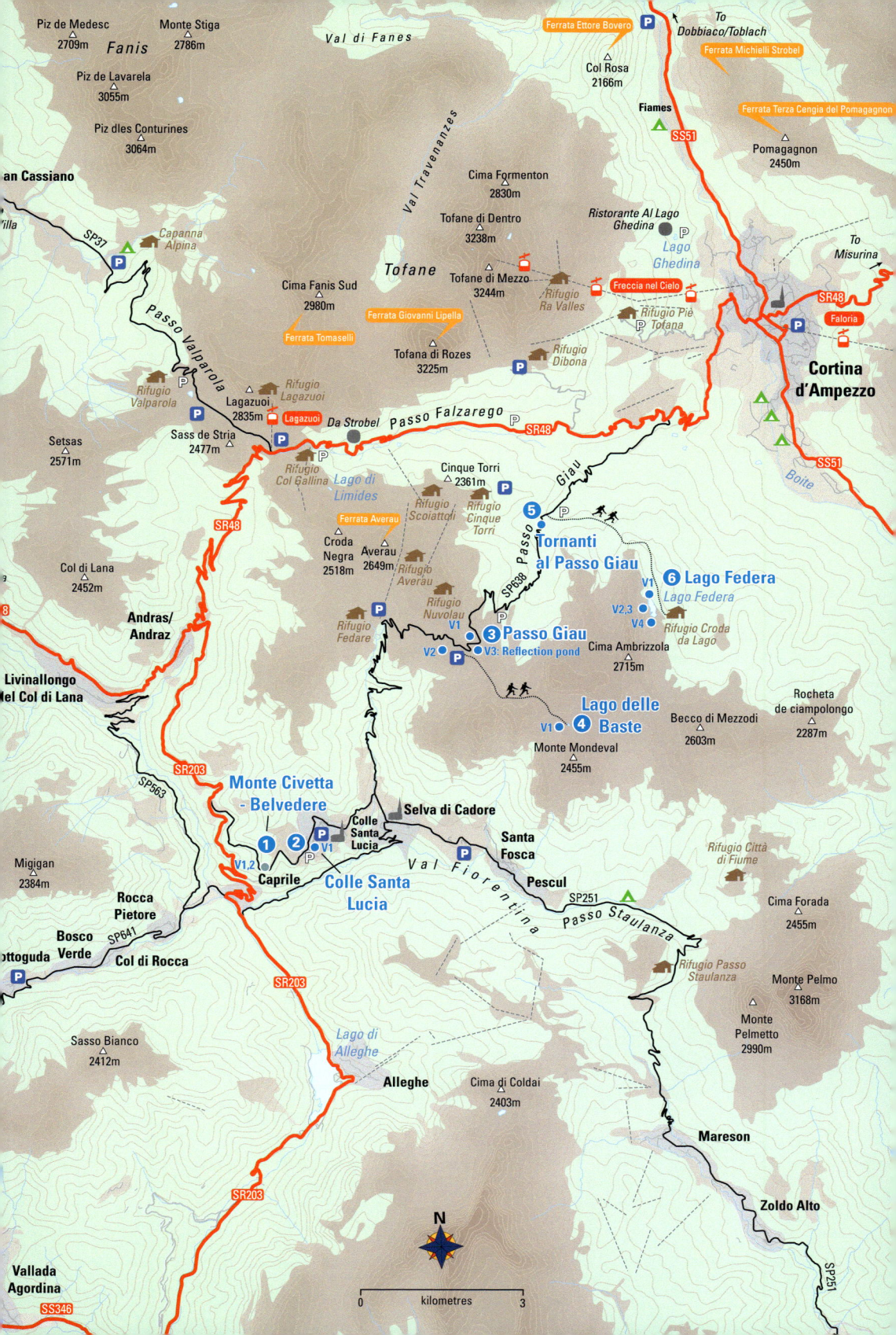

1 MONTE CIVETTA VIEWPOINT

As you travel along the SP251 between the Valle di Livinallongo and the Val Fiorentina, there is an excellent roadside viewpoint looking out over Alleghe and the spectacular north-west face of Monte Civetta. The straightforward and convenient access makes this spot perfect for opportunistic shooting or mixed weather days when it is possible to take pictures straight out of the car window.

What to shoot and viewpoints

Viewpoint 1 – Monte Civetta ♿

Despite the grandeur of the surrounding scenery, it is immediately apparent that this viewpoint was specifically designed with Monte Civetta in mind. A medium focal length nicely frames the mountain while retaining the rolling coniferous forests in the foreground.

The height of Monte Civetta (3220m) is such that it has a profound effect on the weather, and the mountain can often be observed with a large cloud system sitting on the summit which rolls back above the main face. This makes it perfect for some long exposure photography, capturing the motion of the clouds as they roll over the top and stay clear of the face. Scrutiny of this vast rock wall reveals an intricate system of couloirs, towers, shattered ledges and ravines. These can be captured and isolated using a long telephoto to pick out the details, creating smaller landscapes each with a character of their own.

The north-westerly aspect of the mountain ensures this is a perfect spot during the afternoon and evening as the dusk light turns the peak a wonderful shade of deep pink.

Viewpoint 2 – Valentino Moro Larch Sculpture ♿

Designed and constructed in 2020 by Valentino Moro, the lone larch sculpture depicts the resilience of nature following the catastrophic storm Vaia in October 2018 which felled some 14 million trees within the Dolomites. The artwork makes a beautiful foreground looking out over the Cadore valley.

Monte Civetta as seen from Cherz. Canon G12 at 30mm, ISO 100, 1/160s at f/4, Mar.

Atmospheric cloud rolls across Torre di Valgrande on the north face. Nikon Z7II, 24–120mm at 120mm, ISO 64, 1/125s at f/8, Aug.

'Sfida' or the 'challenge' larch sculpture by Valentino Moro. Nikon Z7II, 24–120mm at 30mm, ISO 64, 1/125s at f/13, Jul.

How to get here

The viewpoint is located 1km south-west of Colle Santa Lucia adjacent to the Belvedere Grill Bar and can be approached via the SP251 from the Valle di Livinallongo or Val Fiorentina.

From Selva di Cadore head west on the SP251, following signs for the Passo Falzarego. After 3km pass through the village of Colle Santa Lucia and continue for another kilometre to reach a large car park and the viewpoint on the left.

Lat/Long: 46.44365, 12.00164
what3words: ///contributes.cleared.lows
Tabacco: Map 25 (1:25.000)
Kompass: Map 654 (1:25.000)

Accessibility

Approach: Roadside access.

Disabled access: The location is ideal for disabled access.

Best time of year/day

Monte Civetta is undoubtedly one of the most aesthetic peaks in the Dolomites and looks impressive throughout the year. However, the alpine and somewhat brooding demeanour of the peak is perhaps best conveyed when there is snow on the face. The aspect and height ensure snow is usually present from late autumn until early summer, though the view is arguably the most striking when fresh snow plasters the face.

The main face receives sun during the late afternoon and is a perfect sunset location.

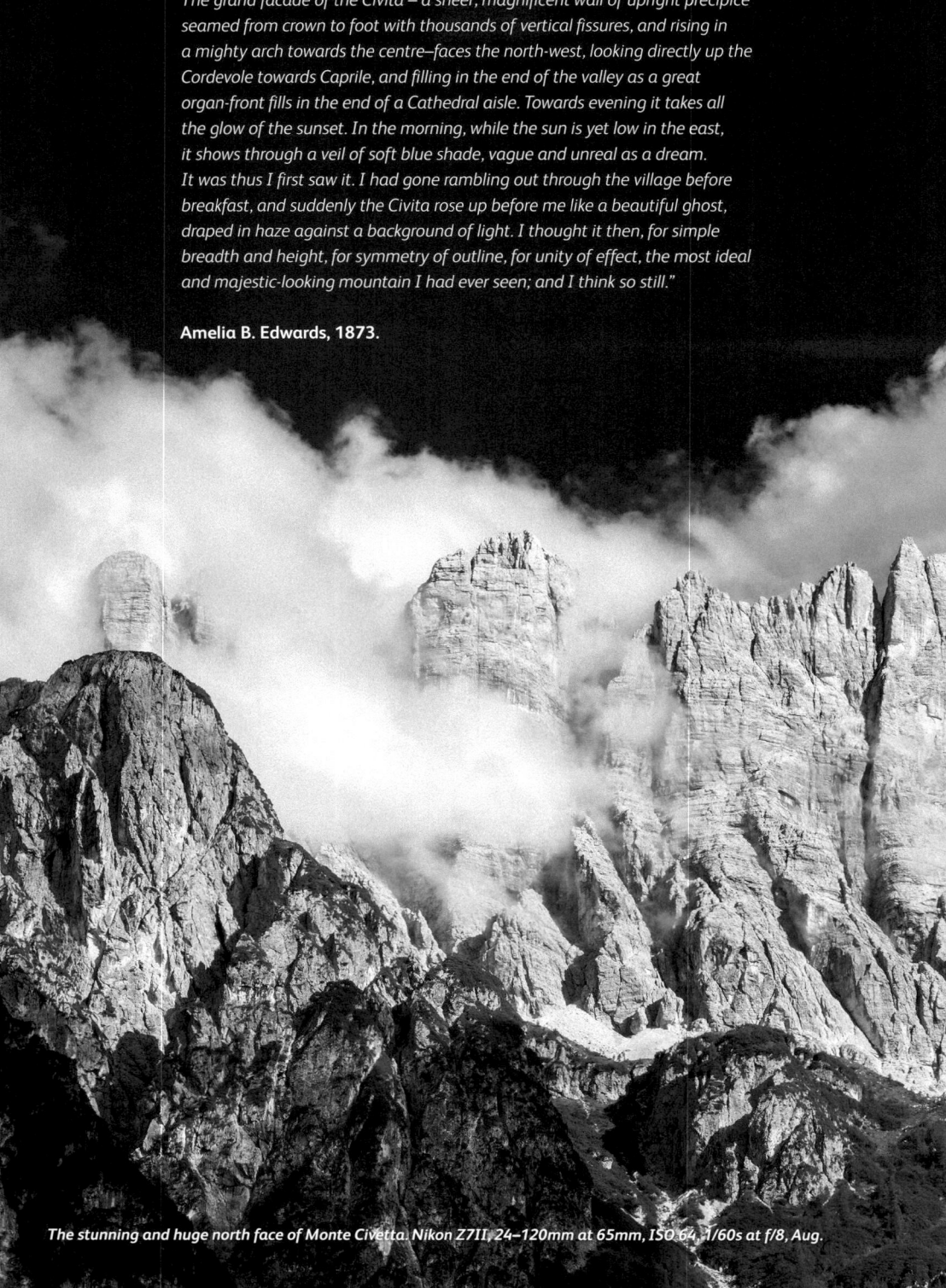

"The grand façade of the Civita – a sheer, magnificent wall of upright precipice seamed from crown to foot with thousands of vertical fissures, and rising in a mighty arch towards the centre–faces the north-west, looking directly up the Cordevole towards Caprile, and filling in the end of the valley as a great organ-front fills in the end of a Cathedral aisle. Towards evening it takes all the glow of the sunset. In the morning, while the sun is yet low in the east, it shows through a veil of soft blue shade, vague and unreal as a dream. It was thus I first saw it. I had gone rambling out through the village before breakfast, and suddenly the Civita rose up before me like a beautiful ghost, draped in haze against a background of light. I thought it then, for simple breadth and height, for symmetry of outline, for unity of effect, the most ideal and majestic-looking mountain I had ever seen; and I think so still."

Amelia B. Edwards, 1873.

The stunning and huge north face of Monte Civetta. Nikon Z7II, 24–120mm at 65mm, ISO 64, 1/60s at f/8, Aug.

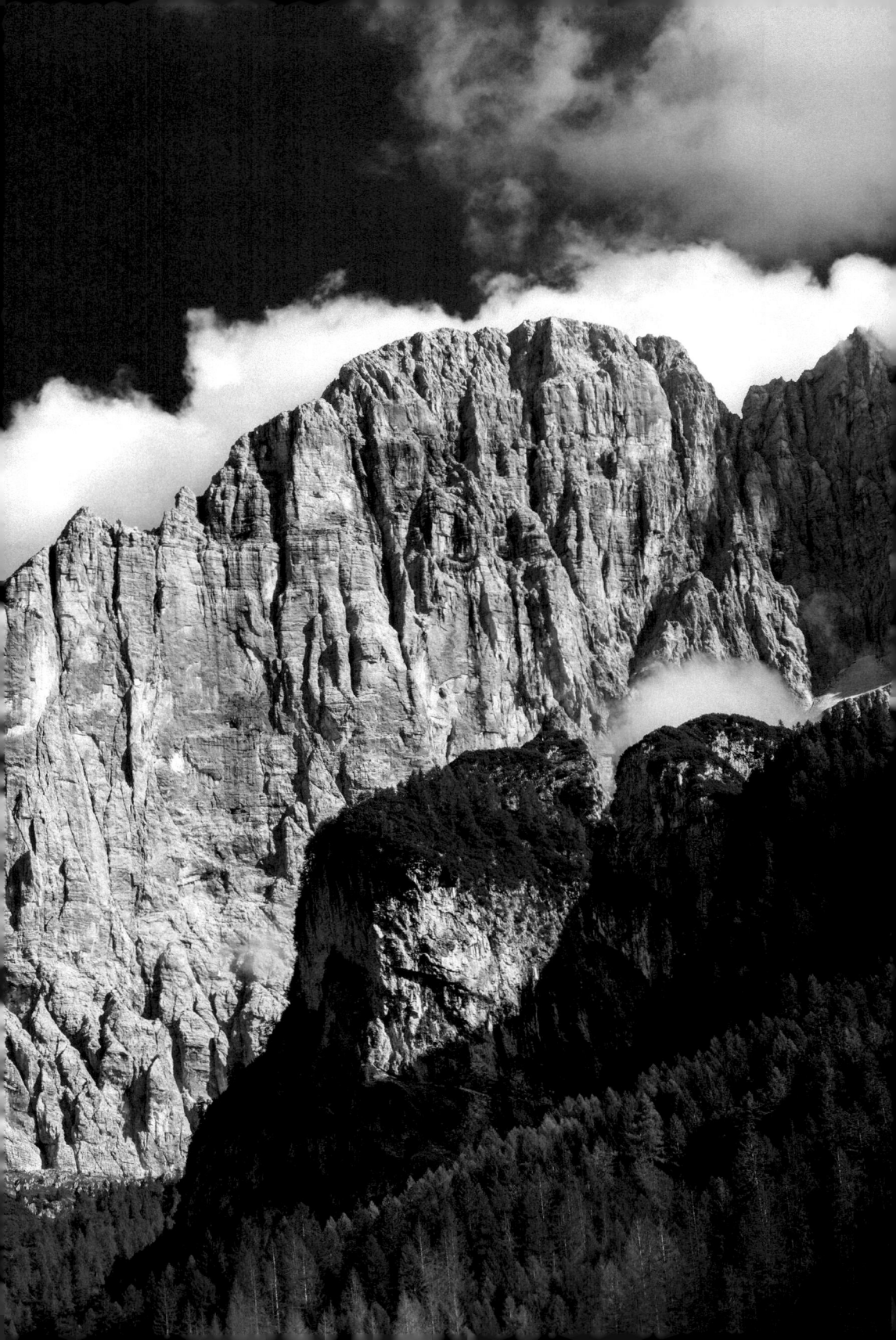

2. COLLE SANTA LUCIA

Despite its appearance of a small village, Colle Santa Lucia is actually a tiny municipality made up of several hamlets within the Val Fiorentina. Regardless of the technicalities, the village church backdropped by Monte Pelmo creates a beautiful scene which has become increasingly popular amongst photographers.

Unfortunately the best vantage point is not quite as pleasant as the view, requiring the photographer to shoot directly from the roadside of the SP251. High visibility clothing is advised and shooting here at night is not recommended.

What to shoot and viewpoints

Viewpoint 1 – Chiesa di Santa Lucia ♿

Sat atop a small rise that was once known as the 'Buchberg' or 'beech tree hill', the church of Santa Lucia dominates the small Ladin/Venetian-speaking village of Villagrande. While its existence was first documented in 1336, it is likely that the building was constructed during the 13th century. Originally built in Gothic style, the building then underwent several extensions and refurbishments in the Baroque and then Rococo styles which characterise the architecture seen today.

From the parking area in the village square, walk south-west back down the SP251 for 200m until Chiesa di Santa Lucia and Monte Pelmo come into view on the left. Be aware of passing cars if you plan on using a tripod.

The steep drop below the road and the trees to either side limit the choice of perspective somewhat, although thankfully the clearing provides a great composition, framing the church on the left and Monte Pelmo to the right. Using the perspective distortion of a longer focal length will help to capture the grandeur of the mountain backdrop; just remember to crop the roofs of Villagrande carefully, particularly the building just left of the church.

Owing to the westerly orientation of both Monte Pelmo and Chiesa di Santa Lucia, the landscape is best shot during the afternoon when the scene is front-lit, bringing out the details of the rock face. At sunset the light sets on the mountain to create some beautiful tones, although unfortunately foreground light on the church is lost.

Monte Pelmo makes for an interesting subject in its own right and can be shot at a longer focal length without including Colle Santa Lucia. This composition is best achieved from the church grounds and removes the need to stand on the road.

How to get here

Colle Santa Lucia is located in the lower half of the Val Fiorentina just west of Selva di Cadore. The municipality can be approached from Cortina d'Ampezzo over the Passo Giau, from the Alta Badia via the Passo Valparola and Passo Falzarego or from Arabba using the SR48.

From Selva di Cadore, head west on the SP251 following signs for the Passo Falzarego to reach Colle Santa Lucia after 3km. There is a small village square with several parking spaces below the church on the left, just before you exit the village.

Lat/Long: 46.447, 12.01407
what3words: ///litmus.rashness.cashless
Tabacco: Map 25 (1:25.000)
Kompass: Map 654 (1:25.000)

Accessibility

Approach: Roadside access.

♿ **Disabled access**: The location is ideal for disabled access, though be sure to take care on the road.

Best time of year/day

The mood conveyed by Colle Santa Lucia changes dramatically throughout the seasons, from an idyllic landscape during the summer to a remote alpine village through the winter. The vibrant green of the foreground hills works particularly well with a snow-capped Monte Pelmo in late spring and early summer. The accessible viewpoint makes it ideal for bad and mixed weather days when it is possible to create some atmospheric images as the cloud temporarily clears. Early in the morning on cold days throughout the winter it is not uncommon for fog to linger low in the valley, creating an especially dramatic scene.

The westerly aspect of Monte Pelmo and Chiesa di Santa Lucia suits afternoon light, although it is also possible to get some great images at dawn by positioning the sun behind the bell tower.

Opposite top: Dusk at Chiesa di Santa Lucia with Monte Civetta visible in the background. © Nicolò Miana.
Bottom: A beautiful summers day at Colle Santa Lucia. Nikon Z8, 24–120mm at 35mm, ISO 64, 1/200s at f/8, Aug.

3. PASSO GIAU

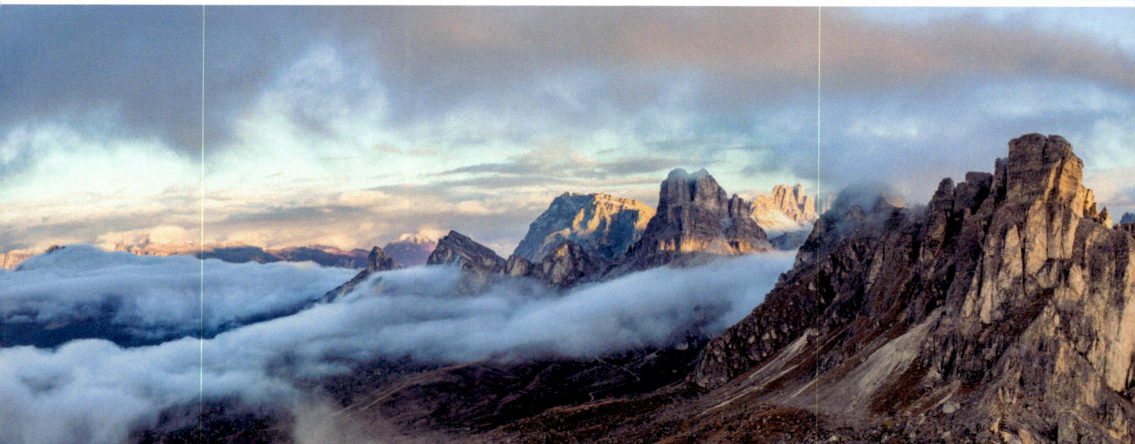

From left to right – Croda Negra, Punta Dallago, Averau and Ra Gusela. The Lagazuoi can be seen illuminated in the distance.

Reaching a height of 2236m, the Passo Giau connects Colle Santa Lucia and the Val Fiorentina with Cortina d'Ampezzo. The west side is the steepest and there are some 29 hairpins ascending along the Val Codalunga, a valley which despite mass engineering schemes still suffers from avalanches throughout the winter. By contrast, the eastwards descent into Cortina is characterised by more open topography and a gentler gradient.

The Passo Giau runs largely parallel to the hugely popular Passo Falzarego yet displays significantly less tourist infrastructure and is noticeably quieter. Local funding and marketing are almost certainly the reason for this as the scenery from the top of the pass, which enjoys spectacular views of Ra Gusela, Lastoni di Formin, Croda da Lago and much of the Eastern Dolomites, is just as good.

What to shoot and viewpoints

Viewpoint 1 – Lastoni di Formin ♿

Looking east, the view is dominated by the dramatic rock walls of Lastoni di Formin. Surrounded by dense forest and watched over by Croda da Lago, this dramatic landscape is best captured during the afternoon and at sunset when the west faces are often spectacularly lit. The meadows surrounding the Passo Giau summit provide many foreground options for a wide-angle shot, particularly when the wildflowers are blossoming during June and July.

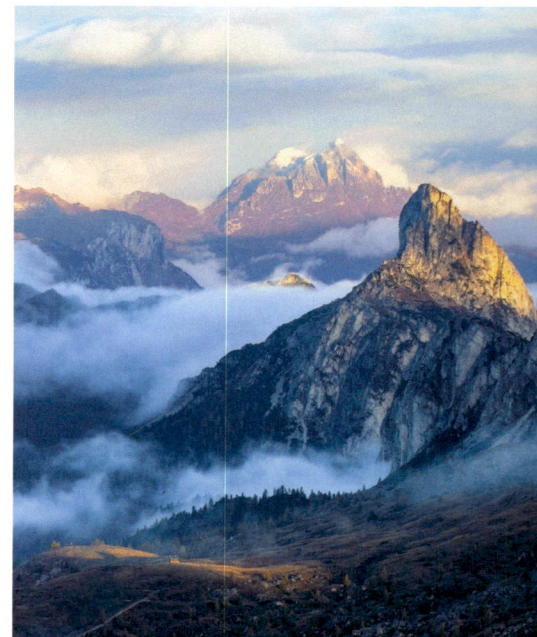

Croda Negra (right) and Sass de Putia (distance) catch the morning light. DJI Mavic Pro 3, 166mm, ISO 400, 1/200s at f/3.4, Sep.

How to get here

The summit of the Passo Giau is easily accessed from the Val Fiorentina to the south or from Cortina d'Ampezzo to the north.

The easiest approach from the Alta Badia is via the Passo Valparola and Falzarego, before turning onto the Giau at Pocol, just above Cortina d'Ampezzo.

There is a large parking area opposite Berghotel Passo Giau.

Viewpoint 1-4 – Passo Giau Summit

- **Lat/Long:** 46.48251, 12.05337
- **what3words:** ///untangle.constructive.annoy
- **Tabacco:** Map 03 (1:25.000)
- **Kompass:** Map 654 (1:25.000)

Viewpoint 5 – Passo Giau Pond

- **Lat/Long:** 46.483373, 12.059995
- **what3words:** ///unnaturally.resurface.sank
- **Tabacco:** Map 03 (1:25.000)
- **Kompass:** Map 654 (1:25.000)

Accessibility

Approach: Roadside access.

Disabled access: The location is ideal for disabled access, providing stunning views straight out of the car park.

Best time of year/day

The summit is extremely photogenic year round, although the pond gets covered in snow during the winter months. At sunrise the first light illuminates Tofana di Rozes and then sets on Lastoni di Formin, making it an ideal location at either end of the day.

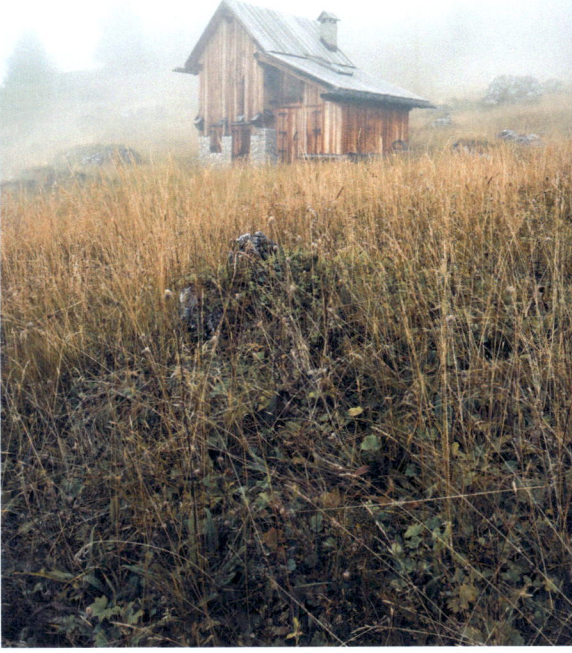

One of the many small wooden cabins found on the Passo Giau. Nikon Z7II, 24–120mm at 24mm, ISO 200, 1/25s at f/14, Sep.

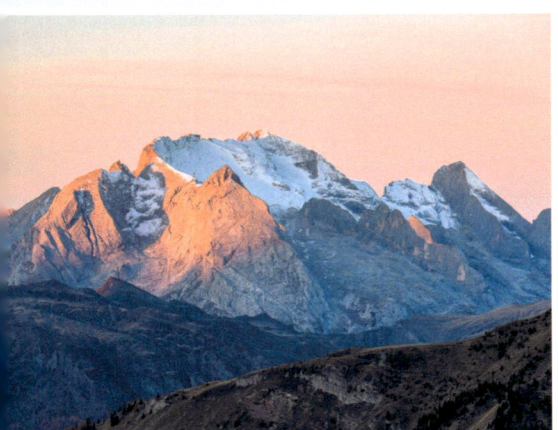

Looking towards the Marmolada at sunrise from Punta di Zonia. Nikon Z7II, 100–400mm at 150mm, ISO 64, 1/25s at f/8, tripod, Sep.

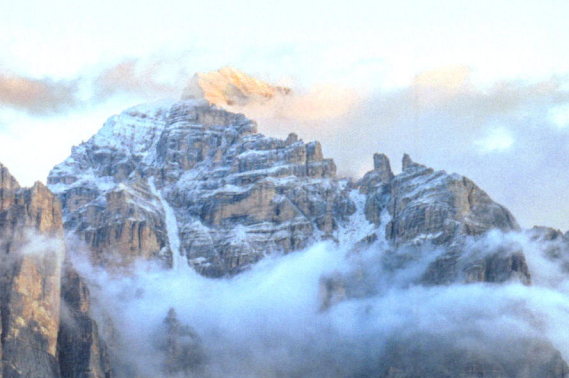

There are excellent views of Tofana di Mezzo from the Passo Giau. Nikon Z7II, 100–400mm at 180mm, ISO 100, 1/200s at f/5.6, Nov.

3 PASSO GIAU

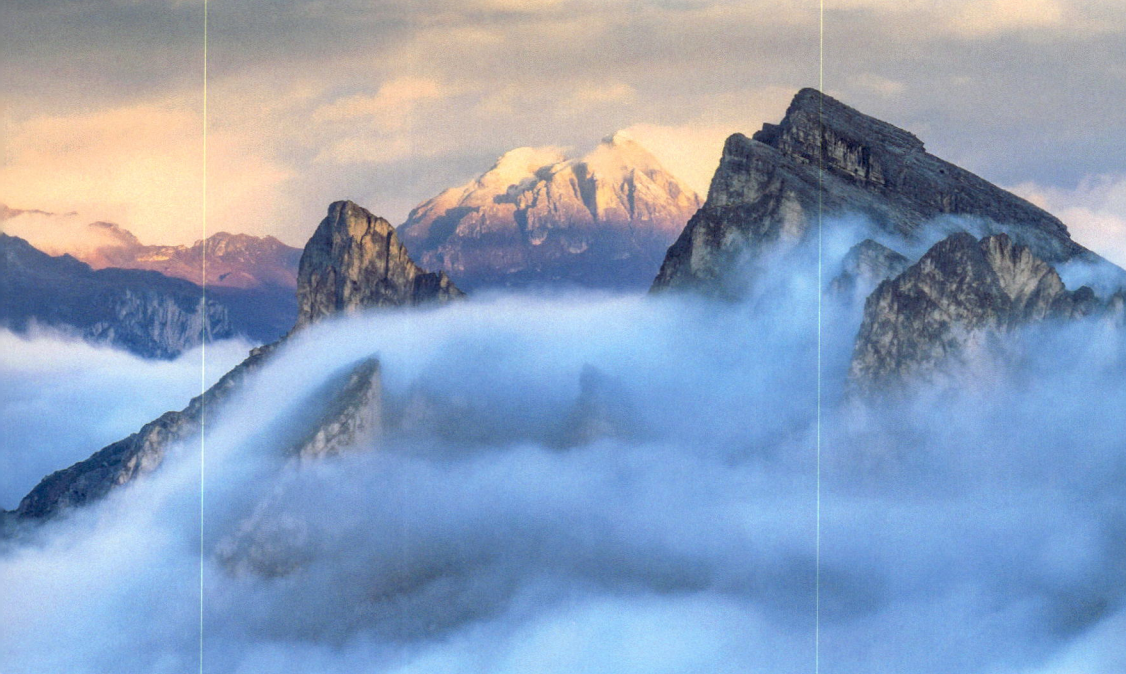

Using a telephoto lens to frame Sass de Putia from near Monte Cernera. DJI Mavic Pro 3, 166mm, ISO 100, 1/100s at f/3.4, Sep.

Viewpoint 2 – Ra Gusela ♿
To the north, Ra Gusela, a subsidiary tower of Nuvolau, stands guard over the pass. Paths 452 and 443 ascend the mountain, departing from the Berghotel Passo Giau. Following the path up past the rifugio you will see a series of stone-flagged steps. These create a perfect leading line into the peak and can be photographed from the steps themselves using a wide-angle lens or from further back with a standard focal length. The grassy ridgeline just south of the road provides an aesthetic perspective, as does a short walk south-east along path 436.

Ra Gusela also makes for a perfect night photography and specifically star trail subject, as the north star sits just right of the peak when viewed from the Passo Giau.

Viewpoint 3 – Punta di Zonia
Situated just south of the Passo Giau, the small ridge of Punta di Zonia provides amazing views in all directions with minimal physical effort. From the parking area follow a small path uphill to the south to gain the ridge above in 10 minutes. Once at the top it is possible to traverse the ridge in both directions, with excellent views over the pass, towards the Marmolada, Monte Pore, Falzarego, Tofane, Lastoni di Formin and Monte Cernera.

Viewpoint 4 – Chiesa di San Giovanni Gualberto ♿
The little chapel bordering the parking area should not be overlooked and can make a great foreground for astrophotography in particular.

There are many excellent lone trees and rocks that make for perfect foregrounds to the dramatic backdrop of Ra Gusela. Nikon Z8, 24–120mm at 40mm, ISO 64, 1/25s at f/13, tripod, Oct.

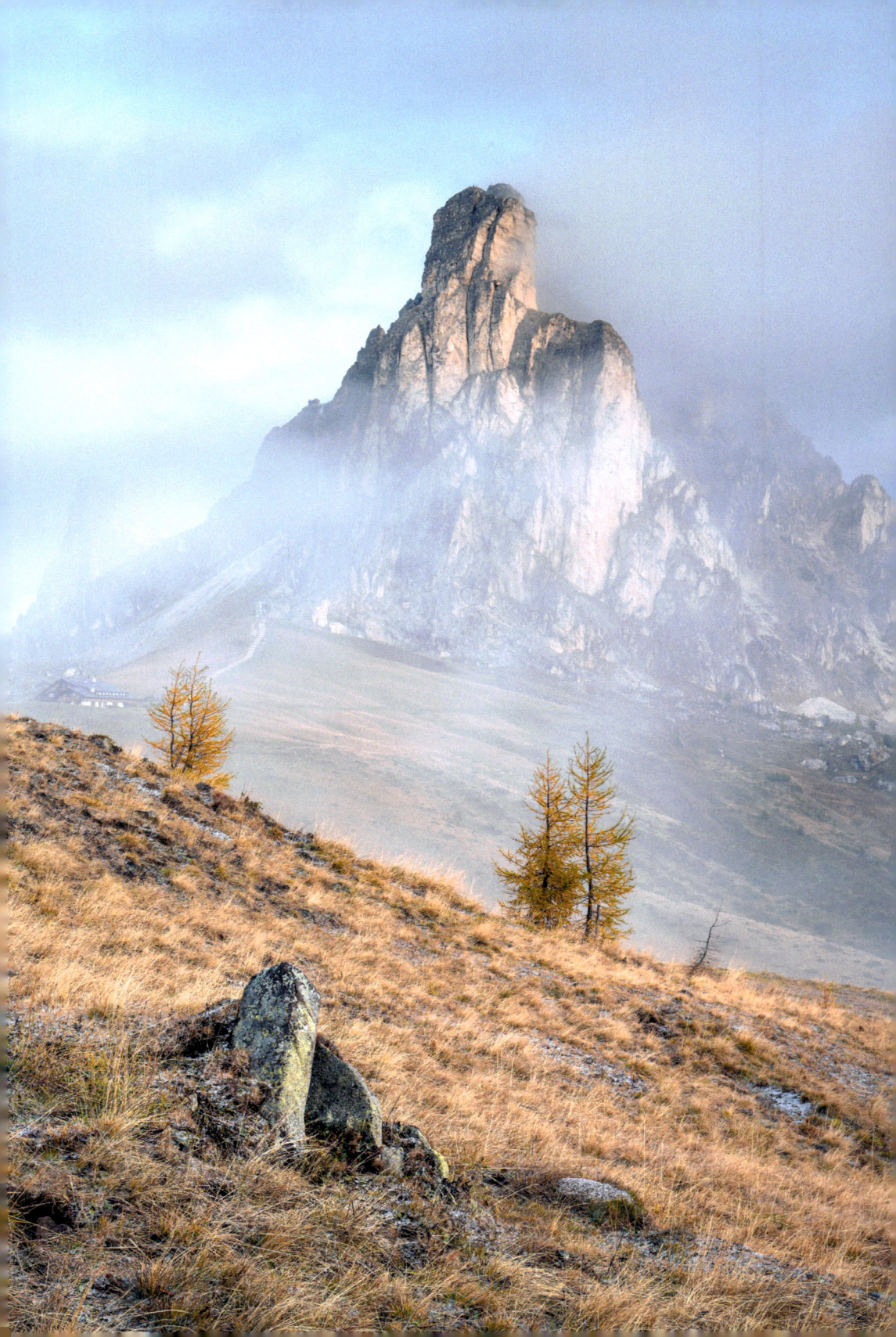

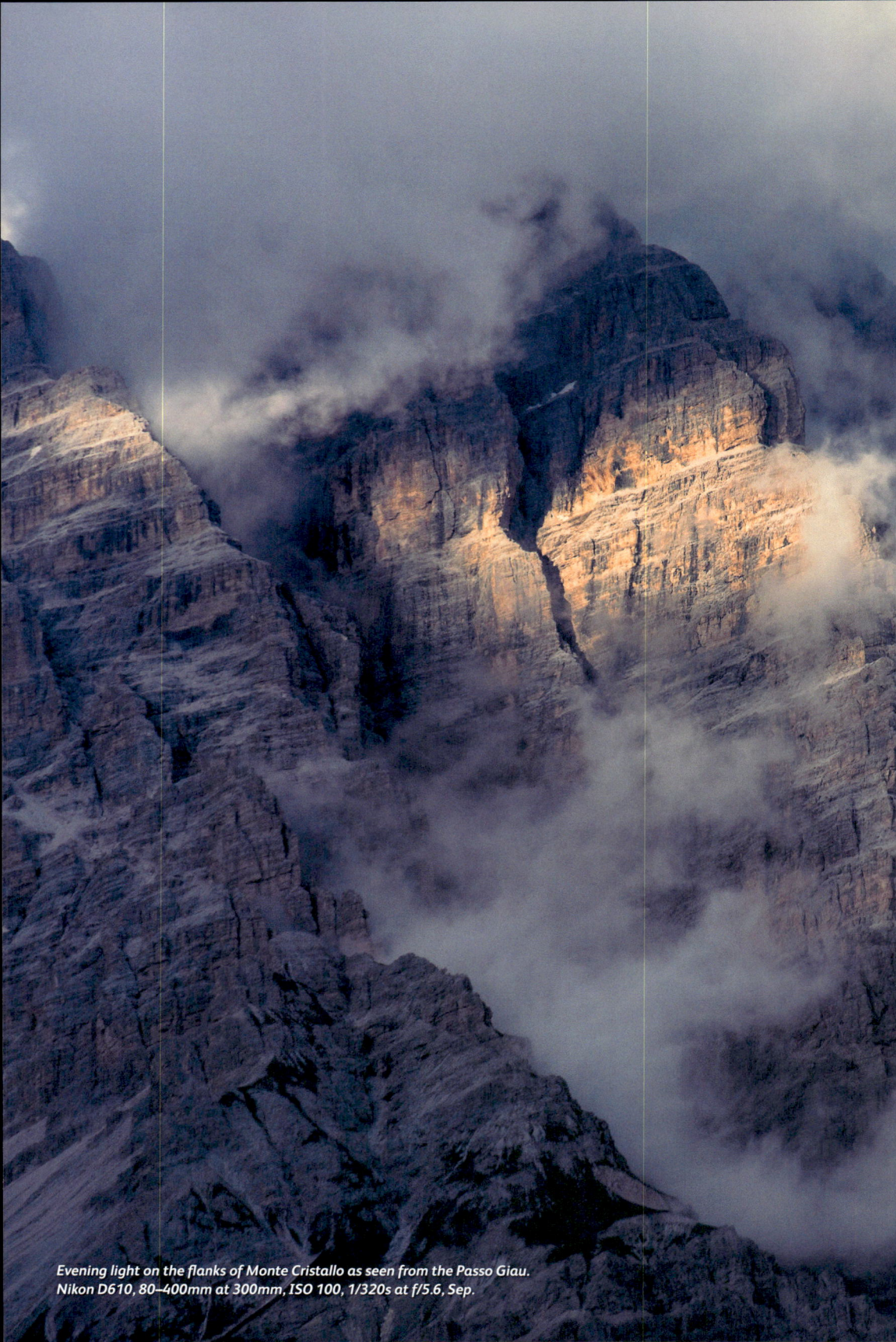

Evening light on the flanks of Monte Cristallo as seen from the Passo Giau. Nikon D610, 80–400mm at 300mm, ISO 100, 1/320s at f/5.6, Sep.

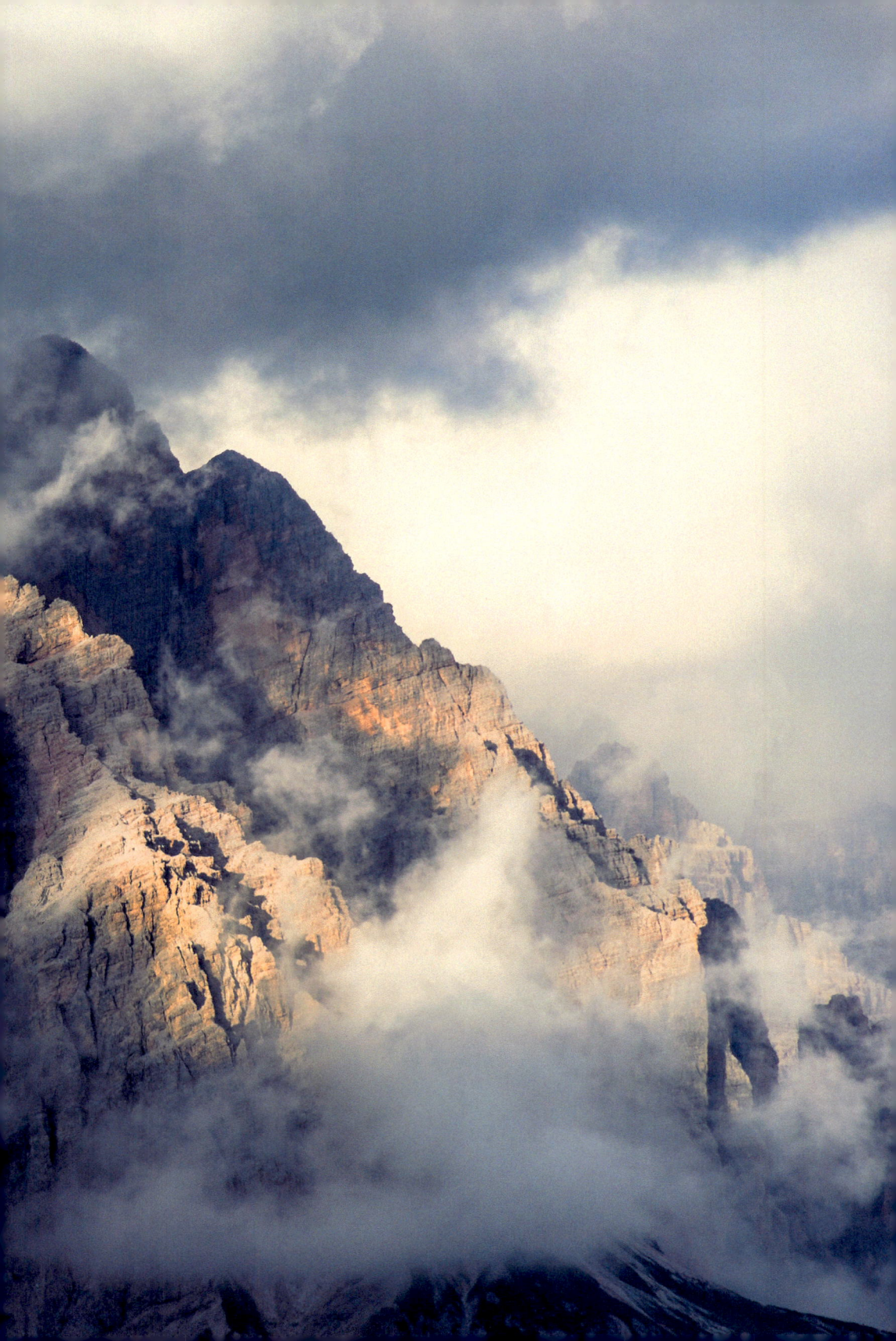

3. PASSO GIAU

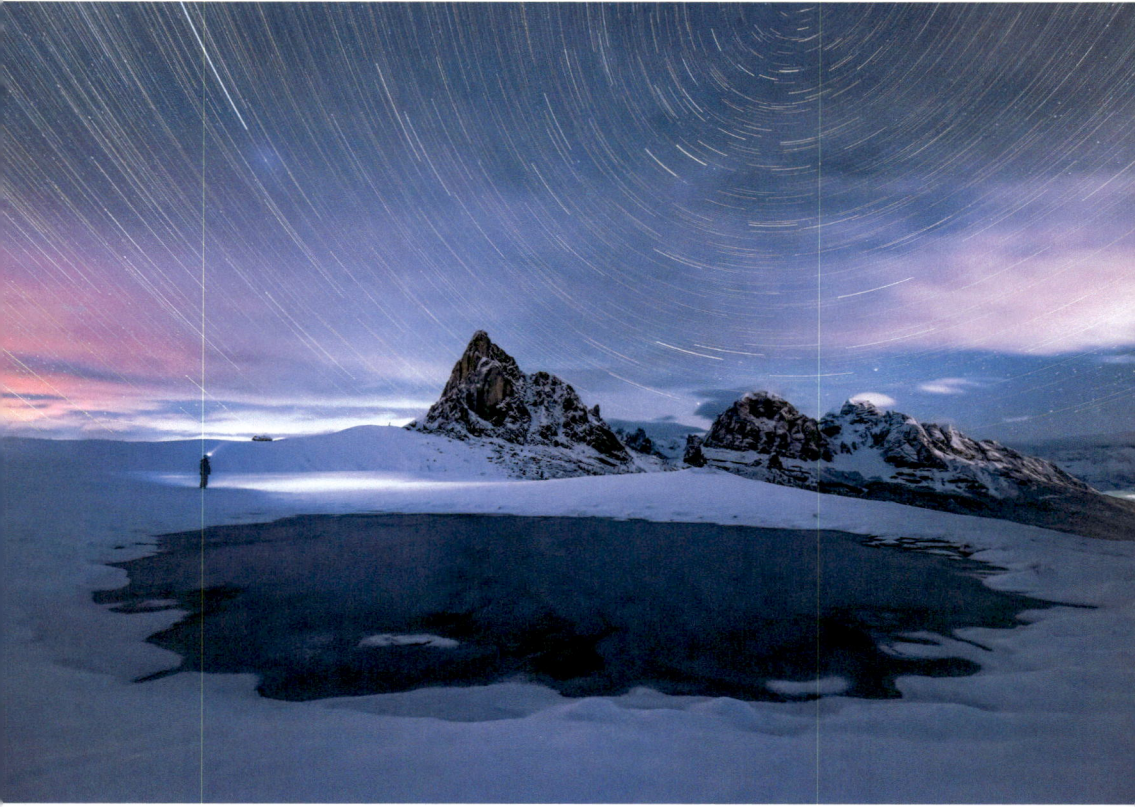

Winter on the Passo Giau. Nikon D810, 14–24mm at 14mm, ISO 800, 30s at f/2.8 (x60), tripod, Nov.

Viewpoint 5 – Passo Giau Pond
There is a small and nameless pond just east of the Passo Giau summit which, despite its unassuming appearance, provides a beautiful foreground looking north towards Ra Gusela and the Tofane. From the top of the pass, descend down the road towards Cortina for 300m until you reach the first hairpin. Turn off right here, heading south-east (if in doubt aim high as the pool is easier to spot from above) through the field for a further 300m, topping a small rise to find the pond (Lat/long: 46.480886, 12.057967).

Ensure you get a low perspective to try to make the reflections as large as possible. If the water level is low, a longer focal length may be necessary to remove the muddy banks that are often trampled by cattle.

A 40 minute stacked startrail using the photographer as a foreground, with reflections of Ra Gusela and the Tofane. Nikon D810, 14–24mm at 14mm, ISO 100, 30s at f/2.8 (x80), tripod, Oct.

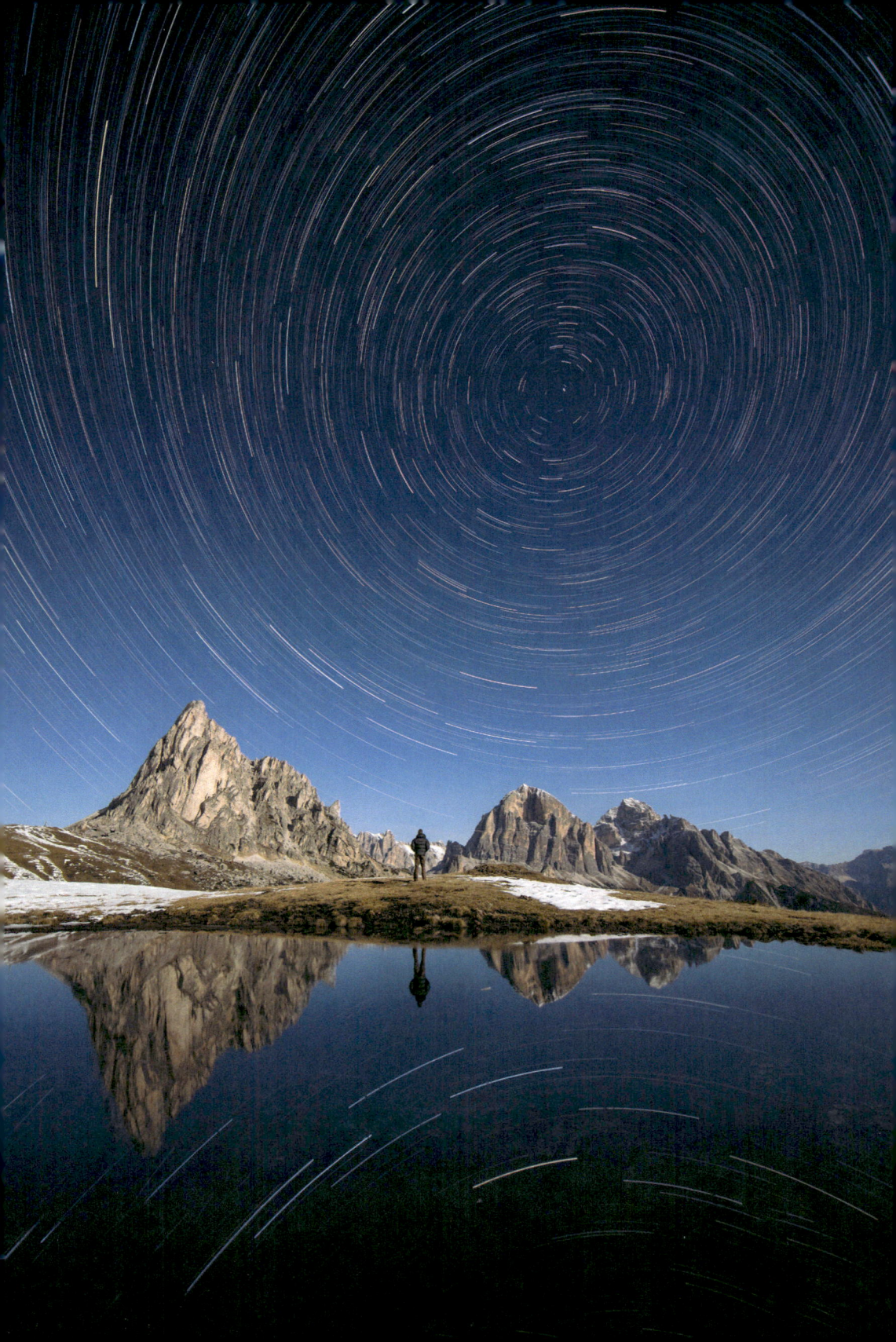

4 LAGO DELLE BASTE

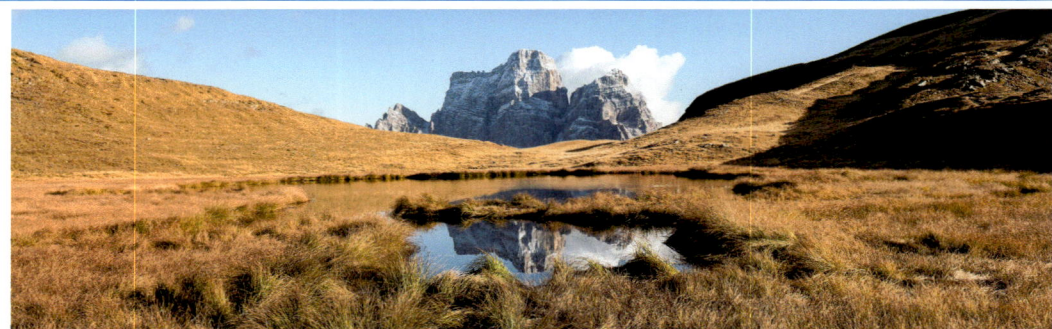

Faming Monte Pelmo using the surrounding grass. Nikon Z7II, 24–120mm at 35mm, ISO 64, 1/100s at f/10, Oct.

Although it could be accused of being something of a one shot wonder, the strikingly minimalistic scene of Monte Pelmo reflected in the waters of Lago delle Baste is more than worth the long approach. The remote location of this hidden gem ensures almost guaranteed solitude, even in the height of peak season. The approach from the pass over the Forcella Giau below the impressive west faces of Lastoni di Formin is an impressive itinerary in itself and can be highly recommended to photographers who enjoy hiking off the beaten track.

What to shoot and viewpoints

From the top of the pass take path 436 south past a small chapel, signposted towards Forcella Giau and Mondeval. The path traverses between Col Piombin and Monte Cernera to arrive at Forcella de Col Piombin. The path now swings east, still on the 436, and traverses across to join the 456. Follow this to reach Forcella Giau, from where Lago delle Baste is now clearly visible to the south-east below Monte Mondeval. Descend a smaller path through a sparse boulder field to reach the lake shore.

Viewpoint 1 – Lago delle Baste & Monte Pelmo

The main composition looks east towards Monte Pelmo from the near shore and works at a variety of focal lengths depending on how minimalistic a shot you want to achieve. Owing to the north-westerly aspect of Monte Pelmo this is a superb sunset location as in midsummer the light sets directly on the face. To return, retrace your steps back to the car; alternatively you can extend the excursion with an ascent of the nearby photogenic Monte Mondeval.

The lake looks excellent with fresh snow providing it is not yet frozen. Nikon Z7II, 24–120mm at 80mm, ISO 64, 1/25s at f/9, Nov.

How to get here

The usual approach starts from the summit of the Passo Giau opposite the Berghotel Passo Giau. The pass can be accessed from the Val Fiorentina to the south or from Cortina to the north.

The easiest approach from the Alta Badia is to take the Passo Valparola and Passo Falzarego then turn onto the Giau at Pocol.

Alternatively, it is also possible to ascend on foot from the hamlet of Toffol, just east of Selva di Cadore in the Val Fiorentina. This very scenic approach using path 465 is much longer however, requiring some 700m of ascent, especially if combined with path 466 to create a circular itinerary.

Lat/Long:	46.48251, 12.05337
what3words:	///untangle.constructive.annoy
Tabacco:	Map 03 (1:25.000)
Kompass:	Map 654 (1:25.000)

Accessibility

Approach: 90 minutes, 3.5km, 200m of ascent.

This location is mainly accessed by rocky mountain paths, with a steep section on the final ascent to Forcella Giau. The area around the lake is often waterlogged requiring appropriate footwear. Ensure you leave enough time for the return journey as you have to re-ascend to Forcella Giau on the way back.

Disabled access: The approach path is narrow and rocky making it unsuitable for disabled access.

Best time of year/day

Due to the north-westerly aspect of Monte Pelmo, Lago delle Baste is best shot during the summer as the face receives more light throughout the day. Late afternoon and sunset are particularly special as the reflections are considerably more pronounced once the water surface is cast into shadow.

⑤ TORNANTI AL PASSO GIAU

This location has gained popularity in recent years – particularly on social media. There are some 29 hairpins on the Passo Giau and they look especially effective when photographed from a top-down perspective using a drone. The stretch of road between Ponte de Ru Curto and Malga Giau has a wonderful quadruple hairpin making this the logical starting point.

For those planning on bringing a drone please check the current rules and regulations before flying as these change frequently. For more information see page 524.

What to shoot and viewpoints

Viewpoint 1 – Passo Giau Switchbacks ♿

The hairpins are located 120m due south of the parking area. Take care on the road which can be busy during peak season. Both portrait and landscape compositions work well – either directly above the road for a more abstract look, or slightly downhill to give the image a more three-dimensional appearance.

Vehicles on the road can be used to provide both scale and context.

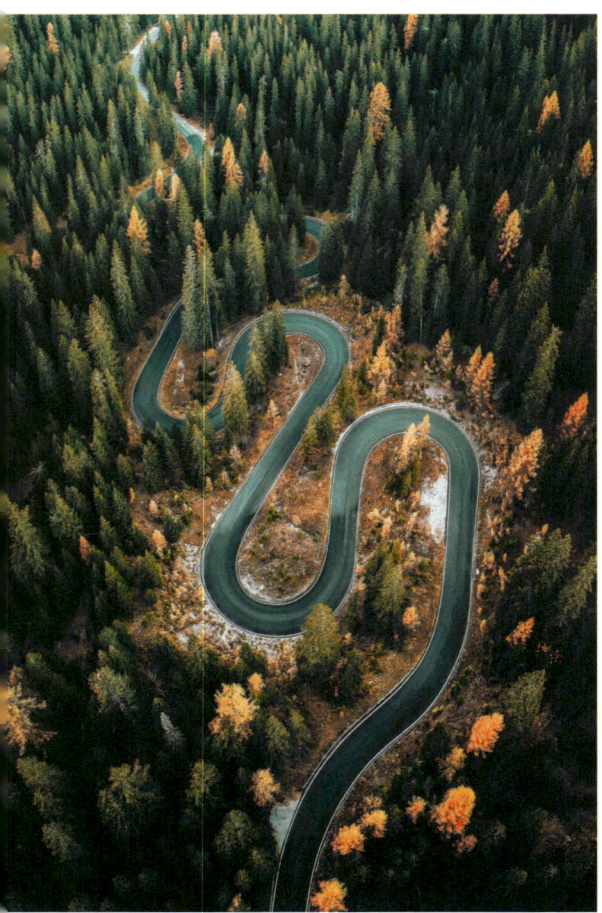

How to get here

From Cortina d'Ampezzo take the SR48 west for 6km to reach the hamlet at Pocol. Just before reaching Hotel Piccolo Pocol turn left onto the SP638 signposted towards Caprile and the Passo Giau. Follow the road for 4.5km, parking on the right just before the quadruple hairpins. The parking area is small so please park carefully.

- **Lat/Long**: 46.50346, 12.07622
- **what3words**: ///scrounge.blimp.decor
- **Tabacco**: Map 03 (1:25.000)
- **Kompass**: Map 654 (1:25.000)

Accessibility

Approach: Roadside access.

♿ **Disabled access**: The location is ideal for disabled access, though be sure to take care on the road.

Best time of year/day

This location works well throughout the year with the ever-changing colours. An overcast or soft light day is recommended to avoid long and harsh shadows.

The surrounding forest looks beautiful in October when the larches change colour. © Eberhard Grossgasteiger.

Opposite: A top down perspective on the Passo Giau hairpins during late summer. DJI Mavic Pro 3, 24mm, ISO 100, 1/20s at f/2.8, Sep.

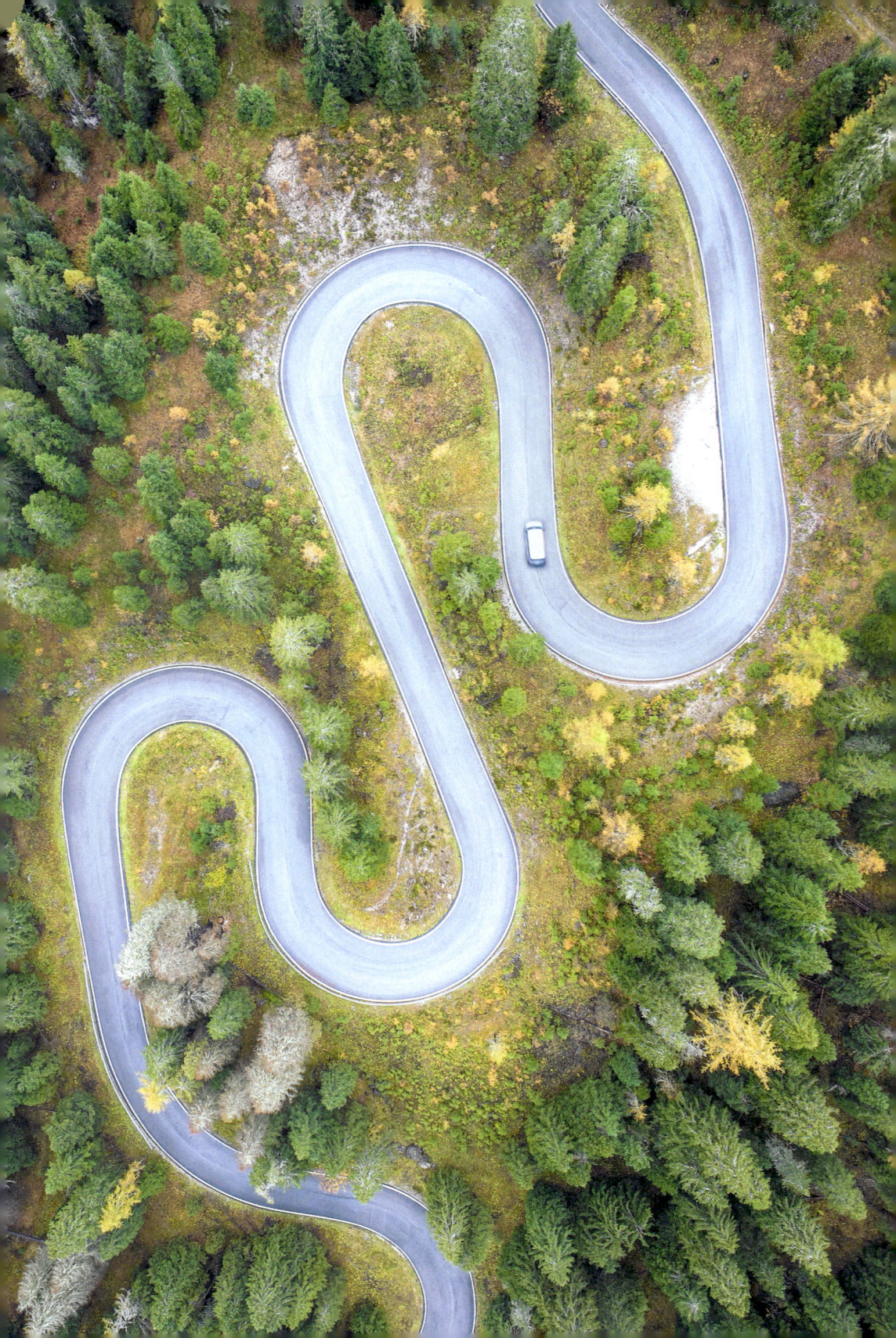

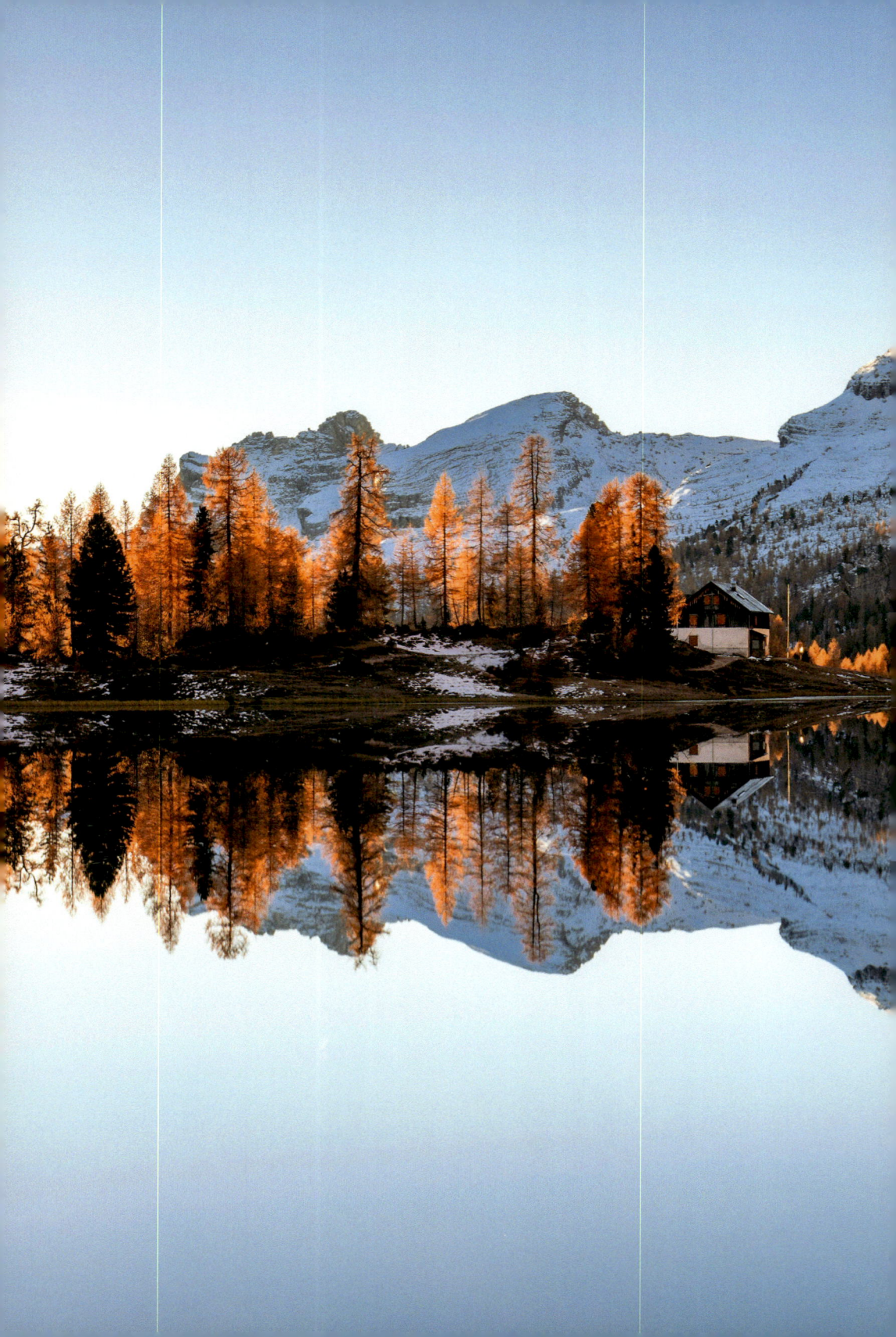

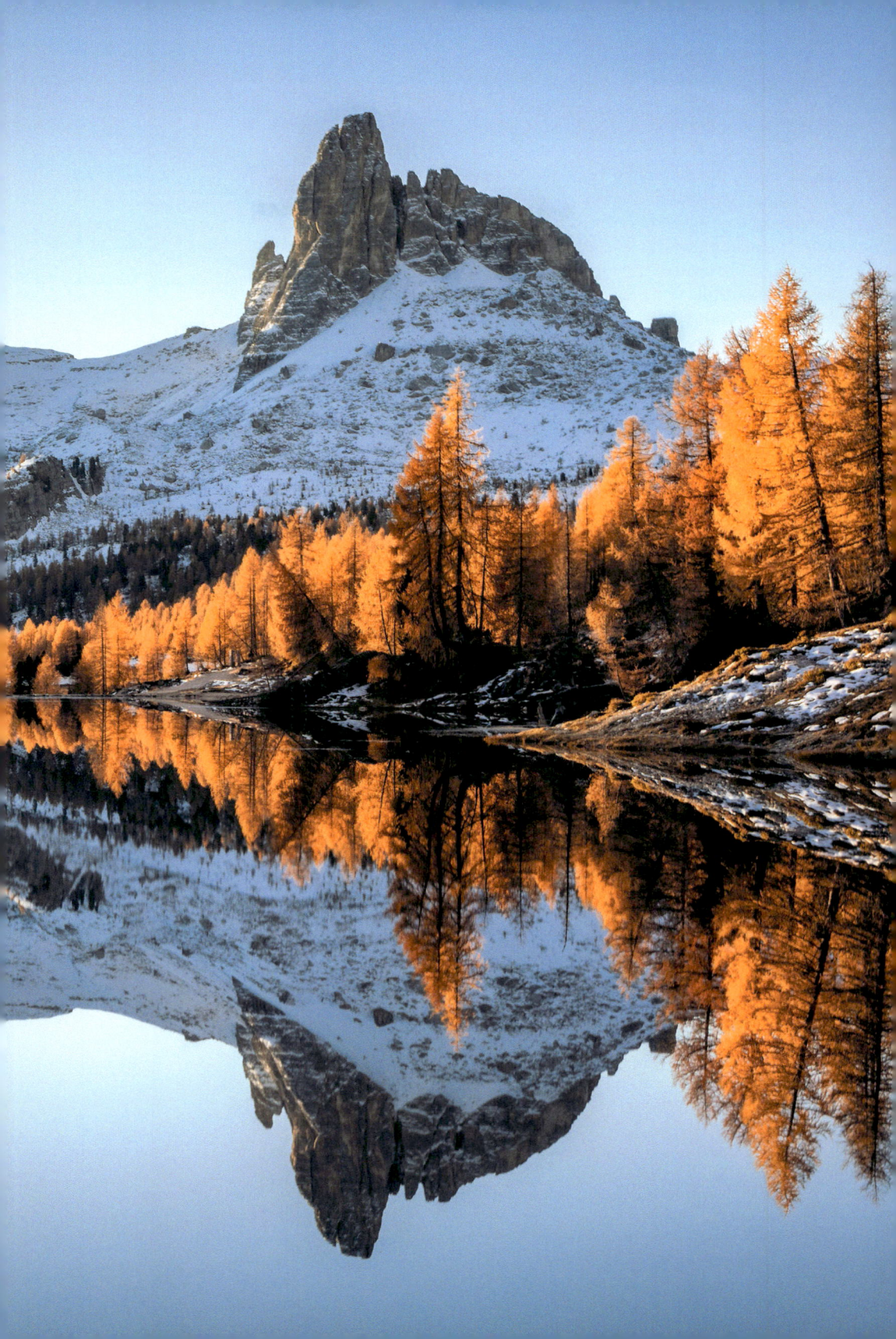

6. LAGO FEDERA – CRODA DA LAGO

Rising above the plateau of Lastoni di Formin, the jagged ridgeline of Croda da Lago is a familiar and easily distinguished landmark when travelling through the eastern Dolomites. Nestled at the base of the majestic east face lies the beautiful Lago Fedèra, a natural lake fed by underground springs. Renowned for its still waters, often providing perfect reflections of Beco de Mezodi, Croda Rossa, Pomagagnon, Cristallo and Sorapiss, the lake is the subject of many a Dolomites postcard.

While the approach is long, the surrounding scenery is some of the best in the area. Indeed, an extension up to Forcella Ambrizzola to create a complete circuit of Croda da Lago with a descent of the Val de Formin is to be recommended as one of the best hikes in the region. An overnight stay in the nearby Rifugio Croda da Lago – Gianni Palmieri is ideal for photographers who wish to shoot the lake at sunrise, sunset or through the night.

How to get here

The usual approach departs from Ponte de Rocurto (1708m) on the north-east side of the Passo Giau. From Selva di Cadore follow SP638 for 11km to the top of the Passo Giau. From here descend for 5km to reach Ponte de Rocurto (1708m) and park in a long lay-by on the right-hand side of the road by a signpost marking path 437.

Alternatively, from June to September there are various jeep taxi services operating out of Cortina that will drive you up the private road to Lago Federa on request. More information can be obtained through the Cortina d'Ampezzo tourist information office.

- **Lat/Long**: 46.505947, 12.079155
- **what3words**: ///unnecessary.connects.imported
- **Tabacco**: Map 03 (1:25.000)
- **Kompass**: Map 654 (1:25.000)

Accessibility

Approach: 90 minutes, 4km, 400m of ascent.

♿ **Disabled access**: The approach path is narrow and rocky, making it unsuitable for disabled access. However, it is possible to hire a private jeep taxi up to Rifugio Croda da Lago – Gianni Palmieri. From here a good path leads around the southern and eastern shores.

Best time of year/day

While the lake is most easily accessed during the summer, Lago Fedèra is undoubtedly at its most spectacular during late October when the surrounding larches provide a wonderful display of autumnal colours.

Thanks to the diverse range of viewpoints, the location is photogenic all day and in nearly all weather conditions. The autumn trees are particularly striking when the sun is low in the sky.

Previous spread: The classic shot of Croda da Lago looking south towards Beco de Mezodi at sunrise. Nikon D810, 16–35mm at 35mm, ISO 100, 15s at f/10, tripod, ND filter, Oct.

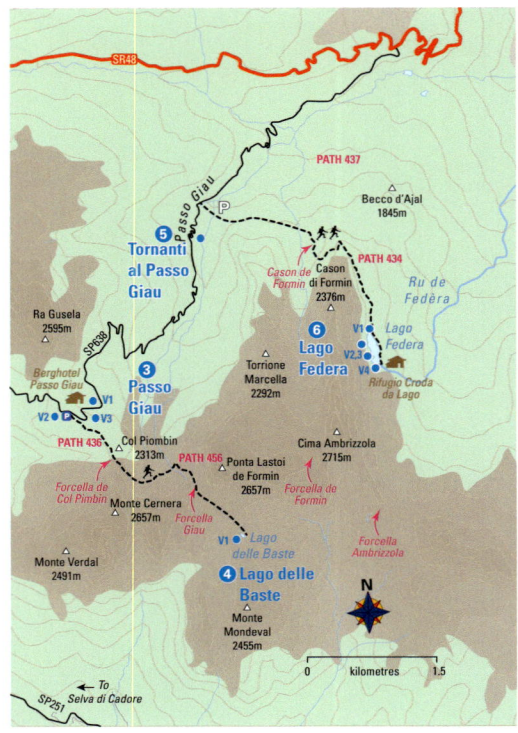

June and July are excellent months for wild flower foregrounds. Nikon Z7II, 24–120mm at 50mm, ISO 64, 30s at f/18, tripod, ND filter, Jun.

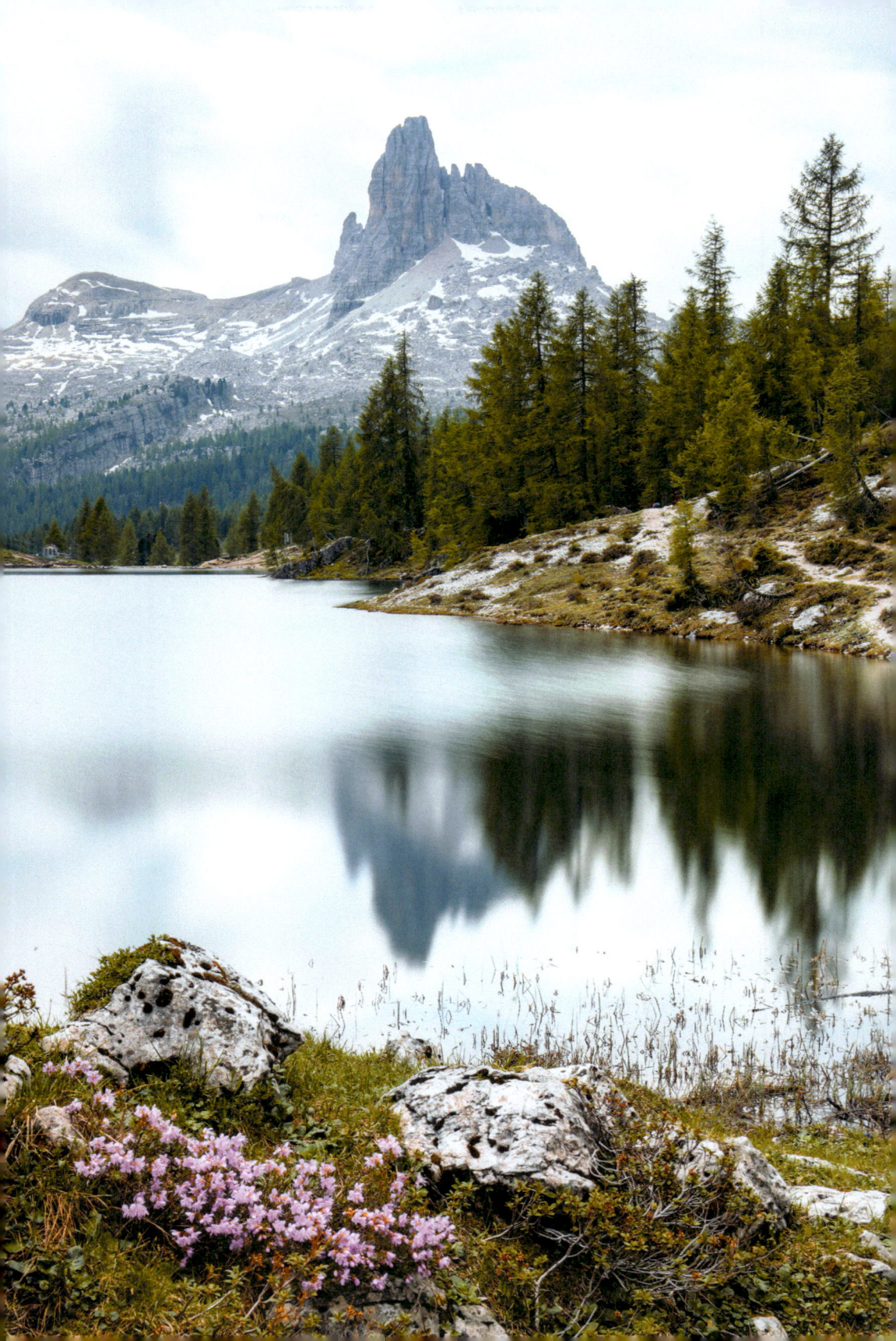

6 LAGO FEDERA – CRODA DA LAGO

What to shoot and viewpoints

From the parking area take path 437 south-east, following signposting towards Rifugio Croda da Lago / Palmieri to immediately cross a bridge over the river Costeana just below the road. The path starts on level ground but soon begins to ascend more steeply, providing excellent views north towards Tofana di Rozes. Cross another bridge over a small gorge above the river Formin to reach a clearing at the Cason de Formin. Turn left as the track forks, turning onto path 434 and still following signs for Rifugio Croda da Lago / Palmieri. The path now begins to ascend more steeply as it leads east and then back south before levelling out just before the north-eastern end of the lake. On the final approach through the forest, keep an eye out for several photogenic gnarled trees with exposed roots.

There are so many potential viewpoints and interesting subjects at Lago Federa that it is difficult to describe them all, particularly on a still day when the reflections create nearly infinite possibilities for symmetrical scenes. The following viewpoints are intended as a rough guide and are described making an anti-clockwise circuit of the lake.

Viewpoint 1 – Beco de Mezodi

This is the classic viewpoint of the lake, looking south towards Rifugio Croda da Lago – Gianni Palmieri and the lone tower of Beco de Mezodi. The obvious composition framing the rifugio on the left and mountain to the right works at a variety of focal lengths, depending on how much foreground you wish to include. On a still day the potential for symmetrical pairings is almost endless. Try taking advantage of the leftwards trending diagonals as the height of the mountains reduces to meet the trees.

This shot works especially well at sunrise when the first rays highlight the lakeside trees, or at sunset when the light sets on the right-hand side of Beco de Mezodi.

This composition can be repeated from different locations, most notably utilising two small spits of land that jut out into the lake on the western shore. The first and smaller of the two requires some careful boulder hopping to avoid getting your feet wet. The larger spit is found further south and is more easily accessed.

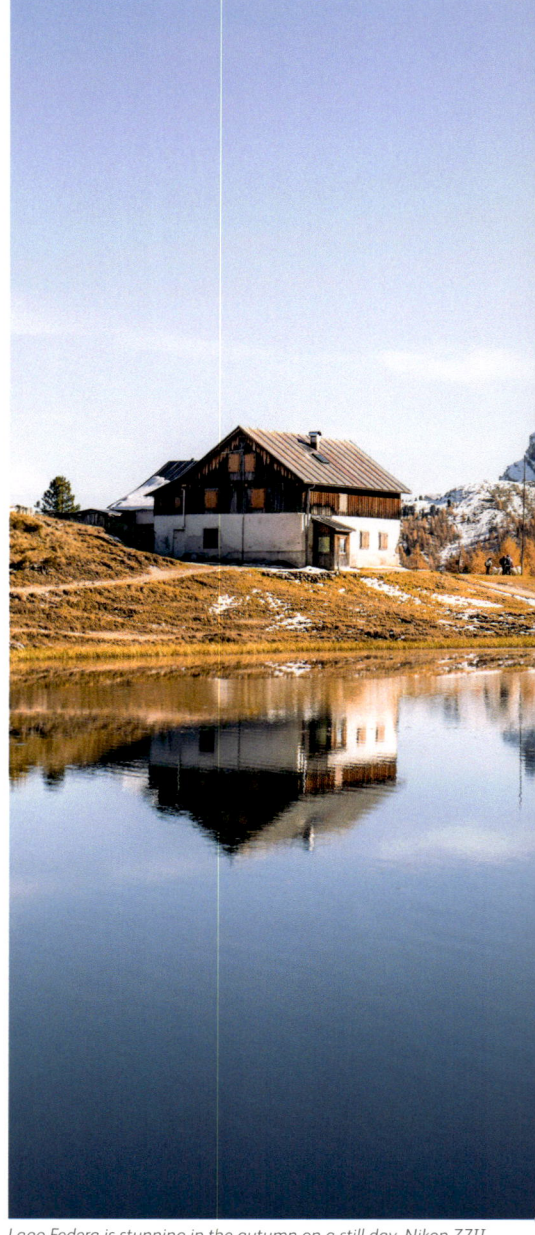

Lago Federa is stunning in the autumn on a still day. Nikon Z7II, 24–120mm at 35mm, ISO 64, 1/200s at f/8, Oct.

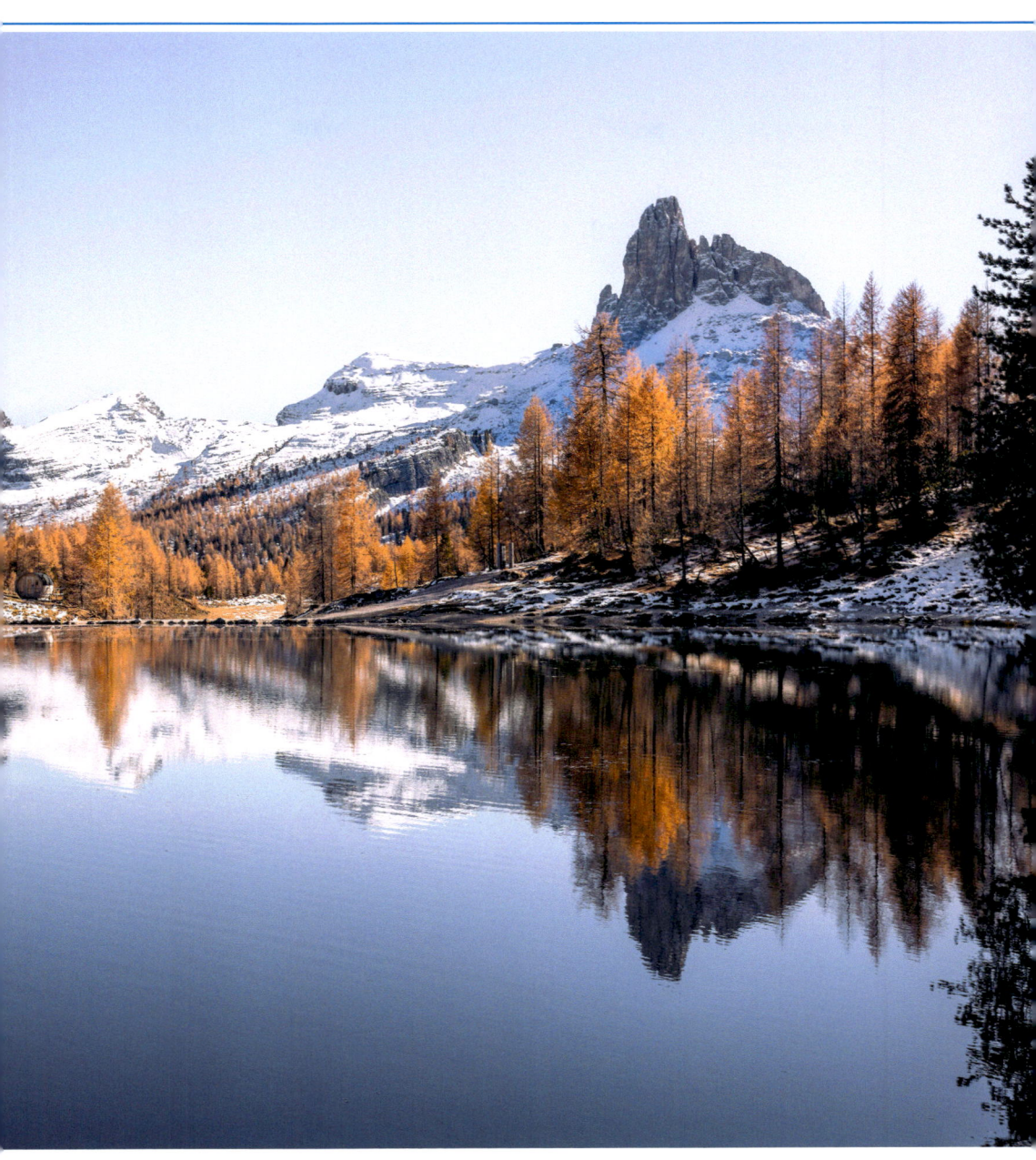

6 LAGO FEDERA – CRODA DA LAGO

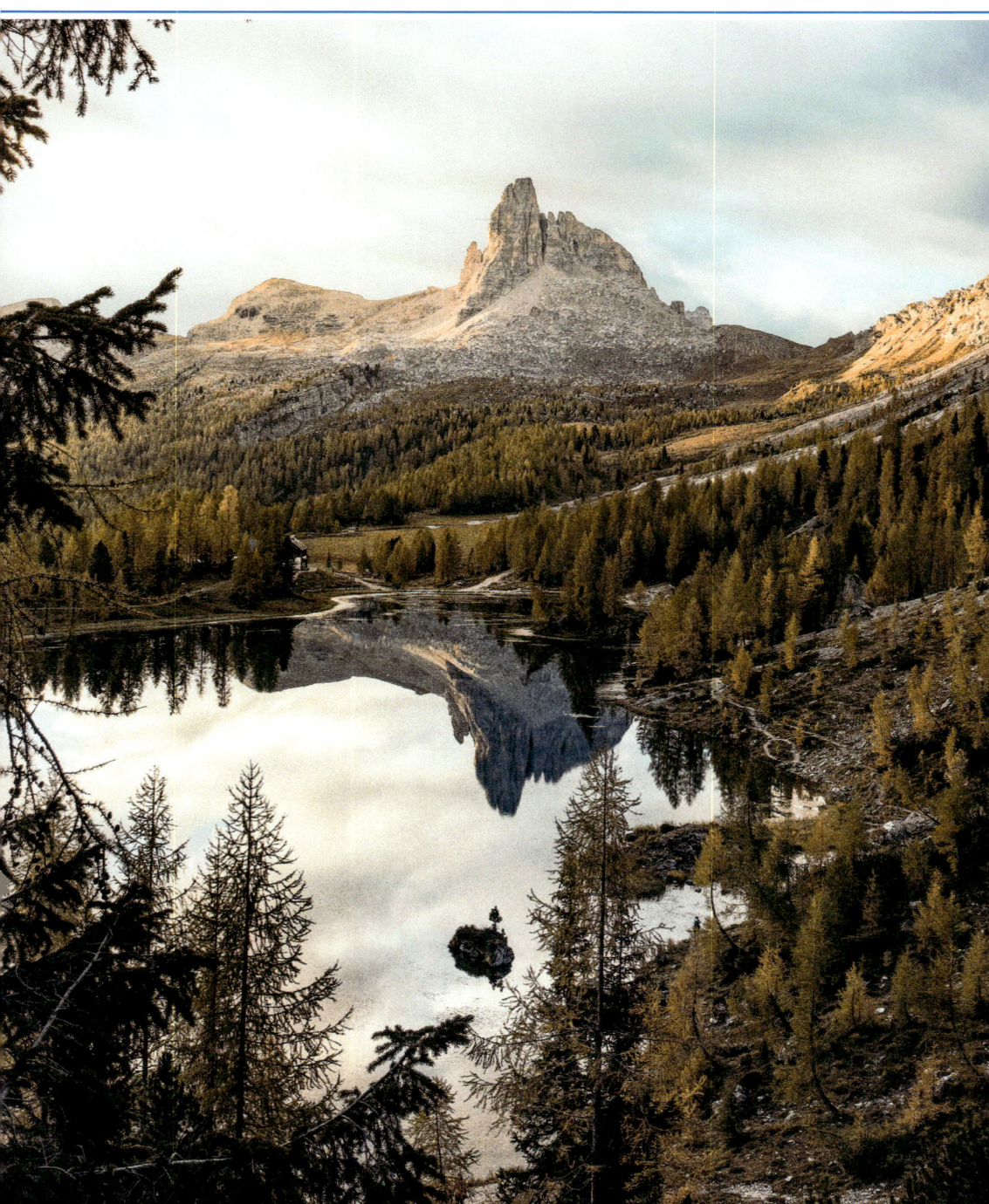

Looking south across Lago Federa. © Filip Zrnzević.

Viewpoint 2 – Small Island

There are several tiny islands at the southern end of the lake that make for excellent focal points when paired with the trees on the eastern shore. The scene looks especially striking during the late autumn when the larches change colour, especially if there is also snow on the ground.

Follow the small, rocky but well-defined path south along the western shore, passing several rocky bays and inlets. Continue just past the aforementioned large spit of land jutting out into the lake until the Sorapiss group and Monte Antelao come into view to the east.

Viewpoint 3 – Rifugio Croda da Lago – Gianni Palmieri, Monte Sorapiss & Antelao

With some careful positioning it is now possible to gain a good side-on perspective of Rifugio Croda da Lago – Gianni Palmieri set against an excellent mountain backdrop. Because of the dense trees behind and alongside the building some perseverance is required to keep a clear view of the peaks, but ultimately this is worth the effort as the fortress-like silhouette of Sorapiss provides a lovely contrast to the quintessentially mountain-shaped Antelao.

Viewpoint 4 – Southern Shore looking North

Continuing round to the southern shore and then looking back down the lake, additional possibilities for symmetry shots are soon revealed. The descending slopes of Cima Bassa del Lago, offset against the increasing tree size as the perspective changes along the right-hand bank, create a beautiful hourglass shape when the waters are still.

To return, either retrace your steps back to the car or for a more complete circular itinerary continue on path 434 up to Forcella Ambrizzola. From the saddle turn right (north) onto path 435 and ascend to the highest point of the route at Forcella de Formin (2462m). The path now descends the rubble-strewn Val de Formin beneath the impressive west faces of Croda da Lago before rejoining the ascent route at Cason de Formin. Turn left back onto path 437 and follow this back to the parking area.

Using a longer lens to pick out areas of interesting light. Nikon Z7II, 100–400mm at 220mm, ISO 100, 1/250s at f/6.3, Oct.

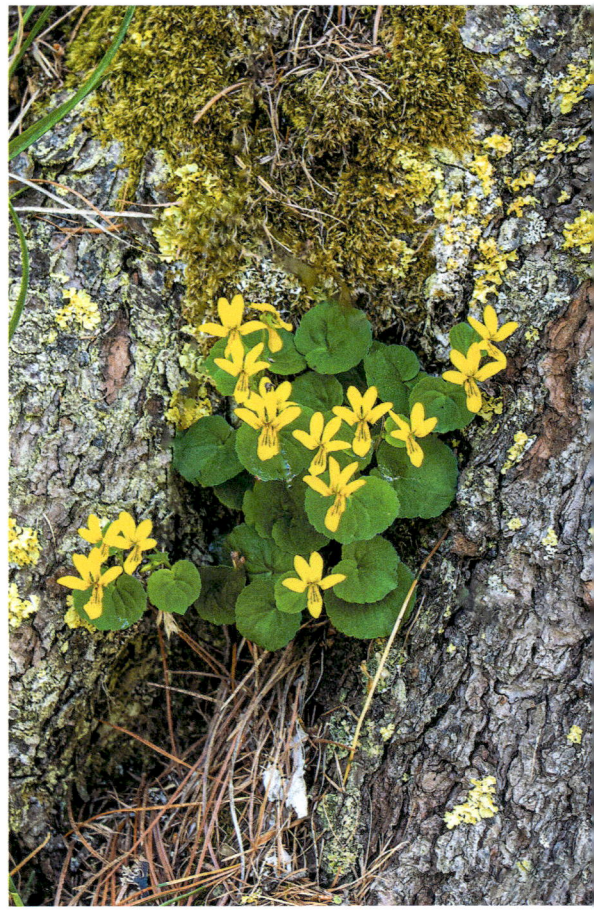

Yellow wood violets (Viola biflora). Nikon D850, 14–24mm at 20mm, ISO 100, 1/50s at f/5.6, Jun.

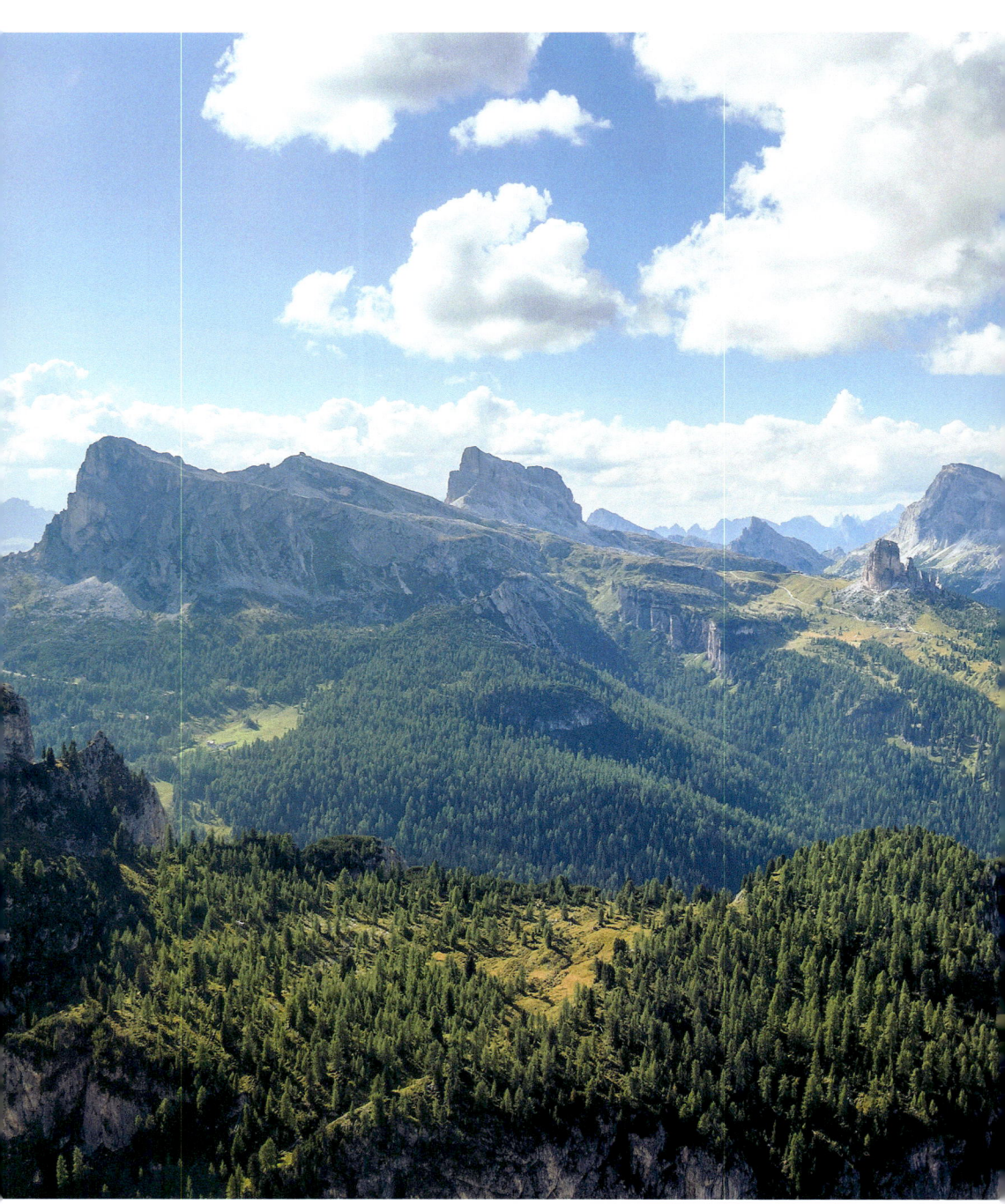

There are several excellent viewpoints looking north over the Giau and Falzarego passes whilst ascending to Lago Federa. Canon G12, 30mm, ISO 100, 1/200s at f/7.1, Aug.

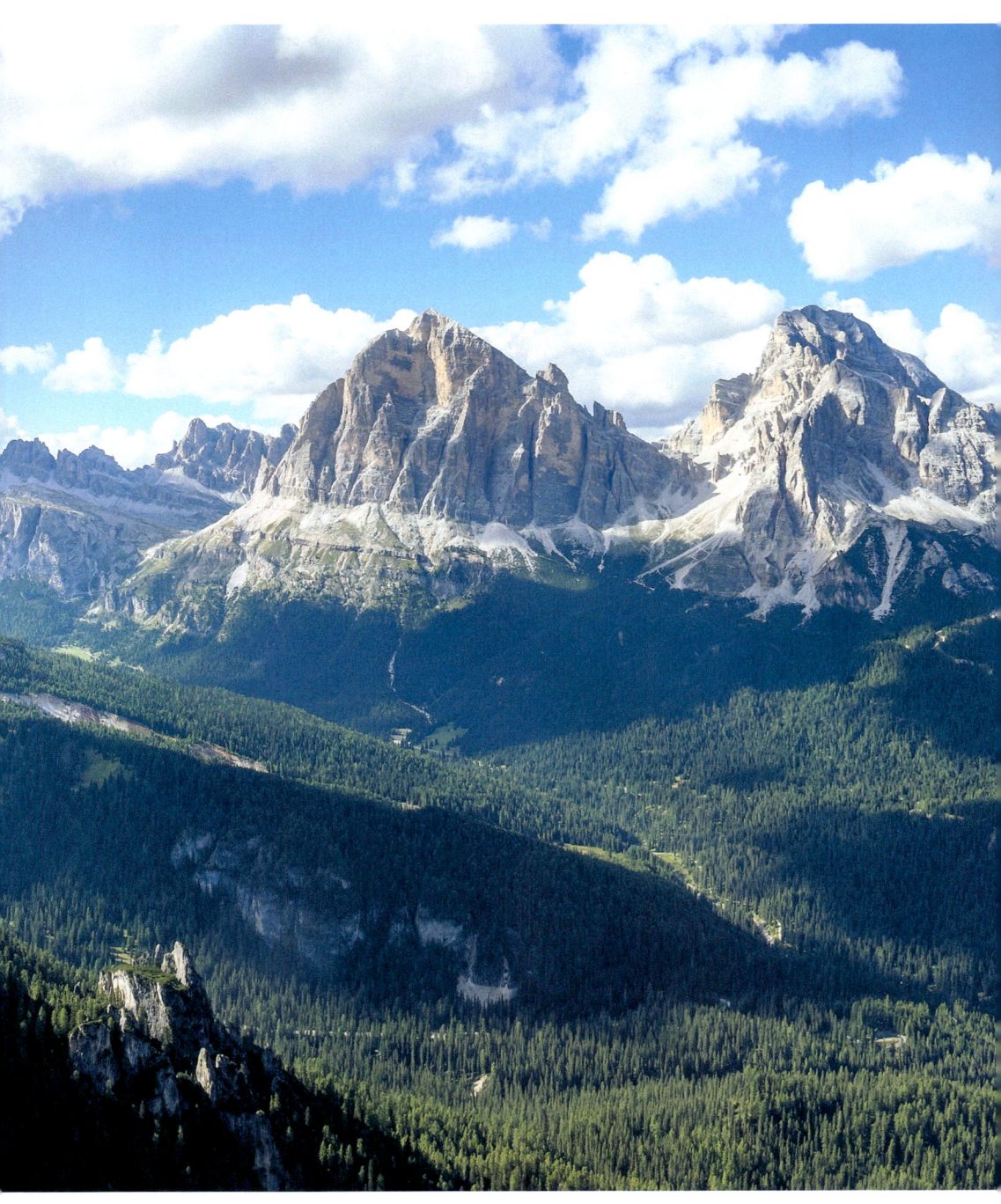

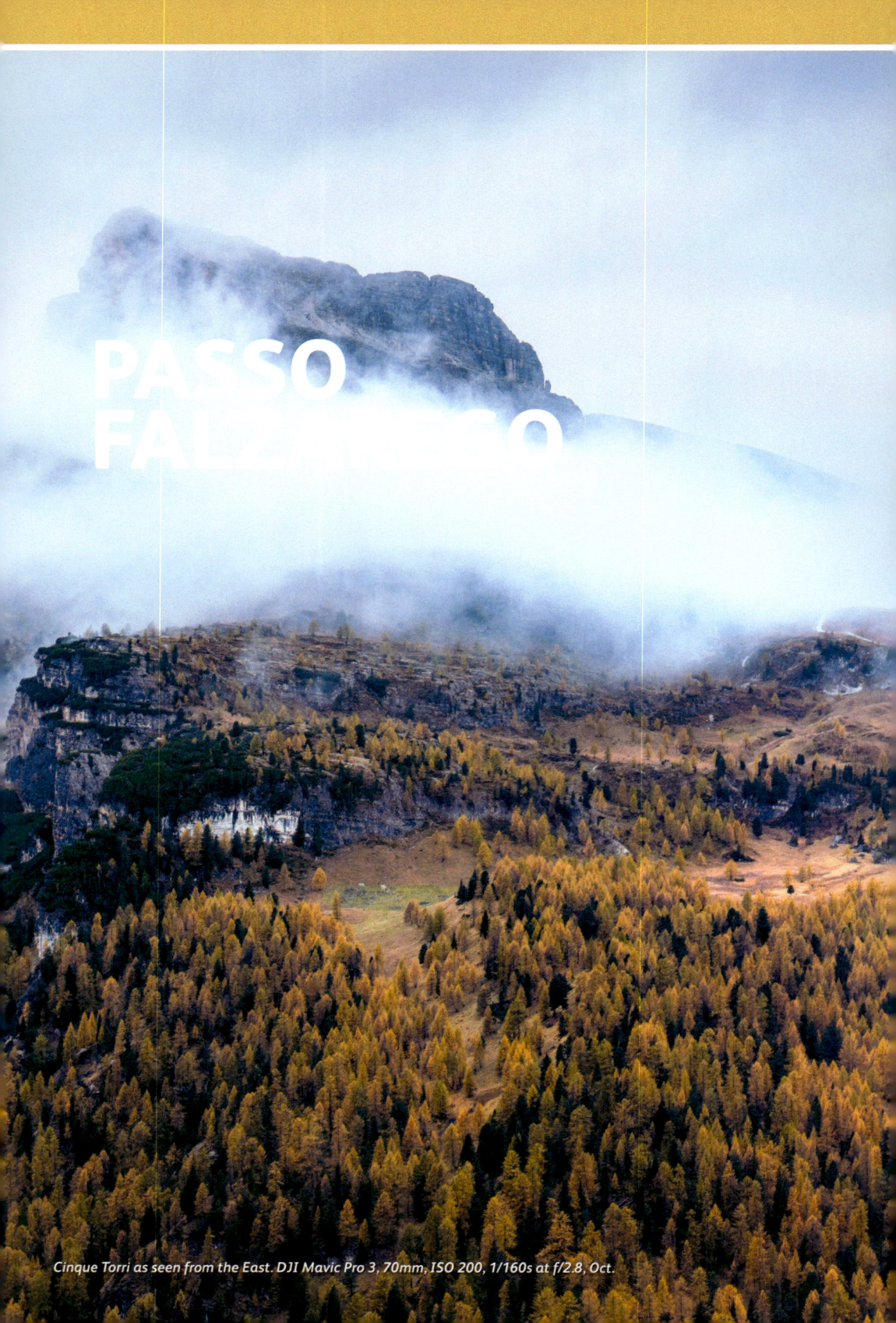

PASSO FALZAREGO

Cinque Torri as seen from the East. DJI Mavic Pro 3, 70mm, ISO 200, 1/160s at f/2.8, Oct.

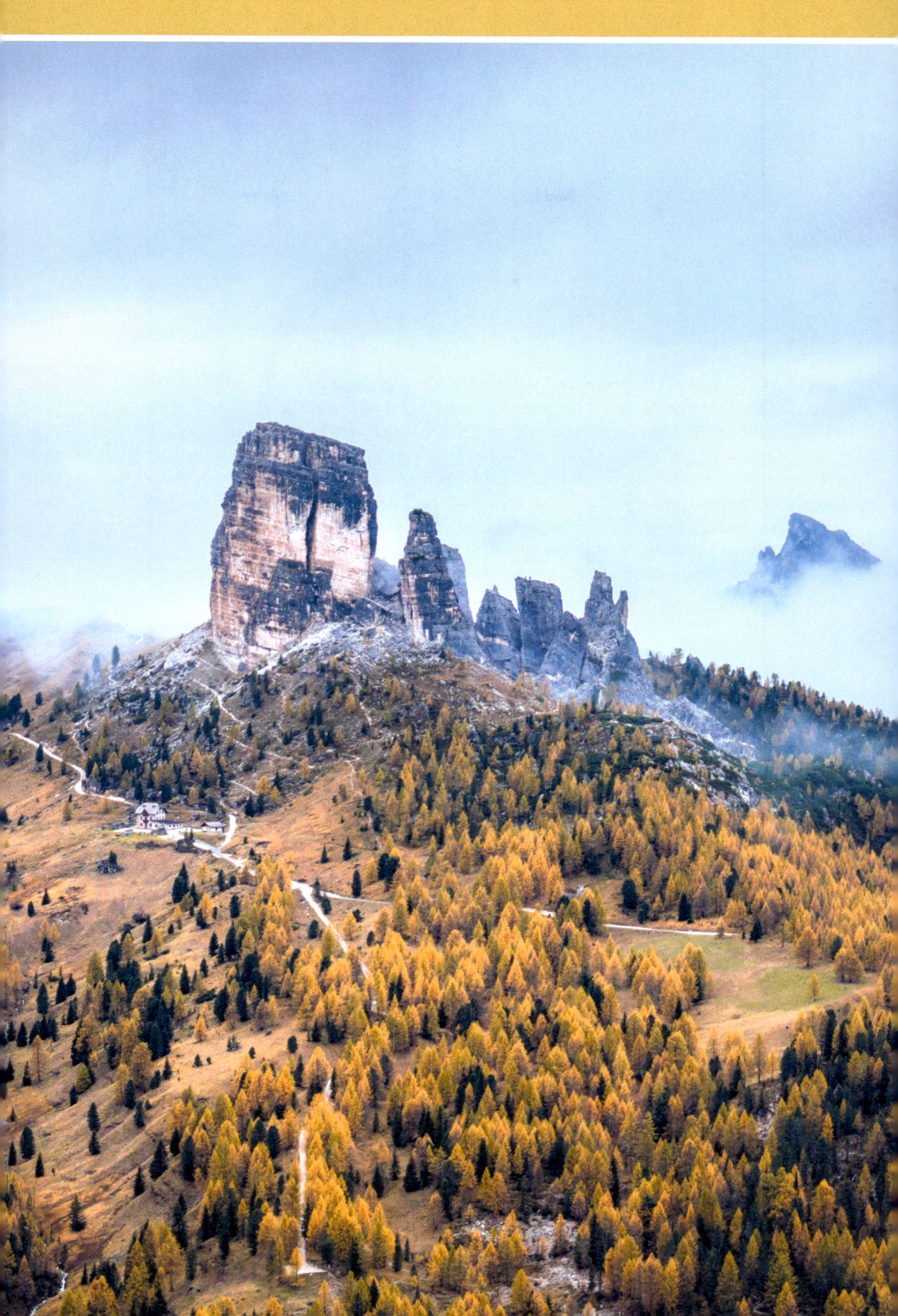

PASSO FALZAREGO – INTRODUCTION

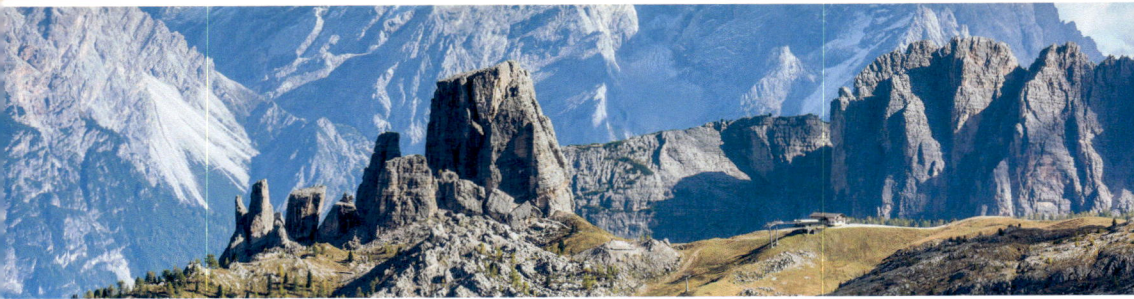

The Falzarego is one of the Dolomites' high passes, running between Andráz in the south to Cortina d'Ampezzo in the east and reaching an altitude of 2105m. The name is derived from 'Falza Rego', which means 'False King' in Ladin and alludes to the king of the Fanes who, according to legend, was turned to stone for betraying his people. Surrounded and enveloped by a myriad of iconic peaks, the region is undoubtedly one of the most photogenic in the Dolomites and boasts a host of classic vantage points; even if you don't intend to photograph here, a drive over the pass is highly recommended.

Due to its obvious strategic significance linking the Ampezzo basin to the Alta Badia and Belluno lowlands, the pass played a central role during the First World War and historic remains can be found throughout the area. The nearby Tre Sassi Fort has now been converted into an excellent war museum, while both Sass de Stria and Cinque Torri have been developed into open air museums. Monte Lagazuoi is of particular note; the peak was subjected to one of the most extensive military tunnelling campaigns seen anywhere in the world, as Italian and Austro-Hungarian forces transformed it into an impenetrable 20th century fortress.

The area is also a haven for mountain sport enthusiasts and is a particularly renowned road biking itinerary, constituting one of the principle passes of the Maratona dles Dolomites, a race described by National Geographic as 'one of the biggest, most passionate, and most chaotic bike races on Earth'. There are ten via ferrata routes accessed from the pass; the longest of these is 'Giovanni Lipella' which leads up the mighty Tofana di Rozes, one of the highest and most photogenic peaks in the Dolomites. The five towers of Cinque Torri have long been the home of the 'Scoiattoli di Cortina', the Cortina Red Squirrels, a renowned group of local climbers who can frequently be seen training on the many bolted and traditional routes found on the extraordinary spires.

In winter the area is transformed into a popular ski venue with 29km of piste located on the pass. The most famous of these is the so-called 'hidden valley'; appearing in several 'best ski slopes of the world' compilations – the piste extends 8.5km from the top of the Lagazuoi down to a horse-drawn ski tow in the nearby village of Armentarola.

LOCATIONS

1	Sass de Stria / Hexenstein	310
2	Monte Lagazuoi	316
3	Lago Limides / Limedes	326
4	Cinque Torri	330
5	Sentiero Astaldi	346

Maps
- Tabacco (Italian): Map 03
- Kompass (German): Map 654

Above: Cinque Torri as seen from the summit of the Lagazuoi. Nikon D810, 80–400mm at 185mm, ISO 100, 1/400s at f/10, Sep.

Next spread: Both Sass de Stria and the Lagazuoi provide excellent views of Monte Averau. Nikon Z7II, 24–120mm at 120mm, ISO 100, 1/200s at f/8, Sep.

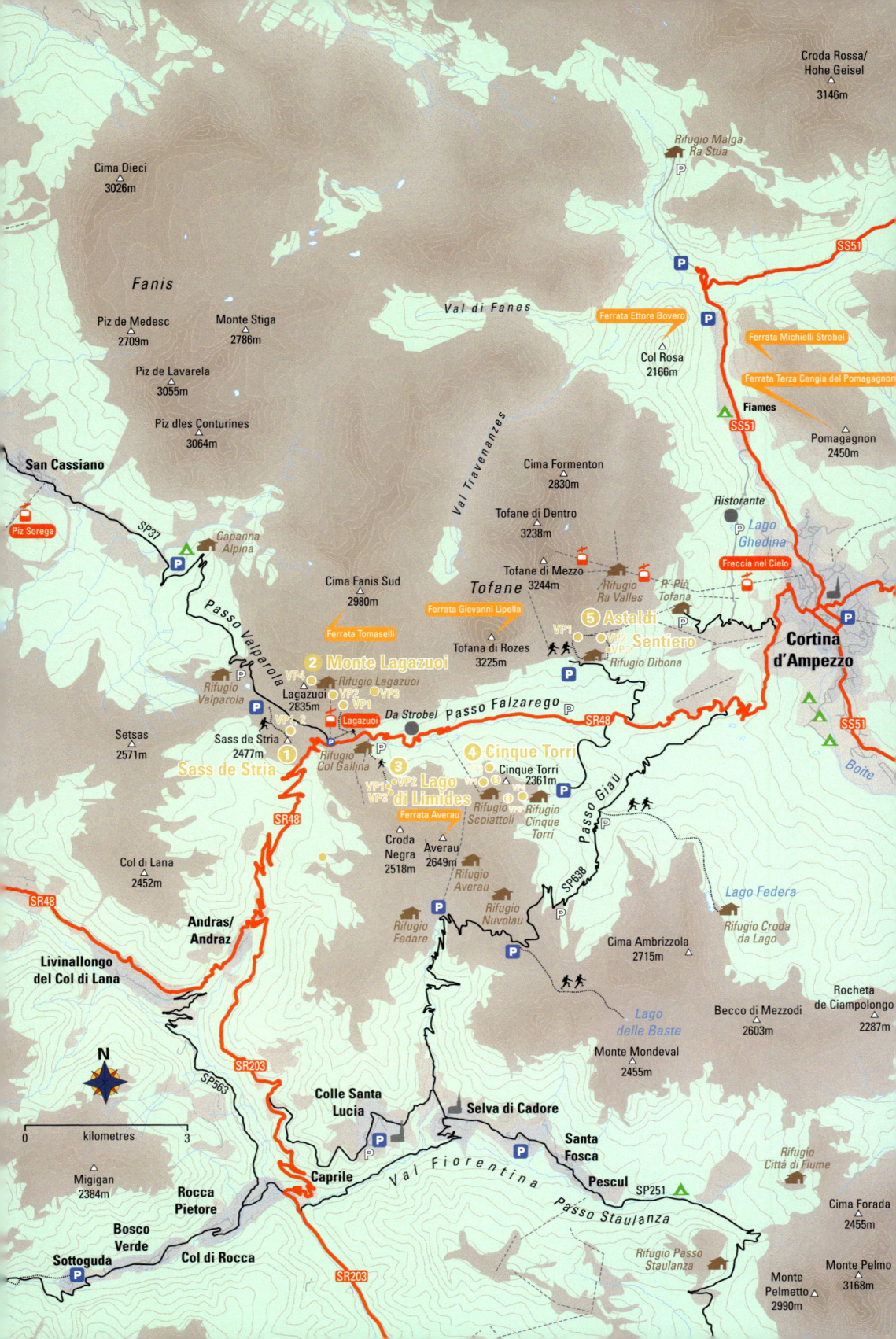

1. SASS DE STRIA / HEXENSTEIN

Creating a striking monument above the Falzarego and Valparola Passes, Sass de Stria, literally meaning 'Witch's Rock' in Ladin, is a small but beautifully formed peak whose rocky and commanding summit provides some of the best views in the region. The approach is challenging however, involving some scrambling and a single short section of ladder as the path negotiates a steep gully, requiring good hiking experience and freedom from vertigo.

Due to its strategic location guarding access to the Val Badia, the peak was extensively tunnelled and fortified by the Austrians during the First World War and proved impenetrable for the Italian Alpini who launched several large scale assaults against the position. There are a number of trenches, tunnels and gun placements that can be explored – just remember to bring a head torch.

Sunrise and sunset are to be particularly recommended for those undaunted by the challenging approach, offering a unforgettable spectacle over the wider Dolomites region.

What to shoot and viewpoints

Despite being a popular and much-frequented route, the approach to the summit of Sass de Stria requires good hill walking experience and should not be underestimated.

From the car park, follow signposts south-west to take a small path traversing the slopes of Sass de Stria. There are now many different possible routes and the path becomes less distinct. Turn left to follow a vague trench up the middle of the mountain, aiming to pass just left of a boulder curiously painted in blue. The path now becomes clearer and you should be able to spot some wooden war memorial crosses on a rocky outcrop above you, surrounded by numerous trenches and war remains.

The sun rises just north of Monte Antelao, illuminating the five towers of Cinque Torri. Nikon D810, 24–70mm at 56mm, ISO 100, 1/50s at f/22, tripod, Oct.

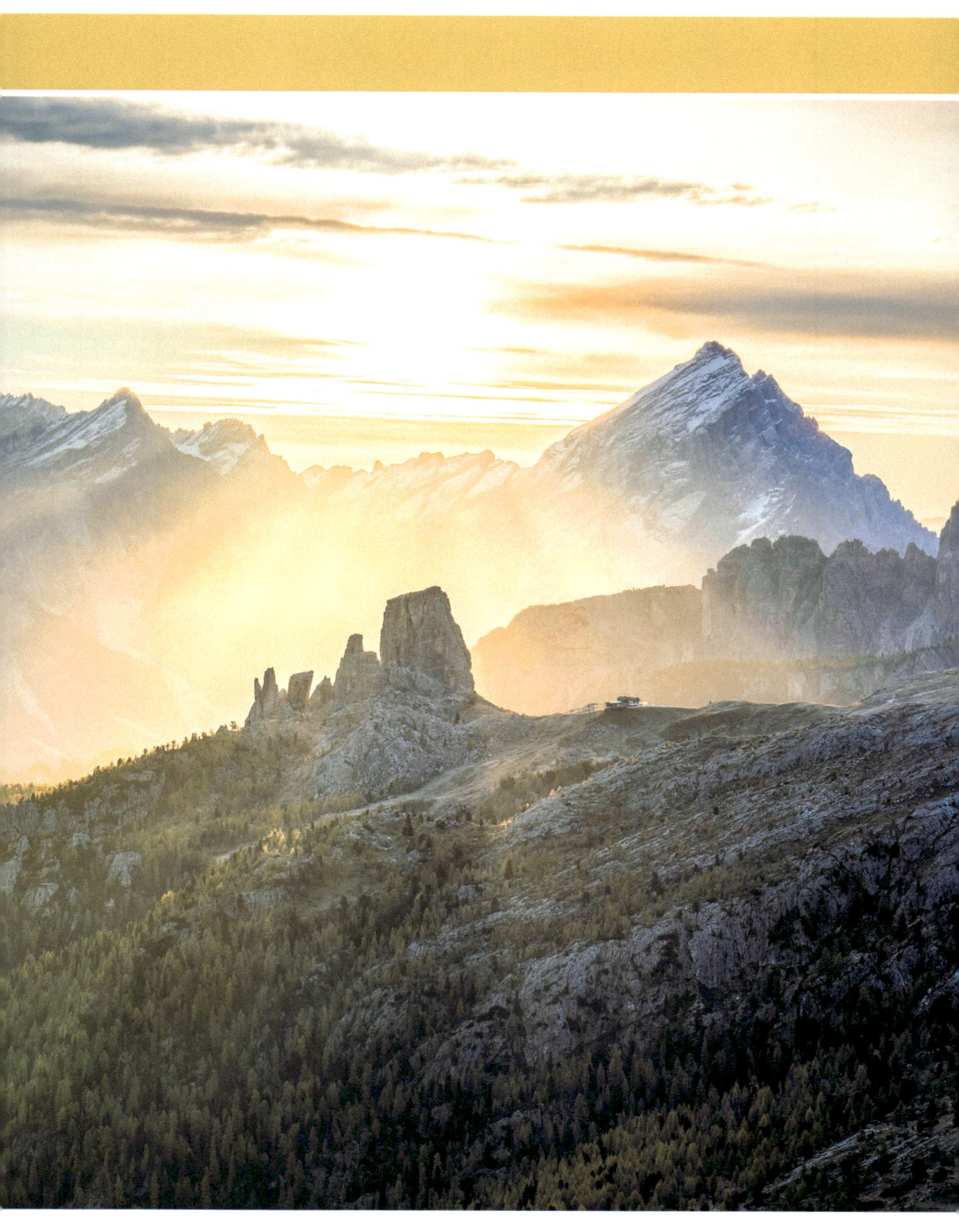

1 SASS DE STRIA / HEXENSTEIN

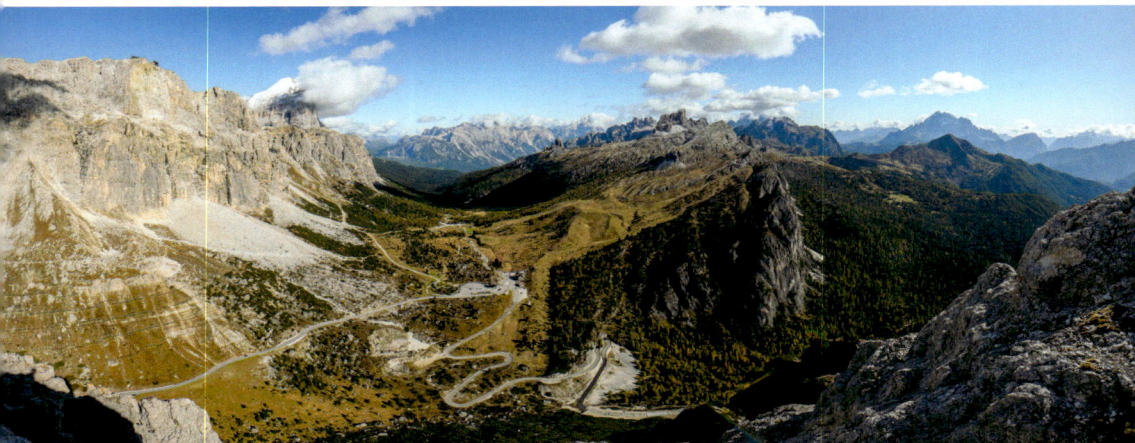

The Passo Falzarego as seen from the summit of Sass de Stria. Nikon D810, 16–35mm at 16mm, ISO 100, 1/400s at f/10, Oct.

Viewpoint 1 – Trenches & War Remains

The north-west flank of Sass de Stria is essentially an open air war museum, featuring a veritable labyrinth of trenches, lookout points and gun emplacements.

Recommending individual locations is pointless here, not least because you tend to discover something new each time you go. This is the perfect opportunity for some spontaneous and creative photography depending on what you find. The wooden crosses provide a sombre reminder of the atrocities which occurred here and serve as an excellent atmospheric foreground, particularly on a dark, moody or misty day.

The trenches make for excellent wide-angle foregrounds and can be combined with a variety of backdrops, while the various lookout windows lend themselves to some dramatic HDR style effects, capturing both the interior of the position and the commanding view over the surrounding landscapes. As well as the expansive panoramas there is also plenty of detail to be found here, be it building remains, discarded tinned rations, barbed wire or ammunition casings.

To access the summit continue uphill, following path markings through the trenches (again, there are a number of possible routes) to eventually reach a large iron ladder. Ascend this and follow the protected path above, taking care on the final scramble to the summit.

Viewpoint 2 – Summit

On reaching the summit the resulting panorama is spectacular, with far-reaching views over the majority of the major peaks in the Dolomites.

The distinctive rectangular shape of the Lagazuoi and its dramatic suspended cable car can be seen just to the north-east then, working clockwise, Col dei Bos and the three Tofane, the Falzarego Pass itself, Sorapiss Group and Antelao above Cortina d'Ampezzo, the five towers of Cinque Torri, the jagged ridge of Croda da Lago and top hat silhouette of Averau can be admired. Further round the bulk of Monte Pelmo and the vast north face of Civetta dominate the scene, followed by the Marmolada, Padon ridge, and the Sella and Puez Odle massifs. In the foreground the volcano-shaped peak of Col di Lana (dubbed 'Col di Sangue' or 'Blood Mountain' for its role in the war) can be seen, easily identified by the vast crater left by 5 tonnes of explosives.

Once again there many possible compositions from this vantage point. The classic shot is taken looking east, overlooking the Passo Falzarego with a wide-angle lens and framing the road in the middle, Tofane on the left and Averau on the right. This shot works particularly well at sunrise when you can get some great sunstars as the sun comes up, or at sunset when many of the west faces are bathed in evening light.

During the autumn the sun rises behind the towers of Cinque Torri, creating some spectacular light rays that can be picked out with a longer lens.

The view south-west towards the Marmolada is also superb, with the crater of Col di Lana providing some excellent foreground interest. Sass di Stria also has a large and striking summit cross that can be effectively captured with a wide-angle, particularly if you have a fellow hill walker to hand for some mountain posing.

How to get here

The easiest approach departs from the Tre Sassi Fort just south of Rifugio Valparola and the Passo Valparola summit. The fort is easily approached from the Alta Badia via the Valparola pass or from Cortina d'Ampezzo and the Val Fiorentina using the Passo Falzarego. There is a large parking area just south (the Falzarego side) of the fort where the approach starts.

Lat/Long: 46.52735, 11.99262
what3words: ///ninja.film.landscapers
Tabacco: Map 03 (1:25.000)
Kompass: Map 654 (1:25.000)

Accessibility

Approach: 60 minutes, 2.5km, 300m of ascent.

Accessing the summit of Sass di Stria should not be underestimated and requires good hill walking experience due to the mountainous nature of the approach and the several exposed sections on loose terrain. While the summit can be accessed during the winter, this is not recommended without mountaineering experience.

The nearby summit of Monte Lagazuoi can be accessed via cable car and is a recommended alternative for those who might find the approach to Sass de Stria difficult.

 Disabled access: The approach path is narrow, rocky and requires several sections of scrambling making it unsuitable for disabled access.

Best time of year/day

The peak is photogenic throughout the year, although access is easier during the middle of summer once the snows have properly melted from the ascent route.

The peak is perfectly suited to sunrise and sunset photography but particular care needs to be taken when approaching or descending in the dark due to the vertiginous nature of the terrain and the abundance of trenches.

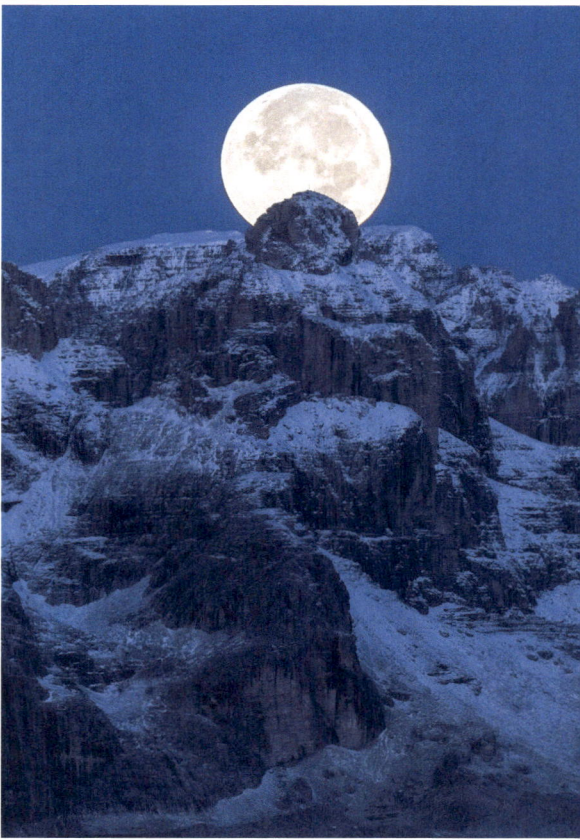

The moon sinks below the Sella group. Nikon D810, 80–400mm at 400mm, ISO 400, 1/125s at f/5.6, tripod, Oct.

Wooden memorials. Nikon D810, 24–70mm at 60mm, ISO 100, 1/5000s at f/2.8, Oct.

MONTE LAGAZUOI

Although not the most striking mountain in its own right, Monte Lagazuoi is superbly situated atop the Passo Falzarego and offers superb panoramic views in all directions; indeed on a clear day there's not much of the Dolomites you can't see. The peak has cable car access leading directly to a viewing platform below Rifugio Lagazuoi and a flight of stairs leads up to the hut itself, from where you can take in the vista while enjoying a drink on the decking.

Like the neighbouring Sass de Stria, Monte Lagazuoi also played a critical role in the First World War due to its obvious strategic significance, and the summit was quickly fortified by the Austrian forces. The Italian troops occupied only a small part of the mountain: a long ledge halfway up the face of Piccolo Lagazuoi. Major Ettore Martini, the commander of the Italian troops, realised the importance of the now eponymous ledge and over the following years developed it into an Italian stronghold. Field kitchens, barracks, storerooms and hospital posts were constructed along the ledge, and the gun emplacements were able to reach the enemy troops stationed in the trenches along the Valparola Pass. Suffering considerable losses from Italian fire, the Austrians looked for any way to oust the Italians from the ledge and thus followed a period of intense mine warfare with both sides tunnelling extensively into the mountain.

Today it is possible to ascend the tunnels all the way from the base of the south-east face through the mountain and up to the summit: a chilling and fascinating experience that is highly recommended.

A helicopter transports building materials to Rifugio Lagazuoi. Nikon Z7II, 24–120mm at 100mm, ISO 64, 1/320s at f/6.3, Oct.

Previous spread: The Lagazuoi cablecar and rocky towers of Cinque Torri as seen from a climbing route on Lagazuoi Piccolo. Nikon Z7II, 24–120mm at 120mm, ISO 800, 1/500s at f/11, Aug.

A walker ascends the tunnels. Nikon D810, 14–24mm at 14mm, ISO 80, 46s at f/9, tripod.

How to get here

Monte Lagazuoi is accessed from the large cable car station on the summit of the Passo Falzarego. The pass can be approached from the Alta Badia using the Passo Valparola or via the Passo Falzarego from Cortina d'Ampezzo. There is a large car park at the lift station.

- **Lat/Long**: 46.51956, 12.00836
- **what3words**: ///timer.hamburger.bursts
- **Tabacco**: Map 03 (1:25.000)
- **Kompass**: Map 654 (1:25.000)

Accessibility

Approach: 120 minutes, 2km, 650m of ascent (optional).

A good level of fitness is required to tackle the 650m of ascent through the tunnels. The journey through the mountain is steep, wet, unlit and low in places, requiring a helmet and head torch.

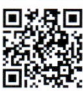 **Disabled access**: While the tunnels are not suitable for disabled access wheelchairs are permitted on the Lagazuoi cable car, although there are several steps to negotiate at the top.

Best time of year/day

The cable car runs from late May to mid October and provides excellent views of the area throughout the season. On overcast days it is often possible to get above the clouds and view some excellent inversions.

The sun rises behind Monte Pelmo and Monte Civetta and sets behind the rifugio, making it a superb location at either end of the day. Unfortunately the cable car is shut during the golden hours and an overnight stay in the nearby Rifugio Lagazuoi is recommended for those wishing to shoot at sunrise and sunset.

Above: The sun rises behind Monte Pelmo (3168m). Nikon D610, 80–400mm at 175mm, ISO 100, 1/30s at f/8, tripod, Jan.

2 MONTE LAGAZUOI

What to shoot and viewpoints

If you plan on taking the cable car to the summit, go straight to viewpoint 2.

Viewpoint 1 – Tunnels & Martini Ledge

To access the tunnels, from the car park take path 402 north-east, following signs to Monte Lagazuoi. After 30 minutes of steep switch-backs reach an obvious fork; turn left here towards the 'Galleria' to reach the first short section of tunnel. Pass through this and follow an exposed series of ledges protected by intermittent cable to reach the main tunnel entrance in a further 10 minutes. As you enter the main tunnel (helmet and head-torch advised), a secondary tunnel leads off to the left, signposted to the Martini ledge. This is an optional out-and-back detour which takes roughly 40 minutes and leads to the exposed ledge in the middle of the face, providing several photo opportunities. The right fork avoids this detour and leads up through the main tunnels to the Lagazuoi summit.

Martini Ledge

The approach to the ledge itself is exposed, with the stunning backdrop of the Falzarego Pass providing an excellent opportunity for action photos. The ledge is south-facing so try dropping the exposure to create a silhouette on one of the more exposed sections.

At the end of the ledge there are a number of old war buildings that make for good foreground subjects when combined with a wide-angle panorama to capture the impressive view looking out towards the Falzarego.

Lagazuoi Tunnels

The tunnels themselves offer numerous opportunities for some unusual and creative photography. Despite the near pitch-black darkness, you can get innovative with what little light there is. If you have a tripod or can find something to rest the camera on, try creating some light trails using the head torches to illuminate the tunnel. The many lookout points create an ideal frame for landscape shots and also provide some stunning light rays that penetrate into the tunnels.

Viewpoint 2 – Trenches & Tofane

As you exit the Lagazuoi tunnels you emerge into a series of trenches. To access the site from the cable car station, take the path clearly signposted towards the 'Galleria' that runs from behind the lift station itself. Follow the protected path downhill for 5 minutes to access the trenches. The trenches, sandbags and scattered barbed wire are a sombre reminder of the events that unfolded between 1914 and 1918. With a wide-angle lens you can capture the trenches and wire using the distinctive shield of Tofana di Rozes (3225m) as an impressive backdrop.

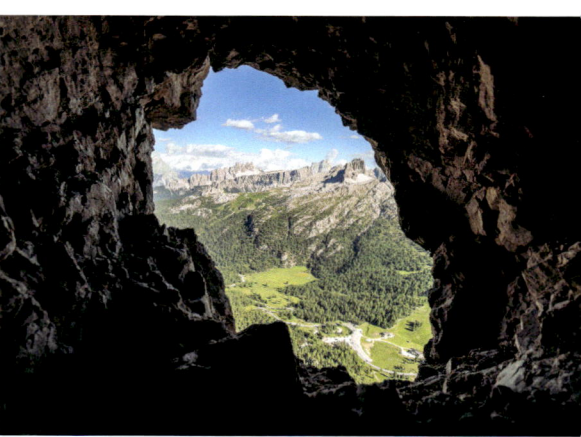

There are many gun emplacements and lookout points throughout the tunnels which provide commanding views over the Falzarego. As the soldiers were digging, rubble and waste was thrown out of these windows during thunderstorms in an attempt to hide their presence from the Austrians above. Nikon D810, 16–35mm at 16mm, ISO 100, 1/400s at f/10, Jun.

Left: A walker descends the tunnels. Nikon D810, 14–24mm at 14mm, ISO 100, 46s at f/9, tripod.

Below: A 20 photo panoramic image taken from the summit looking out over the Falzarego and Rifugio Lagazuoi. Nikon D810, 80–400mm at 80mm, ISO 100, 1/250s at f/7.1, Jun.

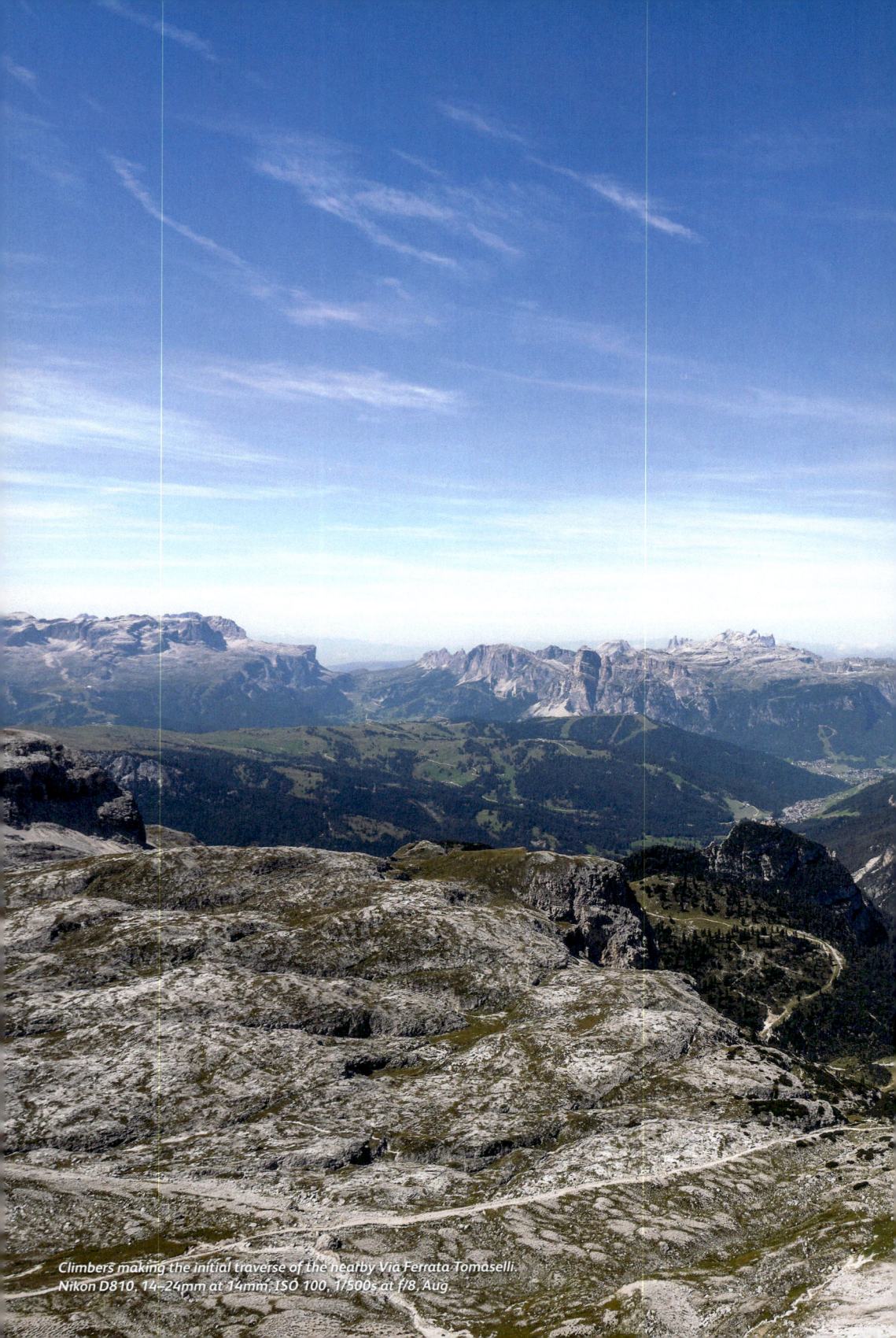

Climbers making the initial traverse of the nearby Via Ferrata Tomaselli. Nikon D810, 14–24mm at 14mm, ISO 100, 1/500s at f/8, Aug.

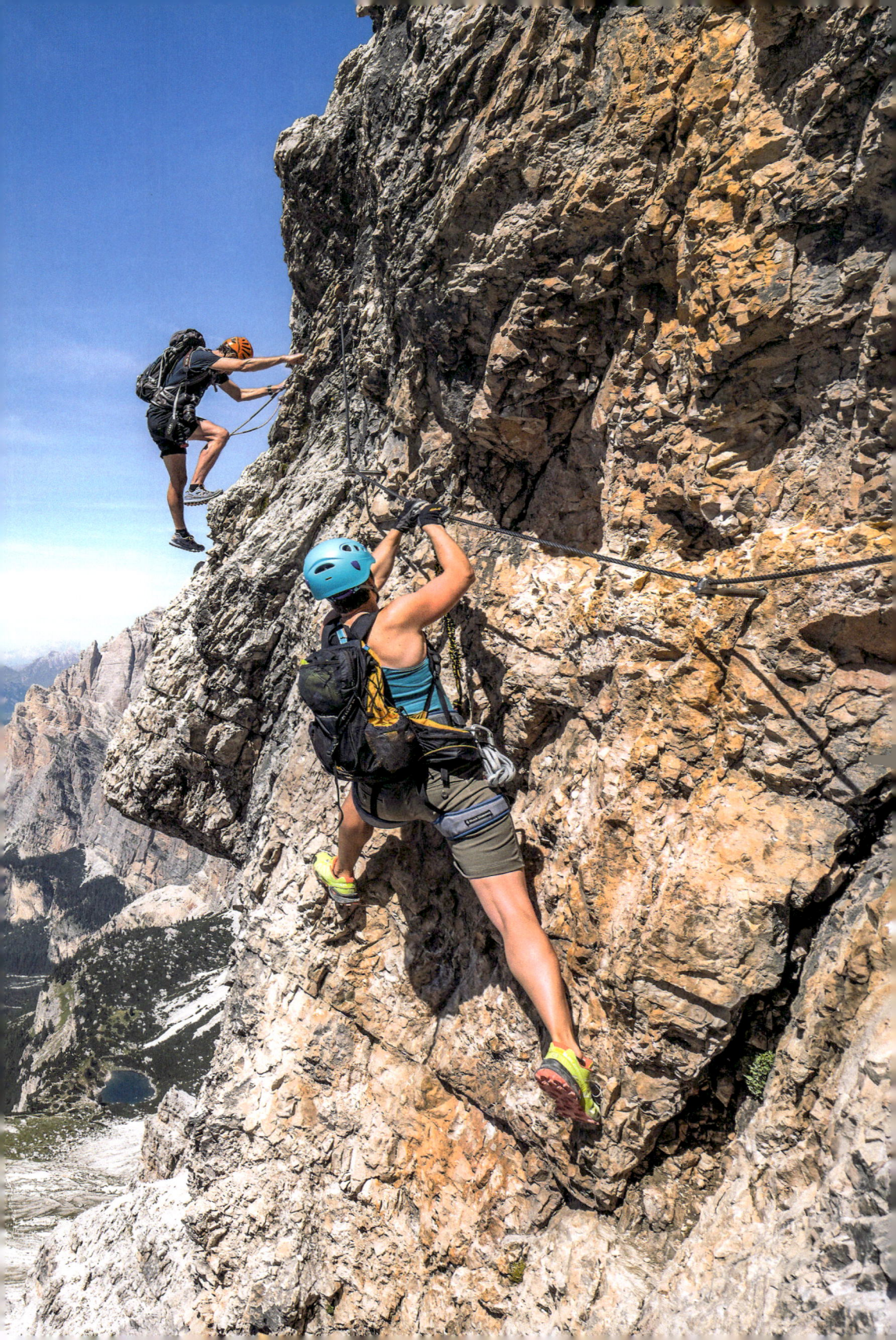

2 MONTE LAGAZUOI

Viewpoint 3 – Rifugio Lagazuoi & Sauna ♿
From the top of the cable car a short flight of steps leads up to the clearly visible Rifugio Lagazuoi. From the terrace there are breathtaking views to the east, south and west.

With a wide-angle or standard zoom you can take in the whole scene, creating some fantastic panoramas. Alternatively, with a long lens you can isolate individual mountains and cloud formations. Sunrise and sunset over these mountains is one of the most characteristic and memorable scenes in the Dolomites; the light interacts subtly with most of the major peaks in the range and gives huge scope for different compositions. There is also a newly installed sauna (the little wooden cylindrical building just below the terrace to the south) which creates a surreal wide-angle foreground, particularly during hours of low light or darkness when it is lit from the inside.

Viewpoint 4 – Monte Lagazuoi Summit ♿
From the terrace of Rifugio Lagazuoi, take the good path leading north-west signposted for "Sentiero dei Kaiserjäger" (sometimes referred to as the Austrian troop path) to reach the summit cross in just under 10 minutes. Again, from here there are excellent views in nearly all directions, the best one arguably looking back towards the rifugio itself for a unique panorama shot, particularly at dawn and dusk.

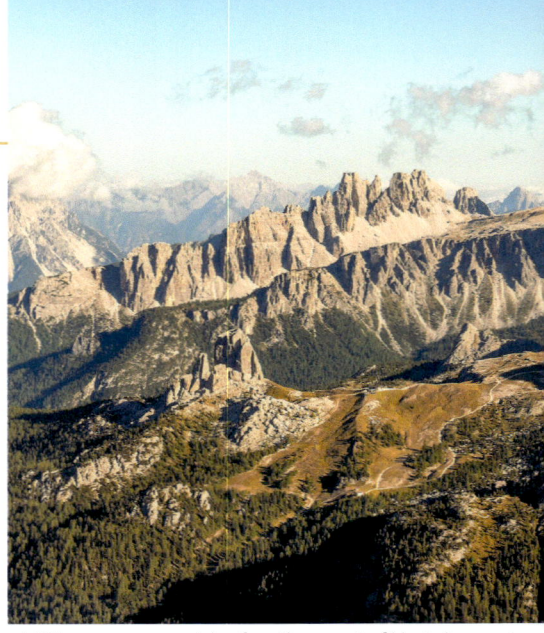

A 20 image panorama taken from the summit of Monte Lagazuoi, looking out over the Falzarego and synonymous rifugio. Nikon D810, 80–400mm at 80mm, ISO 100, 1/250s at f/7.1, Jun.

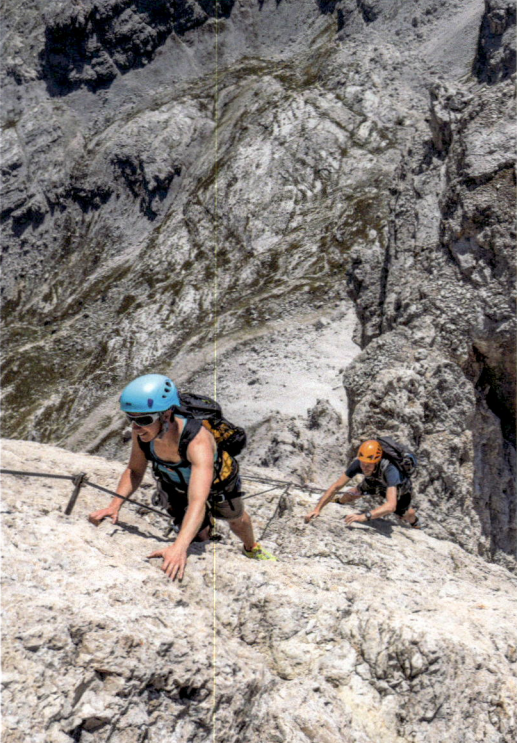

For suitably experienced climbers both Ferrata Degli Alpini and VF Tomaselli can be combined with a trip up the Lagazuoi. Nikon D810, 14–24mm at 14mm, ISO 100, 1/500s at f/8, Aug.

On a clear day the views are far reaching in all directions. Nikon D810, 80–400mm at 400mm, ISO 280, 1/400s at f/5.6, Aug.

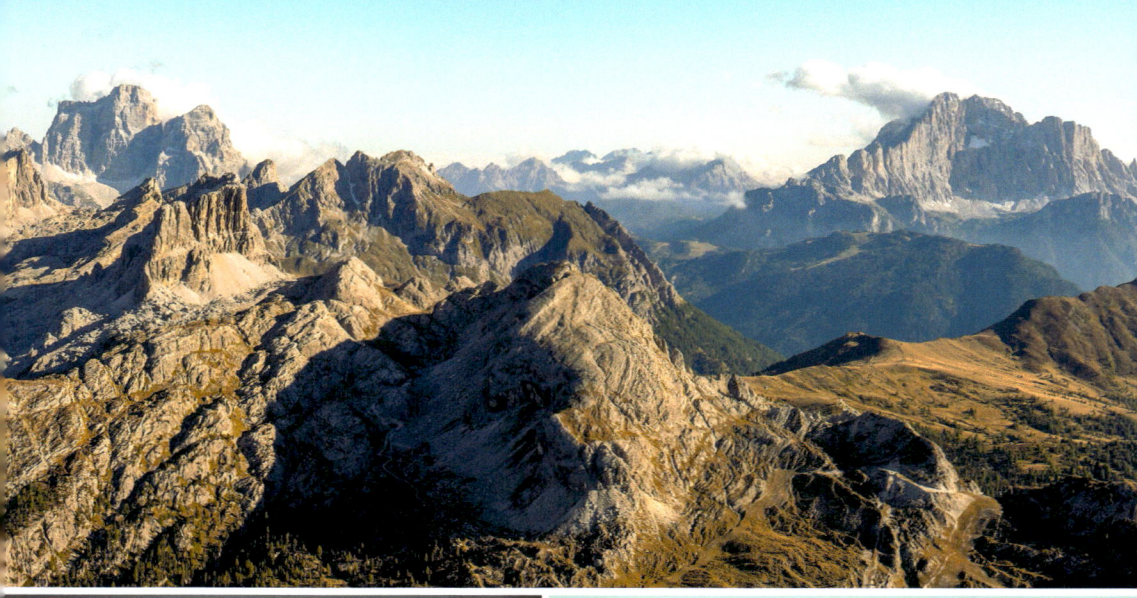

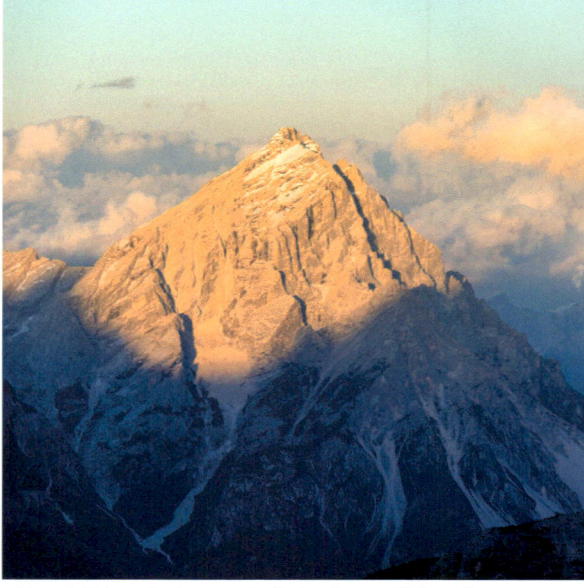

Above left: *Low clouds momentarily clear to reveal Tofana di Rozes. Nikon Z7II, 24–120mm at 50mm, ISO 64, 1/250s at f/8, Nov.* **Above right**: *Last light on Monte Antelao, the 'King of the Dolomites'. Nikon D810, 80–400mm at 210mm, ISO 100, 1/320s at f/9, Jul.*

Left: *Dramatic light looking towards the Fanes Massif. Nikon Z7II, 24–120mm at 65mm, ISO 64, 1/200s at f/8, Oct.*

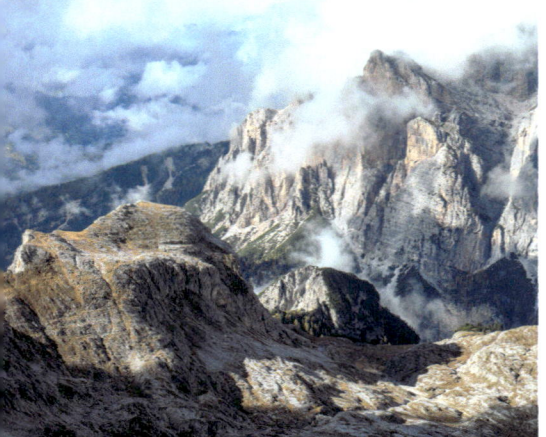

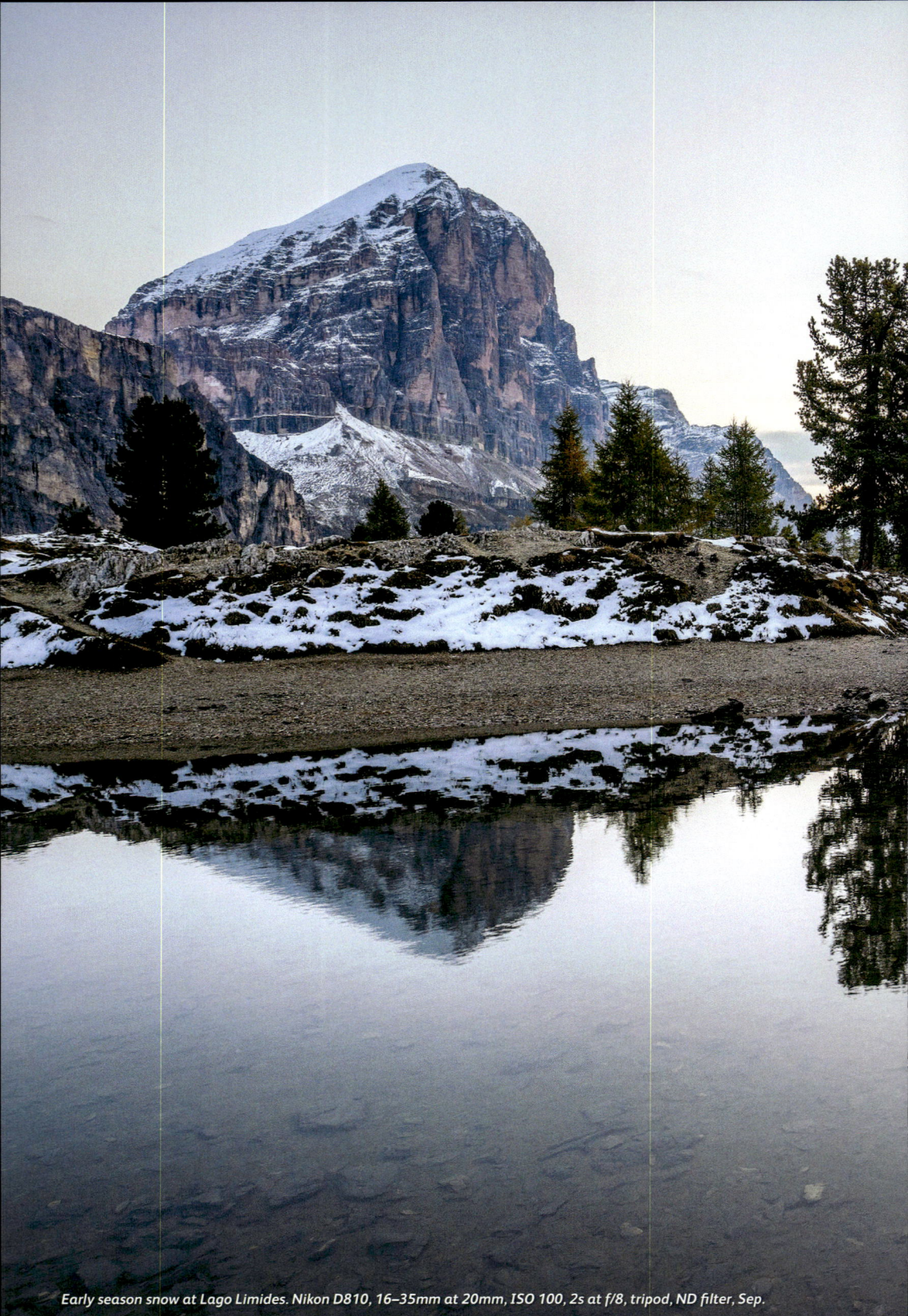
Early season snow at Lago Limides. Nikon D810, 16–35mm at 20mm, ISO 100, 2s at f/8, tripod, ND filter, Sep.

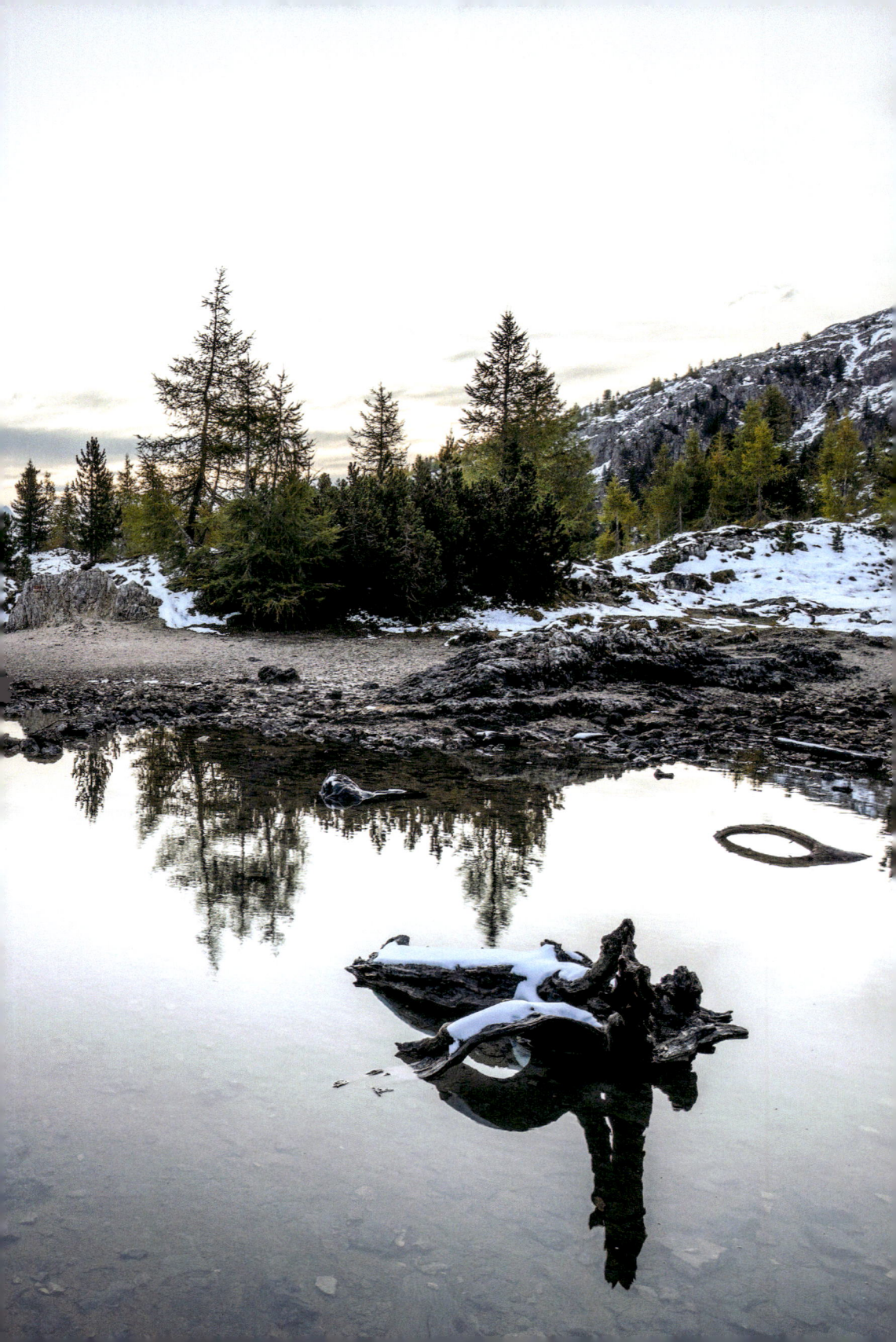

3. LAGO LIMIDES / LIMEDES

How to get here

The lake is most easily accessed from Rifugio Col Gallina, located 1km below the top of the Passo Falzarego on the Cortina (east) side. There is a small parking area adjacent to the rifugio.

It is also possible to park at the top of the pass itself and then approach via path 441 before joining onto path 419. This route actually has less ascent but is harder to navigate.

- **Lat/Long:** 46.519639, 12.019190
- **what3words:** ///detecting.moral.disqualify
- **Tabacco:** Map 03 (1:25.000)
- **Kompass:** Map 654 (1:25.000)

Accessibility

Approach: 15 minutes, 1km, 150m of ascent.

The path up to Lago Limides is rocky and ascends gently uphill the whole way.

Disabled access: The narrow and rocky approach path is not suitable for disabled access.

Best time of year/day

The lake is superbly photogenic year round with the exception of mid winter when the lake is covered in ice and snow. Water levels are highest following the spring thaw and then gradually decrease throughout the season. Be aware in recent years the lake has disappeared completely by late summer.

Lago Limides is generally best photographed in the morning before the sun hits the water's surface. During late summer and autumn the sun rises higher and daubs Tofana di Rozes in a beautiful pink hue as first light strikes the mountain.

The location is also a popular night photography venue shooting north away from the light pollution of Cortina d'Ampezzo. When viewed from the lake edge, Polaris sits directly between the Lagazuoi and Tofana di Rozes.

Tucked away atop the Passo Falzarego, despite its close proximity to the pass Lago Limides remains something of a hidden gem. Offering stunning views of Tofana di Rozes and the Lagazuoi, in the right conditions this small and remarkably tranquil lake offers some of the best viewpoints in the Dolomites.

The lake is fed by snow melt and overland relief as opposed to streams and consequently the water levels fluctuate considerably throughout the season, reaching their highest in spring and lowest in autumn.

What to shoot and viewpoints

From Rifugio Col Gallina take path 419 south, following signs towards Forcella Averau. Ascend the path for 15 minutes until the lake comes into view then scramble around the right-hand (southern) shore.

Viewpoint 1 – Tofana di Rozes

The view to the north-east towards the large shield wall of Tofana di Rozes provides the classic shot. There are several possible spots along the south bank of the lake which provide a good reflection depending on how you wish to frame the mountain. A wide-angle works well for a landscape composition while a standard zoom can be used effectively to isolate Tofana when shooting portrait. Be sure to get low to the surface of the water to make the reflection of the impressive south face as large as possible. There are often several logs and rocks protruding from the lake when the water level is low, providing additional foreground possibilities.

This composition also works well at night when the north star can be framed just left of Tofana di Rozes.

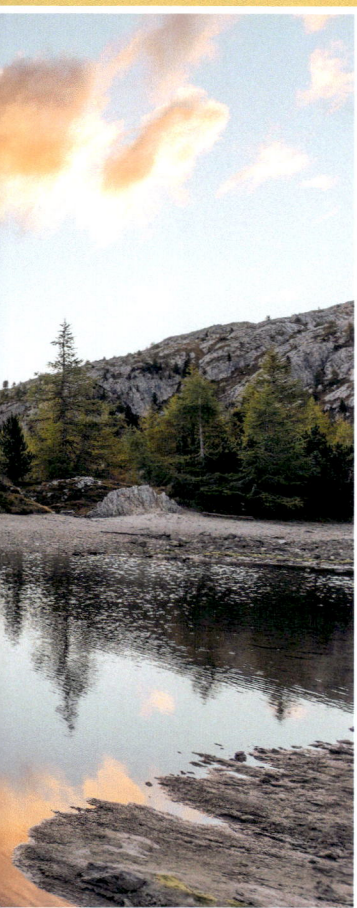

During autumn, first light illuminates the south-east face of Tofana di Rozes. Nikon D810, 16–35 at 16mm, ISO 100, 1/25s at f/8, tripod, Oct.

Viewpoint 2 – Monte Lagazuoi

On the east side of the lake there is a little spit of land jutting into the water which offers a superb view of Monte Lagazuoi and the Fanes group. There is some beautiful symmetry to be found here using both banks of the lake shore and the mountain backdrop. This is a particularly good viewpoint at sunset when the vivid red of the dusk sky is often reflected in the waters, creating a spectacular scene.

Viewpoint 3 – Lago Limides from Above

Scrambling up the southern bank for a short distance reveals an excellent top-down panorama when looking back north. Try a panoramic wide-angle including the Fanes, Lagazuoi, Tofane and Lago Limides.

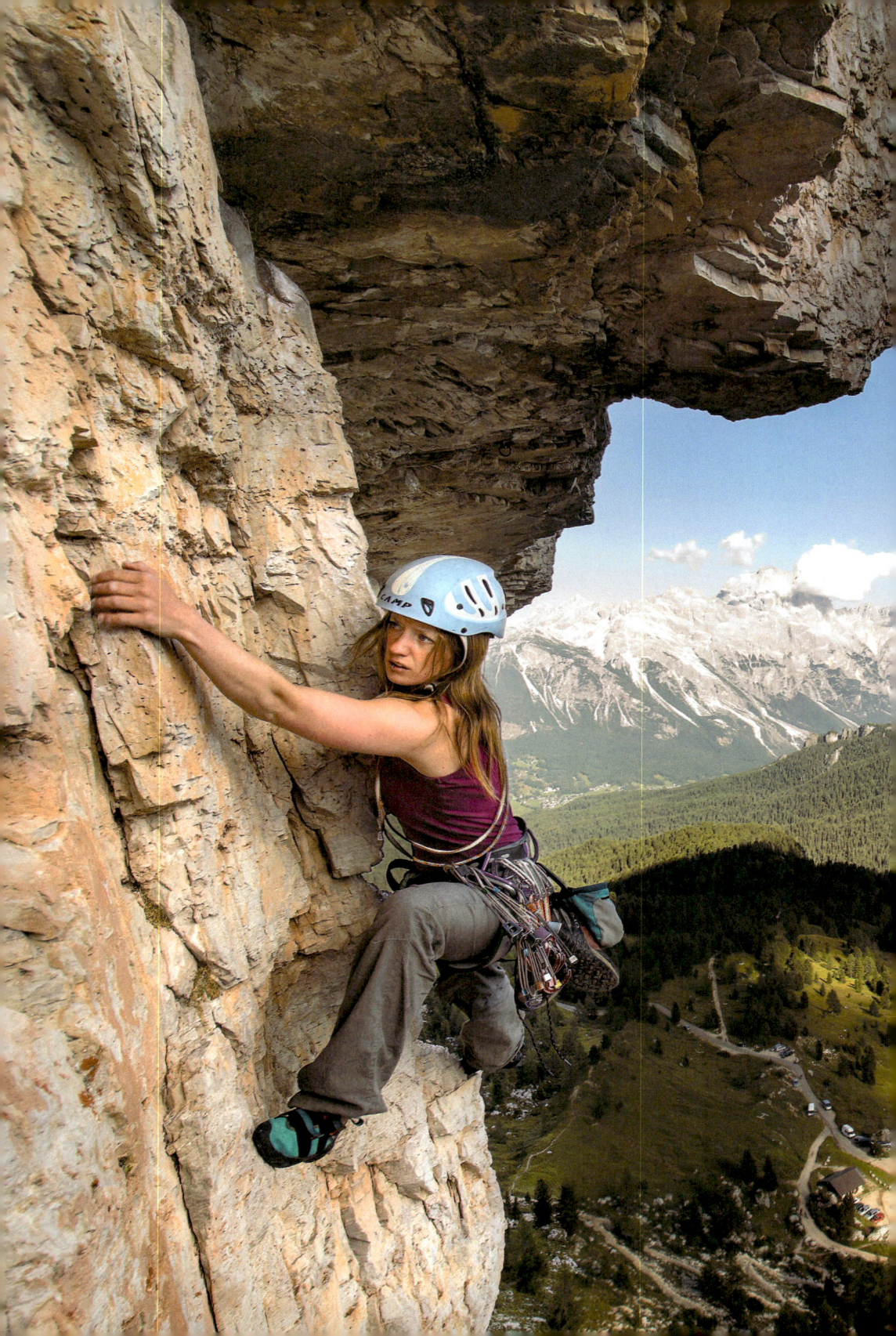

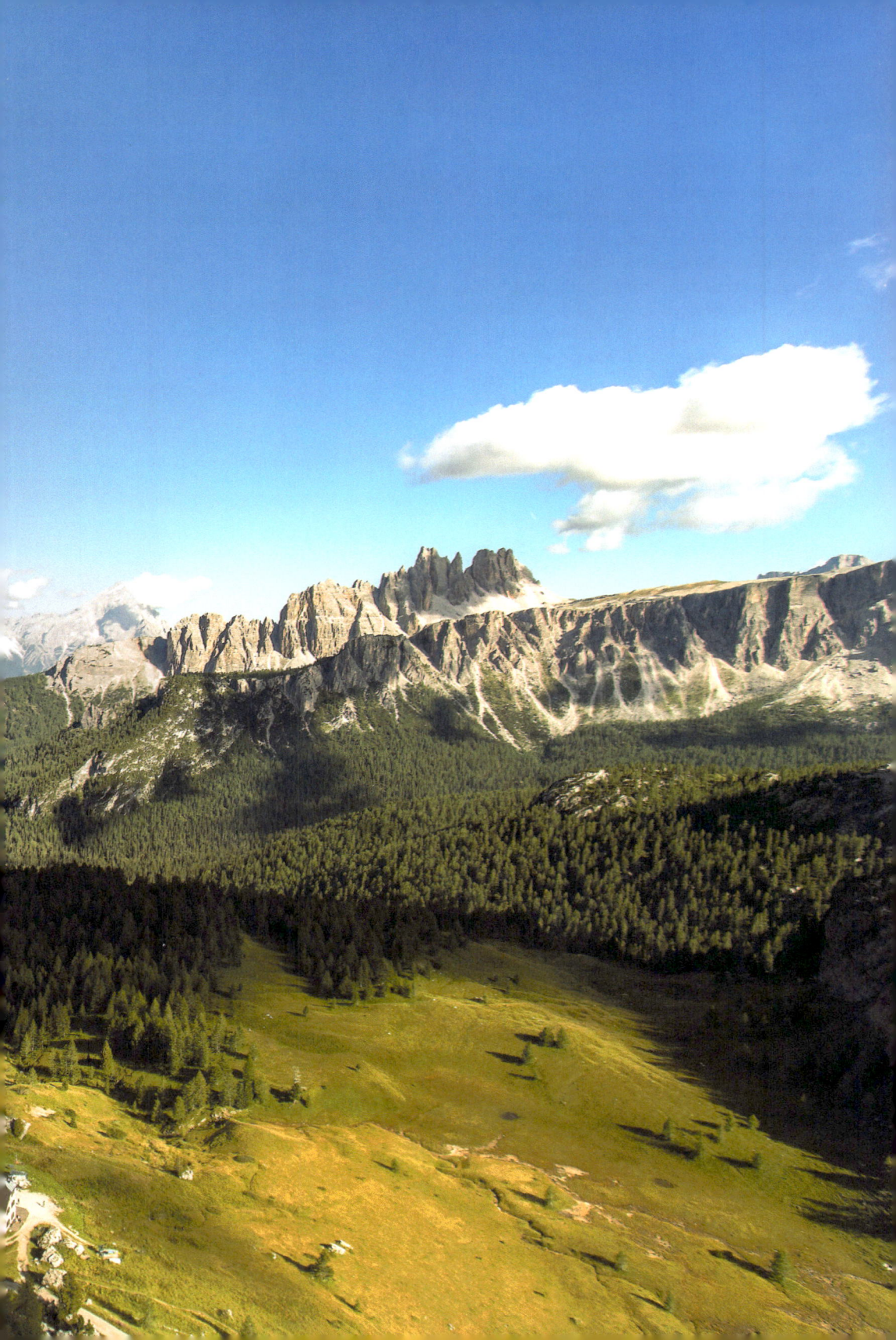

4 CINQUE TORRI

Cutting a dramatic profile above the Cortina basin overlooking the Passo Falzarego, the famous five towers of Cinque Torri are one of the most strikingly beautiful and instantly recognisable rock formations in the Dolomites. Scattered between the main spires lies a wonderful labyrinth of scree, boulders, tunnels and trenches dating back to the Great War. Such was the strategic significance of the area that today the site plays host to a superb open air museum with carefully preserved soldiers' quarters, artillery positions and lookout posts.

Exceptionally photogenic in their own right, the towers are nearly always covered in rock climbers scaling the steep faces, adding some superb drama to the already impressive scene.

Two weekends a year in midsummer, visitors can enjoy the 'Touching History' event where enthusiasts from all over the world dress in military uniform of the era and take part in a remembrance ceremony commemorating the First World War.

The towers are easily accessed via the Rifugio Bai de Dones chairlift. This makes them a deservedly popular tourist destination throughout the summer months and one which can confidently be recommended as a must-see location for any photography enthusiast.

Previous spread: Climbing 'Via Myriam' on Torre Grande at Cinque Torri. Nikon D610, 16–35mm at 16mm, ISO 100, 1/200s at f/7.1, Sep.

Opposite: When viewed from the air it becomes apparent there are considerably more than five towers. Be aware that the immediate area around Cinque Torri is a no fly zone due to the helicopter landing pad. Check www.d-flight.it for more information. DJI Mavic Pro 3, 166mm, ISO 100, 1/500s at f/4, Oct.

How to get here

The towers are situated above the Passo Falzarego and are usually approached using the Cinque Torri chairlift which departs from Rifugio Bai de Dones on the east side of the pass. From Cortina take the SS48 west for 15km, following signs for the Passo Falzarego to reach the large and well signposted chairlift car park.

Either take the chairlift up to Rifugio Scoiattoli which overlooks Cinque Torri or ascend on foot following the ski pistes beneath the lift to reach the towers in one hour.

Alternatively, before reaching the chairlift car park there is an access track which can be used to approach the towers. Turn off at a 112km milestone following signs for Rifugio Cinque Torri and drive up the track for 3km to reach the rifugio. This access track is a steep single-lane road with infrequent passing places and limited parking at the top, so an early start is essential. Please note that this track is closed between 9:30 and 15:30 throughout peak season, on weekends and during national holidays.

Cinque Torri Chairlift

Lat/Long:	46.51897, 12.03792	
what3words:	///boulders.ants.proactively	
Tabacco:	Map 03 (1:25.000)	
Kompass:	Map 654 (1:25.000)	

Rifugio Cinque Torri (Driving Approach)

Lat/Long:	46.508629, 12.056709	
what3words:	///cautionary.boxed.roamed	
Tabacco:	Map 03 (1:25.000)	
Kompass:	Map 654 (1:25.000)	

Accessibility

Approach: Chairlift access.

While the majority of the paths are large and well surfaced, path 425 that leads around the south side of the towers is rocky and uneven.

Disabled access: For disabled users who are unable to use a chairlift, the easiest approach is via the access road leading to Rifugio Cinque Torri. It is then possible to take the gravel road west to Rifugio Scoiattoli, although this can be hard work in a wheelchair.

Best time of year/day

The Cinque Torri chairlift runs from early June until late September and provides the most convenient access.

The towers are arguably at their most spectacular from mid June until the end of July when the majority of the alpine flowers are in bloom. The site also looks beautiful after fresh snowfall during the winter months but requires snowshoes or skis to navigate the towers.

Due to the many different and ever-changing vantage points, the towers are exceptionally photogenic from sunrise to sunset. A stay in Rifugio Scoiattoli is recommended to view the site at either end of the day when the lift system is closed.

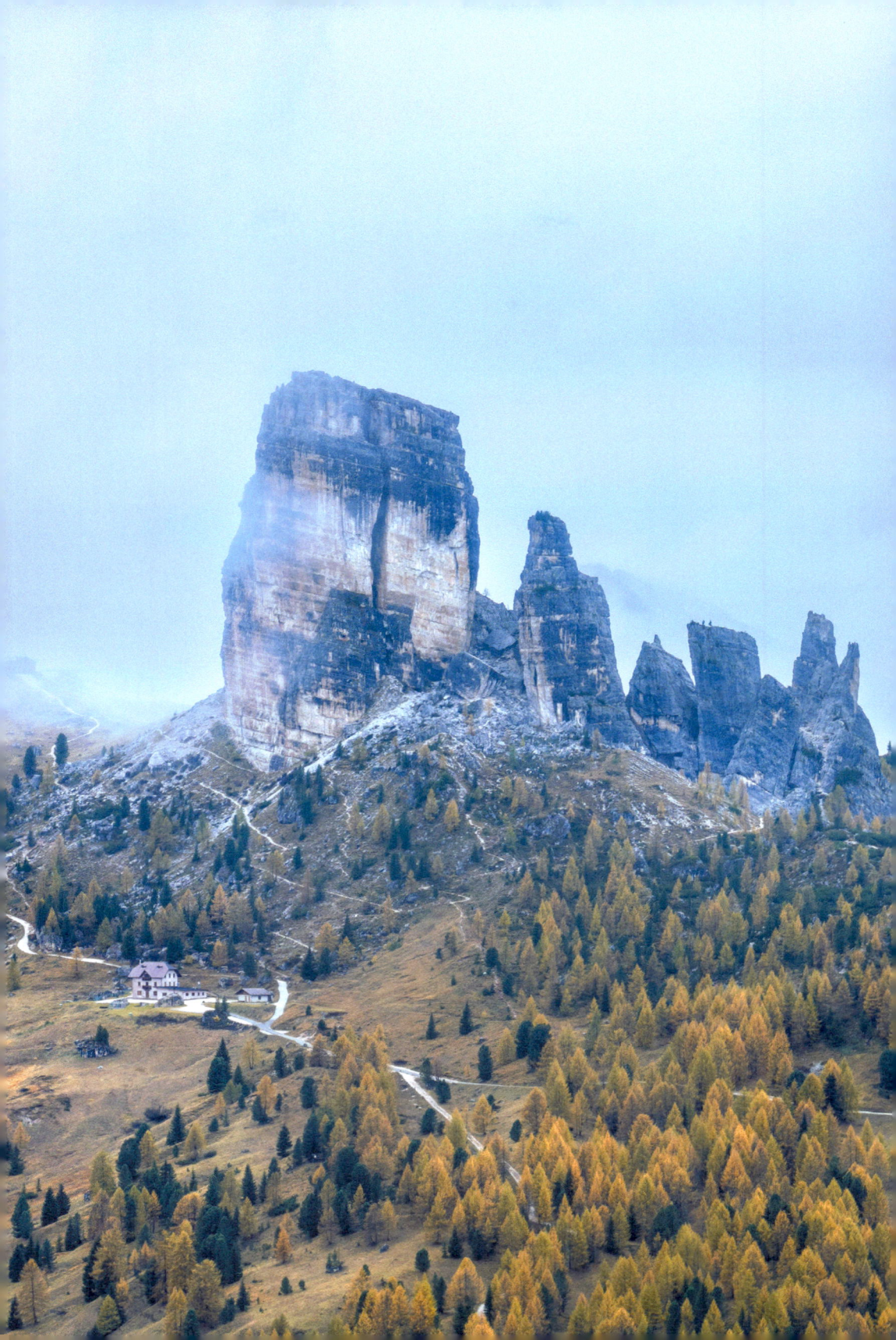

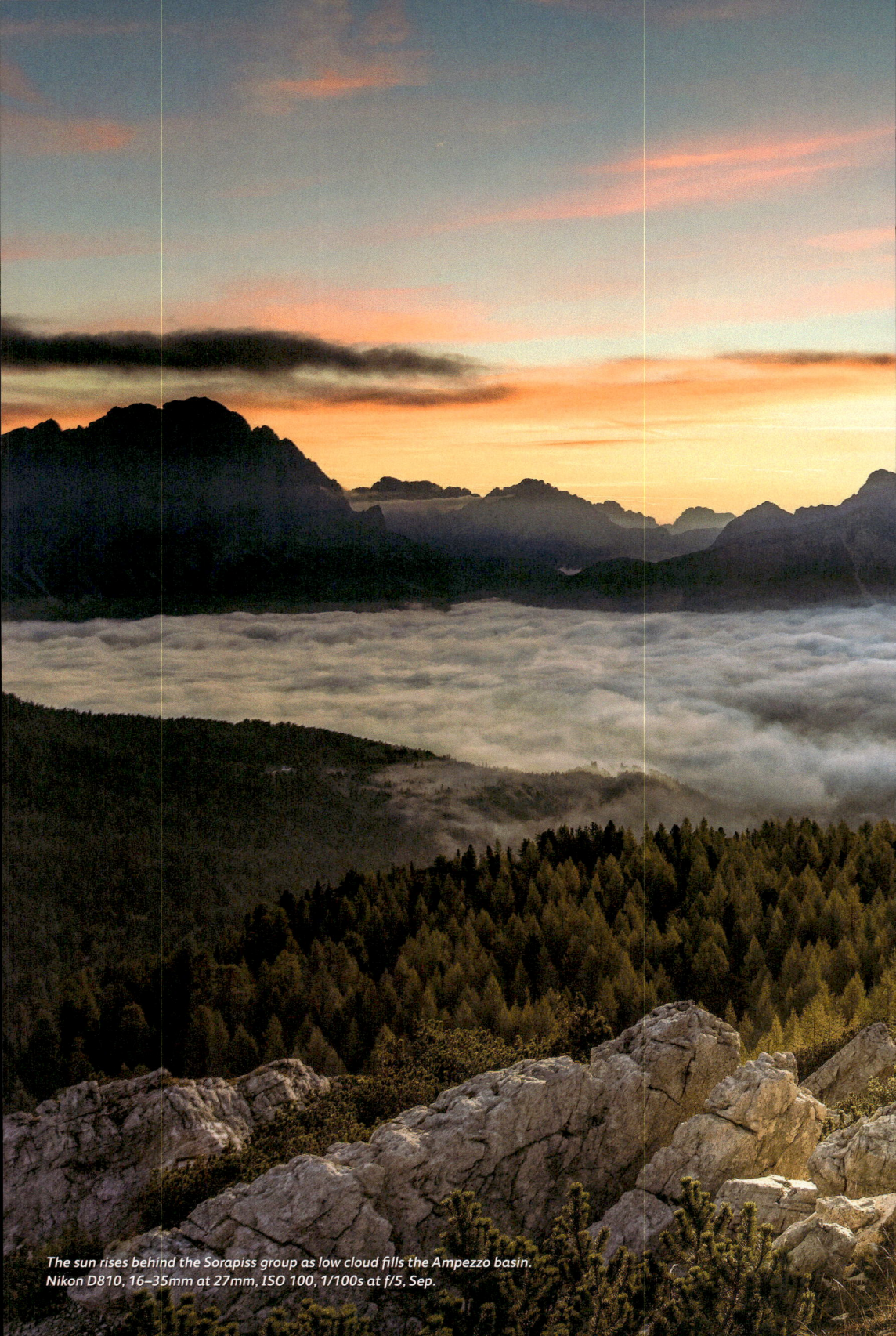

The sun rises behind the Sorapiss group as low cloud fills the Ampezzo basin. Nikon D810, 16–35mm at 27mm, ISO 100, 1/100s at f/5, Sep.

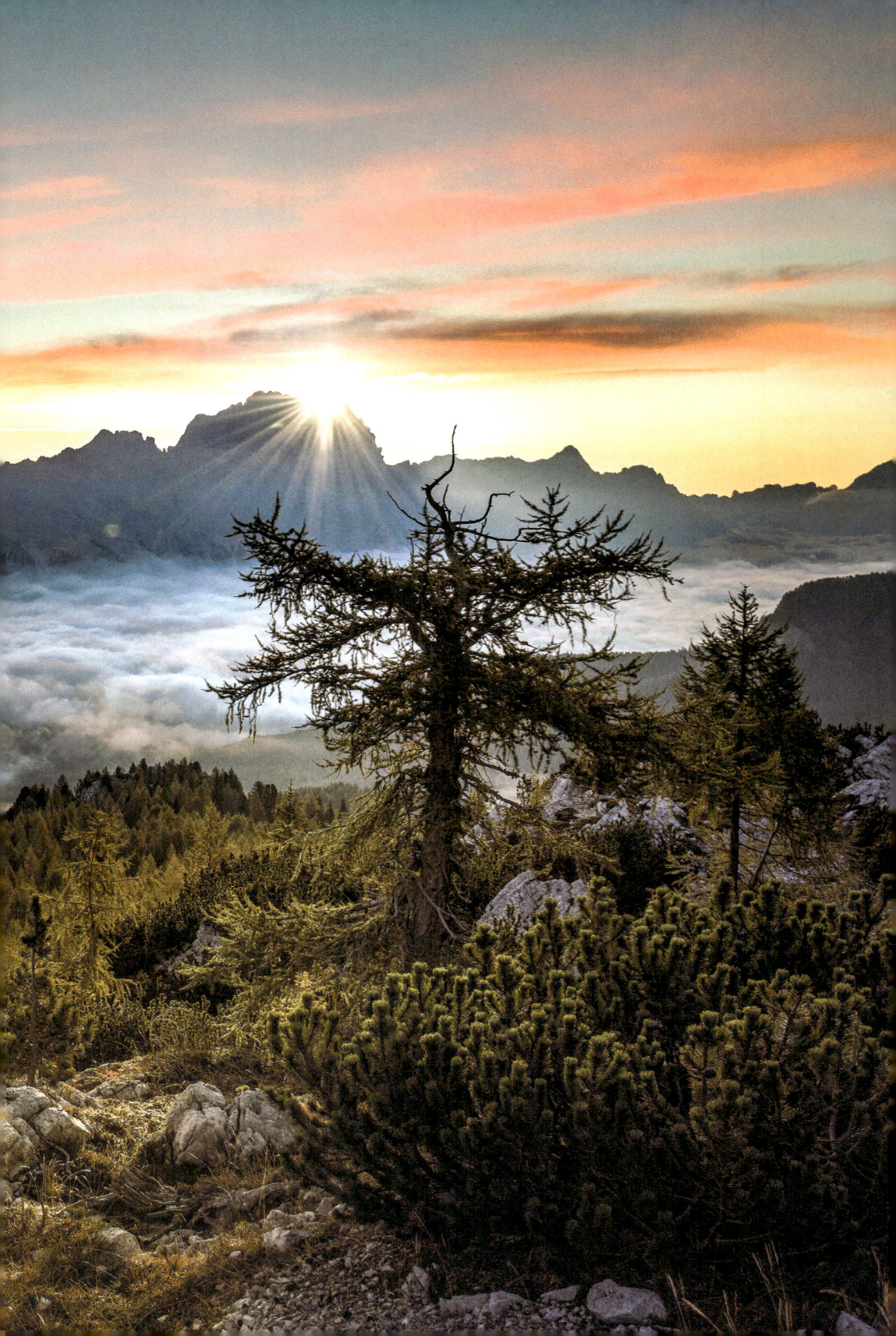

4 CINQUE TORRI

What to shoot and viewpoints

The following viewpoints are described making a clockwise circuit of the five towers, starting and finishing at Rifugio Scoiattoli at the top of the Rifugio Bai de Dones chairlift.

Viewpoint 1 – Towers from Rifugio Scoiattoli

Rifugio Scoiattoli provides the classic viewpoint looking north-east, with the towers arrayed neatly from north to south. In the morning you can often position the sun between the towers to create some striking sunstars if you're willing to ditch the tripod (just be careful not to look through an optical viewfinder; instead use live view). Sunbursts generally look best at smaller apertures, although the number of points you get is entirely dependant on what lens you are using.

By afternoon the sun has moved sufficiently to illuminate the west faces, allowing for some interesting light play particularly once the clouds have formed. If the clouds are thick or low near the towers, a long exposure made possible with the aid of a neutral density filter can create a surreal image as the clouds swirl between the towers.

In June and July the large clumps of Alpenrose provide an easily accessible foreground. Stop the lens down or use a focus blend in conjunction with a tripod to get as much of the scene in focus as possible. Alternatively, a shallow depth of field focusing on the foreground flowers or towers can also prove effective.

Finally throughout midsummer the sun sets directly on the west faces, turning them a fantastic deep red that contrasts beautifully with the shadowed surroundings.

Opposite top left: Last light on Croda da Lago. Nikon Z7II, 24–120mm at 60mm, ISO 200, 1/80s at f/8, Oct. **Top right**: The classic shot of Cinque Torri. Nikon D610, 16–35mm at 16mm, ISO 100, 1/200s at f/10, Jul. **Bottom left**: Marmots are a common sight at Cinque Torri. Nikon D810, 80–400mm at 300mm, ISO 200, 1/320s at f/5.6. Jul. **Bottom right**: The towers as seen from the eastern side. Nikon D850, 14–24mm at 14mm, ISO 100, 1/40s at f/8, tripod, Oct.

Cinque Torri early morning panorama. Nikon D810, 16–35mm at 16mm, ISO 100, 1/320 sec at f/10, Jun.

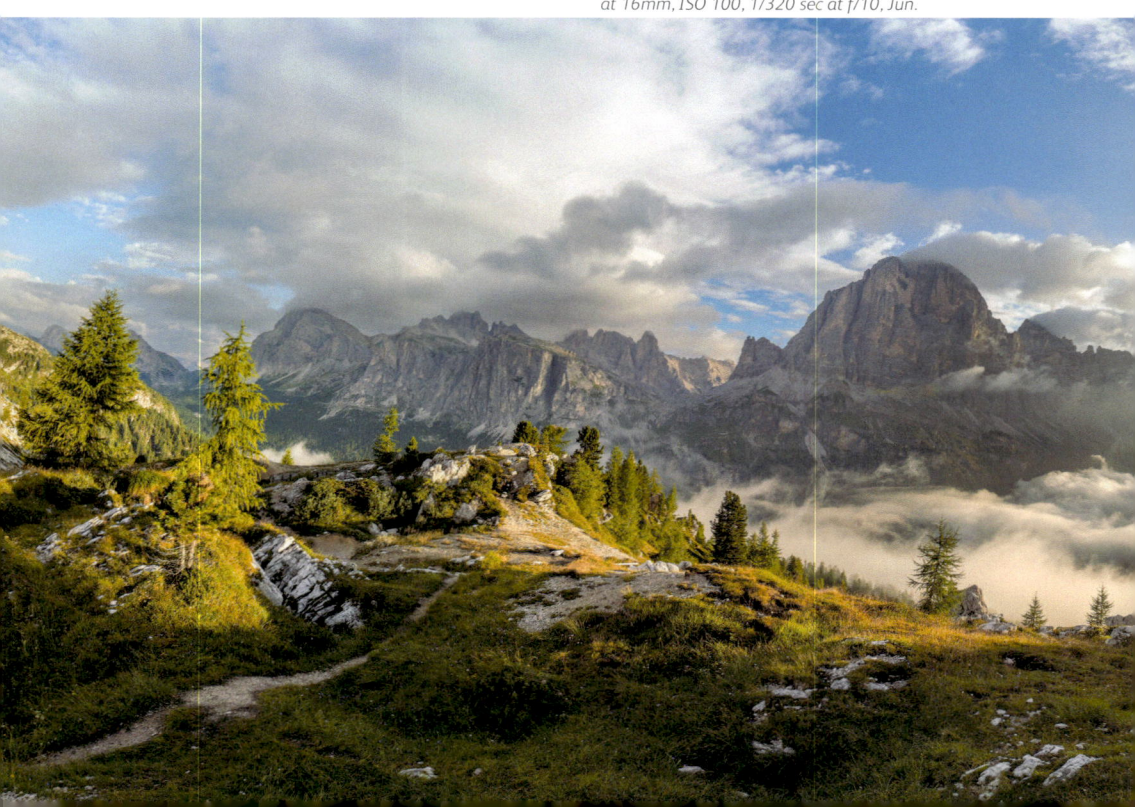

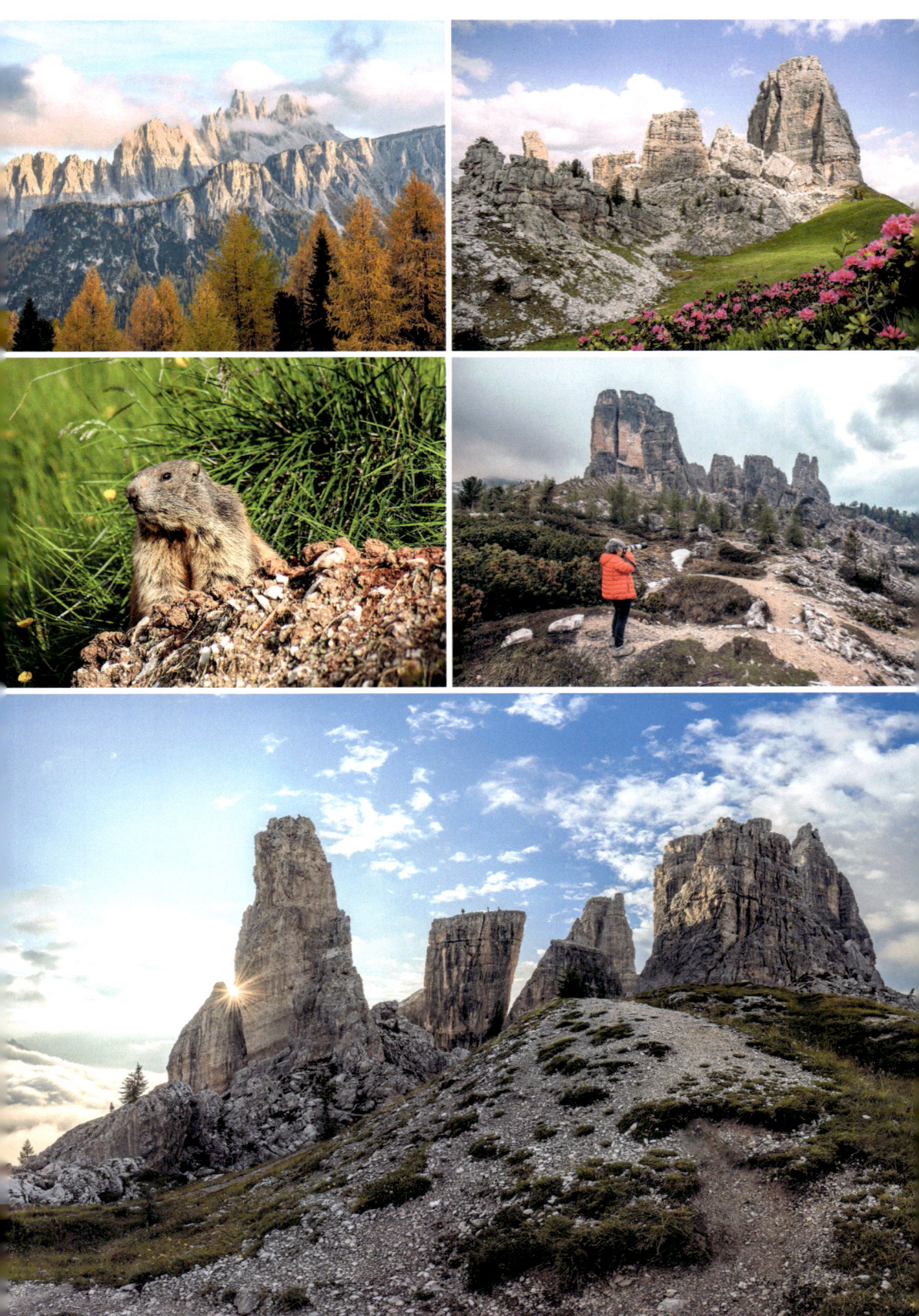

A sequence of different focal lengths capturing the moon above Antelao. **Above**: Nikon Z Nikon Z7II, 100–400mm at 190mm, ISO 100, 1/200s at f/5.6, Sep. **Below**: Nikon D850, 70–200mm at 200mm, ISO 100, 1/250s at f/5.6, Oct.

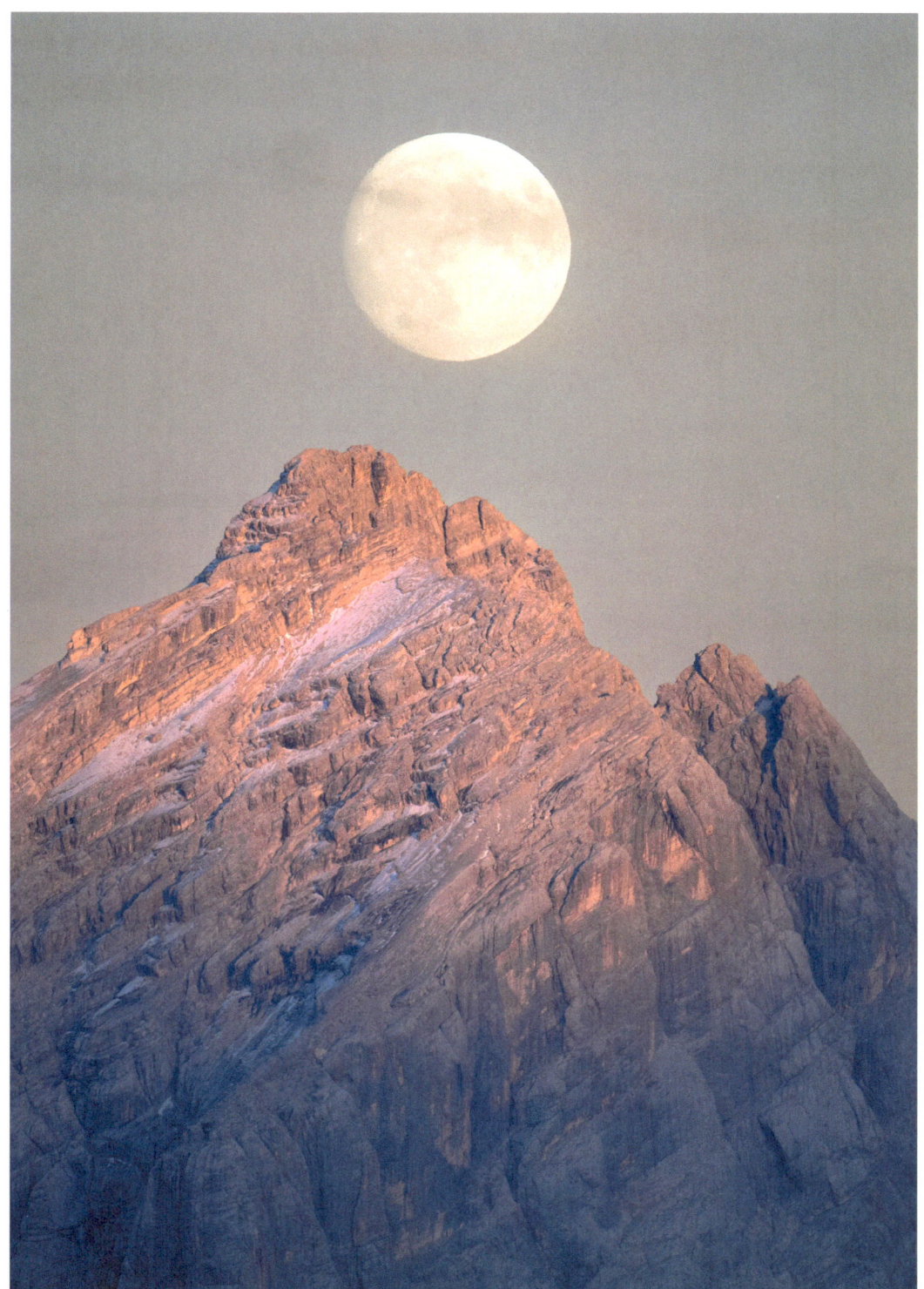
A close crop of Antelao, the second highest peak in the Dolomites. Nikon Z7II, 100–400mm at 400mm, ISO 250, 1/400s at f/5.6, Sep.

4 CINQUE TORRI

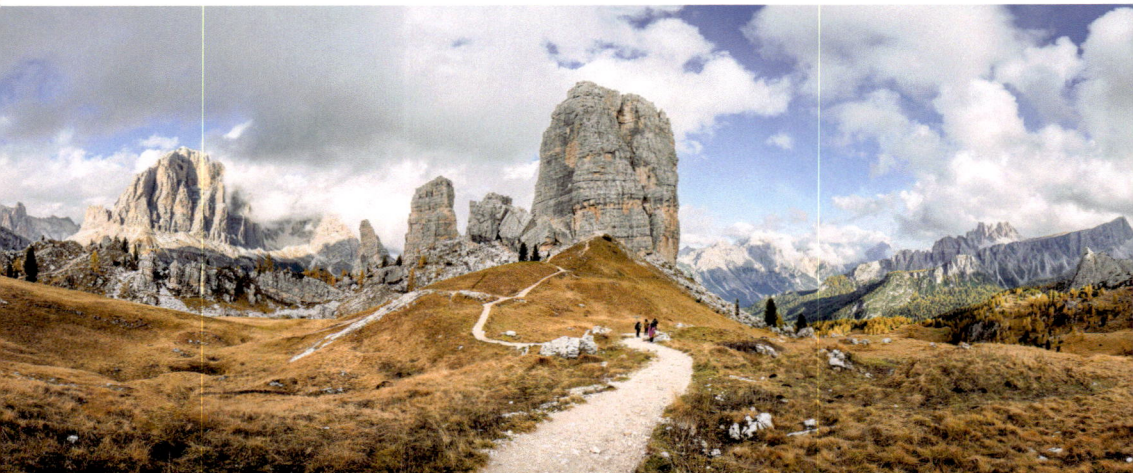

An 8 image panorama of the west side of Cinque Torri. Nikon Z7II, 24–120mm at 24mm, ISO 64, 1/200s at f/8, Oct.

Viewpoint 2 – Open Air Museum
Follow the main path north-east from the rifugio to quickly reach a ridgeline riddled with trenches and buildings. These are a testament to the Great War and are accompanied by a number of information boards and reconstructed artillery positions. Here photographic opportunities abound, particularly on a bad weather day when the dark sky adds to the sombre mood of the trenches.

During the 'Touching History' events this area comes alive with soldiers and field medics wearing traditional uniform, again creating some very unique photo opportunities. The actors are always keen to pose so don't be afraid to approach them and enlist their services in front of a good backdrop.

Viewpoint 3 – Tofana di Rozes & Passo Falzarego
Following path 425 west around the southern side of the towers yields great views north over the Passo Falzarego and in particular the large shield wall of Tofana di Rozes. Here there are a number of tree stumps, gnarled roots and boulders that can create some excellent wide-angle foregrounds, especially during the alpine flower season. In the afternoon cloud often builds on the summit of Tofana di Rozes, giving a real sense of scale to this majestic peak. The scene also works well as a large panorama, starting with Sass di Stria to the north-west before encapsulating the Lagazuoi, Col dei Bos and finally Tofana di Rozes.

Viewpoint 4 – Torre Grande from the East
Continue following path 425 round to the east side of the towers until you reach the end of the trenches. Here be careful not to follow the main path any further as it begins to descend steeply; instead, cut to the right and circumnavigate Torre Grande (the largest tower) until reaching its east side near a large boulder (Sasso Cubico), just above and north of Rifugio Cinque Torri.

Though not as classically famous as its west side, the east of Cinque Torri still provides a superb and much quieter vantage point from which to appreciate the towers. There are several good boulders lying a short distance away that make good viewpoints or foregrounds as desired. The close proximity and height of Torre Grande necessitates the use of a wide-angle lens if you don't wish to resort to stitching.

For early risers this is a particularly good sunrise location when the pale east face glows a deep red as the sun rises behind the nearby Cortina d'Ampezzo.

It is also not uncommon to find climbers scaling the classic route of the east face, 'Via Finlandia', in the morning. The second pitch climbs the distinctive open book corner and is very photogenic from the ground if the climbers are kind enough to wear bright colours.

Above: The 'Touching History' events take place during August. Nikon D810, 28–300mm at 300mm, ISO 100, 1/400s at f/8, Aug.
Below: Traditional military uniform of the Great War. Nikon D810, 28–300mm at 300mm, ISO 100, 1/320s at f/9, Aug.

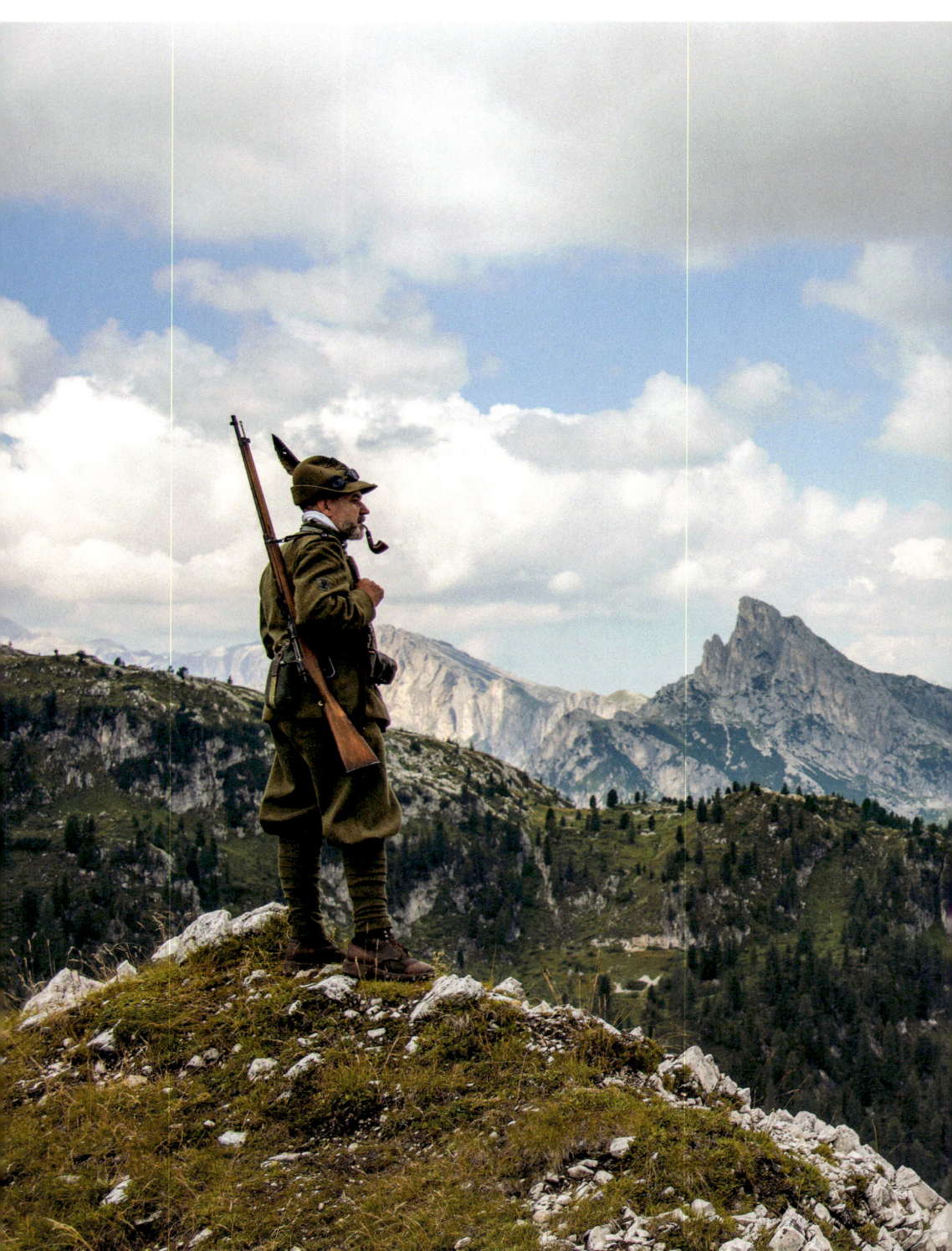
A soldier stands guard over the Passo Falzarego. Nikon D810, 28–300mm at 45mm, ISO 100, 1/320s at f/9, Aug.

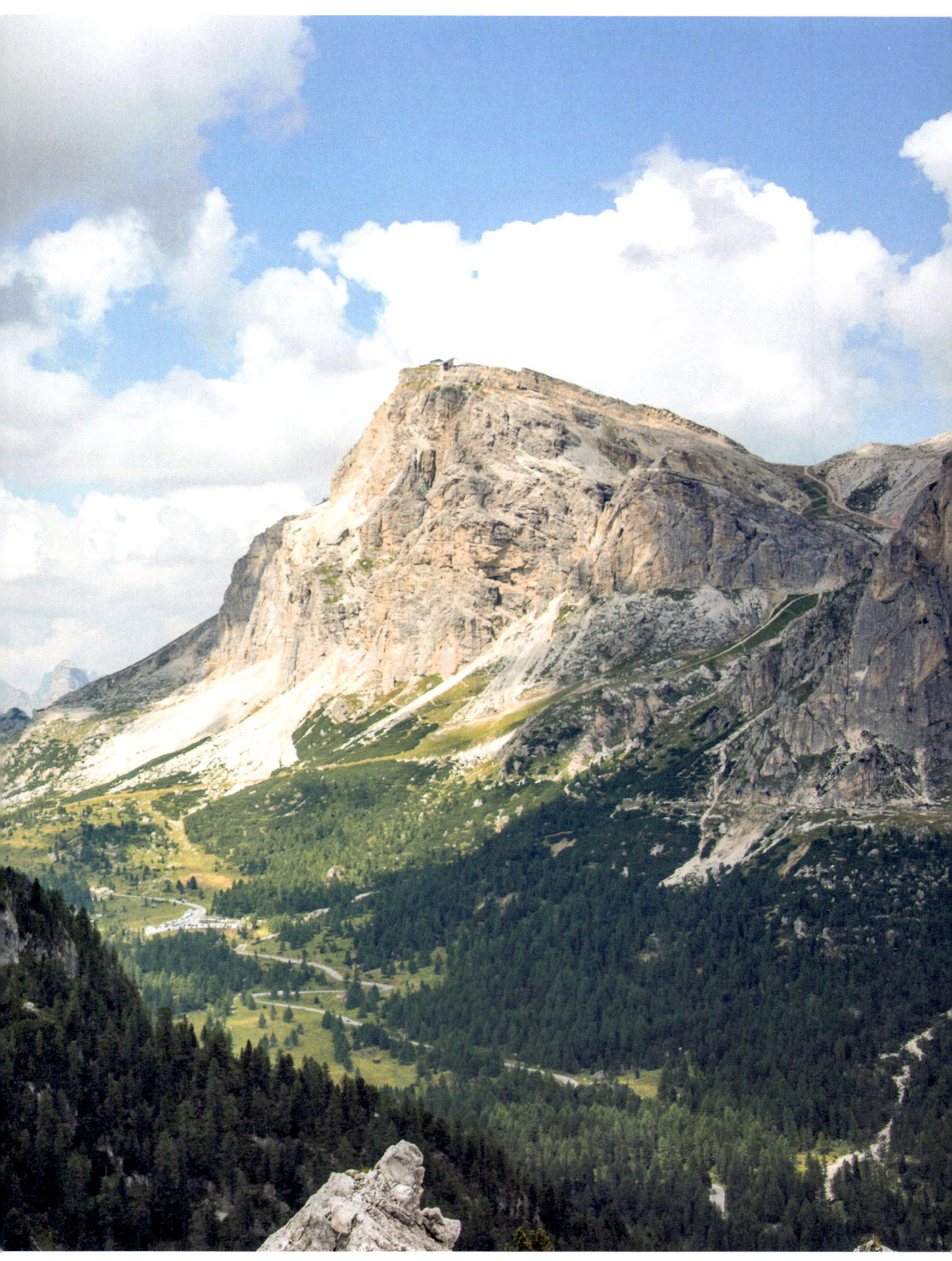

4 CINQUE TORRI

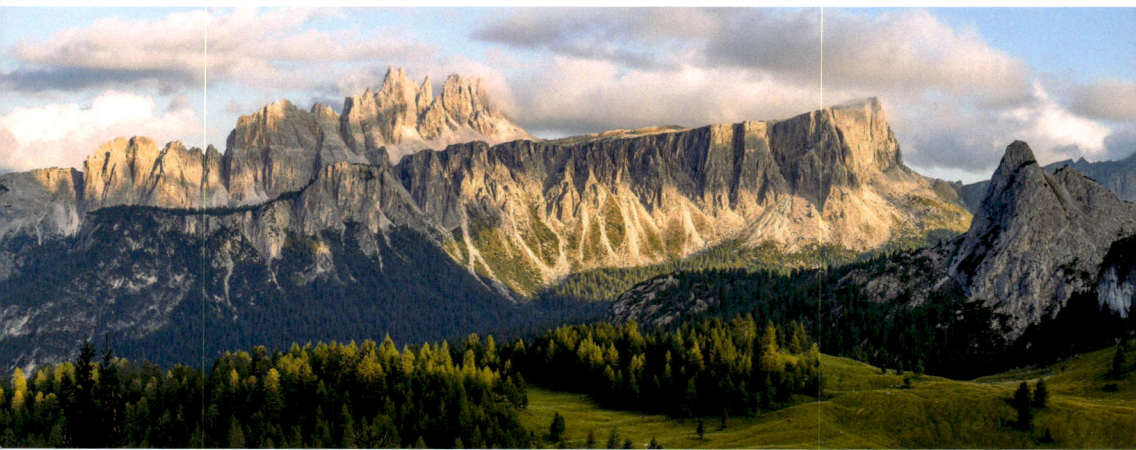

Lastoni di Formin and Croda da Lago. Nikon Z7II, 24–120mm at 30mm, ISO 64, 1/160s at f/8, Aug.

From the east side follow a climbers path down to Rifugio Cinque Torri and join path 439 which leads back up to Rifugio Scoiattoli and the top of the chairlift.

Viewpoint 5 – Rock Climbers

Cinque Torri is an exceptionally popular climbing venue throughout the summer months, when the towers are alive with the echoes of climbing calls and the distinctive jingle of mountain hardware. While there are hundreds of possible rock routes, the most popular and photogenic ones from the ground are located on the south side of Torre Grande as you complete the circuit back to Rifugio Scoiattoli. The aspect of the face ensures the climbers are well lit for the best part of the day, allowing them to picked out against the stunning backdrop.

With a large zoom you can either isolate the climber or, with a side-on view, frame them against the impressive triangular silhouette of Antelao. Try to wait until the climber is in a dynamic position with a single high hand or foot to create a pleasing shape; continuous shooting can really help here. If the climber is well lit and wearing bright clothing, it is possible to use a standard zoom or wide-angle lens to capture the Sorapiss Group and more outlying scenery in the shot as well.

If you do manage to get a good photo of a climber, they will almost certainly appreciate an offer to send the photo to them once they're firmly back on the ground.

Viewpoint 6 – Croda da Lago

Finally, look to the east from the grassy shoulder leading back to Rifugio Scoiattoli for superb views of the quintessentially Dolomitic ridge lines of Croda da Lago and Lastoni di Formin. Another classic view of the Dolomites, the jagged spires of the towers contrast perfectly with the green alpine meadows in the foreground. The view is excellent at any time of the day and makes for an excellent panorama shot with a standard zoom.

*Opposite top left: Climbing 'Ha Chiamato Kubista' on Sasso Cubico. Nikon D610, 14–24mm at 17mm, ISO 100, 1/200s at f/11, tripod, Aug. **Middle left**: Spectacular evening light on Croda da Lago. Nikon Z7II, 100–400mm at 100mm, ISO 64, 1/160s at f/8, Jul. **Right**: Climbers starting up the initial corner of 'Via Finlandia' on the east face of Torre Grande. Nikon D610, 24–70mm at 70mm, ISO 100, 1/200s at f/7.1, Aug. **Bottom**: The distinctive ridgeline of Croda da Lago. Canon G12, 18mm, ISO 80, 1/500s at f/4, Jul.*

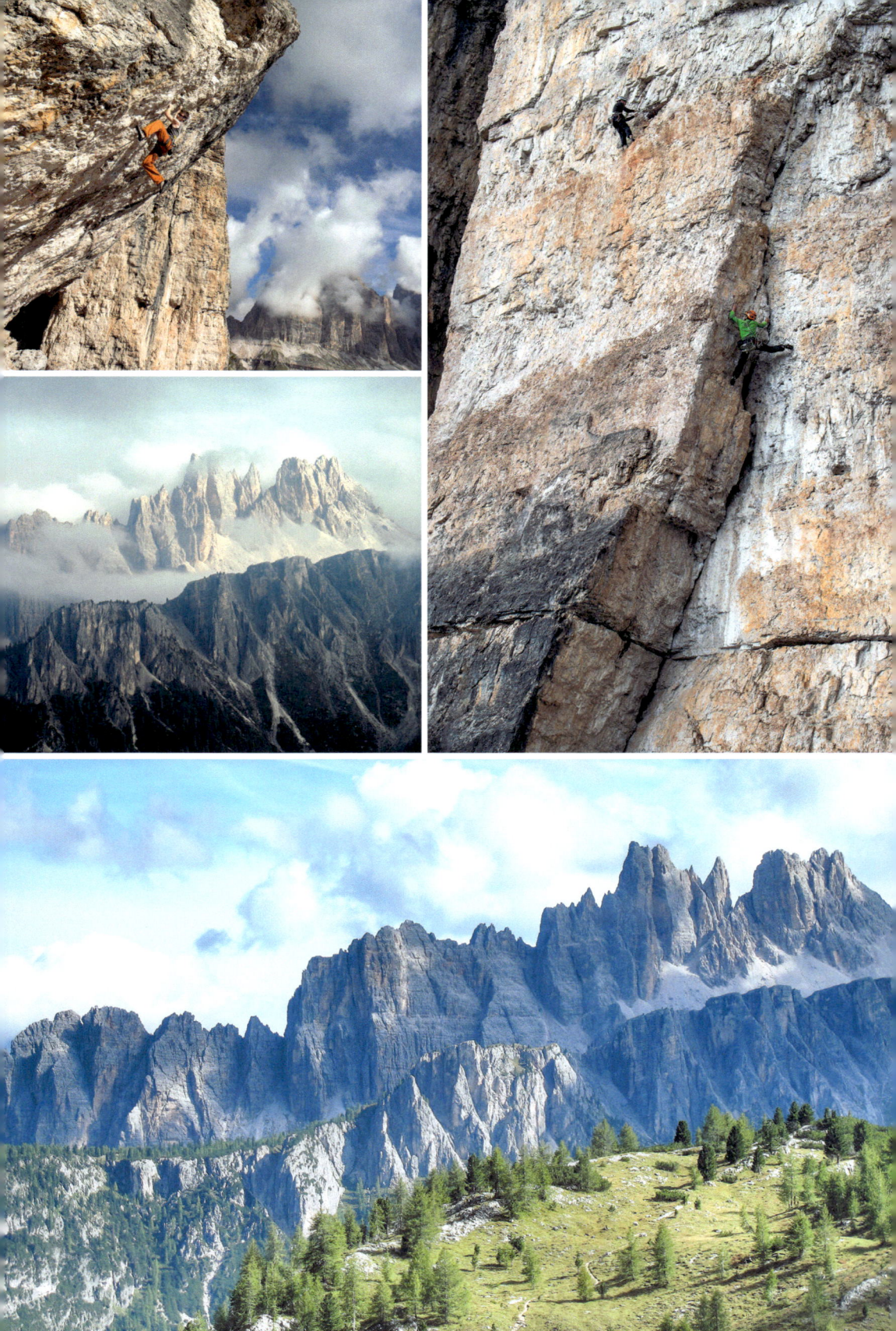

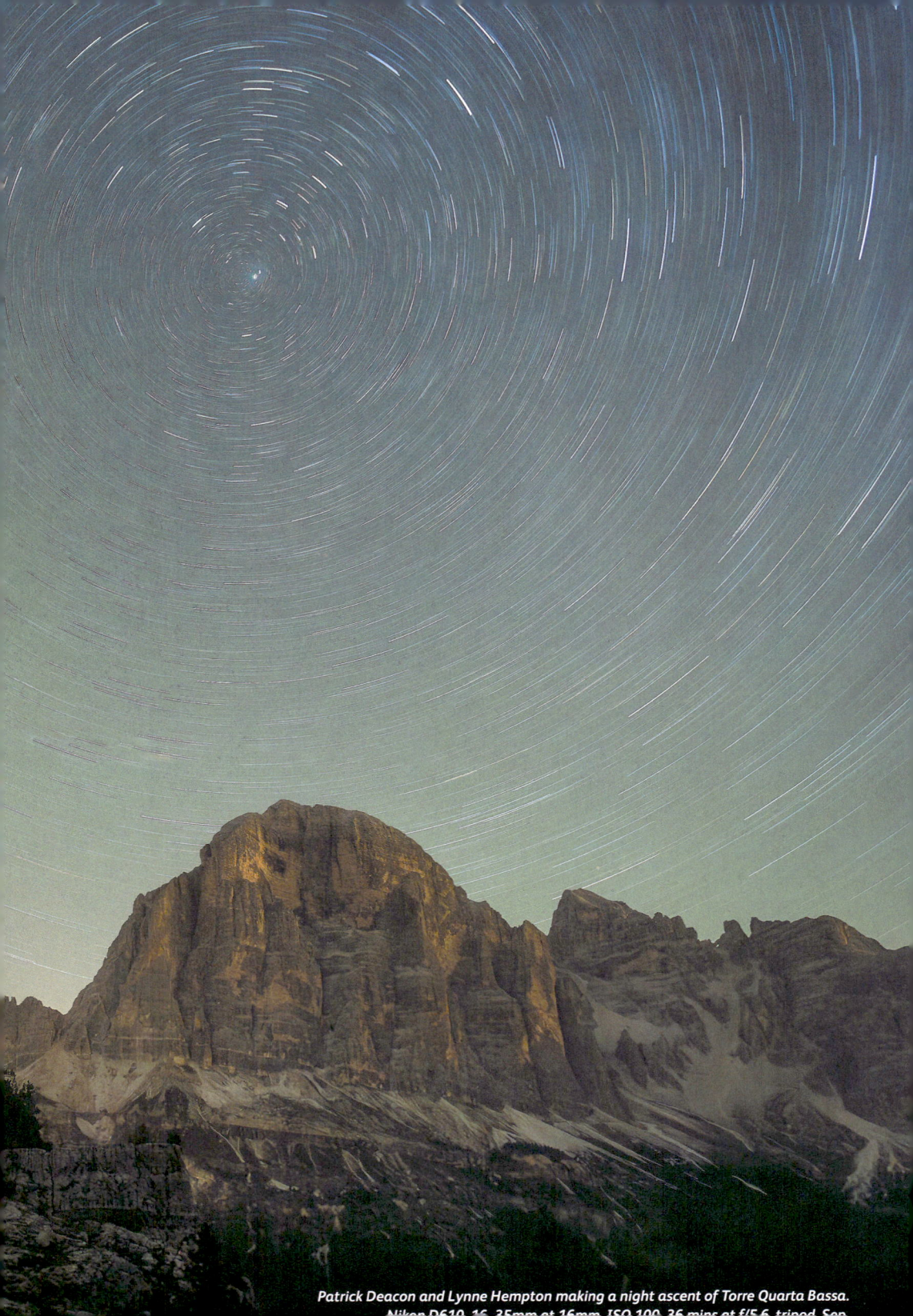

*Patrick Deacon and Lynne Hempton making a night ascent of Torre Quarta Bassa.
Nikon D610, 16–35mm at 16mm, ISO 100, 36 mins at f/5.6, tripod, Sep*

SENTIERO ASTALDI

Sentiero Astaldi is a protected path that traverses the lower slopes of Punta Anna under the imposing profiles of Tofana di Rozes (3225m) and Tofana di Mezzo (3244m), two of the Dolomites' highest peaks. The route is famous for its intriguing geology, displaying some striking bedding planes which are exceptionally vibrant in direct sunlight.

The route takes two hours to complete and confidence on uneven terrain is essential. Via ferrata equipment is recommended for security along the more exposed passages and a helmet is advised due to the loose nature of the rock.

What to shoot and viewpoints

From Rifugio Dibona take path 403 west, signposted towards Rifugio Giussani. Keep following the 403 for roughly 20 minutes until you see a smaller path branching off on the right underneath the rock face above. Follow this for 5 minutes to reach the start of the cable underneath the main face.

Viewpoint 1 – Bedding Planes
Just before the cable begins, a rocky shoulder provides a superb vantage point from which to view the route and the fascinating rock morphology. Consider using the alpine flowers or scattered rocks as a foreground with the rock bands framed behind with a wide-angle. Another possibility is to use a telephoto lens to get in close to the striations, looking to isolate the abstract patterns.

Viewpoint 2 – Sentiero Astaldi
The path is well defined with intermittent sections of cable protecting the more exposed sections. As you progress along the route there are many excellent opportunities for action photos of other walkers traversing the narrow path as it weaves between the multicoloured rocks. The view over to Antelao and the town of Cortina below provides a perfect backdrop, but don't forget to turn around occasionally as the route is very photogenic in both directions. If the subject is moving, remember to use a fast enough shutter speed so as to freeze the motion; blurred hands and feet are rarely pleasing to the eye. As you move along the route keep an eye out for devil's claw (Physoplexis comosa), a unique and exceptionally photogenic flower that grows in cracks and crevices in the rock face itself.

Viewpoint 3 – Descent
After you finish traversing underneath the rock face, continue beyond a section of cable to reach an obvious path junction. Here, turn right and descend path 421 signposted to 'Rifugio Dibona' to return to the car park in 20 minutes. The descent allows you to admire a different perspective on the rock bands above, which can then be picked out with a long lens.

Opposite: Admiring the view east towards Cortina d'Ampezzo and the Sorapiss group from the end of the route. Nikon D810, 16–35mm at 35mm, ISO 100, 1/500s at f/9, Jun.

Looking over Sentiero Astaldi from the start of the route. Nikon D810, 16–35mm at 16mm, ISO 100, 1/80s at f/20, Jul.

An abstract using the wonderful lines of the bedding planes. Nikon D810, 80–400mm at 300mm, ISO 100, 1/400s at f/10.

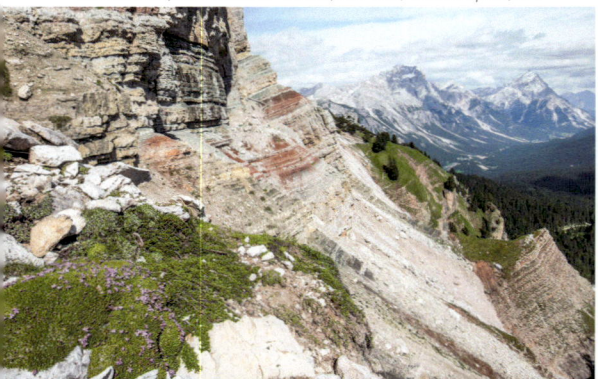

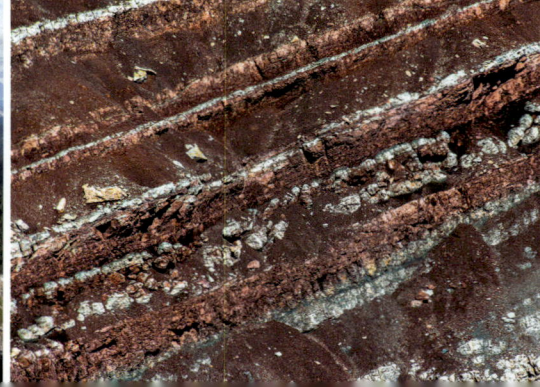

How to get here

The route starts from Rifugio Dibona which can be accessed via a steep access track leading up from the Passo Falzarego road.

From Cortina d'Ampezzo, take the SS48 west following signs for Passo Falzarego. Continue through Pocol, ignoring the turn off for the Passo Giau (SP638), then 3km after the village make a right turn under a wooden height barrier (sometimes absent during low season) signed Parco delle Dolomiti d'Ampezzo. Follow the road to a fork and turn left; the road surface then deteriorates as it ascends to reach a large car park next to Rifugio Dibona.

Lat/Long:	46.5327, 12.07033	
what3words:	///spelling.mellow.cuckoos	
Tabacco:	Map 03 (1:25.000)	
Kompass:	Map 654 (1:25.000)	

Accessibility

Approach: 30 minutes, 2km, 200m of ascent.

The circuit of Sentiero Astaldi should not be underestimated as it requires confidence on loose terrain with considerable exposure. If in doubt, take via ferrata equipment to help protect the cabled sections.

 Disabled access: The route is a protected path with scrambling sections and is not suitable for disabled access.

Best time of year/day

Due to the vertiginous nature of the route, the path needs to be clear from snow and as such is an ideal summer venue. The cliff face has a south-easterly aspect and, given that the vibrant rock colours are most aesthetic in direct sunlight, the location is best shot during the morning and early afternoon.

PASSO FALZAREGO – SENTIERO ASTALDI

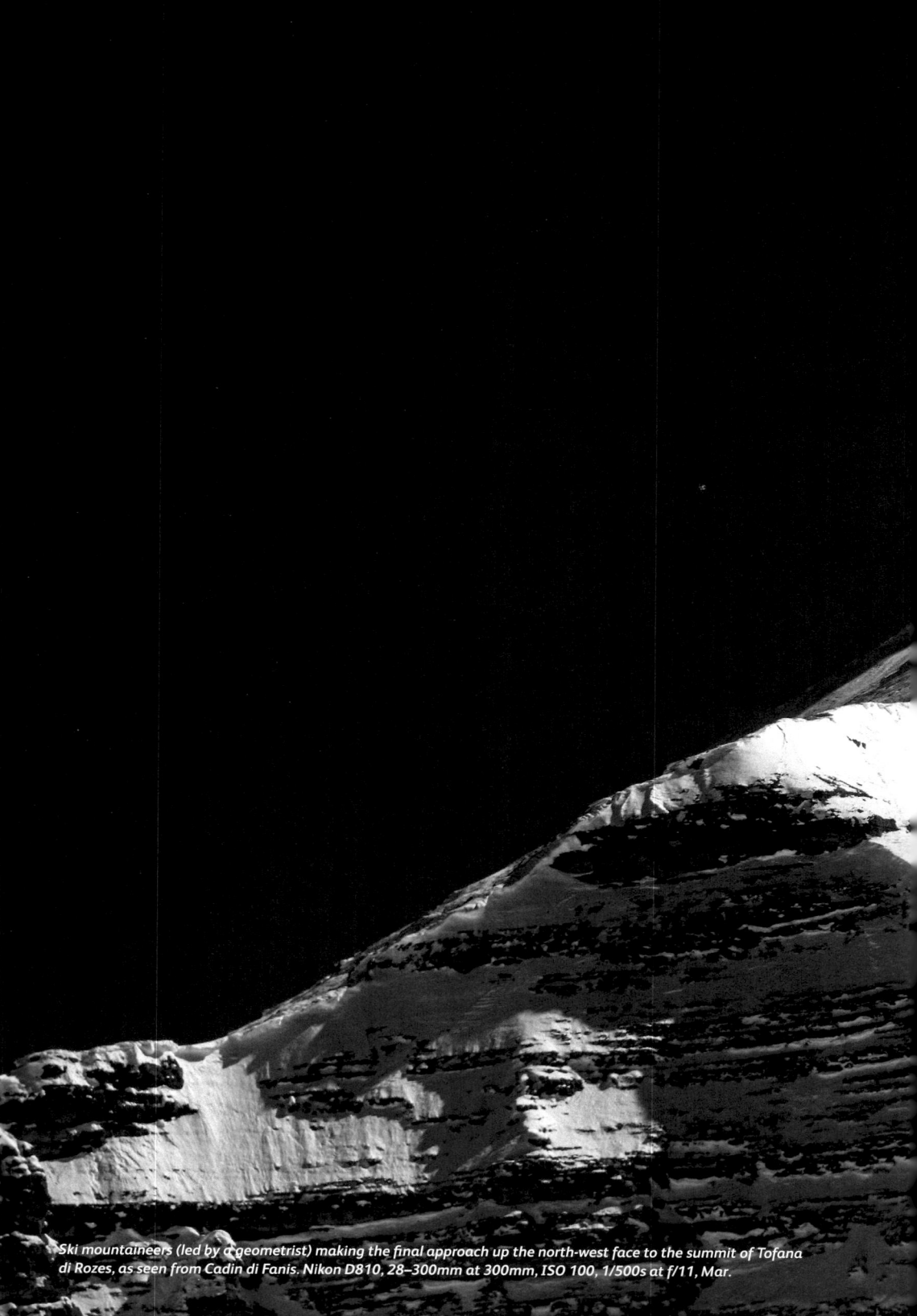

Ski mountaineers (led by a geometrist) making the final approach up the north-west face to the summit of Tofana di Rozes, as seen from Cadin di Fanis. Nikon D810, 28–300mm at 300mm, ISO 100, 1/500s at f/11, Mar.

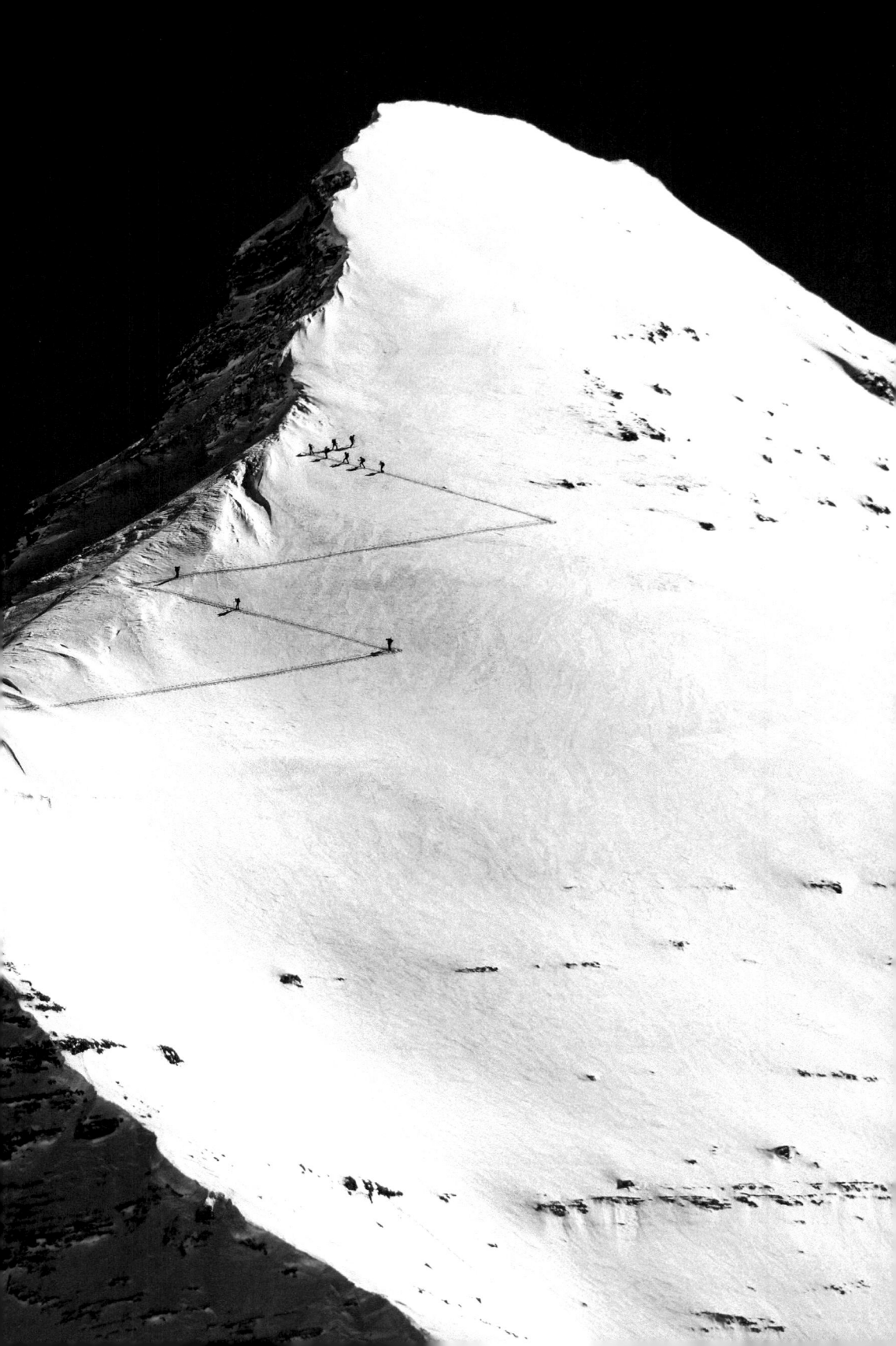

CORTINA D'AMPEZZO & PASSO TRE CROCI

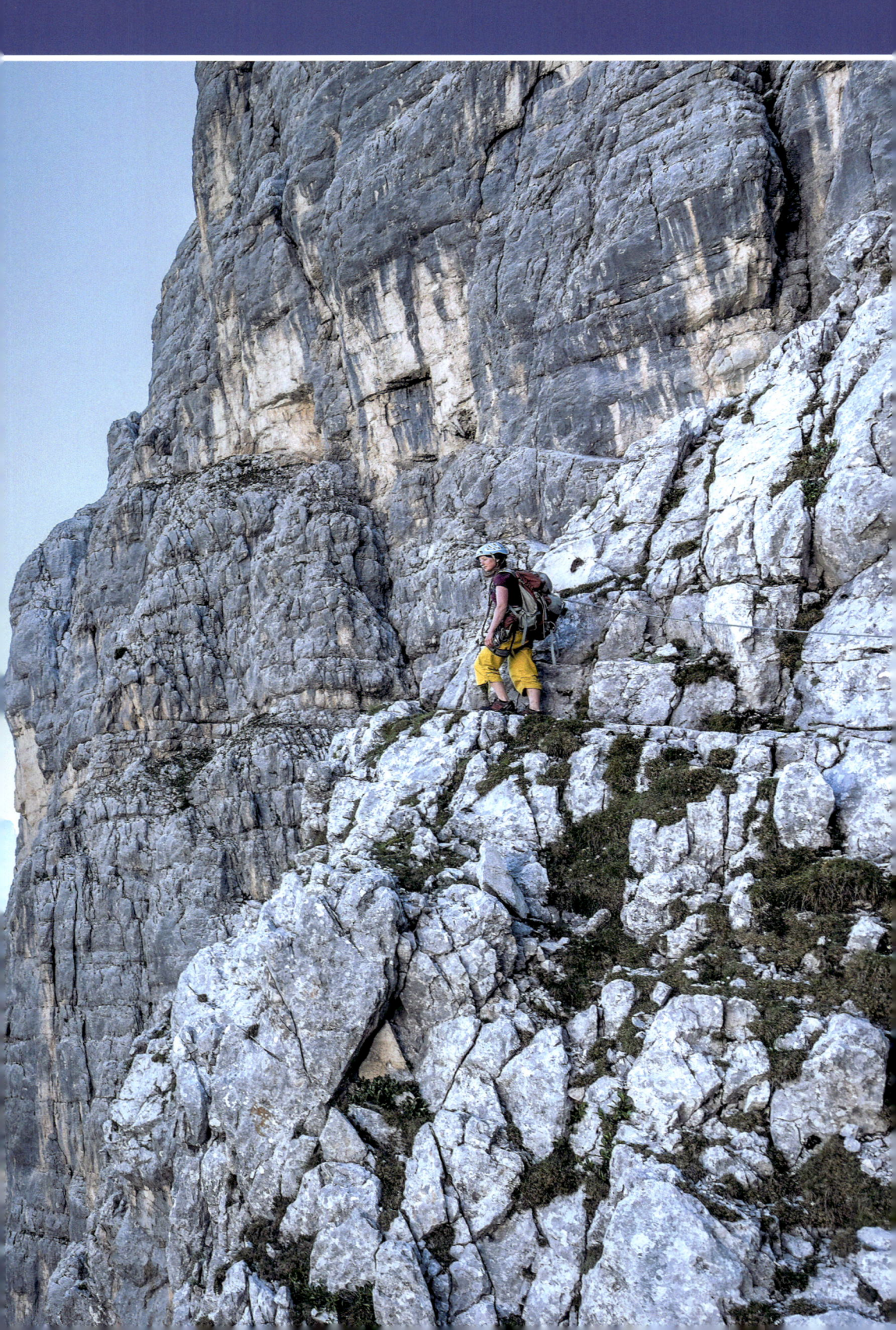

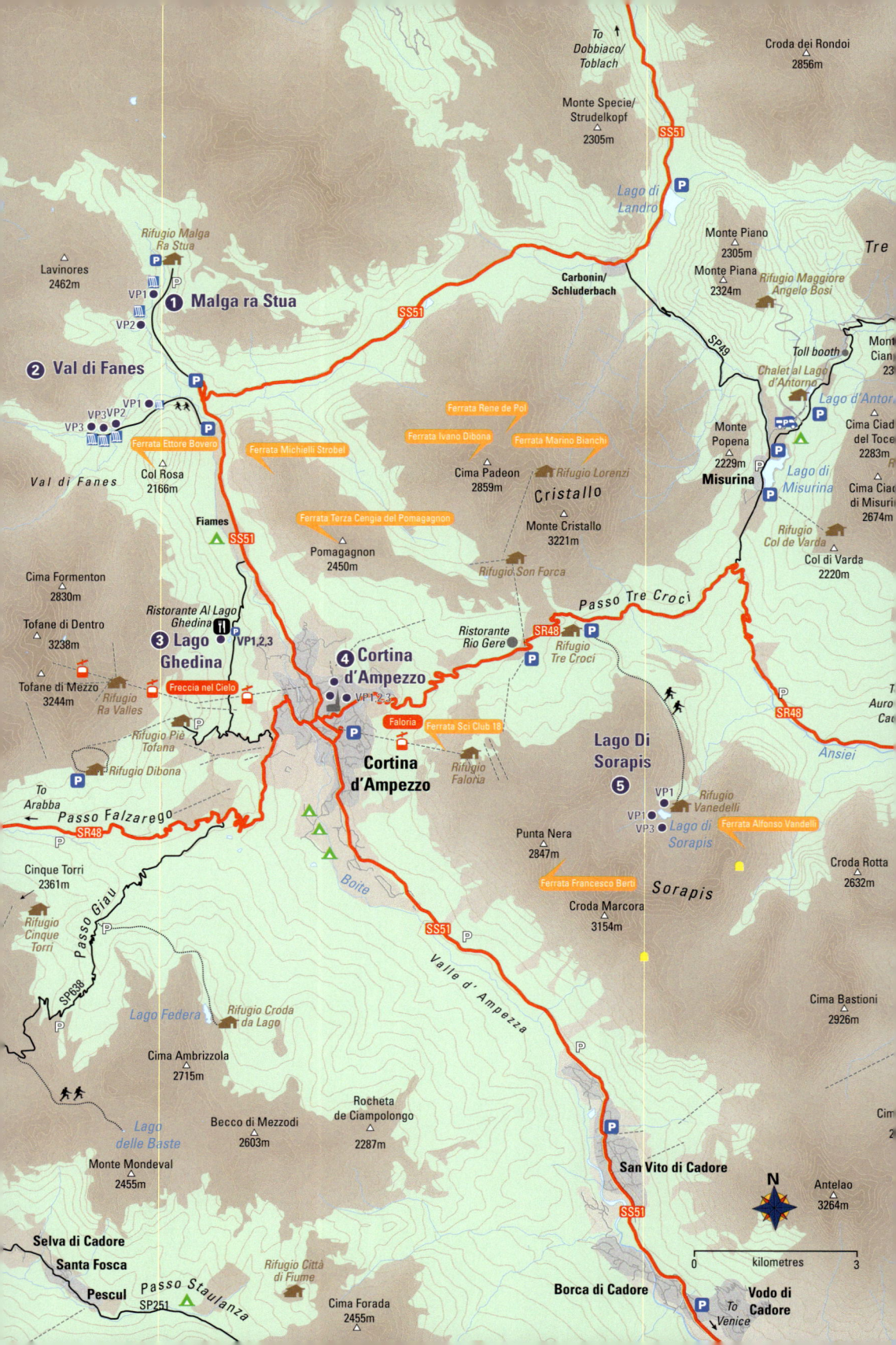

CORTINA D'AMPEZZO & PASSO TRE CROCI – INTRODUCTION

Boasting a proud legacy of accolades such as host city for the 1956 Winter Olympics, the namesake of a certain popular Ford (the two of which entered into an unlikely marriage in a sport called 'Auto-bobbing' – well worth a Google), favourite haunt of celebrities such as George Clooney, the setting of the Bond film 'For Your Eyes Only' and temporary home of writer Ernest Hemingway, Cortina d'Ampezzo is the most high profile town in the Dolomites.

While the 'glitzy' nature of the town often divides opinion, Cortina is undoubtedly superbly situated in some of the best scenery the Dolomites has to offer. Located directly in the centre of the Ampezzo Valley at the head of the Valle del Boite, the town lies nestled under Antelao (3262m), the so-called 'King of the Dolomites' and second highest peak in the region, and Tofana di Mezzo (3244m), the third highest.

To the north lies the Parco delle Dolomiti d'Ampezzo, an intricate network of peaks, valleys, streams and forest covering some 37,000 hectares of alpine wilderness.

Of particular interest are the beautiful gorges found at the bottom of the Fanes valley and just below Malga ra Stua. The crystal clear streams that flow down from Rufiédo, Felizon and Boite before entering into the narrow canyons make for some spectacular photo opportunities, particularly if the weather is bad elsewhere in the park.

The Passo Tre Croci departs from the eastern edge of Cortina and provides the most logical driving route towards Misurina and the world famous Tre Cime. It is however exceptionally photogenic in its own right, as well as providing the departure point for the long approach to Lago di Sorapis. This turquoise lake, fed by glacial melt water and guarded by the bastion of Punta Sorapiss along with the melodramatically named 'Dito di Dio' (Finger of God), is one of the most spectacular in the Dolomites.

LOCATIONS

1	Malga ra Stua – Torrente Boite	354
2	Val di Fanes	362
3	Lago Ghedina	368
4	Cortina d'Ampezzo	374
5	Lago di Sorapis	378

Maps

- Tabacco (Italian): Map 03
- Kompass (German): Map 654

Previous spread: *On the initial ascent of Via Ferrata Alfonso Vandelli. Nikon D810, 14–24 at 14mm, ISO 100, 1/500s at f/4.5, Aug.*

MALGA RA STUA – TORRENTE BOITE

Just to the south of the beautifully situated Malga ra Stua farmhouse, the Torrente Boîte is funnelled into a narrow but accessible gorge in the heart of the Parco delle Dolomiti d'Ampezzo. This easily approachable location provides excellent mountain stream perspectives and can be particularly recommended as a wet weather venue if the clouds are down in the rest of the park.

What to shoot and viewpoints

The first waterfall is opposite the lay-by parking, recessed into the back of a cave, and is easy to miss if you are not looking for it.

Viewpoint 1 – Souto de Ra Stua Waterfalls & Torrente Boite

Recessed at the back of a little open cave, the first fall can be photographed directly from the roadside or a lower perspective by carefully scrambling down to the water level. The dark nature of the cave means it is usually possible to use a longer shutter speed without resorting to a neutral density filter.

It is then possible to continue descending alongside the stream, following signs for Cascate del Boite. The path is a little vague at first but soon becomes clearer, descending the left side of the stream as it drops into a small gorge. There are five or six additional small cascades which offer many creative shooting possibilities.

After 600m of descent, the path rejoins the road, where it is possible to walk uphill back to the parking area.

Viewpoint 2 – Malga ra Stua & Val Boite ♿

For those looking to explore further afield, there are a number of walking trails leading up the Val Boite from the Malga ra Stua rifugio with good geological interest.

A cropped 12 image hand-held panorama of the top and arguably most photogenic waterfall at Souto de Ra Stua. Nikon Z8, 20mm, ISO 400, 1/20s at f/8, Oct.

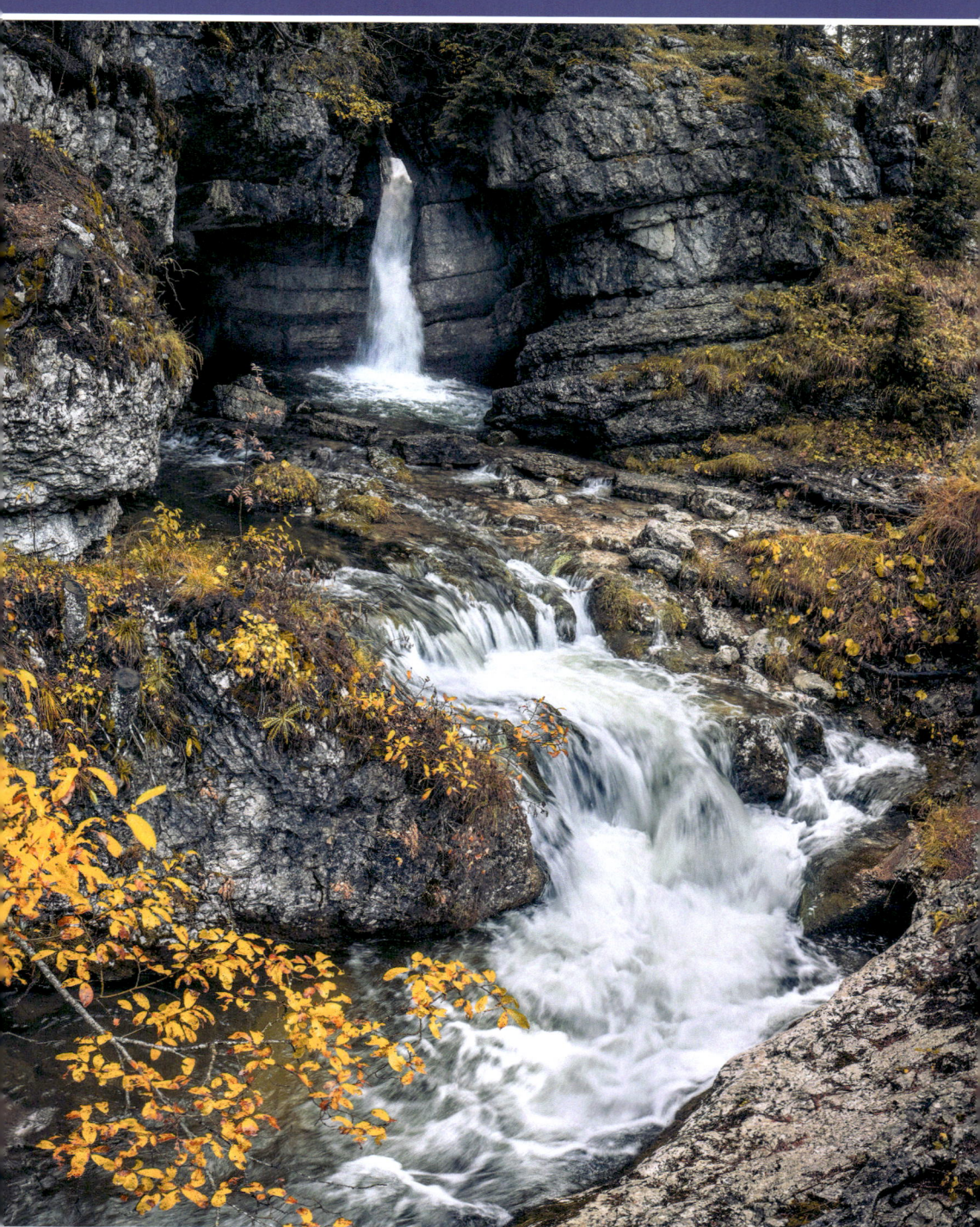

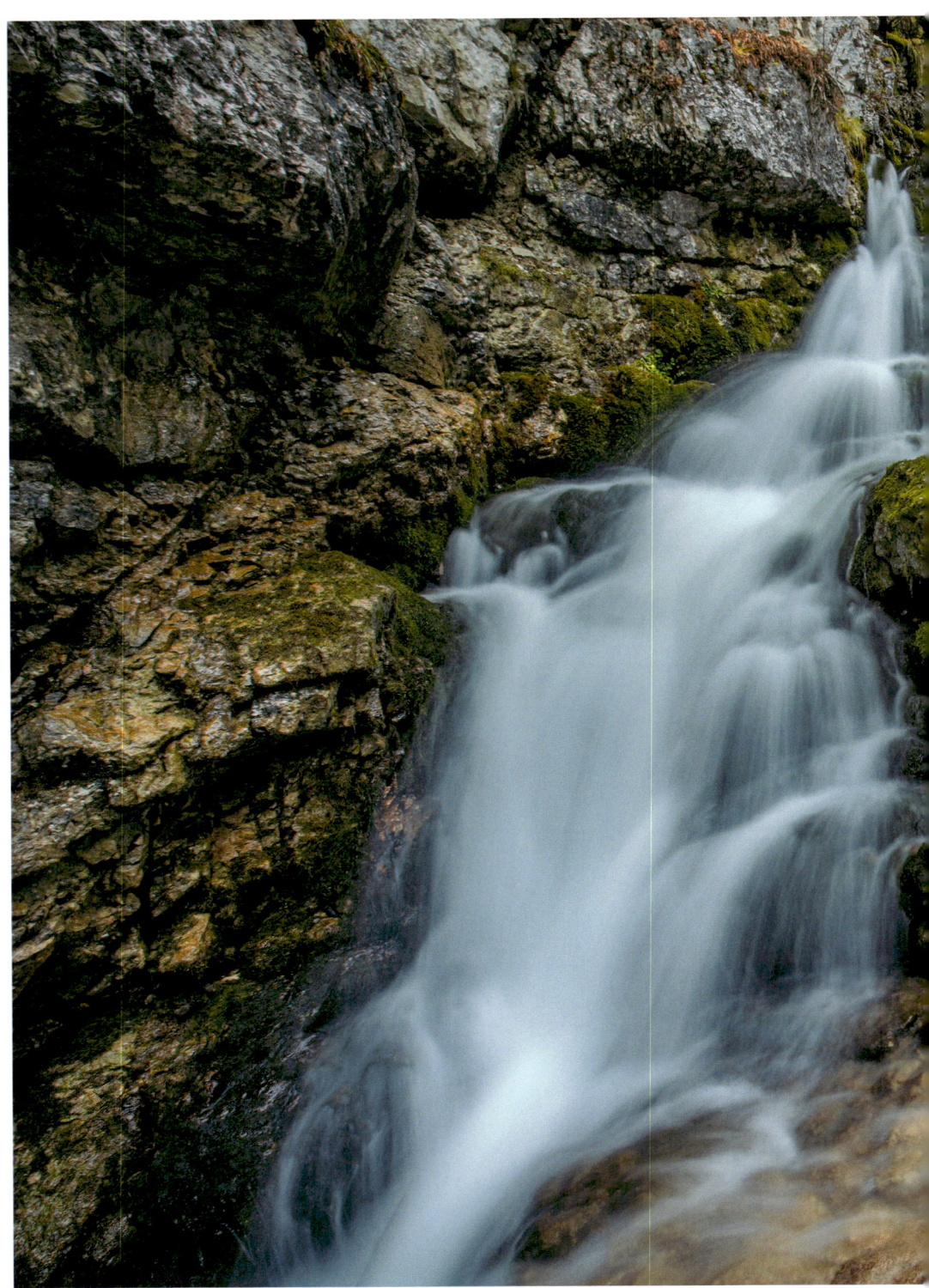
Using an ultra-wide-angle on the lower falls. Nikon Z7II, 14–24mm, ISO 64, 1s at f/22, tripod, Oct.

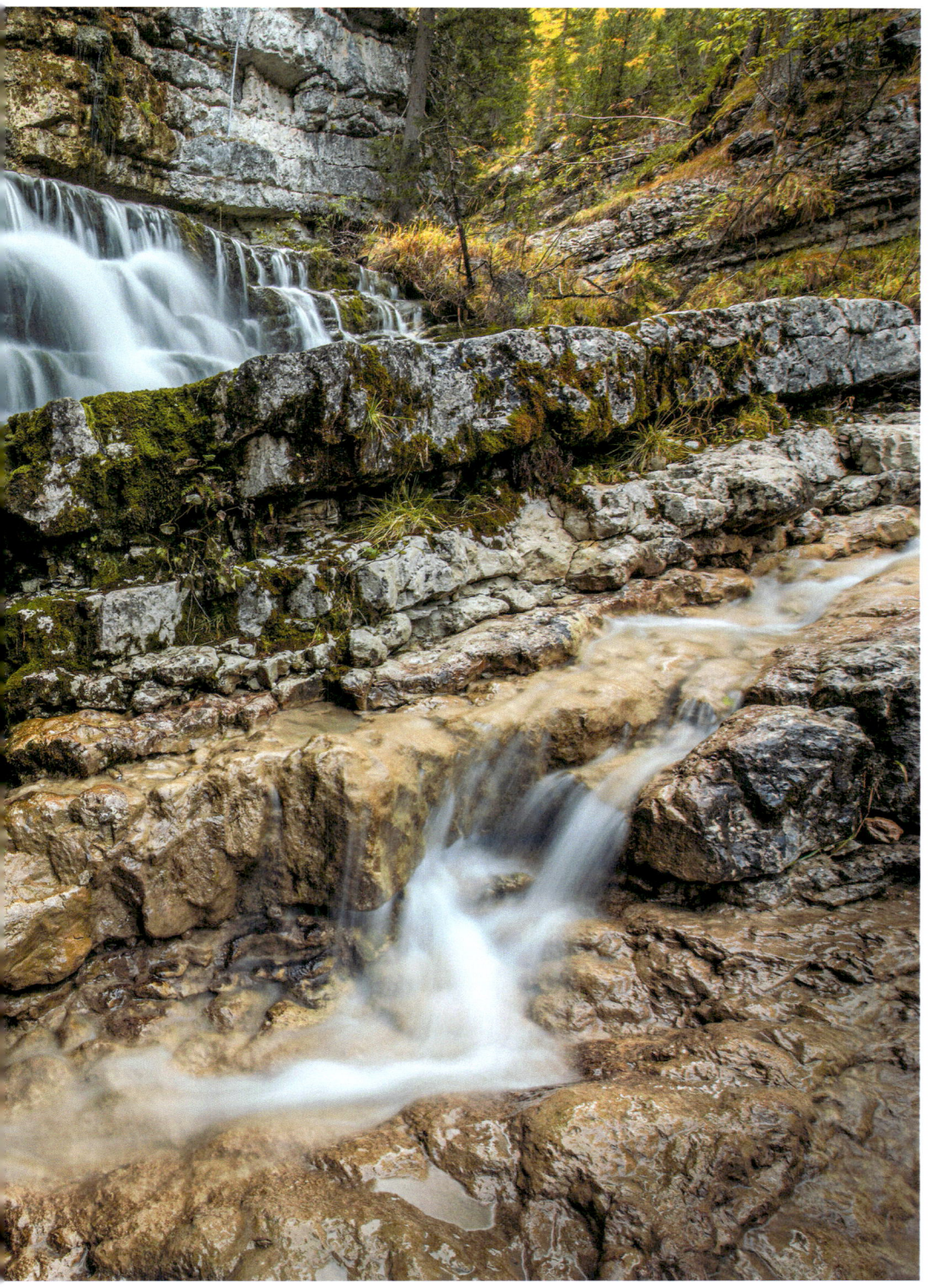

1 MALGA RA STUA – TORRENTE BOITE

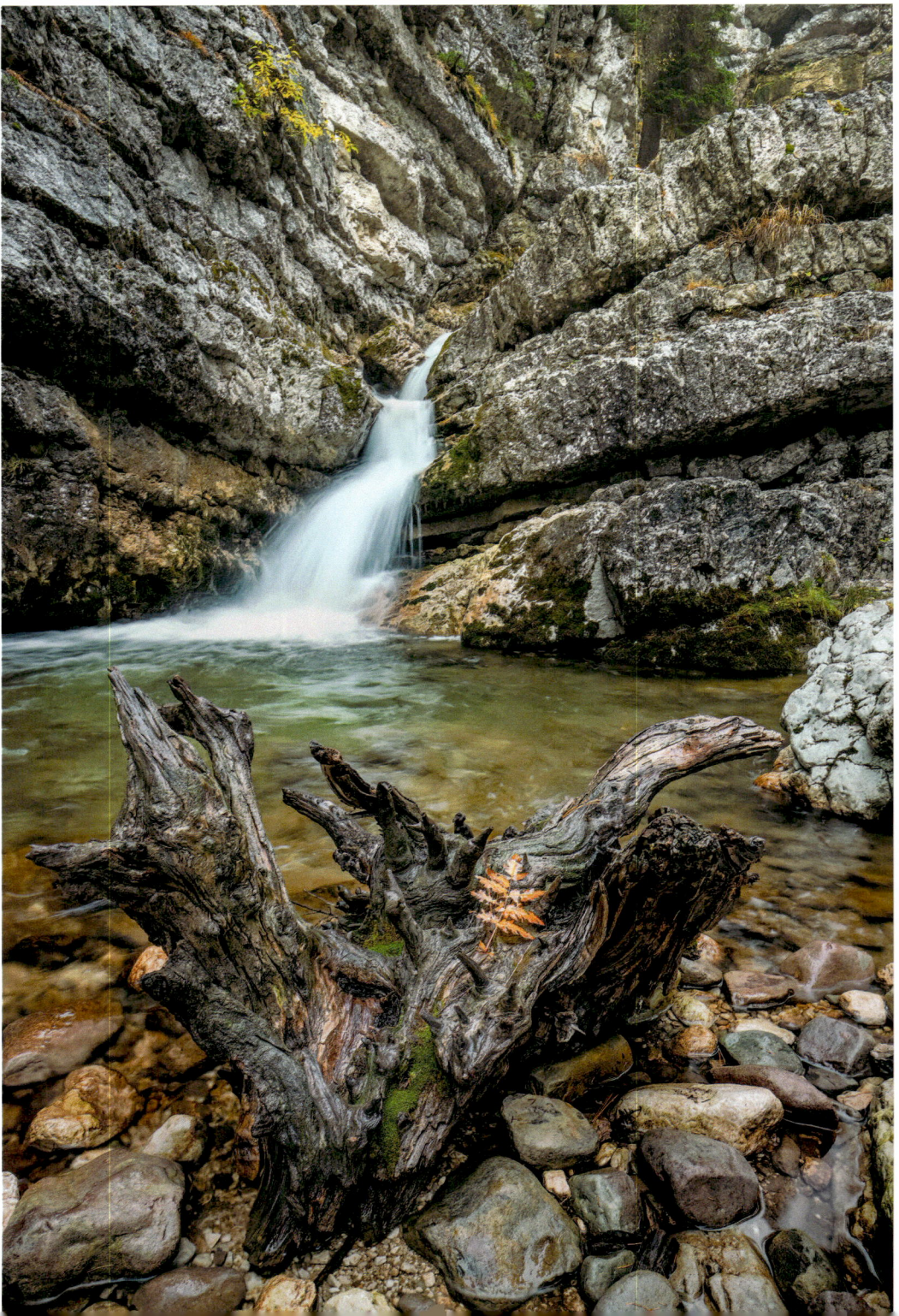

How to get here

From Cortina take the SS51 north, following signs for Dobbiaco. Follow the road for 8km to reach the large parking area of Sant'Uberto just as the road bends steeply up to the right. In low season you can continue up the access road (narrow and steep in places) for a further 2.5km, parking in a small lay-by on the right of the road just after a steep left turn, opposite the top waterfall. If the lay-by is full continue for another 400m and park at Malga ra Stua, walking back down the road to the waterfalls. There is only space for two vehicles here

If the access road is closed for peak season (from early July until September), it is possible to take the Malga ra Stua shuttle service which departs from the village of Fiames just outside the tourist information office.

Alternatively, the walk up to Malga ra Stua from the parking area at Sant'Uberto takes 40 minutes.

Waterfall Roadside Parking (Small Space)

- **Lat/Long**: 46.623582, 12.100415
- **what3words**: ///atoms.populate.rehash
- **Tabacco**: Map 03 (1:25.000)
- **Kompass**: Map 654 (1:25.000)

Malga ra Stua (Large Carpark)

- **Lat/Long**: 46.625100, 12.099050
- **what3words**: ///scenting.disappear.points
- **Tabacco**: Map 03 (1:25.000)
- **Kompass**: Map 654 (1:25.000)

Accessibility

Approach: 5 minutes, 0.5km, 50m of descent.

While it is possible to get some good shots from the access road, the best compositions require some scrambling on often wet rock and stream banks.

 Disabled access: The road leading down from the car park at Malga ra Stua is well surfaced but steep in places. You can get some excellent views up the Val Boite from the car park itself.

Best time of year/day

The stream is photogenic year round and makes for an excellent wet weather itinerary. Water levels are highest during the spring when the snow is melting; this results in more dramatic waterfalls although often at the expense of less clear water. During the autumn you get some fantastic hues as the surrounding vegetation changes colour.

Opposite: Taking advantage of some driftwood (and a cheeky placed leaf). Nikon Z8, 20mm, ISO 100, 4s at f/9, tripod, ND filter, Oct.

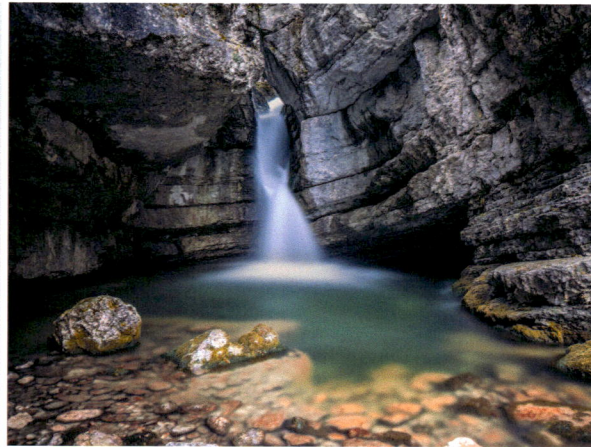

Using a very long exposure to create a minimalist effect. Nikon D810, 16–35mm at 25mm, ISO 100, 5s at f/8, tripod, ND filter, Jul.

Using a fast shutter speed to freeze the spray. Nikon D810, 105mm, ISO 7200, 1/8000s at f/3.

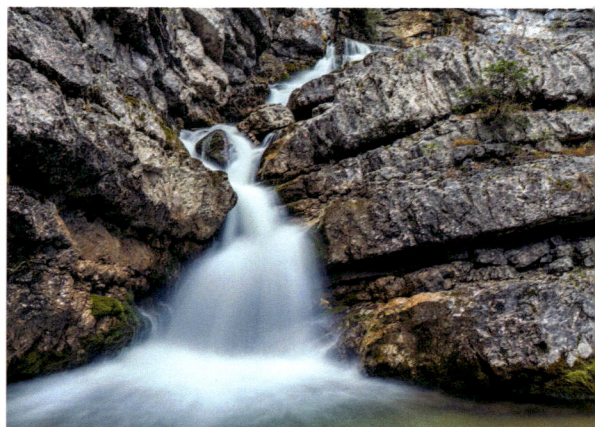

One of the many secondary falls found further downstream. Nikon D810, 24–70 at 35mm, ISO 100, 2.5s at f/13, tripod, ND filter, Sep.

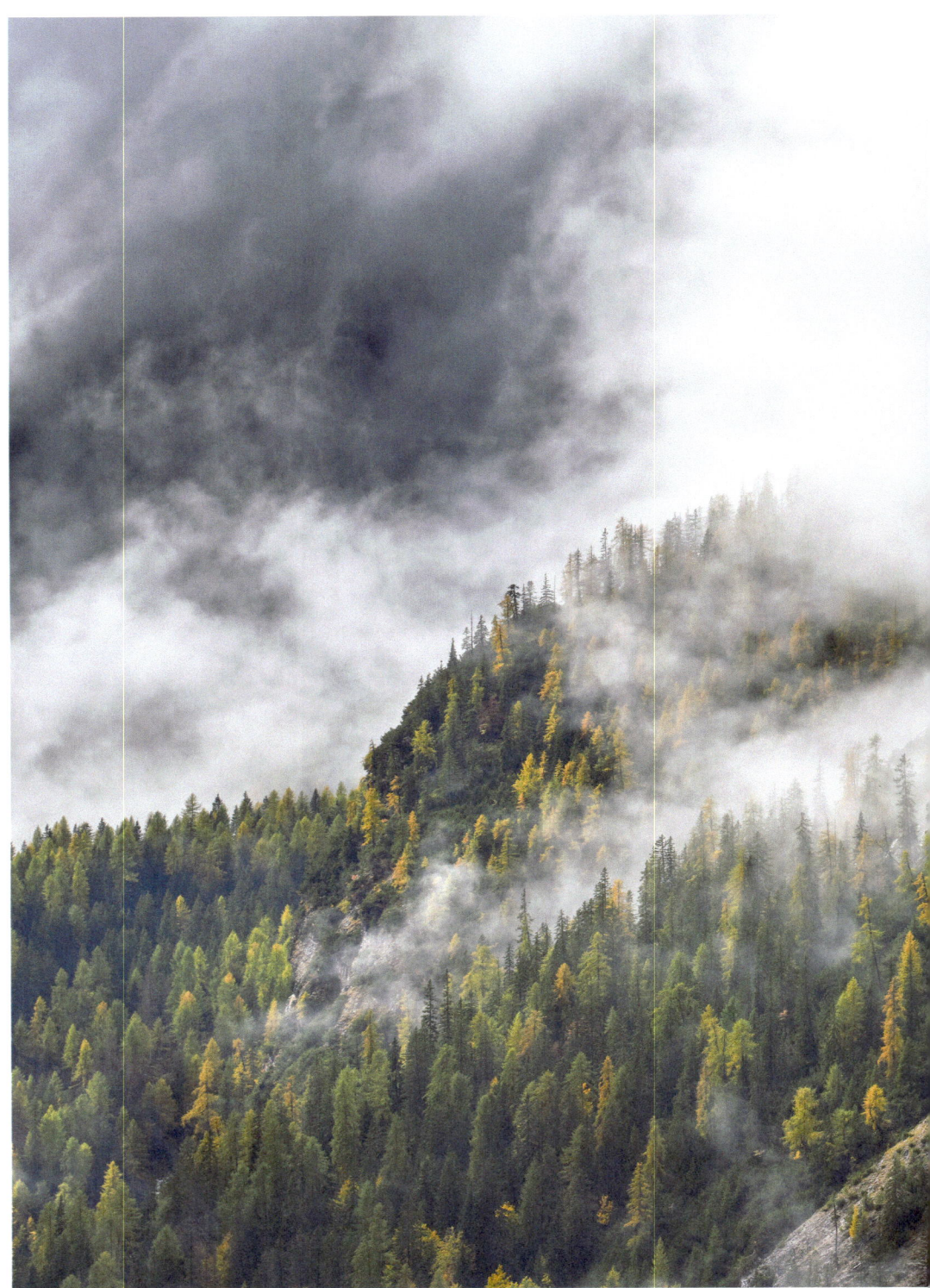
Using the mist to isolate a lone tree at Son Pouses on the drive up to Malga ra Stua (small layby at Lat/Long: 46.60713, 12.10057).

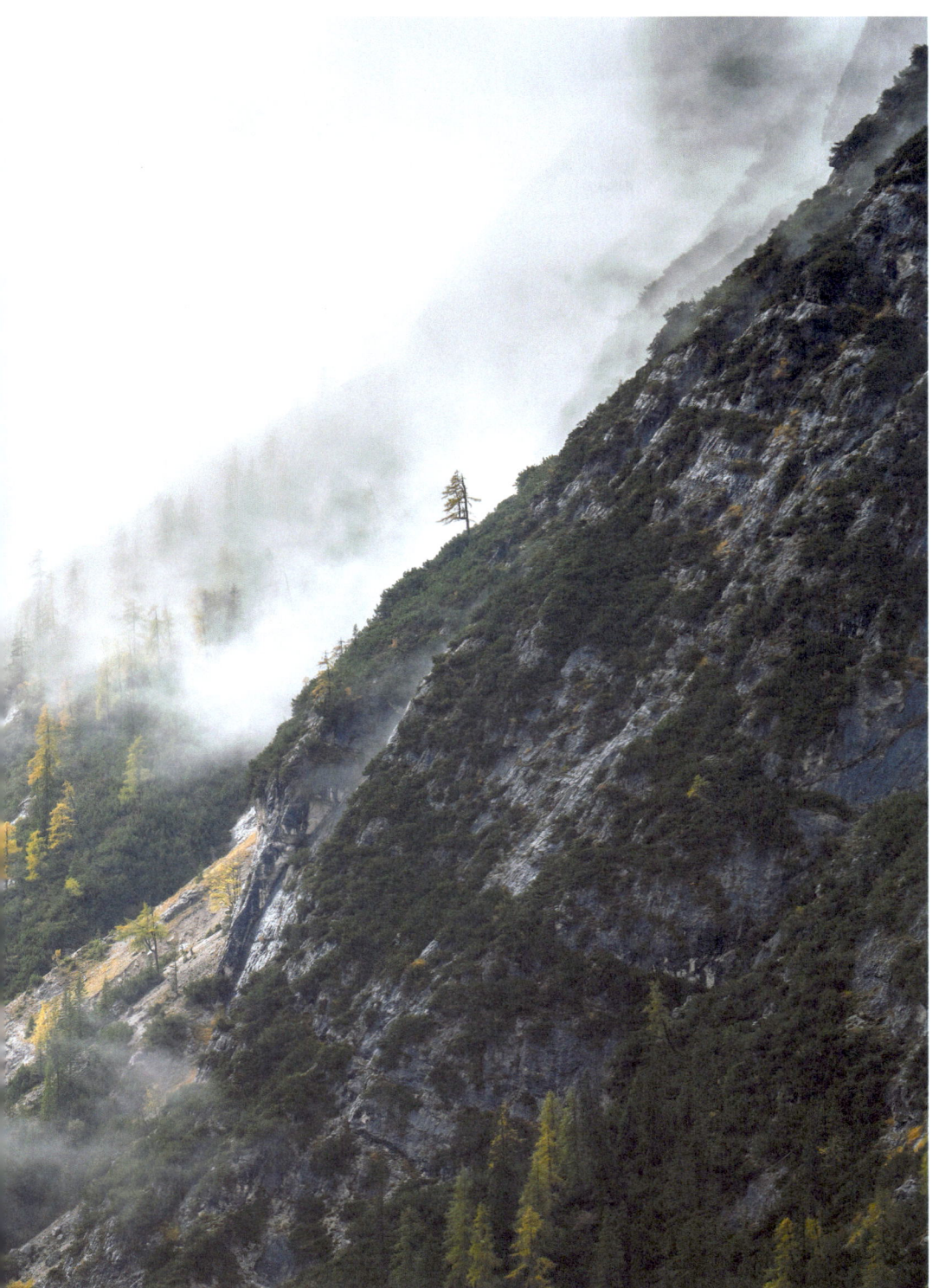

Nikon 24–120mm at 120mm, ISO 64, 1/500s at f/8, Nov.

[2] VAL DI FANES

At the confluence of the Fanes, Travenenzes and Ra Vales valleys lie the remote Cascate di Fanes waterfalls, part of a hugely significant hydro-geological landscape that has helped shape the Parco delle Dolomiti d'Ampezzo. This unspoilt assortment of narrow gorges, rocky ravines and plunging rapids provides a spectacular yet seldom frequented photo opportunity with the chance to shoot behind two impressive cascades.

Although never too steep, the approach is long and the best compositions are accessed by short sections of Grade 1 via ferrata with some scrambling above exposed terrain. As such the location can only be recommended to those with extensive mountain experience and a head for heights.

What to shoot and viewpoints

Viewpoint 1 – Cascate di Fanes
The ledge offers an excellent view of the falls, allowing you to isolate them to create a nice portrait and landscape composition using a standard focal length. If it's a windy day with a high volume of water it can be tough to keep the lens dry; a large lens hood really helps here.

How to get here

From Cortina d'Ampezzo, follow the SS51 north, passing International Camping Olympia and Hotel Fiames on the left. Shortly after Hotel Fiames and 5.5km from Cortina, turn left down a narrow road with a wooden archway overhead reading "Parco Naturale delle Dolomiti Ampezzane". Follow the road down for 1km and park in the large clearing at the end of the road.

- **Lat/Long**: 46.59351, 12.11322
- **what3words**: ///receiving.hilariously.antiquated
- **Tabacco**: Map 03 (1:25.000)
- **Kompass**: Map 654 (1:25.000)

Accessibility

Approach: 45 minutes, 5km, 200m of ascent.

The approach is long and requires good navigational skills and stamina. In addition, the best viewpoints are accessed from brief sections of grade 1 via ferrata which require scrambling experience and a good head for heights. Visitors may wish to hire via ferrata lanyards, harnesses and helmets which are available in Cortina.

Disabled access: Due to the remote nature of the waterfalls and difficult approach, this location is unsuitable for disabled access.

Best time of year/day

The falls are at their most spectacular during spring when the melt water elevates the river levels and during October when the surrounding vegetation produces some beautiful autumnal colours.

The cascades often freeze in January and February, creating beautiful chandeliers of vertical ice that are frequented by alpinists looking to scale the delicate features. Access during the winter months is extremely difficult however, and is not recommended without extensive mountaineering experience.

This is an ideal location for periods of bad weather as flat light is perfect for stream photography and you are likely to get wet even on a good day.

Above: *The Cascata di Sopra and Cengia di Mattia are particularly spectacular in the autumn. Nikon D810, 80–400 at 125mm, ISO 100, 30s at f/6.3, tripod, ND filter, Oct.*

2 VAL DI FANES

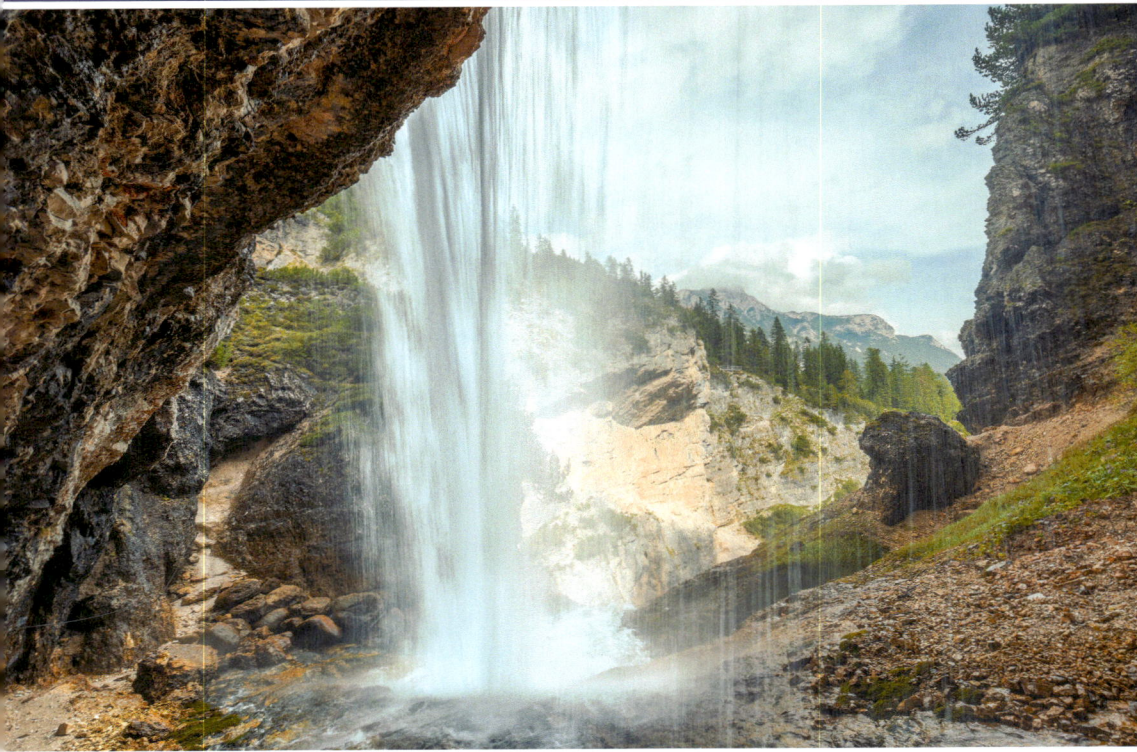

The path leading behind Cascate di Fanes. Nikon D810, 14–24mm at 14mm, 1/20s at f/22, tripod, Aug.

Viewpoint 2 – Behind Cascate di Fanes

To continue, follow the path carefully as it traverses behind the fall itself using the metal wire for assistance. This creates a rather unique vantage point as the water pours overhead. With a wide-angle you can capture both the fall and subjects on the path, or alternatively with a longer lens you can isolate individual droplets with a fast shutter speed as they pass above. Again the greatest challenge is keeping your lens and kit dry. Most photographers opt to retrace their steps back to the picnic area from here, thus avoiding the hardest part of the ferrata (see viewpoint 4).

However, for those that wish to complete the circuit continue following the wire as it passes through a narrow gap and then descends down the side of a gorge to reach a small metal suspension bridge crossing the bottom of the falls. Take care descending the wire which is exposed and often wet.

Viewpoint 3 – Cascate di Fanes from Below

A subject on the suspension bridge at the base of the falls makes for an excellent foreground and really helps to portray a sense of scale (if they don't mind getting wet in the name of modelling).

To continue, ignore the path leading left which takes a series of steep reinforced wooden switchbacks to exit the gorge and instead cross over the bridge and climb the subsequent wire as it ascends the southern side of the gorge to return back to the picnic area and the start of the ferrata.

To continue to Cengia di Mattia from the picnic site, ascend the track uphill to the west, following signs for Sentiero dei Canyons e delle Cascate until a small path leads off right. Take this, ascending through woodland to reach another junction; keep right again, crossing a bridge and following the course of the river upstream.

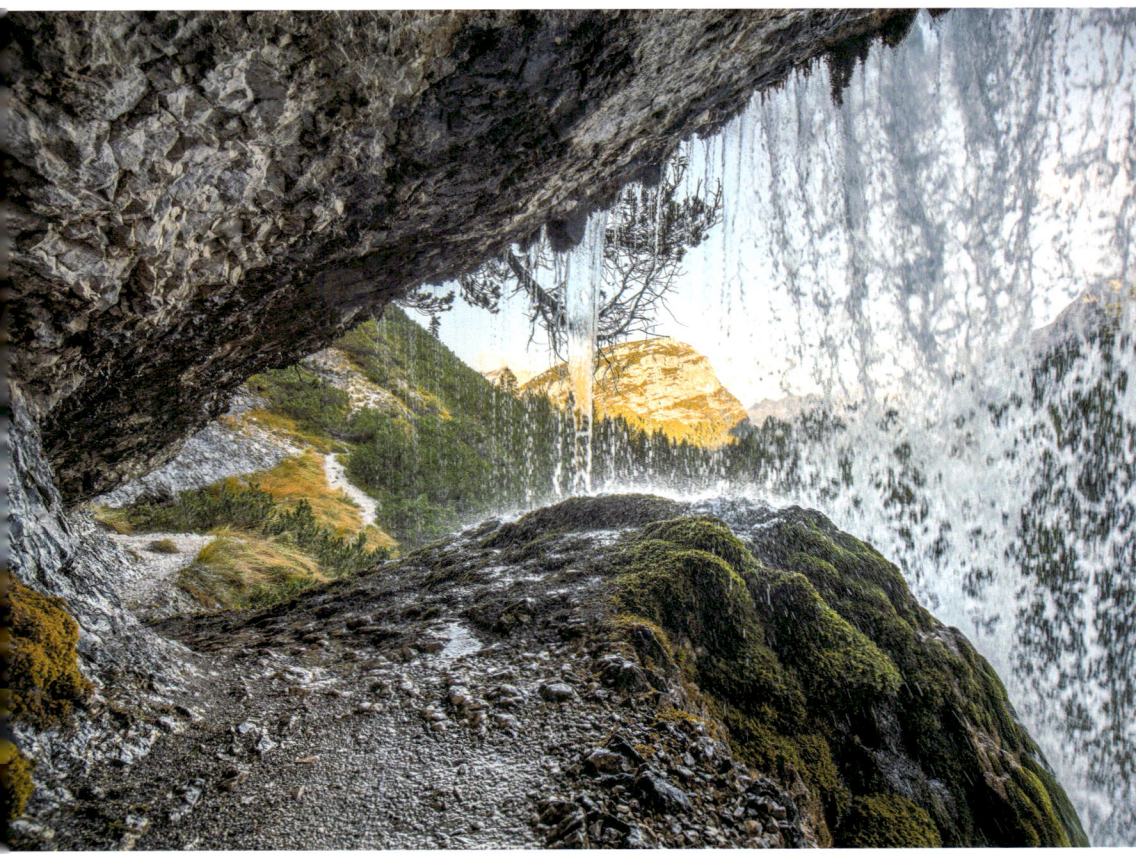

Behind Cascata di Sopra on the Cengia di Mattia. Nikon D810, 14–24mm at 14mm, ISO 100, 1/80s at f/4.5, Sep.

Viewpoint 4 – Rio Fanes

As you ascend the Sentiero dei Canyons e delle Cascate towards the Cascata di Sopra, you are presented with a number of photographic opportunities along the way. The stream bed is liberally dotted with small rocks that are beautifully rounded as a result of abrasion. Vibrant moss clings to their surface for much of the year and creates the potential for some excellent stream abstracts.

Continue following the path as it crosses back and forth over the stream a number of times, passing several smaller falls to eventually reach more level ground and a clear view of Cascata di Sopra.

Viewpoint 5 – Cascata di Sopra

From the left bank there is an excellent view of Cascata di Sopra. While the fall isn't as large as Cascate di Fanes, it is nonetheless perfectly proportioned and flows over some really photogenic bedrock.

If the water levels are high there is often some additional runoff on the right from the cascade spilling dramatically from the forest above.

Viewpoint 6 – Cengia di Mattia

The path then ascends to the left side of Cascata di Sopra, where a wire protects the traverse behind the wall along the Cengia di Mattia ledge. The fall width combined with the vibrant moss allows for a number of creative possibilities with a wide-angle lens – let your imagination run wild.

To continue, climb up a short wall on the opposite bank to rejoin the main path to the left. Turn left to descend east back towards Ponte Outo, eventually joining a gravel track (there is shortcut on a steep woodland path here; either route will lead back to Ponte Outo). On reaching Ponte Outo, retrace your steps across the bridge back to the car.

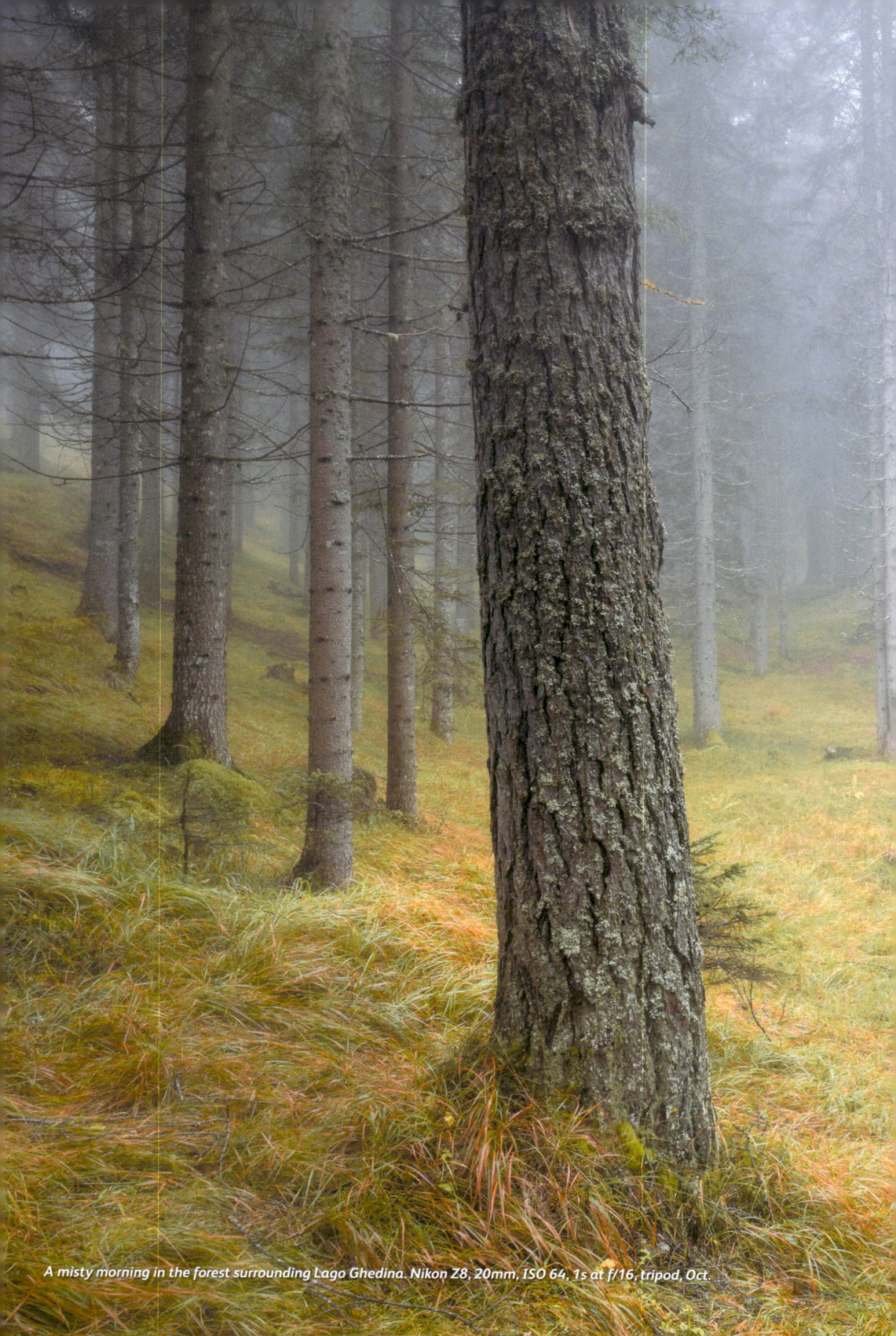

A misty morning in the forest surrounding Lago Ghedina. Nikon Z8, 20mm, ISO 64, 1s at f/16, tripod, Oct.

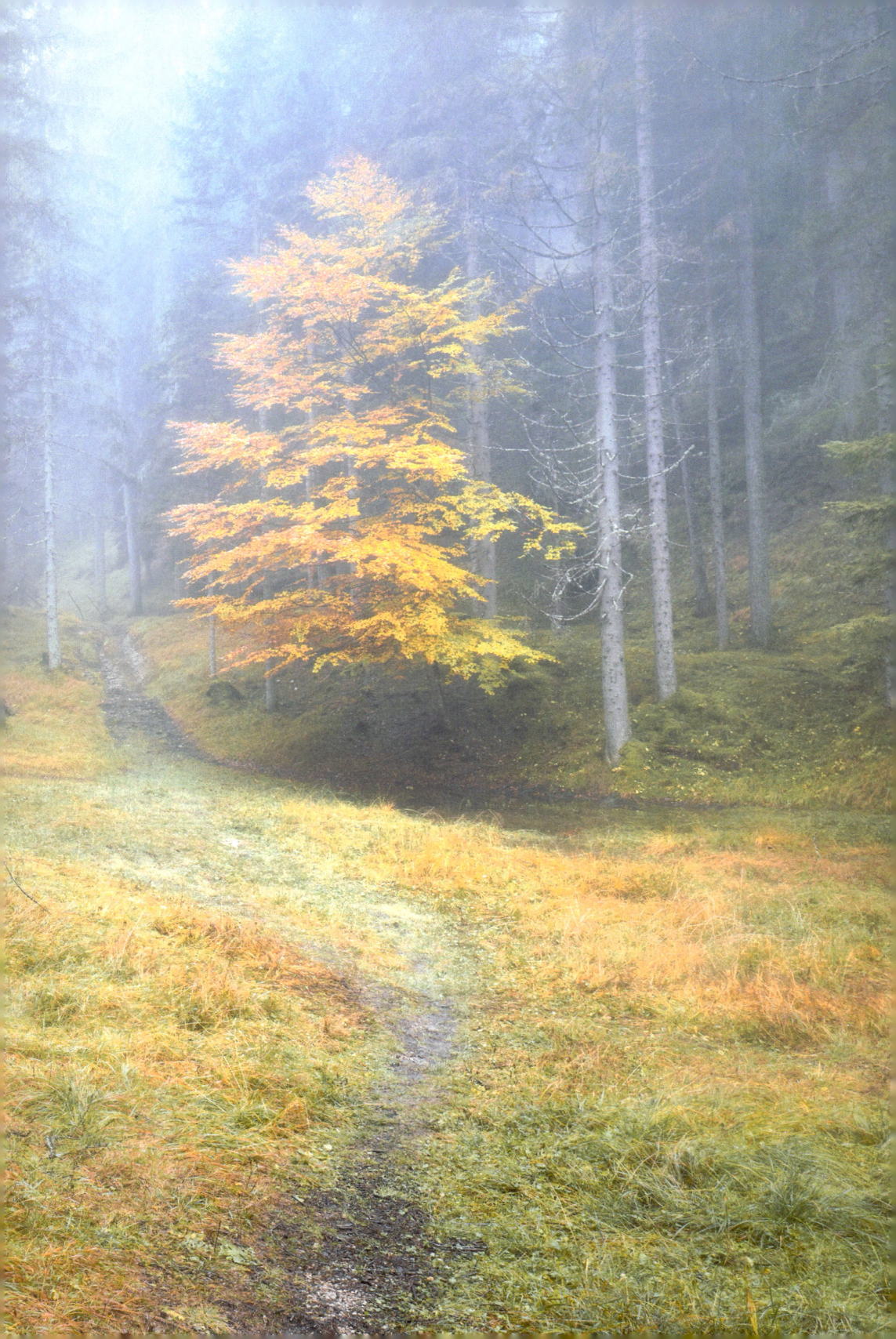

3 LAGO GHEDINA

Lago Ghedina is a small but idyllic lake situated just north-west of Cortina with easy access by road. The shore is dominated by Ristorante Al Lago Ghedina, an establishment that epitomises the Cortina culinary ideal. While this may be a little expensive for many of us, it does provide an effective backdrop for a range of photographic compositions. Boasting crystal clear waters filled with trout and dramatic reflections of Tofana di Dentro, this is an excellent and accessible venue despite the relative lack of viewpoints.

How to get here

From the centre of Cortina take the SR48 west following signs for the Passo Falzarego for 3km. Soon after leaving the main town, turn right into Località Gilardon following good signposting towards Lago Ghedina. Pass through the hamlet of Gilardon, taking care on the narrow and steep road, until a sharp right turn is signposted towards Lago Ghedina. Turn right here and follow the road as it traverses the forest to reach the lake in just over 2km.

P Lat/Long:	46.555962, 12.113647	
P what3words:	///cements.tour.watermelon	
P Tabacco:	Map 03 (1:25.000)	
P Kompass:	Map 654 (1:25.000)	

Accessibility

Approach: Roadside access.

The lake is situated adjacent to the parking area and is easily accessed with a good path around much of the lake. Much of the land is private and belongs to Ristorante Al Lago Ghedina. Please respect the signs and do not trespass.

Disabled access: The northern and western shores near Ristorante Al Lago Ghedina have good disabled access on well-surfaced paths and roads.

Best time of year/day

Lago Ghedina is a consistently good location throughout the year, though the road can be inaccessible during the winter.

There are effective compositions from three sides of the lake, making this a reliable destination throughout the day.

A cropped wide-angle panorama of Ristorante Al Lago Ghedina. Nikon D850, 14–24mm at 16mm, ISO 100, 1/80s at f/13, Sep.

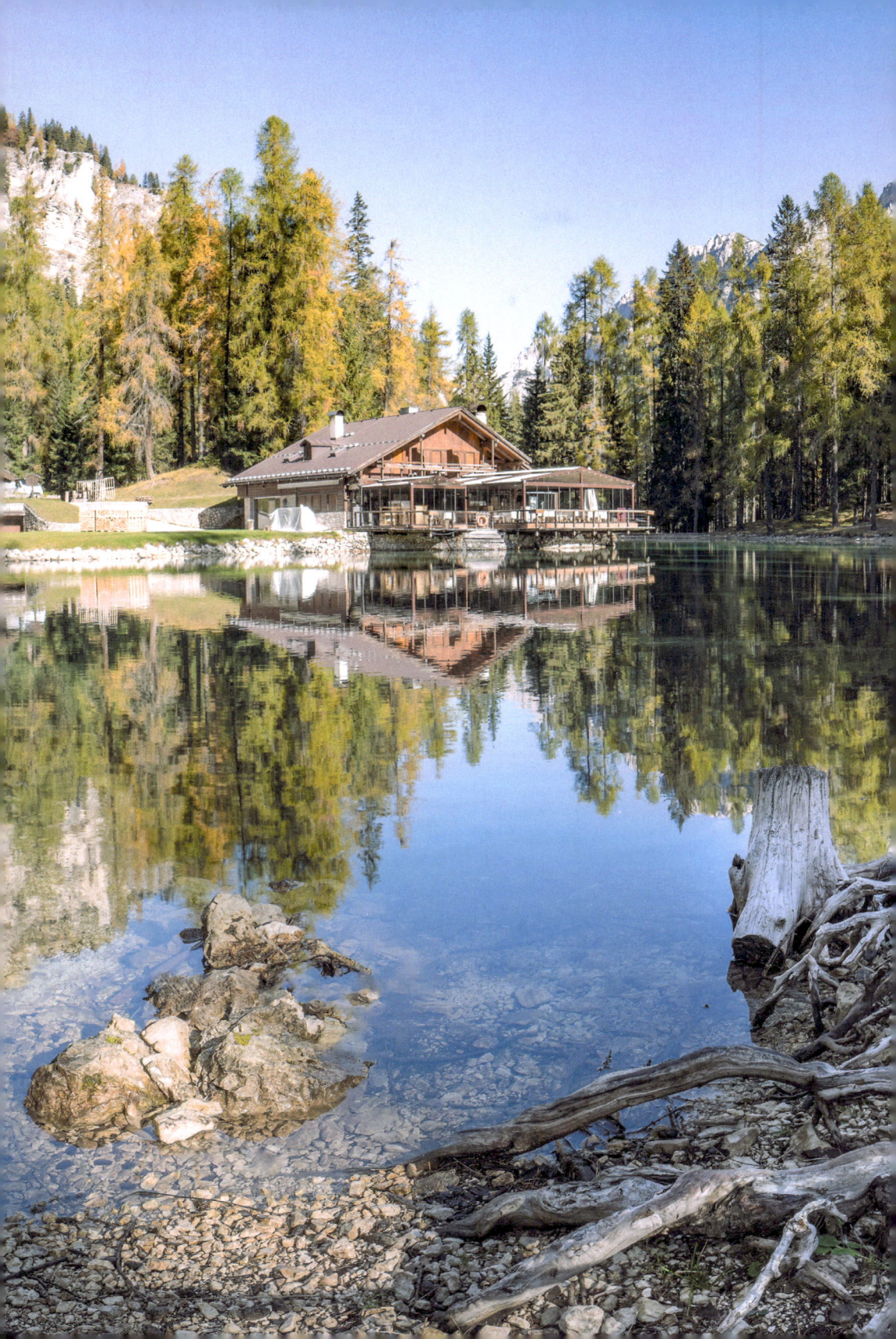

3 LAGO GHEDINA

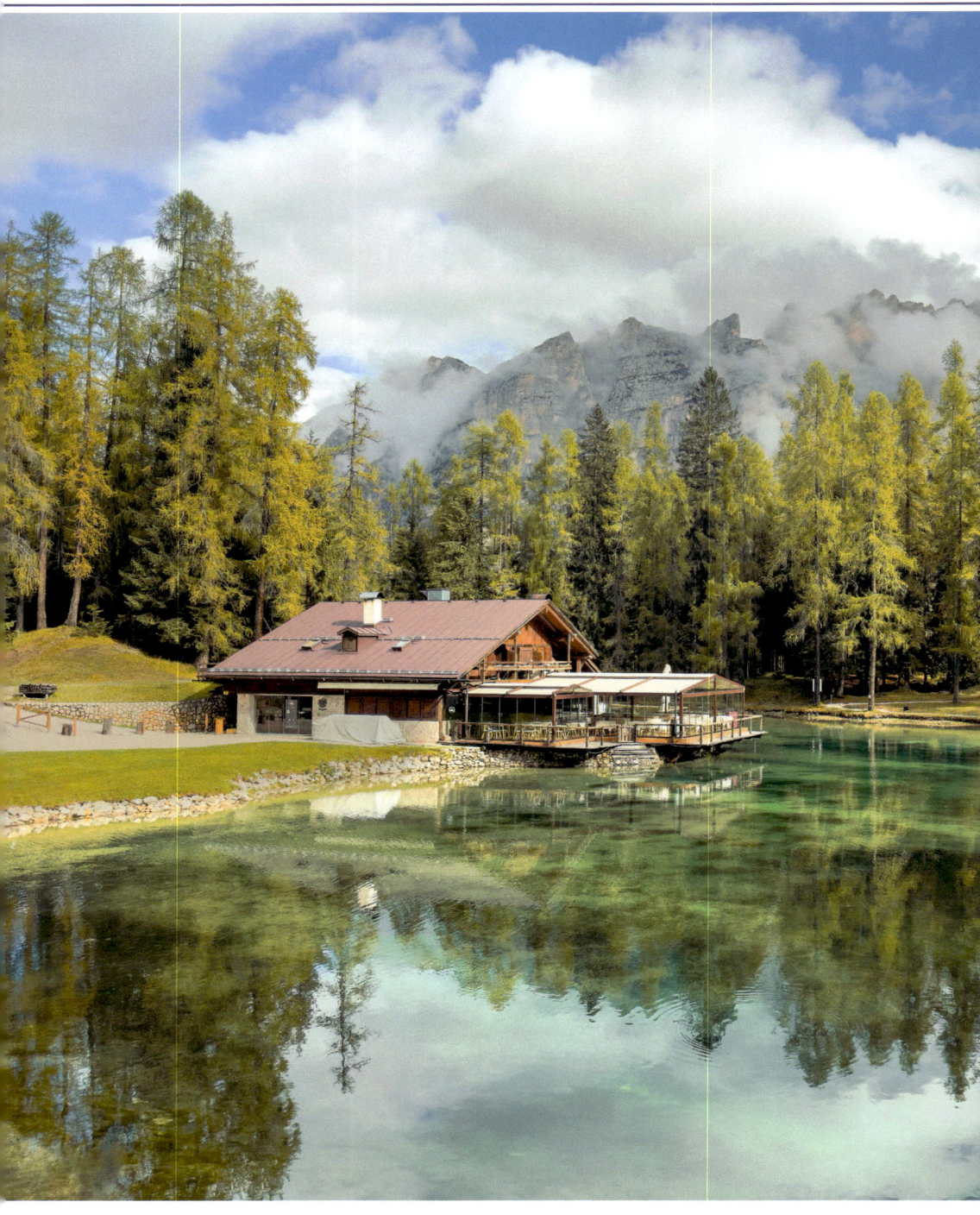

What to shoot and viewpoints

Viewpoint 1 – Ristorante Al Lago Ghedina ♿
The restaurant provides the classic focal point and is normally shot from the southern shore with a wide-angle lens. The decking and moored wooden boats provide some excellent reflections, particularly at night when the candle lights from dining patrons are reflected in the waters. Occasionally groups hire out the rowing boat which can create additional foreground interest.

Viewpoint 2 – Tofana di Dentro ♿
Looking west you will see a number of subsidiary summits and buttresses descending from Tofana di Dentro. These can be framed nicely on the left of Ristorante Al Lago Ghedina; this composition works particularly well when the sun is low in the sky, illuminating the peaks but casting the water surface in shadow. Make sure you don't crop out the reflections which will stand out well as the highlighted mountains contrast pleasingly with the dark water.

Viewpoint 3 – Lake Bed ♿
The crystal clear waters provide some great opportunities for photographing fish and the intricate patterns created by tree roots encroaching into the lake. The west shore in particular has some beautiful abstracts created by old and now flooded tree roots.

Looking north-east across Lago Ghedina towards Gruppo del Cristallo. Apple iPhone 14 Pro, 24mm, ISO 100, 1/3700s at f/1.8, Sep.

Intentional camera movement (ICM) using a slow shutter speed. Nikon Z8, 14–105mm at 105mm, ISO 64, 0.4s at f/22, Nov.

When combined with the rippling water you get a watercolour effect. Nikon Z8, 100–400mm at 170mm, ISO 64, 1/5s at f/22, Nov.

4. CORTINA D'AMPEZZO

Situated astride the River Boite, Cortina d'Ampezzo is arguably the most famous town in the South Tyrol. Hosting the Olympic ski jump and bobsleigh run, Hotel de la Poste – temporary home of Ernest Hemingway, the five star Miramonti Majestic Grand Hotel frequented by James Bond and dominated by the Basilica Minore dei Santi Filippo e Giacomo, the town is liberally studded with iconic landmarks.

With a local population of 7000 that swells to some 50,000 during the height of the ski season, it's fair to say that the hospitality sector is central to the town's success. Yet despite its unashamedly glitzy style, Cortina somehow manages to retain a strong ethos of traditional culture and much of the population speaks fluent Ampezzano, a variant of Ladin unique to the region and recognised as a separate dialect in its own right. Outside of the winter season, the town has a more down-to-earth feel than its reputation might suggest and a stroll through the streets made familiar by scenes from The Pink Panther and For Your Eyes Only is highly recommended.

What to shoot and viewpoints

The nature of street photography lends itself to a more spontaneous approach, particularly in a location like Cortina d'Ampezzo when you are never quite sure what you will find. Here are just a few suggestions:

Viewpoint 1 – Basilica Minore dei Santi Filippo e Giacomo ♿
Built between 1769 and 1775 in Baroque style, the Roman Catholic basilica dominates the town centre and is very photogenic both inside and out.

Viewpoint 2 – Corso Italia ♿
Featuring architecture designed by renowned Italian architects such as Edoardo Gellner and Luigi Vietti, Corso Italia is Cortina's vibrant high street, its varied store fronts presenting a host of artistic possibilities particularly when looking south-east towards Monte Antelao.

Viewpoint 3 – Interior Architecture ♿
If you can obtain permission, the luxurious yet traditional hotels, restaurants and bars present nearly infinite possibilities for photojournalism and portrait shoot venues.

Cortina is excellent for spontaneous street photography. Nikon D810, 80–400mm at 400m, ISO 100, 1/400s at f/6.3, Apr.

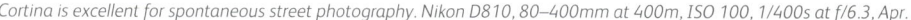

Dusk on the main high street with views of the Basilica.
Nikon D810, 24–70mm at 70mm, ISO 220, 1/80s at f/2.8, Oct.

Shop windows often provide inspiration for some artistic creativity.
Nikon D810, 24–70mm at 45mm, ISO 100, 1/60s at f/4, Dec.

How to get here

Cortina d'Ampezzo is superbly situated and can be accessed from the Alta Badia via the Passo Falzarego, from the Val Fiorentina via the Passo Giau, or from Belluno via Valle del Boite and the SS51.

	Lat/Long:	46.53804, 12.13895
	what3words:	///cannily.huggable.consequently
	Tabacco:	Map 03 (1:25.000)
	Kompass:	Map 654 (1:25.000)

Accessibility

Approach: The town centre can be reached in 10 minutes from the main car park.

Cortina is well equipped with all the amenities you would expect from a town of its size. Beware of the somewhat convoluted one way system that can be confusing on the first visit. While there are a number of parking areas, the large pay and display car park next to the Faloria cable car is arguably the most convenient.

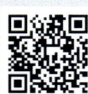 **Disabled access**: Disabled access throughout the town is good and there are a number of disabled parking spaces.

Best time of year/day

While Cortina is photogenic year round, the photo opportunities vary greatly depending on the season. The town is busiest during the ski season, especially during February and March. Fresh snowfall in the streets provides the stereotypical and quintessential 'winter sports' scene so associated with Cortina. Come summer, the ambience changes back to that of a sleepy mountain village, allowing you to focus on the architecture and beautifully decorated houses adorned with vibrant flower boxes.

Cortina d'Ampezzo hosts a number of festivals and events throughout the year which can present unique photo opportunities:

- December – Christmas markets
- June – Lavaredo & Cortina Ultra Trail Marathons
- July – Coppa d'Oro delle Dolomiti (vintage car rally)
- July, August – Dino Ciani Festival and Academy (classical music)
- July, August – Feste Campesetri dei Sestrieri (dance & food)

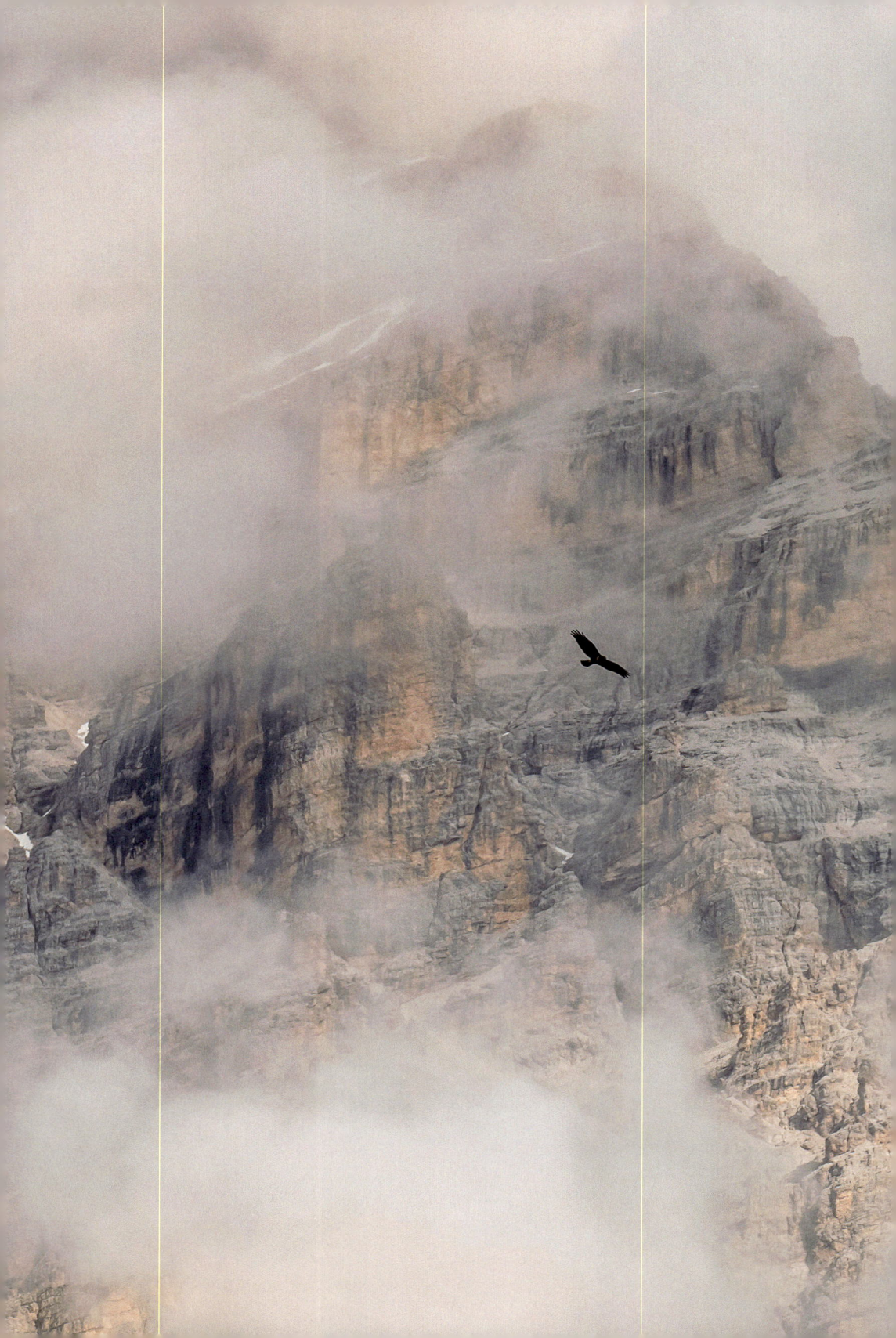

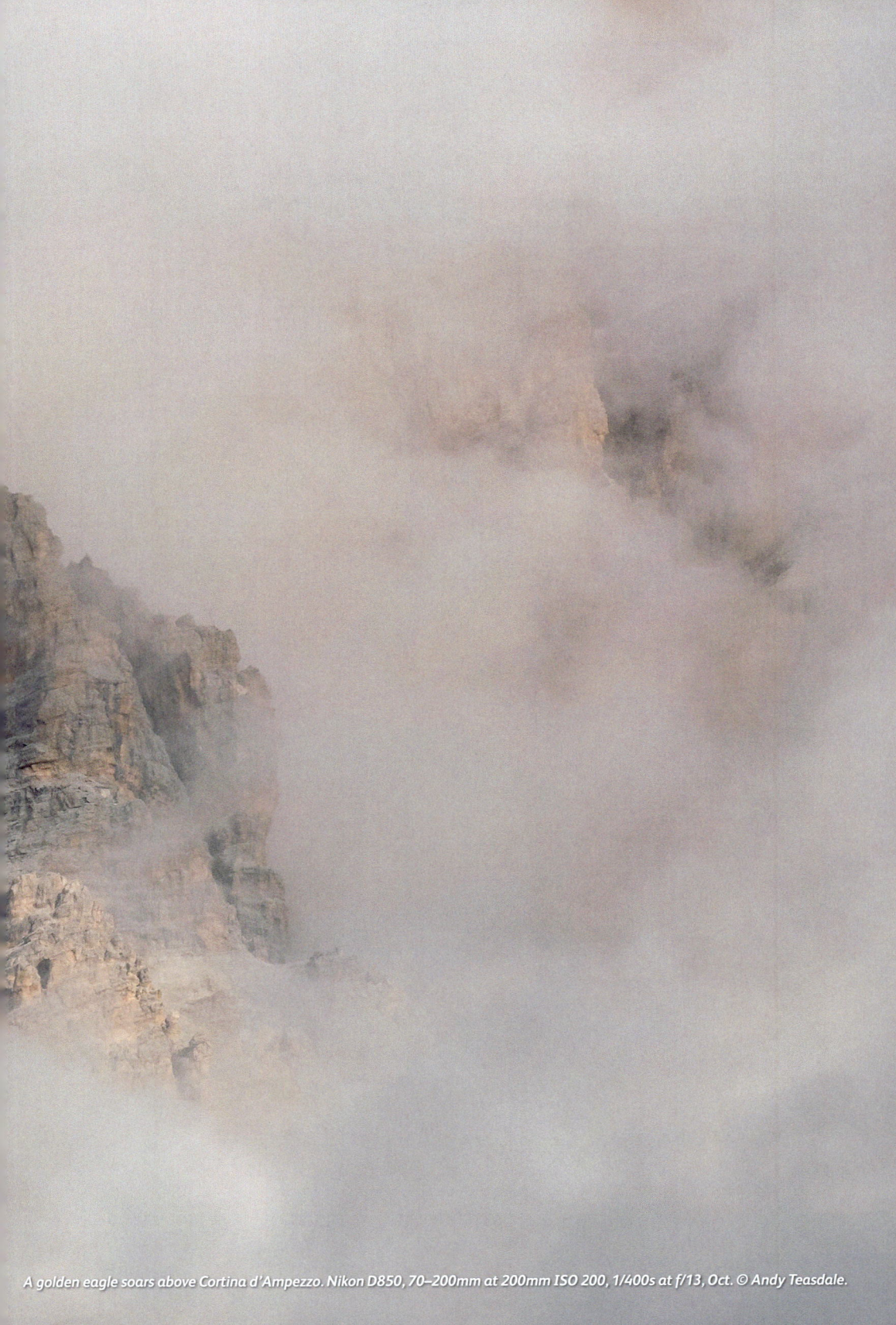
A golden eagle soars above Cortina d'Ampezzo. Nikon D850, 70–200mm at 200mm ISO 200, 1/400s at f/13, Oct. © Andy Teasdale.

5. LAGO DI SORAPIS

Situated at the heart of the Sorapiss Group and nestled directly under the dramatically named 'Dito di Dio' (Finger of God), this remote mountain lake is one of the most beautiful in the Dolomites and indeed the Alps. Mineral deposits from the Circo del Sorapis give the water such a vivid aqua-blue colour that people are sure to accuse you of over-saturating your photos. The approach is fairly long but this does help to moderate the crowds, ensuring you can get this idyllic gem to yourself at either end of the day.

What to shoot and viewpoints

From the top of the Passo Tre Croci, follow the road downhill to the east (in the direction of Misurina) for 200m before turning off right onto path 215. Following signs for Rifugio Vandelli, ascend the well-marked path through forest and then dwarf pines to reach the hut in just under two hours.

How to get here

Lago di Sorapiss is a remote lake situated by Rifugio Vandelli directly under the immense horseshoe of rocks walls formed by the Sorapiss Group.

From Cortina take the SS48 east, following signs for the Passo Tre Croci and continuing to the top of the pass. There are several small car parks and plenty of roadside parking spaces along the verge.

Lat/Long: 46.55617, 12.20424
what3words: ///yarns.tone.sciences
Tabacco: Map 03 (1:25.000)
Kompass: Map 654 (1:25.000)

Accessibility

Approach: 2 hours, 7km, 500m of ascent.

The ascent to Rifugio Vandelli from the top of the Passo Tre Croci is well marked and signposted but requires good mountain fitness. The path has several metal staircases and a narrow passage protected by cable towards the end. It is also possible to approach the lake from the Cortina Faloria gondola via paths 215 or 216.

The remote nature of the lake combined with the difficult approach make it unsuitable for disabled access.

Disabled access: The remote nature of the lake combined with the difficult approach make it unsuitable for disabled access.

Best time of year/day

The lake is best viewed in the spring, particularly when the alpenrose is in blossom as the vibrant red of the flowers contrast so well with the strong blue of the lake.

The lake is undoubtedly idyllic in sunny conditions but it also photographs well on days with soft light. Low cloud and mist can look particularly striking, giving the lake an ephemeral glow as the pale waters meet the white of the clouds.

As Dito di Dio provides the principle backdrop, it is worth catching the morning sun so the spire isn't silhouetted as the sun moves around and behind the tower. The long approach and spectacular setting make an overnight stay in the nearby Rifugio Vandelli a popular choice for photographers looking to capitalise on the lake's potential.

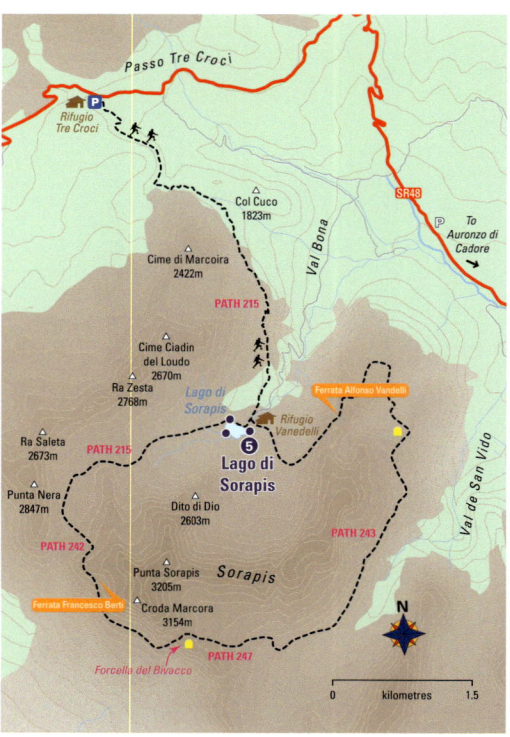

Alpenrose found in June and July makes for a lovely foreground. Nikon Z7II, 14–24mm at 14mm, ISO 64, 1/50s at f/22, Jul.

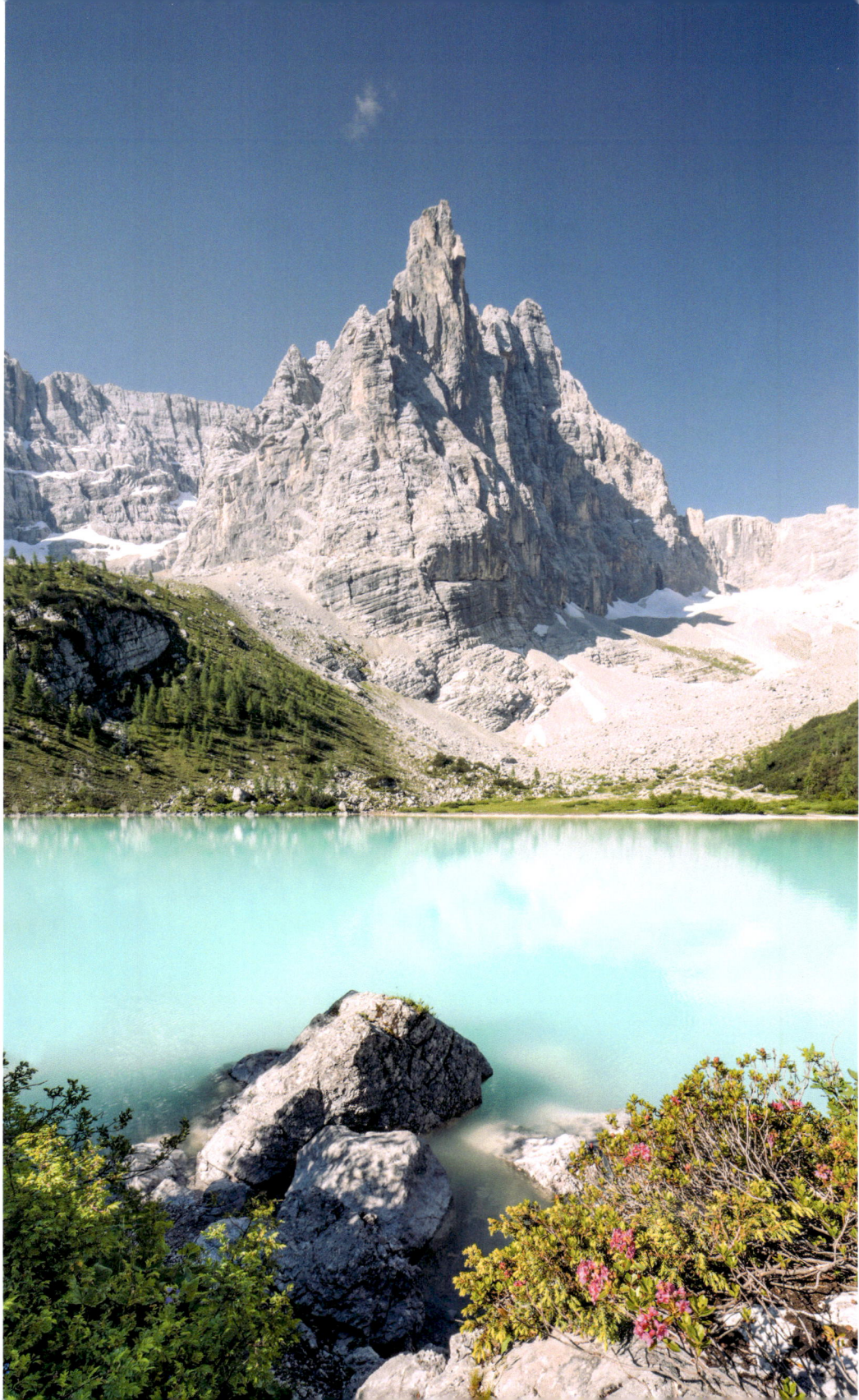

5 LAGO DI SORAPIS

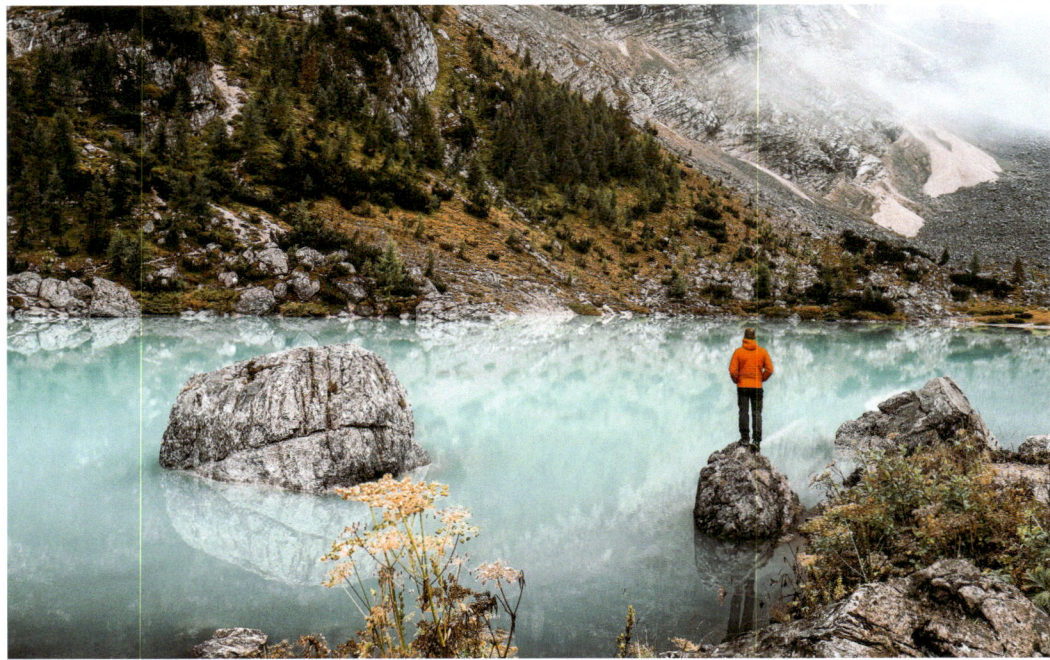

Using a subject to provide additional foreground interest at Lago di Sorapis. © Peter Orsel.

Viewpoint 1 – Northern Shore & Dito di Dio
Follow the main path beyond the left turn to Rifugio Vandelli to quickly reach the northern shore of the lake. This is the main viewpoint, with a large boulder protruding out of the water supplying the foreground and the characteristic spire of Dito di Dio providing a stunning backdrop. Both a wide-angle lens and/or multi-image panorama work well here to capture the grandeur of the location. Two distinctive trees on the right side of the lake work well to frame the right-hand side of the shot while simultaneously drawing the eye towards the lake and leftwards slant of the mountains.

In June and July the alpenrose (Rhododendron ferrugineum) is in full bloom, creating the possibility for additional compositions by moving back from the water's edge and framing some of the flowers. Stop down your lens to get as much of the background in focus as possible or if using a tripod you can focus stack. As Dito di Dio is north-east facing, the shot is best taken in the morning when the spire is illuminated but the sun has not yet hit the lake's surface.

Viewpoint 2 – Western Shore & Dito di Dio
Following the lakeside path anti-clockwise for 40m, come out of the dwarf pines to enter into a more open area. Here on the left you will see a number of rocks in the water which create an excellent portrait opportunity when combined with Dito di Dio. The scene requires an extreme wide-angle, some panoramic stitching or ideally a tilt-shift lens to fit everything in the frame.

Viewpoint 3 – Island
As you round the western corner of the lake there is a small island some 5 metres out into the water with several bushes growing on it. With a wide-angle lens you can use this as a foreground with a number of different compositions, either shooting towards Dito di Dio again or using the little bay to the north.

*Opposite top: Afternoon light illuminates a group of larches during autumn. Nikon Z8, 100–400mm at 200mm, ISO 200, 1/200s at f/6.3, Oct. **Left**: Lago di Sorapis and Dito di Dio. © Tomáš Malík. **Right**: The wildflowers are spectacular during late June and throughout July. © Riccardo Cervia.*

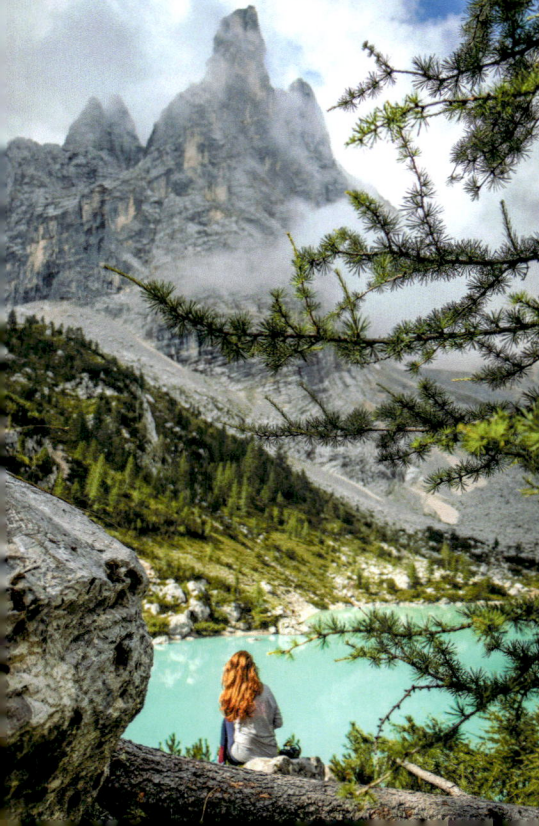
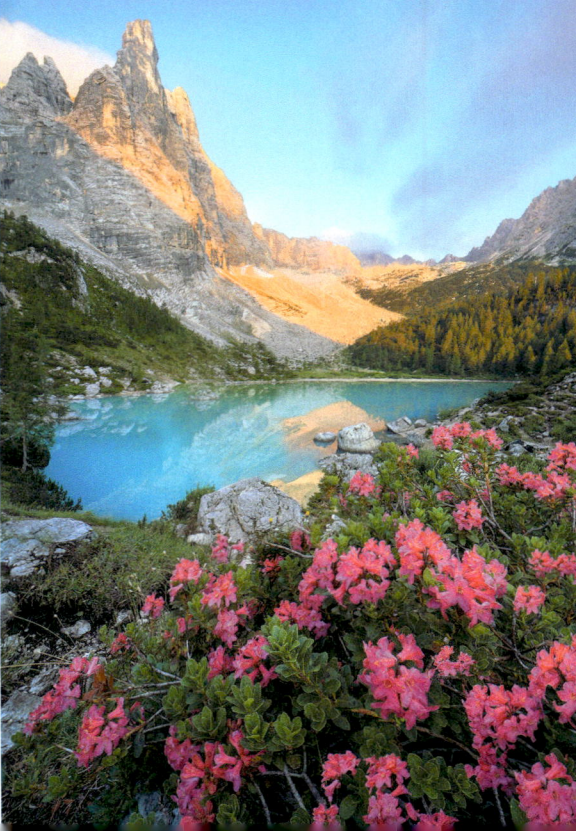

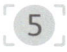 5 LAGO DI SORAPIS

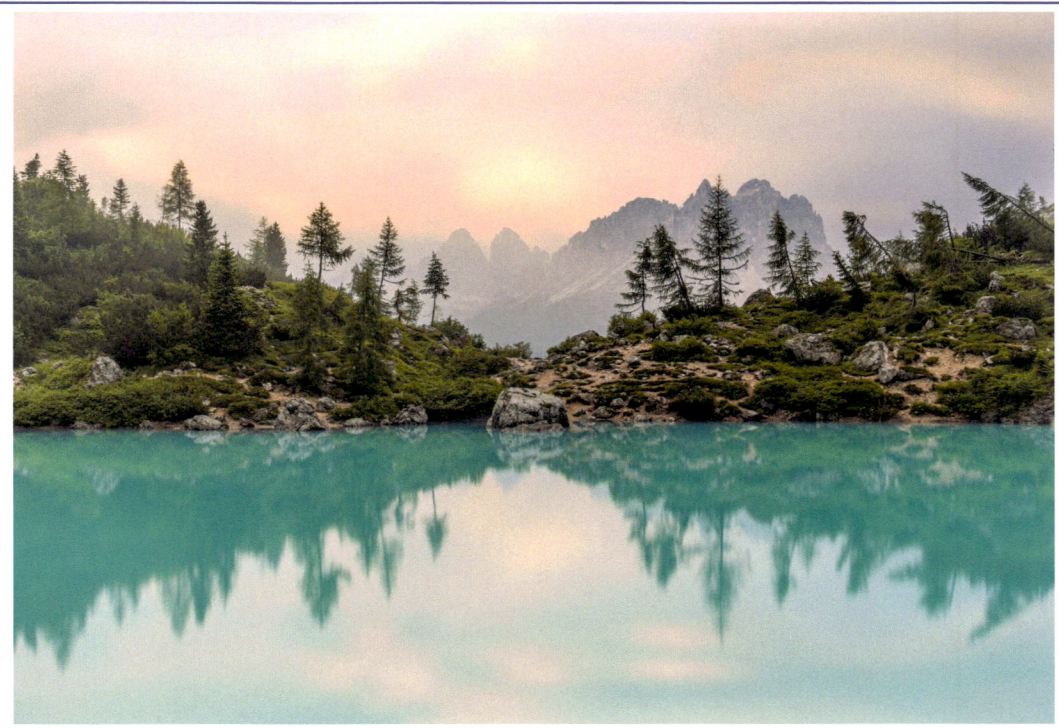

Sunset looking towards the Cadini di Misurina. Nikon D810, 24–70mm at 70mm, ISO 100, 1/100s at f/5, Jul.

Viewpoint 4 – Tree Stump

Following the main path just past the north-western corner of the lake, there is a beautiful old tree stump on its side. Get in nice and close to capture the fantastic detail while framing Dito di Dio in the background for a dramatic portrait composition. Unlike the other shots here, this one works best on a moody day in flatter light to really show off the intricate patterns and to capture the almost sinister nature of the gnarled old stump.

Viewpoint 5 – Ciadini & Tre Cime Groups

Finally as you reach the western and southern sides of Lago Sorapiss there are a number of opportunities for framing the distant Ciadini and Tre Cime groups. Try a longer lens to bring them closer, using the water and opposite shoreline as a foreground. The opposite bank slopes towards the path and there is a well-placed boulder which can be used to create some striking symmetry when combined with reflections in the lake. This works particularly well at sunset when the sky contrasts wonderfully with the aquamarine colour of the lake.

Opposite: *The tree stump at the south-west end of the lake. Nikon D810, 16–35mm at 16mm, ISO 100, 1/200s at f/7.1, Aug.*

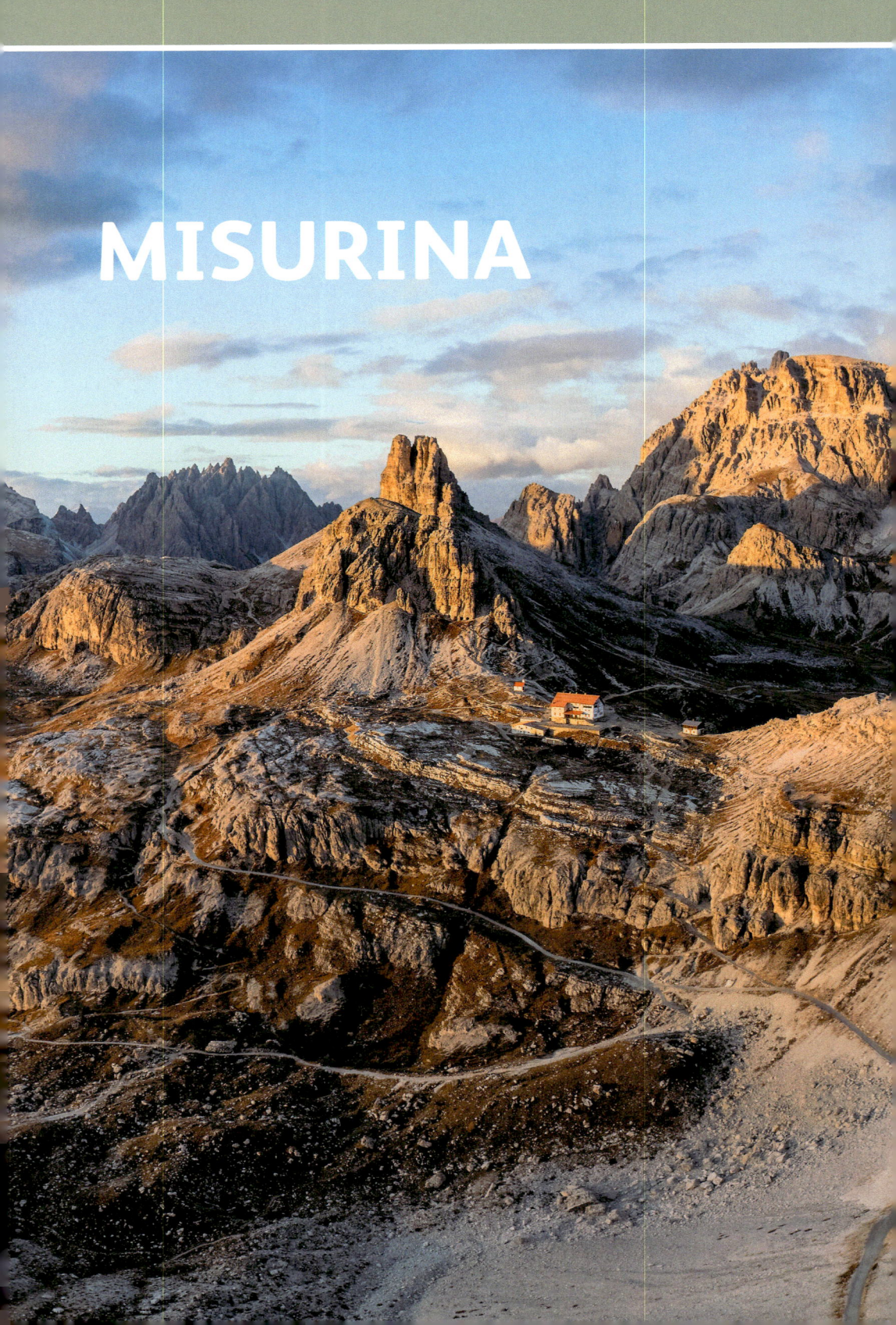
MISURINA

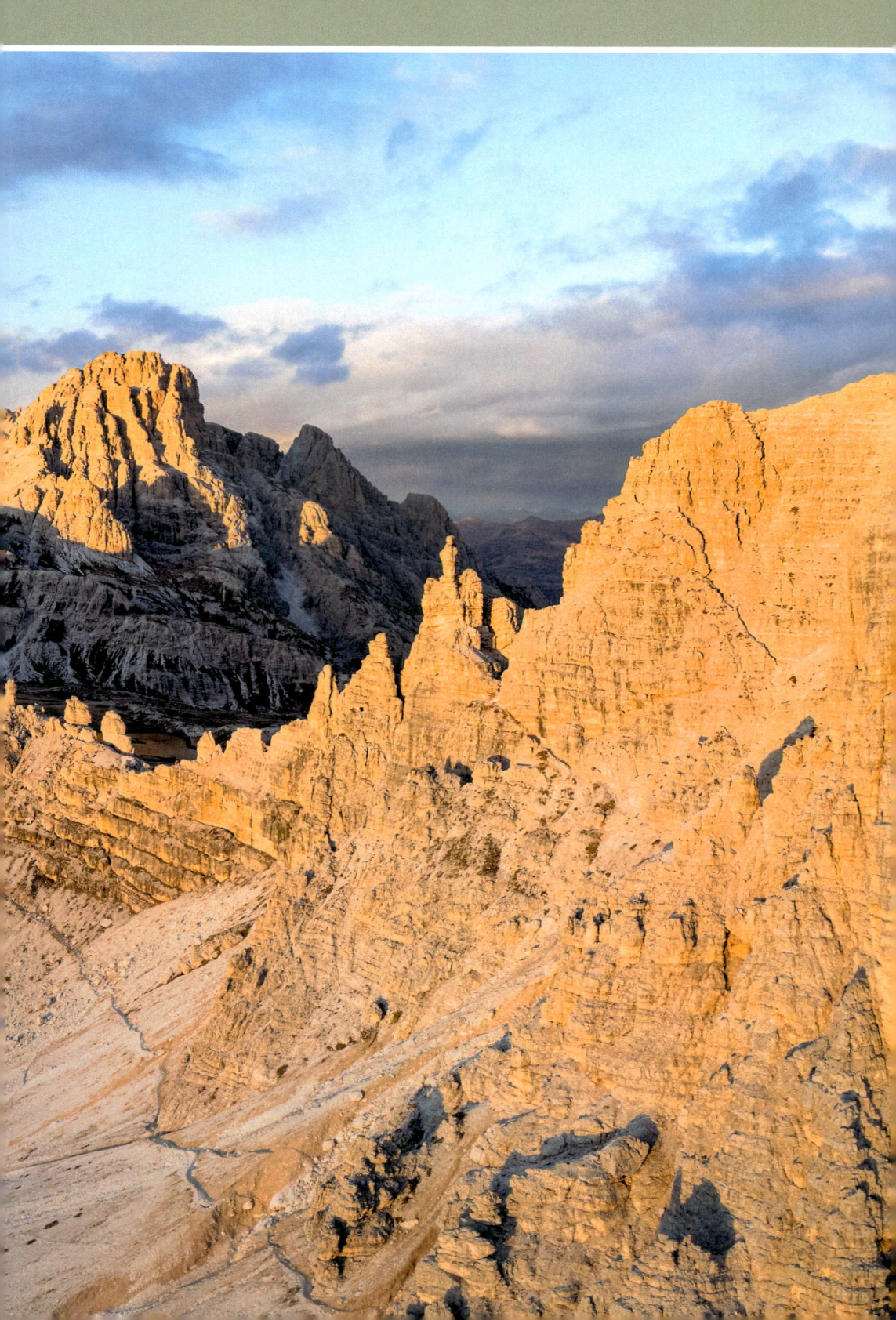

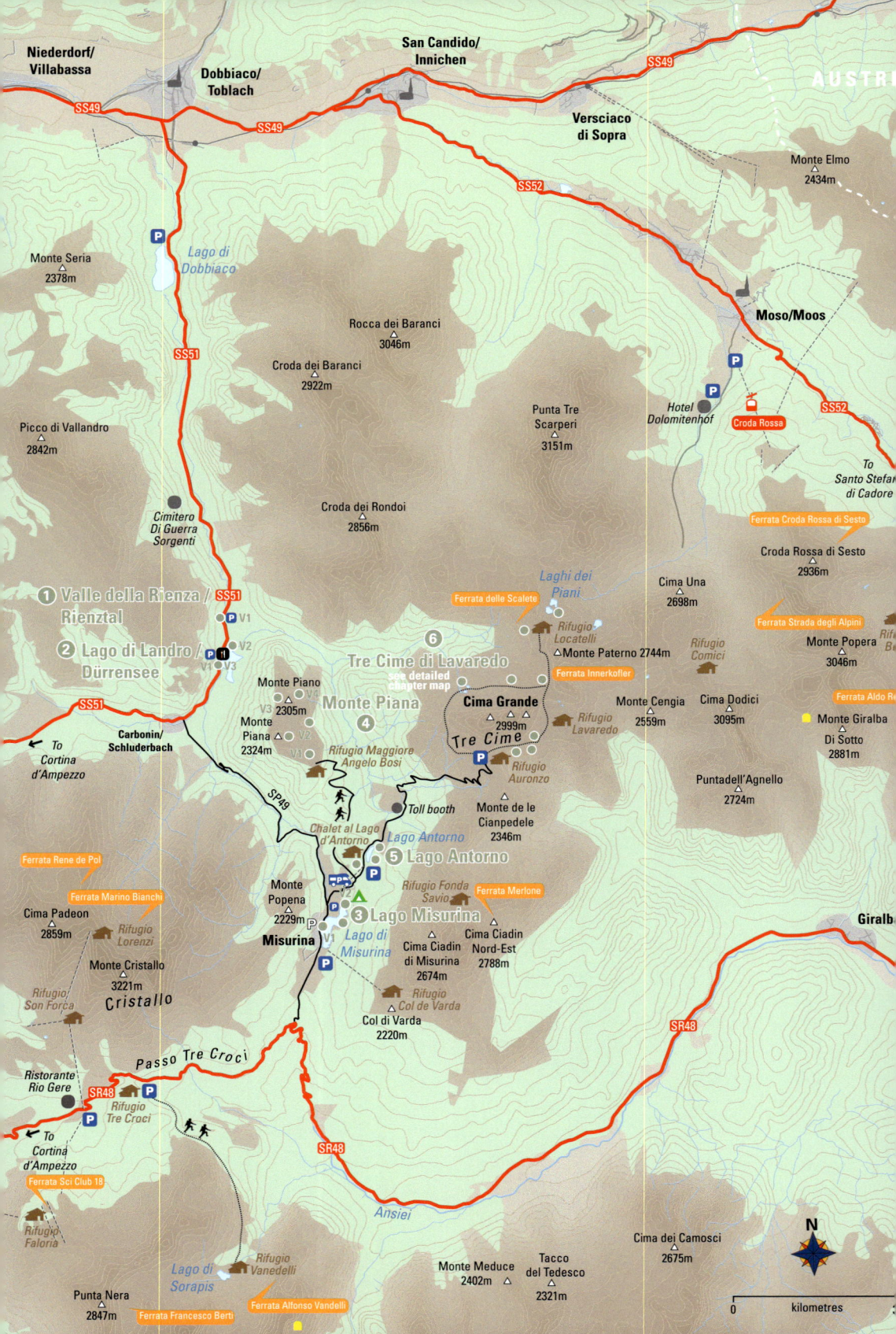

MISURINA – INTRODUCTION

At 1756m above sea level, Misurina is the highest hamlet in the municipality of Auronzo di Cadore and with a population of just 61 inhabitants at the last census, it is also one of the smallest. The hamlet itself is somewhat garish, capitalising on the huge tourist industry generated by visitors seeking a glimpse of the Tre Cime di Lavaredo, the Dolomites' most famous landmark. However, the views from the lake itself are undeniably spectacular whether looking south for the classic shot towards the Sorapiss group or capturing reflections of the Cadini di Misurina.

The magical atmosphere of the lake has led to numerous myths, tales, stories and legends surrounding the region. Perhaps the most ubiquitous of these is the story of a capricious little Princess named Misurina and her doting grandfather King Sorapiss. One day the Princess demanded he get her a magic mirror from the evil witch Cristallo and, unable to refuse her demands, he complied. However, the witch's price for the mirror was the King's life and when Misurina discovered his sacrifice she cried until the lake was filled by her tears. In despair she cast the mirror into the waters, which is why the lake still provides magical reflections to this day.

Although amenities are scarce in the small village itself, there are several large hotels, a campsite, supermarket and a camper van parking area or 'Stellplatz' set just back from the lake. Misurina lies equidistant from the larger towns of Cortina d'Ampezzo to the west and Auronzo di Cadore to the east, a scenic 12km drive in either direction for anyone requiring additional facilities. The mighty triad of monoliths that form the Tre Cime di Lavaredo can be accessed via the (very expensive) private toll road that departs just north of the lake. Forming part of the Sesto/Sexten group and once a Triassic coral reef, these three awe-inspiring peaks draw in thousands of visitors each year. The imposing north face of Cima Grande, first climbed by Emilio Comici in 1933, is regarded by climbers as one of the great north faces of the Alps and is one of the most distinctive and photographed mountains in the world. Once again the popularity of this area means large crowds and high prices are to be expected during high season, but if you stay overnight in one of the mountain huts you will find relative solitude at dusk and dawn.

Until 1919 these peaks formed part of the border between Italy and the Austro-Hungarian Empire. Now they lie on the border between the Italian provinces of the Alto Adige and Belluno, forming a linguistic boundary between German and Italian-speaking majorities. A fiercely contested location in the First World War, the whole area is riddled with history and scars of the past in the form of tunnels, trenches and dilapidated fortifications. One of the most fascinating places to see the impact of the war on this area is Monte Piana; standing high above Lago Misurina, the rocky summit plateau offers panoramic views of the surrounding mountains but was also the site of much tragedy and loss.

LOCATIONS

#	Location	Page
1	Valle della Rienza / Rienztal	388
2	Lago di Landro / Dürrensee	390
3	Lago Misurina	394
4	Monte Piana / Piano	398
5	Lago Antorno	406
6	Tre Cime di Lavaredo / Drei Zinnen	416
7	Monte Campedelle & Cadini di Misurina Viewpoint	434

Maps
- Tabacco (Italian): Map 10
- Kompass (German): Map 047

Previous spread: Rifugio Locatelli at sunset. Nikon Z7II, 24–120mm at 30mm, ISO 100, 1/100s at f/11, Oct.

① VALLE DELLA RIENZA / RIENZTAL

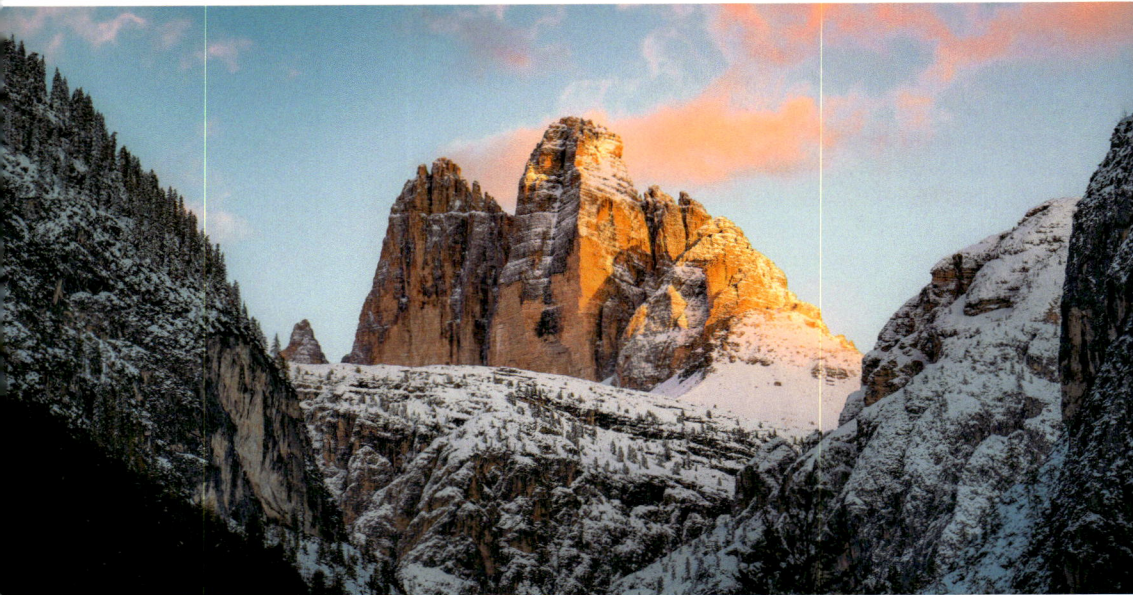

Last light on Cima Ovest. © Daniel Seßler.

Cutting a line east to west from the Tre Cime to Lago di Landro, the Valle della Rienza offers spectacular roadside views up to the iconic three peaks at Lavaredo (see page 416). Whilst the left tower – Cima Piccola is partially obscured, there are still excellent views of Cima Grande and in particular Cima Ovest.

This location is perfect for those who would like to view the Tre Cime north faces without having to make the hour-long walking approach from Rifugio Auronzo; or for those wishing to photograph the peaks during winter when access is difficult.

What to shoot and viewpoints

Viewpoint 1 – Tre Cime di Lavaredo North Faces & Cima Ovest

The towers should be clearly visible from the parking area when looking east on a clear day. Different perspectives can be gained by exploring the meadows and paths surrounding the carpark – the key is finding an uncluttered foreground whilst keeping the towers in view. A longer lens helps here, allowing the frame to be filled by the rock monoliths.

How to get here

Valle della Rienza is easily accessed using the SS51 which runs the length of the Valle di Landro. From Dobbiaco take the SS51 south for 12km, following signposting towards Cortina d'Ampezzo. The parking area is found on the left just before reaching Lago di Landro.

P Lat/Long:	46.63981, 12.23208
P what3words:	///misfits.halts.dealing
P Tabacco:	Map 10 (1:25.000)
P Kompass:	Map 47 (1:25.000)

Accessibility

Approach: Roadside access.

Disabled access: There is good disabled access on the paths surrounding the parking area.

Best time of year/day

This location is exceptionally photogenic and easy to access year-round provided the towers are free of low cloud.

The western aspect of Cima Ovest makes this an ideal late afternoon and sunset location when the face receives light. Four weeks on either side of summer solstice the sun moves around enough to illuminate the north faces before setting.

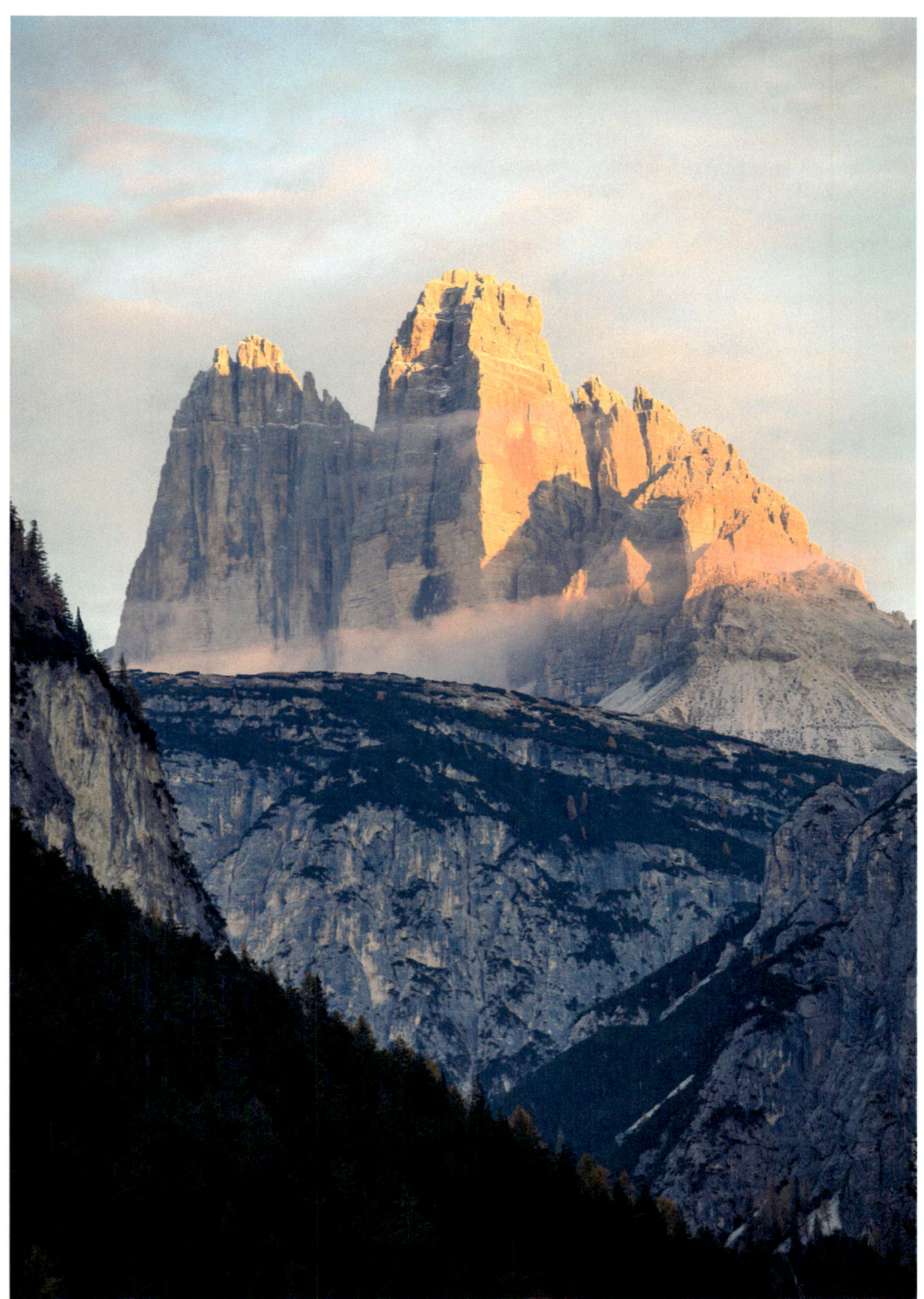

This is a perfect and easy to access sunset location. Nikon Z7II, 100–400mm at 150mm, ISO 64, 1/200s at f/5.6, Sep.

② LAGO DI LANDRO / DÜRRENSEE

Both easily accessible and stunningly beautiful, Lago di Landro straddles both the Fanes-Senes-Braies and Tre Cime Nature Parks. Relatively shallow for its size, the azure waters offer excellent reflections of the Cristallo group when looking south, whilst the eastern vista is dominated by Monte Piano (p.398).

Conveniently located on the SS51 linking Dobbiaco to Cortina d'Ampezzo through the Val di Landro, this location can easily be combined with stops at Lago Dobbiaco (p.110), the Valle della Rienza (p.388), Misurina (p.394) and Lago Antorno (p.406) to create an accessible roadside itinerary of idyllic views.

What to shoot and viewpoints

Please note that water levels vary significantly in Lago di Landro, dramatically changing both the foreground and accessibility of the lake shore.

Viewpoint 1 – Monte Piano & Piana ♿
Looking east from the parking area you immediately get a good view of Monte Piano and Piana, two trench-covered peaks that saw some of the fiercest fighting during the First World War. With a wide-angle, it is possible to take in the entire scene, whilst with a longer lens it is possible to isolate some of the trees on the eastern shore – a composition that works particularly well during the autumn.

Looking south along Lago di Landro towards the Cristallo group.

An old tree stump makes a perfect foreground on a still day. Nikon Z7II, 24–120mm at 50mm, ISO 64, 1/100s at f/8, Oct.

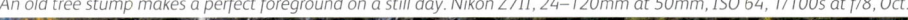

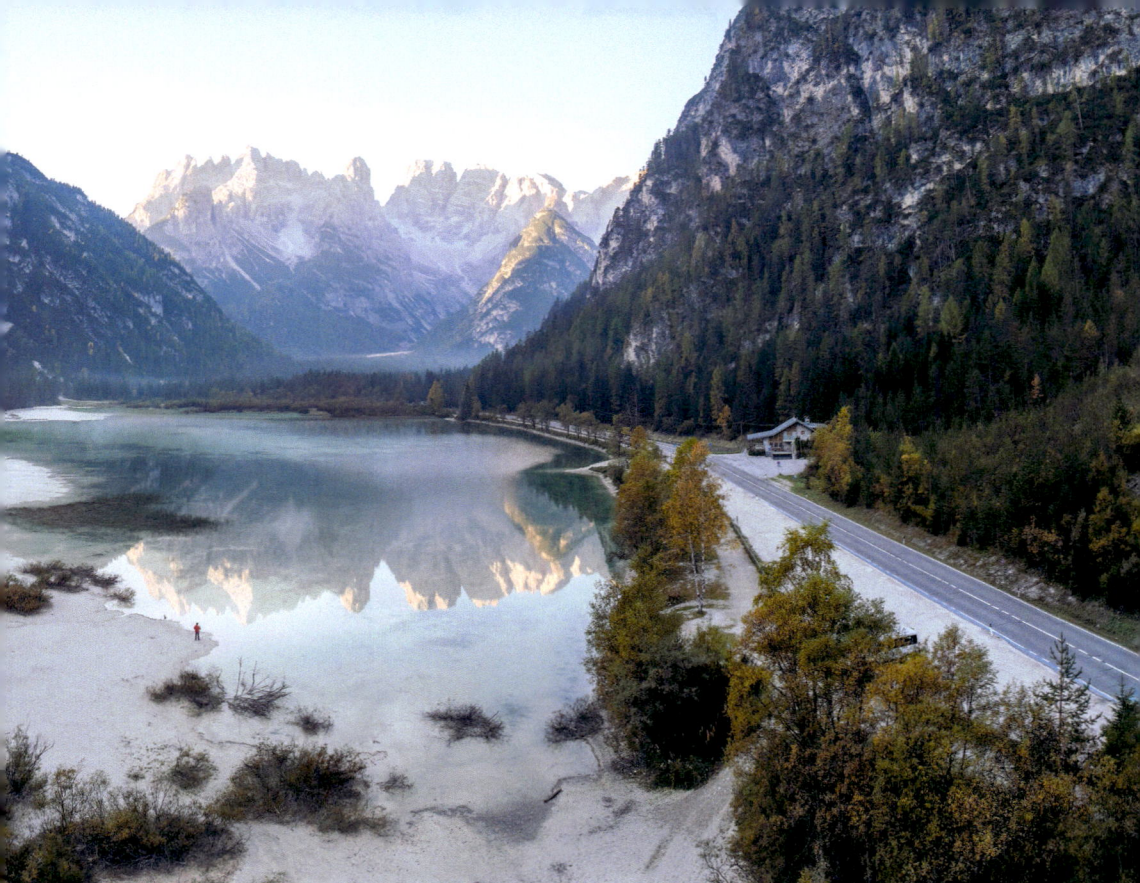

How to get here

Lago di Landro is easily accessed using the SS51 which runs the length of the Valle di Landro. From Dobbiaco take the SS51 south for 13km, following signposting towards Cortina d'Ampezzo. Just past the Valle della Rienza the lake comes into view on the left – there is a large parking area on the lake shore.

- **P Lat/Long**: 46.63368, 12.23081
- **P what3words**: ///sulked.equestrian.giver
- **P Tabacco**: Map 10 (1:25.000)
- **P Kompass**: Map 47 (1:25.000)

Accessibility

Approach: Roadside access.

Be aware the clay-rich ground can get extremely muddy near the shore when the water has recently receded. It is worth bringing a change of footwear.

♿ **Disabled access**: There a good views across the lake from the parking area. Disabled access to the northern shore will very much depend on the current water levels.

Best time of year/day

Roadside access and omnidirectional views make this a consistently good location year round – providing the lake is not completely frozen and covered in snow during the winter.

Viewpoint 2 – Cristallo Group

A path leads down to the lake shore from the northern end of the parking area. If the water levels are high it may be necessary to continue further north before doubling back to the lake edge. Dwarf pines, bushes, logs, patterns in the mud, and people all make for good foreground subjects looking south across the lake towards the dramatic peaks surrounding Monte Cristallo.

Viewpoint 3 – Western Shore

Throughout October and early November, the larches along the western shore make an impressive subject in their own right, especially when the lake is still, filling the waters with vibrant reflections of the autumn hues.

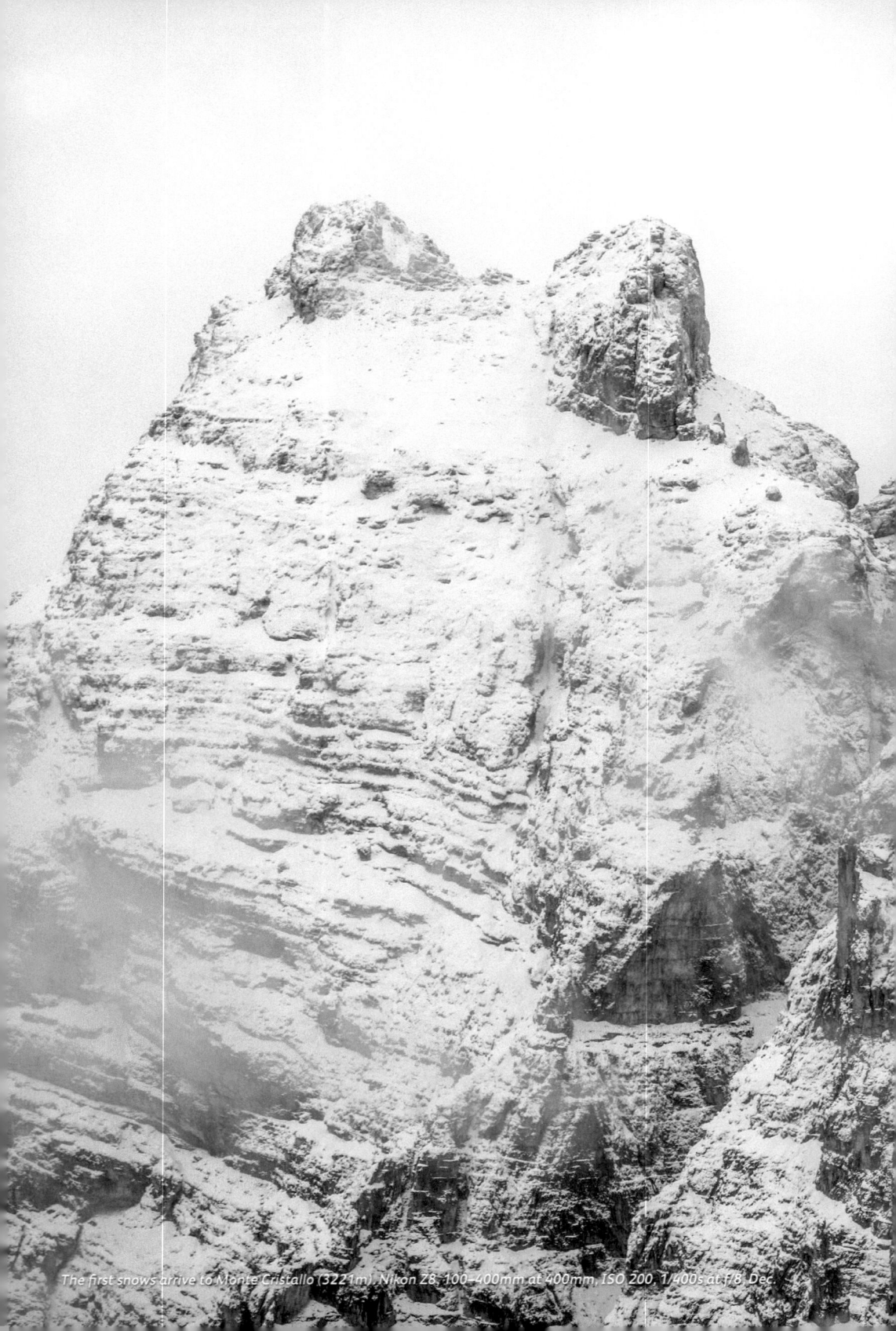

The first snows arrive to Monte Cristallo (3221m). Nikon Z8, 100–400mm at 400mm, ISO 200, 1/400s at f/8. Dec.

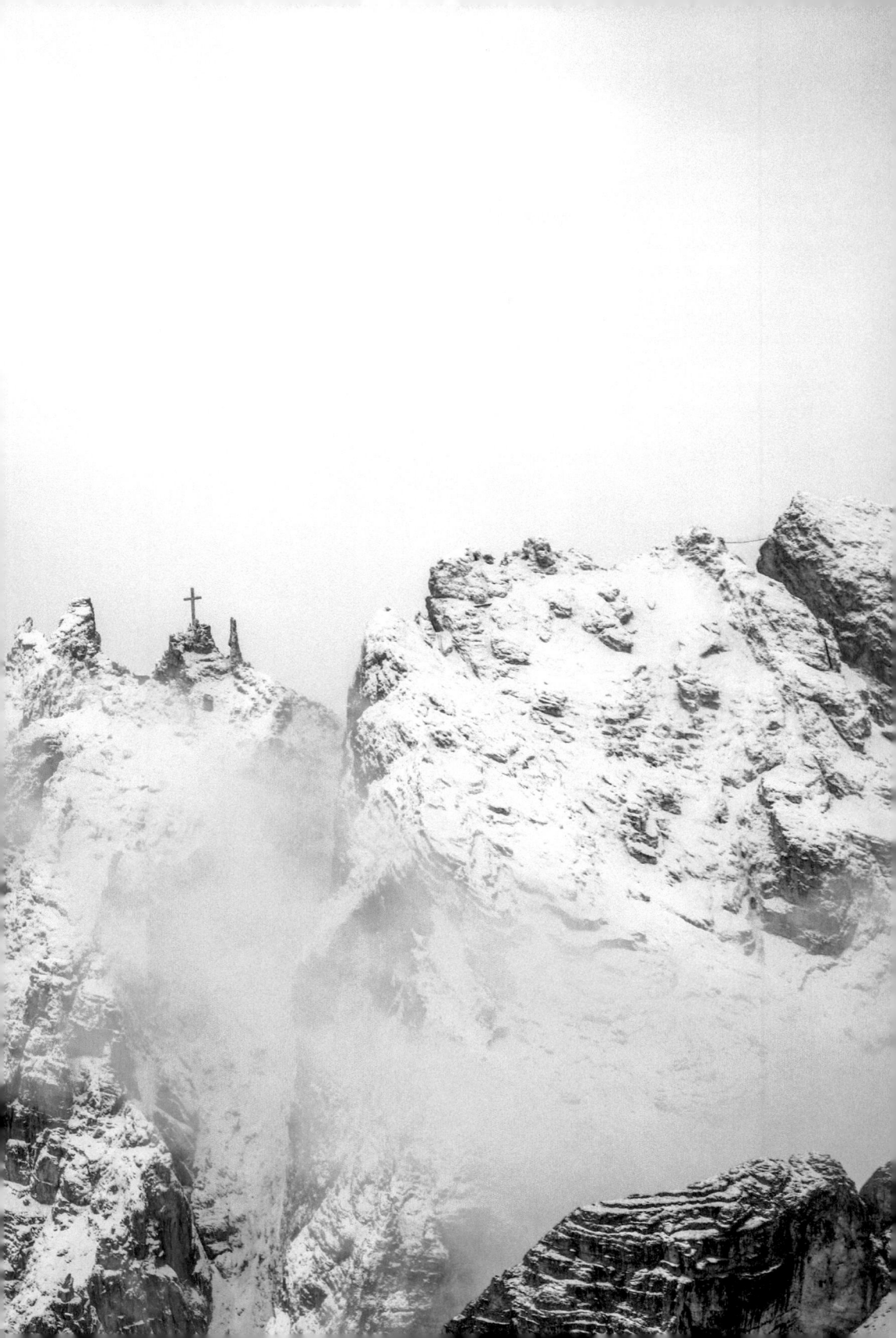

3 LAGO MISURINA

While some areas of Misurina have undoubtedly suffered from a somewhat overzealous approach to tourism, the views are undeniably spectacular, especially to the north and south. The lake is to be particularly recommended during the spring and autumn when the crowds have abated, allowing the excellent scenery to be shot in relative solitude. The ease of access and close proximity to the Tre Cime, Lago Antorno and Monte Piana make this a worthy stop as you explore the region.

What to shoot and viewpoints

Viewpoint 1 – Tre Cime South Faces ♿
Looking north-east from the parking area there is an excellent view of Ristorante Locanda Al Lago and the Tre Cime south faces. The linear shape and subtle colours of the restaurant make for an aesthetic reflection which provides a nice focal point without detracting from the rest of the image. During peak season cars parked along the road can look a little unsightly and a wider focal length may be required to ensure they don't draw the eye.

Viewpoint 2 – Sorapiss & Istituto Pio XII ♿
To reach the main viewpoint on the lake's northern shore, continue clockwise around the lake, following the road to reach a parking area just short of Ristorante Locanda Al Lago. Looking south there is now an excellent view of the respiratory hospital Istituto Pio XII backed by the Sorapiss group. The pale yellow building makes an excellent focal point, particularly if positioned in the dead centre of the frame to create some beautiful symmetry on a still day when the water reflections are clear. The shot works at a variety of focal lengths but take care not to crop out the full reflection of the Sorapiss mountains.

Opposite top: Early morning mist is a common sight on the lake. Canon G12 at 18mm, ISO 80, 1/160s at f/4, Jun. **Bottom**: A hard morning winter frost. Nikon D850, 24–70mm at 50mm, ISO 100, 1/800s at f/2.8, Feb.

Using a long exposure to help bring out the reflections of Istituto Pio XII. Nikon Z7II, 24–120mm at 60mm ISO 64, 15s at f/11, tripod, ND filter, Oct.

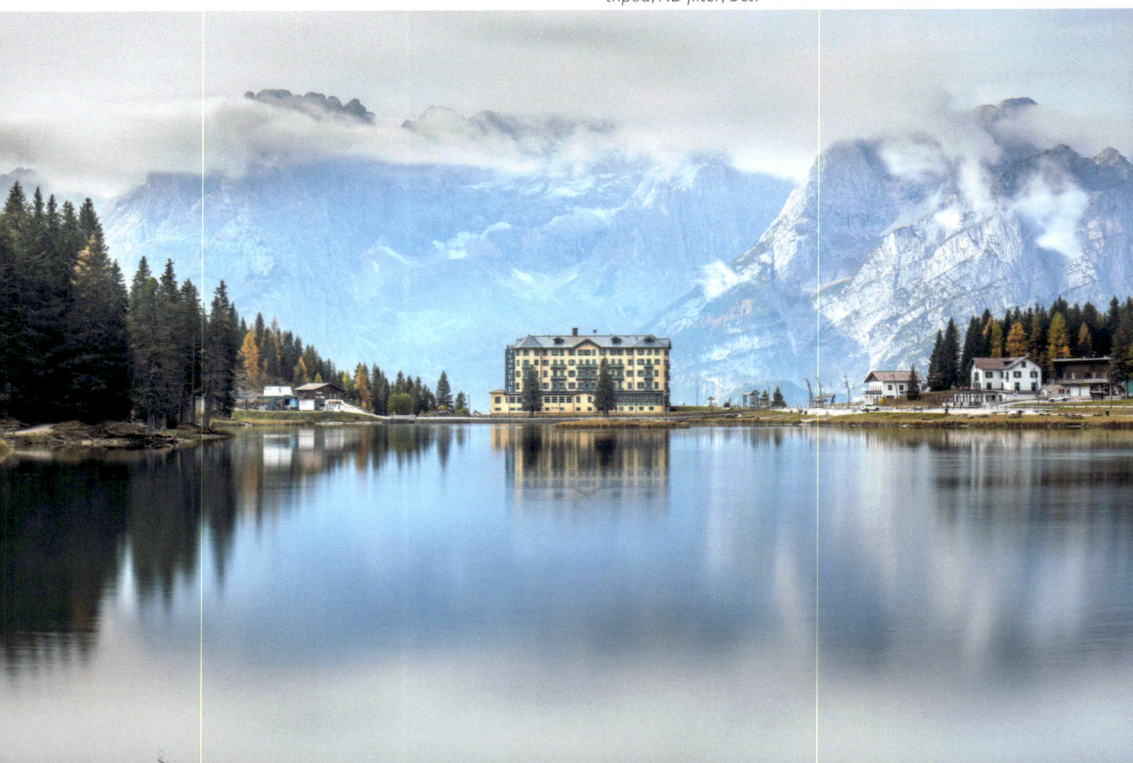

How to get here

Misurina can be approached from Cortina d'Ampezzo via the Passo Tre Croci, from Dobbiaco via the SS51 or Auronzo via the SR48. There is a large parking area on the western shore.

Lat/Long:	46.58401, 12.25392	
what3words:	///assessed.stylistic.pesky	
Tabacco:	Map 10 (1:25.000)	
Kompass:	Map 47 (1:25.000)	

Accessibility

Approach: Roadside access.

Disabled access: A good and well-surfaced path circumnavigates the lake and provides excellent disabled access.

Best time of year/day

The lake is best shot throughout the spring and autumn, taking advantage of the relative tranquillity of low season. The mountain backdrops and in particular the Sorapiss group look especially striking when they're covered in snow, contrasting nicely with the green of the nearby forests.

Thanks to the opposite facing viewpoints, good light can be found throughout the day although sunrise is to be particularly recommended if only for the solace it provides.

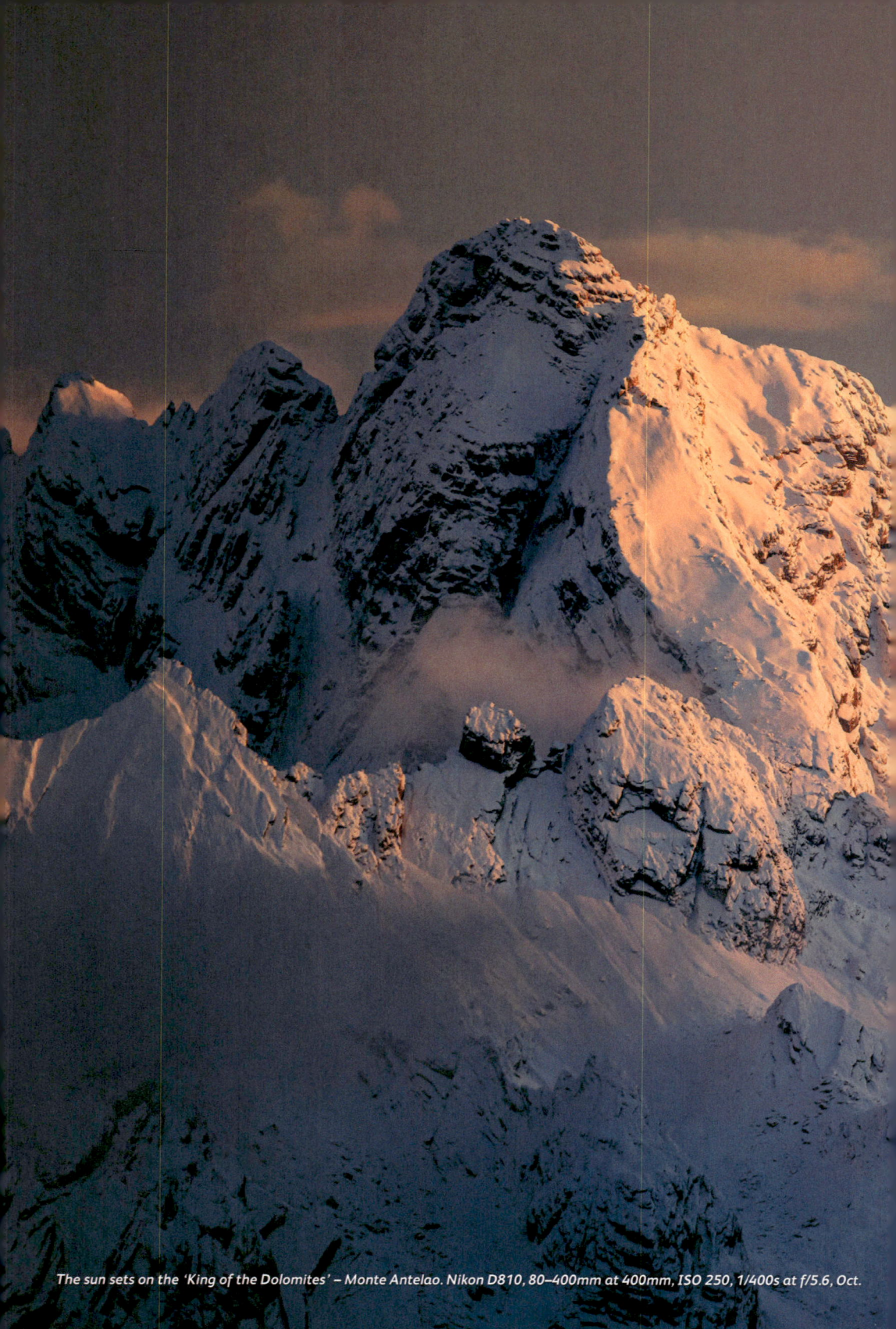
The sun sets on the 'King of the Dolomites' – Monte Antelao. Nikon D810, 80–400mm at 400mm, ISO 250, 1/400s at f/5.6, Oct.

[4] MONTE PIANA / PIANO

The broad mountain top of Monte Piana is superbly positioned, offering 360 degree views encapsulating many of the most iconic peaks surrounding Cortina d'Ampezzo, Misurina and Auronzo di Cadore. The isolated location boasts unobstructed views over the Tre Cime di Lavaredo, Sesto, Cadini di Misurina, Sorapiss and Cristallo groups while also providing a bird's eye perspective over Lago Misurina itself. This undeniably spectacular vantage point made it a key objective during the Great War where more than 14,000 soldiers lost their lives contesting the 2km wide summit plateau. Following the tactical withdrawal of the Austro-Hungarian forces to the highlands, the Italian troops secured the peak of Monte Piana while the Austrians occupied and fortified the nearby summit of Monte Piano to the north. Separated by the Forcella dei Castrati a period of tunnelling, trench warfare and extreme close quarter fighting ensued with neither side making significant advancements. Today the site is the location of a vast open air war museum first established by the Austrian Colonel Walter Schaumann as part of his 'Friends of the Dolomites' initiative.

From a photographer's perspective, the diverse mix of stunning views, war memorabilia, trenches and tunnels combined with the presence of several exposed protected paths that criss-cross the site makes it an ideal shooting venue.

During the summer months the mountain is easily accessed using the Jeep taxi service that runs between Misurina and Rifugio Maggiore Angelo Bosi, from where a short walk leads to the summit.

Last light on Monte Cristallo. Nikon D810, 80–400 at 400mm, ISO 360, 1/400s at f/5.6, Nov.

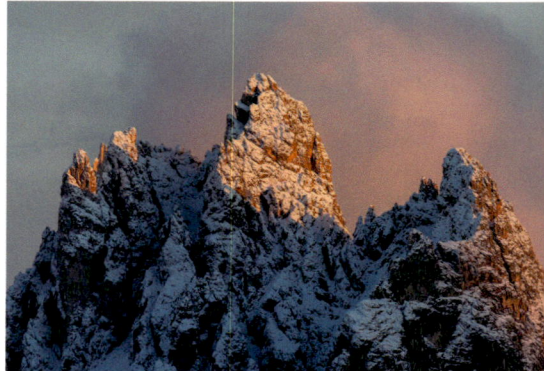

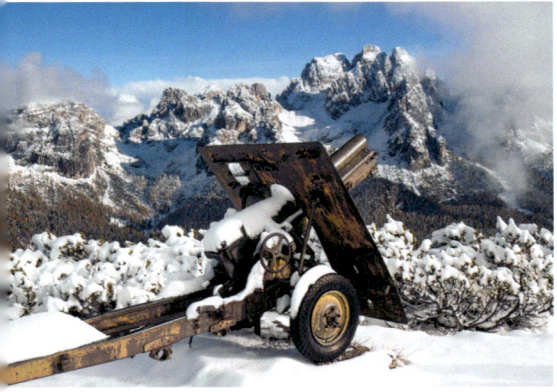

What to shoot and viewpoints

Viewpoint 1 – Artillery Piece & Chapel ♿

Just north and adjacent to Rifugio Maggiore Angelo Bosi sits an authentic field gun dating back to the First World War. The weapon enjoys a good field of view out over the valley and can be used as an effective foreground when shooting the Cadini di Misurina spires. Alternatively the rapidly corroding metalwork, gears, pulleys and levers make for an excellent industrial abstract that is definitely at odds with the surrounding landscape. The scene is particularly striking during bleak and stormy weather allowing for an evocative and sombre composition to be attained.

The nearby chapel is also worthy of photographic attention as the approaching steps make for a great set of symmetrical leading lines towards the structure. A wide-angle lens is ideal for creating a stark and minimalistic image of converging lines.

Top: Following Sentiero Storico, with views of the Tre Cime and Val Rienza. Nikon D810, 16–35mm at 35mm, ISO 64, 1/320s at f/9, Sep.

Above: An artillery piece watches over the valley. Nikon D810, 24–70mm at 42mm, ISO 100, 1/3200s at f/2.8, Oct.

Opposite: One of the many memorial crosses found on the plateau. Nikon D810, 16–35mm at 16mm, ISO 100, 1/320s at f/9, Oct.

 MONTE PIANA / PIANO

Co-habitation

The two armies lived shoulder to shoulder. Berti told of an infantryman who got lost with his mess tin in hand brimming with wine, and who wandered into the Austrian camp and was taken prisoner. Standschuetzen Luigi Ghedina, son of the photographer Giacinto, took the coat of an Alpini soldier who had gone to relieve himself behind a spur, and had to escape with his trousers around his ankles. Finally, there are countless tales of trades made well away from the prying eyes of the officers. Austrian tobacco was traded for meat rations and good white bread that the Italian army still distributed in the trenches.

One of the memorials and tributes adorning Monte Piana. Nikon D810, 80–400mm at 250mm, ISO 100, 1/400s at f/10, Oct.

4 MONTE PIANA / PIANO

From Rifugio Maggiore Angelo Bosi the summit of Monte Piana is well signposted to the north-west. It is also possible to follow the Sentiero Storico, a protected path with several exposed passages that winds between the two summits exploring a number of historical sites of interest.

Viewpoint 2 – War Remains & Open Air Museum
The site is liberally covered with tunnels, trenches, gun emplacements, shrines, memorials and barbed wire that make for a nearly endless supply of shooting opportunities and suit an impulsive style of photography.

Viewpoint 3 – Monte Piana & Piano Summits
The two peaks are clearly marked with large summit crosses and both provide excellent vantage points from which to shoot the surrounding landscape. As with the war remains, the possibilities are numerous with excellent views in every direction. Once again it's better to be spontaneous depending on the conditions, picking out the best light with a variety of focal lengths as required.

Viewpoint 4 – Highliners
A number of ravines and chasms carve up the plateau perimeter, creating a series of dramatic buttresses which are perfect for highliners looking to walk between the gaps. In fact, Monte Piana has become a renowned venue for the sport and there is now an international gathering each year in September.

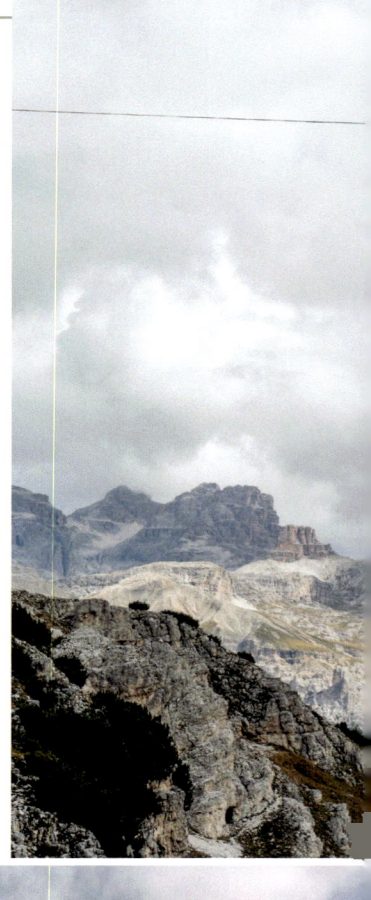

Jediah Doohan highlining in front of the Tre Cime di Lavaredo. Nikon D810, 16–35mm at 35mm, ISO 100, 1/400s at f/10, Sep.

Looking down at Lago Misurina from Monte Piana. Nikon Z7II, 100–400mm at 220mm, ISO 64, 1/250s at f/8, Oct.

How to get here

Monte Piana is approached from Area Sosta, a large parking area opposite Camping Alla Baita on the north shores of Lake Misurina.

Misurina can be approached from Cortina d'Ampezzo via the Passo Tre Croci, from Dobbiaco via the SS51 or Auronzo via the SR48.

During the summer a well-marked and signposted Jeep taxi service runs between the car park and Rifugio Maggiore Angelo Bosi.

Alternatively, Monte Piana can be approached on foot along the access track used by the taxis or along path 122 which departs from Lago Antorno.

Finally, for a more adventurous approach Monte Piana can also be approached from Lago di Landro to the north-west using Via Ferrata Bilgeri (suitable via ferrata equipment required).

Lat/Long:	46.58862, 12.25726	
what3words:	///festivities.evolves.wimp	
Tabacco:	Map 10 (1:25.000)	
Kompass:	Map 47 (1:25.000)	

Accessibility

Approach: 20 minutes, 1km, 150m of ascent.

The paths navigating the open air museum are rocky and uneven, while the Sentiero Storico is exposed in places.

♿ Disabled access: While it is possible to access Rifugio Maggiore Angelo Bosi and Viewpoint 1 using the Jeep taxi service, the rocky and undulating nature of the main plateau make it less than ideal for disabled access.

Best time of year/day

The location is most easily accessed when the Jeep taxi service is in operation between mid June and early November. This also coincides with the opening of Rifugio Maggiore Angelo Bosi which offers accommodation for anyone wishing to take advantage of sunrise and sunset. The barren nature of the plateau makes it less seasonally dependant than other areas, although the site is difficult to access during the winter without mountaineering experience.

The variety of viewpoints and backdrops makes it ideal for shooting throughout the day, following the best light.

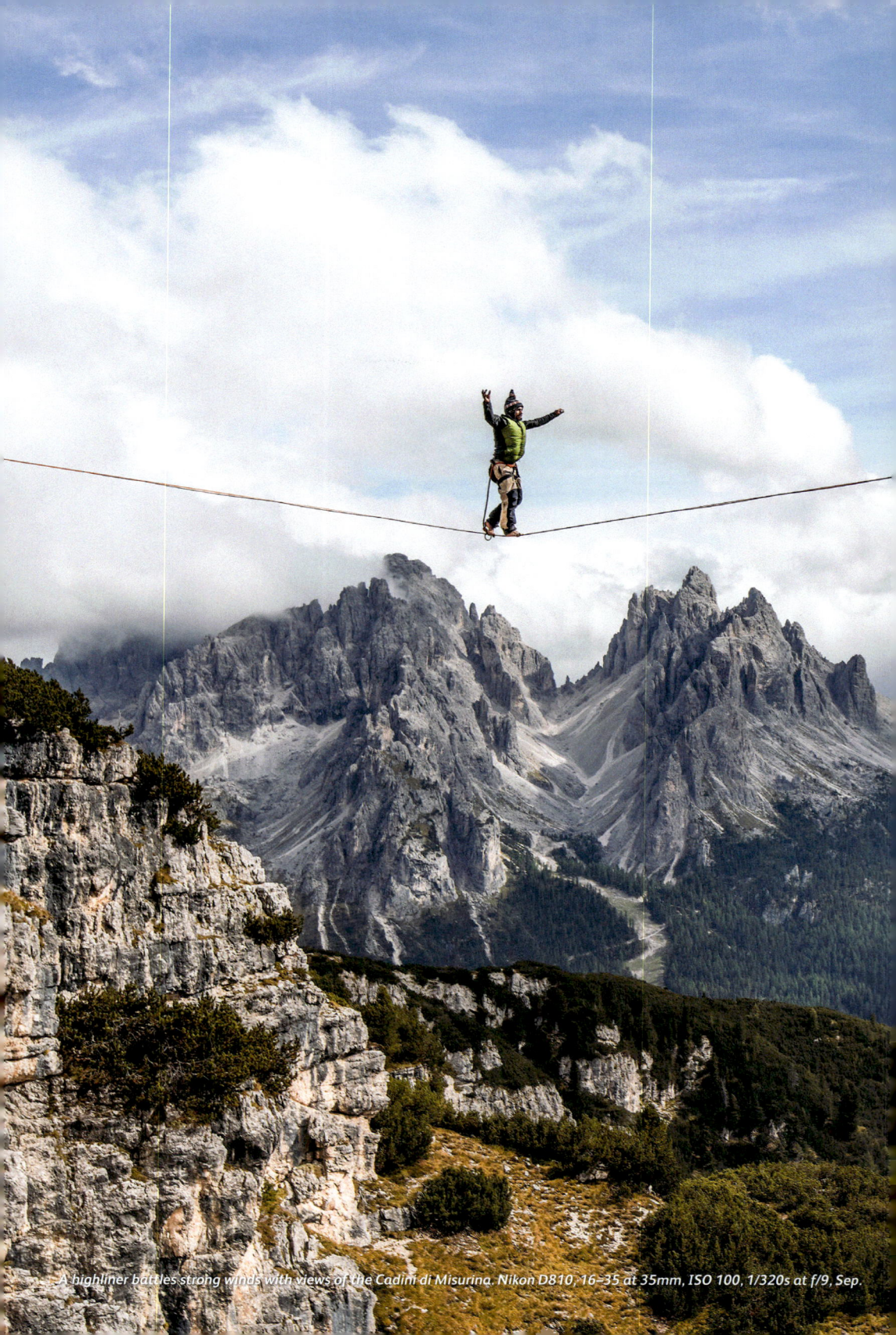
A highliner battles strong winds with views of the Cadini di Misurina. Nikon D810, 16–35 at 35mm, ISO 100, 1/320s at f/9, Sep.

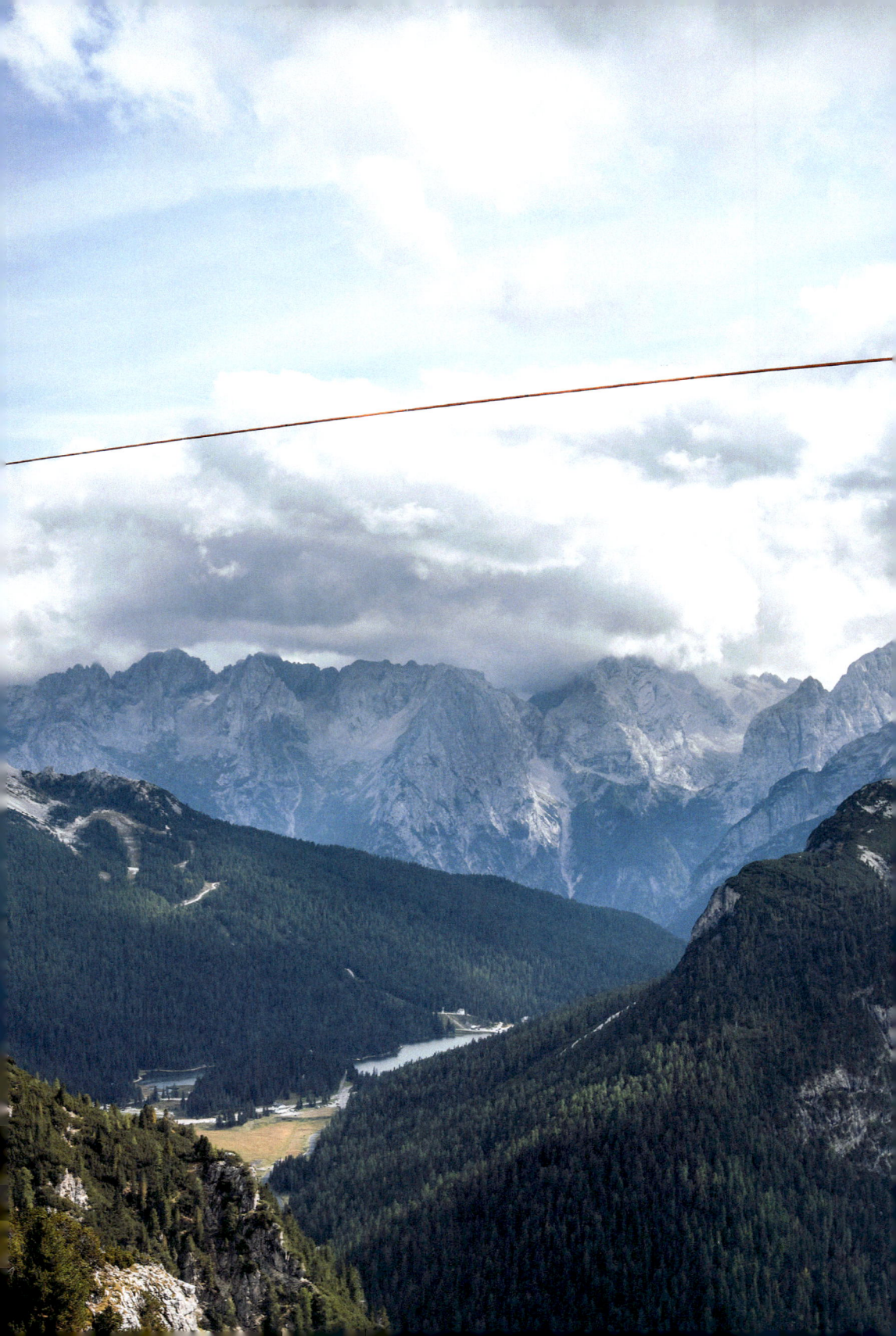

5 LAGO ANTORNO

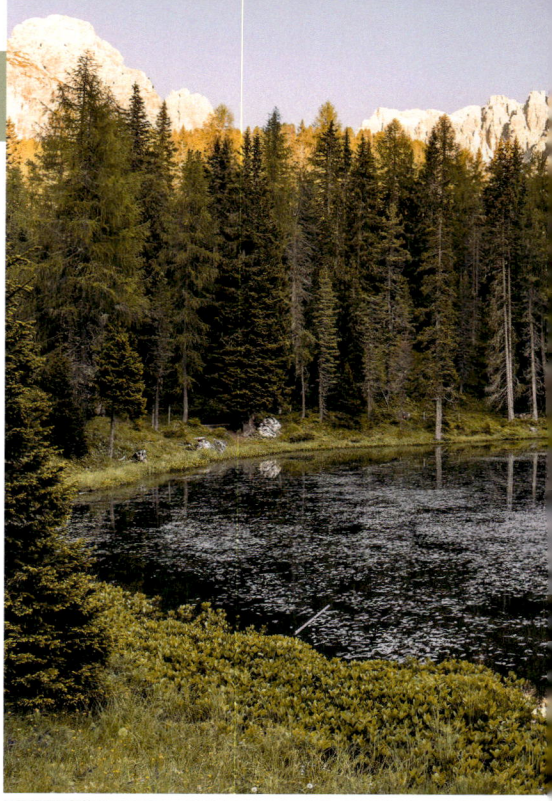

This beautiful little lake situated just before the Auronzo toll road station is often ignored by tourists eager to reach the world-famous Tre Cime. However, in their haste they miss a truly beautiful little spot which has a lot to offer the creative photographer, in particular providing some stunning reflections of the Tre Cime south faces, Cadini di Misurina and Sorapiss groups. Despite the lake's modest dimensions, the site offers a number of superb vistas, some great wildlife opportunities and an eclectic range of freshwater flora. The close proximity to the road offers very convenient access yet the lake retains a natural feel and is rarely crowded.

While the majority of the best viewpoints are situated in close proximity to the small (and very photogenic) bridge opposite Chalet al Lago d'Antorno, it is worth taking the time to make a quick circuit of the lake to take in the many different viewpoints and panoramas.

What to shoot and viewpoints

Viewpoint 1 – Wooden Bridge ♿

Located opposite Chalet al Lago d'Antorno and easily visible from the road lies a small wooden bridge on the south-western shore of the lake. Thanks to its close proximity to the lake's edge and neighbouring pond, it provides an excellent foreground for a number of different compositions. A wide-angle lens allows you to frame the Tre Cime towers in the back left of the shot while using the bridge as a front right foreground, the pond providing some excellent reflections if the light is right. It is also possible to shoot east, framing the bridge against the impressive mountain backdrop of the Cadini di Misurina. Finally, if you can find a suitable model try a portrait shoot isolating the bridge itself; the wooden beams on the side provide a number of creative options.

Opposite top: A 6 photo panorama of Lago Antorno taken from the lakes northern end. Nikon Z8, 20mm, ISO 64, 1/100s at f/8, Aug.
Bottom: The classic perspective using the pond and wooden bridge for foreground interest. Nikon Z7II, 24–120mm at 24mm, ISO 64, 1/30s at f/8, Aug.

How to get here

Lago Antorno is located just before the toll station on the road to Rifugio Auronzo and the Tre Cime di Lavaredo. From Misurina, drive north on the SS48 keeping the lake on the right. Continue 50m past the end of the lake to where a road is signed right to the Tre Cime. Follow this past a camper van park (left) and campsite (right) and continue steeply uphill for 1km to reach Chalet al Lago d'Antorno, from where the lake is clearly visible on the right. There is ample parking on both sides of the road.

📍 **Lat/Long**:	46.59422, 12.26411
📍 **what3words**:	///parapet.holly.poach
📍 **Tabacco**:	Map 10 (1:25.000)
📍 **Kompass**:	Map 47 (1:25.000)

Accessibility

Approach: Roadside access.

♿ **Disabled access**: There is good disabled access to the south and west lake shores.

Best time of year/day

Best avoided in winter as the lake is covered in ice and snow, this site is an excellent venue in spring, summer and autumn and is well worth combining with a trip to the Tre Cime di Lavaredo.

When viewed from the lake, the south-westerly aspect of the Tre Cime makes for a particularly good late afternoon/evening shoot when the towers are often bathed in a beautiful evening light. The location is also worth a visit in mixed weather conditions

Above: During September dragonflies can be seen along the banks. Nikon D810, 80–400mm at 400mm, ISO 100, 1/500s at f/7.1.
Below: Sunrise from the northern end looking towards the Sorapis group. Nikon Z7II, 24–120mm at 30mm, ISO 64, 1/20s at f/8, Jun.

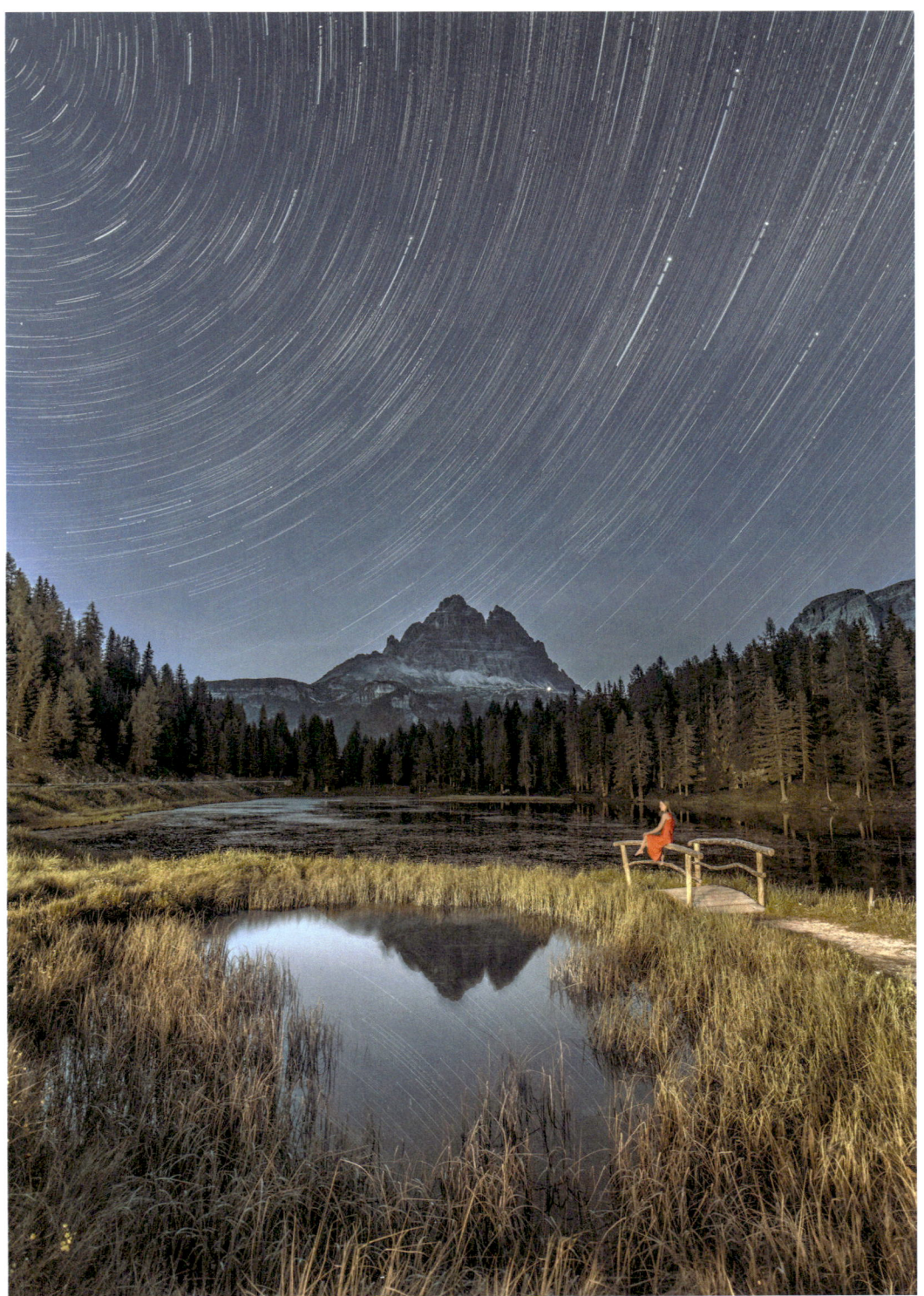
The bridge presents an excellent portrait opportunity. Nikon D810, 14–24mm at 18mm, ISO 400, 30s (x75) at f/2.8, tripod, Jun.

Intentional camera movement (ICM) using a long focal length. Nikon D850, 70–200mm at 200mm, ISO 31, 0.4s at f/22, Oct.

5 LAGO ANTORNO

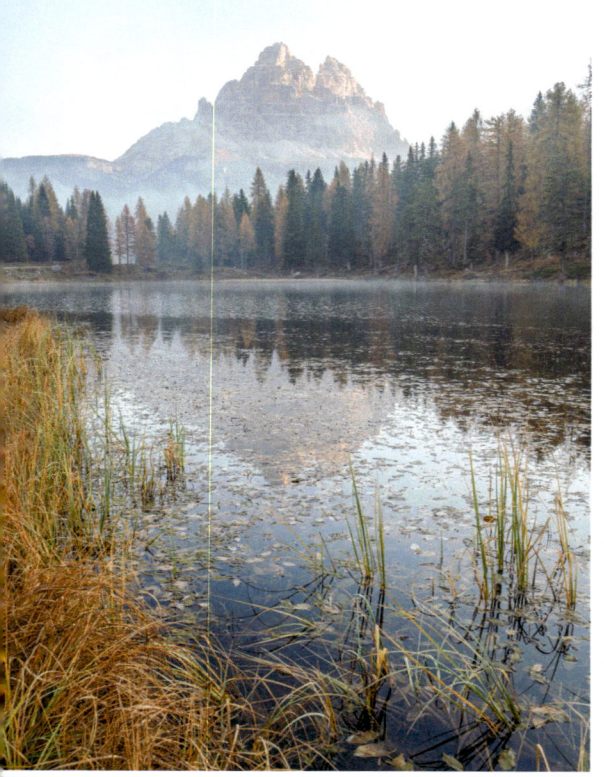

Viewpoint 2 – Boat Launch ♿
Some 10m south of the bridge lies a seldom-used boat launch. Here much of the surface vegetation has been removed, allowing a cleaner reflection of the Tre Cime south faces. With a wide-angle lens you can create some fantastic symmetry between the towers and trees on the opposite shore. Try to frame the Tre Cime in the area of clearer water for maximum effect. With a longer lens and portrait orientation it is also possible to isolate the Tre Cime on their own, again creating some really striking symmetry. Try to avoid using a polarising filter as this reduces the vibrancy of the water surface reflections.

Viewpoint 3 – Sorapiss Group ♿
If you traverse Lago di Antorno to its north side (it is shorter to move clockwise but the anti-clockwise direction is arguably more scenic), you are rewarded with some lovely views towards the Sorapiss and Marmarole massifs.

The grassy island dominating the north-east corner of the lake forces the composition somewhat (unless you're lucky enough to catch the two weeks of the year when it is in flower) and the area adjacent to the road usually provides the best composition. A lack of striking foreground on the shore and the distance of the mountain groups dictates the use of a longer lens to take advantage of the perspective compression created by a large zoom, bringing the mountains closer.

Viewpoint 4 – Wooden Bench ♿
Finally at the south-west corner of the lake there is a very photogenic wooden bench looking down the length of Antorno towards the Tre Cime. The wood grain makes for a good foreground in itself but place a couple of subjects on the bench looking into the distance and you have a superb composition to play with. This shot works particularly well in late afternoon when there is often excellent light on the south faces.

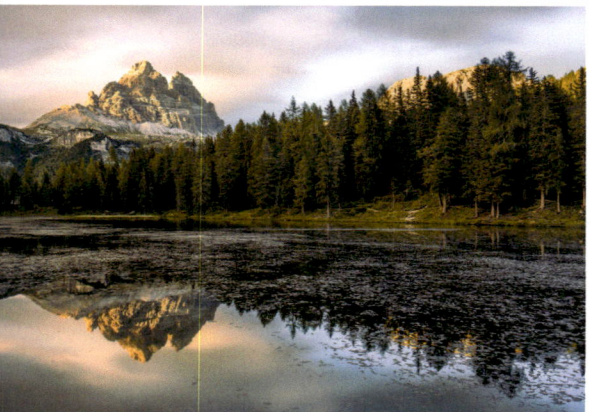

Top: There are lots of reeds that make for excellent foregrounds. Nikon Z7II, 24–120mm at 24mm, ISO 64, 1/25s at f/14, Oct.

Above: A still day produces the best results at Antorno. Nikon D810, 28–300mm at 28mm, ISO 100, 30s at f/16, tripod, ND filter, Jun.

Opposite: Afternoon storm light on the Tre Cime south faces. Nikon D810, 28–300 at 50mm, ISO 400, 1/100s at f/11, Jun.

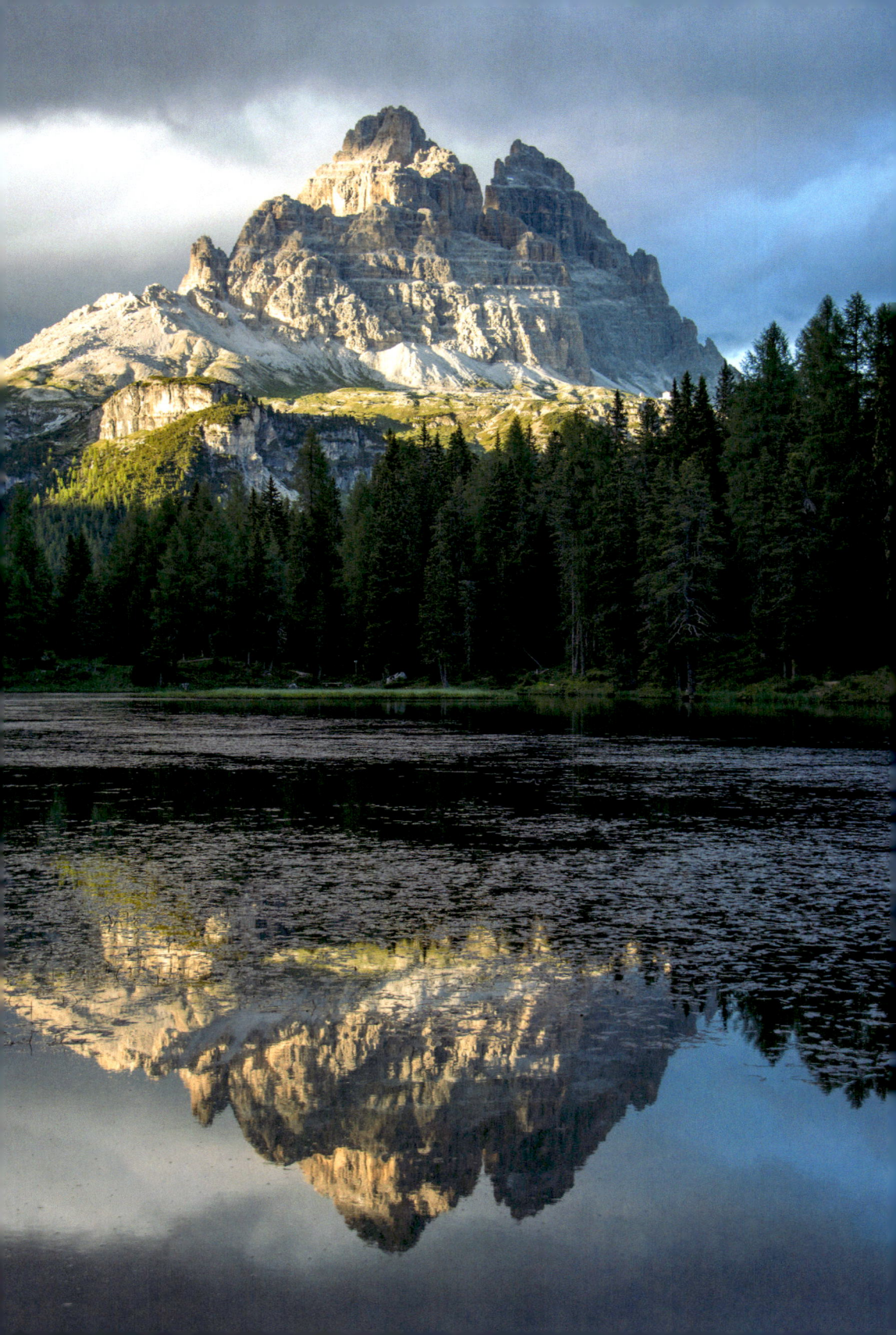

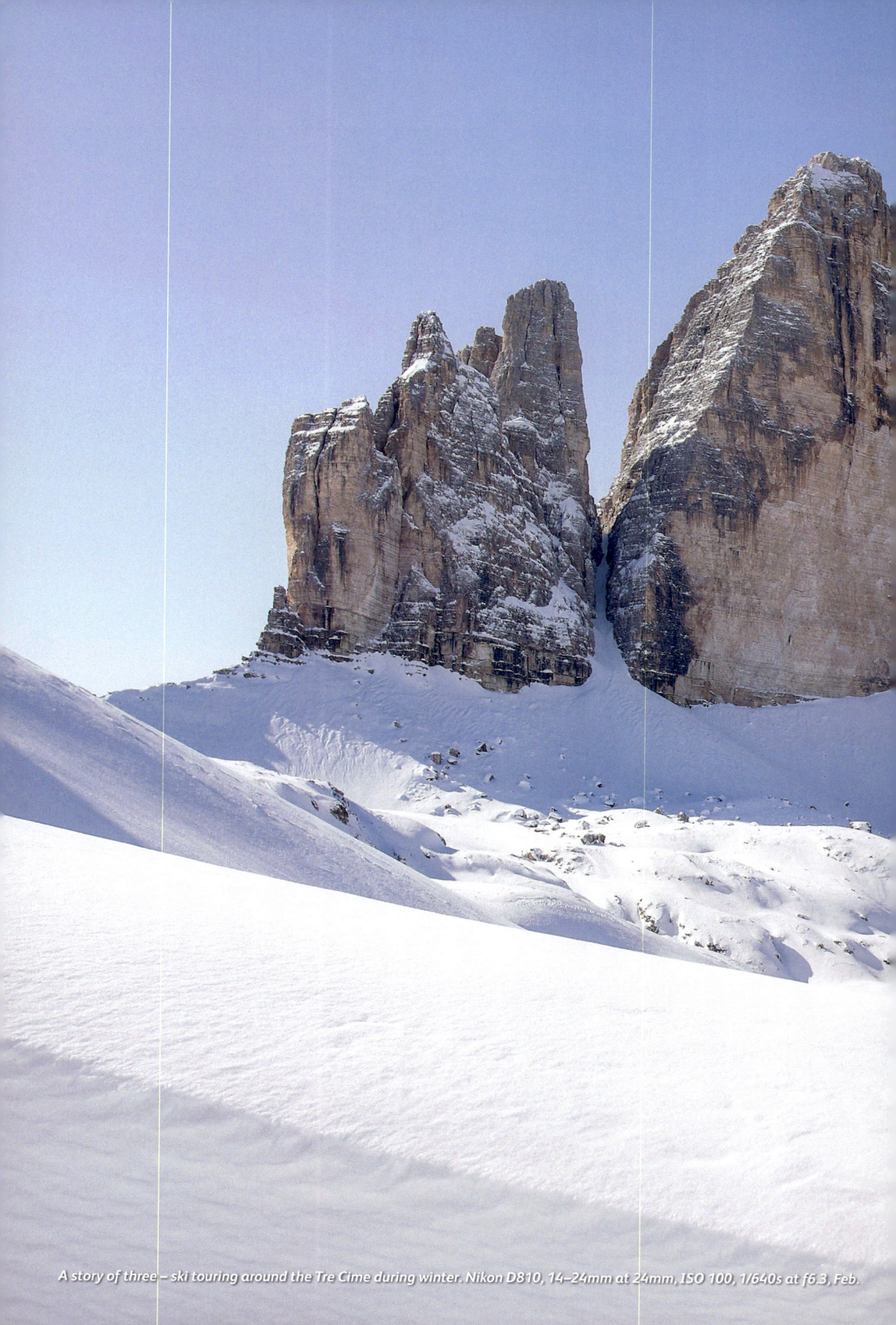

A story of three – ski touring around the Tre Cime during winter. Nikon D810, 14–24mm at 24mm, ISO 100, 1/640s at f6.3, Feb.

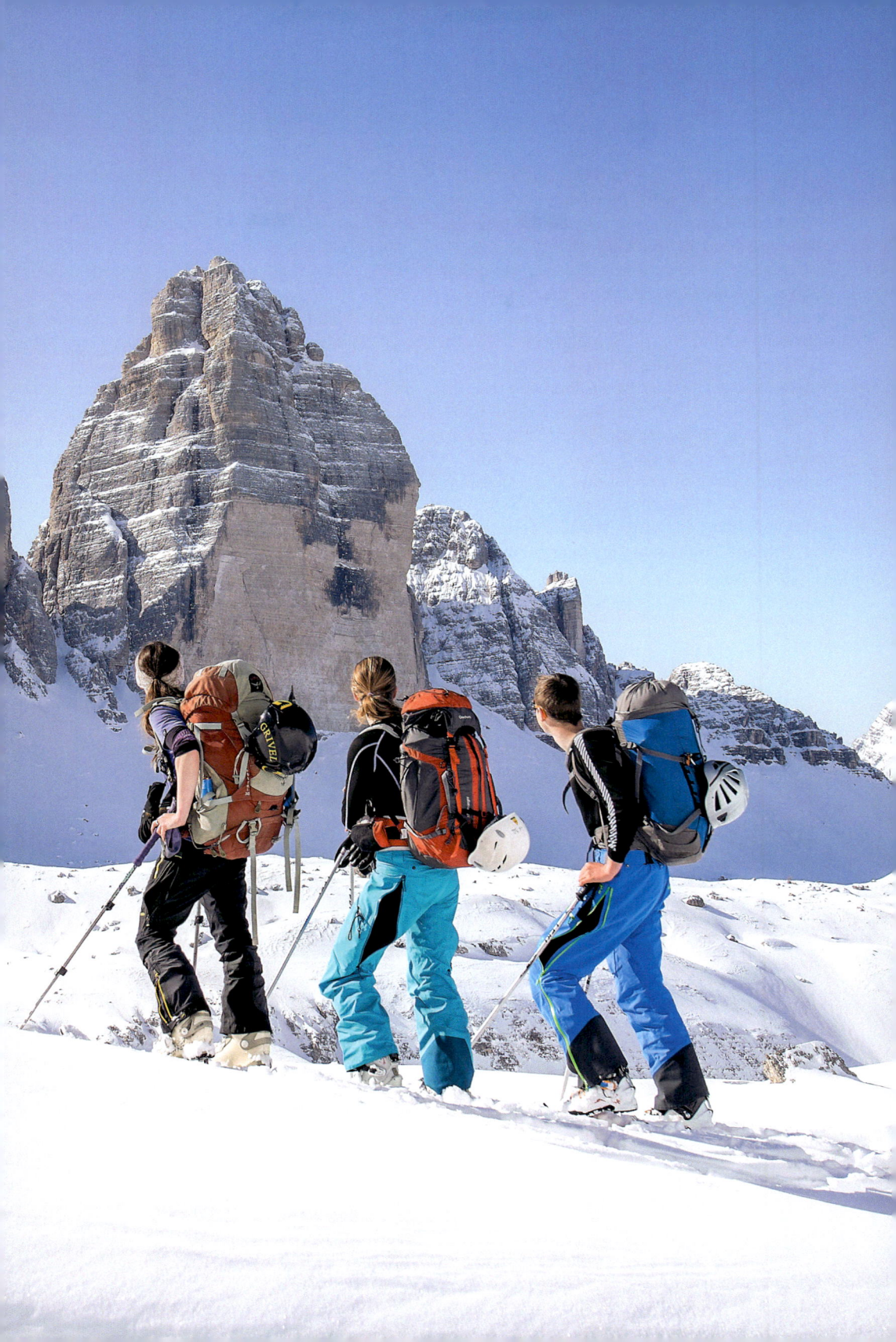

6 TRE CIME DI LAVAREDO / DREI ZINNEN

The Tre Cime di Lavaredo are without doubt the most famous landmark in the Dolomites and visitors come from all over the world to view the celebrated triad. For the uninitiated there are in fact eleven or so towers that make up the group, but it is the three largest monoliths and their north faces that have captured the imagination of travellers, climbers and photographers alike for centuries. Cima Piccola, as the name suggests, is the smallest of the three and is found on the east side. Cima Grande is the largest at 2999m and is particularly renowned as one of the six great alpine north faces, making it much coveted among the climbing community. Cima Ovest on the west side of the group completes the iconic trinity and is superbly situated on a pedestal above three small and picturesque lakes.

While the three towers are the undisputed stars of the show, the surrounding area also provides some of the best views in the Dolomites.

Unfortunately, during peak season the area does get a little overrun with visitors coming to see the towers and this coupled with the rather expensive toll road can give the area a very commercial feel. However, during a photographer's 'golden hours' the area is wonderfully quiet, making it a perfect early morning and evening venue when the crowds have dispersed for the day and you can take in the magical scene in relative solitude. An overnight stay at Rifugio Locatelli is particularly recommended as it provides one of the best views of the north faces.

What to shoot and viewpoints

The following viewpoints are described making a complete anti-clockwise circuit of the Tre Cime towers, starting and finishing at Rifugio Auronzo. The complete circuit including small diversions to viewpoints described here makes for a long day covering some 10km. While this won't appeal to everybody, it is worth making the hike to Forcella Lavaredo, reached in just under an hour, to view the north faces.

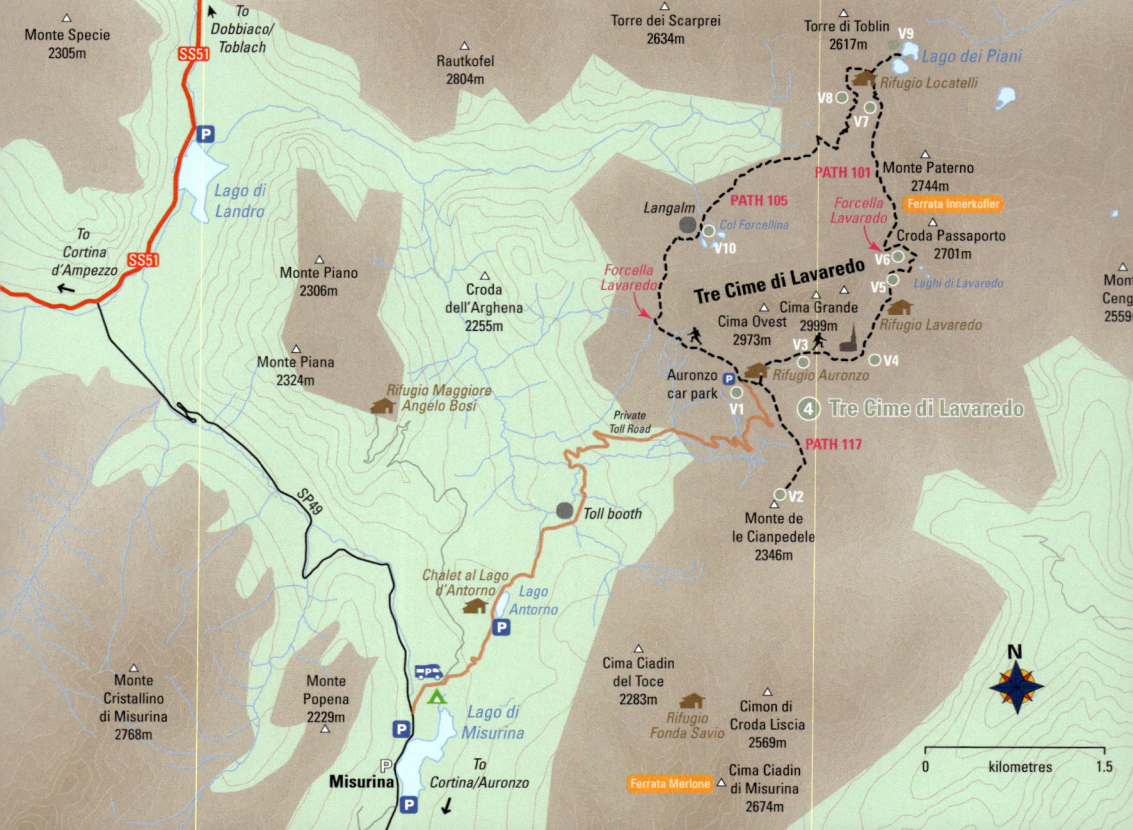

How to get here

The Tre Cime are located in the Sesto / Sexten Dolomites and are accessed via a private toll road that ascends to Rifugio Auronzo from Misurina. The towers are well signposted from the northern end of the lake where the road turns off just past the Grand Hotel. Follow the road uphill for 2km, passing Lago Antorno to reach the toll booths that mark the start of the private road. Pay the steep fee and ascend the steep but well-surfaced road for a further 7km to reach the large parking area just below Rifugio Auronzo.

For those wishing to avoid the toll, the cheapest way of accessing the Tre Cime (without walking) is to use one of the locally operated bus services which depart from just outside the supermarket underneath the Grand Hotel Misurina.

If you do wish to approach on foot, you can park at Chalet al Lago d'Antorno or at the toll barriers before following path 101 uphill to reach Rifugio Auronzo in just under two hours.

Lat/Long:	46.61284, 12.29311
what3words:	///spaceman.terminated.backlash
Tabacco:	Map 10 (1:25.000)
Kompass:	Map 47 (1:25.000)

Above: Observing the milky way as it hangs above the north faces. Nikon D810, 14–24mm at 14mm, ISO 3200, 30s at f/2.8, tripod, Jul.

Accessibility

Approach: 1 hour, 3km, 130m of ascent to Forcella Lavaredo.

Although the circuit suggested here is largely on good paths, the route should not be underestimated and requires a good level of fitness to complete. During the winter months the toll road is closed and alpine experience (preferably good ski touring knowledge) is required to access the north faces.

♿ **Disabled access**: The views from Rifugio Auronzo and the car park are excellent in their own right. It is possible to reach Forcella Lavaredo with a wheelchair, although there are occasional steep gravel sections which may pose some difficulty.

Best time of year/day

Access to the Tre Cime di Lavaredo is easiest when the toll road is open and clear of snow, usually between May and early November. The north faces in particular look their best during midsummer when the towers are illuminated with afternoon and evening light. Unfortunately, this coincides with the busiest holiday period and the incessant throng of tourists can definitely detract from the beautiful environment.

For those visiting during midsummer and in particular August, it is important to arrive early as the carpark can fill up by 5am despite being able to accommodate some 700 vehicles.

6. TRE CIME DI LAVAREDO / DREI ZINNEN

Early morning light in the Val Marzon & Val d'Ansiei. Nikon D610, 24–70mm at 40mm, ISO 100, 1/125s at f/8, Sep.

Viewpoint 1 – Cadini di Misurina & Cristallo ♿

Looking south and south-west from the Auronzo car park you can immediately admire the view of the jagged spires of the Cadini di Misurina and Cristallo groups. There isn't a great deal in the way of foregrounds so you will need a longer lens to isolate some of the peaks where you can capture the changing light as it plays over the spires. The group is quite high and there are often banks of clouds flowing between the summits particularly in the morning, which can be very effective when combined with a long exposure to capture the cloudy tendrils. Getting up for sunrise can be particularly rewarding as the faces of the Cristallo group face east and often glow a beautiful pink colour as the sun comes up.

Viewpoint 2 – Monte Campedelle & Cadini di Misurina Viewpoint

Previously seldom frequented, this optional out-and-back hike from Rifugio Auronzo has become so popular in recent years it now has its own entry on p.416. The approach following path 117 and Alta Via 4 along the Sentiero Bonacossa takes approximately an hour in each direction, with superb views of both the Tre Cime south faces and Cadini di Misurina group.

Viewpoint 3 – Val Marzon & Val d'Ansiei ♿

To start the circuit, take the large and obvious track 101 leading east from Rifugio Auronzo, following signs towards Rifugio Lavaredo. As you walk down the initial section of the track there is an outstanding view to the right down the Val Marzon into the Val d'Ansiei and to the town of Auronzo di Cadore. In normal conditions the location is not exceptional, but early in the morning the sun shines directly up the valley to create some fantastic light play.

As the day continues, the afternoon cloud often creeps up the valley to create some very special inversions; this is undoubtedly a situational spot that becomes exceptional in the right conditions.

Top: A misty morning at the Tre Cime. Nikon Z7II, 24–120mm at 70mm, ISO 64, 1/200s at f/8, Aug. **Above**: Heat layers follow the ridgelines. iPhone 14 Pro, 77mm, ISO 32, 1/850s at f/2.8, Aug.

Rifugio Lavaredo and the Cadini di Misurina ridgeline. Nikon Z8, 24–120mm at 70mm, ISO 64, 1/800s at f/8, Oct.

Golden light bathes Monte Cristallo. Nikon D810, 28–300mm at 300mm, ISO 320, 1/320s at f/5.6, Aug.

Above: The Cadini di Misurina as seen from Forcella Col di Mezzo. Nikon Z7II, 100–400mm at 190mm, ISO 100, 1/200s at f/5.6, Sep.
Below: Monte Cengia breaching the clouds. Nikon Z7II, 100–400mm at 155mm, ISO 64, 1/500 at f/5.6, Aug.

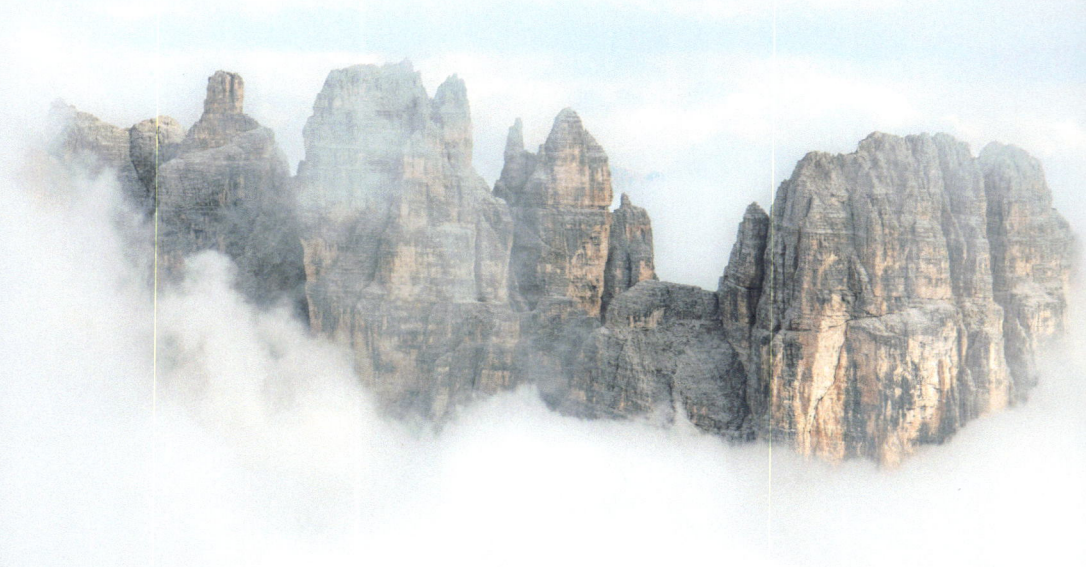

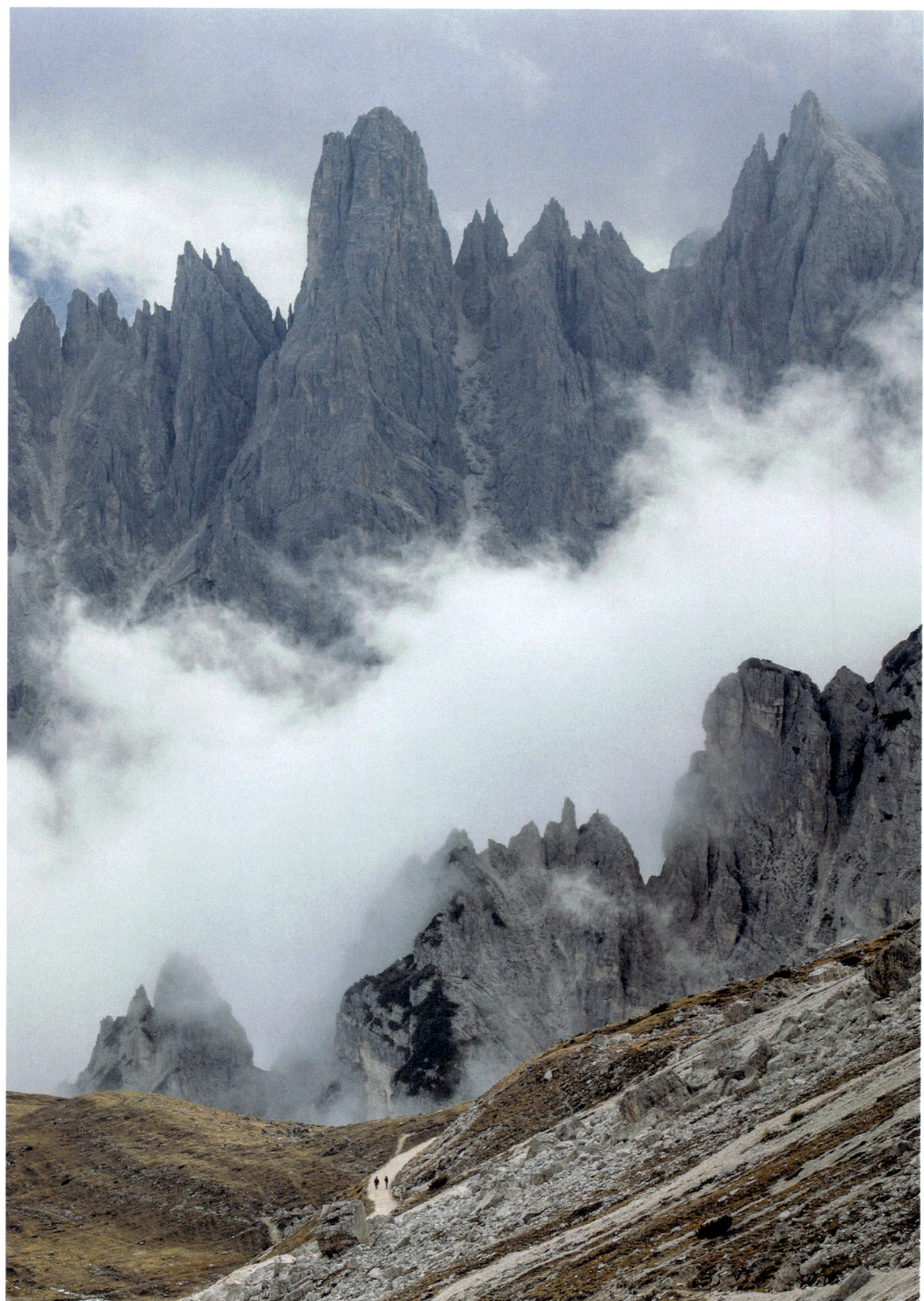
Two hikers returning to Rifugio Auronzo. Nikon Z7II, 100–400mm at 100mm, ISO 64, 1/200s at f/8, Sep.

6 TRE CIME DI LAVAREDO / DREI ZINNEN

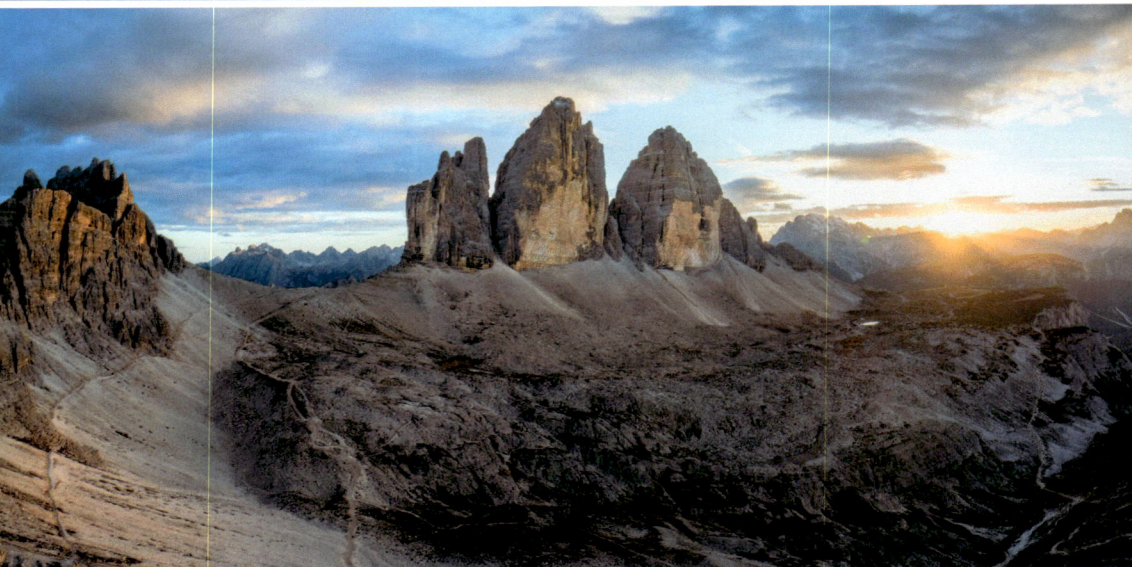

A 60 image exposure bracketed panorama of the Tre Cime di Lavaredo at sunset, as seen from Monte Paterno.

Viewpoint 4 – Obelisk and War Memorial ♿

Follow path 101 for 15 minutes to reach the Cappella Alpini chapel, a worthy photo subject in itself. From here, look south-east to see a small obelisk and a war memorial not far from the cliff edge, accessed from the chapel by a small path. Both make for excellent foregrounds in nearly all directions; choose the best composition depending on the conditions. The war memorial features a sword wielding angel and works particularly well on a moody day when shooting towards the south-east faces of the Tre Cime, creating an incredibly dramatic shot. With a long lens the statue can be isolated to capture the intricate details and contrasting colours of the lichen.

Viewpoint 5 – Monte Cengia ♿

Continue past the Cappella Alpina chapel to where the path forks; turn right and follow the main track to reach Rifugio Lavaredo in 10 minutes. From the rifugio, continue on the track for a further 10 minutes to reach a junction with path 101 on the left and path 104 leading off to the right. Ultimately you want to take path 101 to the left leading up to Forcella Lavaredo, but before you do it is worth taking a quick two minute detour down path 104 to reach the top of the little limestone plateau to the right.

From here you get excellent views across to the jagged buttress of Monte Cengia to the east. It is quite common to get some superb cloud inversions in the afternoon and evening where the cloud rolls in from Auronzo. Throughout the summer months the peak is also beautifully lit in early evening and often makes for a spectacular sunset location, especially if there is low lying cloud. There are also two small ponds nearby; these are very pretty but due to their location in a deep trough it is frustratingly difficult to create a pleasing composition.

Viewpoint 6 – Forcella Lavaredo ♿

At the junction between paths 101 and 104 keep left, continuing on path 101 to shortly reach Forcella Lavaredo and your first view of the north faces.

While the old adage that 'a wide-angle lens is not for fitting everything in' is generally true, in this case the close proximity of Cima Piccola and Grande necessitate just such an approach. A fish-eye or extreme wide-angle lens can produce some really eye-catching effects if you make use of the distortion, wrapping the top of the towers forward and further accentuating the impossible steepness of the faces.

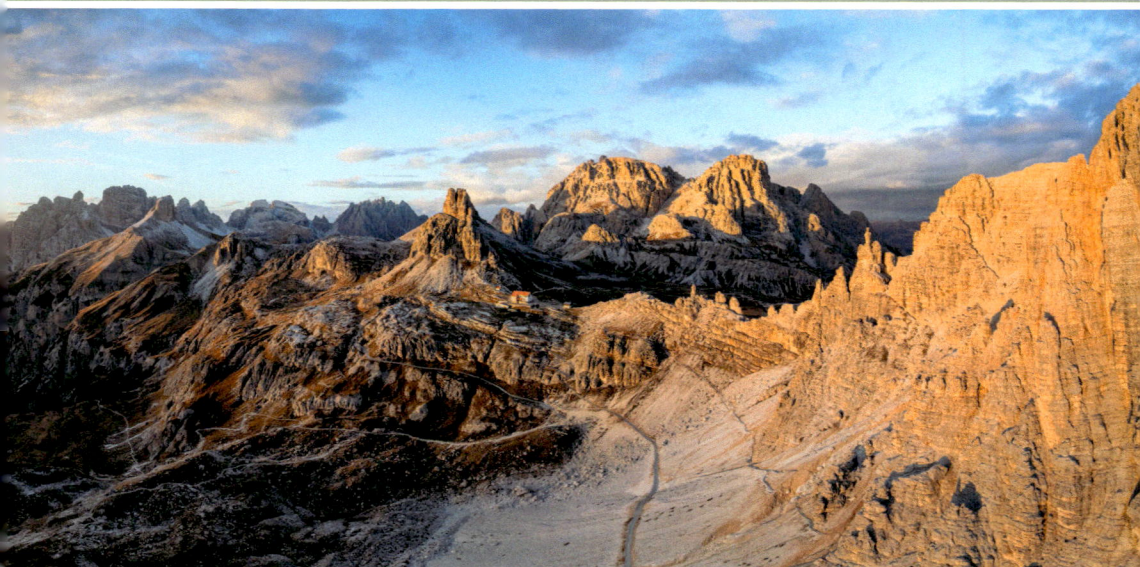

Nikon Z7II, 24–120mm at 30mm, ISO 100, various at f/11, Oct.

From the saddle you also get an excellent panorama unfolding to the north as a number of walking paths all converge on the striking red-roofed building of Rifugio Locatelli. Situated on a small plateau and backdropped by Torre Toblino, the rifugio makes a obvious subject that can be captured with a standard zoom. Try to include the surrounding paths which make for a superb set of leading lines, drawing your eye to the main subject.

Viewpoint 7 – Tre Cime North Faces – Tunnels

To continue, follow either one of the two parallel paths that traverse to the now clearly visible Rifugio Locatelli. The lower of the two is larger, wider and better surfaced, though the upper path does offer arguably better views as you approach. As both of the paths begin to ascend more steeply up to the plateau, you will notice a number of war time tunnels dug into the surrounding rock faces. These can be explored with care and feature several gun emplacements and lookout windows that can be used to frame the towers.

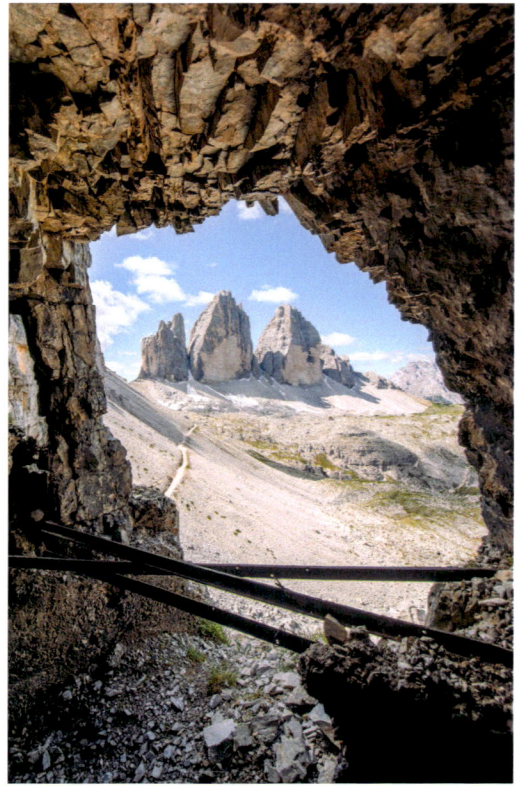

An exposure bracketed image of one of the several Tre Cime tunnel lookouts. Nikon Z7II, 14–24mm at 14mm, ISO 64, various at f/8, tripod, Jun.

A climbing party of three making good progress on the overhangs of Cima Piccolissima. **Above**: Nikon Z8, 100–400mm at 200mm, ISO 500, 1/500s at f/8, Oct. **Left**: Nikon Z8, 100–400mm at 140mm, ISO 100, 1/160s at f/8, Oct. **Below**: Nikon Z8, 100–400mm at 400mm, ISO 450, 1/500s at f/8, Oct.

6 TRE CIME DI LAVAREDO / DREI ZINNEN

Viewpoint 8 – Tre Cime North Faces – Locatelli Plateau

Once you reach Rifugio Locatelli you are presented with the classic view of the north faces and a vast array of possible perspectives and arrangements.

If you walk behind the rifugio you can use Locatelli and the adjacent chapel as a foreground with a wide-angle lens. This is a particularly good and much-favoured composition at night when the buildings are illuminated.

With an extreme wide-angle it is possible to get a close up of the chapel backdropped by the towers. Unfortunately, the land drops away to the north-east making it difficult to isolate just the chapel with a longer lens. Once again a fish-eye can produce some very dramatic and artistic results.

If you traverse the plateau to the west for 100m or so you will find all kinds of boulders, rock graffiti, stone circles, limestone pavement patterns and flowers during the spring which can create some excellent foregrounds. Moving further west also makes it easier to include the photogenic ridgeline of Monte Paterno in the shot. The jagged north-south crest receives afternoon light and is often spectacularly lit.

During midsummer, roughly a month either side of solstice, the sun actually sets on the north faces themselves. This provides one of the most photogenic spectacles in the Dolomites and is well worth waiting for.

For those with suitable alpine experience the venue is also superb in winter when the landscape is pristine, empty and blanketed in snow. The surrounding peaks create some excellent shadows and reflections on the snow, while the evening light turns the sky a wonderful purple hue.

A quick out-and-back ascent of the nearby Sasso di Sesto (2539m) takes about an hour and yields a similar but more top-down perspective on the surrounding landscape. The summit cross provides an effective foreground as does a lone figure stood surveying the panorama.

A cropped 14 photo panorama of the Tre Cime at sunset. Nikon D810, 14–24mm at 14mm, ISO 100, 1/100s at f/8, tripod, Jun.

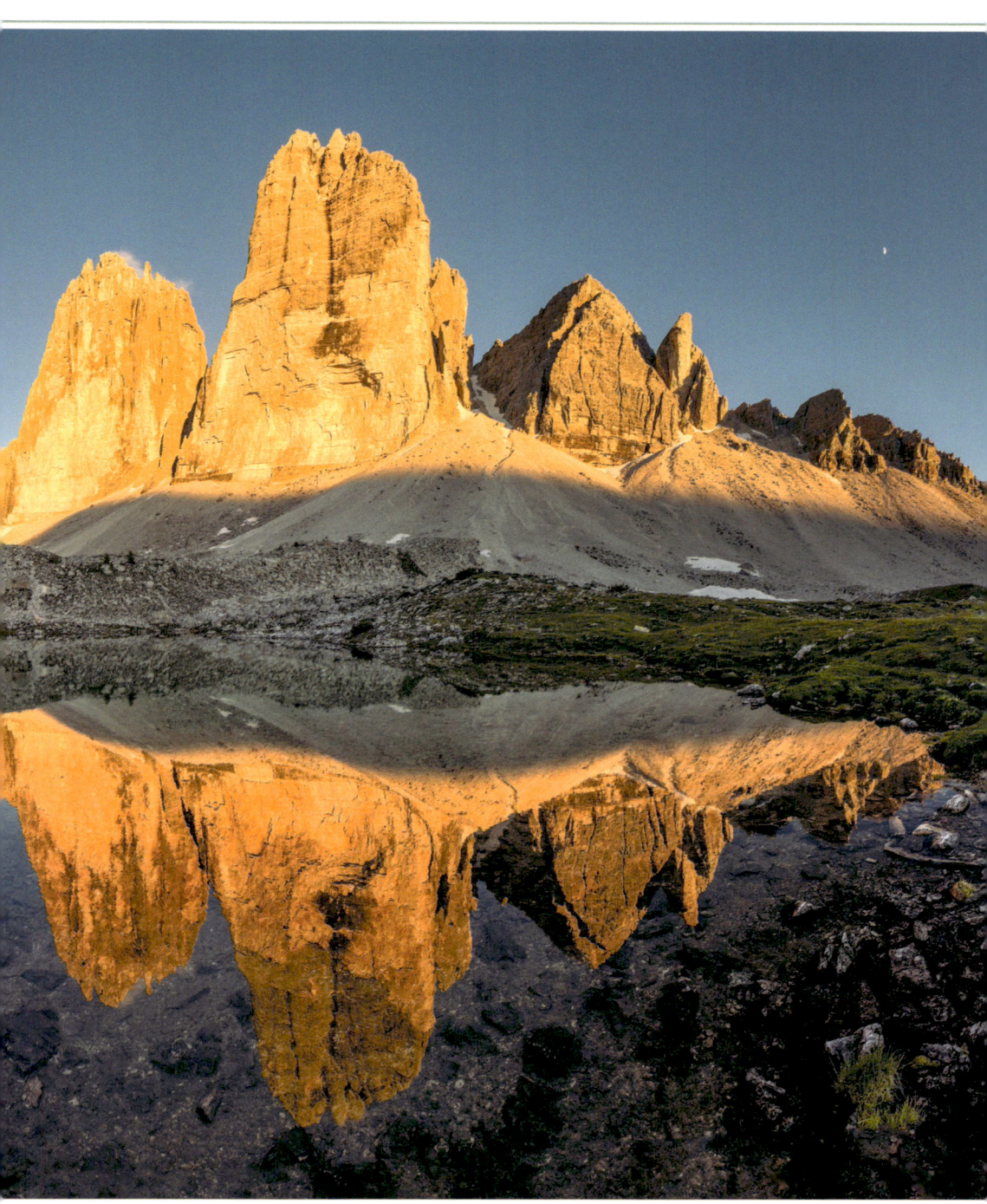

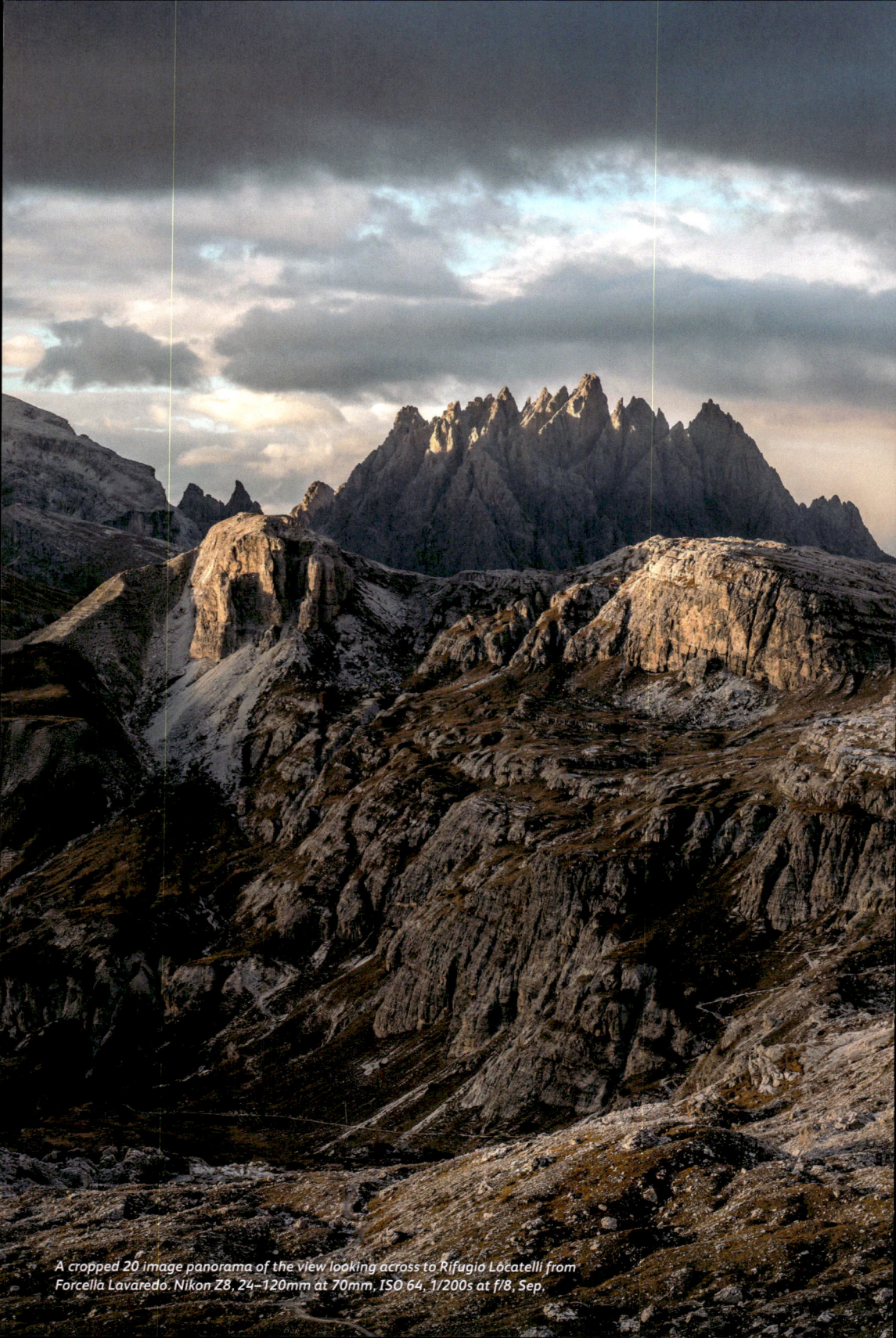

A cropped 20 image panorama of the view looking across to Rifugio Locatelli from Forcella Lavaredo. Nikon Z8, 24–120mm at 70mm, ISO 64, 1/200s at f/8, Sep.

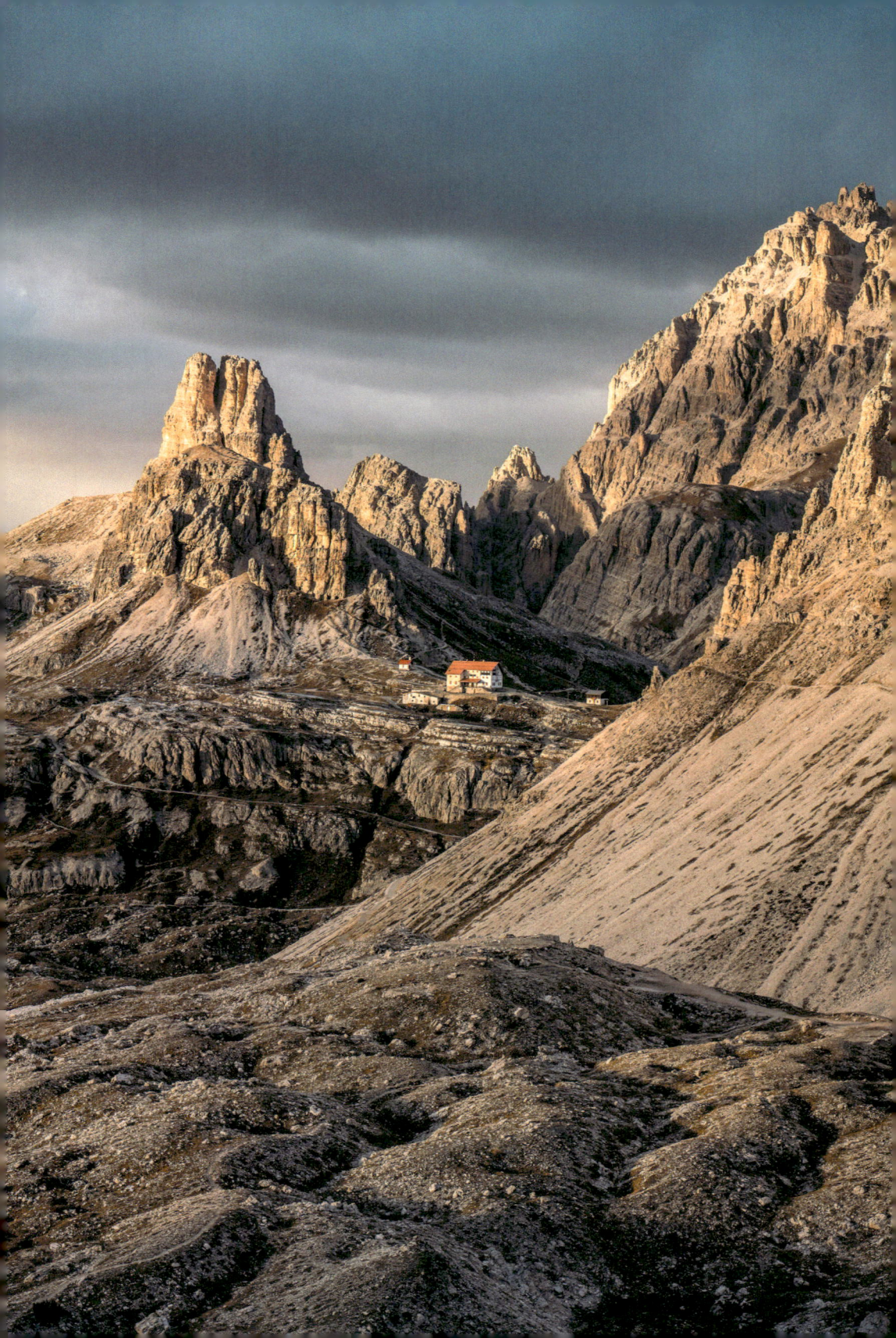

TRE CIME DI LAVAREDO / DREI ZINNEN

Viewpoint 9 – Laghi dei Piani

To the north-east and clearly visible from Rifugio Locatelli lie the Laghi dei Piani lakes (these form a single lake when the water is high as they join in the middle). It is possible to follow any number of small paths down to the shores and once again there are many possible compositions, usually dependant upon the weather and water level.

The best backdrop is almost certainly Monte Paterno viewed from the north end of the lake. However, the ideal foregrounds are arguably to be found on the south side of the lake, where a number of photogenic rocks lie just offshore in the water. Finally, there is also a raised area on the east side of the lake where the changing depth of the water creates some superb colour changes when viewed from above, using Torre Toblino to complete the composition.

Viewpoint 10 – Col Forcellina Lakes

From Rifugio Locatelli, path 105 leads first downhill and then steeply back uphill to reach the small Langalm rifugio at Col Forcellina in one hour. Just past the hut the path skirts the first of three small lakes, all of which provide excellent foregrounds when viewing the Tre Cime north faces, providing particularly good views of Cima Ovest.

The easternmost lake is perhaps the most photogenic of the three as it offers a slightly better angle on the towers. Located in a series of small troughs, the sheltered nature of the surrounding landscape frequently means a still water surface can be found. The shady aspect of the lakes combined with the motionless water often creates ideal conditions for strong reflections, particularly when the sun is low in the sky. Solstice is to be especially recommended, allowing for some dramatic symmetry as the sun sets.

To return, continue anti-clockwise on path 105 to return to Rifugio Auronzo in 40 minutes.

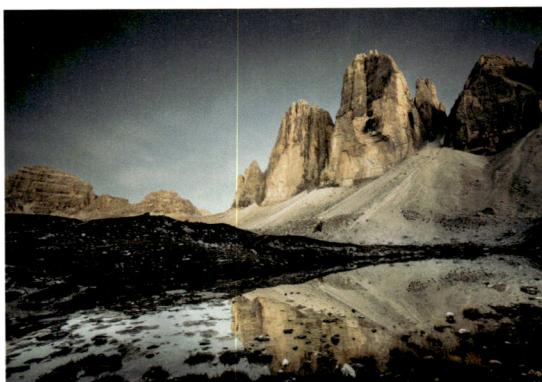

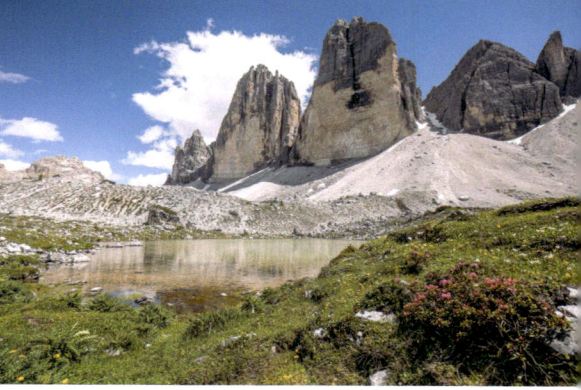

Opposite top: The Tre Cime by night, shot from Col Forcellina. Nikon D610, 14mm, ISO 3200, 30s at f/2.8, tripod, Oct.
Left: Reflections in Laghi dei Piani. Nikon Z7II, 20mm, ISO 180, 1/20s at f/11, Oct.

Top: Laghi dei Piani and Monte Paterno. Nikon D610, 16–35mm at 20mm, ISO 100, 8s at f/10, tripod, ND filter, Jul.

Above left: A wedding shoot near Rifugio Auronzo. Nikon Z8, 100–400mm at 250mm, ISO 400, 1/200s at f/8, Oct. **Right**: Round-leaved Pennycress is found amongst the scree. Nikon Z7II, 24–120mm, ISO 64, 1/100s at f/10, Jun.

Right: One of several small lakes at Col Forcellina. Nikon D810, 14–24mm at 14mm, ISO 100, 1/400s at f/10, Jun.

[6] TRE CIME DI LAVAREDO / DREI ZINNEN

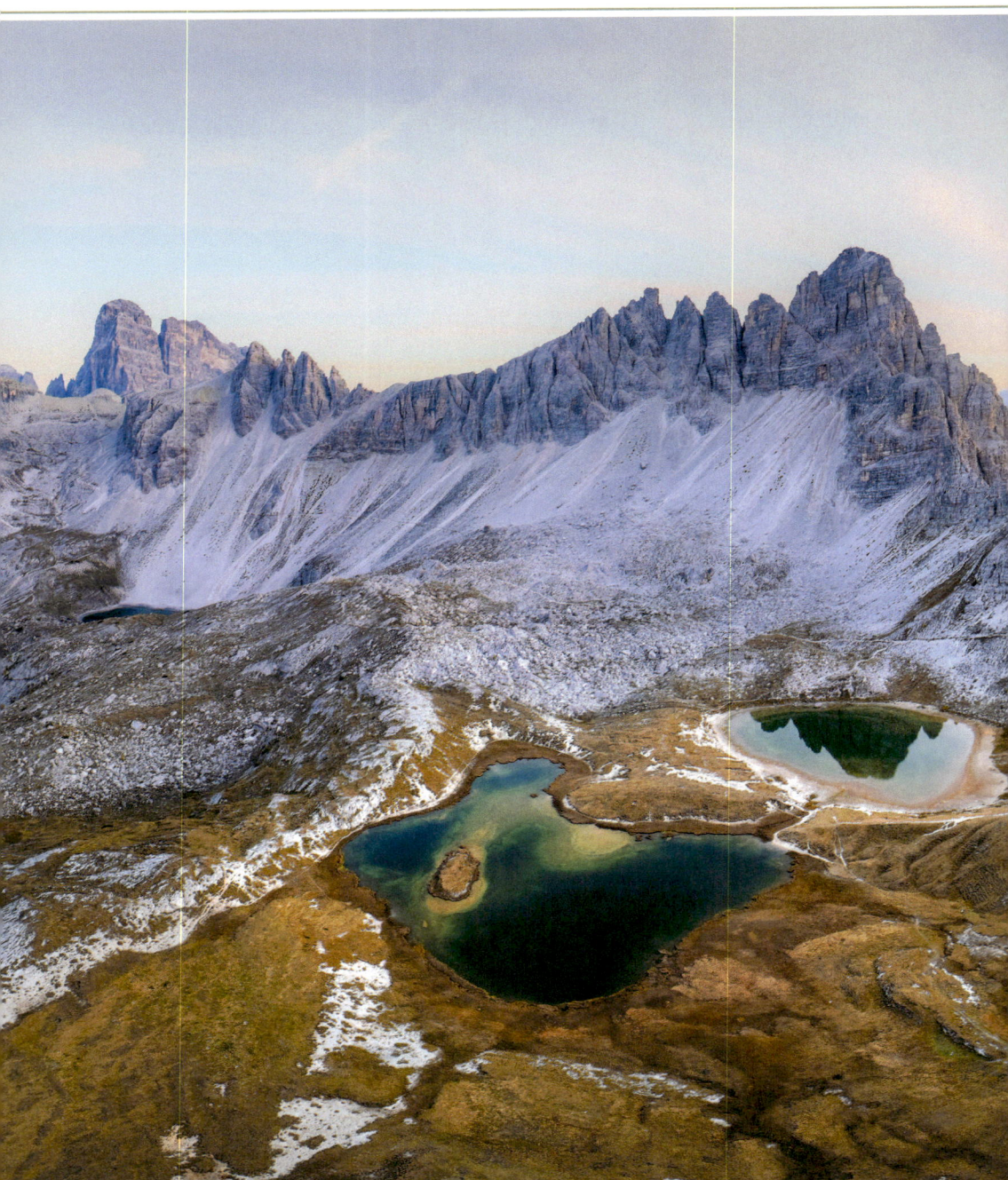

An exposure bracketed panorama of Laghi dei Piani, Monte Paterno, Rifugio Locatelli and the Tre Cime as seen from near Selletta Bassa.

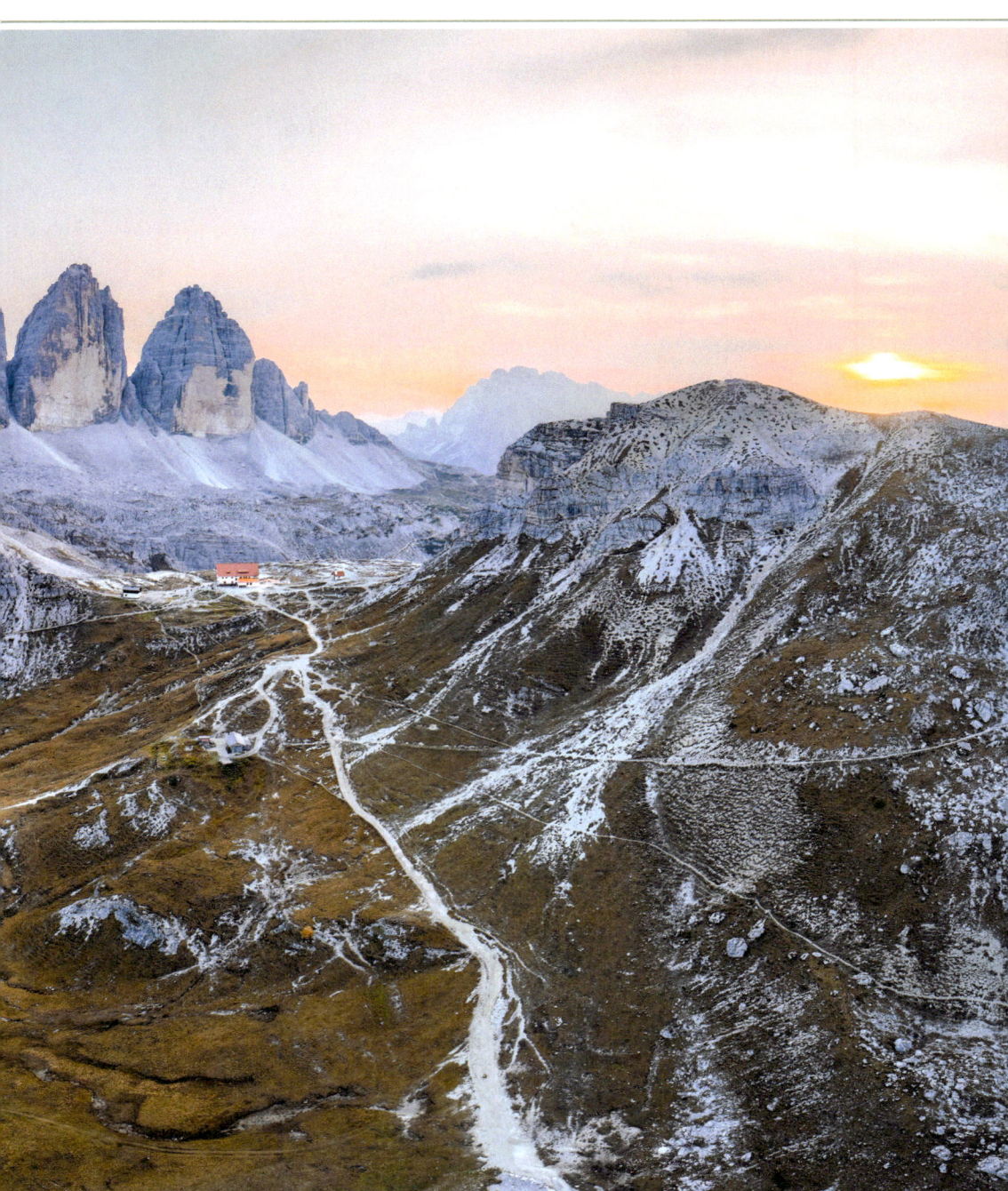

Nikon D610, 24–70mm at 24mm, ISO 100, various at f/10, Oct.

7 MONTE CAMPEDELLE & CADINI DI MISURINA VIEWPOINT

Wonderfully situated between the Tre Cime di Lavaredo and Cadini di Misurina, the undulating ridgeline of Monte Campedelle offers some of the best views in the Dolomites. Primarily known for a rocky outcrop overlooking the Cadini di Misurina, this location has become something of a modern social media phenomenon, and during peak season, it is not uncommon to find a long queue of visitors awaiting their turn to stand on 'the viewpoint'.

Fortunately, there are many excellent perspectives and vantage points throughout the walk; just don't expect to find solitude here.

What to shoot and viewpoints

Viewpoint 1 – Monte Campedelle Summit
From the terrace of Rifugio Auronzo, take path 117 south-east, following signposts towards Rifugio Col De Varda and Rifugio Fonda Savio (be careful not to follow everyone else along path 101, which leads around the Tre Cime). Initially, the track descends slightly before ascending again along the ridge. Follow the trail for 1km until the path forks, keeping left and staying on the 101 to reach the summit of Monte Campedelle.

There are excellent views throughout the walk and from the summit looking back north towards the Tre Cime. The toll road leading up to Rifugio Auronzo makes for an effective leading line, whilst the summit can also be highly recommended as a great long-exposure night location. For those that enjoy startrails, Polaris sits directly above the towers and allows for some excellent symmetry as the peaks reach towards the night sky.

Viewpoint 2 – Cadini di Misurina Viewpoint
Continue west for another 250m to reach another fork. Turning left leads to the classic rocky outcrop and some considerable exposure (lat/long: 46.600914, 12.295438), while the right fork gains a higher perspective overlooking the scene. To return, retrace your steps back to the car. For those with suitable experience, it is possible to follow the Sentiero Bonacossa protected path all the way to Rifugio Fonda Savio in the Cadini di Misurina (allow 6 hours).

How to get here
The easiest approach to Monte Campedelle begins from Rifugio Auronzo, adjacent to the Tre Cime parking area. This is accessed via a private toll road that ascends from Misurina. The towers are well signposted from the northern end of the lake where the road turns off just past the Grand Hotel. Follow the road uphill for 2km, passing Lago Antorno to reach the toll booths that mark the start of the private road. Pay the entrance fee and ascend the steep but well-surfaced road for a further 7km to reach the large parking area just below Rifugio Auronzo.

For those wishing to avoid the toll, the cheapest way of accessing Rifugio Auronzo (without walking) is to use one of the locally operated bus services which depart from just outside the supermarket underneath the Grand Hotel Misurina.

If you do wish to approach on foot, you can park at Chalet al Lago d'Antorno or at the toll barriers, before following path 101 uphill to reach Rifugio Auronzo in just under two hours.

Lat/Long:	46.61284, 12.29311
what3words:	///spaceman.terminated.backlash
Tabacco:	Map 10 (1:25.000)
Kompass:	Map 47 (1:25.000)

Accessibility
Approach: 1 hour, 3km, 130m of ascent to Monte Campedelle.

Despite this hikes popularity, it should not be underestimated, particularly for those making a sunrise or sunset visit. Several narrow and vertiginous sections require care, especially during darkness or inclement weather.

During the winter months the toll road is closed and alpine experience (preferably good ski touring knowledge) is required to access this itinerary.

Disabled access: The approaching path is rocky and exposed in places making it unsuitable for disabled access.

Best time of year/day
Access to the start point at Rifugio Auronzo is easiest when the toll road is open and clear of snow, usually between May and early November. During peak season the carpark fills up very quickly making an early start essential.

With good views in both directions, this location is photogenic throughout the day, though sunrise and sunset are recommended for the classic Cadini di Misurina viewpoint, both to limit the number of people and also to avoid looking towards the sun.

Opposite: The classic perspective looking out at the Cadini di Misurina group with Cima Cadin in the centre.
© Loïc Lagarde.

Next Spread: Via Ferrata Strada degli Alpini in the Sesto Dolomites. Nikon D850, 14–24mm, ISO 100, 1/250s at f/8, Jul.

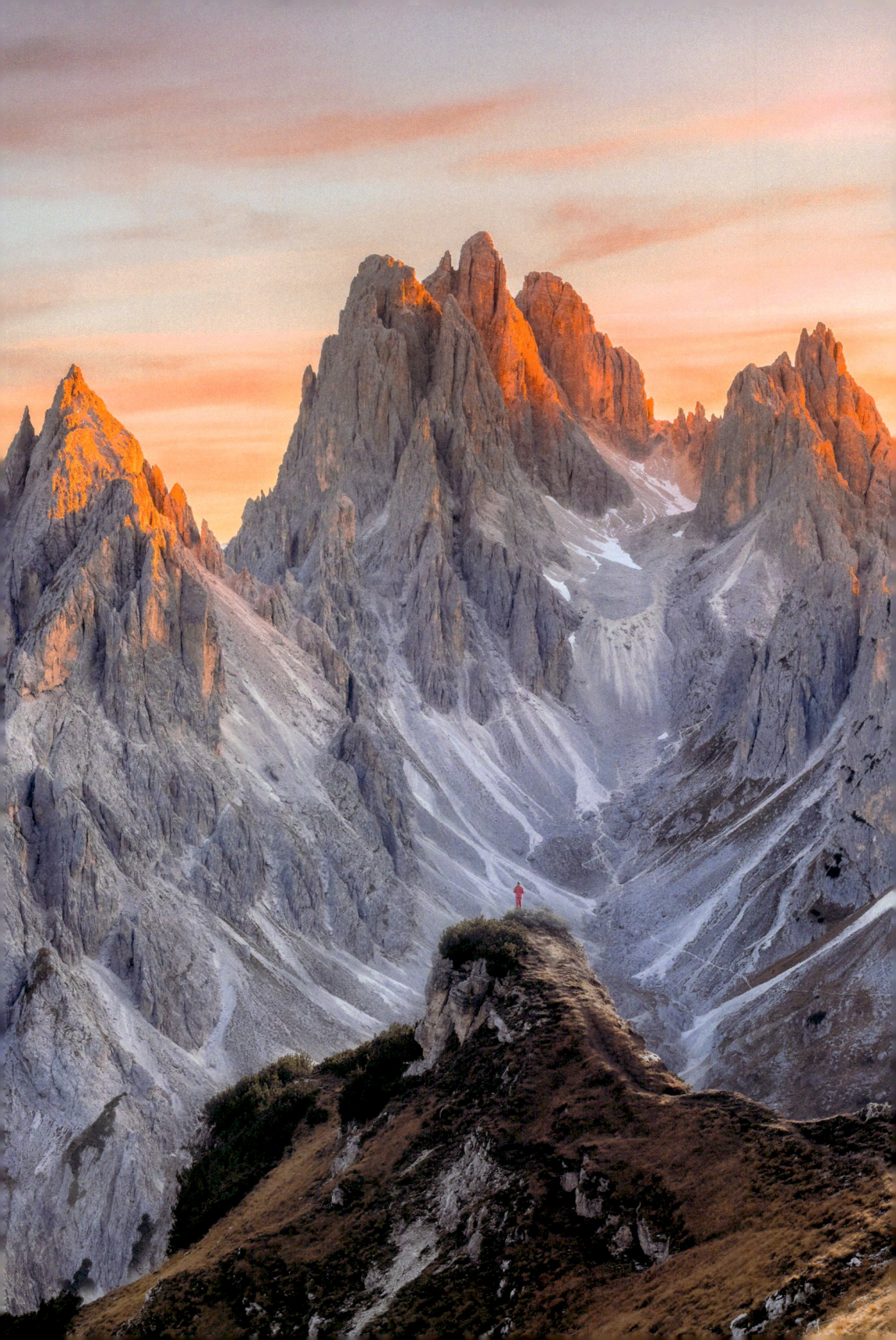

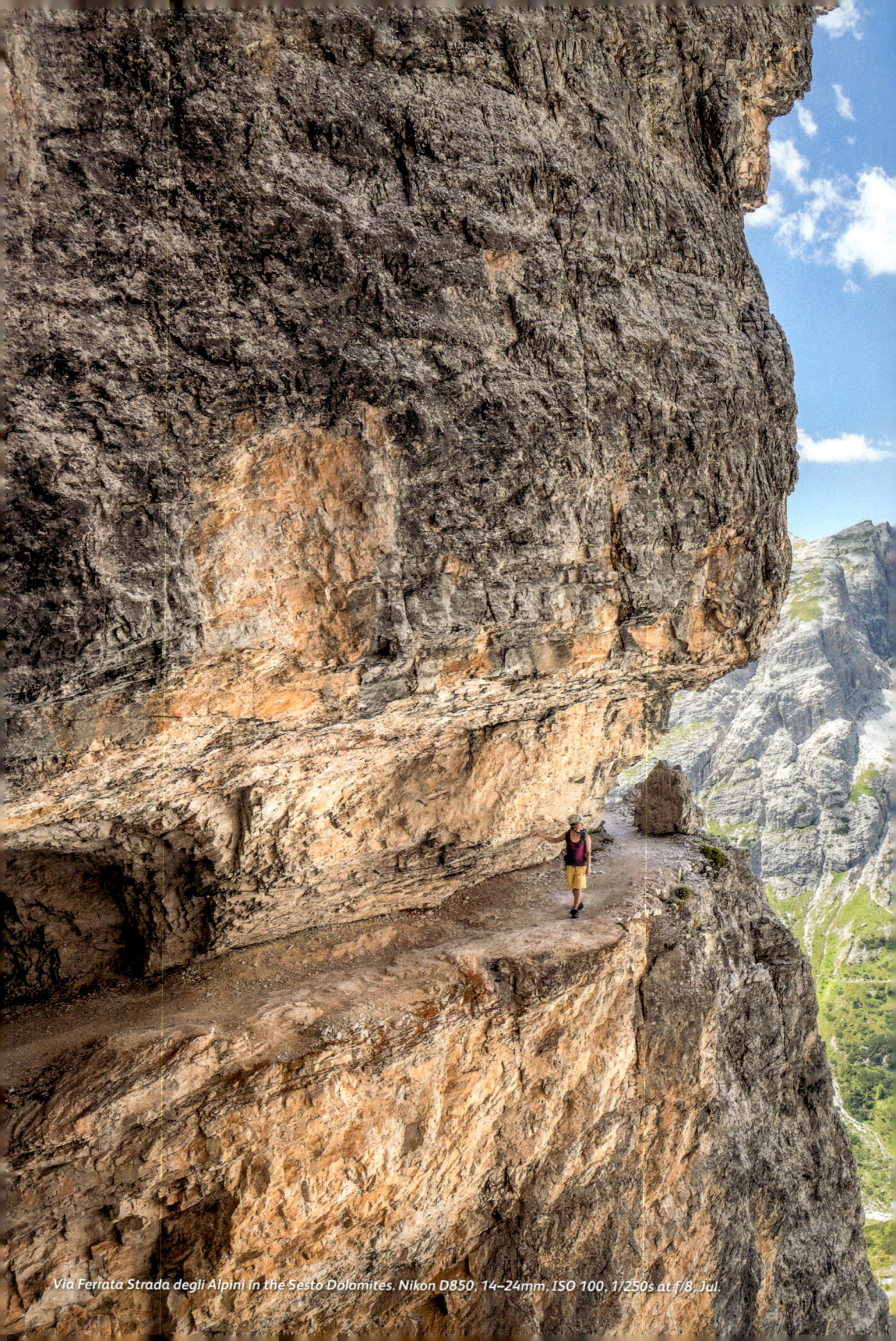
Via Ferrata Strada degli Alpini in the Sesto Dolomites. Nikon D850, 14–24mm, ISO 100, 1/250s at f/8, Jul.

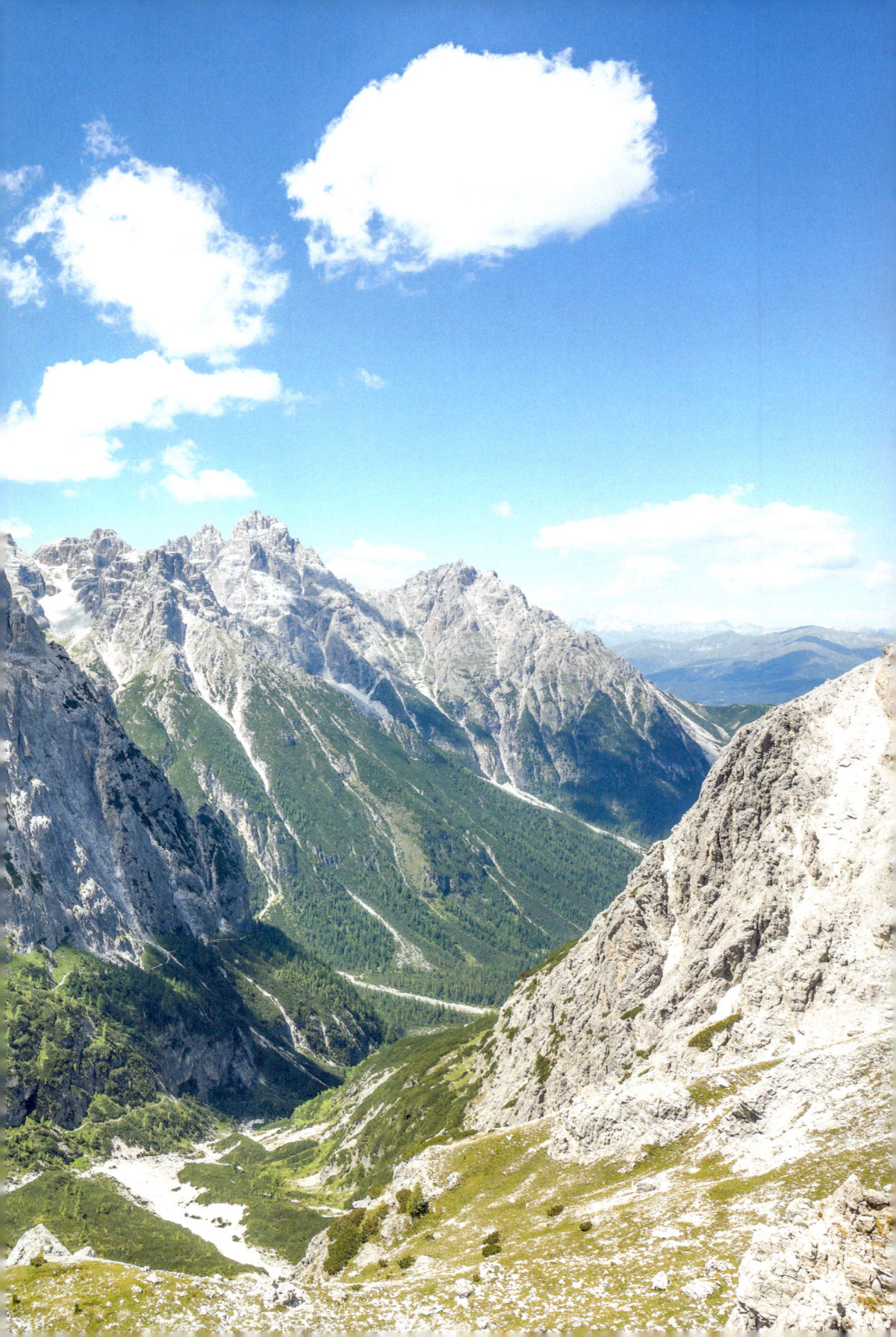

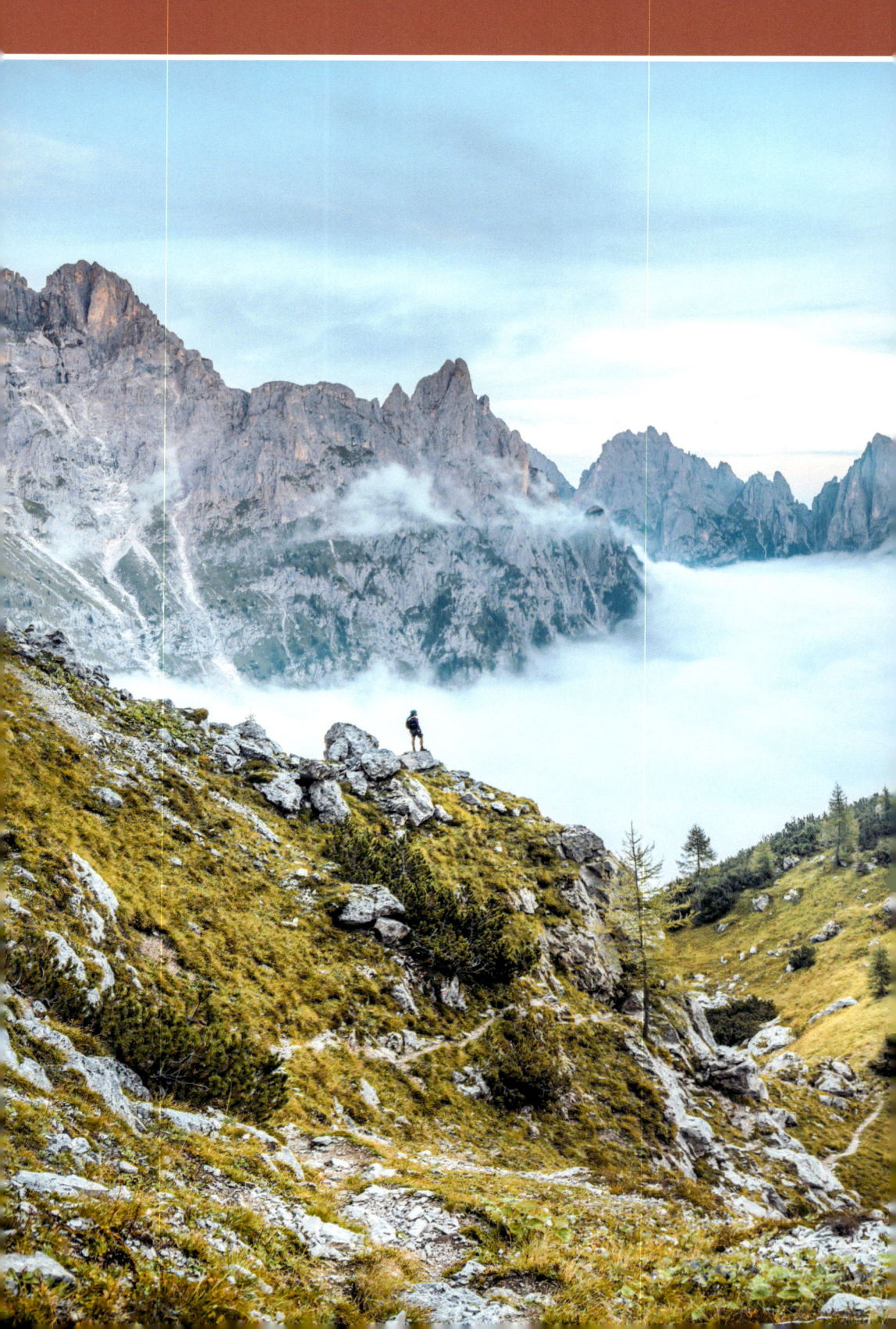

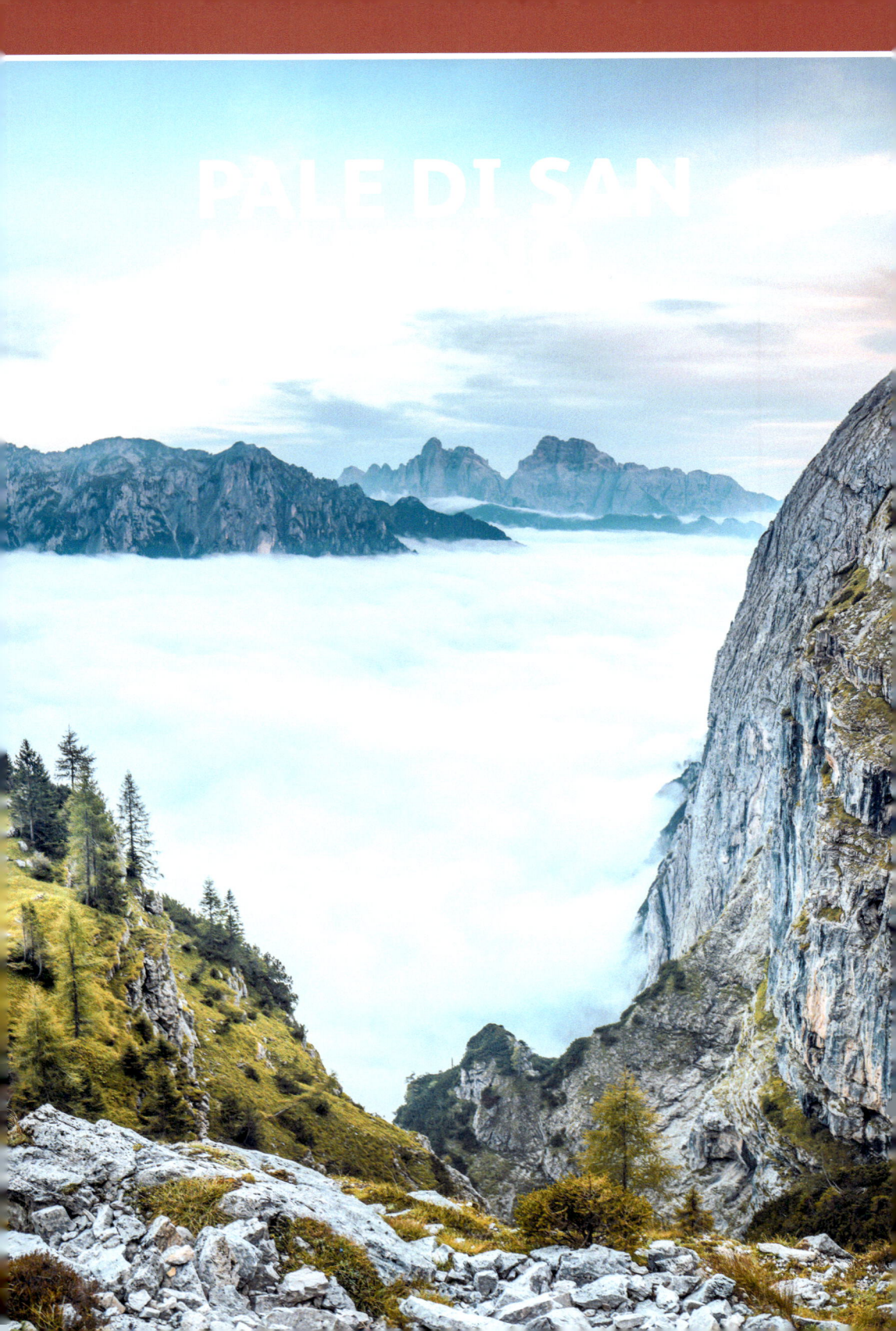

PALE DI SAN MARTINO – INTRODUCTION

Sometimes referred to as the Dolomiti delle Pale, Gruppo delle Pale or simply the Pala Dolomites, Pale di San Martino is a vast and remote group located in eastern Trentino and the province of Belluno. Situated within the Parco Naturale Paneveggio at the southern tip of the Dolomites chain and far away from the well known resorts of the north, this stunning range is often overlooked, especially during the summer months. With the exception of San Martino di Castrozza which enjoys an excellent reputation as a ski destination, the towns of the region offer a wonderfully authentic alpine experience characterised by a very close-knit local populace.

Boasting five subcategories, reaching an elevation of 3192m and covering 240 square kilometres, the Pala is amongst the largest of the Dolomite groups. At its heart lies the vast lunar landscape of the Altopiano delle Pale, a rocky and otherworldly plateau that inspired the setting for Dino Buzzati's novel 'Il deserto dei Tartari' and subsequent screenplay 'The Desert of the Tartars'. Perhaps the most iconic and instantly recognisable of these captivating peaks is Cimon della Pala (3184m), once described by Irish mountaineer John Ball as 'the Matterhorn of the Dolomites'. The profile of this undeniably majestic peak is best experienced from the lake at Baita Segantini, an idyllic spot that becomes truly captivating at sunset.

The ancient green forest of Paneveggio dominates the northern sector of the park, blanketing 2,700 hectares in dense woodland. Red fir (Picea abies) make up 85% of the tree species found here and produces a timber that is particularly elastic, the lymphatic vessels which resonate like tiny organ pipes making it perfect for crafting stringed instruments. In fact, Paneveggio is also referred to as the 'forest of the violins' and it is said that Stradivarius himself personally wandered the woods, selecting the best trees with which to make his violins. Harbouring a particularly rare species of Euro-Siberian orchid without chlorophyll (Epipogium aphyllum) and the scarce three-toed woodpecker, the state-owned red fir forest is now the focus of much ecological study.

Built between 1863 and 1874 when the area still belonged to Austria, the Passo Rolle links Predazzo to San Martino di Castrozza, providing easy access to the high mountains and a scenically stunning drive. Further south towards the village of Mezzano, the Valle del Cismon widens and rolling hills begin to emerge once again. The Val Canali and Val Pradidali strike back north here, providing some spectacular views of the retreating Pala peaks once again, especially when framed against the lush foreground and flowers of the alpine pastures.

Wildlife is abundant within the park and it is not unusual to experience close-up encounters with deer, ibex, foxes, pine martins and mountain hares. The red deer is the symbol of the park and there are now more than 500 living in the area. These can be seen up close at the visitors' centre on the west side of the Passo Rolle.

LOCATIONS

1	Val Focobon	442
2	Laghi di Colbricon	450
3	Cima & Lago Cavallazza	452
4	Monte Castellazzo	456
5	Baita Segantini & Cimon della Pala	460
6	Belvedere Geologica di Crode Rosse	466
7	Val Pradidali	470
8	Lago di Calaita	474

Maps
- Tabacco (Italian): Map 22
- Kompass (German): Map 653

Previous spread: Looking out over the Val Pradidali whilst descending from Sass Maor. Nikon Z7II, 24–120mm at 30mm, ISO 200, 1/50s at f/6.3, Sep.

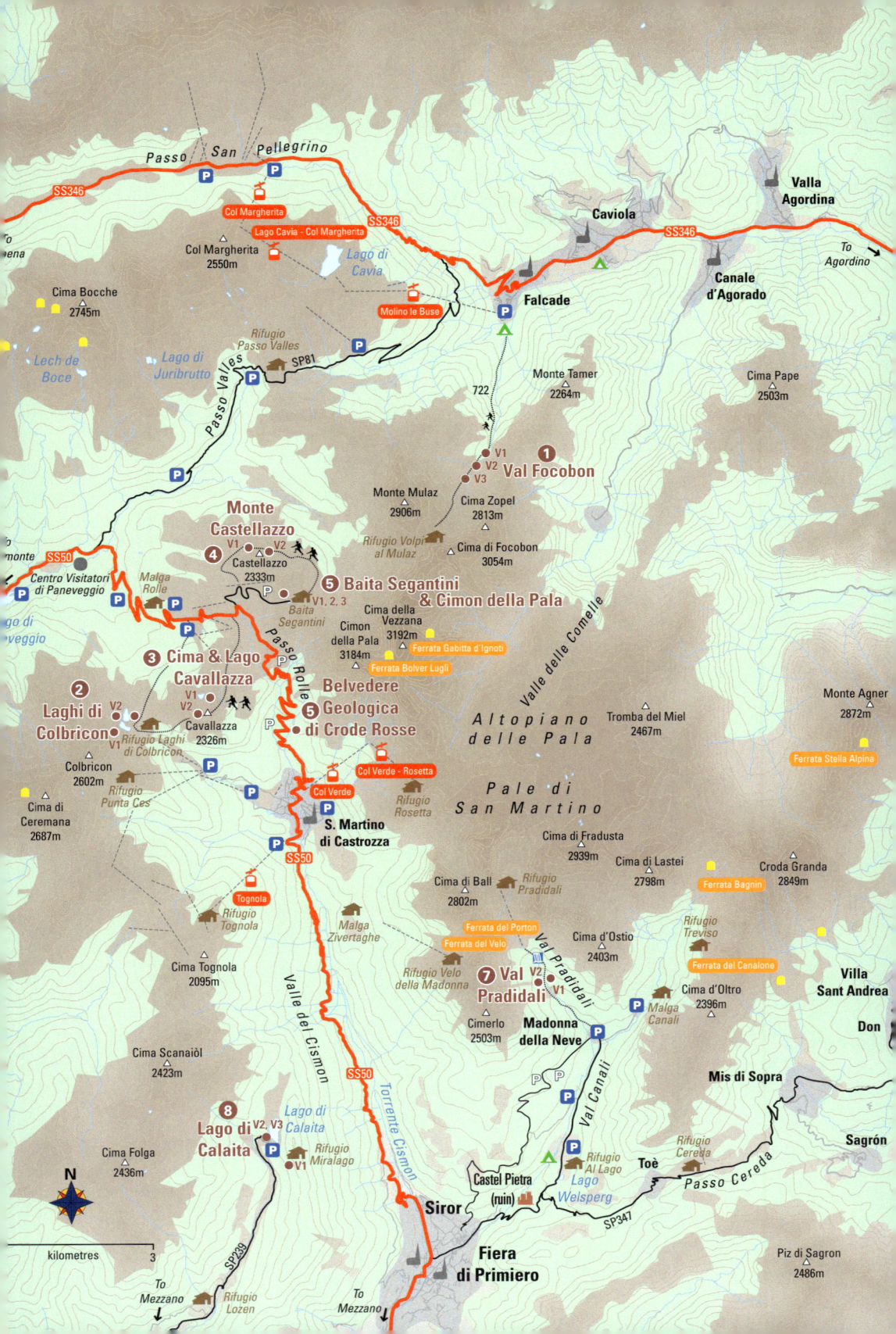

1. VAL FOCOBON

Situated within the larger Pale di San Martino range, the Focobon Group is characterised by a series of incredibly steep towers, faces and rugged peaks, offering a striking contrast to the verdant valleys below. This epitome of the Dolomites ideal is seldom frequented due to its remote and difficult-to-access location. For photographers who enjoy hiking, however, there are few more impressive locations to be found within the Dolomites.

What to shoot and viewpoints

Follow Via Pécola south past Camping Eden until the surfaced road becomes a gravel one. Continue following this due south for 1km until path 722 turns off left and starts to climb uphill more steeply. Follow path 722 uphill for two hours until the trees recede and the valley opens out, providing a spectacular view of the Focobon group.

The path now crosses the Torrente Focobon stream at a small wooden bridge – this provides the first viewpoint.

How to get here

Val Focobon is most easily accessed from Falcade at the foot of the San Pellegrino pass, on the northern side of the Pale di San Martino group. Falcade can be approached from either Moena to the west or Agordo to the east and is roughly equidistant between the two.

Entering Falcade it is best to follow signposting towards Camping Eden, Rifugio Bottari and Mulaz. There is limited parking just past Camping Eden on Via Pécola, or in peak season there is a large carpark at Piazzale Molino opposite the Molino – Le Buse lift station.

Lat/Long:	46.346951, 11.861640	
what3words:	///walkers.climate.resides	
Tabacco:	Map 22 (1:25.000)	
Kompass:	Map 653 (1:25.000)	

Accessibility

Approach: 3 hours, 8km, 700m of ascent to Casera Focobon.

Access to the Val Focobon is via a steep and remote mountain path that requires good navigation and hillwalking experience. Reception in the valley is patchy at best and the area is seldom frequented during low season – photographers should prepare accordingly.

The high elevation and northerly aspect means snow can persevere late into the season and there are several exposed sections to negotiate. It is important to take one of the paper maps listed above.

Disabled access: The approach to the Val Focobon is long and on difficult terrain making it unsuitable for disabled access.

Best time of year/day

This location is best visited during the summer and autumn once the approach is free from snow. During winter the nearby Monte Mulaz is a popular ski mountaineering itinerary for those photographers with suitable experience.

The northerly aspect of the Focobon group makes sunrise, late afternoon during the summer and evening the best time to photograph the peaks. Cesera Focobon is an excellent resource for photographers looking to stay the night – just be aware the unmanned hut is little more than an emergency shelter and exceptionally basic, requiring you to bring your own sleeping bag, roll mat and cooking equipment.

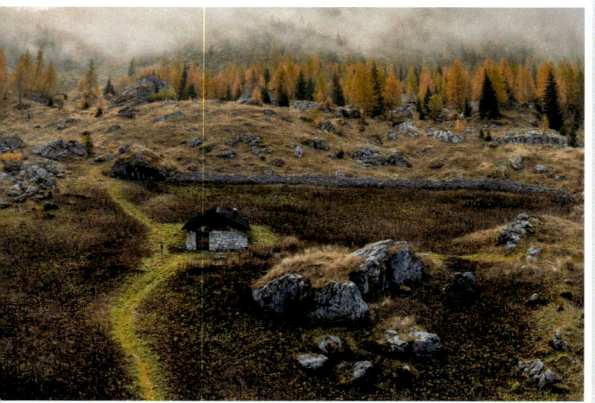

Casera Focobon provides very basic shelter for those that need it. DJI Mavic Pro 3, 24mm, ISO 200, 1/250s at f/2.8, Oct.

Opposite: With an extreme wide-angle positioning the peaks near the edge of the frame will make them look larger due to the lens distortion. The north facing aspect of the valley often necessitates some exposure bracketing. Nikon Z8, 14–24mm at 14mm, ISO 64, various at f/11, tripod, Oct.

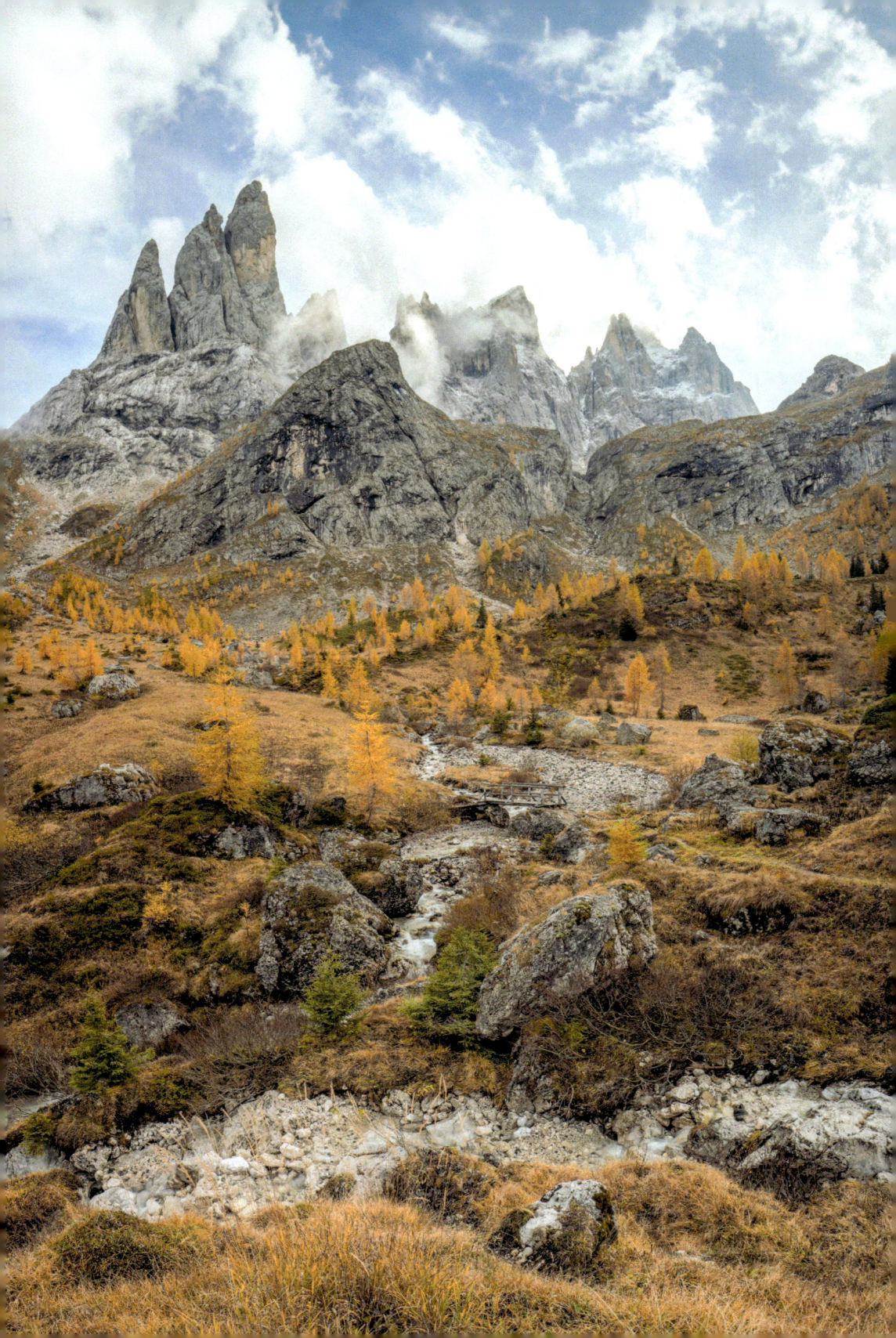

Above*: Late morning looking towards the Focobon group as the first sun hits the valley. Nikon Z8, 20mm, ISO 100, 1/80s at f/16, Oct.*
Below*: Sunlight picks out a selection of larch trees in early autumn. Nikon Z8, 100–400mm at 270mm, ISO 200, 1/320 at f/6.3, Oct.*

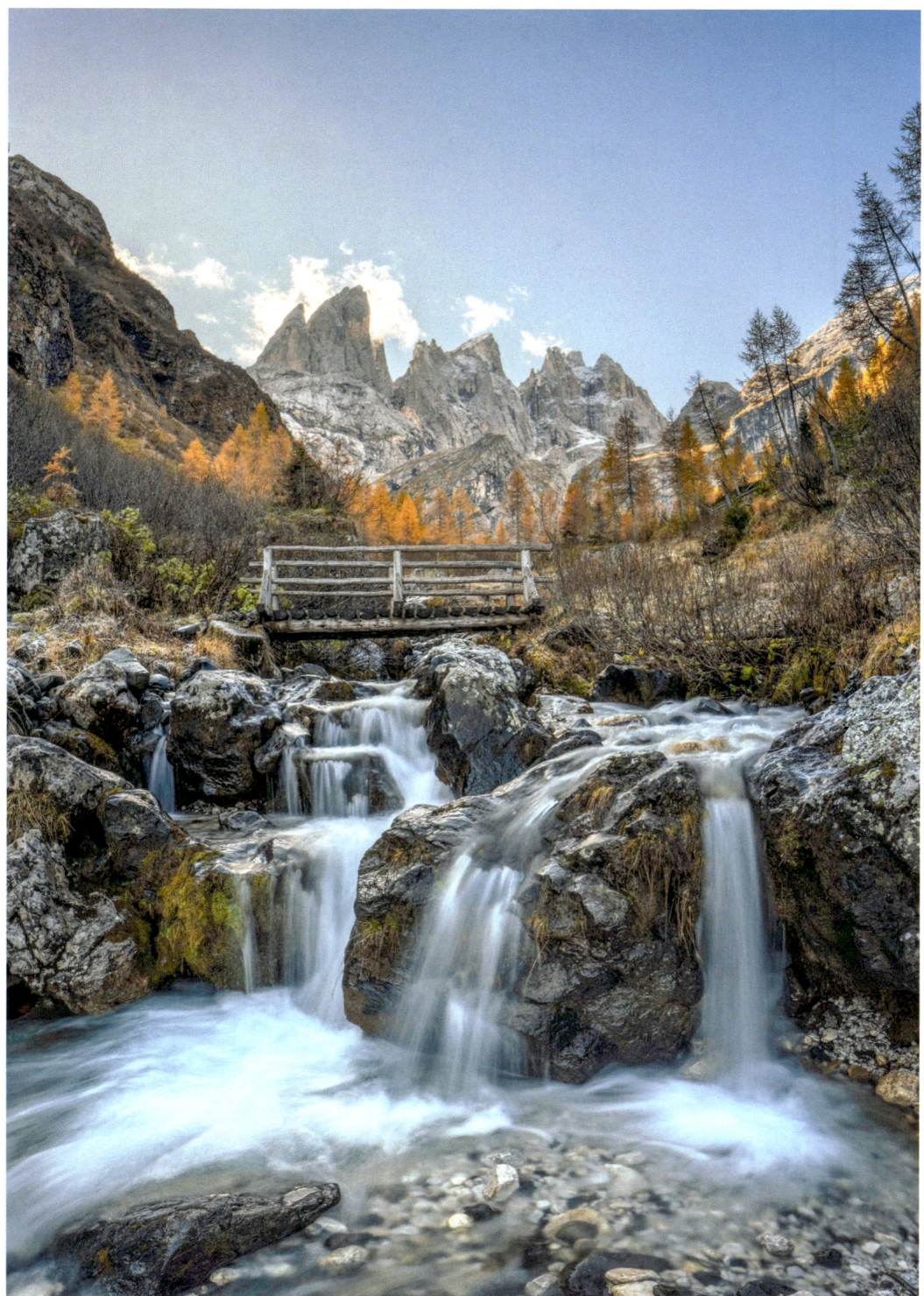
An exposure bracketed wide-angle looking up Val Focobon. Nikon Z8, 14–24mm at 14mm, ISO 64, various at f/22, tripod, Oct.

1 VAL FOCOBON

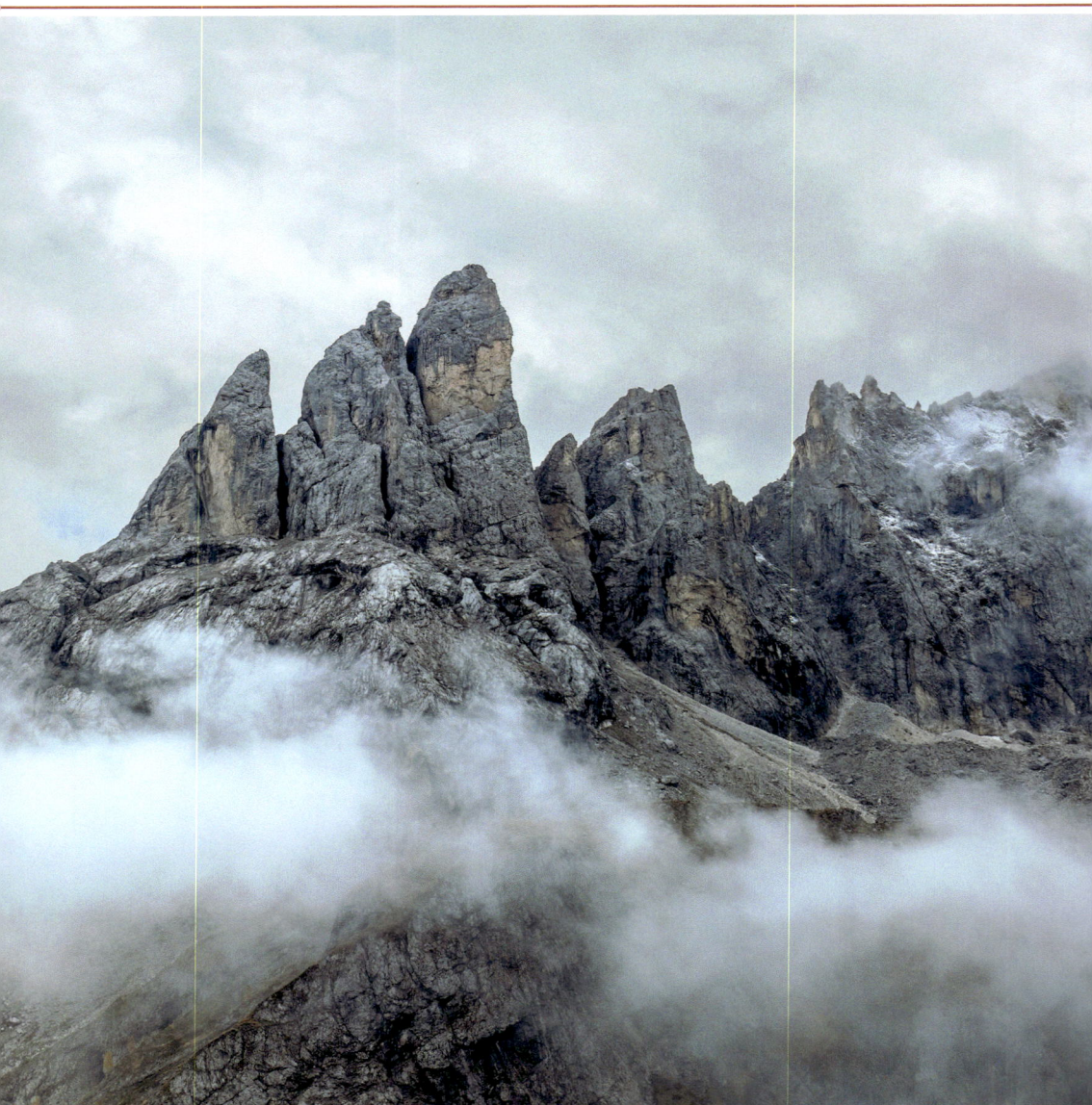

A 10 image panorama of the Focobon group. From left to right the towers of Campanili dei Lastei (2721m), Cima Zopel (2813m), Cima di Campido (3001m) and Cima del Focobon (3054m). DJI Mavic Pro 3, 70mm, ISO 140, 1/800s at f/2.8, Nov.

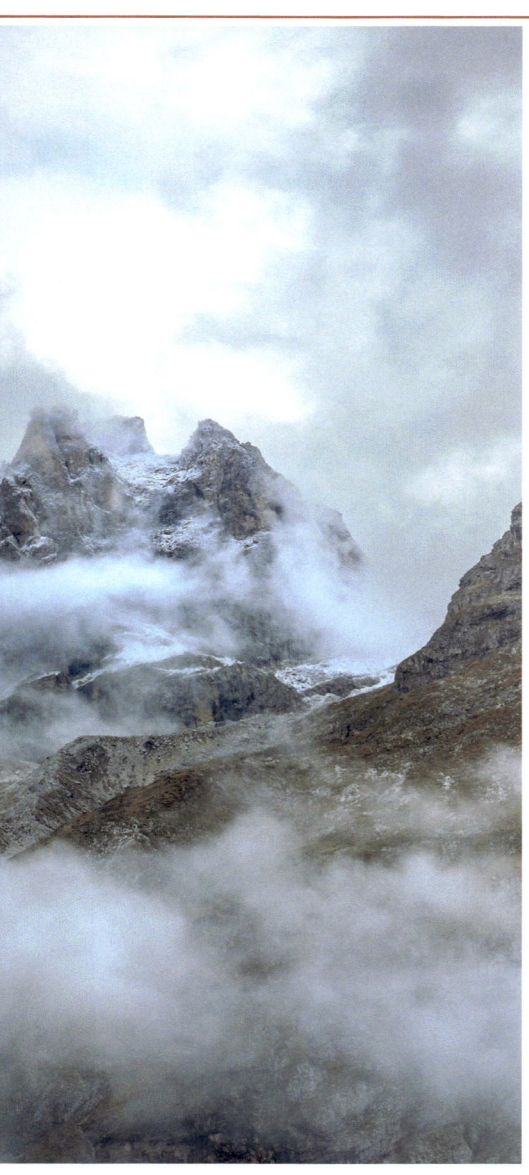

Viewpoint 1 – Wooden Bridge & Focobon Group
Just below the wooden bridge, a small waterfall makes for an excellent foreground looking up the valley when combined with an extreme wide-angle lens. The bridge also makes for a good subject and can be photographed without including the waterfall if desired.

Viewpoint 2 – Torrente Focobon
Shortly after crossing the wooden bridge, path 722 veers away from the stream. It is possible to turn off here, following the stream bank carefully uphill for a time. The channel makes for an excellent leading line and several photogenic smaller waterfalls provide additional interest. Once these have been photographed it is worth retracing your steps back to the main path as the terrain is difficult.

Viewpoint 3 – Casera Focobon & Wooden Bridge
Continuing up path 722 for another 20 minutes leads to Casera Focobon. The shelter is an interesting subject in its own right and there are a choice of backdrops looking west and north. Following path 722 to the south-east for 200m leads to another photogenic wooden bridge backdropped by the Focobon Group. There are also several large boulders in the meadow which also make interesting focal points.

To return retrace your steps back to the car.

Viewpoint 4 – Other Ideas
For those wishing to explore further afield, it is possible to continue up path 722 to the wonderfully situated Rifugio Volpi al Mulaz. This requires an additional 700m of ascent and is not for the faint of heart! During summer it is possible to stay at the rifugio before ascending to the summit of Monte Mulaz (2906m) the following day.

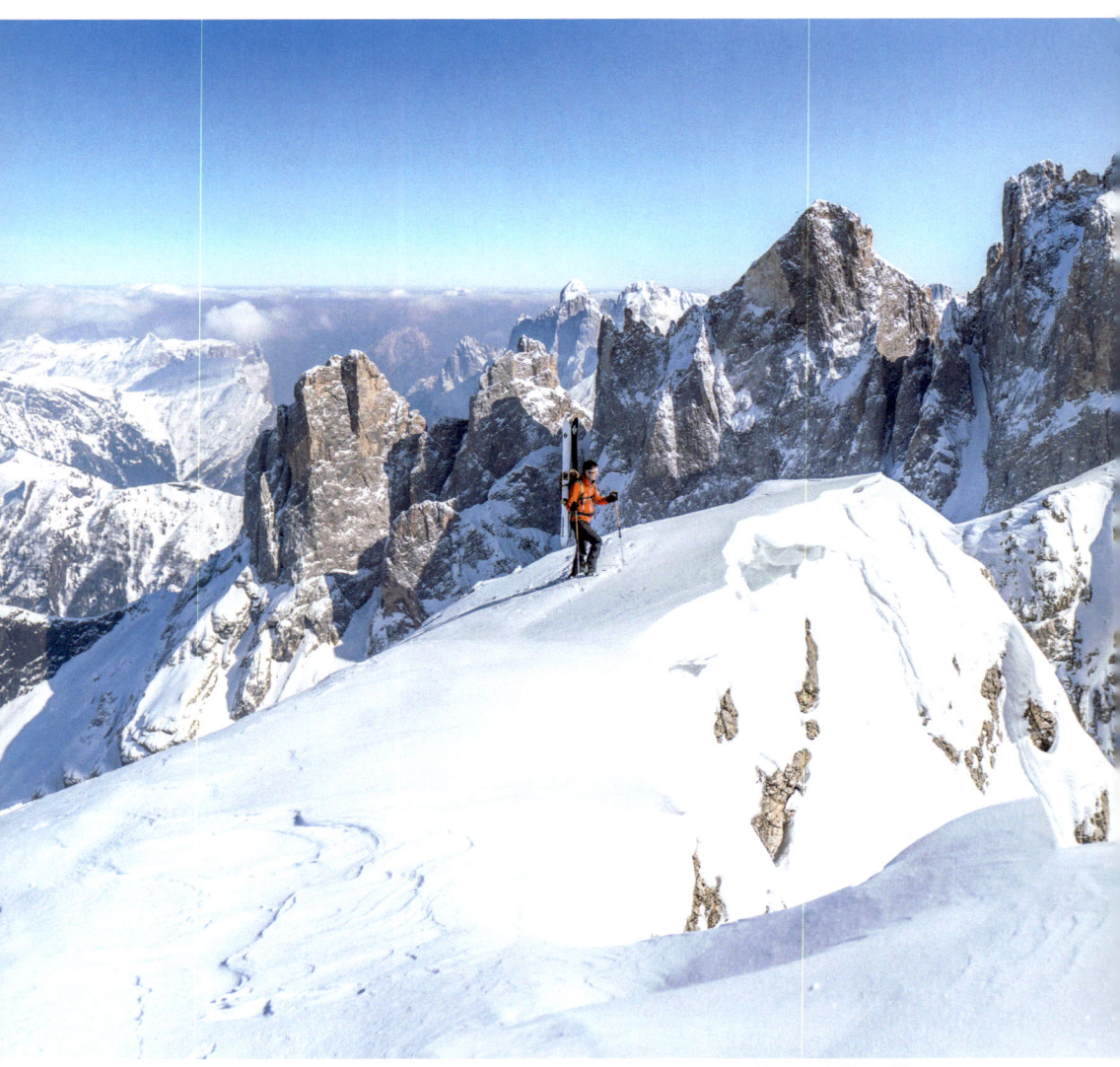

Approaching the summit of Monte Mulaz during winter. Nikon D850, 24–70mm at 24mm, ISO 100, 1/500s at f/8, Mar.

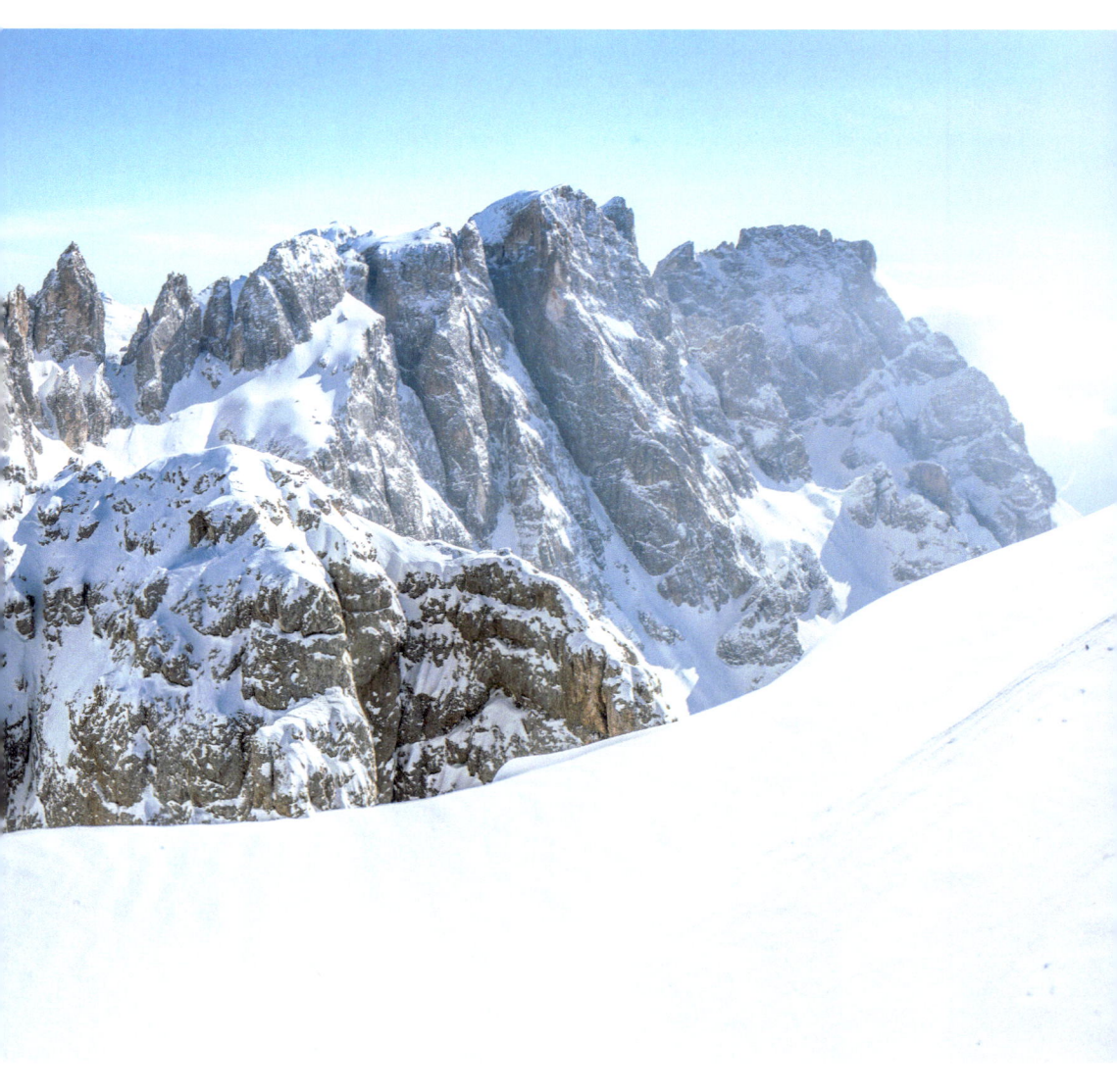

2. LAGHI DI COLBRICON

Situated on the volcanic chain of the Lagorai, the twin lakes of Laghi di Colbricon offer a very different landscape to those usually associated with the Dolomites. Recently, as many as twelve separate Mesolithic sites believed to be just over 10,000 years old were discovered along the lake shores; these would most likely have been used for hunting game in what was at the time a Boreal landscape of mountain grassland.

Today the area is still great for wildlife, particularly during early morning and late evening when the area is quieter. The southern lake watched over by Rifugio Colbricon is the more accessible of the two, while the northern lake has a somewhat wilder ambience. The lakes can be incorporated with a visit to Cima & Lago Cavallazza (see next location) to create a beautiful if long itinerary exploring the Lagorai group.

What to shoot and viewpoints

From the car park at Malga Rolle, follow good signposting south along path 348 to the bottom of the Paradiso chairlift (closed in summer). Continue following path 348 through undulating woodland for 30 minutes to reach Rifugio Laghi di Colbricon and the lakes.

Viewpoint 1 – Southern Lake
The best composition for the southern lake is achieved by walking a short distance towards the peak of Colbricon to then look back east to take in the lake, rifugio, Cima Cavallazza and Cimon della Pala.

Viewpoint 2 – Northern Lake
The northern lake is accessed via a series of small steep paths that run north-west from Rifugio Laghi di Colbricon. The southern shore provides some wonderful symmetry looking north while a volcanic outcrop on the eastern edge lends significant foreground interest.

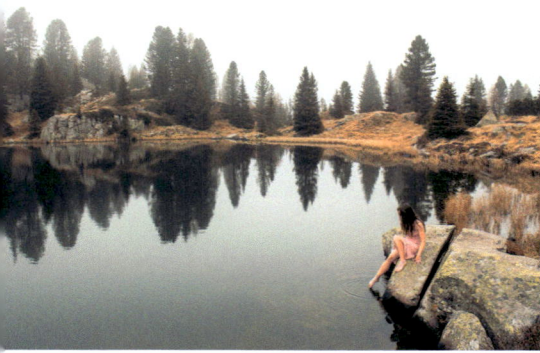

Opposite top: A morning frost highlights some long-dead roots. Nikon D810, 24–70mm at 44mm, ISO 100, 1/50s at f/3.5, Nov.
Bottom: Don't be afraid to use a person for some additional foreground interest. Nikon D810, 24–70mm at 24mm, ISO 100, 1/125s at f/5.6, Oct.

Top: Looking north across Laghi di Colbricon towards the Marmolada South Face. Nikon D810, 16–35mm at 16mm, ISO 100, 1/800s at f/8, Oct.

Above: A misty morning at Laghi di Colbricon. Nikon D810, 24–70mm at 26mm, ISO 100, 1/160s at f/6.3, Oct.

How to get here

From San Martino di Castrozza drive north up the SS50 for 10km to reach the top of the Passo Rolle. Descend down the western side of the pass for 1.5km to reach a large car park adjacent to the superbly situated Malga Rolle (an excellent spot to sample some local food and wine).

🅿 **Lat/Long**:	46.29592, 11.7759	
🅿 **what3words**:	///precise.undervalued.barcode	
🅿 **Tabacco**:	Map 22 (1:25.000)	
🅿 **Kompass**:	Map 653 (1:25.000)	

Accessibility

Approach: 30 minutes, 2km, 50m of ascent.

The initial approach to Rifugio Laghi di Colbricon and the southern lake follows a good, well-trodden path, but accessing the edge of the northern lake requires a steep descent on a smaller path.

♿ **Disabled access**: The approach path is rocky and uneven in places and as such is unsuitable for disabled access.

Best time of year/day

Thanks to the straightforward approach the lakes can be shot year round, although in the winter months they are often covered in snow and ice. In high season and particularly in August the area can get very busy and an early start to beat the crowds is advised.

Surrounded by several ridgelines and located in a small trough, the lakes don't receive much light at sunrise or sunset and so are best visited as a late morning and early afternoon venue. The area looks particularly beautiful after a hard frost with some low lying mist still lingering above the waters.

3 CIMA & LAGO CAVALLAZZA

Cima Cavallazza dominates the south side of the Passo Rolle and offers wonderful 360 degree views over the pass and the town of San Martino di Castrozza. The bird's eye perspective gained from the conical summit reveals two dramatically contrasting landscapes as the volcanic porphyritic Lagorai chain meets the sedimentary Altopiano delle Pale. The small lake of Lago Cavallazza lies just north of the main peak and provides a superb foreground against the backdrop of the Parco Naturale Paneveggio, Monte Mulaz and Cimon della Pala.

The location can be highly recommended to photographers looking for something a little of the beaten track as the strenuous approach ensures this beautiful summit and adjacent lake is seldom frequented. For those who enjoy hiking, this itinerary can be combined with the nearby Laghi di Colbricon to create a superb traverse of the Lagorai.

What to shoot and viewpoints

From the parking area, either ascend the ski piste underneath the Cimon chairlift or follow the broad ridge of Tognazza itself. In either case the unofficial path leads south to the top of the chairlift following a logical route sporadically marked with cairns and rock graffiti. Continue traversing south-west, passing a series of small ponds to reach Lago Cavallazza or ascending the ridgeline to the west to reach Cima Cavallazza.

Viewpoint 1 – Lago Cavallazza
The surrounding terrain forces the perspective somewhat and the best views are undoubtedly to the north. An effective shot can be had from the water's edge or from slightly above the lake as Cimon della Palla comes into view.

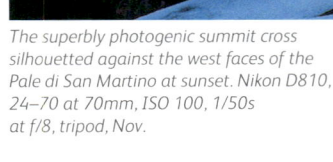

The superbly photogenic summit cross silhouetted against the west faces of the Pale di San Martino at sunset. Nikon D810, 24–70 at 70mm, ISO 100, 1/50s at f/8, tripod, Nov.

Viewpoint 2 – Cima Cavallazza
Although the summit provides several possible shooting options, the view east towards Cimon della Palla taking in the wooden cross is particularly spectacular; this is especially true at dusk as the sun sets on the dramatic west faces.

Dappled light looking north over the Passo Rolle. Nikon D810, 80–400 at 220mm, ISO 100, 1/200s at f/7.1, Sep.

Shooting east as the evening light illuminates Crode Rosse. Nikon D810, 80–400 at 150mm, ISO 100, 1/160s at f/6.3, May.

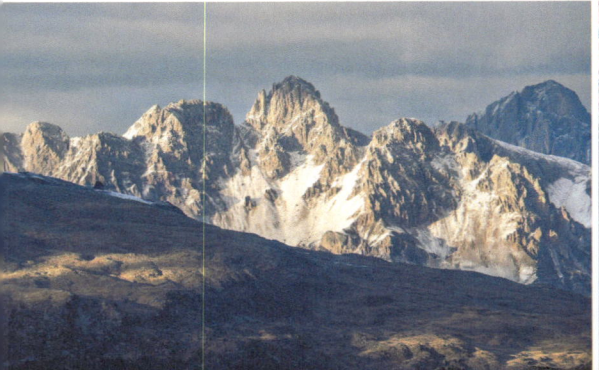
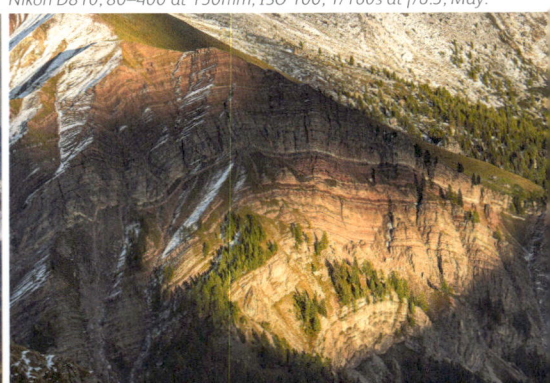

How to get here

From San Martino di Castrozza drive north up the SS50 for 10km to reach the top of the pass in twenty minutes, parking in a large car park on the left just before Hotel Venezia.

Alternatively, it is also possible to approach Cima & Lago Cavallazza from Laghi di Colbricon before ascending to Cima Cavallazza via the west ridge (see previous location). Allow two hours for this approach.

Lat/Long:	46.296275, 11.784235	
what3words:	///hatch.furred.roadsides	
Tabacco:	Map 22 (1:25.000)	
Kompass:	Map 653 (1:25.000)	

Accessibility

Approach: 90 minutes, 4km, 400m of ascent.

Cima & Lago Cavallazza are remote, difficult to access and require good navigation and hillwalking skills. While there is a sparsely marked small mountain path (occasionally referenced as R02), the route is unofficial hence the lack of waymark number.

There are several steep and exposed sections on the final ascent to the summit of Cima Cavallazza which are intermittently protected with cable. Take particular care when descending after sunset.

Disabled access: The location is remote and hard to access, making it unsuitable for disabled access.

Best time of year/day

Because of its remote position, this location is best approached in mid summer when the peak and ridgeline are free of snow and the days are longer, allowing for a safer ascent.

During early morning it is possible to create some fantastic sunstars as the sun rises behind the many spires of Cimon della Pala. The peak then remains photogenic throughout the day thanks to the various shooting opportunities in almost every direction.

Sunset is particularly special from both the lake and summit, an experience that is highly recommended for experienced parties. Finally the peak is also an excellent location for astrophotography.

Perfect powder in the trees of the Parco Naturale Paneveggio. Nikon D810, 80–400mm at 130mm, ISO 100, 1/320s at f/9, Mar.

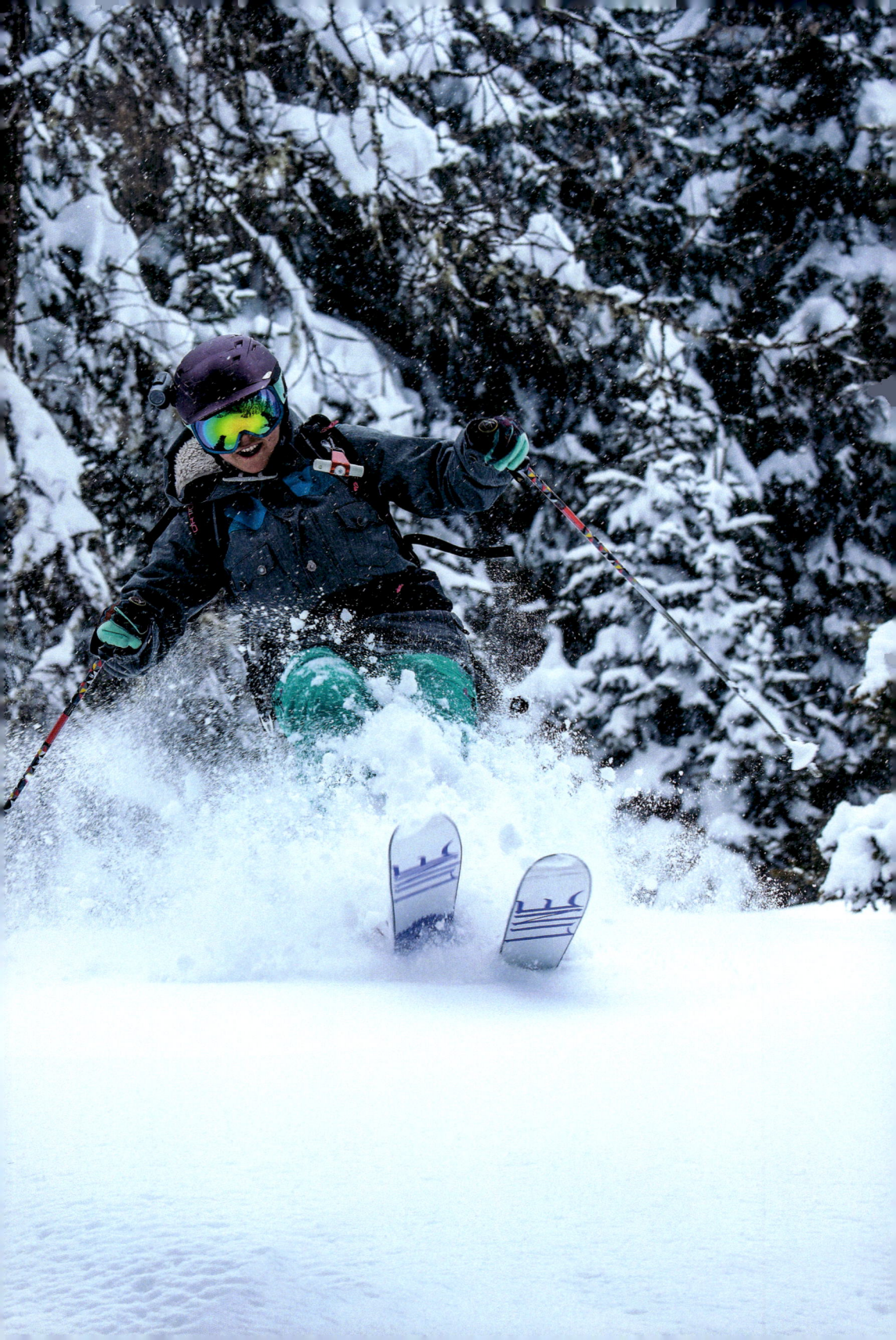

4. MONTE CASTELLAZZO

Monte Castellazzo is an isolated peak located to the north of the Passo Rolle. Reaching a fairly modest height of 2333m, the summit is famous for its Cristo Pensante (Thinking Christ) sculpture created by Paolo Lauton, a work of art designed to encourage self-reflection in the mountains. The sculpture is located aside Pierpaolo Dellantonio's huge summit cross, airlifted to the site by Chinook on June 16th 2009. The commanding views over the Pale di San Martino, Cimon della Pala, Lagorai, Bouches-Luribrutto and Passo Rolle made the peak a significant vantage point during the First World War, when an extensive network of tunnels was dug under the mountain to protect the troops stationed there.

The 'Trekking del Cristo Pensante' tour which departs from Baita Segantini and ascends to the summit of Monte Castellazzo makes for a perfect photography circuit with a memorable summit experience.

What to shoot and viewpoints

From Baita Segantini follow the gravel track leading east past the rifugio, descending gently for 80m to reach a junction. Turn left here (north), following path R01 and signs towards 'Castellazzo' and 'Trekking del Cristo Pensante'. Follow the path for 20 minutes as it traverses around the eastern edge of Costazza to reach another path junction; turn right here, still following for 'Castellazzo' and taking in good views of the peak. Ascend switchbacks up the north-eastern side of the mountain to pass various war remains and information boards before reaching the summit.

Viewpoint 1 – Cristo Pensante & Summit Cross

Both the Thinking Christ sculpture and dramatic summit cross offer excellent focal points that can be shot close-in with a wide-angle or from one of the many small buttresses that characterise the summit.

The scene works particularly well during the golden hours or when the features are back-lit by the sun to create a distinctive and easily recognisable pair of silhouettes.

Viewpoint 2 – Far-Reaching Views

As with Cima Cavallazza, the summit offers superb 360 degree views of Cimon della Pala, Tofane, the Marmolada south face, Passo di Valles, Passo Rolle, the Lagorai and San Martino itself. A long telephoto works well here, allowing you to pick out the best light and most interesting subjects depending on the weather and time of day.

To continue the circuit, keep following the path as it descends to the south to eventually rejoin the Baita Segantini access road. Turn left and follow this back to the start.

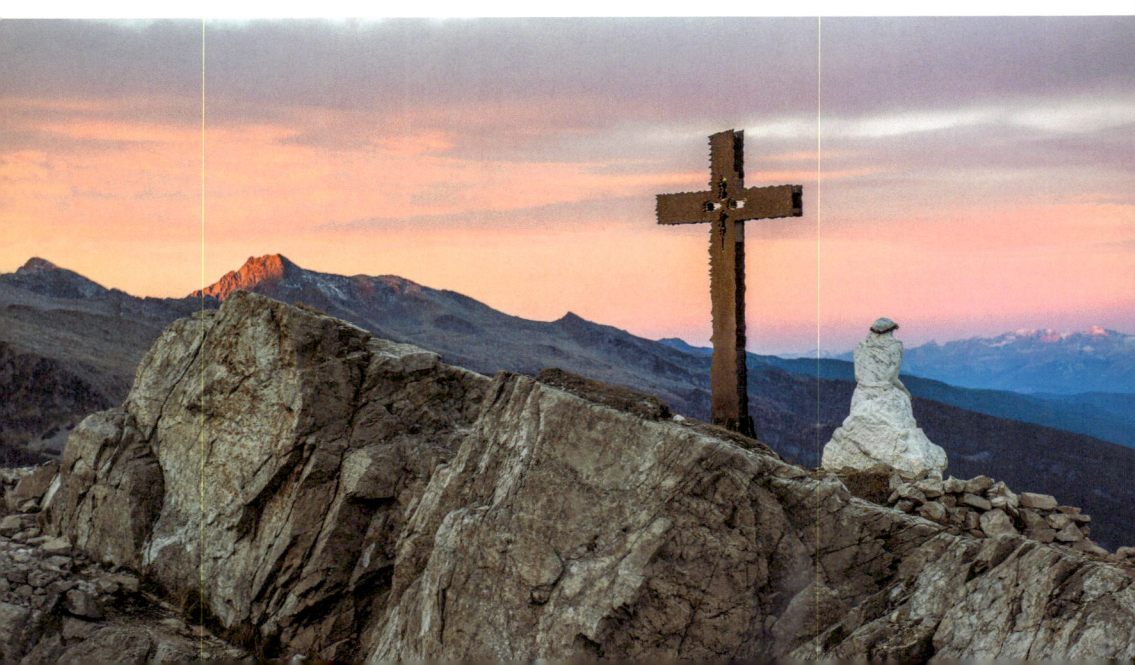

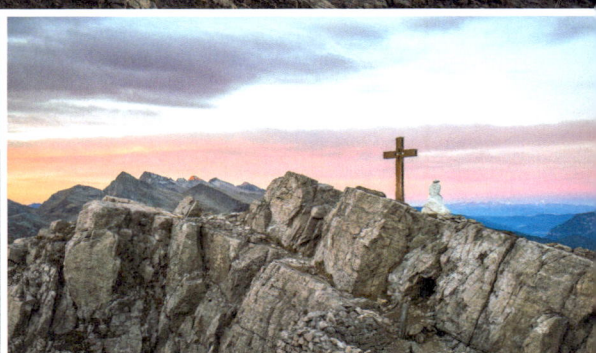

How to get here

From San Martino di Castrozza drive north up the SS50 for 10km to reach the top of the pass, from where the access track to Baita Segantini is clearly signposted off to the right on the final hairpin before the pass. In low season it is possible to drive up to the rifugio itself and park just past the building on the left, whereas in high season the access track is closed to vehicles and a taxi shuttle runs regularly from the top of the pass. Alternatively it is possible to ascend on foot to reach Baita Segantini in just under half an hour.

Lat/Long:	46.298879, 11.804589
what3words:	///excited.sled.defaulted
Tabacco:	Map 22 (1:25.000)
Kompass:	Map 653 (1:25.000)

Accessibility

Approach: 75 minutes, 4km, 150m of ascent.

Disabled access: Despite the good path network, the long approach makes this location unsuitable for disabled access.

Best time of year/day

Although the approach is relatively long, this peak is a popular walking destination and is best visited during low season (coinciding with vehicle access to Baita Segantini). The mountain is exceptionally prone to avalanche and should be avoided when there is snow on the ground. The summit is photogenic throughout the day, particularly during the golden hours at sunrise and sunset.

Top: The summit cross and Cristo Pensante make for a particularly striking foreground. Nikon D810, 14–24mm at 14mm, ISO 100, 1/25s at f/2.8, Nov. *Above left*: The sun illuminates the distant Tofana di Rozes. Nikon 80–400mm at 400mm, ISO 110, 1/400s at f/5.6, Oct. *Right*: The summit cross works best framed in the sky. Nikon D810, 24–70mm at 30mm, ISO 100, 1/50s at f/7.1, Nov.

Opposite: Sunrise looking west from the summit of Monte Castellazzo at sunrise. Nikon D810, 24–70mm at 70mm, ISO 100, 1/80s at f/4.5, Oct.

Above: Early morning mist obscures the autumn trees. Nikon Z8, 100–400mm at 400mm, ISO 64, 1/8s at f/7.1, tripod, Oct.
Below: Dramatic hairpins on the upper section of the Passo Rolle. Nikon D810, 24–70mm at 50mm, ISO 100, 90s at f/10, tripod, Oct.

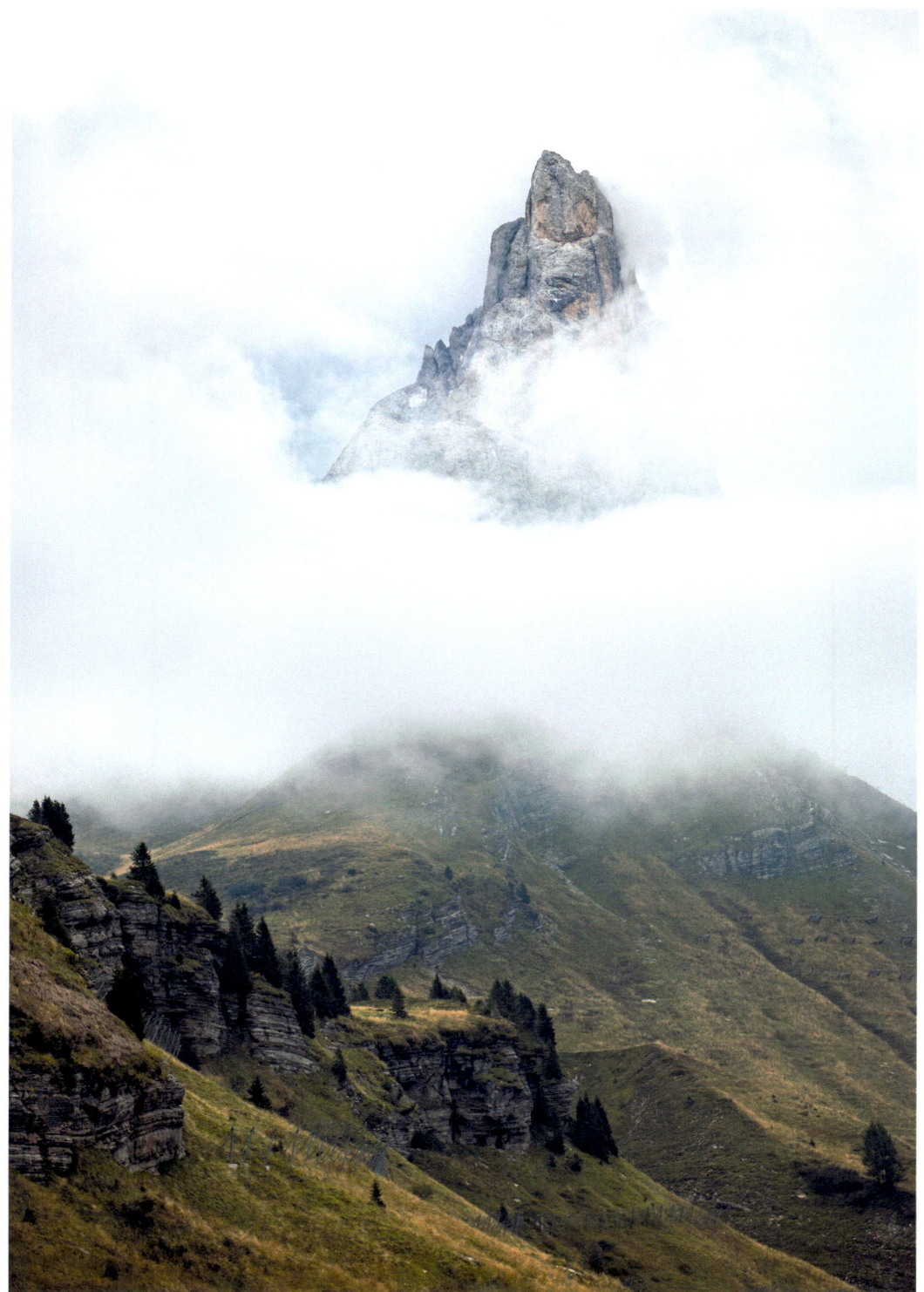
Cimon della Pala as seen from the south-west. Nikon Z7II, 24–120mm at 60mm, ISO 64, 1/200s at f/8, Aug.

5 BAITA SEGANTINI & CIMON DELLA PALA

Utilising an old road dating back to the First World War, artist Alfredo Paluselli built Baita Segantini by hand in 1936 as a retreat in order to be near his beloved Cimon della Pala. He went on to live there in solitude for the next 35 years as he worked on a number of pictorial and poetic artistic creations inspired by the rifugio's namesake, the Italian Arco-born artist Giovanni Segantini. By diverting a nearby stream, Paluselli was able to create a small lake alongside the building which would perfectly reflect the spires of the Cimon della Pala he loved so much.

Today this arrangement of lake and mountain is one of the most photographed and iconic scenes of the Dolomites; just don't expect to get it to yourself!

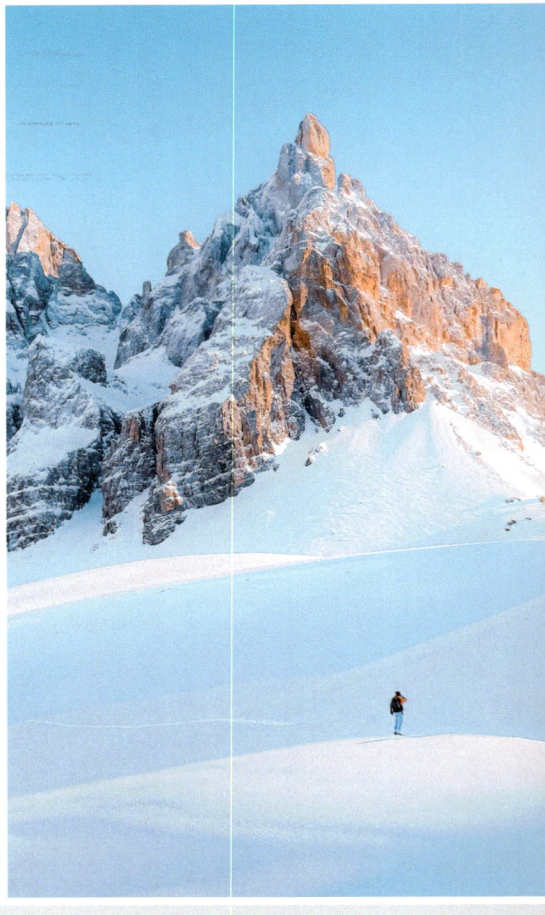

Right: Cimon della Pala in the winter. © Cristina Gottardi.

Opposite: Baita Segantini makes an excellent foreground alternative to the classic composition using the lake reflection. © Eberhard Grossgasteiger.

How to get here

From San Martino di Castrozza drive north up the SS50 for 10km to reach the top of the pass, from where the access track to Baita Segantini is clearly signposted off to the right on the final hairpin before the pass. During low season it is possible to drive up to the rifugio itself and park just past the building on the left. Take care on the unsurfaced road which is narrow and steep in places.

During high season the access track is closed to vehicles and a taxi shuttle service runs regularly from the top of the pass.

Alternatively it is possible to ascend on foot to reach Baita Segantini in just under half an hour.

P Lat/Long: 46.298879, 11.804589
P what3words: ///excited.sled.defaulted
P Tabacco: Map 22 (1:25.000)
P Kompass: Map 653 (1:25.000)

Accessibility

Approach: Roadside access or taxi shuttle service available.

♿ **Disabled access**: The roadside access to the site coupled with good paths surrounding the area makes it ideal for disabled access.

Best time of year/day

Due to the venue's popularity coupled with easier access when the service road is open, this is an ideal location during low season. If the snow has melted sufficiently to allow access to the rifugio, June is to be particularly recommended as the wildflowers will be blooming yet the area remains quiet.

The west-facing aspect of Cimon della Pala makes it perfect for sunset photography throughout the year, particularly during mid summer and winter. The exposed situation of the lake requires a calm and still day in order to get the characteristic reflections.

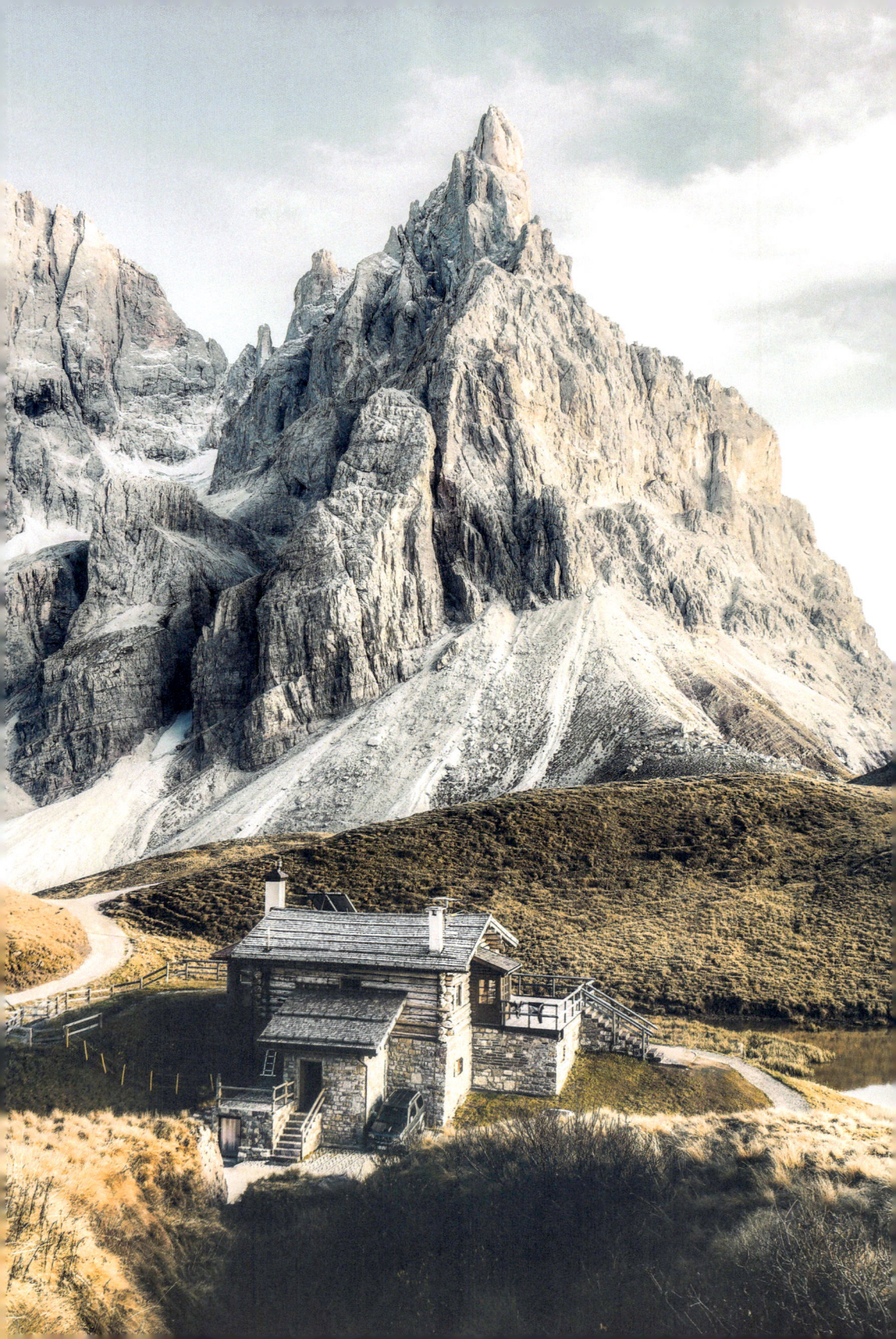

 # BAITA SEGANTINI & CIMON DELLA PALA

What to shoot and viewpoints

Viewpoint 1 – Baita Segantini & Cimon della Pala Lake Reflections ♿

Looking east towards Cimon della Pala it immediately becomes apparent why this viewpoint is so popular. The classic shot utilises an ultra wide-angle lens (or some panoramic trickery) to capture Cimon della Pala and the mountain's reflection in a landscape orientation.

This composition works best during the afternoon when Baita Segantini is bathed in light; or at sunset when the last light illuminates the peaks but the water's surface is in shadow, allowing the reflections to stand out more clearly.

Viewpoint 2 – Baita Segantini ♿

By climbing a small grassy hill north-west of Baita Segantini the rifugo makes an excellent foreground to Cimon della Pala – a composition that works particularly well in a portrait orientation.

Viewpoint 3 – Meadows & Cimon della Pala ♿

Relative solitude can often be found by leaving the water's edge and exploring the meadows surrounding Baita Segantini. During June and July the fields are awash with wildflowers of every shape, size and colour, all of which can be used as an alternative foreground to the impressive Cimon della Pala to create a slightly different take on the much photographed peak.

The classic view of Baita Segantini and Cimon della Pala. Nikon D810, 16–35 at 16mm, ISO 100, 1/500s at f/8, Sep.

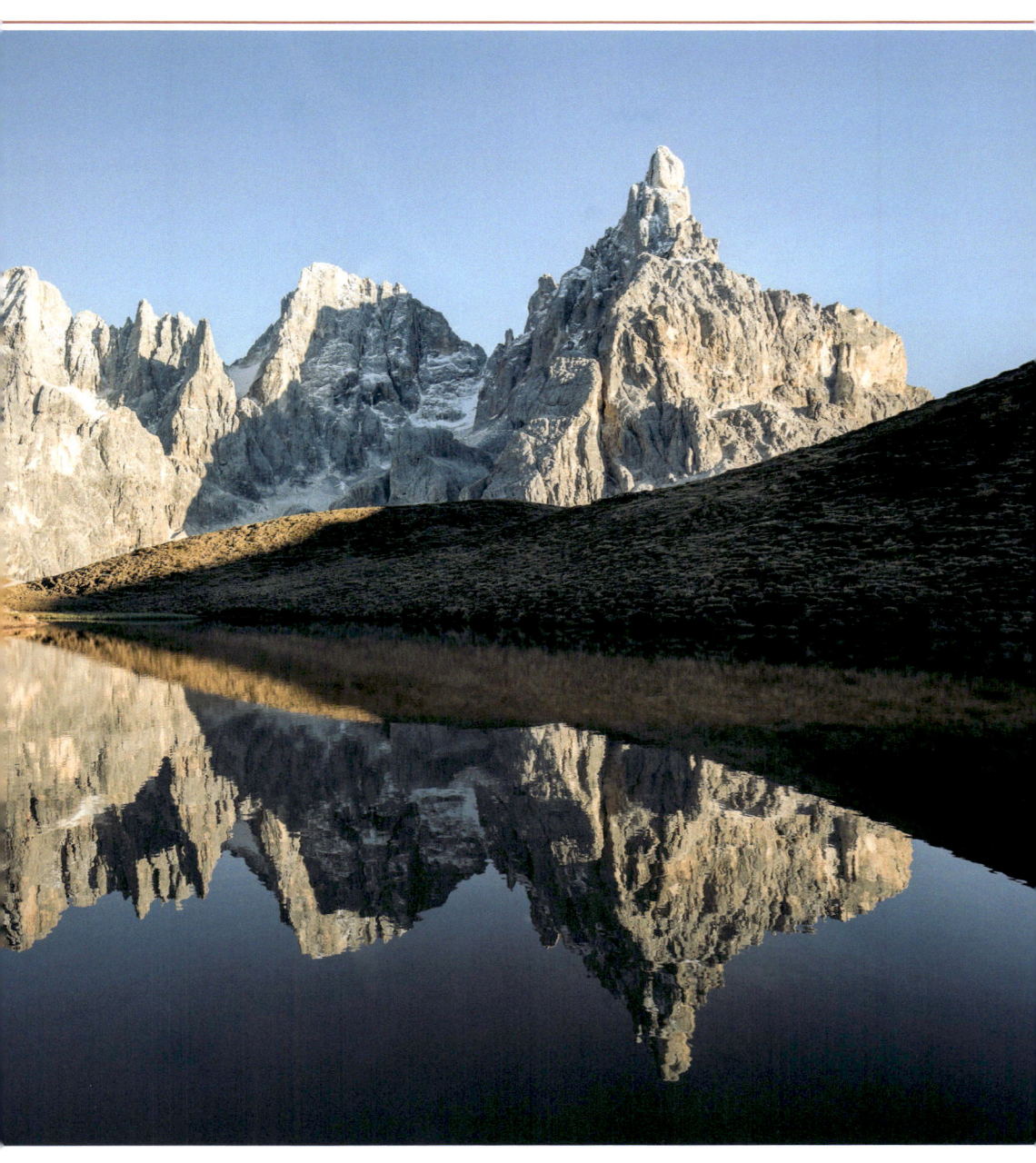

Next spread: Early season snow blankets Crode Rosse, as seen from Passo Rolle. Nikon Z7II, 24–120mm at 50mm, ISO 64, 1/500s at f/8, Oct.

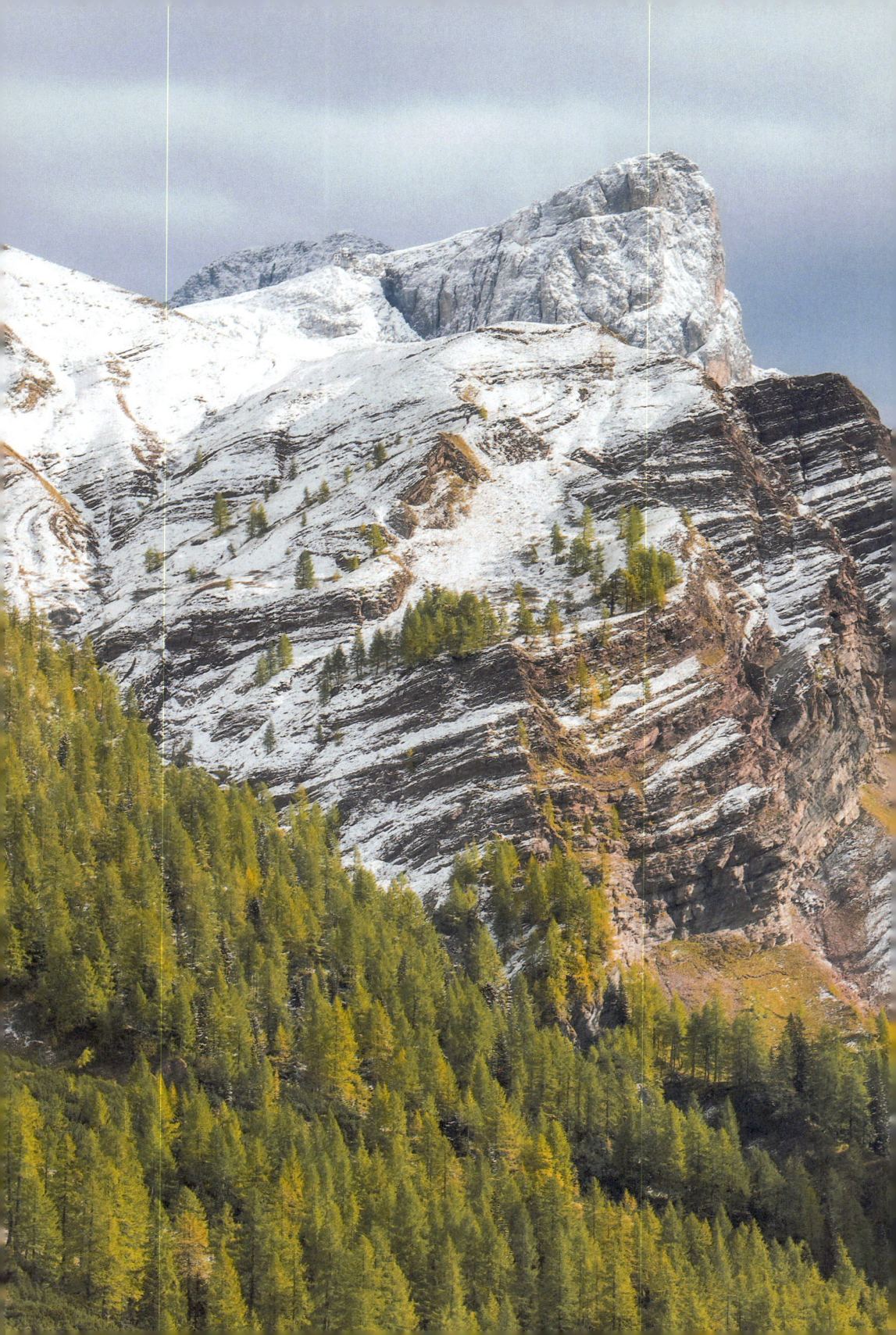

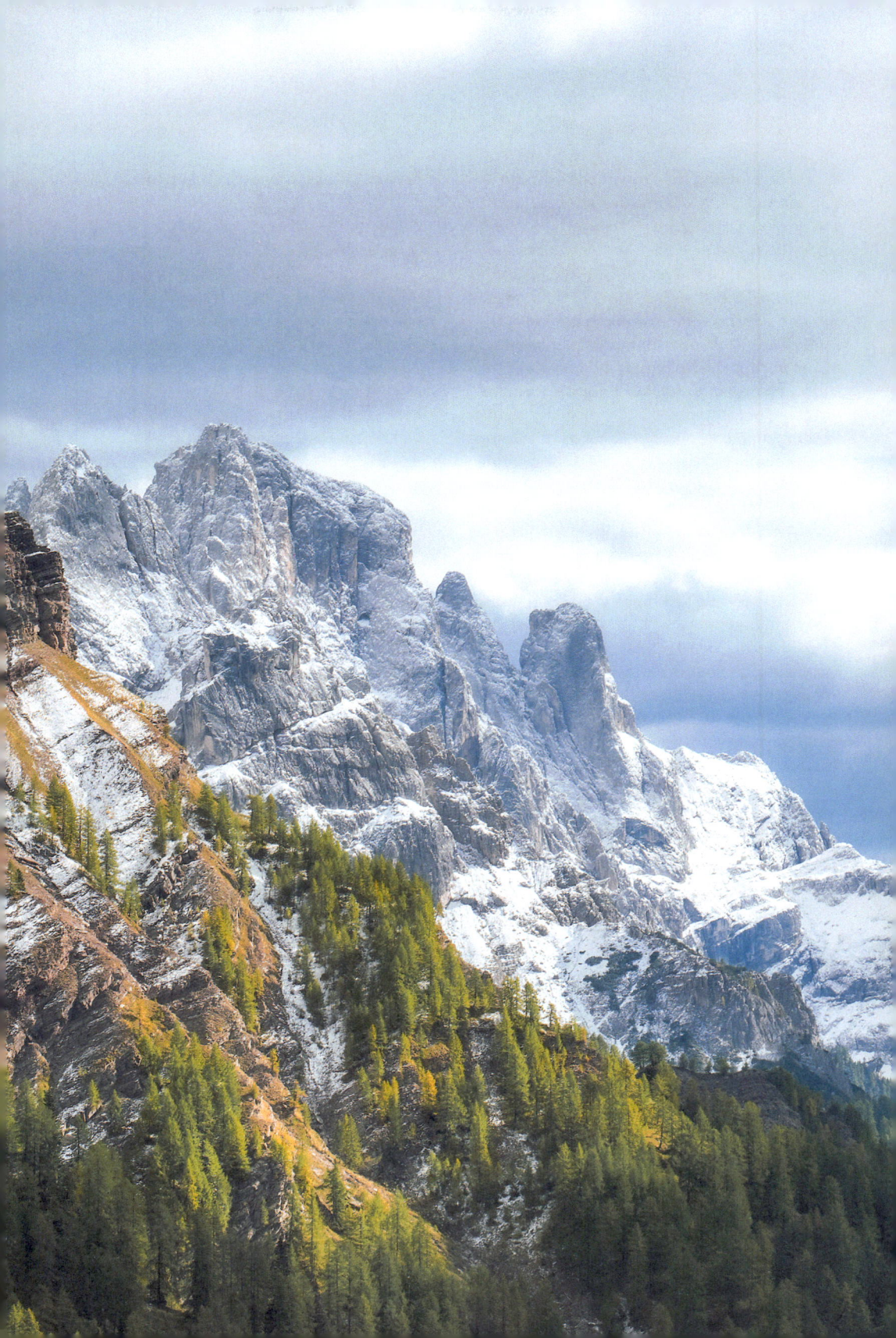

6. BELVEDERE GEOLOGICA DI CRODE ROSSE

As you drive along the Passo Rolle you can't help but notice the dramatic multicoloured and deep red rock bands of the aptly named Crode Rosse to the east. These impressive cliffs are testament to the recovery of life following the Permo-Triassic extinction 252 million years ago and are the source of much geological study. The visible outcropping of sedimentary rock is part of the Bellerophon Formation and was formed in shallow waters where sea water evaporated due to a tropical dry climate creating an environment known as a 'Sabkhas' (the phonetic translation of the Arabic word for a salt flat). The habitat is perfect for the formation of sedimentary 'evaporites', in this case gypsums and dolomite. The obvious folding was caused by the African and Eurasian plates colliding during the Alpine orogeny, forcing the pliable sedimentary rocks to buckle under the pressure.

The undeniably spectacular geology is easily captured from the roadside of the SS50 just north of San Martino di Castrozza, making this a convenient and recommended stop for anyone travelling up or down the Passo Rolle.

What to shoot and viewpoints

Viewpoint 1 – Crode Rosse ♿
The vibrant and multi-coloured rock bands that make up the west face of Crode Rosse are superbly photogenic, even from the roadside. The nearby forest which gradually thins with altitude against the looming backdrop of Cimon della Palla makes for a well-balanced and effective composition when combined with a suitably long focal length to remove any foreground distractions.

The scene is best shot after midday when the sun has moved around sufficiently to light the face, highlighting all the fantastic details and bringing the image to life.

The ease of access makes this shot achievable throughout the year and is particularly striking in winter when the vivid geology contrasts nicely with the surrounding snow.

Viewpoint 2 – Detail & Rock Abstracts ♿
Utilising a long telephoto it is possible to isolate and capture areas of particular interest, creating some fantastic rock abstracts. The lower part of the face just above the car park is a perfect example of sigmoidal tensional veins subjected to chevron folding, creating a characteristic 'S' pattern which is especially photogenic.

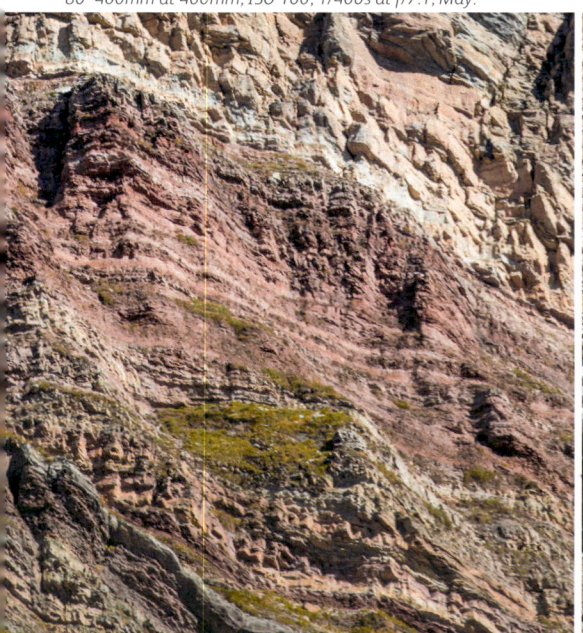

Capturing the rock patterns high up on the west face. Nikon D810, 80–400mm at 400mm, ISO 100, 1/400s at f/7.1, May.

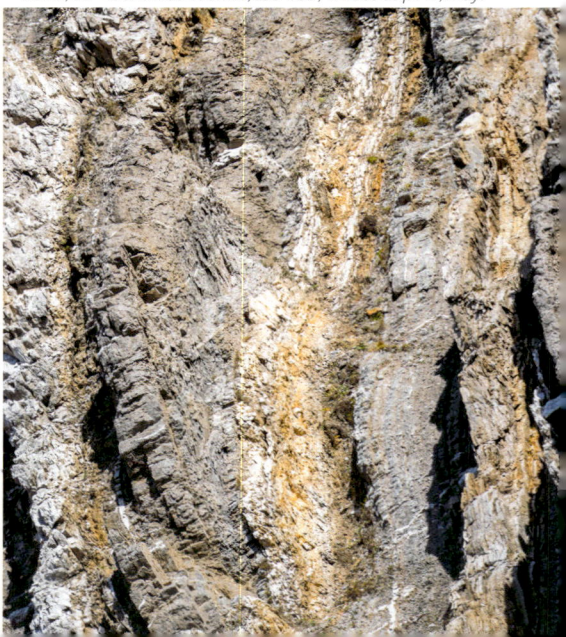

A rock abstract making use of the vertically aligned planes. Nikon D810, 80–400mm at 400mm, ISO 100, 1/400s at f/7.1, May.

How to get here

From San Martino di Castrozza, drive north up the SS50 following signs for the Passo Rolle. After 3km, reach a large hairpin bending round to the left with good views of Crode Rosse. Immediately after the hairpin there is a lay-by on the left with a display board providing information on the geology of the area. A gate on the opposite side of the road, directly on the hairpin, provides an unrestricted view of the rock face.

	Lat/Long:	46.275332, 11.800682
	what3words:	///excited.sled.defaulted
	Tabacco:	Map 22 (1:25.000)
	Kompass:	Map 653 (1:25.000)

Accessibility

Approach: Roadside access.

 Disabled access: Thanks to the roadside location, this site is ideal for disabled access.

Best time of year/day

Located directly on the road between San Martino di Castrozza and the Passo Rolle, this is an ideal opportunistic venue for photographers travelling between locations in the Pale di San Martino. The ease of access makes this a convenient location for shooting year round, providing that the west face isn't holding too much snow which obscures the rock bands.

Owing to the westerly aspect of the mountain, Crode Rosse is best photographed in the afternoon when the sun shines directly onto the main face. Equally, during mid summer it is possible to get some golden light illuminating the highest spires and the Cimon della Pala backdrop at sunset.

Above: The cloud clears to reveal the west face of Crode Rosse after fresh snowfall. Nikon D810, 80–400mm at 120mm, ISO 100, 1/200s at f/7.1, May.

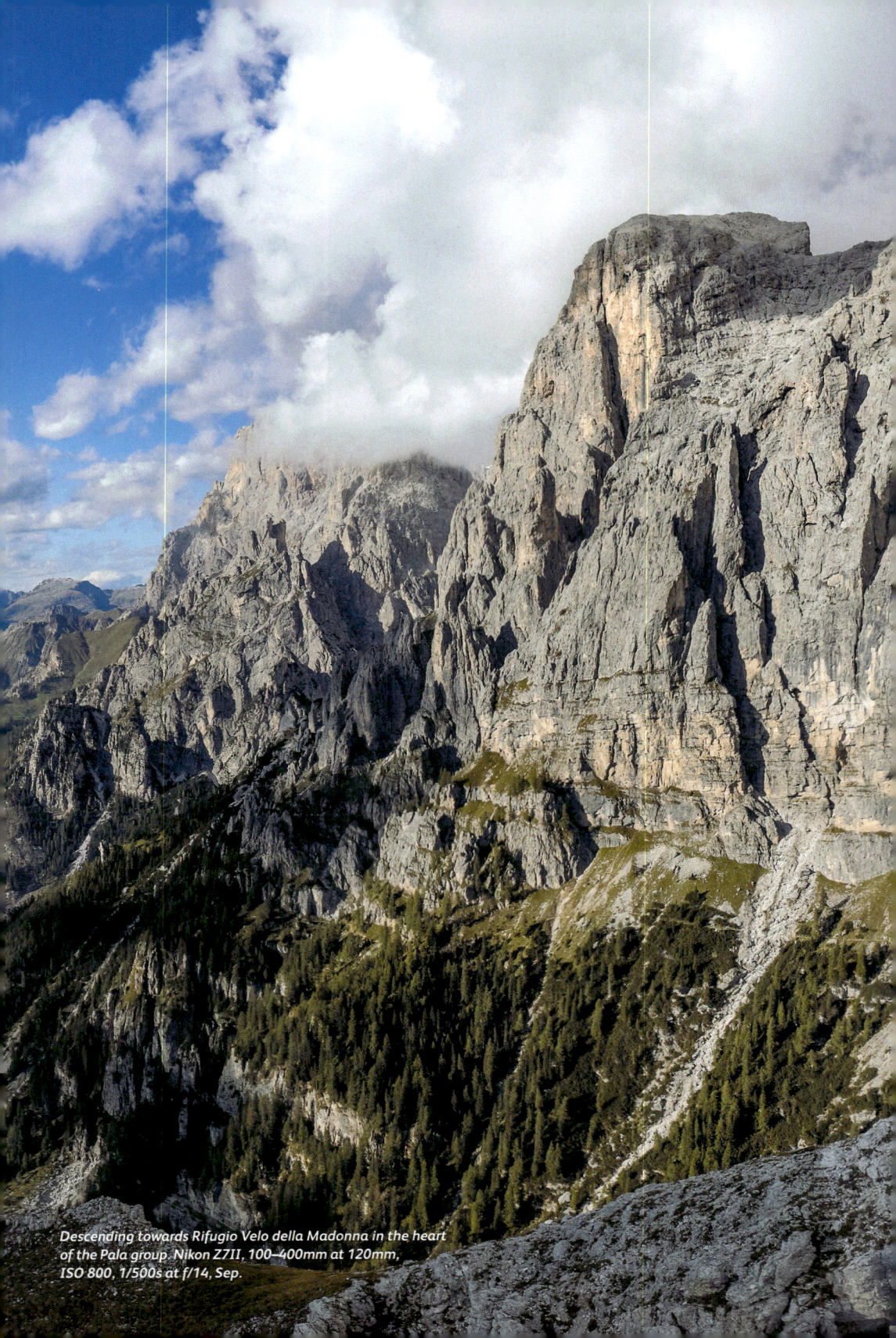

Descending towards Rifugio Velo della Madonna in the heart of the Pala group. Nikon Z7II, 100–400mm at 120mm, ISO 800, 1/500s at f/14, Sep.

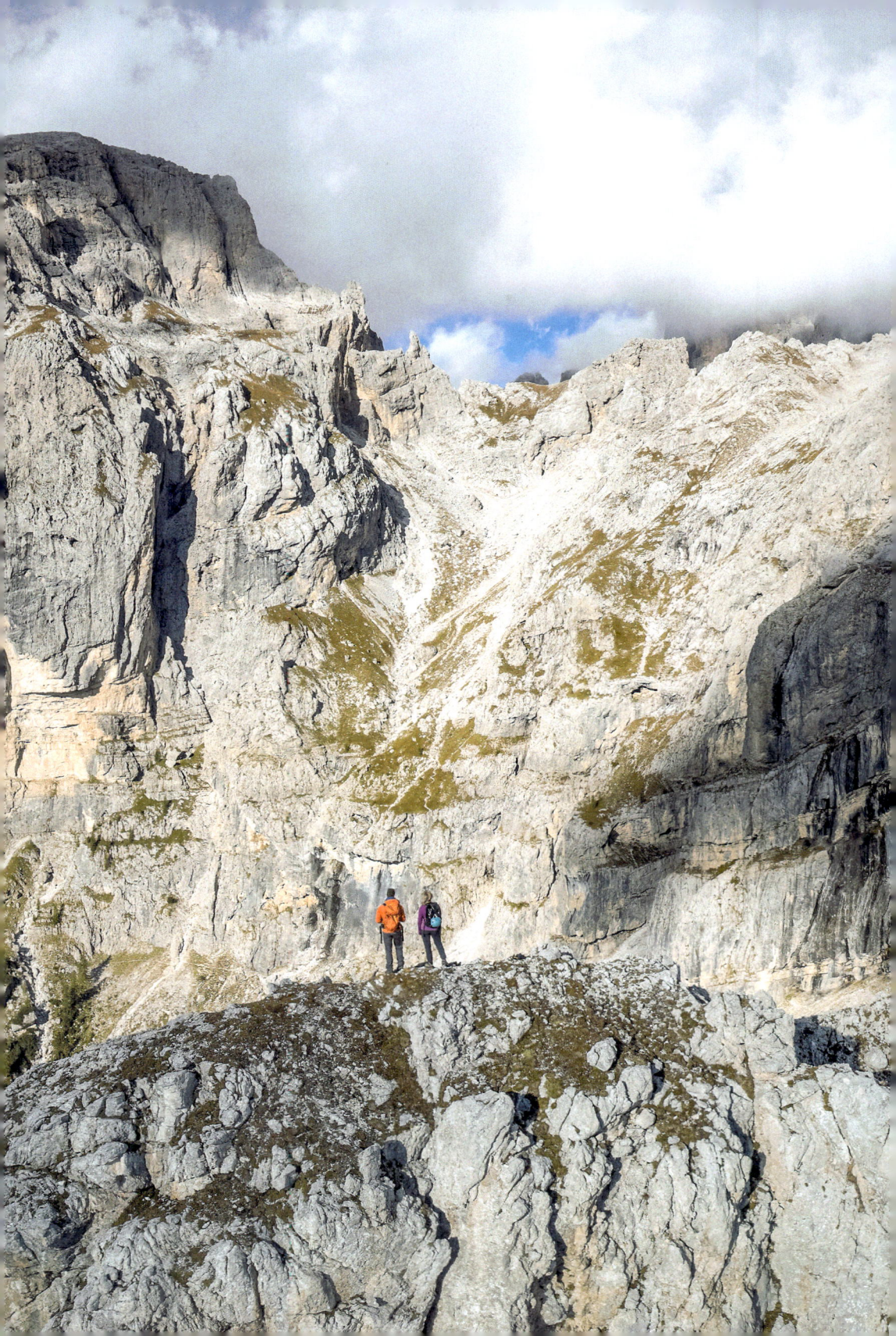

7 VAL PRADIDALI

Branching north-west off the larger Val Canali and extending into the heart of the Pale di San Martino, the Val Pradidali is a remote and beautiful valley which will appeal to photographers looking to test their skills in a wilder environment. The Pradidali name hails from a Primiero dialect and can be roughly translated as 'yellow meadows', so-called because of the many yellow Rhaetian Alps poppies (Papaver rhaeticum) that bloom below the vast rock walls lining the valley.

The twin towers of Sass Maor and Cima Canali stand guard over the head of the valley and make for an excellent backdrop when shooting the many streams that flow into the lower basin. For photographers looking to explore further afield, a hike up to Rifugio Pradidali and the nearby Lago Pradidali is highly recommended.

What to shoot and viewpoints

From the parking area, head north-east to pick up signposting towards Rifugio Pradidali on path 709. Follow the track between the houses and cross a bridge over the stream. Turn right, still following for Rifugio Pradidali on path 709 and ascending the steep track for 30 minutes to exit into an open area where the path crosses over onto the right side of the stream.

Viewpoint 1 – Sass Maor
Just right of the path, several small tributaries converge to create a beautiful little waterfall that flows over some wonderfully coloured yellow and red rock. Backdropped by the tooth-shaped Sass Maor tower, this makes for an excellent composition using a relatively wide focal length.

The shot works particularly well at sunrise when the tower is illuminated, or otherwise on a flat light and atmospheric day when the low cloud hints at the scale of the pinnacles behind.

There are several more photogenic waterfalls located just downstream; however, access is tricky and requires several sections of downwards scrambling.

Viewpoint 2 – Rio Pradidali
Follow the stream uphill from Viewpoint 1 to soon enter beautiful and dense woodland. Taking care not to trample this beautiful ecosystem anymore than is absolutely necessary, it is possible to follow the meandering channel as it passes through vibrant moss, dense ferns and cascades over several small but perfectly formed waterfalls. Although an overcast day is generally perfect for shooting streams, in this case the dense undergrowth often allows for some artistic shots which make the most of the dappled light that filters through the surrounding spruce and larch trees.

Suitably fit parties may enjoy an extension up to Rifugio and Lago Pradidali (allow 2–3 hours for the 800m of ascent), or alternatively a shorter walk to the nearby Malga Canali yields some spectacular views.

How to get here

From San Martino di Castrozza take the SS50 south down the valley for 13km to reach the villages of Siror and Fiera di Primiero. Make a left turn onto the SS347 and follow the road for 4km before making another left turn onto a smaller road, clearly signposted for the Val Canali. Drive up the road, ignoring turn-offs to the left and right for 5km to reach a large parking area between Albergo Cant del Gal and Albergo La Ritonda.

- **Lat/Long**: 46.217464, 11.877819
- **what3words**: ///divots.chin.potentially
- **Tabacco**: Map 22 (1:25.000)
- **Kompass**: Map 653 (1:25.000)

Accessibility

Approach: 30 minutes, 1km, 180m of ascent.

The first viewpoint requires some scrambling over wet boulders and rocks in order to gain the best perspective.

Disabled access: The steep approach on a small gravel path makes the location unsuitable for disabled access.

Best time of year/day

The valley generally looks most photogenic during late spring and early summer when the water level of the streams is high and the Rhaetian poppy is in flower.

Owing to the south-easterly aspect of Sass Maor, the classic shot of the stream looking up the valley looks particularly striking at sunrise when the peaks are illuminated but the water remains soft without excessive contrast.

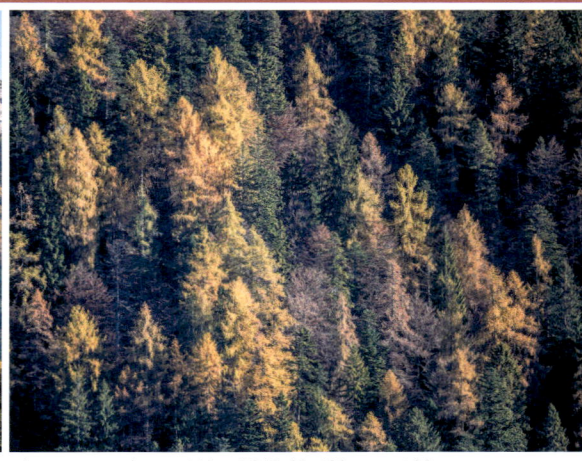

The ruins of Castel Pietra at the entrance to the Val Canale. Nikon D810, 80–400mm at 300mm, ISO 64, 1/320s at f/7.1, Oct.

Autumn tree abstract. Nikon D810, 80–400mm at 400mm, ISO 140, 1/400s at f/5.6, Oct.

The classic shot of the Val Pradidali looking towards Sass Maor at sunrise. Nikon D810, 16–35mm at 26mm, ISO 100, 2.5s at f/10, tripod, ND filter, Nov.

The Rio Pradidali as it flows through dense woodland in the upper half of the valley. Nikon D810, 16–35mm at 19mm, ISO 100, 1s at f/22, tripod, Nov.

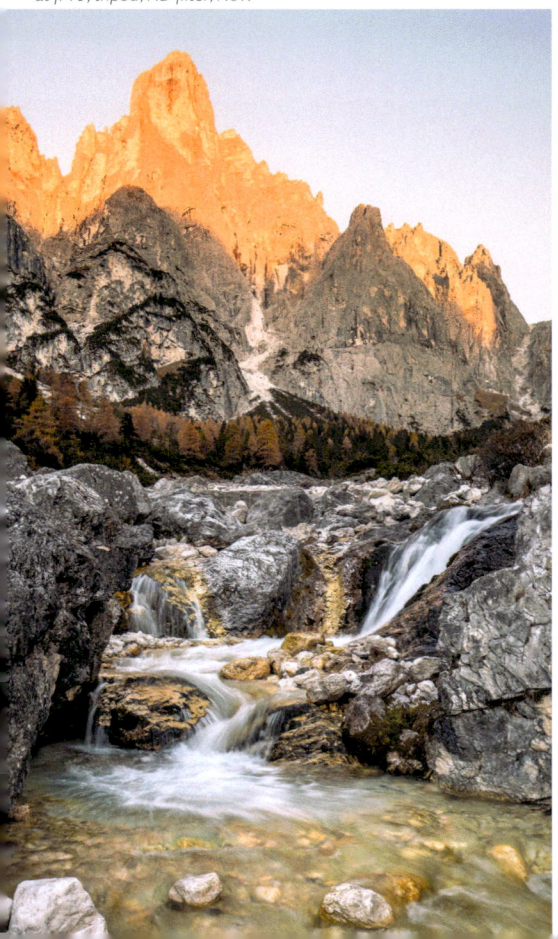

Above: *An unexpected flyby whilst ascending Monte Agnér. Nikon Z8, 24–120mm at 105mm, ISO 560, 1/1000s at f/4, Aug.*
Below: *The wonderful Chiesetta degli Alpini on the Passo Duran. Nikon Z8, 24–120mm at 120mm, ISO 64, 1/125s at f/11, Sep.*

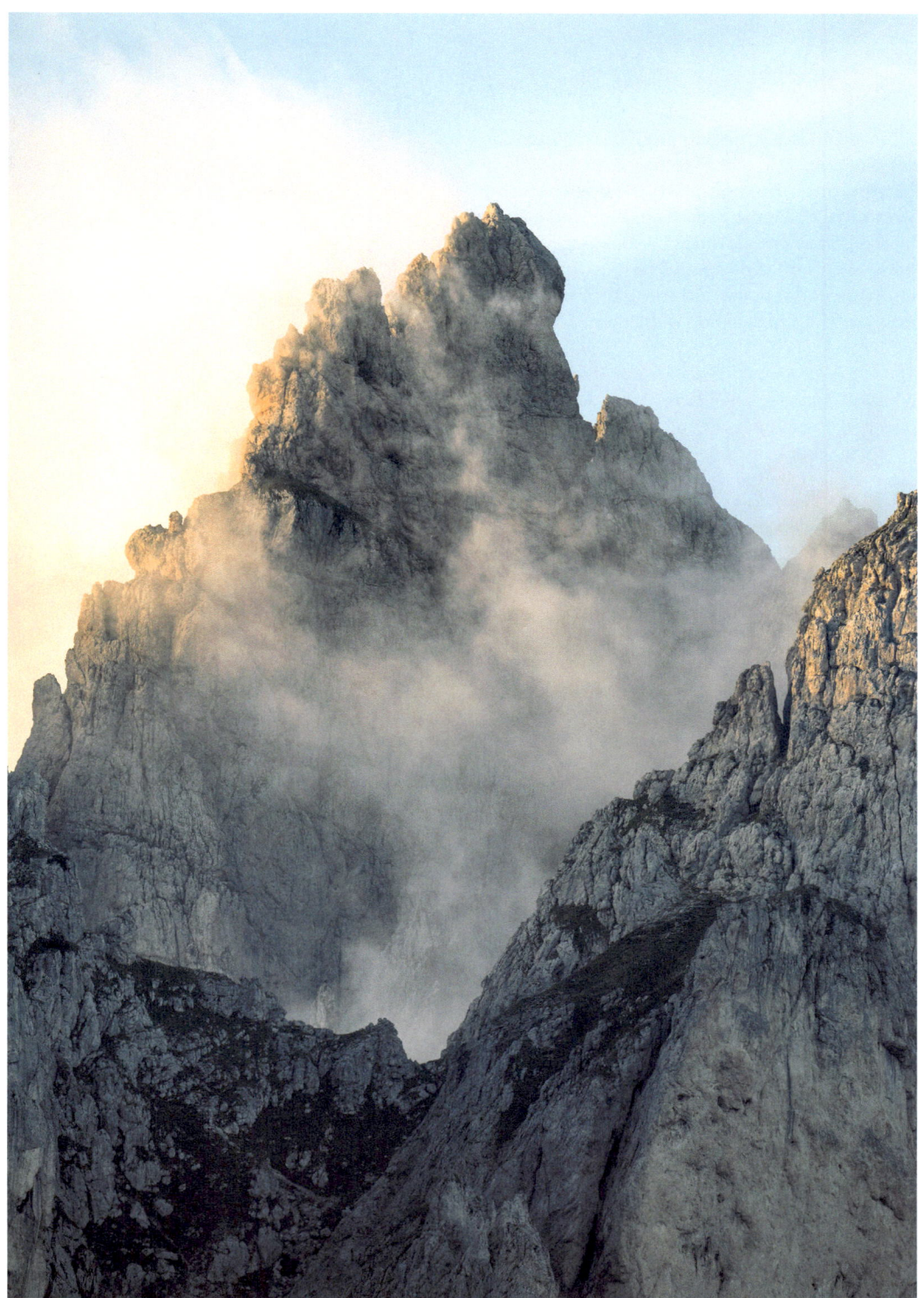
Looking back towards the Pala Group from the Passo Duran. Nikon Z7II, 100–400mm at 280mm, ISO 220, 1/320s at f/5.6, Jul.

8. LAGO DI CALAITA

Situated on the large Campigol Doch plateau, Lago di Calaita is one of the gems of the Pale di San Martino, offering superb views towards the west faces of Cimon della Pala. Watched over by the homonymous rifugio dating back to the early twentieth century, this natural lake creates a picture-perfect postcard scene that appears in many of the shops in San Martino di Castrozza.

The lake is famous for its wildlife and fishing, boasting a population of brown trout, Arctic char, minnows and rudd. Herons and other large predatory birds can often be seen along the shore drawn by the abundant supply of fish.

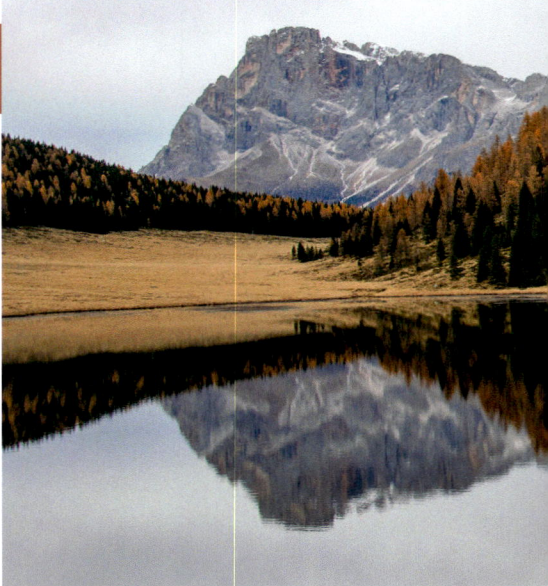

What to shoot and viewpoints

Viewpoint 1 – Cimon della Pala ♿
Looking north-east from the rifugio, it is easy to see why this is the classic viewpoint of the lake. The huge rock walls of Cimon della Pala that catch the afternoon and evening light are perfectly reflected in the clear waters of Lago Calaita, making an excellent backdrop to an already impressive foreground. The more immediate hills and forest are ideal for creating additional symmetry on a still day, using a landscape orientation. It is worth using a slightly longer focal length, cropping the image tightly in order to bring the rock walls of Cimon della Palla closer and helping to emphasise the scale of the peaks.

Viewpoint 2 – Rifugio Miralago Calaita ♿
Following the path around the western shore it is possible to gain a good perspective looking back towards Rifugio Calaita, positioning the nearby hills on the left of the frame. This composition is particularly striking when there is low cloud and mist on the lake, giving the building a haunted look.

Viewpoint 3 – Wildlife ♿
As well as fish and waterfowl, the lake is an important habitat feature for roe deer, chamois, foxes, badgers and marmots. These are best spotted during early morning and late evening when the area is quiet. A small path circumnavigates the lake shore and is worth exploring for new perspectives on this much-photographed location.

How to get here

While it is possible to traverse in on foot all the way from the Sass Maor campsite on the outskirts of San Martino di Castrozza using path 350, the usual approach is via the Passo della Gobbera west of Mezzano.

From San Martino di Castrozza take the SS50 south for 16km to reach the village of Mezzano. Turn right onto the SP79 and follow the road for 8km, passing over the Passo della Gobbera to reach a well-signposted right turn to Lago Calaita at a large hairpin. Turn right and follow good signposting to reach the lake in a further 8km. There is a large car park next to Rifugio Miralago Calaita.

- **Lat/Long**: 46.201962, 11.789770
- **what3words**: ///smoggy.deplorable.renounced
- **Tabacco**: Map 22 (1:25.000)
- **Kompass**: Map 653 (1:25.000)

Accessibility

Approach: Roadside access.

♿ **Disabled access**: The roadside access and good path network along the western shore make this location ideal for disabled access.

Best time of year/day

During June and July the surrounding fields are awash with wildflowers, creating an idyllic scene that lends itself to good weather photography. Finally, in autumn the surrounding larch trees change colour to a perfect sunset orange, contrasting beautifully with the neighbouring evergreens.

The westerly aspect of the Cimon della Pala backdrop makes it a perfect venue for sunset photography throughout the season.

Above: The still waters provide some excellent symmetry. Nikon D810, 28–300 at 28mm, ISO 100, 1/250s at f/8, Nov.

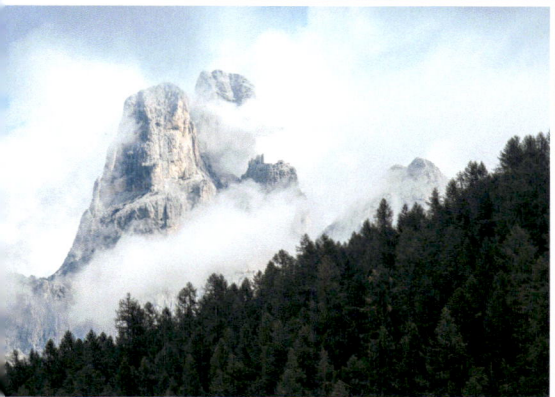

Low clouds engulfs Cima Rosetta and surrounding peaks. Nikon Z8, 100–400mm at 155mm, ISO 110, 1/320s at f/8, Aug.

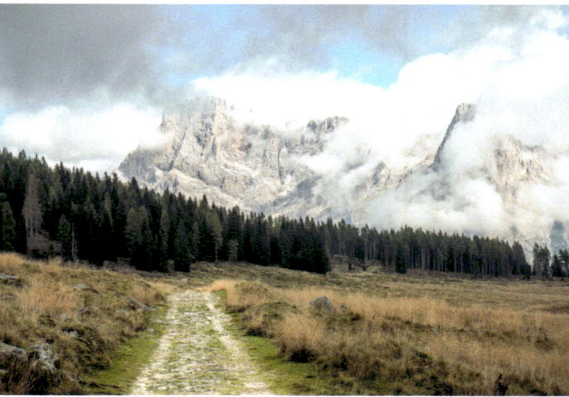

Using the walking track as a leading line towards the Pala group. Nikon Z7II, 24–120mm at 70mm, ISO 140, 1/160s at f/13, Sep.

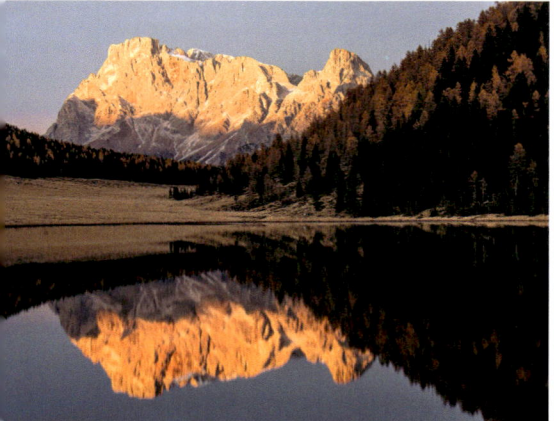

The sun sets on Cimon della Pala. Nikon D810, 28–300mm at 60mm, ISO 100, 30s at f/10, tripod, ND filter, Nov.

Funivia Rosetta leads onto the Pala plateau. Nikon Z7II, 100–400mm at 250mm, ISO 200, 1/400s at f/10, Aug.

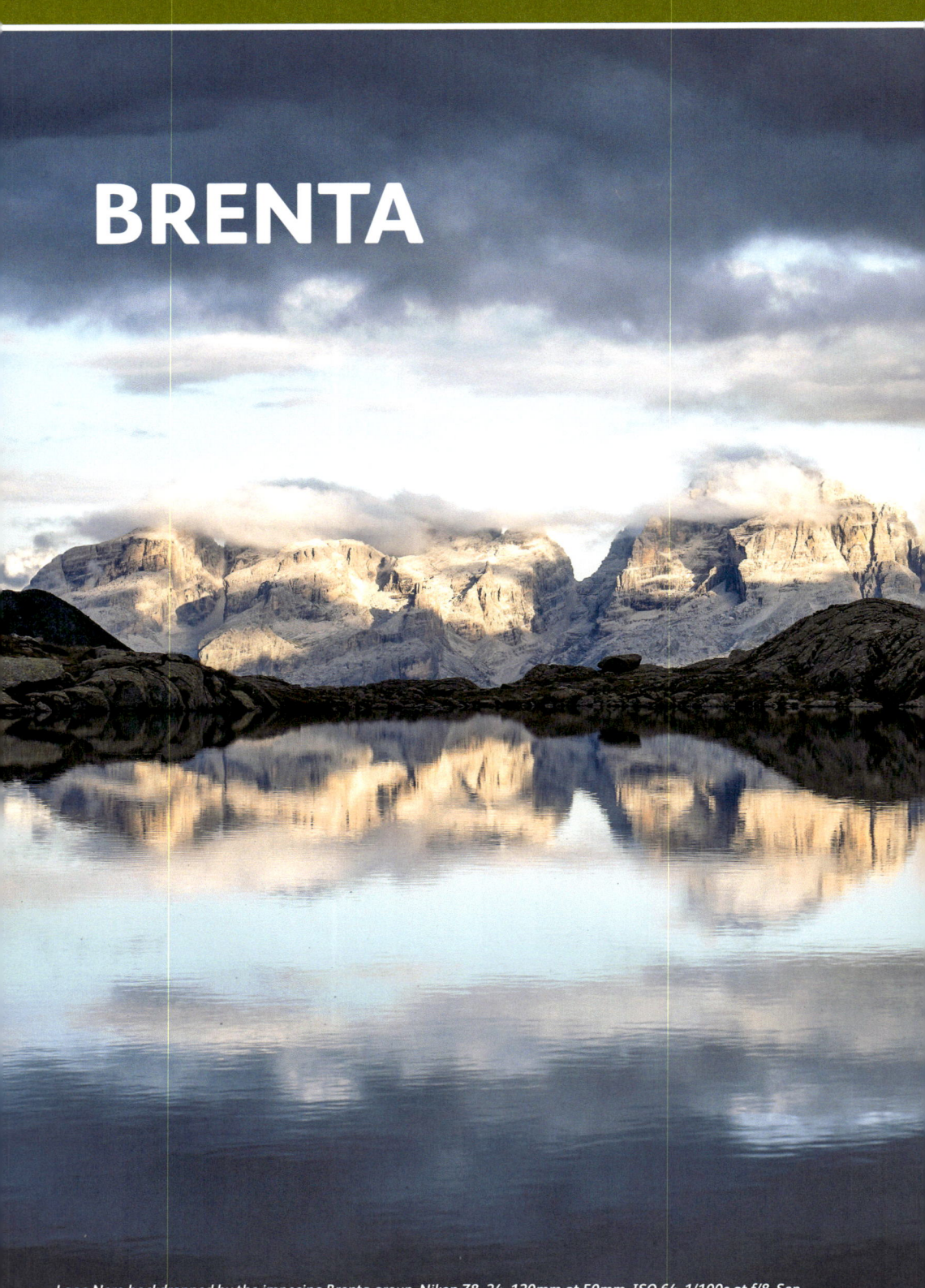

BRENTA

Lago Nero backdropped by the imposing Brenta group. Nikon Z8, 24–120mm at 50mm, ISO 64, 1/100s at f/8, Sep.

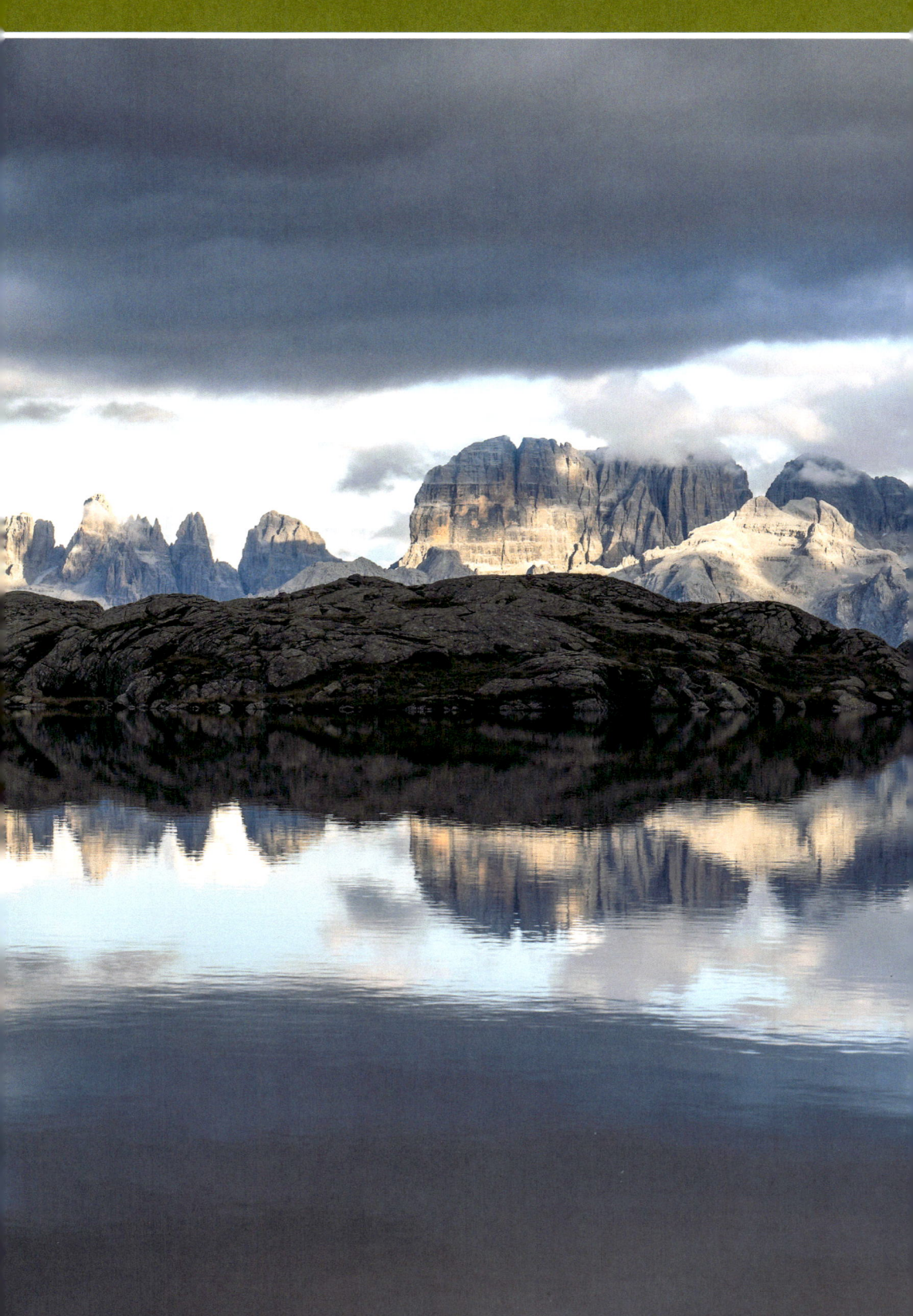

BRENTA – INTRODUCTION

Separated from the central Dolomites by the wide Val D'Adige (Etschtal) valley and eponymous river, the Brenta Dolomites quite literally stand apart from their more well-known counterparts to the north-east despite sharing their UNESCO World Heritage status.

Less developed and more remote, the Brenta Dolomites are part of the Adamello Brenta Natural Park – a vast area of wilderness that when combined with the adjacent Stelvio National Park, Adamello Regional Park and Swiss National Park forms the largest protected area in the entire Alpine chain. Unsurprisingly the Brenta is a haven for wildlife – most notably the brown bear which has become synonymous with the region. It is also possible to find ibex, golden eagles, roe deer, mouflon and even the occasional bearded vulture.

Boasting eight peaks over 3000m, the Brenta enjoys a rich history of mountaineering and famous first ascents. From John Ball's (founder of the Alpine Club) early traverse of the group in 1864, to the audacious ascent of Campanile Basso in 1897 when Garbari, Tavernaro and Pooli got to within 12m of the summit before having to retreat – Garbari famously telling Pooli to 'finish the climb or die'.

Torre di Brenta (3014m) and Campanile Alto (2937m) in the Brenta Group. Nikon Z7II, 100–400mm at 400mm, ISO 200, 1/400s at f/8, Sep.

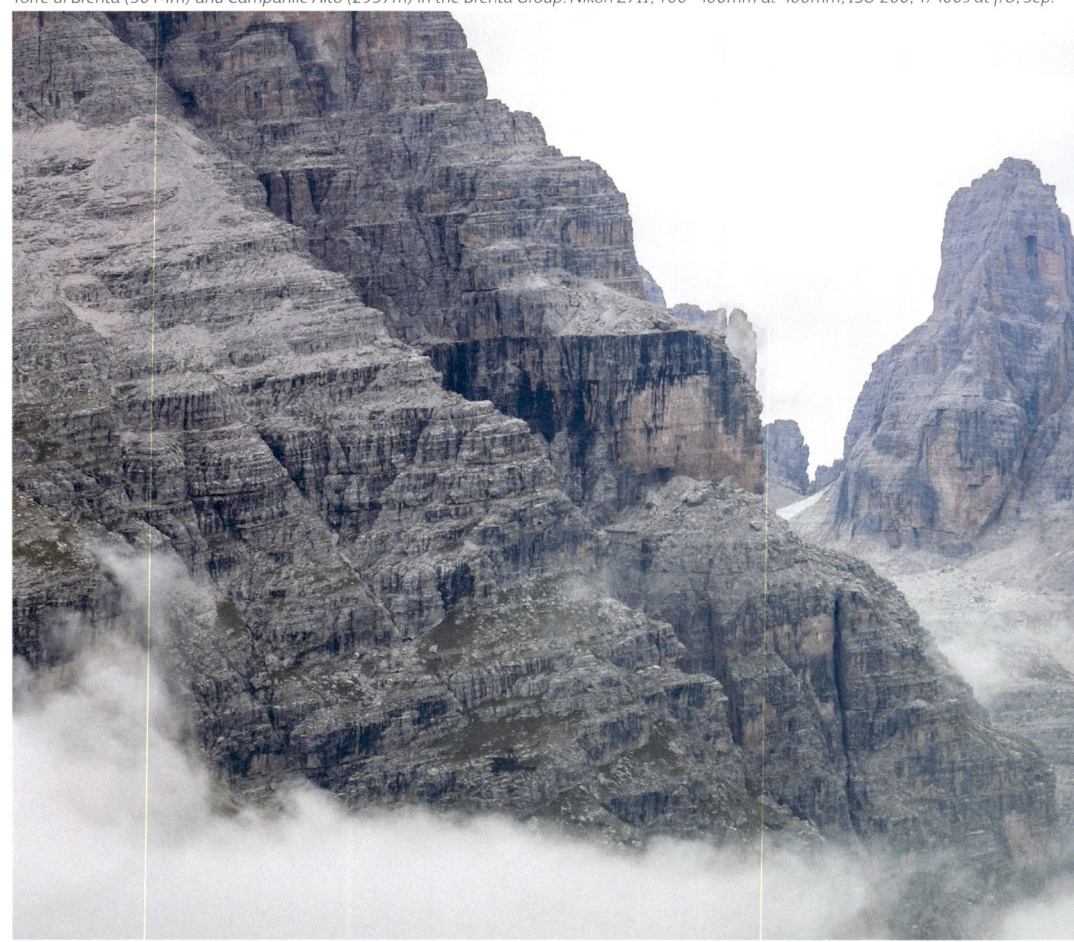

Today the multi-day via ferrata linkup 'Via delle Bocchette' is one of the most famous routes in the Dolomites – a spectacular high-altitude traverse along the steel cables cutting through the heart of the range.

From a photographer's perspective, the superbly situated Madonna di Campiglio makes for a great base, giving access to a diverse range of locations packed tightly together.

Molveno is the principal settlement on the eastern side of the range – a town famous for its lakeside views, outdoor sports and good food. Frequently described as a 'mini Lake Garda' the waterfront offers spectacular views up to the Brenta Dolomites, whilst a lift system allows visitors to get closer to the impressive peaks.

The Brenta is recommended to photographers who have explored the Central Dolomites extensively – or for those looking for something a little different off the beaten track.

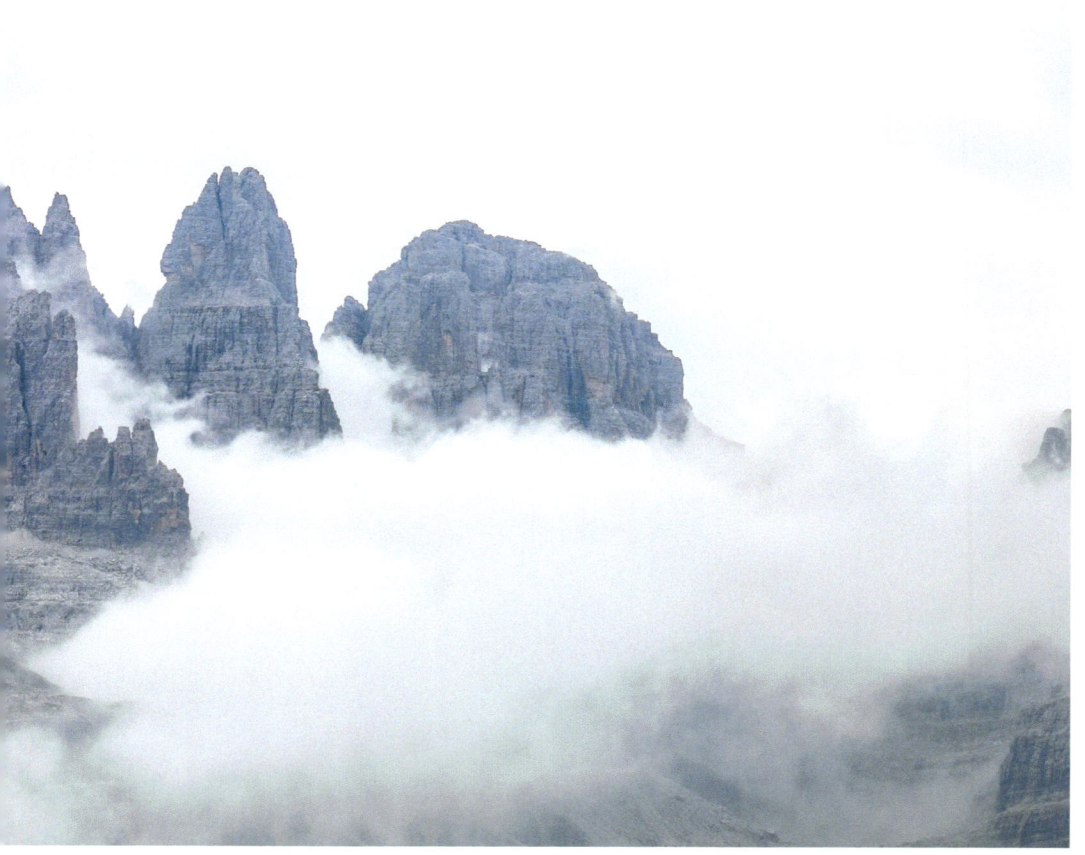

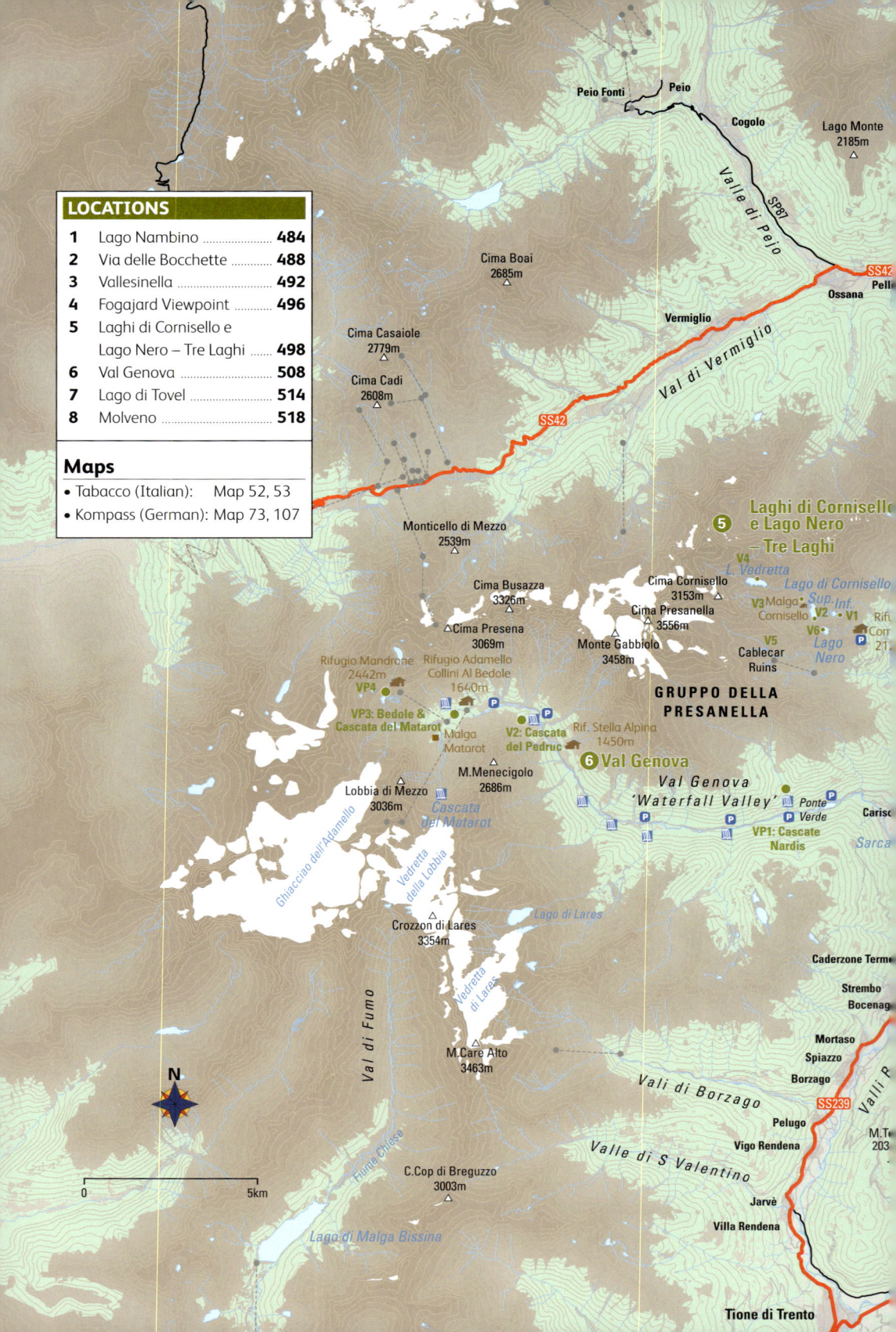

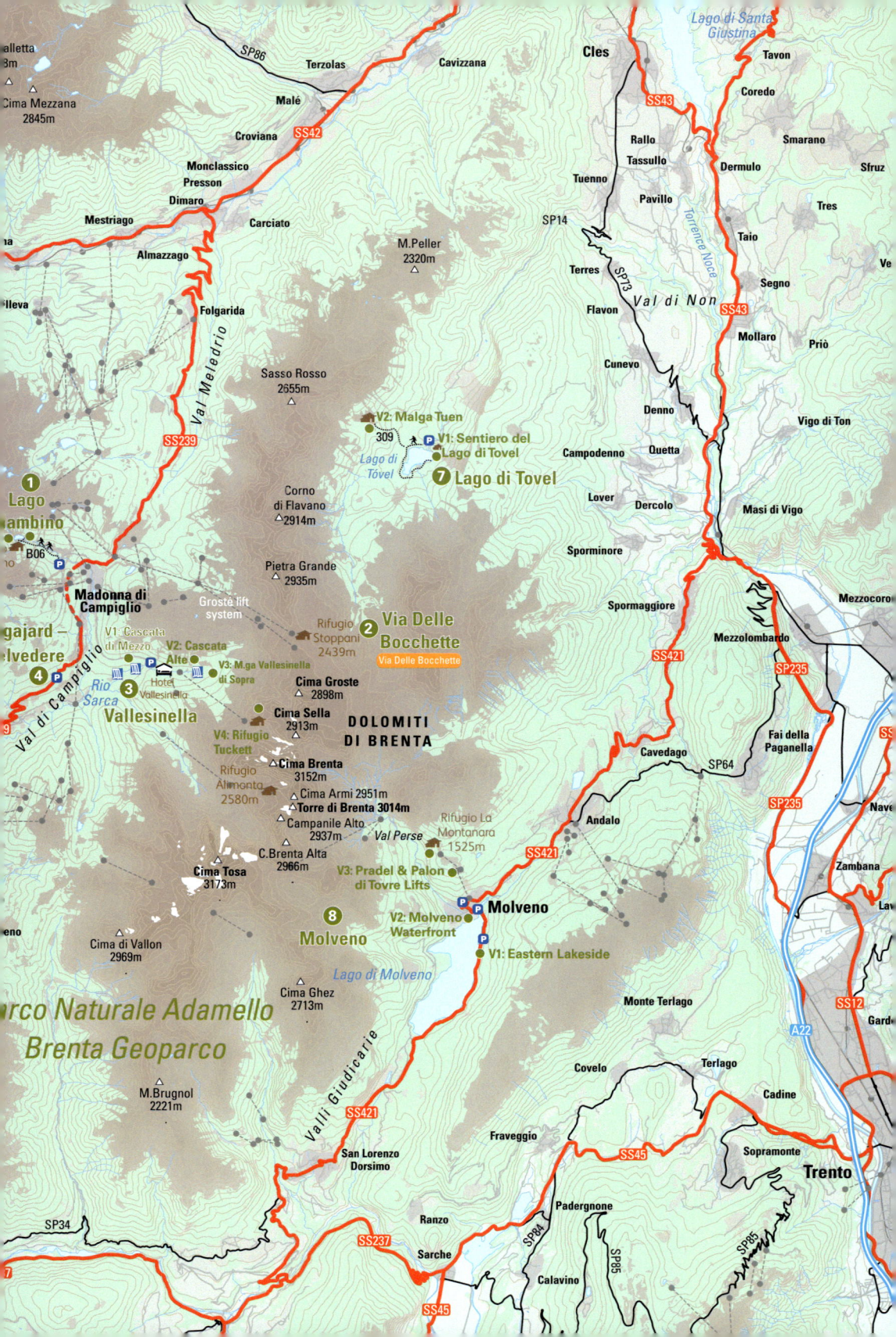

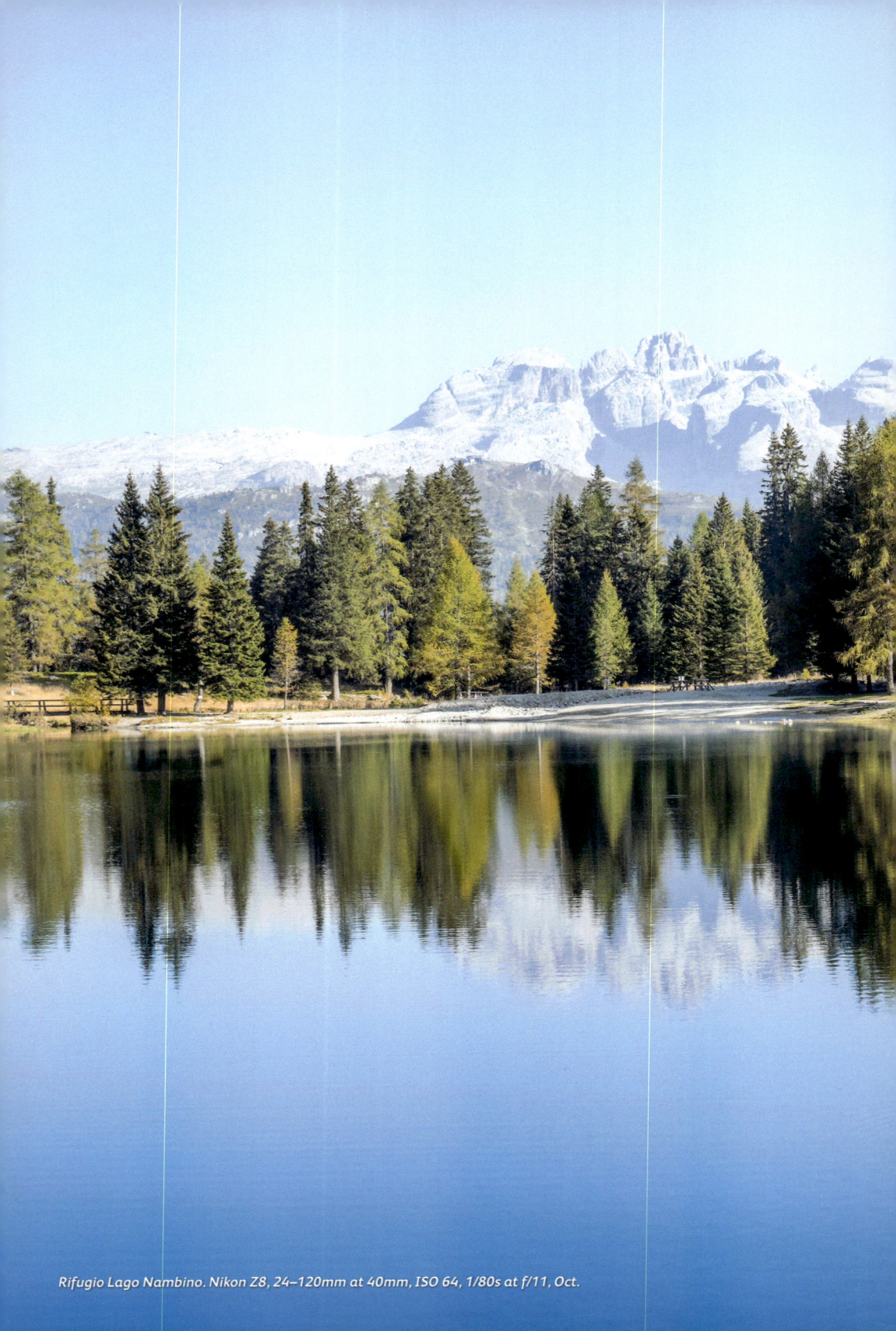
Rifugio Lago Nambino. Nikon Z8, 24–120mm at 40mm, ISO 64, 1/80s at f/11, Oct.

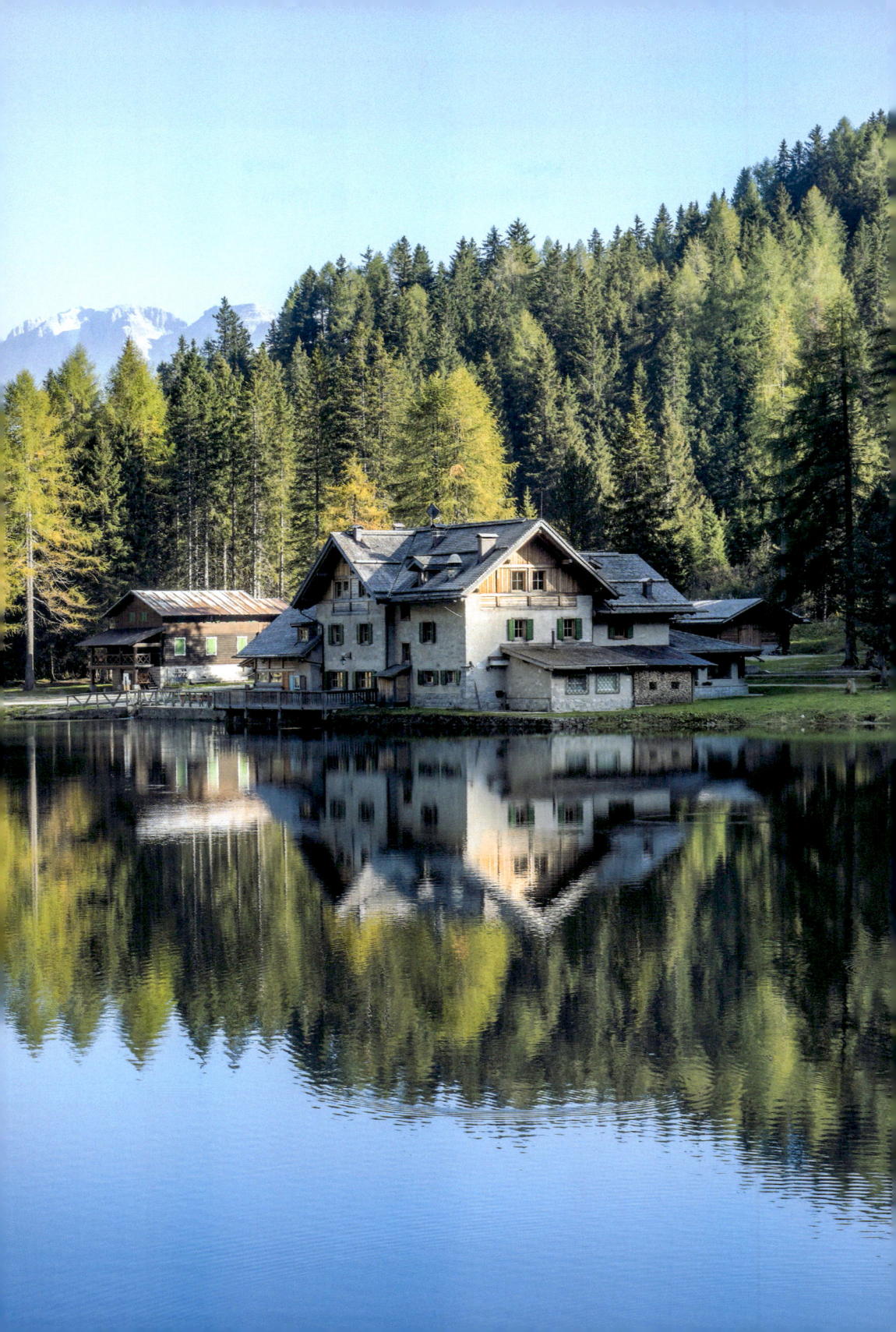

1. LAGO NAMBINO

Nestled in the woods above Madonna di Campiglio, Lago Nambino is an accessible photo location that can be visited on foot from town, or via a very short drive.

The eponymous lakeside rifugio offers food and shelter whilst also serving as a wonderful focal point. Sheltered by the surrounding fir trees, yet still offering a clear view of the Brenta group, the reflections here are often excellent.

What to shoot and viewpoints

From the top of the carpark path B06 heads north-west towards Lago Nambino and is clearly signposted. The signposting indicates the time to the lake is 45 minutes, though this is very conservative. Follow the path and boardwalks, ignoring any smaller path junctions, to reach the lakeside in approximately half an hour.

It is then worth making a clockwise circuit of the lake, starting at Rifugio Nambino.

Viewpoint 1 – Lago & Rifugio Nambino from the Western Shore

The best viewpoints look south-east towards the Brenta group from the far end of the lake. Rifugio Nambino provides the main foreground interest, though there are also some reeds, boulders and several logs that provide additional interest.

A bracketed image taking looking west towards Rifugio Lago Nambino, on an autumn afternoon. Nikon Z7II, 24–120mm at 30mm, ISO 64, various at f/8, Oct.

The scene works equally well as a wide-angle panorama or cropped in close, shifting the focus to Corno di Flavona and Pietra Grande (2935m) dominating the background.

Viewpoint 2 – Rifugio Nambino from the Eastern Shore

Continuing around to the eastern shore there is a good view back towards Rifugio Nambino. Whilst the backdrop is less impressive from this side, a beautiful beach and several trees make for a lovely scene – particularly when the sun is low in the sky during early evening.

To return retrace your steps back to the parking area, or alternatively, descend via path 217.

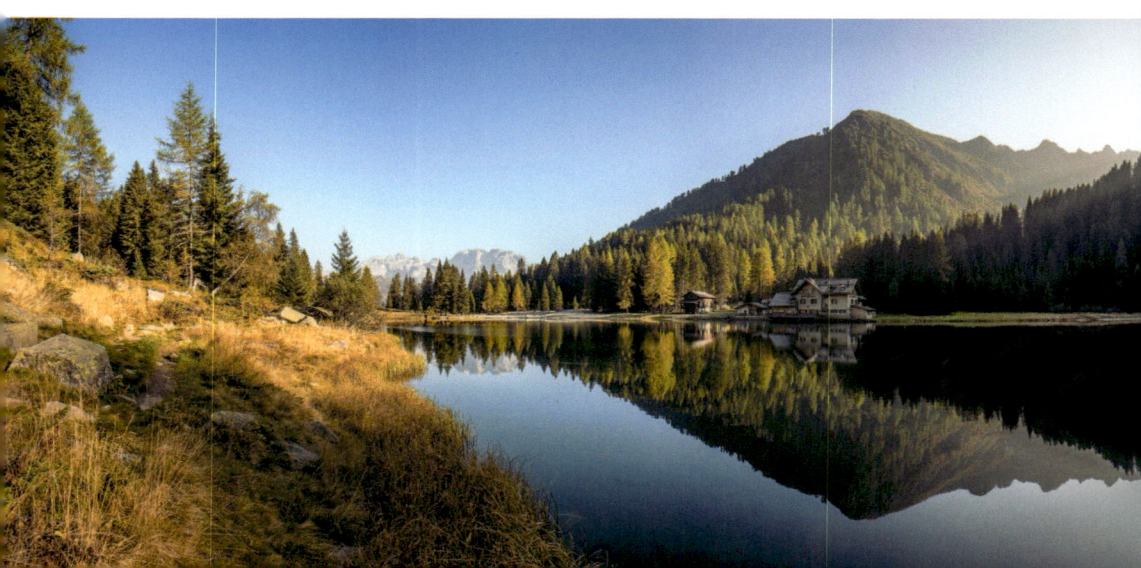

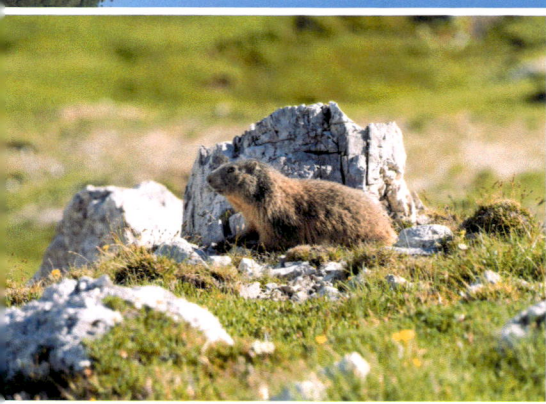

How to get here

Is is possible to walk directly to Lago Nambino from Madonna di Campiglio in about an hour. The shortest approach however is from the parking area at Patascoss which can be reached by driving along Via Nambino for 2.5km from the northern side of town.

Alternatively, it is possible to park at Parcheggio Sentiero Lago di Nambino and then approach along path 217. The path is a little more rugged and has slightly more height gain though.

P Lat/Long:	46.231, 10.81612	
P what3words:	///intros.overcoming.washable	
P Tabacco:	Map 53 (1:25.000)	
P Kompass:	Map 73 (1:25.000)	

Accessibility

Approach: 30 minutes, 2.5km, 20m of ascent.

 Disabled access: There is good disabled access to Rifugio Nambino, though not around the lake.

Best time of year/day

Lago Nambino can generally be accessed year-round (snow levels dependent). The Brenta Dolomites that form the backdrop are west-facing making this an ideal afternoon venue when the peaks are catching the light, or a good sunrise location. Be careful not to leave it too late if you want light on the rifugio, as the surrounding trees and hillsides block the sun earlier than you might expect.

Top: Lago Nambino is best photographed in still weather to take advantage of the reflections. Nikon Z8, 24–120mm at 55mm, ISO 64, 1/100s at f/10. Oct.

Above: A marmot enjoys the sun. Nikon Z8, 100–400mm at 400mm, ISO 100, 1/500s at f/8, Oct.

Opposite: A 6 image panorama taken from the northern shore. Nikon Z8, 24–120mm at 24mm, ISO 320, 1/400s at f/8, Oct.

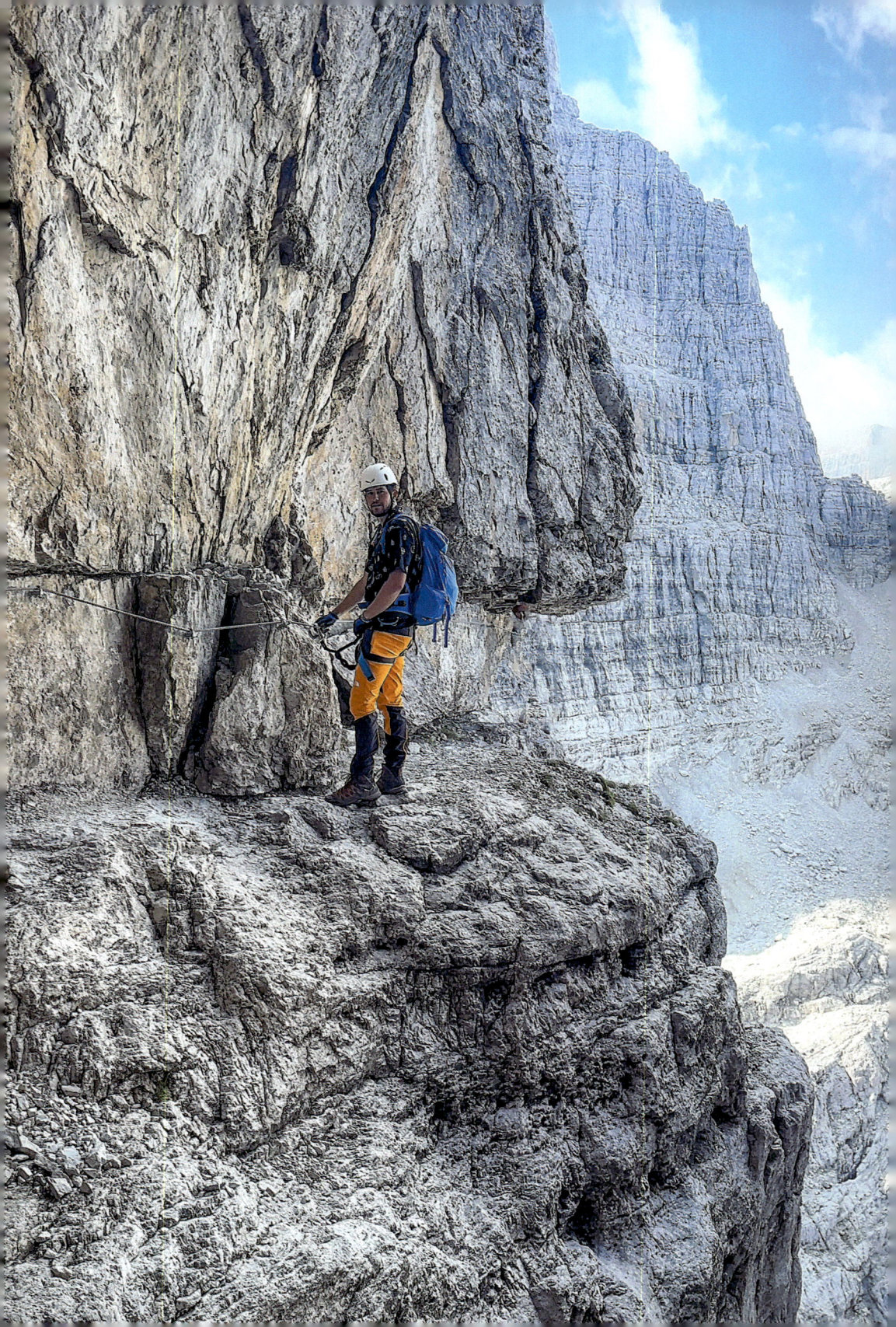

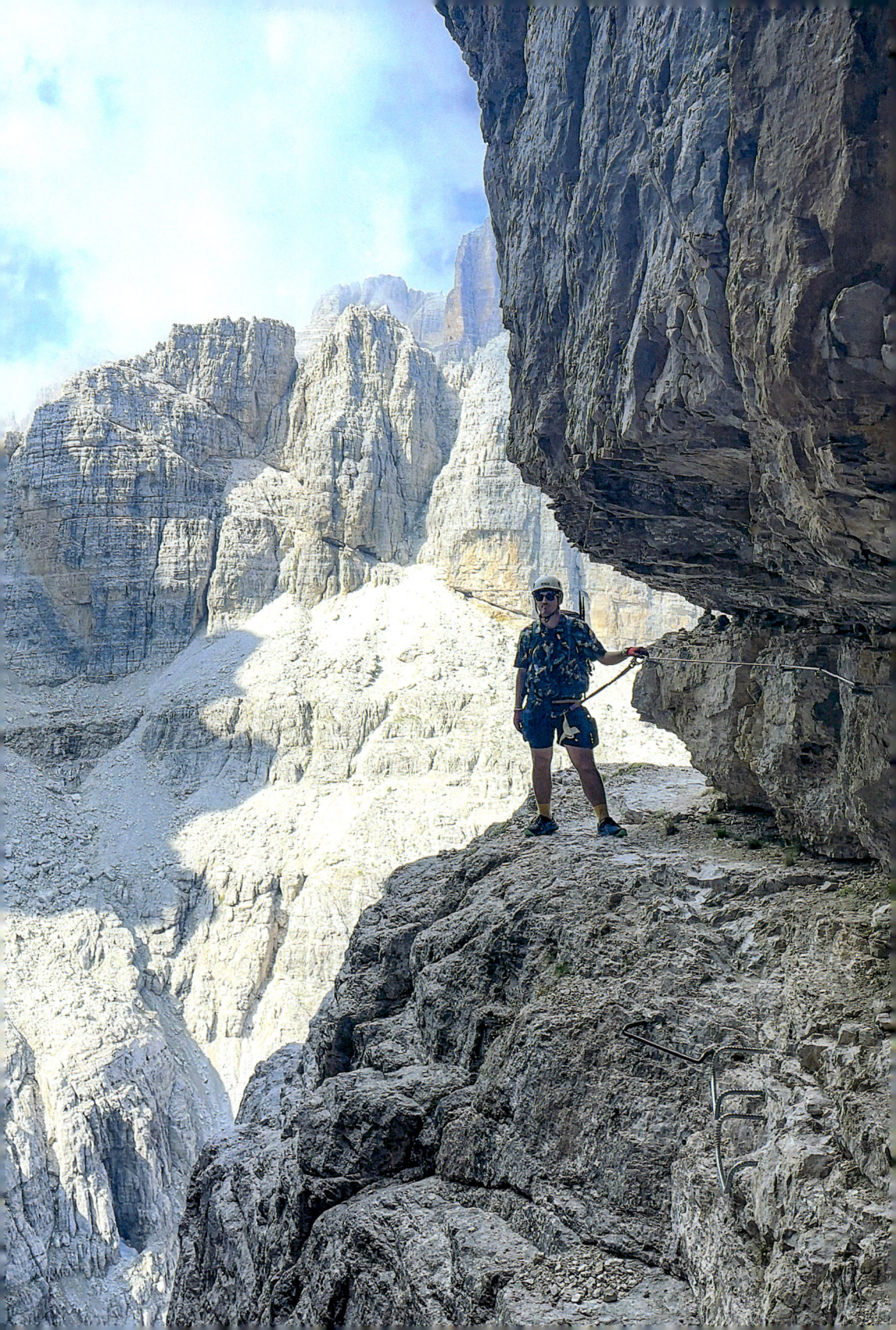

2. VIA DELLE BOCCHETTE

Whilst well beyond the scope of this guide, it would be remiss not to mention the Dolomites most famous multi-day Via Ferrata linkup as both the scenery and situations are stunning. Adventure photographers with mountaineering experience are encouraged to do some additional research as the route provides some of the best photographic opportunities in the area.

Originally conceptualised by Arturo Castelli, warden of Rifugio Pedrotti – the aim was to create a high-altitude traverse linking the isolated valleys of the Brenta using the natural ledges so characteristic to the group. Even though construction work of this audacious route began in 1936, it would take 34 years of laying cable between the vertiginous peaks for Castelli's dream to become a reality by 1970.

New routes have since been added and there is now an extensive network of high-altitude Via Ferrata traversing the Brenta group in both directions. At least five days should be allowed for a complete circuit, though many climbers opt for shorter variations with an onus on Via Ferrata Bocchette Centrali, arguably the most beautiful route of the linkup.

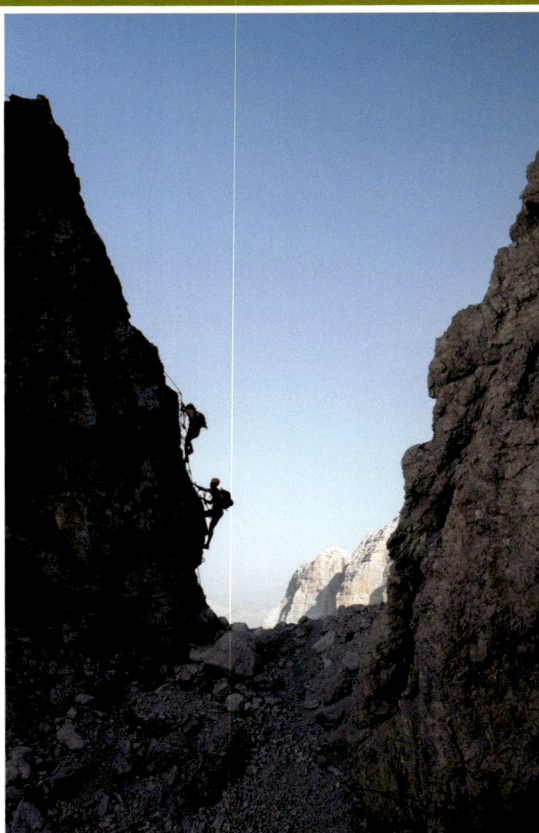

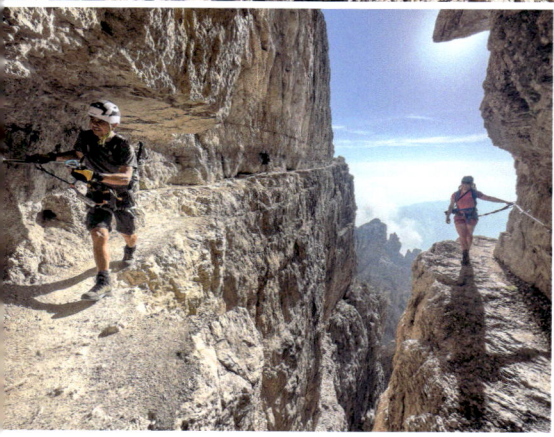

How to get here

Most itineraries start from Rifugio Stoppani at the top of the Grosté lift system which departs from Madonna di Campiglio. For those looking to focus primarily on Via Ferrata Bocchette Centrali this route can be approached from Molveno using the new Via Ferrata Felice Spellini constructed in 2010.

Example itineraries

There are many possible variations for completing some or all of Via delle Bocchette depending on the party's fitness and experience, the weather conditions and rifugio availability. The following is an example itinerary making a clockwise traverse of the group taking in most of the major routes.

Day 1: VF Alfredo Benini (9km, 620m ascent, 5 hrs)
Day 2: VF Bocchette Alte & Orsi (10km, 910m ascent, 8 hrs)
Day 3: VF Bocchette Centrali & Brentari (15km, 1050m ascent, 9 hrs)
Day 4: VF Castiglioni & Ideale (14.5km, 1000m ascent, 7 hrs)
Day 5: VF SOSAT & return to Grosté (9km, 500m of ascent, 5 hours)

Accessibility

Whilst the majority of the via ferratas along the Via delle Bocchette are of moderate difficulty, they unfold in a remote and serious environment. Previous via ferrata and mountaineering experience is essential – if in doubt hire an IFMGA Mountain Guide.

Best time of year/day

July, August and early September are the best months for attempting the Via delle Bocchette. It is worth checking the current route conditions with the rifugios or Alpine Guides office based in Madonna di Campiglio. An ice axe and crampons are often necessary during the early season.

Opposite top: Using the backlight to create a prominent silhouette against the sky. Nikon Z7II, 24–120mm at 35mm, ISO 100, 1/100s at f/8, Aug. *Opposite*: A 4 photo panorama on one of the many laddered sections. Nikon Z7II, 24–120mm at 24mm, ISO 64, 1/800s at f/8, Aug.

The exposed ledges of Via Ferrata Bocchette Centrali.
Top: Nikon Z7II, 14–24mm at 14mm, ISO 64, 1250s at f/8, Aug.
Above: iPhone 14 Pro, 14mm, ISO 50, 1/2000s at f/2.2, Aug.

Previous spread: Using panorama mode where the ledge doubles back. iPhone 14 Pro, 24mm, ISO 200, 1/950s at f/1.8, Aug.

2 VIA DELLE BOCCHETTE

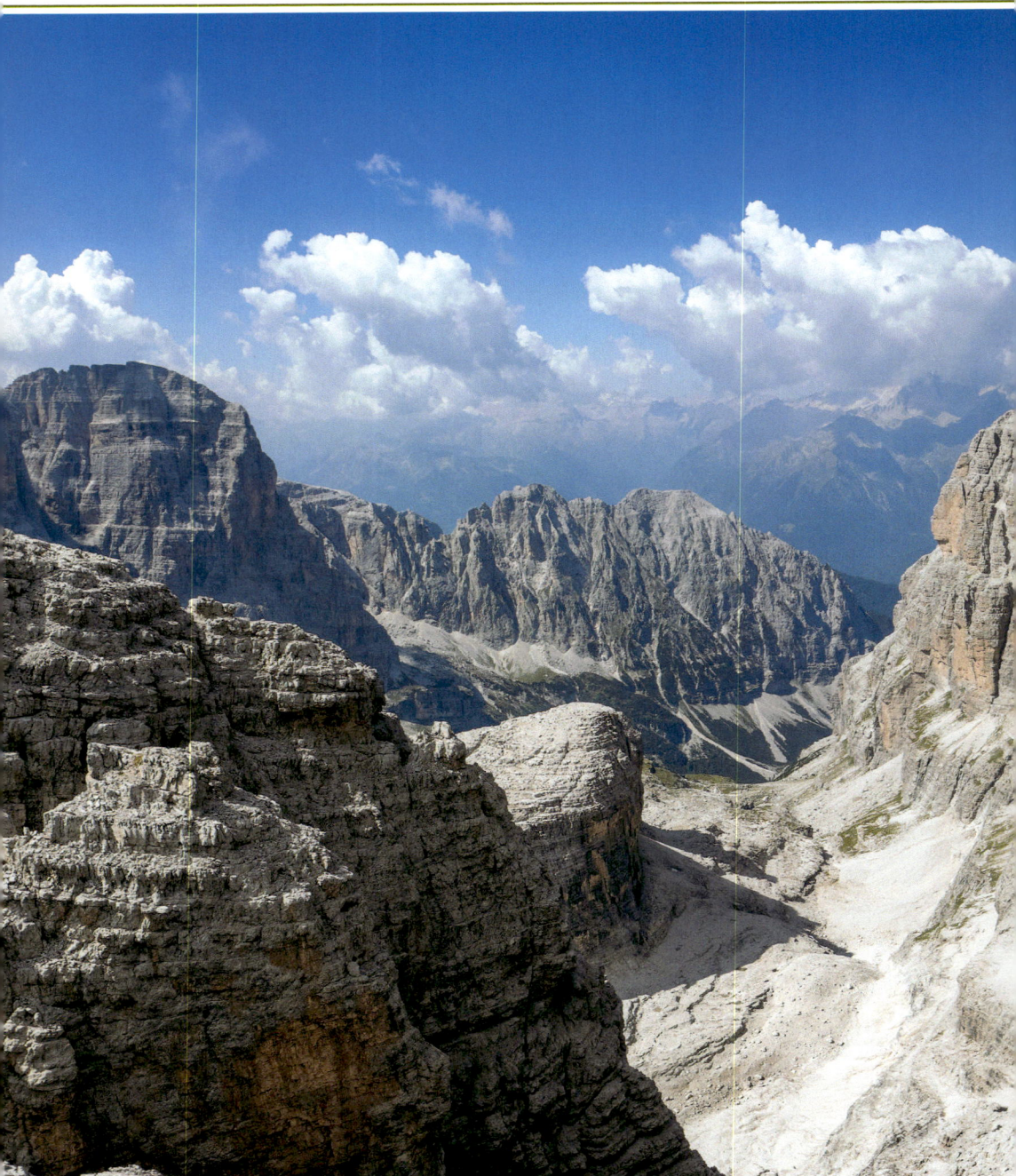

A 21 image panorama of the stunningly situated Via Ferrata Bocchette Alte. Nikon Z8, 24–120mm at 24mm, ISO 64, 1/500s at f/8, Aug.

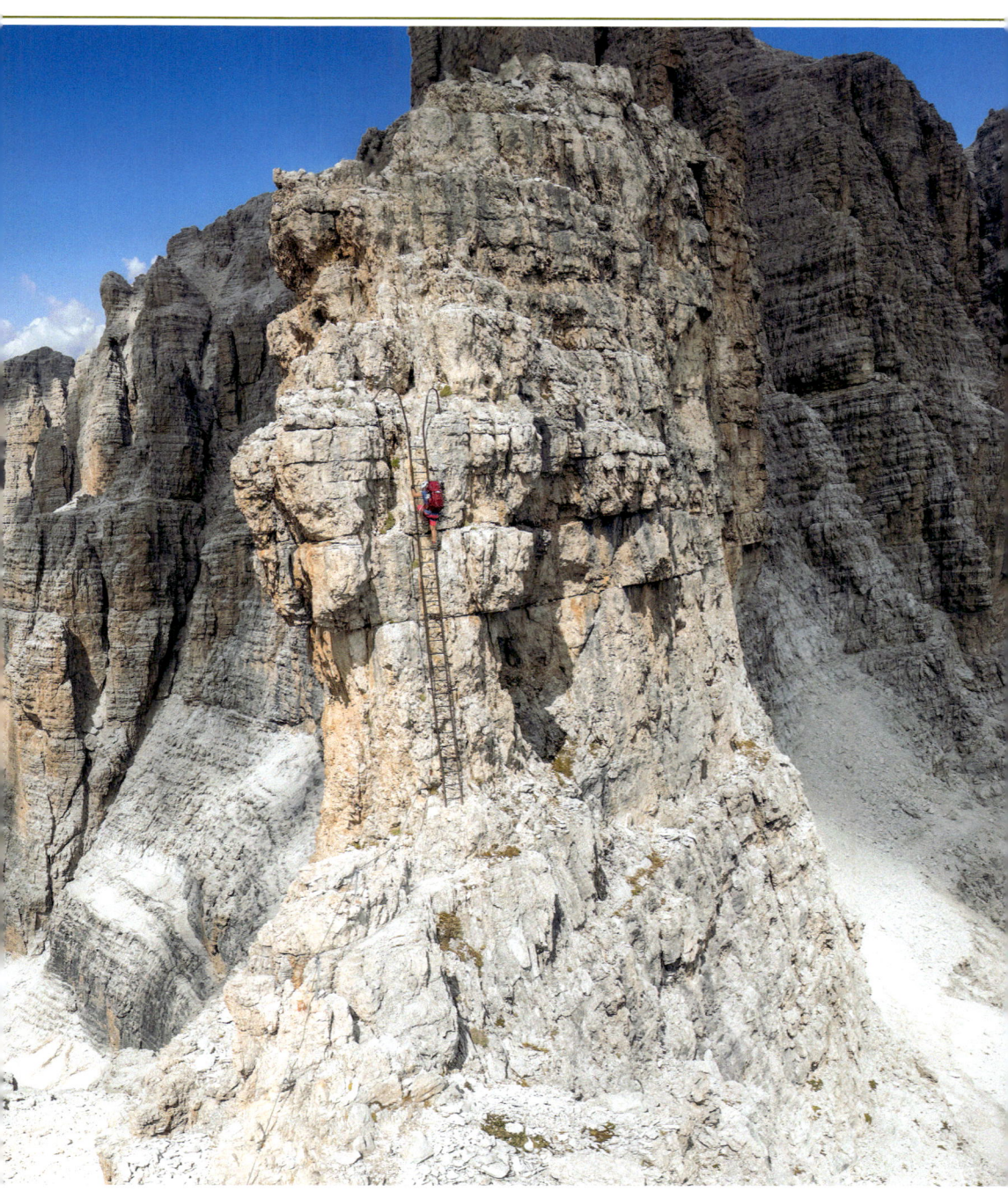

[3] VALLESINELLA

Just a short distance from Madonna di Campiglio, the beautiful Vallesinella runs east to west, cutting a line underneath the vast rock walls surrounding Cima Grostè. Carved out by a branch of the river Sarca, the valley contains three impressive waterfalls, the upper two being of particular interest to photographers.

For those wanting to explore further afield, Vallesinella also acts as a convenient gateway to Rifugio Tuckett – one of the principal bases for climbers and walkers looking to explore the vast rock walls of the Brenta Dolomites.

What to shoot and viewpoints

Cascate di Mezzo is situated downhill from the carpark, whilst Cascate Alte is located above it. The former makes a good start point, though it is possible to go straight to VP2.

Viewpoint 1 – Cascata di Mezzo

From the parking area adjacent to the Vallesinella Hotel, take path C51 which leads downhill to the west, following signposting towards Rifugio and Cascata di Mezzo, to reach the waterfall in 15 minutes.

Shortly after arriving at the waterfall, the path descends towards the rifugio where a lovely side perspective is gained. The surrounding foliage provides many foreground opportunities – these can either be blurred out using a shallow depth of field or focus stacked to frame the fall.

For the adventurous, it is possible to scramble behind the cascade to gain a unique vantage point. To return retrace your steps back to the parking area.

Long exposures of Cascata di Mezzo in late September.
Below left: *Nikon Z7II, 20mm, ISO 64, 1s at f/9, tripod, ND filter.*
Opposite: *Nikon Z7II, 20mm, ISO 64, 5s at f/13, tripod, ND filter.*

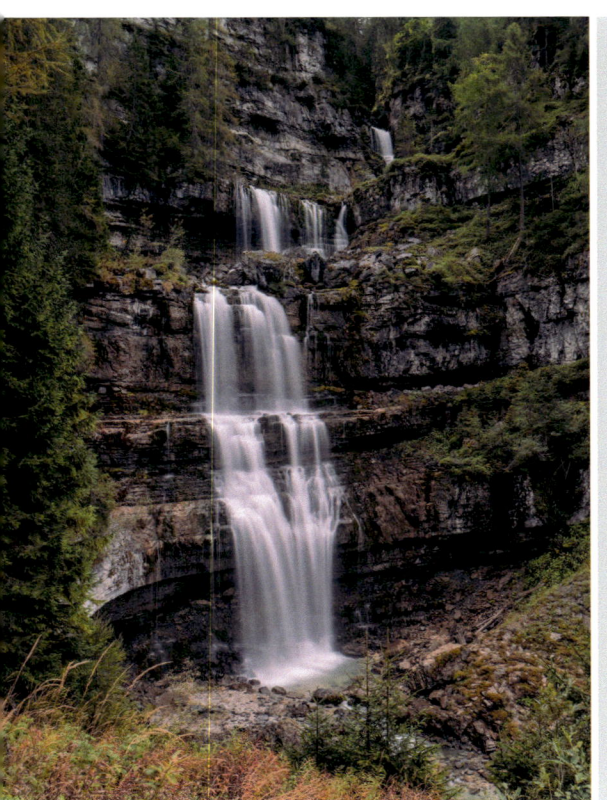

How to get here

Vallesinella is easily accessed directly from the south side of Madonna di Campiglio using the road Via Vallesinella. Vehicles are only permitted to drive along the 5km long approach road before 10 am and after 5.30 pm during peak season. Between these hours the only approach is via public bus. For more information on dates, times, prices and parking or bus reservations visit:

www.pnab.it/en/live-the-park/vallesinella-parking-transportation

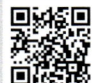

Lat/Long:	46.207, 10.85071	
what3words:	///searchers.speak.poacher	
Tabacco:	Map 53 (1:25.000)	
Kompass:	Map 73 (1:25.000)	

Accessibility

Approach: 15 minutes, 1km, 100m of descent.

Disabled access: Single-file dirt paths lead to the two waterfalls and these are unsuitable for disabled access.

Best time of year/day

The Vallesinella waterfalls can be visited year-round, though snowshoes and crampons will often be required during the winter. Spring sees high water levels, whilst autumn provides some stunning fall colours.

As with all waterfall photography flat light is ideal to avoid any harsh contrast. The falls are predominantly west-facing and can be difficult to photograph during the morning on bright days.

3 VALLESINELLA

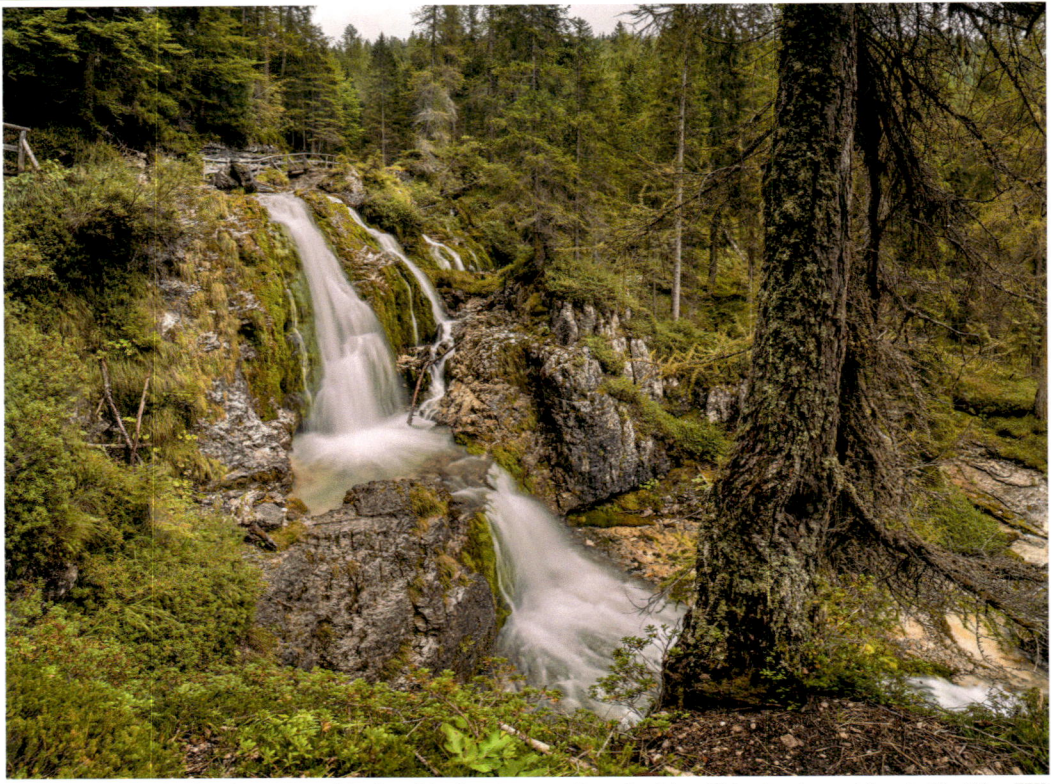

Above: An exposure bracketed panorama of the first of the Cascate Alte falls. Nikon Z7II, 20mm, ISO 64, various at f/10, tripod, Jun.

Opposite: A beautiful rock archway at Cascate Alte. Nikon Z7II, 24–120mm at 80mm, ISO 64, 5s at f/10, tripod, ND filter, Jun.

Viewpoint 2 – Cascate Alte

From the parking area at Hotel Vallesinella take the main track uphill to Vallesinella di Sotto, following signposting towards Cascate Alte Vallesinella and Sentiero delle Cascate. Follow path 382 initially, before turning off right onto the C54, signposted towards Sentiero delle Cascate.

The path follows the Sarca River on its left side for around 30 minutes until the first small waterfall is reached. Shortly after the path swings round to the left into an open area containing multiple falls of varying sizes. There are lots of possible compositions here, both with a wide-angle and using a longer lens to pick out interesting details. Don't miss the rock arch just above the first pool.

From here most people then opt to retrace their steps back to the parking area.

Viewpoint 3 – Malga Vallesinella di Sopra

For those wanting more, the switchbacks can be followed uphill on the right side of Rio Sarca for 20 minutes to reach Piana and Malga di Vallesinella – a lovely open clearing and farmhouse beneath the faces of the Brenta Dolomites.

Path 382 can then be used to descend back to the carpark completing a nice circuit.

Viewpoint 4 – Rifugio Tuckett

Alternatively, it is possible to continue ascending to the superbly situated Rifugio Tuckett along paths 317B and 317, passing the Casinei Mountain Hut. This long ascent requires an additional 400m of height gain and should not be underestimated. The views from Tuckett are spectacular however and it is possible to stay in the rifugio overnight, descending the following day.

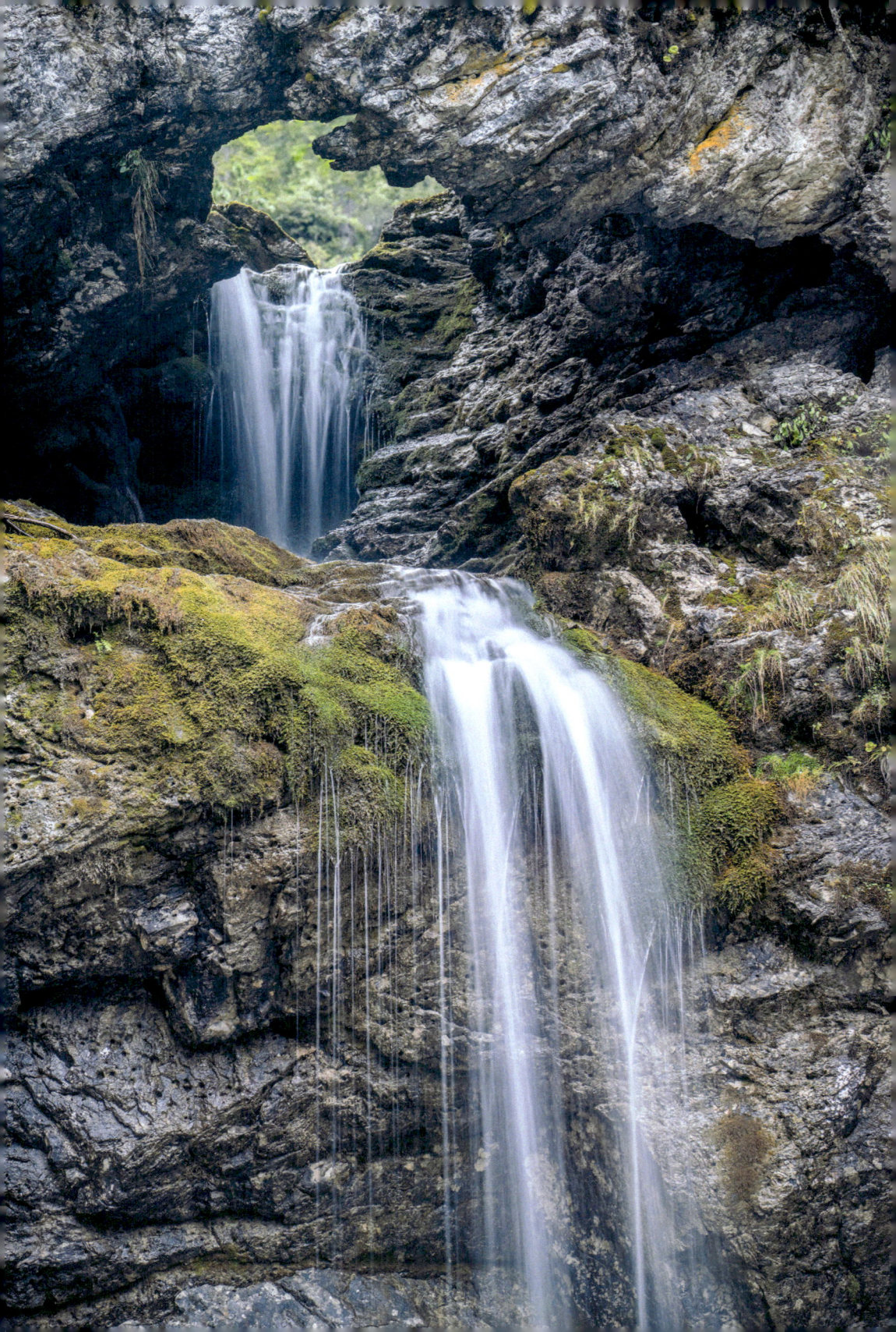

4 · FOGAJARD VIEWPOINT

This is an excellent roadside location for photographers seeking an easy-to-access vantage point overlooking the west faces of the Brenta group. Typically the steep valleys surrounding the main plateau make viewing the peaks difficult – fortunately, the Viale Dolomiti di Brenta road (SS239) running between Madonna di Campiglio and Sant'Antonio di Mavignola enjoys clear views towards the massif.

What to shoot and viewpoints

Viewpoint 1 – Brenta West Faces ♿

Reaching the parking area it becomes immediately apparent a long lens will be useful here. Find a good unobstructed view and then try to isolate an area of interest – the spires surrounding both Torre di Brenta and Cima Brenta are very dramatic, particularly with low clouds. This is an ideal location for inclement weather, where the changing scene can be enjoyed from the safety of your vehicle.

How to get here

From Madonna di Campiglio take the SS239 south for 3km towards Tione di Trento. Shortly after passing Panorama Hotel Fontanella the Brenta peaks come into view to the left. Park in the designated area on the left by several picnic tables.

Lat/Long: 46.20453, 10.8129
what3words: ///fling.cloying.dummy
Tabacco: Map 53 (1:25.000)
Kompass: Map 73 (1:25.000)

Accessibility

Approach: Roadside access.

♿ **Disabled access**: The roadside access makes this an ideal location for disabled photographers.

Best time of year/day

This location is easily accessed throughout the year and there is no best time to visit.

The west-facing aspect of the peaks makes this a good sunrise, late afternoon and sunset location. Atmospheric haze can be a problem with such distant subjects and hot days should be avoided.

From left to right – Cima Armi (2951m), Torre di Brenta (3014m), Gruppo Sfulmini and Campanile Alto (2937m). Nikon Z8, 100–400mm at 400mm, ISO 80, 1/400s at f/7.1, Aug.

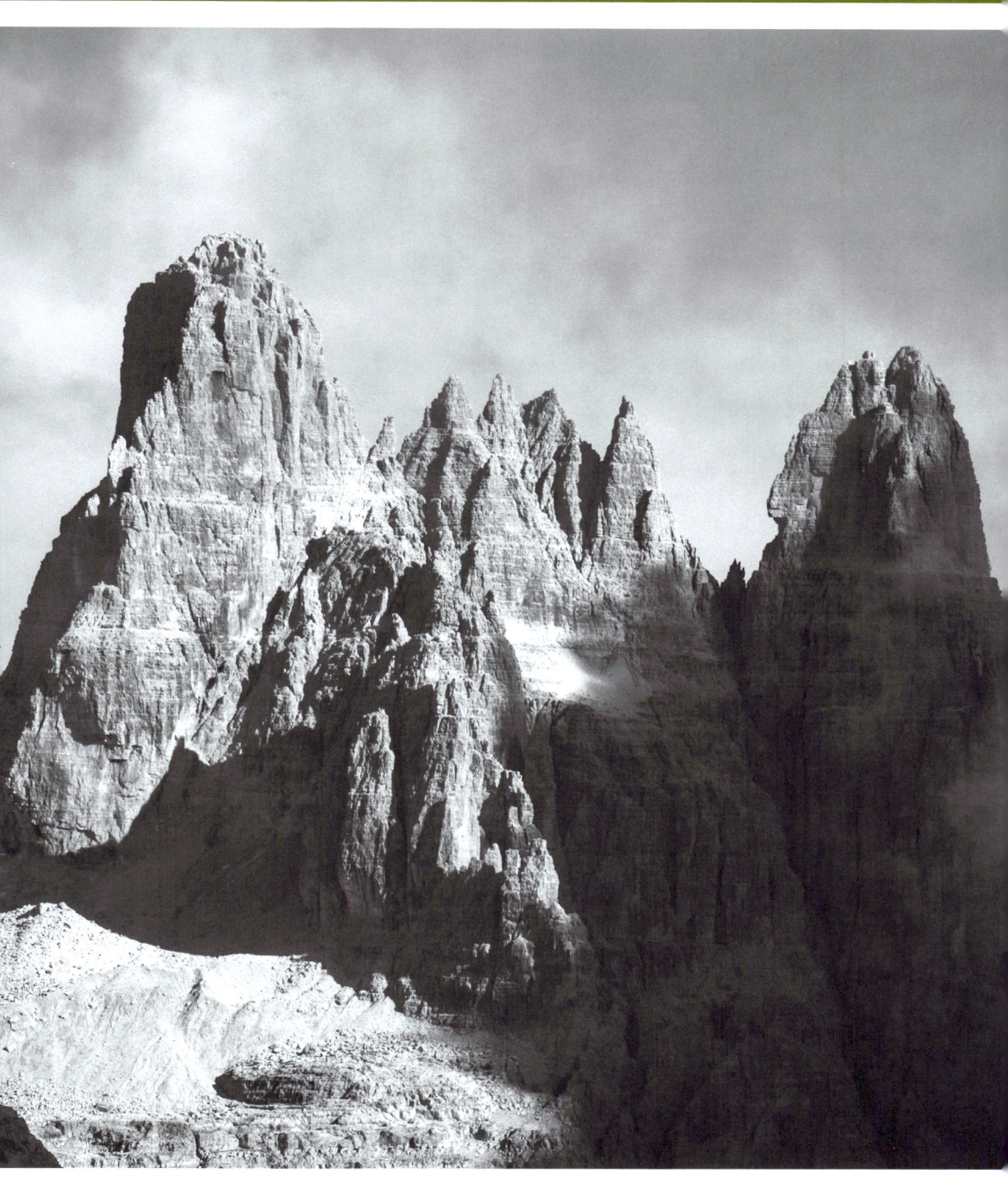

[5] LAGHI DI CORNISELLO E LAGO NERO – TRE LAGHI

Perched above the beautiful Val Nambrone and Val d'Amola, underneath the wild and seldom frequented Presanella group lies a trio of stunning high-altitude lakes. Each exhibiting distinct characteristics, Lago di Cornisello Inferiore and Superiore are distinguished by vivid turquoise waters, whilst to the south the aptly named Lago Nero displays much darker tones. The latter can confidently be recommended as one of the best photo locations in the Dolomites, the inky waters reflecting the many towers, spires and west faces of the vast Brenta group.

Whilst the driving approach to the improbably positioned Rifugio Cornisello is not for the faint of heart, the potential rewards are well worth the effort. Visitors can explore the Presanella group, making a 7km walking circuit of all three lakes, or head directly for Lago Nero.

For those wanting to maximise their chances of capturing a good sunset a stay at Rifugio Cornisello is recommended. For bookings, food reservations and more information visit:

www.rifugiocornisello.it

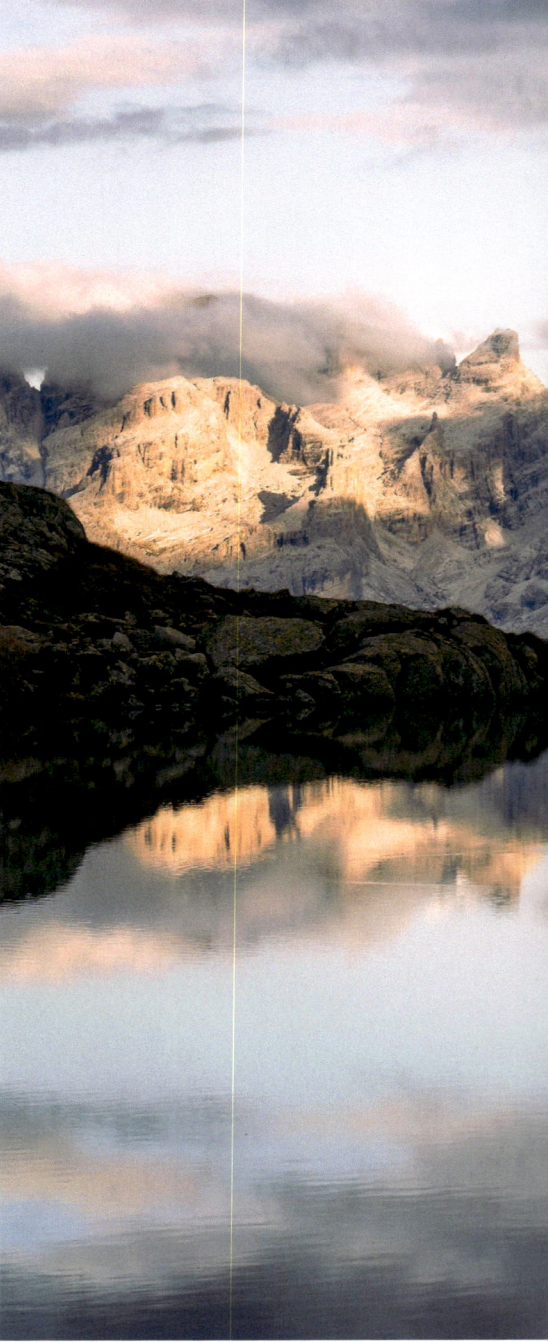

Lago Nero is undoubtedly the most photogenic of the three lakes, though they're all lovely locations. Nikon Z7II, 24–120mm at 60mm, ISO 64, 1/125s at f/8, Sep.

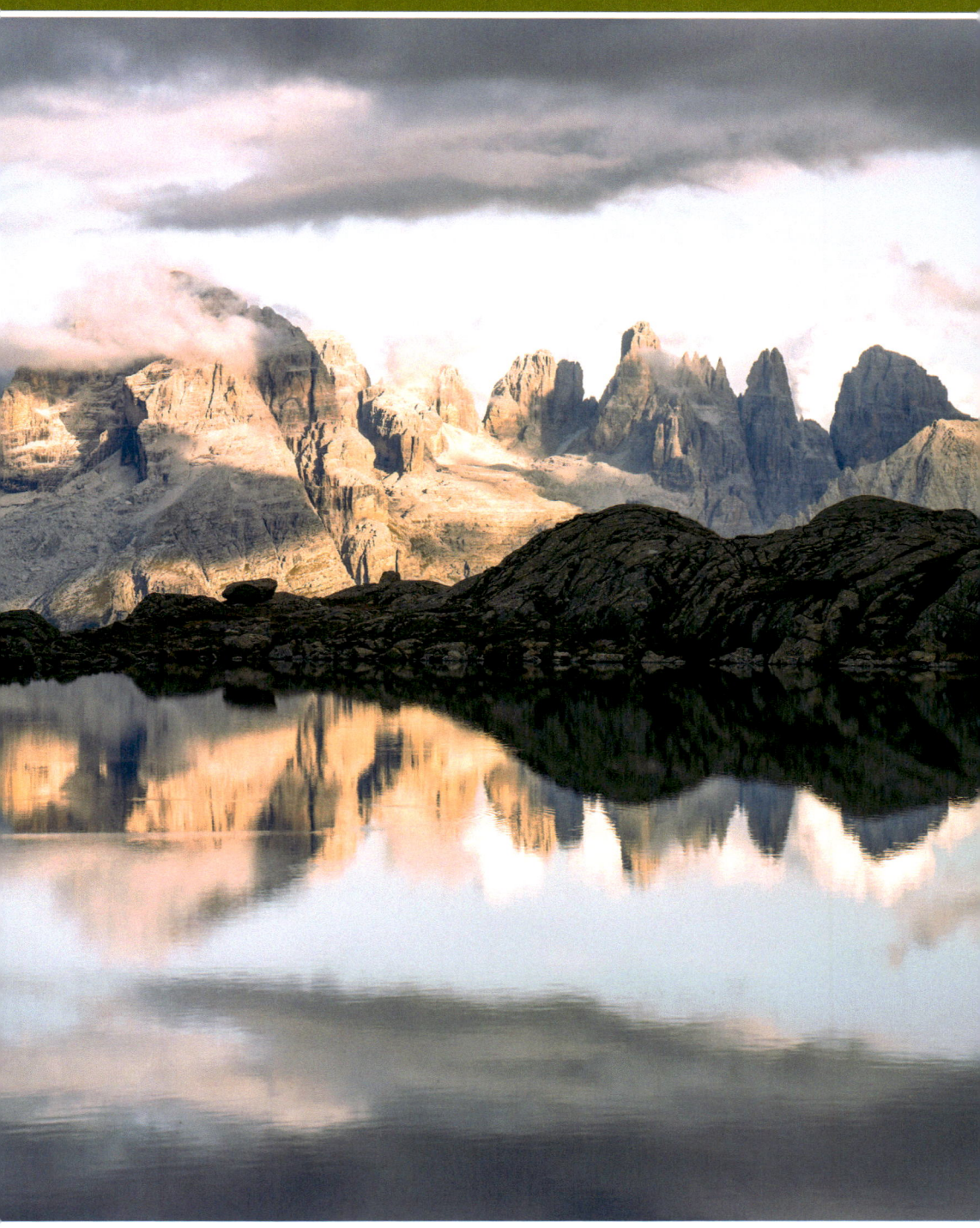

5 — LAGHI DI CORNISELLO E LAGO NERO – TRE LAGHI

What to shoot and viewpoints

There are lots of different hiking trails departing from Rifugio Cornisello and many possible variations. The proposed itinerary makes an anti-clockwise circuit of all three lakes, finishing at Lago Nero hopefully in time to enjoy the afternoon light on the Brenta west faces. Allow at least four hours with photographic breaks to complete the full route – longer if you're a methodical photographer.

Alternatively for those short on time, it is possible to go directly to Lago Nero. This takes approximately 30 minutes from Rifugio Cornisello at a good pace, following path 238.

Viewpoint 1 – Lago di Cornisello Inferiore ♿

Take path 239 which departs from just below the parking area following signposting towards Lago di Cornisello Inferiore and Superiore, to reach the former in 10 minutes of easy walking.

The best compositions are generally found at the eastern end of the lake when you first arrive. There is a small pond, a lone tree, a wooden bridge and an outflow that all make for interesting foregrounds looking west across the lake.

A stream joining Lago di Cornisello Superiore. Nikon Z7II, 24–120mm at 85mm, ISO 1100, 1/1000s at f/8, Aug.

On a clear day, it is possible to see the distinctive rocky spire of Cima Cornisello (3153m) in the distance. This makes for an eye-catching focal point when the lake is still providing good reflections.

To continue keep following the large gravel track on path 239 for just over 10 minutes to reach the second lake – Lago di Cornisello Superiore.

How to get here

The drive to the parking area at Rifugio Cornisello is narrow (single track occasionally), steep and takes place above exposed terrain requiring confident driving skills.

From Madonna di Campiglio take the SS239 south towards Pinzolo for 7km. Just after passing through the village of Sant'Antonio di Mavignola the road makes a very sharp left turn. On this hairpin turn off right, following the signposting towards the Val Nambrone.

Drive up the valley for 3km to reach the parking area at Amola di Nambrone – a popular walking area for those wanting to visit Cascata Amola along the Sentiero Amolacqua.

Continue driving up the valley for a further 6km, negotiating some steep and narrow hairpins until the road eventually forks. Keep right here, following good signposting towards Rifugio Cornisello for a further 2km as the road makes a spectacular traverse high above the upper section of the Val Nambrone. Park in the large designated area below the rifugio (the final few hundred meters up to the building are reserved for overnight guests).

P Lat/Long:	46.22081, 10.73986
P what3words:	///naivety.cloud.fluffs
P Tabacco:	Map 52 (1:25.000)
P Kompass:	Map 107 (1:50.000)

Accessibility

Approach: 30 minutes, 2km, 150m of ascent (directly to Lago Nero)

Care needs to be taken approaching Lago Nero as there are some short sections of easy scrambling that can be slippery when wet.

♿ **Disabled access**: Both Lago di Cornisello Inferiore and Superiore are accessed via a gravel track that provides good, albeit bumpy access to the lakes. The path to Lago Nero is steep and rocky however making it unsuitable for disabled access.

Best time of year/day

The drive up to Rifugio Cornisello can only be made in late spring, summer and early autumn when the road remains clear of snow. To check the current conditions the rifugio can be contacted at:

www.rifugiocornisello.it

Above: *Looking west towards Lago di Cornisello Inferiore and Cima Cornisello. Nikon Z7II, 20mm, ISO 800, 1/1000s at f/4, Sep.*
Below: *A lone tree on the eastern shore of Lago di Cornisello Inferiore. Nikon Z7II, 24–120mm at 24mm, ISO 64, 1/100s at f/10, Aug.*

5. LAGHI DI CORNISELLO E LAGO NERO – TRE LAGHI

Viewpoint 2 – Lago di Cornisello Superiore ♿
Arriving at Lago di Cornisello Superiore the track skirts around the eastern side of the lake. At the northern end turn off onto a smaller path that leads down through picturesque meadows towards Malga Cornisello. If the conditions are suitable photograph the small island on the way.

Viewpoint 3 – Malga Cornisello
Built by fishermen and used as a mountain shelter, the malga makes for a good panoramic subject when combined with the nearby wooden bridge crossing the stream. To continue cross the bridge and ascend the left side of the stream to regain the large gravel track again.

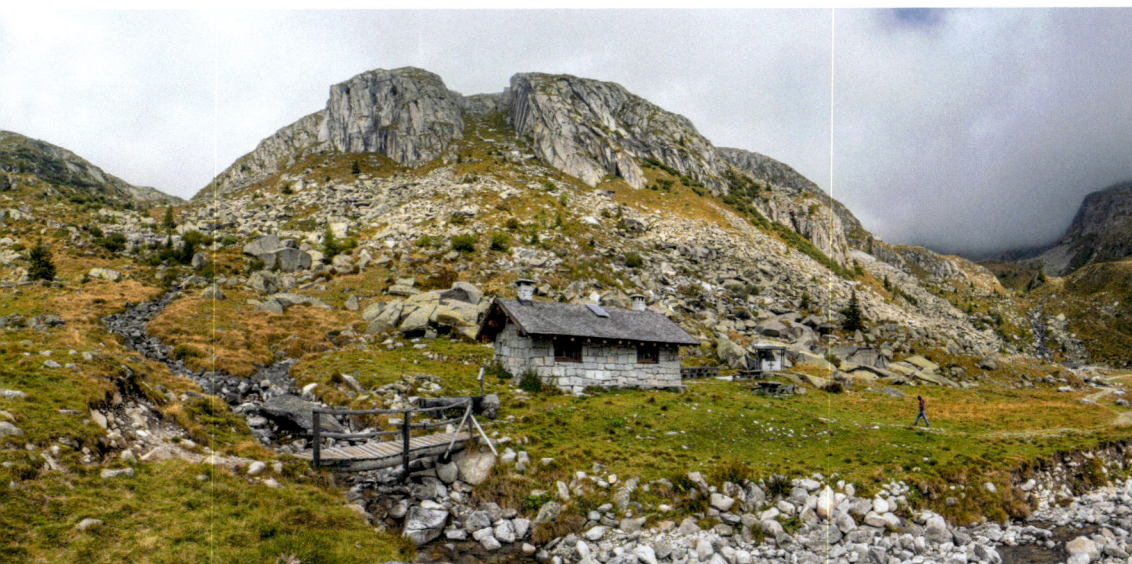

An 8 image panorama of Malga Cornisello. Nikon Z7II, 20mm, ISO 64, 1/80s at f/13, Sep.

Viewpoint 4 – Lago Vedretta
At this point, an optional fourth lake can be added to the itinerary by making an out-and-back ascent to Lago Vedretta using path 239 which departs from just above Malga Cornisello. This rugged mountain path adds an additional 500m of height gain and three hours to the route. As such it is only recommended for experienced hillwalkers.

Viewpoint 5 – Cablecar Ruins
Looking across the lake there are good views of the derelict cablecar station. Abandoned in 1960 the lift was intended to transport workers maintaining and building a dam in the Cornisello valley. The plan never came to fruition and the building has remained unused since. With a long lens and some low cloud, it is possible to create a haunting image that works well in monochrome.

Continue on the vehicle track for another 700m before following path 216 as it turns off right, leaving the larger track in favour of a smaller mountain path. Ascend this steeply for 15 minutes with good views back down over Lago di Cornisello Superiore backdropped by Cima Giner, until another junction is reached.

Turn left here onto path 238, following good signposting towards Lago Nero (continuing straight ahead on path 216 leads to Bocchetta de l'Om, a saddle that offers more lovely views from those that wish to extend the trail further).

Another 10 minutes of now easier walking leads to the first views of Lago Nero and the Brenta Dolomites.

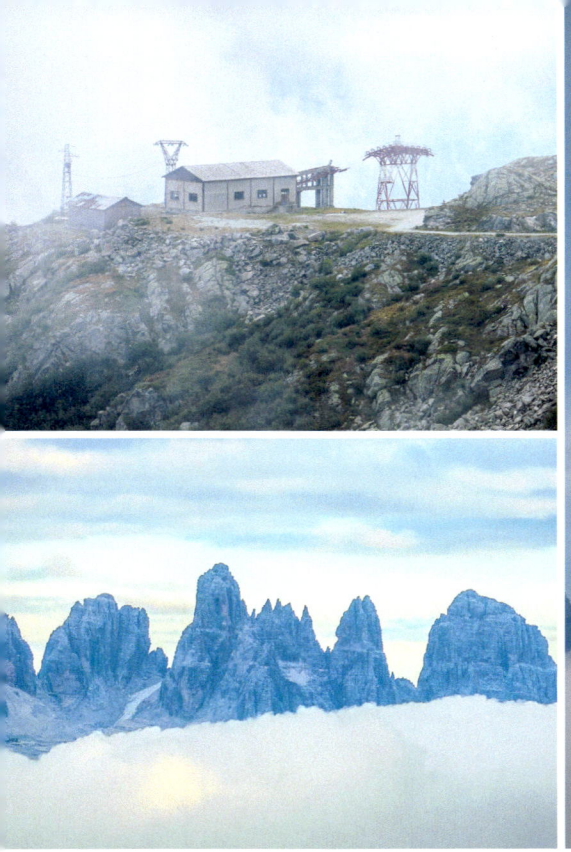
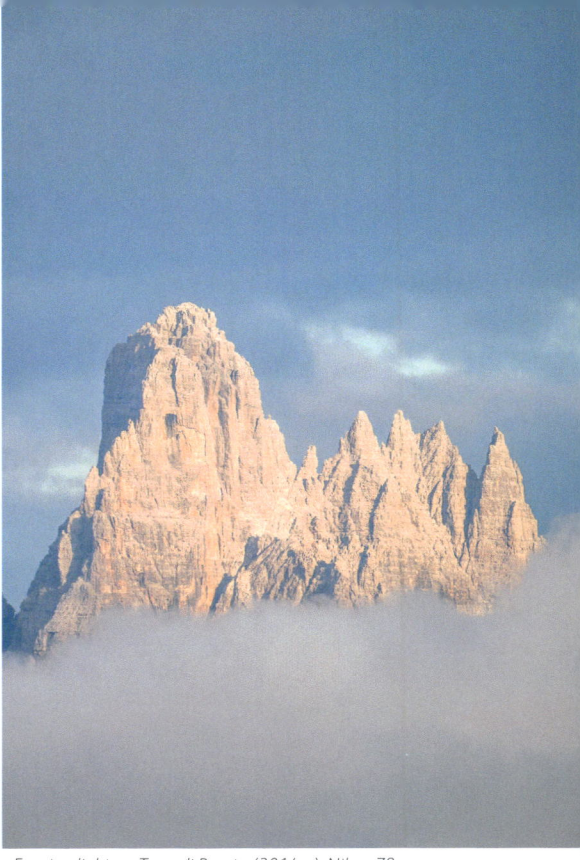

Top: The cablecar ruins above Rifugio Cornisello. Nikon Z7II, 100–400mm at 300mm, ISO 200, 1/500s at f/8, Aug. **Above**: Looking east towards the Brenta Dolomites. Nikon Z7II, 100–400mm at 250mm, ISO 200, 1/250s at f/6.3, Sep.

Evening light on Torre di Brenta (3014m). Nikon Z8, 100–400mm at 400mm, ISO 220, 1/400s at f/5.6, Sep.

A paragliders perspective on Lago Nero. Nikon Z7II, 24–120mm at 24mm, ISO 2000, 1/1000s at f/6.3, Aug.

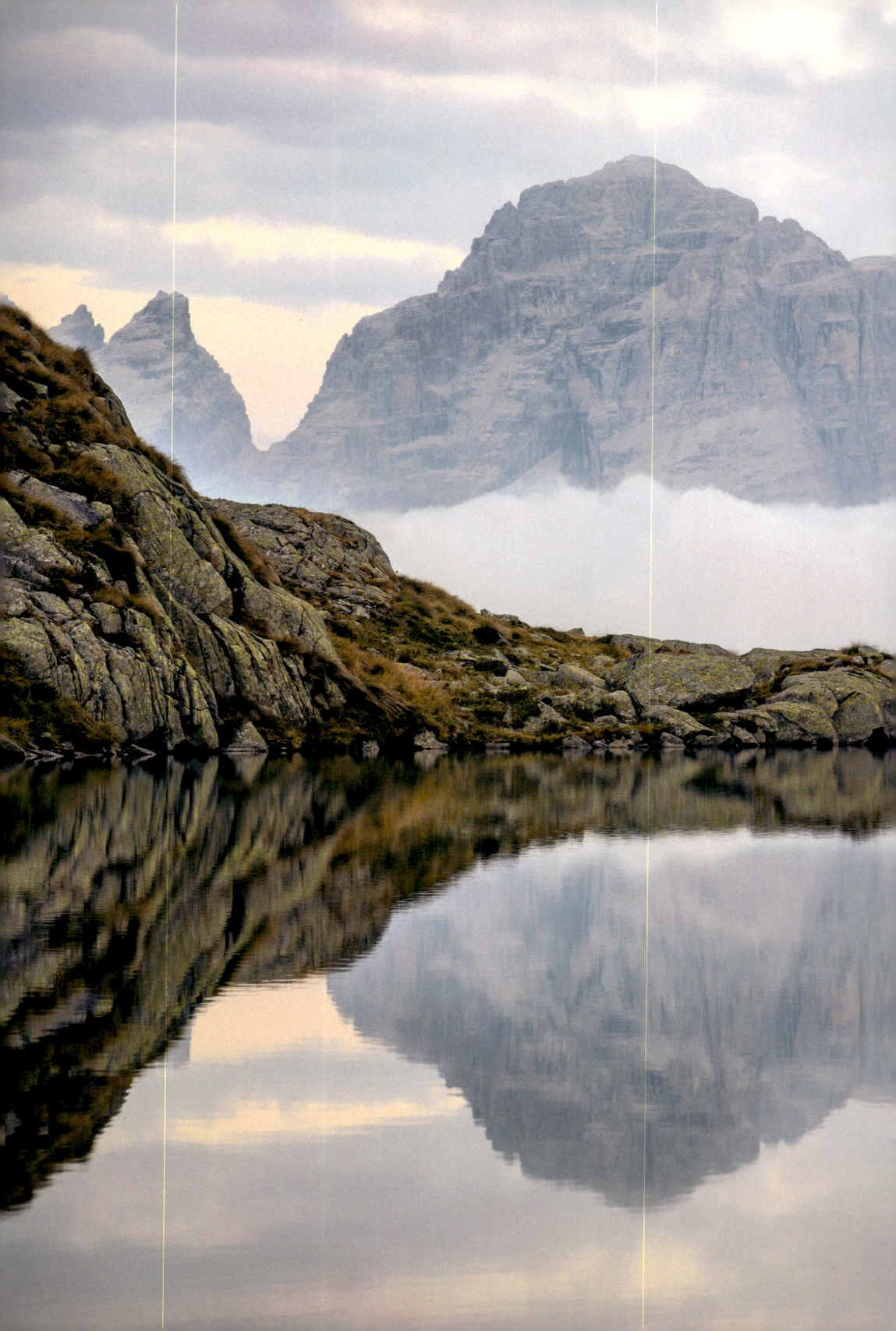

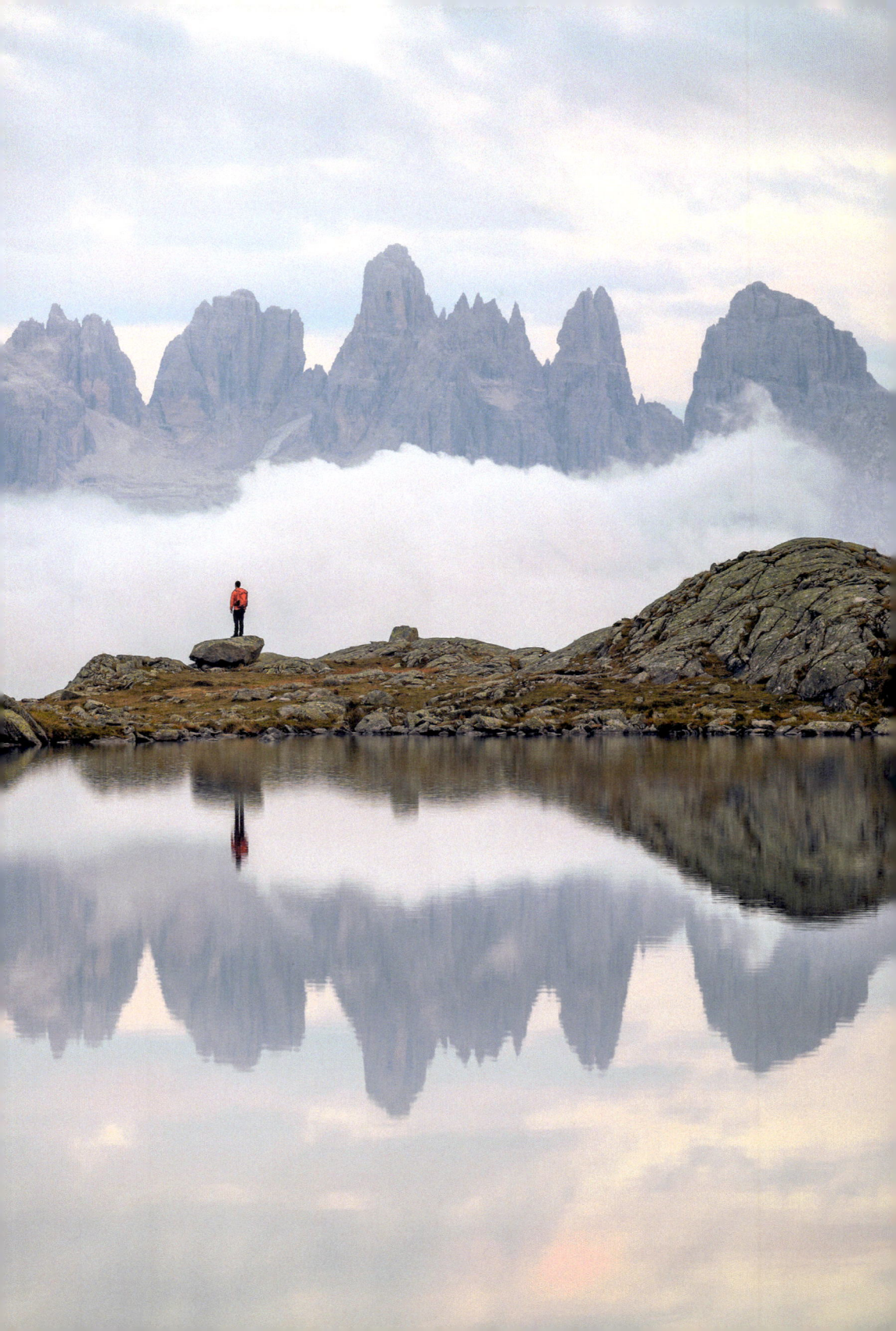

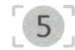 5 LAGHI DI CORNISELLO E LAGO NERO – TRE LAGHI

Viewpoint 6 – Lago Nero & the Brenta

Arriving at Lago Nero it is easy to see why this is such a popular photography location – particularly if the weather is calm providing good reflections. Situated at 2200m on its rocky plateau the lake provides unobstructed views across to the entire Brenta group. From here it is possible to see almost all of the principal peaks – Cima Falkner (2990m), Cima Sella (3094m), Cima Brenta (3151m), Torre di Brenta (3014m) and finally Cima Tosa (3158m), the highest peak in the group.

A reasonably long focal length is important to make use of the associated perspective distortion, essentially bringing the background closer and allowing the west faces to fill the frame. If the reflections are good they make an ideal composition – try and get low to the water to make them as large as possible. If the water is disturbed you can crop a little closer, utilising the opposite shoreline as a foreground instead. Two really good boulders can be used for additional interest.

It is worth taking the time to explore the east side of the lake as well. Whilst not as spectacular as the view towards the Brenta, there are still excellent compositions to be had looking back towards the Presanella group.

To return to Rifugio Cornisello and the parking area continue following path 238 east, descending a rocky section (take care not to lose the path) to join a gravel vehicle track once again. Follow this past the old lift station to reach the rifugio and carpark in 30 minutes.

Previous spread: A beautiful cloud inversion at Lago Nero.
Nikon Z7II, 24–120mm at 105mm, ISO 64,
1/10s at f/8, tripod, Aug.

Right: Looking east towards the Brenta Group.
Nikon Z7II, 100–400mm at 155mm, ISO 64,
20s at f/11, tripod, ND filter, Sep.

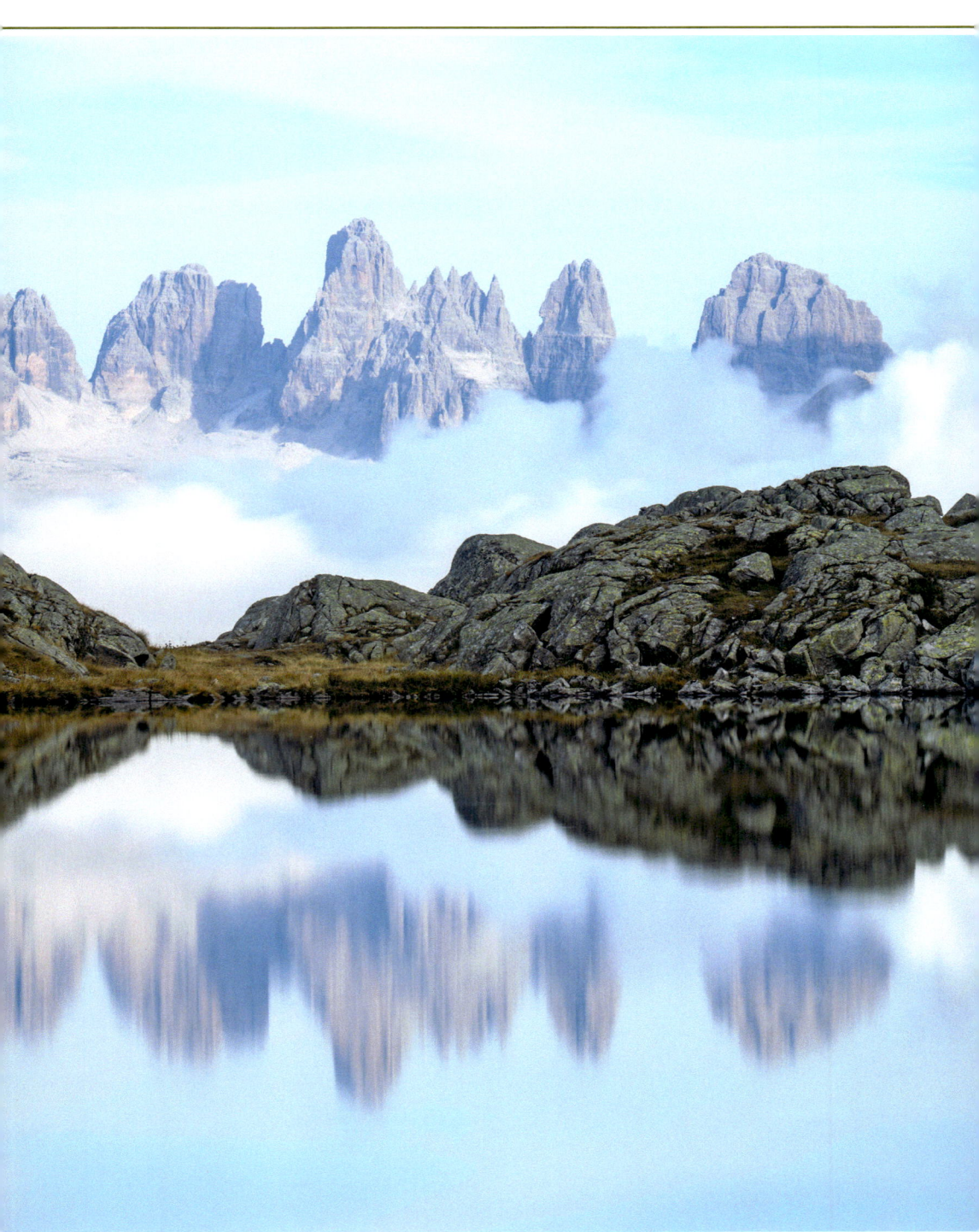

6 VAL GENOVA

Known affectionately as 'waterfall valley', the Val Genova extends east to west for 17km, splitting the Adamello and Presanella groups. A key site for flora and fauna within the Adamello-Brenta Nature Park the valley is rich in wildlife with ibex, chamois, roe deer, golden eagles and even the occasional brown bear to be found.

What to shoot and viewpoints

There are a plethora of mountain trails to be found here – the most popular of which is the 15km long 'waterfalls trail' that runs between Ponte Verde and Bedole. From a photographer's perspective, Cascate Nardis is the most impressive and is easily accessible with roadside views and a nearby carpark. The following viewpoints are suggestions only and visitors are encouraged to plan their own itineraries.

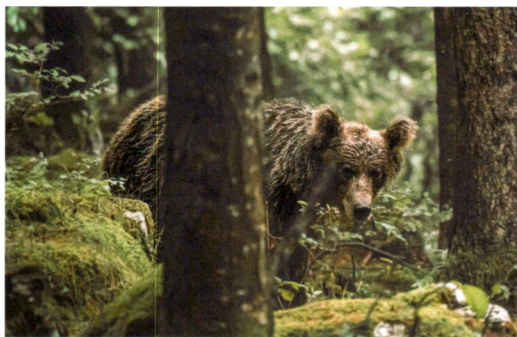

Though exceptionally rare there are occasional Slovenian brown bears in the Val Genova. © Federico Di Dio.

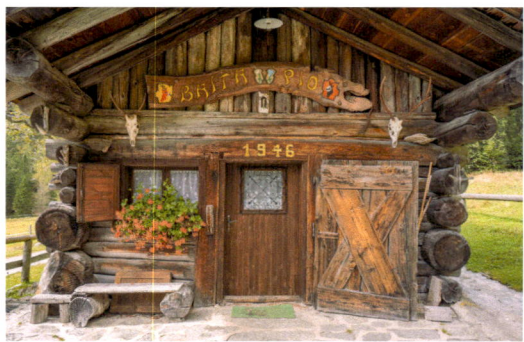

Baita Pio in the Val Genova. Nikon Z7II, 24–120mm at 24mm, ISO 64, 1/50s at f/11, Sep.

Viewpoint 1 – Cascate Nardis ♿

Arguably the most impressive waterfall in the Brenta region, Cascate Nardis is situated near the beginning of the valley making it both easy to access and an excellent wet weather option. From the parking area follow the road westwards up the valley for 500m to reach the cascade. If water levels are low the fall can be photographed from the road, whilst during peak flow it will be necessary to move further back to avoid the abundant spray.

How to get here

The Val Genova is approached from the village of Carisolom 12km south of Madonna di Campiglio.

During low season it is possible to pay a toll and drive the Val Genova in its entirety – from Carisolo along the 16km of paved road to the last parking area at Bedole. During peak season the road is closed beyond Cascate Nardis and visitors will need to use the public shuttle bus. For times, dates, parking reservations and limited mobility enquiries visit:

https://book.pnab.it/en &
www.pnab.it/en/live-the-park/val-genova-mobility

Viewpoint 1 – Cascate Nardis

- Lat/Long: 46.169, 10.72117
- what3words: ///incoherent.sightsee.seafront
- Tabacco: Map 52 (1:25.000)
- Kompass: Map 107 (1:50.000)

Viewpoint 2 – Cascata del Pedruc

- Lat/Long: 46.19518, 10.62456
- what3words: ///devolves.bids.gravy
- Tabacco: Map 52 (1:25.000)
- Kompass: Map 107 (1:50.000)

Viewpoint 3 & 4 – Bedole & Cascata del Matarot

- Lat/Long: 46.19922, 10.60577
- what3words: ///authenticity.grudgingly.bluffed
- Tabacco: Map 52 (1:25.000)
- Kompass: Map 107 (1:50.000)

Accessibility

Mountain paths predominate, though there is good disabled access to Cascate Nardis and up the valley from the Bedole parking area to Rifugio Adamello Collini. A paper map and good hiking experience is essential for those contemplating the longer trails.

Best time of year/day

From a photographer's perspective visiting the Val Genova in June, July and September when the road is open to private vehicles provides a much greater degree of flexibility.

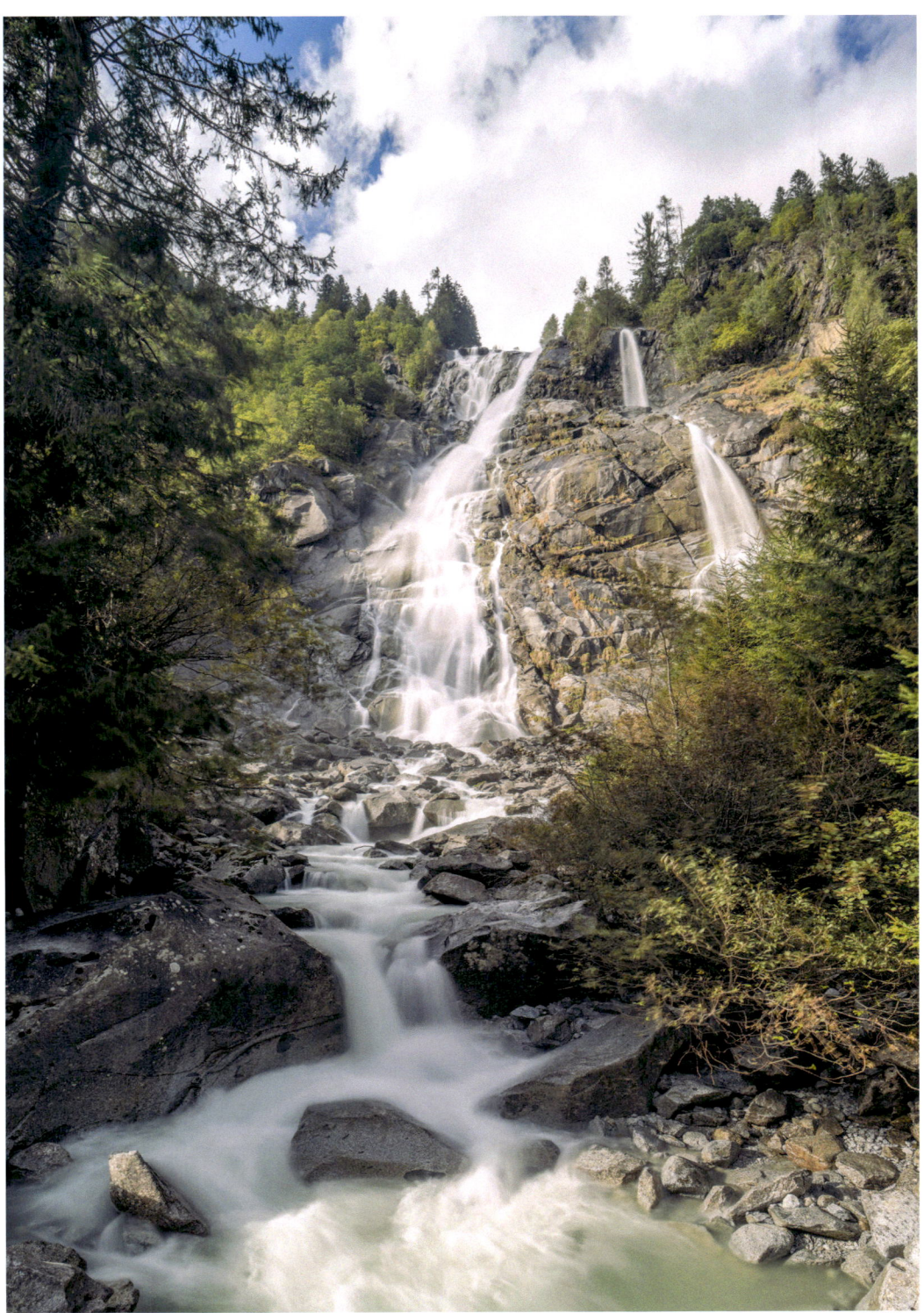
Cascate Nardis. Nikon Z7II, 20mm, ISO 64, 1s at f/8, tripod, ND filter, Jul.

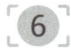

VAL GENOVA

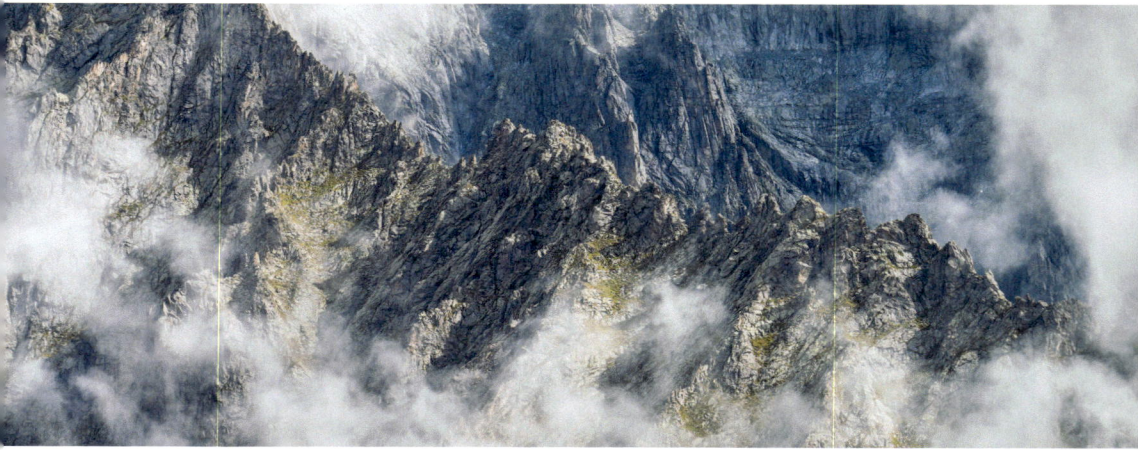

Clouds swirl around the Campanili del Gabbiolo ridge. Nikon Z7II, 100–400mm at 220mm, ISO 72, 1/250s at f/8, Sep.

Viewpoint 2 – Cascata del Pedruc

Whilst less well known than the nearby Cascata Di Lares, Cascata del Pedruc is both easier to access and photograph. The fall can be viewed from a wooden bridge crossing the gorge above, though this offers a restricted view. Instead, take path B01 which starts opposite the parking area at Ponte del Pedrùch and descend steeply down through trees to reach the base of the cascade. Due to the high volume of water a fast shutter speed often works best here.

Viewpoint 3 – Bedole & Cascata del Matarot

Pian di Bedole lies at the end of the Val Genova and marks the end of the drivable road. There are several options for walks starting here. This proposed hike leads up to Malga Matarot, a small farmhouse that provides good views up towards Cascata del Matarot. This 5km route takes approximately two hours with 250m of height gain.

Walking south-west up the valley from the parking area quickly leads to a gorgeous open meadow populated by wildflowers and a scattering of old farm buildings. There are wonderful views towards Cima Presena (3068m) and Cima Busazza (3326m) to the north, and Lobbia di Mezzo (3036m) to the south – the farm buildings providing good foreground interest in both directions.

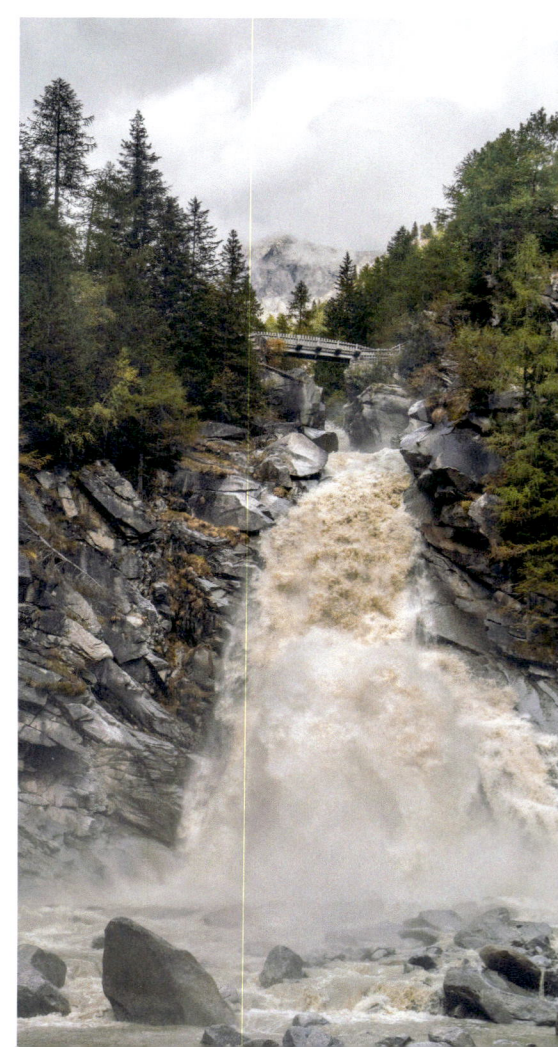

Cascata del Pedruc is impressive in spring and during hot weather. Nikon Z8, 24–120mm at 30mm, ISO 200, 1/1000s at f/6.3, Aug.

Cascata del Matarot flows from the Lobbia glacier. Nikon Z7II, 100–400mm at 155mm, ISO 400, 1/160s at f/8, Sep.

Continue following the gravel track up the valley for 15 minutes to reach Rifugio Adamello Col ini Al Bedole. Just past the rifugio it is worth making a small diversion to Ponte delle Cambiali which is signposted off to the right just before the bridge crosses the Sarca River. Follow this uphill for 10 minutes to reach the narrow gorge and waterfall at Ponte delle Cambiali. Cross the bridge and rejoin the main track once again.

Continue ascending path 241 for a further 30 minutes to reach Malga Matarot. Carry on past the building for another 250m until the trees thin and the terrain opens out. There are now excellent views looking up the valley towards the Lobbia glacier and Cascata del Matarot, whilst looking north-west gives good views of Cascata del Mandron (GPS: 46.190578, 10.585831).

To return retrace your steps back to the car, taking time to photograph Monte Gabbiolo on the descent.

Viewpoint 4 – Other Ideas

For suitably experienced hikers a longer ascent up to Rifugio Mandrone is highly recommended as the views over the surrounding area are spectacular. To reach the rifugio take path 212 north from Rifugio Adamello Collini Al Bedole and follow it uphill for 3 hours, passing the glacier observatory and war graveyard. There can be some good wildlife opportunities on this trail and it is well worth packing a longer lens.

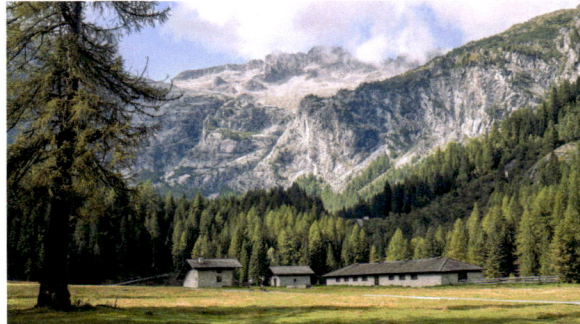

Organic farm buildings in the meadows surrounding Malga Bedole. Nikon Z7II, 24–120mm at 40mm, ISO 64, 1/80s at f/8, Aug.

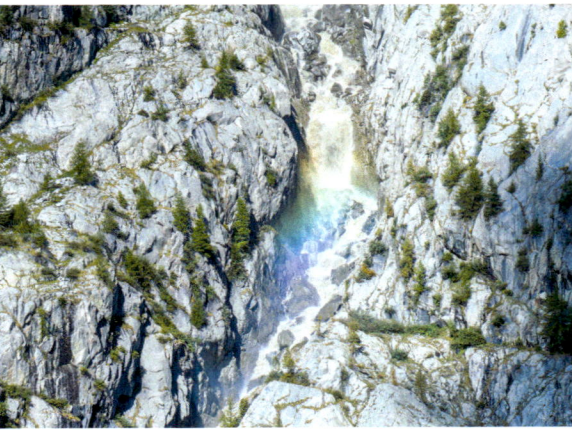

Cascata del Mandron flows down from Lago Nuovo and Mandrone. Nikon Z8, 100–400mm at 300mm, ISO 200, 1/500s at f/9, Sep.

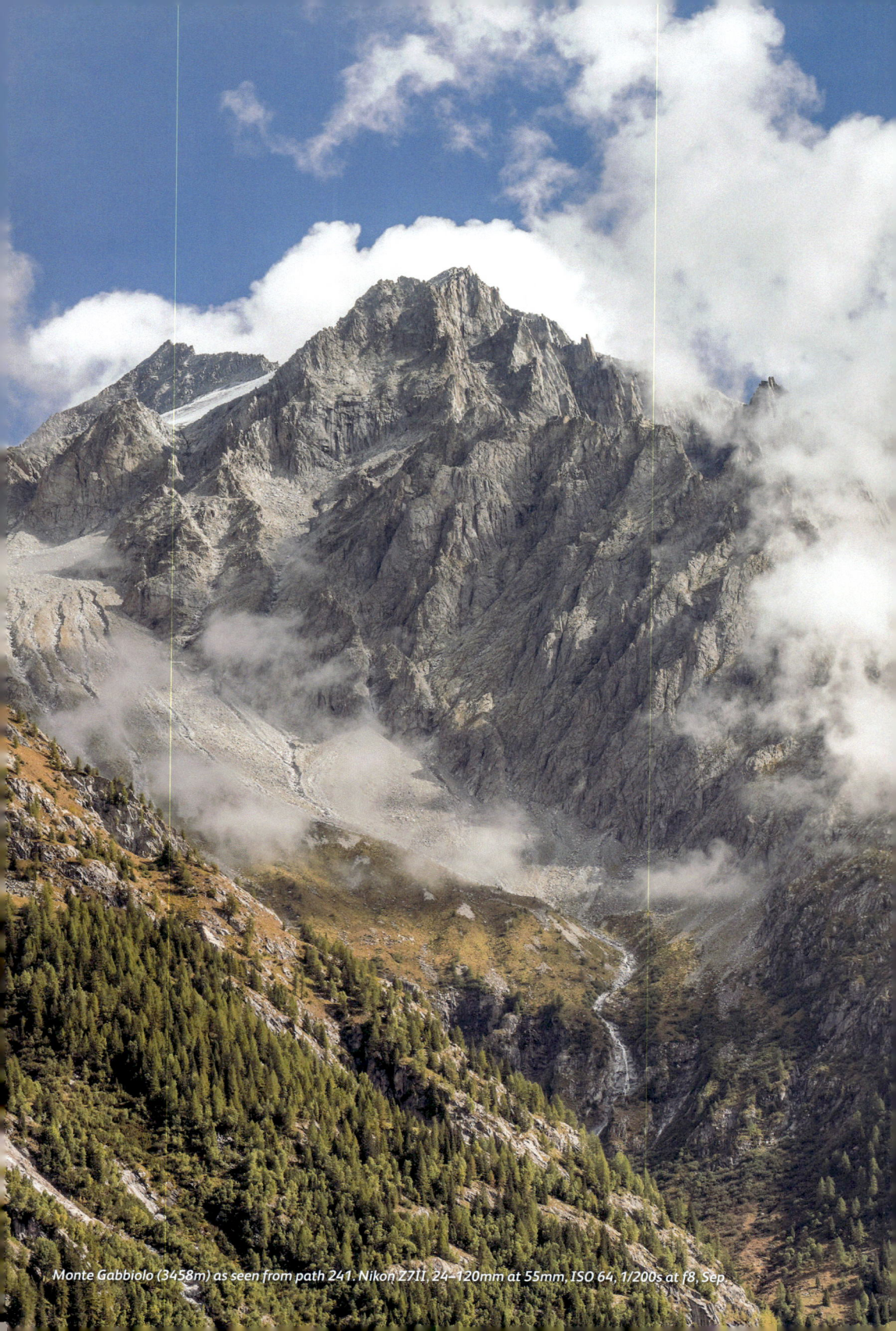
Monte Gabbiolo (3458m) as seen from path 241. Nikon Z7II, 24-120mm at 55mm, ISO 64, 1/200s at f8, Sep.

7 LAGO DI TOVEL

Originally famous for its rust-red waters caused by an alga named Glenodinium sanguineum (later renamed Tovellia sanguinea in honour of the lake) – a phenomenon that unfortunately stopped in 1964 following changes to the upland environment, Lago di Tovel now boasts emerald and blue hues that complement the surrounding landscape perfectly.

Formed by glaciers and then expanded by a landslide during the late 13th Century, Lago di Tovel covers an ancient forest and is designated as an important geosite within the Adamello-Brenta Nature Park. Swimming is popular here, though situated at a height of 1178m and fed by two freshwater mountain streams the water is cold! The lake has become extremely popular during peak season and is best avoided during high summer.

What to shoot and viewpoints

Viewpoint 1 – Sentiero del Lago di Tovel
There is no single best viewpoint at Lago di Tovel and photographers are encouraged to be spontaneous, making a circuit of the lake following the best light. The eastern side provides views across to the Brenta Dolomites and makes a logical starting point, though there are good compositions throughout the hike. A complete 5km circuit takes around 90 minutes and is well signposted.

Viewpoint 2 – Malga Tuena
For those looking to explore a little further afield an ascent to Malga Tuena (1749m) provides lovely panoramic views over the Brenta Dolomites and surrounding area. This out-and-back itinerary has 600m of height gain, is 5.5km long and takes approximately three and a half hours. The ascent starts from the north-west corner of the lake on path 309.

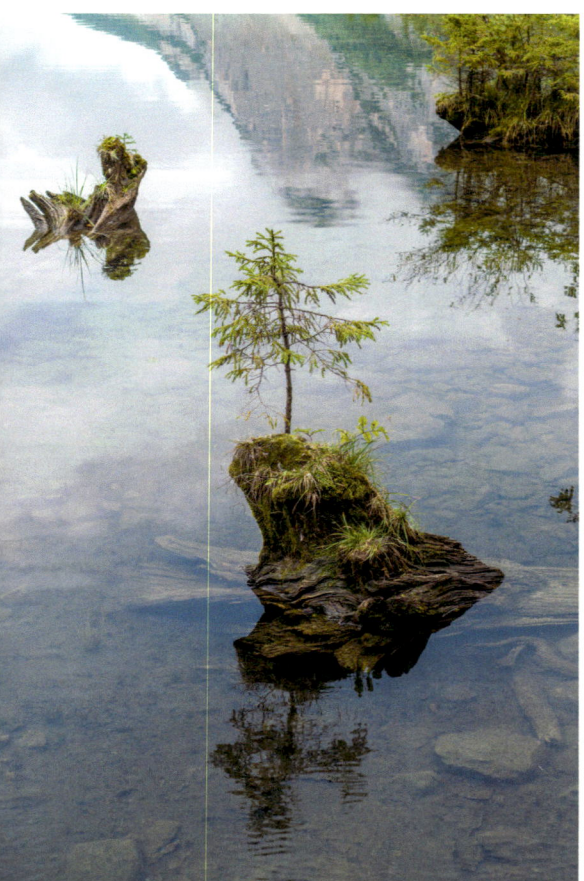

How to get here
Lago di Tovel is accessed via the SP14 from Tuenno in the Val di Non. In recent years there have been driving restrictions along the road during peak season, those these keep changing. For current information visit the Val di Non tourist information page at:

www.visitvaldinon.it/en/poi/lake-tovel-useful-information

The road is normally closed during winter from December to March.

- **Lat/Long**: 46.26695, 10.95323
- **what3words**: ///eagles.rebukes.reserving
- **Tabacco**: Map 53 (1:25.000)
- **Kompass**: Map 73 (1:25.000)

Accessibility
Approach: 15 minutes, 1km, 10m of ascent (to the lake shore)

Disabled access: There is good disabled access to the northern shore whilst smaller paths predominate around the rest of the lake.

Best time of year/day
April, May, June and October are perfect months to visit Lago di Tovel as these provide some of the best photographic conditions whilst there are fewer driving restrictions on the road. The autumn colours through October are particularly special.

A lone tree at the south-western corner of the lake. Nikon Z8, 24–120mm at 30mm, ISO 64, 1/100s at f/8, Nov.

Opposite: One of several beautiful beaches.
© Cristina Gottardi.

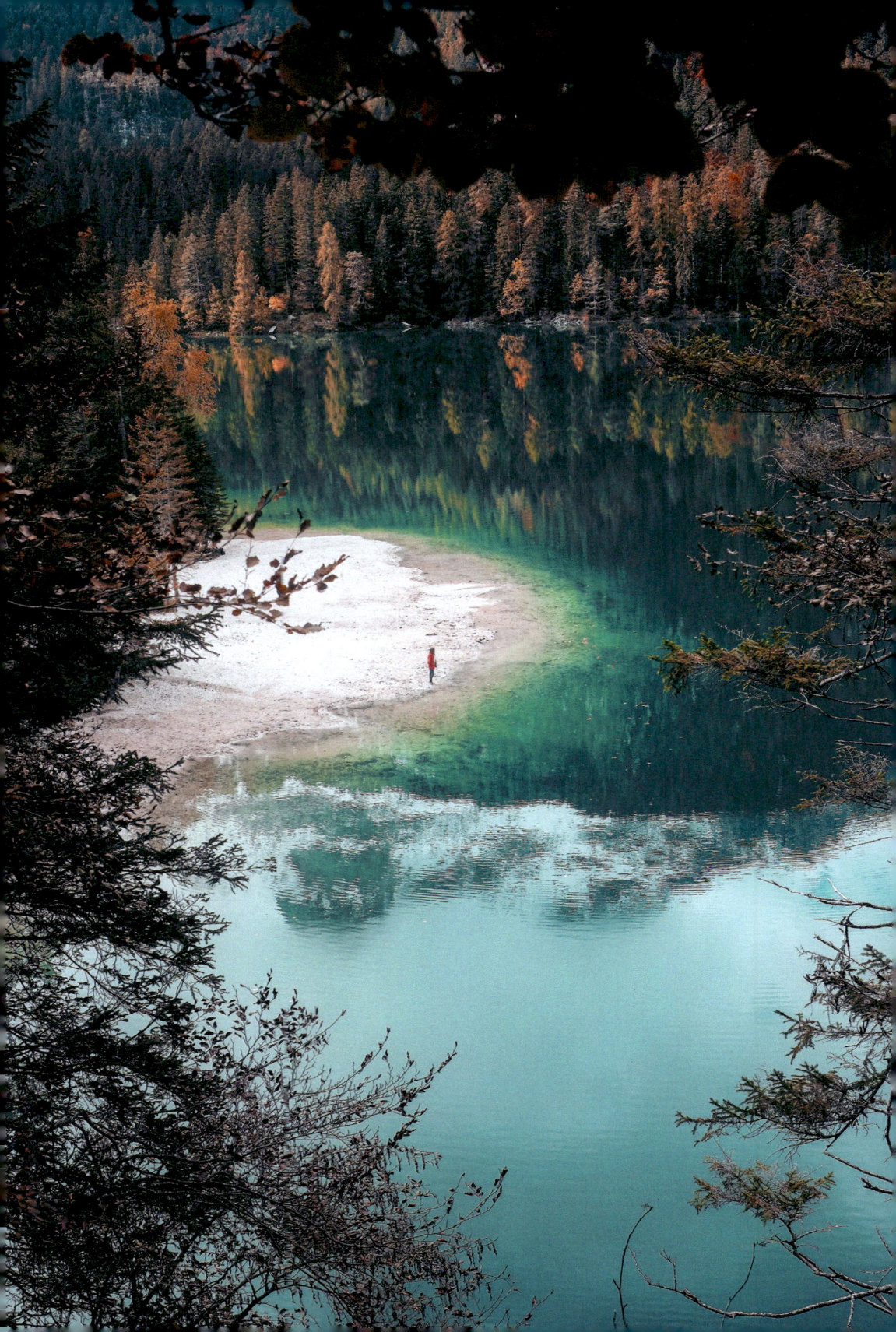

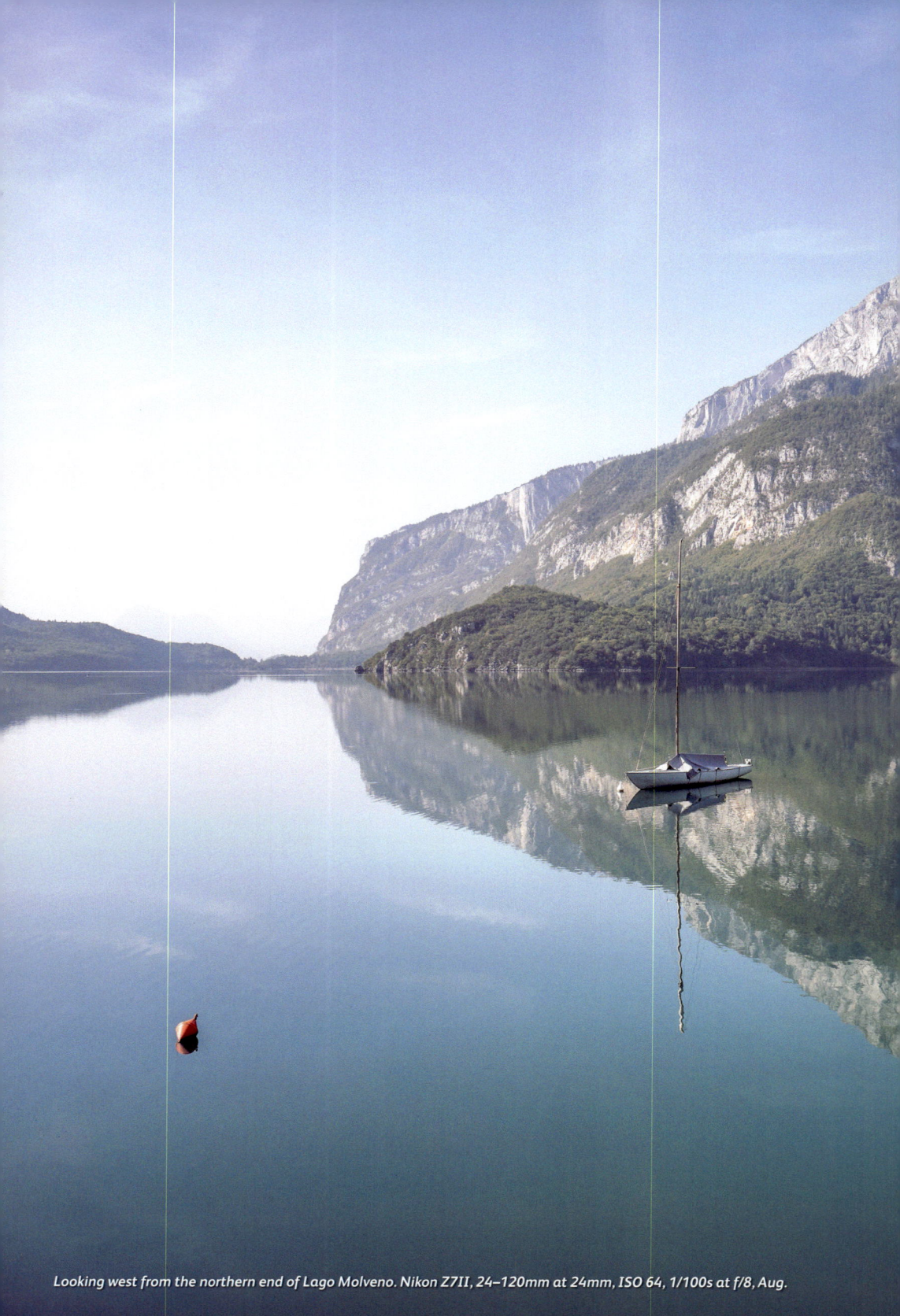

Looking west from the northern end of Lago Molveno. Nikon Z7II, 24–120mm at 24mm, ISO 64, 1/100s at f/8, Aug.

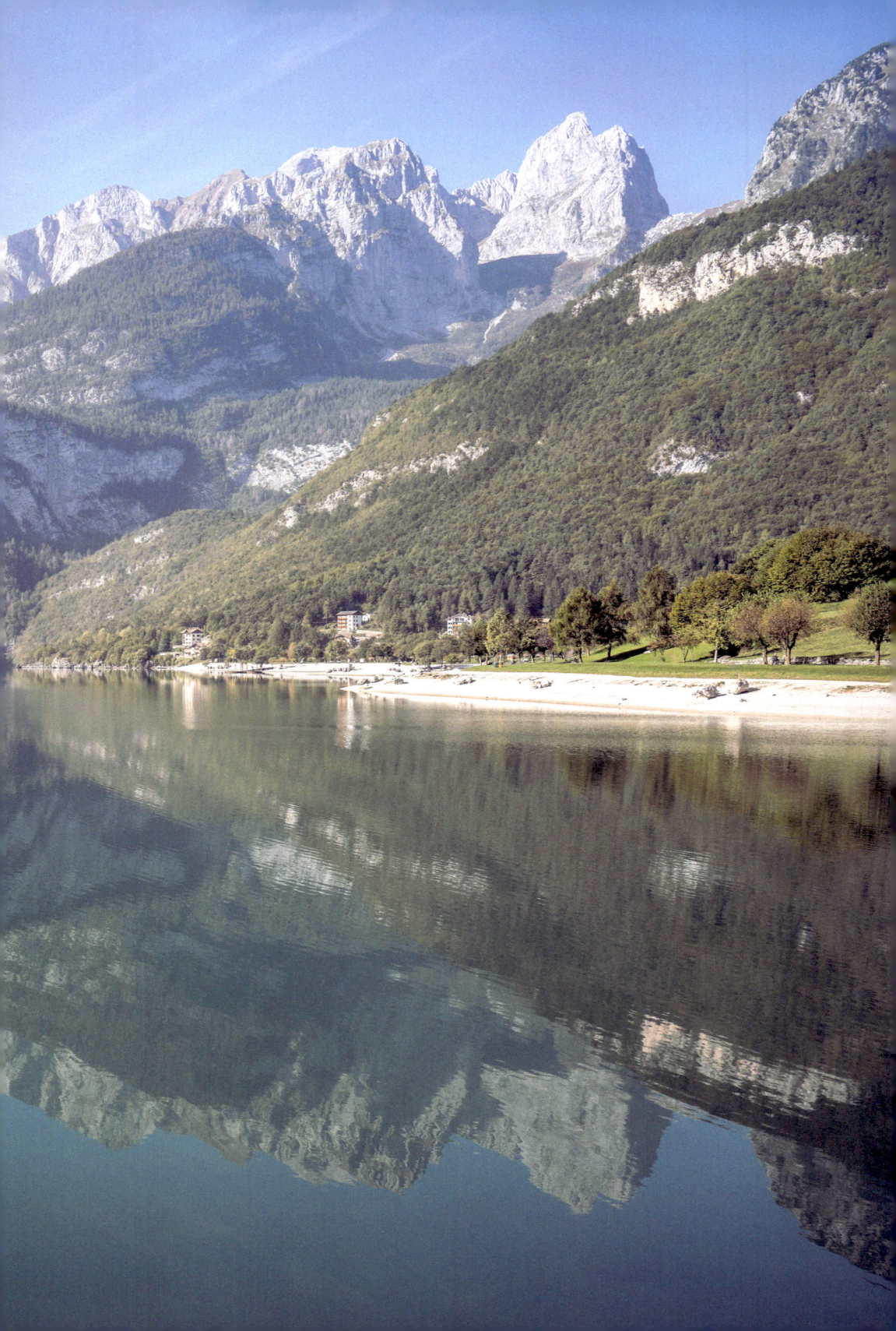

8 MOLVENO

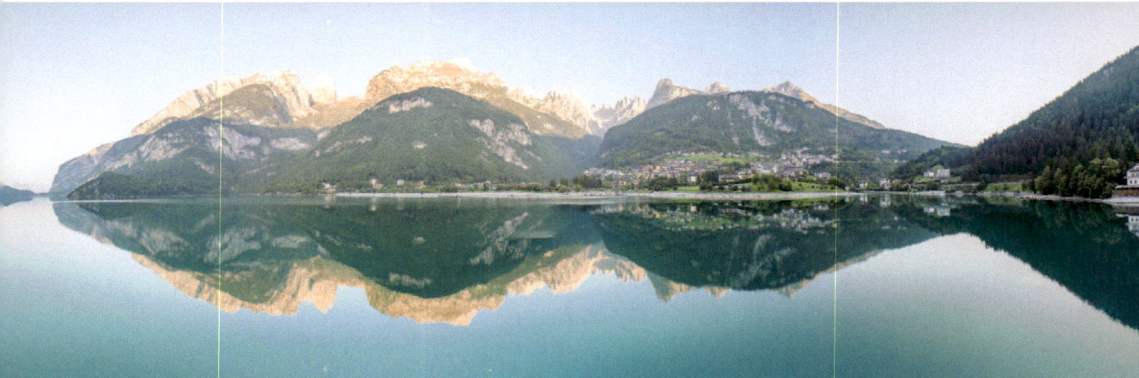

A 150 image bracketed panorama of Lago Molveno. Nikon Z7II, 20mm, ISO 64, various at f/9, tripod, Oct.

Opposite: Looking up Rio Massò from the lakefront bridge. Nikon Z7II, 24–120mm at 50mm, ISO 64, 1/6s at f/9, tripod, ND filter, Oct.

Reminiscent of a smaller Lake Garda, Molveno is the principal town on the eastern side of the Brenta Dolomites. Not only is this a perfect base for those staying in the area, it is also an excellent photography location in its own right.

With a population of one thousand, Molveno is found on the northern shores of its eponymous lake. The town has won numerous awards with the Italian Touring Club and Legambiente, both for its beauty and environmental sustainability.

What to shoot and viewpoints

Whilst the whole lake is photogenic the best viewpoints are found at the northern end, looking over the town and along the waterfront from within Molveno. Use the QR codes opposite for parking information.

Viewpoint 1 – Eastern Lakeside ♿
The north-eastern lakeshore provides a wonderful view looking across Molveno to the Brenta Dolomites. Take the path down to the beach beneath the parking area to gain the best perspective. Several rocks in the water make for a lovely foreground and the scene works well as a wide panorama. This is a perfect sunrise location for anyone staying in town.

How to get here
Molveno is located 40km from Trento and can be approached along the SS421 from Riva del Garda.

Viewpoint 1 – Eastern Lakeside

- **Lat/Long**: 46.1385, 10.97088
- **what3words**: ///kindled.calming.touching
- **Tabacco**: Map 53 (1:25.000)
- **Kompass**: Map 73 (1:25.000)

Viewpoint 2 – Molveno Waterfront

- **Lat/Long**: 46.14117, 10.96776
- **what3words**: ///porpoise.riverbeds.bandage
- **Tabacco**: Map 53 (1:25.000)
- **Kompass**: Map 73 (1:25.000)

Viewpoint 3 – Pradel & Palon di Tovre Lifts

- **Lat/Long**: 46.144346, 10.964638
- **what3words**: ///pancakes.friendly.cooperating
- **Tabacco**: Map 53 (1:25.000)
- **Kompass**: Map 73 (1:25.000)

Accessibility
Molveno is well-equipped with all the amenities you would expect from a town of its size.

♿ **Disabled access** throughout the town is good and there are a number of disabled parking spaces. The second of the two lifts described in Viewpoint 3 is unsuitable for those with disabilities.

Best time of year/day
Molveno is wonderfully picturesque year-round. The east-facing Brenta peaks that rise above the lake and town receive beautiful morning light. Many of the best lake compositions take advantage of the reflections requiring still weather.

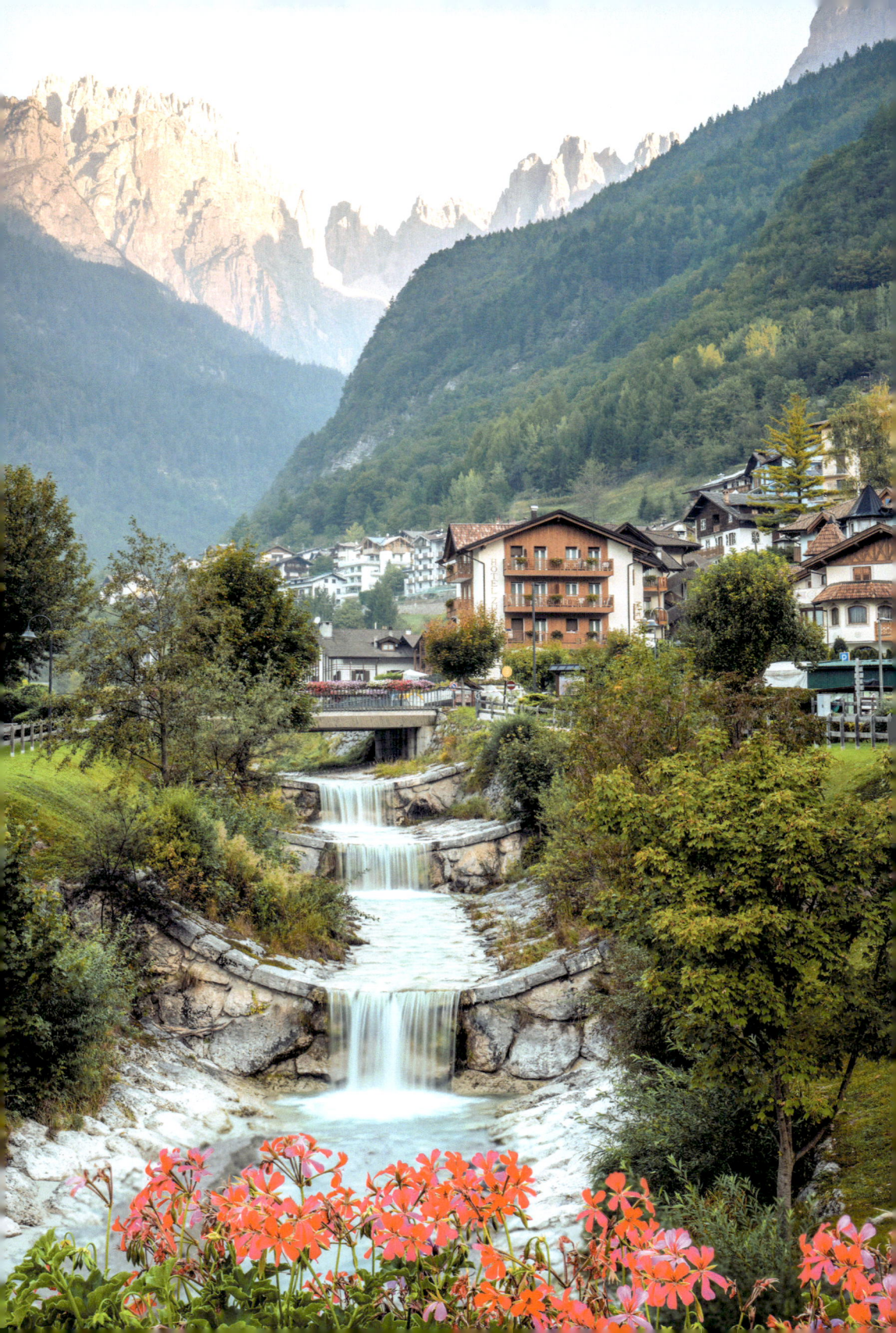

[8] MOLVENO

Viewpoint 2 – Molveno Waterfront ♿
For those staying in Molveno, it is easy to walk to the waterfront. For visitors, the easiest approach is along the lakefront path that leads south from the parking area at Pozza on the outskirts of town. There are several nice beaches and moored boats that can be used for foreground interest. After 10 minutes the path crosses Rio Massò via a small wooden bridge (GPS: 46.13996, 10.96344) – looking upstream there is a trio of waterfalls backdropped by the Brenta peaks that make a lovely composition, especially when the bridge flowers are in bloom.

The path can be followed to Camping Spiaggia where it joins Via Lungolago. Turn right on the road here and follow it back through town to the parking area.

Viewpoint 3 – Pradel & Palon di Tovre Lifts
Departing from the northern side of town the Pradel gondola and Tovre chairlift allow photographers to quickly access the Brenta group and gain a bird's eye perspective over Lago Molveno. Paragliders take off just west of the first gondola top station and add lovely colour to the Brenta peaks rising above the forest.

From the top of the Tovre chairlift head north for 100m to reach Rifugio La Montanara. From the balcony there are spectacular views towards the Brenta peaks – Cima Brenta Alta (2962m), Campanile Basso (2877m), Torre di Brenta (3013m) and Cima dei Armi (2951m), all of the major peaks along the famous Via delle Bocchette are visible.

The lifts can then be taken back down to the parking area. Alternatively, it is possible to descend on foot using Path 340 to Rifugio Croz dell'Altissimo and then Path 319 down the Valle delle Seghe. Allow two and a half hours to make the 7.5km descent to Molveno.

Paragliding in front of the Brenta group as seen from the top of the Tovre lift. Nikon Z8, 24–120mm at 70mm, ISO 640, 1/500s at f/8, Oct.

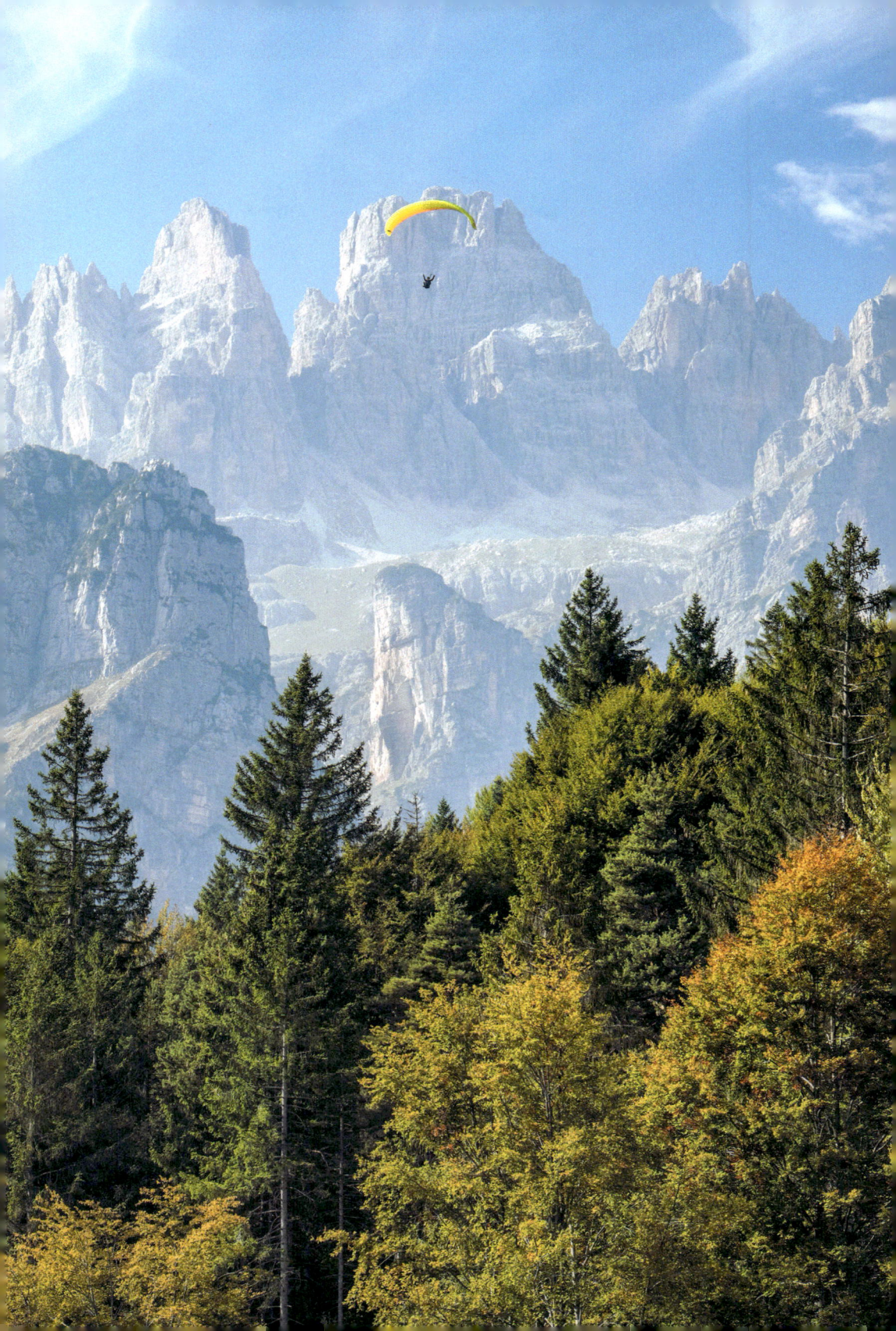

DRONE INFORMATION

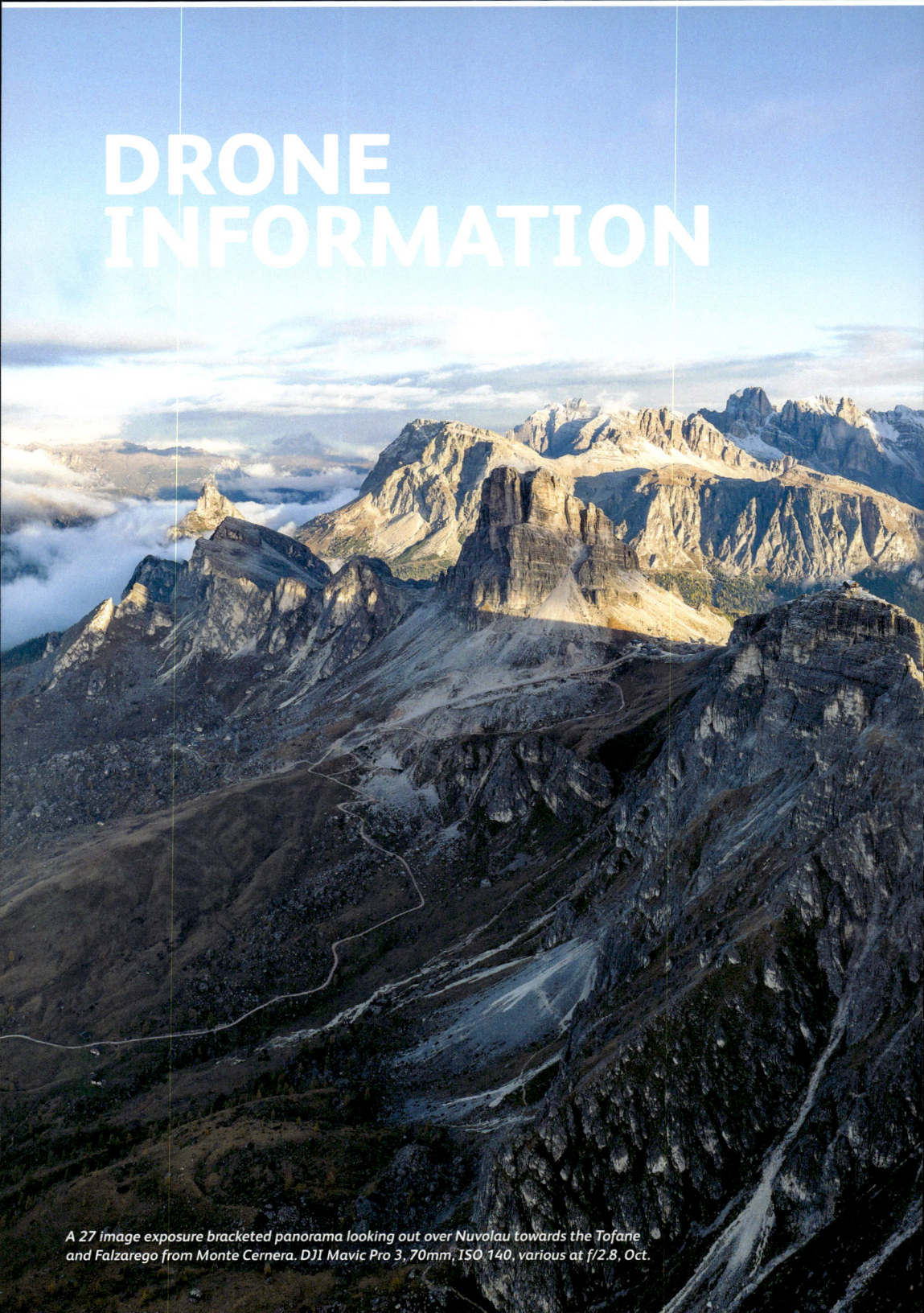

A 27 image exposure bracketed panorama looking out over Nuvolau towards the Tofane and Falzarego from Monte Cernera. DJI Mavic Pro 3, 70mm, ISO 140, various at f/2.8, Oct.

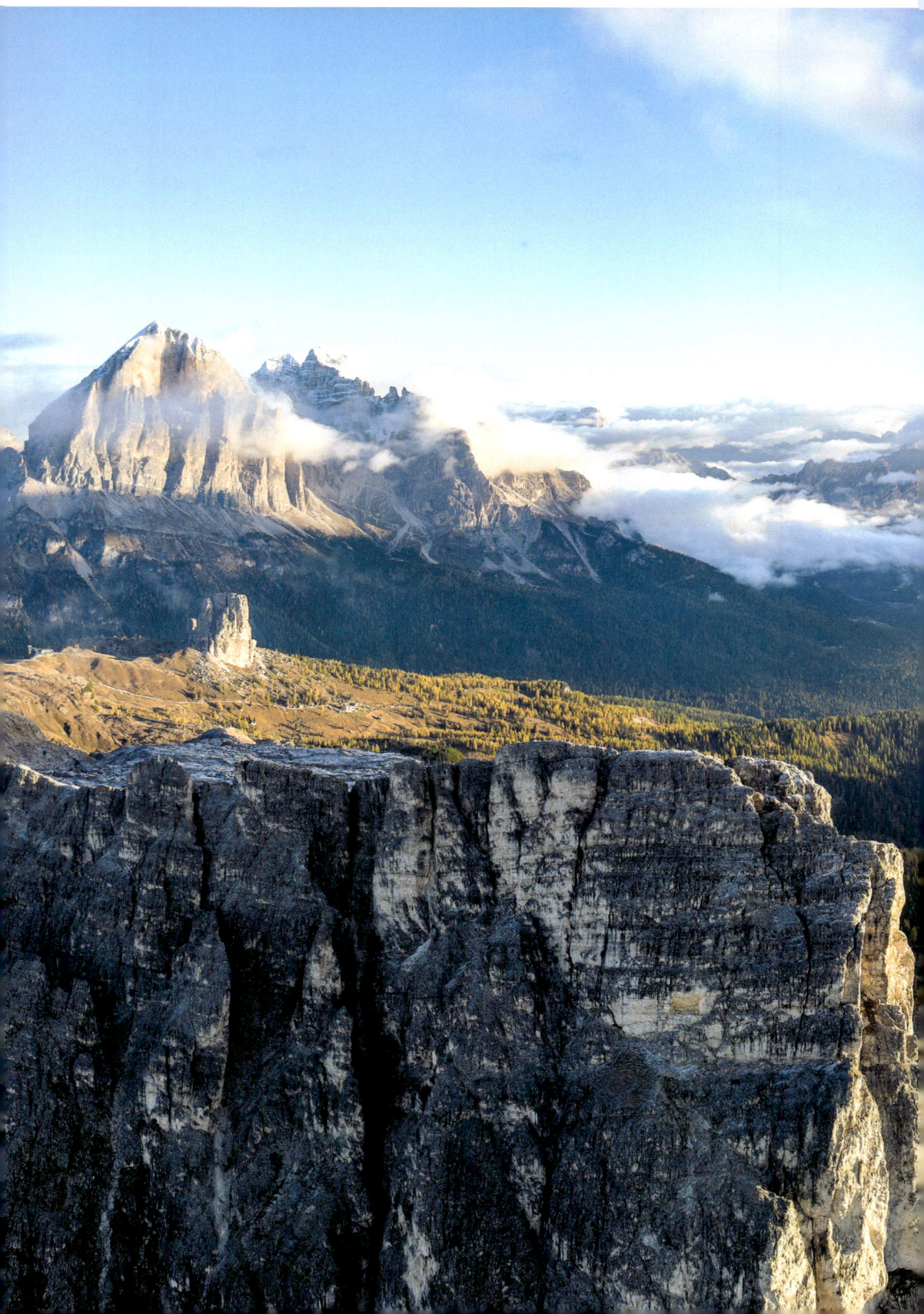

DRONE INFORMATION

Farmsteads surrounding Castelrotto. DJI Mavic Pro 3, 70mm, ISO 100, ISO 140, 1/500s at f/2.8, Oct.

Recent advances in drone technology have made aerial photography more accessible than ever, allowing access to exciting new vantage points and perspectives. These new freedoms should be exercised responsibly and visiting photographers are encouraged to familiarise themselves with the current regulations.

*Drone legislation is evolving rapidly and it is the drone pilots responsibility to check current operating guidelines. The following is intended to be used as a point of reference only.

European Union Aviation Safety Agency

Italy follows legislation laid out by the European Union Aviation Safety Agency (EASA) and this should be the starting point for checking current guidelines. These can be found at:

www.easa.europa.eu/en/domains/civil-drones-rpas/open-category-civil-drones

There are different categories and subcategories depending on the drone type, weight and the intended usage. This will dictate whether an operating license and liability insurance is required.

Flying in Italy

For rules specific to Italy the Italian Civil Aviation Authority publishes updates to their website: ***www.enac.gov.it/sicurezza-aerea/droni***

Italy also requires that all drones be labelled with an operator ID and registered with d-flight: ***www.d-flight.it***

d-flight is a superb resource as it offers an interactive map (***www.d-flight.it/web-app***) showing current flight restrictions to a particular area. To register you will need your tax identification number or national insurance number.

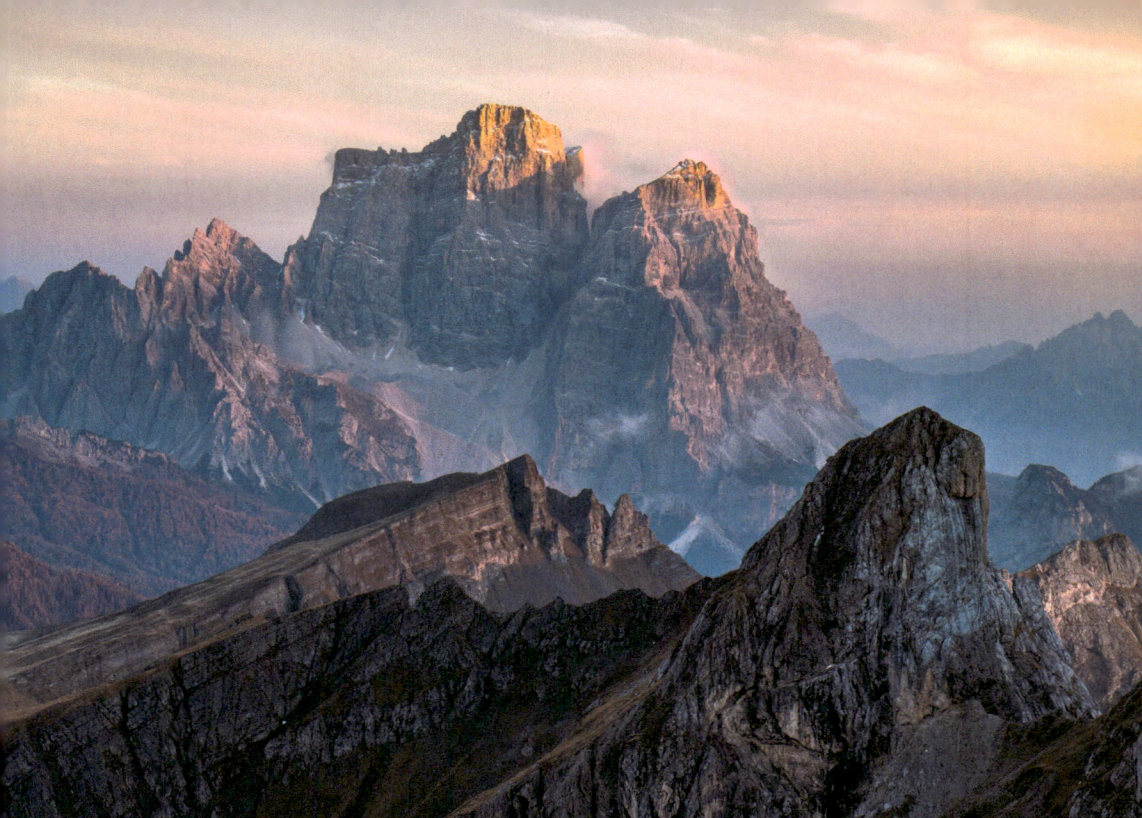

Last light on Monte Pelmo. DJI Mavic Pro 3, 166mm, ISO 400, 1/500s at f/2.8, Oct.

Flying in the Dolomites

There are several additional flying restrictions found within the Dolomites. Most notably flying is not permitted within any of the nine national parks. For commercial projects, you can write to the relevant national park authority for permission. From east to west, the parks are:

Parco Naturale Dolomiti Friulane
Parco Nazionale Dolomiti Bellunesi
Parco Naturale Paneveggio - Pale di San Martino
Parco Naturale Dolomiti Ampezzane
Parco Naturale Fanes-Senes-Braies
Parco Naturale Tre Cime
Parco Naturale Puez-Odle
Parco Naturale Sciliar-Catinaccio
Parco Naturale Adamello Brenta

The easiest way to check park boundaries is using the aforementioned interactive map provided by d-flight. There are also numerous prohibited zones surrounding the helicopter landing pads found throughout the range. Again these can be checked using d-flight.

Flying responsibly

Assuming all the criteria for a safe and legal flight are met it is still important to be a good UAV ambassador. Drones are very divisive, even among photographers and the following points are worth considering:

- Avoid disturbing the peace. Keep drones away from those enjoying the mountain tranquillity.
- Ask if people in the vicinity mind you flying.
- Practice before arriving in the Dolomites. Get used to hand catching and launching in difficult terrain.
- Do not chase or hassle wildlife.
- Be a good ambassador – engage with people who are curious when it is safe to do so.
- Carry a copy of your drone license on your phone.
- Ensure you have liability insurance if required.

Opposite: Recovered drone wreckage found at the Tre Cime.

Next spread: Elaborate dress processions are common at festivals. Nikon D810, 80-400 at 400mm, ISO 110, 1/400s at f/5.6.

DRONE INFORMATION

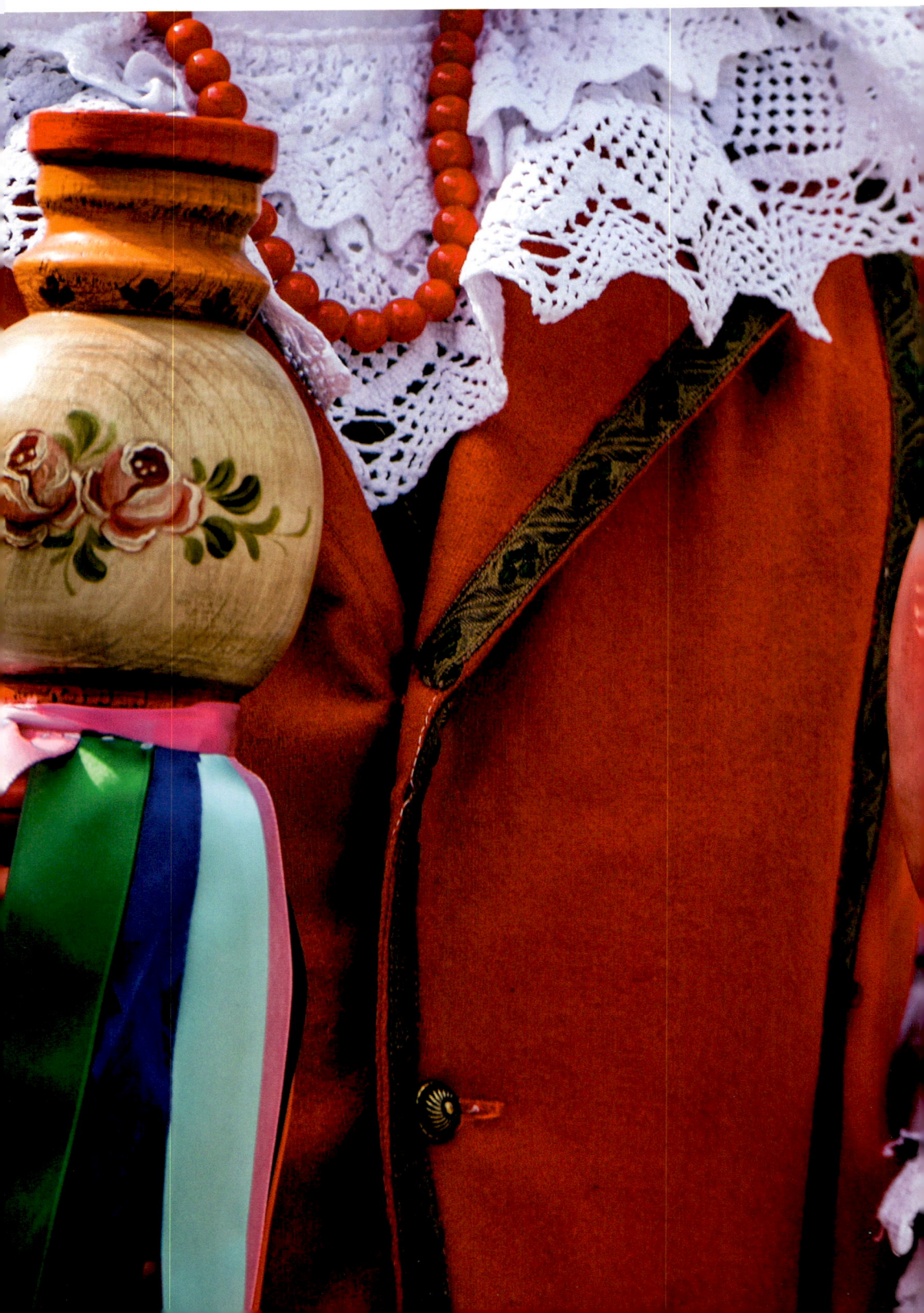

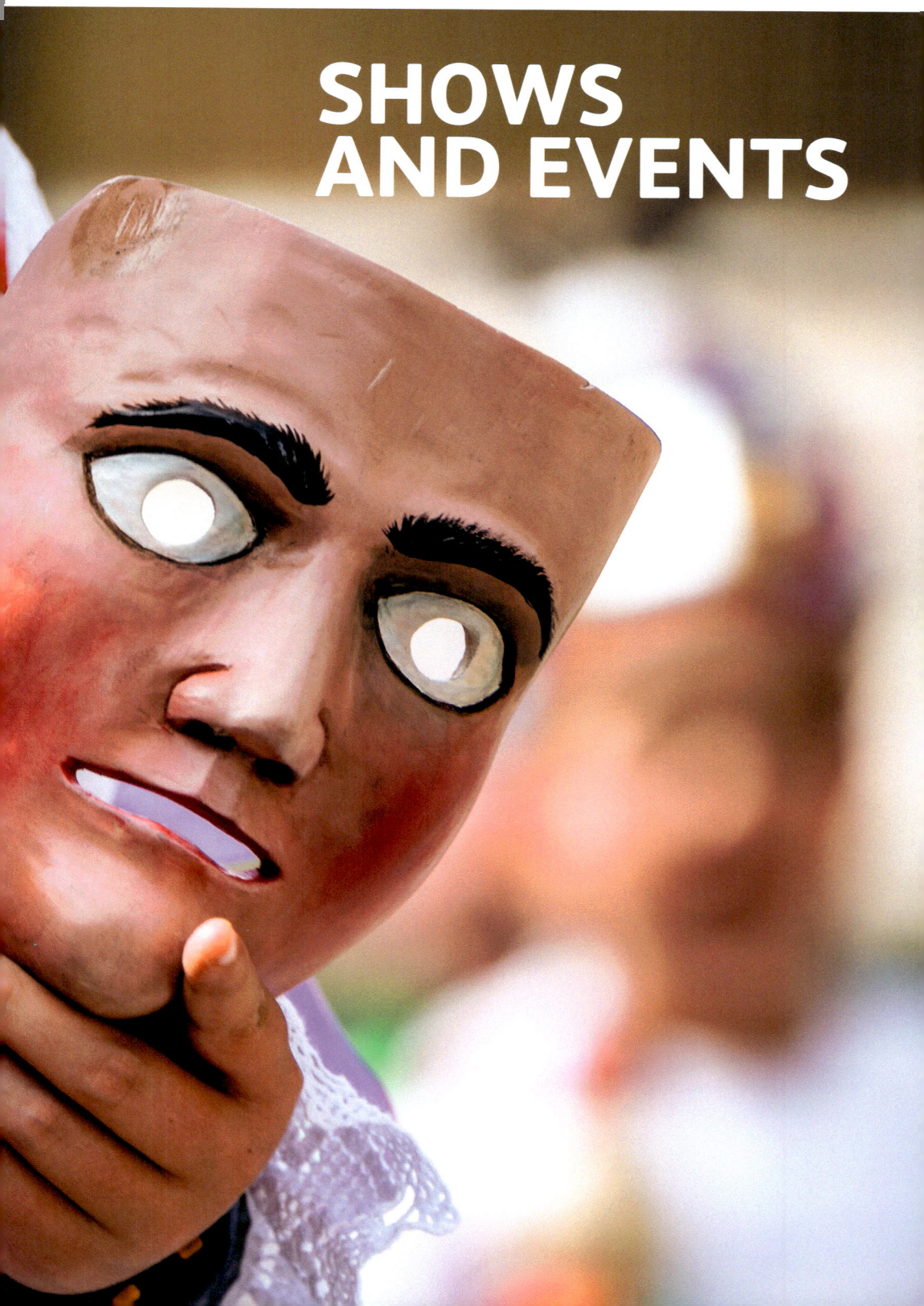

SHOWS AND EVENTS

SHOWS AND EVENTS

The Dolomites is home to a rich, varied and proud Tyrolean culture that is perhaps best displayed through the many celebrations, events and festivals held each year.

While there are too many shows and events to provide a fully comprehensive list, the following pages provides a good reference point to the major occasions. Please be aware that the dates do vary.

January

New Year Celebrations – Major Dolomites Ski Villages
The firework displays that take place in many of the towns over New Year make for excellent photo opportunities. Corvara, backdropped by Sassongher, is especially photogenic.

Ski Shows – Major Dolomites Ski Villages
There are several ski shows held in Arabba, Corvara, Selva and Cortina. Look out for tandem skiers, freestyle tricks and the occasional bath tub coming down the piste!

Alpine Ski World Cup – Cortina & San Vigilio
The race season continues with the women's race events and Giant Slalom in San Vigilio.

Sottoguda Ice-Climbing Festival – Serrai di Sottoguda
The international climbing meet at the Dolomites' premier winter venue provides a superb photo opportunity.

February

Serrai di Sottoguda Torchlit Parade – Sottoguda
A torchlit procession that takes place on Shrove Tuesday departing from the village of Sottoguda.

Winter Polo – Cortina d'Ampezzo
Traditional polo played on horseback but in the snow isn't something you see often and makes for a great spectacle.

Arc'teryx King of Dolomites – Moena
A freeride ski photography competition and event hosted by Arc'teryx. Photographers and athletes enter as teams.

Carnevale – Major Towns of the Dolomites
Also known as carnival or mardi gras, Carnevale is celebrated throughout Italy and can fall anywhere between February 3rd and March the 9th. There are usually celebrations and festivals at most of the major towns. A trip to Venice to see the fireworks and masked celebrations is particularly recommended.

March

Sella Ronda Ski Marathon – Arabba
A two-man team race at night utilising the pistes which encircle the Sella massif. Uphill progress is made using skins.

April

Ski Carousel Vintage Party
A vintage-themed end to the ski season as a resort from decades past is recreated. Fancy dress is naturally obligatory.

May

Giro d'Italia
Italy's largest bike rice occasionally passes through the Dolomites in late May or early June.

June

Sella Ronda Road Bike Race #1 – Corvara in Badia
A 55km road bike race using the Campolongo, Pordoi, Sella and Gardena mountain passes encircling the Sella massif. The roads are closed to motorised traffic and some 10,000 cyclists take part.

Sella Ronda Mountain Bike Hero – Selva Val Gardena
A largely off-road mountain bike race around the Sella massif with a choice of 60km and 86km courses.

Lavaredo Ultra Trail – Cortina d'Ampezzo
A demanding 120km running race with just over 5800m of ascent starting and finishing at Cortina d'Ampezzo.

There are often many spontaneous portrait opportunities at the numerous festivals and events. Nikon D810, 105mm, ISO 100, 1/400s at f/2.8.

SHOWS AND EVENTS CONTINUED

July

Maratona dles Dolomites Road Bike Race
A gruelling 138km road race over seven mountain passes with an annual participation of some 9000 riders.

Dolomites Sky Race – Canazei in Val di Fassa
A running race from the village of Canazei to the summit of Piz Boè and back down again.

Copa d'Oro Dolomiti – Cortina d'Ampezzo
The 'Dolomites Gold Cup Race' is a classic car race dating back to 1947 that traverses the Dolomites.

Sounds of the Dolomites – Dolomites Rifugios
A series of music events that takes place in remote mountain rifugios through July and August. A program is available in the local tourist offices.

Dino Ciani Festival and Academy – Cortina d'Ampezzo
A classical music festival with various events through July and August in Cortina d'Ampezzo.

Feste Campesetri dei Sestrieri – Cortina d'Ampezzo
A dance and food festival that runs in conjunction with the Dino Ciani Festival and Academy in Cortina d'Ampezzo.

August

Touching history – Cinque Torri
This event usually occurs over two weekends a year through August. Local enthusiasts dress in military uniform of the era and take part in a remembrance ceremony commemorating the First World War. The Alpini troops often do a helicopter and military demonstration.

Ferragosto – Major Towns of the Dolomites
Coinciding with the major Catholic feast of the Assumption of Mary, Ferragosto is celebrated throughout Italy. There are usually celebrations and festivals throughout the region.

Festival of the Mills
During August in the Val de Murin several of the mills are opened up to the public and there are daily demonstrations as the waterwheels are engaged.

September

Sella Ronda Road Bike Race #2 – Corvara in Badia
A 55km road bike race using the Campolongo, Pordoi, Sella and Gardena mountain passes encircling the Sella massif. While this event is less popular that the one held in June there is invariably still a good turnout.

Gran Festa da d'Istà – Canazei in Val di Fassa
A traditional Ladin festal to celebrate the end of the summer season in the Val di Fassa.

Highline Meeting Monte Piana – Misurina
Italy's biggest highline festival normally occurs at the start of September. Unfortunately, the 2016 festival didn't go ahead due to unresolved access issues.

Fassa Sky Expo – Campitello di Fassa
An international meet of paragliders and hang gliders.

October

Transhumance – Alpe di Siusi / Val di Funes / Vallunga
The moving of cattle from the high pastures back down to the villages usually occurs on the 1st of October and is accompanied by a harvest celebration, the largest of which takes place in the town of Castelrotto.

Eggentaler Herbst Classic Car Rally – Val d'Ega
A classic car rally across many of the Dolomites passes.

December

Krampusnacht – Dobbiaco / Toblach
Traditionally held on the 5th December this is not to missed for those that enjoy the darker side of Christmas.

Alpine Ski World Cup – Val Gardena & Alta Badia
The season starts with the Super-G and the Men's downhill in the Val Gardena before moving onto La Villa for the Giant Slalom and Parallel Giant Slalom.

Christmas Markets – Major Towns of the Dolomites
Many of the villages host excellent Christmas Markets throughout the festive period.

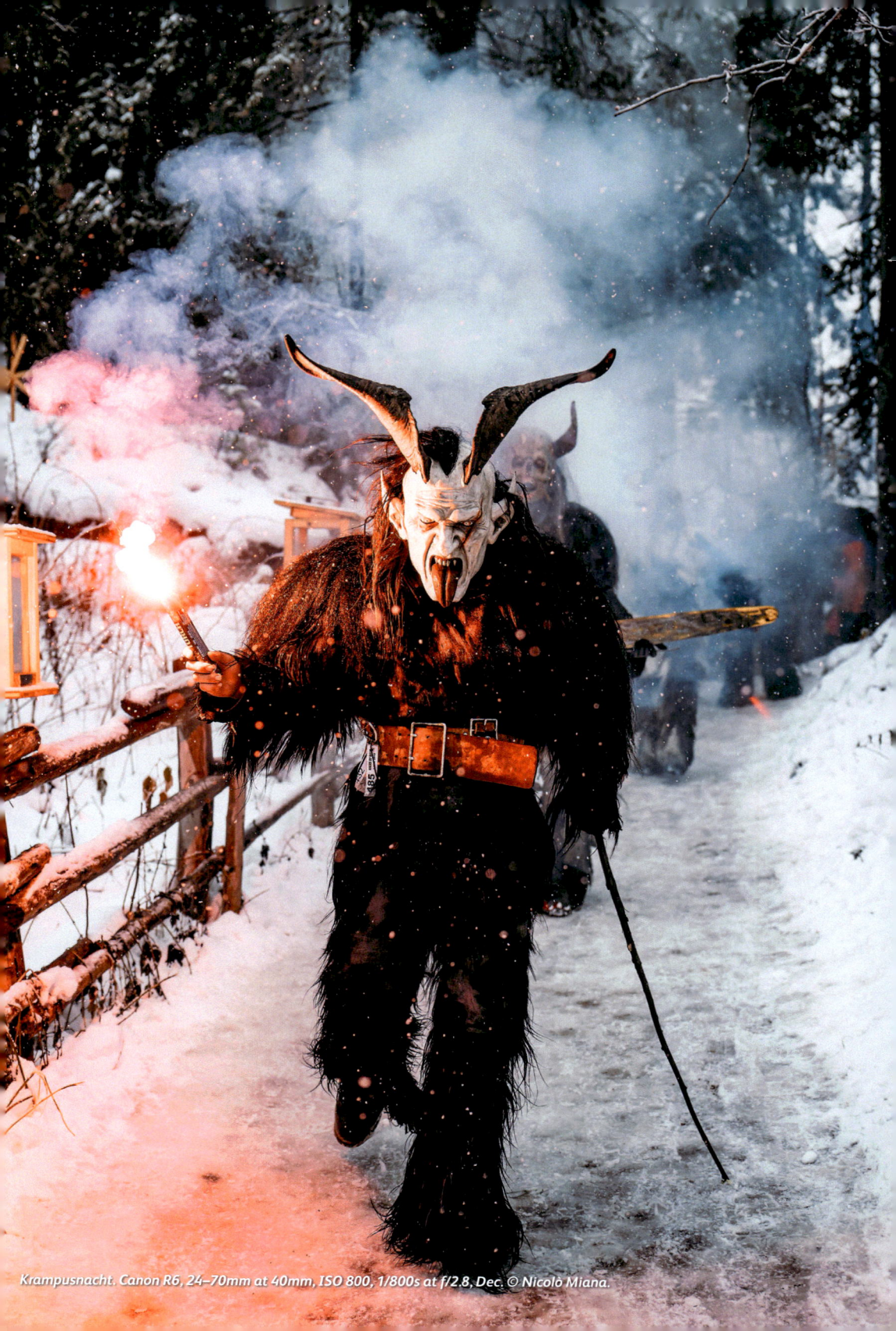

Krampusnacht. Canon R6, 24–70mm at 40mm, ISO 800, 1/800s at f/2.8, Dec. © Nicolò Miana.

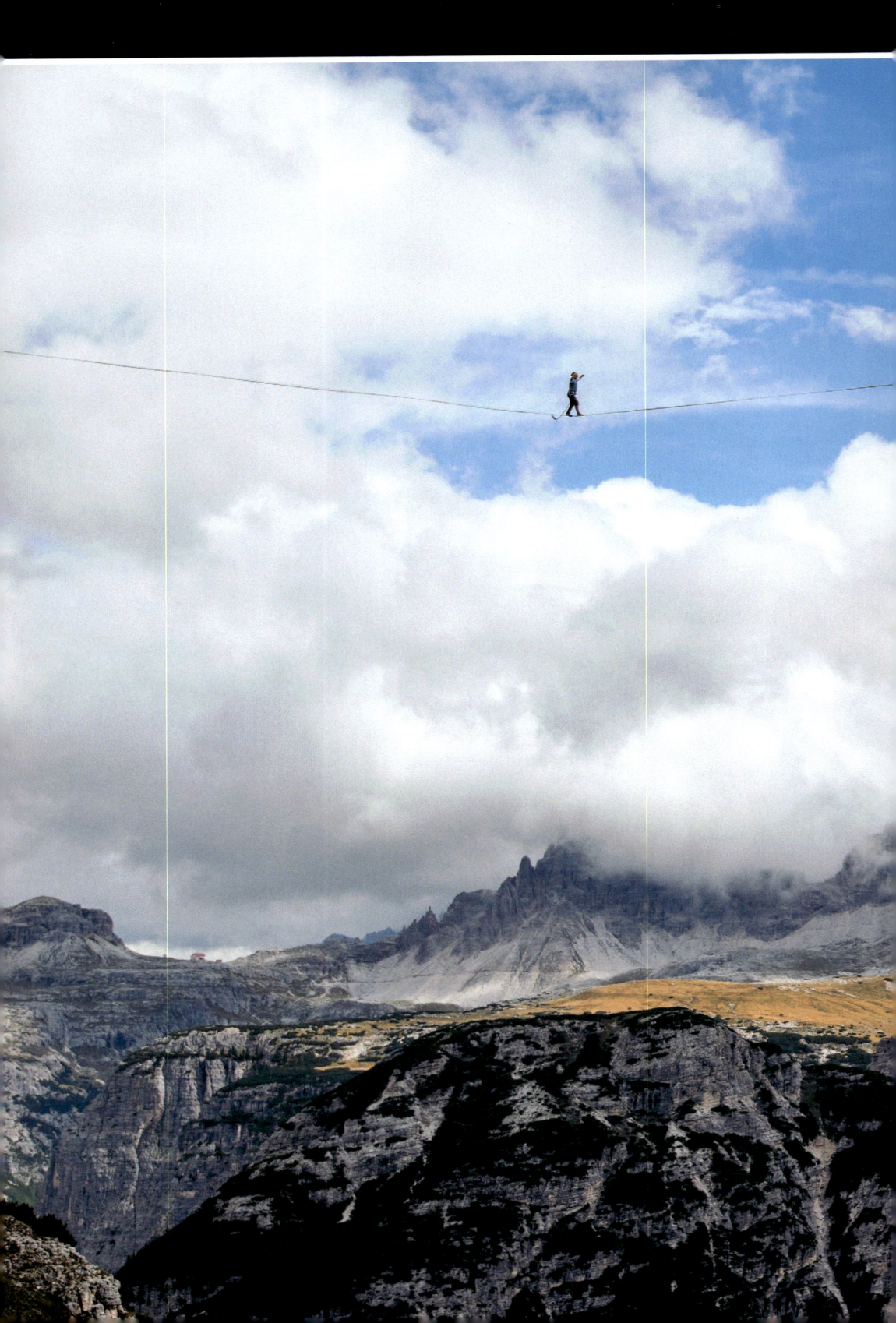

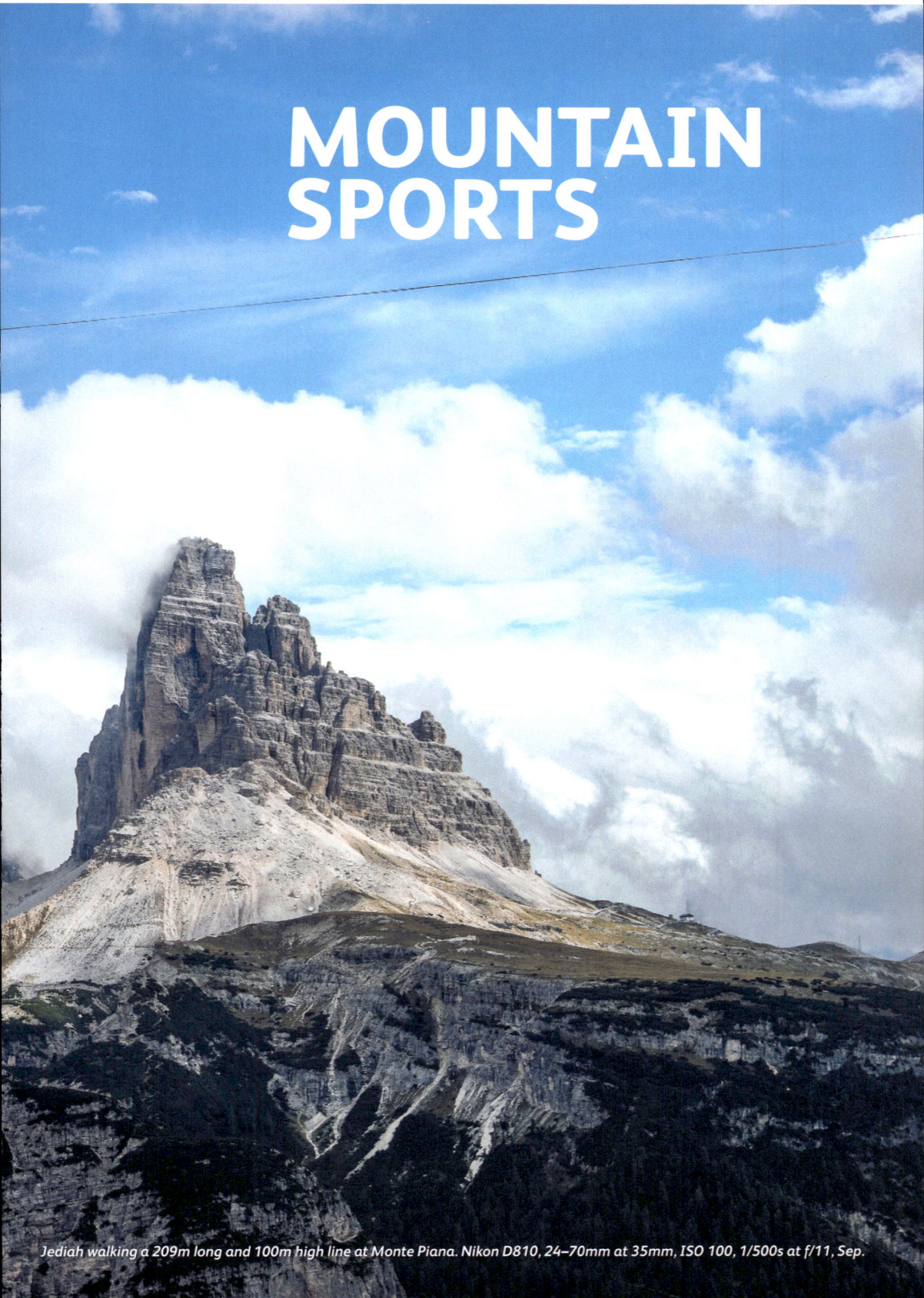

MOUNTAIN SPORTS

Jediah walking a 209m long and 100m high line at Monte Piana. Nikon D810, 24–70mm at 35mm, ISO 100, 1/500s at f/11, Sep.

MOUNTAIN SPORTS – CLIMBING & VIA FERRATA

Climbing in the Dolomites really took off during the late 19th Century as the wealthy British and German nobility began to explore the region. In 1857, inspired by descriptions of the 'Pale Alps', mountaineer and naturalist Sir John Ball ventured to the Dolomites and subsequently became the first person to summit Monte Pelmo. He was shortly followed by the eminent Paul Grohmann who would later make the first ascents of the three Tofanas, Antelao, the Marmolada and Cristallo. His publication and map 'Karte der Dolomiten-Alpen' would further attract alpinists to the region, a trend that would only be halted by the onset of the First World War. The ensuing conflict gave rise to many new via ferrata routes, the wires, ladders and suspension bridges allowing troops and supplies to be conveniently moved across the precipitous terrain.

Today both via ferrata and rock climbing are popular sports throughout the Dolomites, presenting photographers with some unique photo opportunities.

Rock Climbing

Climbers in brightly colouring clothing can make for some really interesting foregrounds, providing an excellent sense of scale to the surrounding peaks. Keep an eye out for spontaneous photo opportunities as you pass beneath the large rock walls. You are likely to encounter climbers in the following locations throughout the book:

Torri del Vajolet / Vajoletturm	136
Brigata Tridentina Viewpoint	206
Sasso della Croce / Sass dla Crusc	222
Città dei Sassi	238

Sass Pordoi / Pordoi Spitze	250
Sass de Stria / Hexenstein	310
Monte Lagazuoi	316
Cinque Torri	330
Tre Cime di Lavaredo / Drei Zinnen	416

Via Ferrata

For suitably equipped, experienced and adventurous photographers, the via ferrata routes of the Dolomites provide a wealth of potential photo opportunities. The following routes are particularly photogenic and worthy of additional research:

Sentiero Attrezzato Sass de Putia (Puez-Odle)	Grade 1A
Sentiero Astaldi (Tofana)	Grade 1A
Ferrata Giovanni Barbara/Cengia de Mattia (Fanes)	Grade 1A
Alta Via Günther Messner (Puez-Odle)	Grade 1B
Ferrata Piz da Cir V (Cir)	Grade 2A
Ferrata Masare (Catinaccio)	Grade 2B
Ferrata Ivano Dibona (Cristallo)	Grade 2B
Ferrata Marino Bianchi (Cristallo)	Grade 2B
Ferrata Strada degli Alpini (Sesto)	Grade 2B
Ferrata Michielli Strobel (Fiames)	Grade 3B
Ferrata Brigata Tridentina (Sella)	Grade 3B
Ferrata Oskar Schuster (Sassolungo)	Grade 3B
Ferrata Piz da Lech (Sella)	Grade 3B
Ferrata delle Scalette (Sesto)	Grade 3B
Giro del Sorapiss – Berti / Minazio / Vandelli	Grade 3C
Ferrata Bocchette Centrali (Brenta)	Grade 3C
Ferrata Bocchette Alte (Brenta)	Grade 4C
Ferrata delle Mesules (Sella)	Grade 4C
Ferrata Bolver Lugli (Pala)	Grade 4C
Ferrata Cesare Piazzetta (Sella)	Grade 5C
Ferrata Cesco Tomaselli (Fanes)	Grade 5C
Punta Anna & Gianni Aglio (Tofana)	Grade 5C

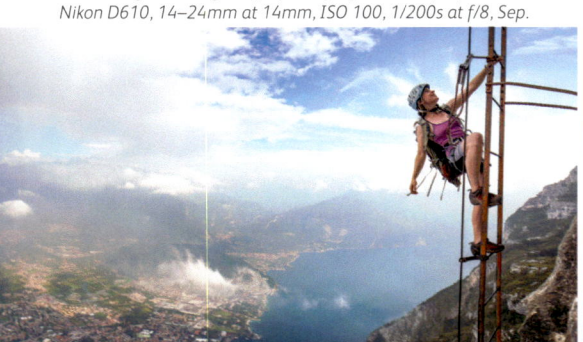

A wide-angle lens is great for portraying a sense of exposure. Nikon D610, 14–24mm at 14mm, ISO 100, 1/200s at f/8, Sep.

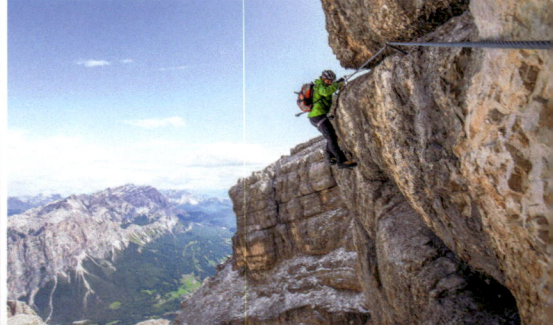

Making the famously exposed traverse on Punta Anna. Nikon D610, 14–24mm at 14mm, ISO 100, 1/320s at f/9, Sep.

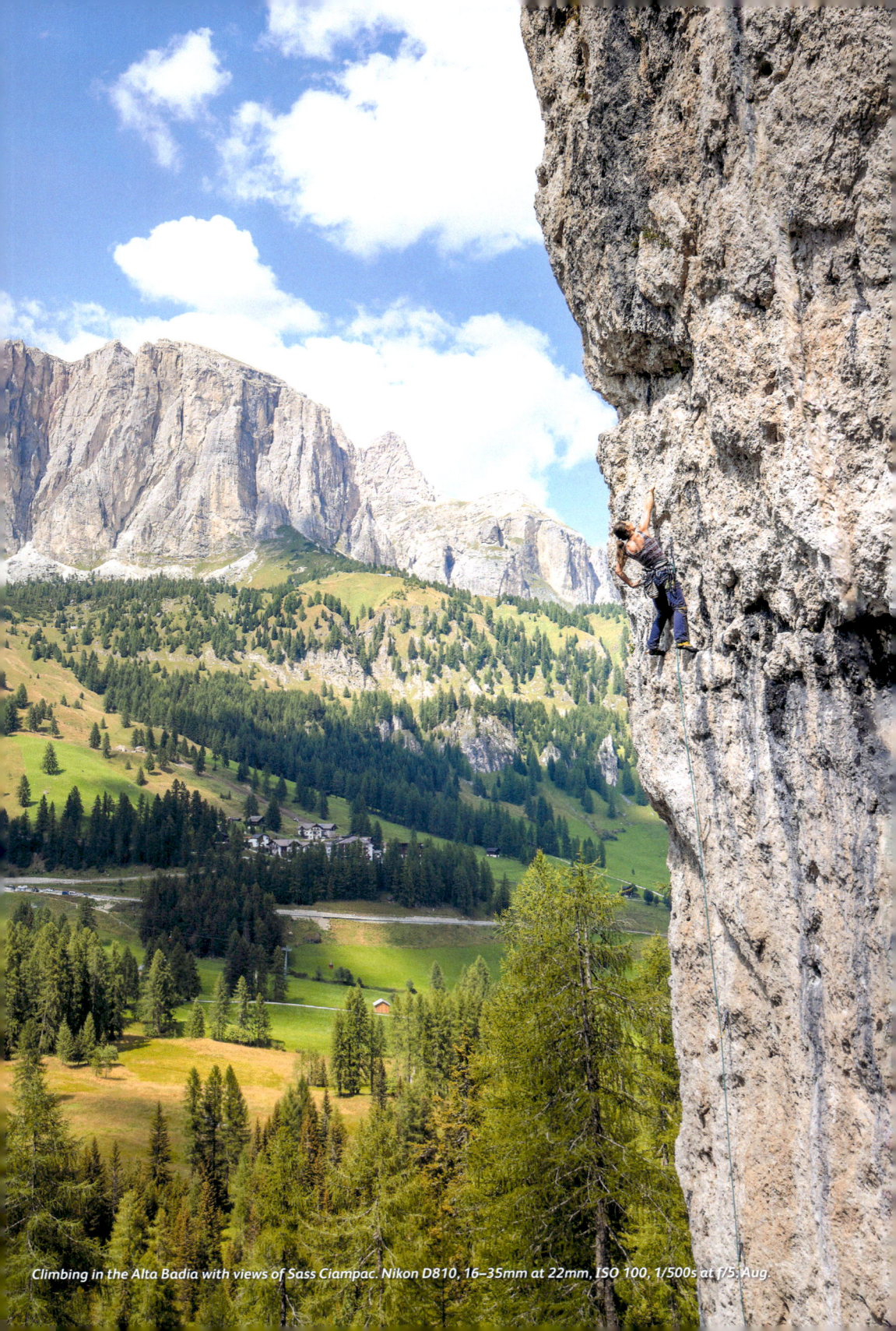
Climbing in the Alta Badia with views of Sass Ciampac. Nikon D810, 16–35mm at 22mm, ISO 100, 1/500s at f/5. Aug.

MOUNTAIN SPORTS – CLIMBING & VIA FERRATA

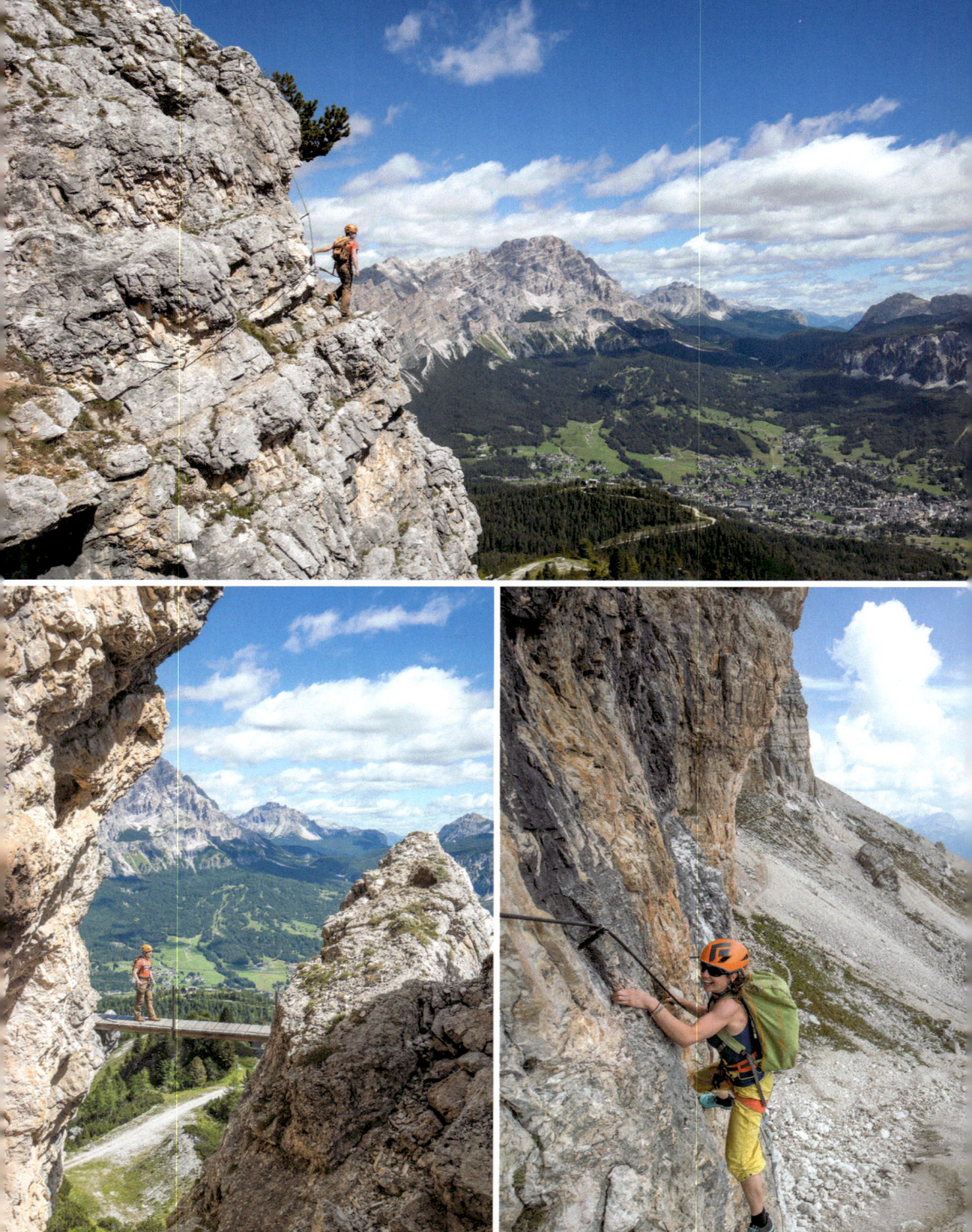

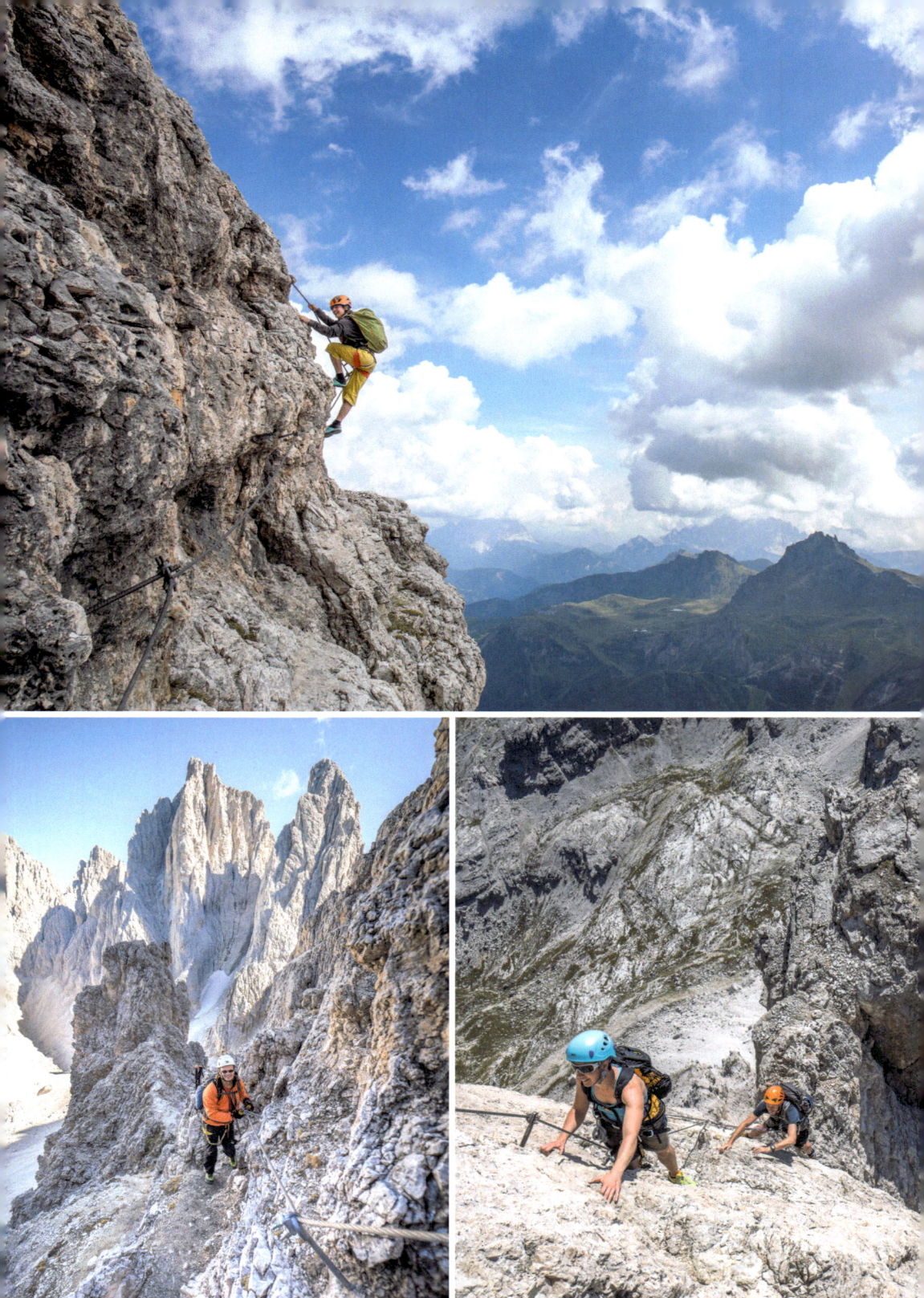

MOUNTAIN SPORTS – SKIING & ICE CLIMBING

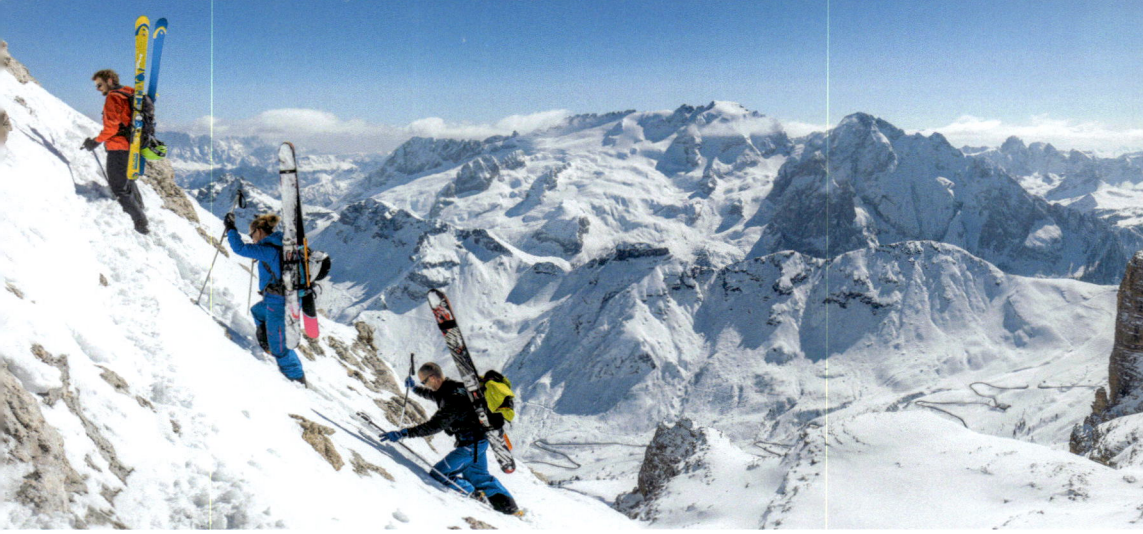

Approaching the summit of Piz Boé from Sass Pordoi. Nikon D810, 28–300mm at 28mm, ISO 100, 1/500s at f/11, Feb.

When the first snowfall arrives, the Dolomites is transformed into a veritable winter playground.

Skiing

The Dolomites is exceptionally popular in the winter and boasts one of the largest pisted ski areas in Europe. The 'Sella Ronda', a circular network of lifts and pistes that can be completed in either direction around the Sella Massif, is particularly popular and draws thousands of visitors every year. However, away from the hustle and bustle of the piste lies an intricate network of peaks, ridges, couloirs, open faces and snow-covered valleys; a winter paradise for those willing to venture off the beaten track and get into the backcountry with a camera.

With suitable ski touring experience the following locations make for excellent winter venues:

Val Duron	142
Puez Odle / Geisler – Seceda & Col Raiser	186
Sasso della Croce / Sass dla Crusc	222
Seres – Val di Morins / Muhlenweg	226
Sass Pordoi / Pordoi Spitze	250
Passo Giau	282
Cinque Torri	330
Malga ra Stua – Torrente Boite	354
Tre Cime di Lavaredo / Drei Zinnen	416
Val Pradidali	470

Opposite: The 3rd pitch of La Spada di Damocles above Colfosco. Nikon D610, 14–24mm at 14mm, ISO 100, 1/320s at f/9, Feb.

Ascending Monte Pore on the Passo Giau. Nikon D810, 28–300mm at 28mm, ISO 100, 1/500s at f/11, Feb.

Dropping a boulder whilst descending Forcella Sassolungo. Nikon D810, 28–300mm at 300mm, ISO 200, 1/1000s at f/8, Mar.

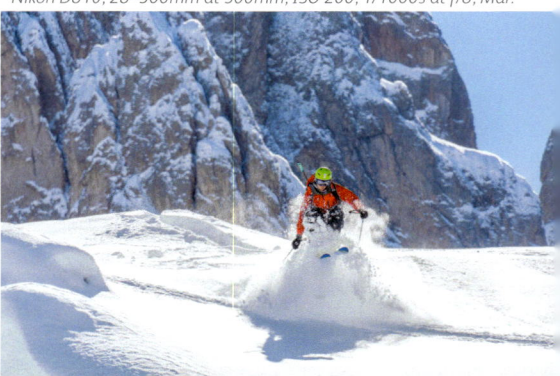

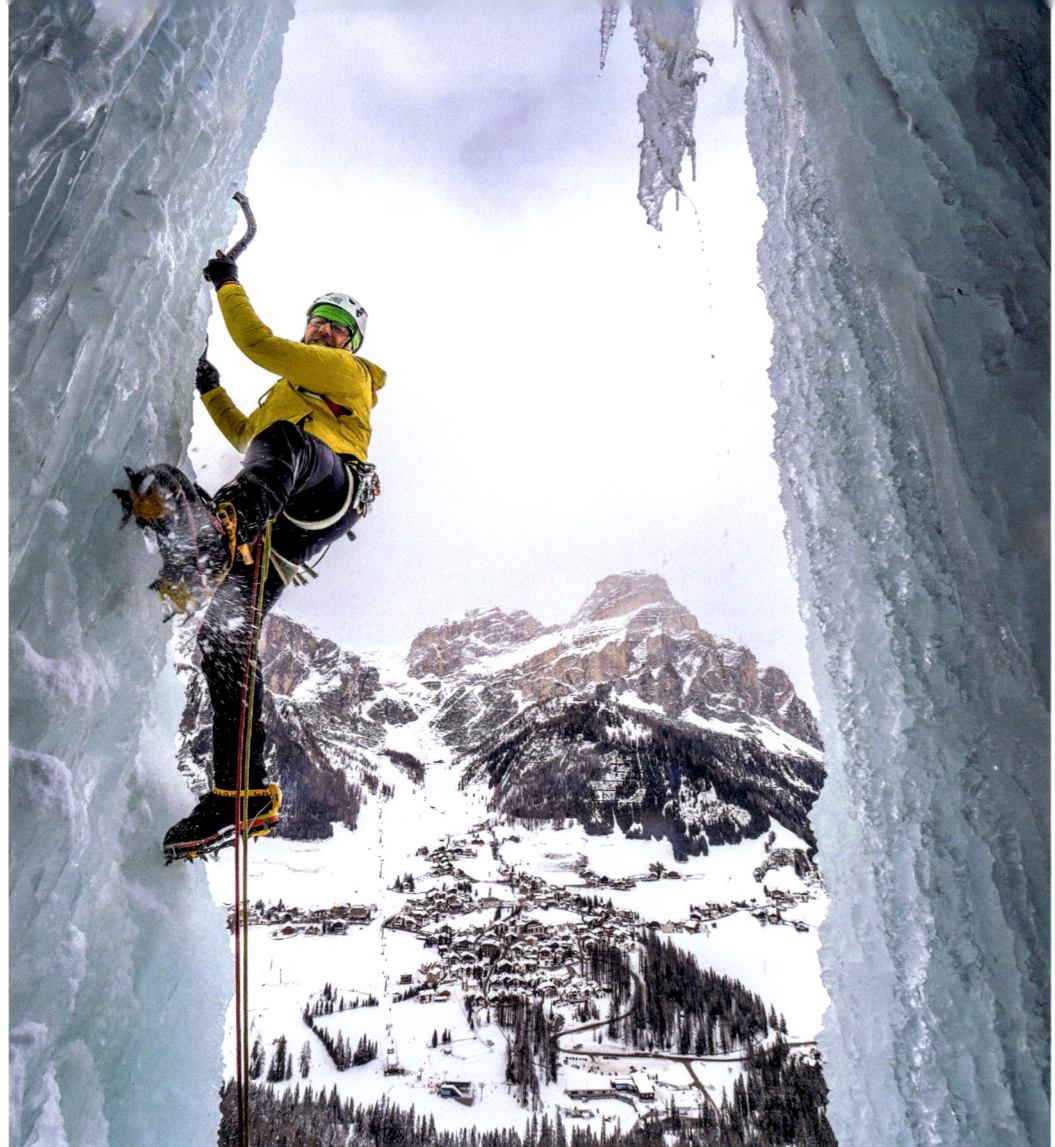

Ice Climbing

The ice climbing season from January to early March represents an excellent opportunity for photographers to capture this wonderfully aesthetic sport. Parties should ensure they have the relevant experience to access the locations and then take great care not to stand immediately below anyone climbing. The following locations are worthy of further research:

Vallunga – This beautiful valley branches north-east from Selva di Val Gardena and is easily accessed.

Val Travenanzes – Cutting through the heart of the Fanes and Tofane groups the Val Travenanzes is a remote and spectacular valley containing some 50 ice falls.

Colfosco – The north face of the Sella massif opposite Colfosco rarely receives any sun throughout the winter and as such features a number of fantastic falls which are nearly always in great condition.

Serrai di Sottoguda – The Dolomites premier ice climbing venue is covered in detail on page 266.

MOUNTAIN SPORTS – ROAD & MOUNTAIN BIKING

Since the Giro d'Italia first came through the Dolomites in 1937, road biking has been hugely popular in the region. The Maratona dles Dolomites and the Sella Ronda Bike Day followed, with some 30,000 cyclists taking to the road each year for the official events alone. In fact, during the summer months the road cyclists often outnumber the cars as you traverse the mountain passes.

While undoubtedly smaller in scale, mountain biking is also seeing a surge in popularity following the construction of several dedicated downhill freeride tracks. New trails are going up all the time and the Sella Ronda lift system can now be utilised to reduce the amount of ascent around the famous circuit of the massif.

From a photographer's perspective, the bikes and cyclists of both disciplines present some excellent foreground opportunities to the surrounding mountains, or indeed make for interesting shooting subjects in their own right.

Road Biking

If you wish to photograph road cyclists in the Dolomites, the official race events (Giro d'Italia, Maratona dles Dolomites and Sella Ronda Bike Day) undoubtedly present the best opportunities. The roads are closed to motorised traffic and the volume of cyclists makes creating dramatic compositions much easier. Try and pick a suitable scenic location near the start of the race when the riders will be bunched up together. For example, the Passo Campolongo looking down towards Corvara and Sassongher is perfect for the Sella Ronda Bike Day. The races take place in:

Giro d'Italia Late May or Early June
Sella Ronda Bike Day June & September
Maratona dles Dolomites .. July

To photograph cyclists outside of the official race days, the mountain passes are the obvious place to start. The Campolongo, Pordoi, Sella, Gardena, Valparola, Falzarego and Giau passes are amongst the most photogenic.

Mountain Biking

The Sella Ronda off-road circuit is one of the most popular mountain bike itineraries and provides a logical start point for photographers looking to capture the cyclists in action. The route can be completed in either direction, although anti-clockwise is generally considered to be harder and is subsequently less frequented. The trail is well marked and maps of the exact route can be picked up from any of the tourist offices found in the major towns.

Alternatively there are now a number of dedicated 'freeride' downhill tracks found within the Dolomites that are perfect for fast and dramatic action shots. Just take care to keep well clear of the course while shooting, avoiding potential fall zones.

The following runs are perfect for sports photographers:

VAL DI FUNES & VAL GARDENA
Freeride Ciampinoi trail
www.val-gardena.com/?artid=1957&lang=eng&pagid=63

ALTA BADIA
Freeride Furcia
Freeride Gassl
Freeride Herrnsteig
Freeride Piz de Plaies
www.kronplatz.com/en/summer/downhill-freeride

CORTINA D'AMPEZZO
Bike Cinque Torri Freeride 15
Bike Mietres Freeride 14
Bike Superpanorama Freeride 6
www.dolomiti.org/en/cortina/tours-itineraries/bike-routes-trails

PALE DI SAN MARTINO
San Martino Bike Arena
www.sanmartinobikearena.com/en

Next spread: The Tre Cime di Lavaredo. Nikon D810, 14–24mm at 14mm, ISO 100, 1/160s at f/6.3, Jun.

Above: Amateur cyclists leaving Corvara and beginning the ascent up the Campolongo pass during Sella Ronda Bike Day. Nikon D810, 14–24mm at 14mm, ISO 100, 1/500s at f/5.6, Jul. ***Below***: The dedicated downhill trails are excellent for action photography; just be sure to stand well out of the way! Nikon D610, 14–24mm at 14mm, ISO 5000, 1/2000s at f/2.8, Oct.

APPENDIX

APPENDIX A – USEFUL CONTACT INFORMATION

General
www.visitdolomites.com
Best overview site of the Dolomites with lots of information.

www.dolomitisupersummer.com/en
The primary resource for activities and lift information throughout the summer months.

www.dolomitisuperski.com/en
The primary resource for skiing and lift pass information.

www.dolomites.org
Overview site with a focus on accommodation.

www.accommodation-dolomites.com
Accommodation search resource.

Airport transport services
www.altoadigebus.com
Transfer service from Munich, Innsbruck, Bergamo and Milan airports.

www.busgroup.eu
Transfer service from Milan, Bergamo and Munich airports.

www.cortinaexpress.it
Transfer services from Treviso and Venice airports.

Bus companies
www.cortinaexpress.it
In addition to offering airport transfers, it offers local services between Cortina and the Alta Badia.

www.dolomitibus.it
Public service serving the Belluno and Cadore regions.

www.sad.it
Public service serving Bolzano, Brunico, the Alta Badia, the Val Gardena and Cortina.

www.sii.bz.it/en
An online timetable for local bus services in the Dolomites. This is the best resource for planning a journey and can also be used to buy bus passes.

Tourist information

VAL PUSTERIA
+39 0474 555722
www.pustertal.com

BOLZANO, CATINACCIO & CAREZZA
+39 0462 609500
www.fassa.com

VAL DI FUNES & VAL GARDENA
+39 0471 777900
www.valgardena.it

ALTA BADIA
+39 0471/836176
www.altabadia.org

PASSO SELLA, PORDOI & FEDAIA
+39 0436 79130
www.arabba.it

VAL FIORENTINA & PASSO GIAU
+39 0437 720243
www.valfiorentina.it

CORTINA D'AMPEZZO & PASSO TRE CROCI
+39 0436 866252
www.cortina.dolomiti.org

MISURINA
+39 0435 99603
www.auronzomisurina.it/en

PALE DI SAN MARTINO
+39 0439 768867
www.sanmartino.com

BRENTA
+39 0465 447501
www.campigliodolomiti.it

The Tre Cime south faces as seen from Lago Antorno. Nikon D810, 16–35mm at 16mm, ISO 100, 15s at f/16, tripod, ND filter, Jun.

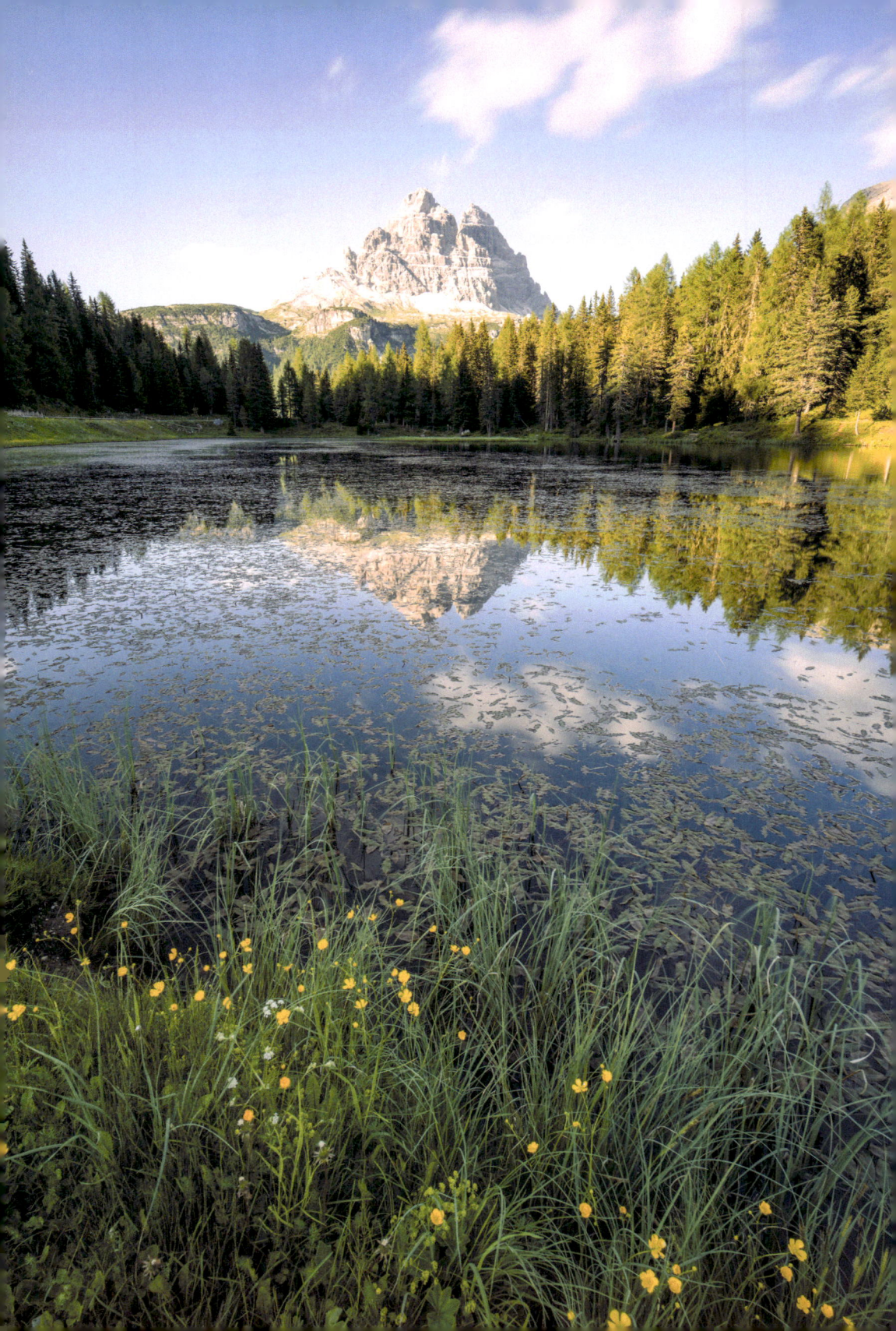

APPENDIX B – GLOSSARY OF PLACE NAMES

Below is a list of the more commonly used Italian and German names used throughout the Dolomites. For more information on the Dolomites unique melange of spoken languages see page 66.

Towns and passes

Italian	German
Badia	Abtei
Bolzano	Bozen
Brunico	Bruneck
Campitello	Kampidel im Fasstal
Canazei	Kanetschei
Castelrotto	Kastelruth
Chiusa	Klausen
Colfosco	Kolfosch
Cortina d'Ampezzo	Hayden (obsolete)
Corvara in Badia	Kurfar / Corvara
Dobbiaco	Toblach
La Villa	Stern
Longiarù	Campill
Ortisei	St Ulrich
Passo Campolongo	Campolongopass
Passo Carezza / Costalunga	Karerpass
Passo delle Erbe	Würzjoch
Passo Falzarego	Falzaregopass
Passo Gardena	Grödnerjoch
Passo Giau	Giaupass
Passo Pordoi	Pordoijoch
Passo San Pellegrino	Sankt-Pelegrin-Pass
Passo Sella	Sellajoch
Passo Staulanza	Staulanzapass
Passo Valparola	Valparolapass
Pozza di Fassa	Potzach im Fasstal
San Cassiano	Sankt Kassian
San Martino in Badia	Sankt Martin in Thurn
Santa Cristina	St. Christina in Gröden
Selva di Val Gardena	Wolkenstein in Gröden
Sesto	Sexten

Mountains and groups

Italian	German
Alpe di Suisi	Seiser Alm
Catinaccio	Rosengarten
Catinaccio d'Antermoia	Kesselkogel
Cima Catinaccio	Rosengartenspitze
Cinque Dita	Fünffingerspitze
Croda Rossa	Hohe Gaisl
Marmolada	Marmolata
Monte Specie	Strudelkopf
Odle	Geisler
Piz Boè	Boespitze
Punta Grohmann	Grohmannspitze
Sass de Putia	Pietlerkofel
Sassolungo	Langkofel
Sass de Stria	Hexenstein
Sasso della Croce	Heiligkreuzkofel
Sass Pordoi	Pordoi Spitze
Sass Rigais	Geislerspitzen
Sciliar	Schlern
Torri del Vajolet	Vajolettürme
Tre Cime	Drei Zinnen

Lakes

Italian	German
Lago di Braies	Pragser Wildsee
Lago Carezza	Karersee
Lago di Dobbiaco	Toblacher See
Lago di Landro	Dürrensee

***Above**: Last light on Vallunga valley and the Puez-Odle group. Nikon Z7II, 100–400mm at 200mm, ISO 200, 1/500s at f/8, Sep.
Below: A 12 image panorama of Lago Ghedina. Nikon Z7II, 20mm, ISO 64, 1/100s at f/11, tripod, Sep.*

APPENDIX C – USEFUL PHRASES

Opposite: Traditional Tyrolean dress. Nikon D810, 80–400mm at 400mm, ISO 280, 1/400s at f/5.6.

Above: A procession through the town of Canazei in the Val di Fassa. Nikon D810, 105mm, ISO 100, 1/640s at f/2.8.

Useful phrases in Italian and German

English	Italian	German
Thank you	Grazie	Danke
Thank you very much	Grazie tante	Vielen dank
You're welcome	Prego	Bitte schön
Please	Per favore	Bitte
Yes	Sì	Ja
No	No	Nein
Excuse me / Pardon me	Mi scusi	Entschuldigung
I'm sorry	Mi dispiace	Es tut mir leid
I don't understand	Non capisco	Ich verstehe nicht
I don't speak Italian/German	Non parlo italiano	Ich spreche kein Deutsch
I don't speak Italian/German well	Non parlo molto bene italiano	Ich speche nicht viel Deutsch
Do you speak English?	Parla inglese?	Sprechen Sie Englisch?
Please speak slowly	Parli piano, per favore	Bitte langsam sprechen
What is your name?	Come si chiama?	Wie heißen Sie?
How are you?	Come va?	Wie geht's?
How much does that cost?	Quanto costa?	Wie viel kostet das?
Where is the bathroom / toilet?	Dov'è la toilette?	Wo ist die Toilette?
Excuse me sir you are in my shot	Scusa ma sei nella mia foto	Entschuldigen aber sie sind in meinem Foto
Say cheese	Sorridi!	Bitte lächeln

ABOUT THE AUTHOR – JAMES RUSHFORTH

Biography

James Rushforth is a climber, mountaineer, skier, travel writer and guest speaker. An internationally acclaimed photographer and author who has worked with distinguished publishing houses Rockfax, Cicerone Press and FotoVue. James was the *Travel Media Awards Photographer of the Year* in 2022, *GTMA Global Travel Award winner* and *British Drone Photographer of the Year* in 2020, the *British Guild of Travel Writers Photographer* of the Year in 2018, 2019, 2020, 2021, 2022, 2023 and 2024, a double category winner at the *International Photography Awards* in 2018, and Epson Digital Splash Photographer of the Year, also in 2018.

In 2021 James authored 'Photographing Iceland' – a two volume set of photo-location guidebooks that would claim four prestigious publishing awards during 2022 – Travel winner at the *Best Indie Book Awards*, Guidebook of the Year at both the *British Guild of Travel Writers* and *Outdoor Writers and Photographers Guild* annual awards, and Travel Guidebook of the Year at the *Foreword INDIES* awards.

His work frequently appears in guidebooks, publications and magazines around the world, with recent double page spreads in the Guardian, Telegraph, Express, Star and Independent newspapers. He has been interviewed on the BBC and his images have been exhibited at high profile venues such as Edinburgh Waverley, the National Maritime Museum and London Paddington; whilst on social media he is part of the National Geographic Your Shot photography team.

Based in the UK, James spends much of his time exploring the Dolomites and Iceland, where he has authored a number of books to both regions. He has partnered with Wild Photography Holidays to lead specialist photography workshops to the Arctic, Greenland, Iceland, the Faroe Islands, Norway, India and Italy.

James is a member of the British Guild of Travel Writers, a Breakthrough Photography, Wilkinson Cameras & f-stop ambassador, is part of the Norrøna Pro Team and is kindly supported by Hilleberg.

If you would like more information on James' work, are interested in his public speaking or photography workshops, or would just like to get in touch, please don't hesitate to contact him.

Connect with James on:

Instagram – James.Rushforth
Facebook – James Rushforth Photography
– www.JamesRushforth.com

James is also the author of the climbing guidebook to the Dolomites published by Rockfax, the Via Ferrata guidebook to the Dolomites, and the ski touring and snowshoeing guidebook to the Dolomites, both published by Cicerone.